MILLER'S
Picture
PRICE GUIDE

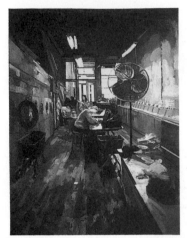
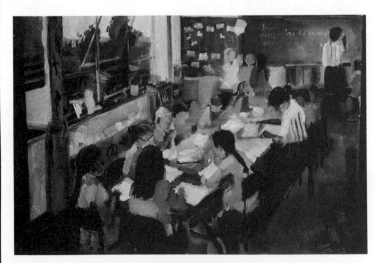

MILLER'S
Picture
PRICE GUIDE

Consultants
Judith and Martin Miller

General Editor
Madeleine Marsh

1996–1997
Volume IV

MILLER'S PICTURE PRICE GUIDE 1996/97

Created and designed by
Miller's Publications
The Cellars, High Street,
Tenterden, Kent, TN30 6BN
Tel: 01580 766411

Consultants: Judith & Martin Miller

General Editor: Madeleine Marsh
Editorial and Production Co-ordinator: Sue Boyd
Editorial Assistants: Gail Jessel, Marion Rickman, Jo Wood, Gill Judd
Production Assistants: Gillian Charles, Karen Tayler
Advertising Executive: Melinda Williams
Advertisting Assistant: Joanne Daniels
Index compiled by: DD Editorial Services, Beccles
Design: Jody Taylor, Kari Reeves, Matthew Leppard
Photographers: Ian Booth, Robin Saker

First published in Great Britain in 1995
by Miller's, an imprint of
Reed International Books Limited,
Michelin House, 81 Fulham Road,
London SW3 6RB
and Auckland, Melbourne, Singapore and Toronto

© 1995 Reed International Books Limited

A CIP catalogue record for this book is
available from the British Library

ISBN 1-85732-609-1

Bromide output by Perfect Image, Hurst Green, E. Sussex
Illustrations by G.H. Graphics, St. Leonards-on-Sea
Colour origination by Scantrans, Singapore
Printed and bound in England by William Clowes Ltd.,
Beccles and London

Front Cover Illustrations:
Top left: *William Henry Hamilton Trood (1860–99) – Wait till the Clouds Roll by.* **£7,000–8,000** C
Top right: *William Stephen Coleman (1829–1904) – Halcyon Days.* **£8,000–9,000** Bon
Centre left: *Albrecht Dürer (1471–1528) – The Rhinoceros.* **£112,000–120,000** S
Bottom left: *Osi Audo (b1955) – The Sleepwalker.* **£2,500–3,000** SG
Bottom right: Hamlet *poster, 1949.* **£1,200–1,500** S(NY)

ACKNOWLEDGEMENTS

The publishers would like to acknowledge the great assistance given by our consultants:

Chris Beetles	8 Ryder Street, London SW1Y 6QB
Timothy Bruce-Dick	Alberti Gallery, 114 Albert Street, London NW1 7NE
Laurence Hallett	Tel: 0171 798 8977
Claudia Hill	Bonhams, Montpelier Galleries, Montpelier Street, London SW7 1HH
Rebecca Hossack	Rebecca Hossack Gallery, 35 Windmill Street, London W1P 1HH
Bill Jackson	Heath Gallery. Tel: 01491 875758
Joy Jarrett	Witney Antiques, 96-100 Corn Street, Witney, Oxfordshire OX8 7BU
James Lloyd	Burlington Paintings, 10 Burlington Gardens, London W1X 1LG
Joslyn McDiarmid	Grosvenor Prints, 28 Shelton Street, London WC2H 9HP
Andrew McKenzie	Phillips, 101 New Bond Street, London W1Y 0AS
Mrs. L. Minahan	Equus Art Gallery, Sun Lane, Newmarket, Suffolk CB8 8EW
Charley O'Brien	Bonhams, Montpelier Galleries, Montpelier Street, London SW7 1HH
Bernard Reed	Marine Watercolours. Tel: 01372 272374
Martin Riley	Brightwell Antiques Centre, Tetsworth, Oxfordshire, OX9 7AB
Michael Whitehand	Marine Prints, 21 Meadowcroft Road, The Ridings, Driffield, Yorkshire YO25 7NJ
Christopher Wood	Christopher Wood Gallery, 141 New Bond Street, London W1Y 9FB

We would like to extend our thanks to all auction houses and dealers who have assisted us in the production of this book.

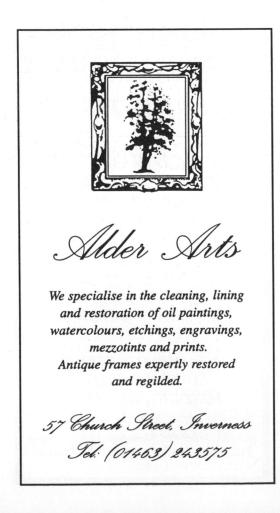

KEY TO ILLUSTRATIONS

*Each illustration and descriptive caption is accompanied by a letter code. By referring to the following list of Auctioneers (denoted by *) and Dealers (•) the source of any item may be immediately determined. Inclusion in this edition no way constitutes or implies a contract or binding offer on the part of any of our contributors to supply or sell the goods illustrated, or similar articles, at the prices stated. Advertisers in this year's directory are denoted by †.*

If you require a valuation for an item, it is advisable to check whether the dealer or specialist will carry out this service and if there is a charge. Please mention Miller's when making an enquiry. Having found a specialist who will carry out your valuation it is best to send a photograph and description of the item together with a stamped addressed envelope for the reply. A valuation by telephone is not possible.

Most dealers are only too happy to help you with your enquiry, however, they are very busy people and consideration of the above points would be welcomed.

1853 • 1853 Gallery, Salts Mill, Victoria Road, Saltaire, Shipley, Yorkshire BD18 3LB. Tel: 01274 531163

AH *† Hartley, Andrew, Victoria Hall, Little Lane, Ilkley, Yorkshire LS29 8EA. Tel: 01943 816363

ALG • Alberti Gallery, 114 Albert Street, London NW1 7NE. Tel: 0171 485 8976

AMC • Chadwick, Anna-Mei, 64 New Kings Road, London SW6 4LT. Tel: 0171 736 1928

AND • Anderson, Joan & Bob, Hatch End Antiques Centre, 294 Uxbridge Road, Hatch End, Pinner, Middlesex HA5 4HP. Tel: 0181 561 4517

APS • Antique Print Shop, The, 11 Middle Row, East Grinstead, Sussex RH19 3AX. Tel: 01342 410501

Art •† Artistic License, The Old Coach House, Dundalk Street, Carlingford, Co Louth, Ireland. Tel: 00 353 427 3745

AwL • Lloyd Gallery, Andrew, 17 Castle Street, Farnham, Surrey GU9 7JA. Tel: 01252 724333

BCG •† Betley Court Gallery, Betley, Nr Crewe, Cheshire CW3 9BH. Tel: 01270 820652

Bea * Bearnes, Rainbow, Avenue Road, Torquay, Devon TQ2 5TG. Tel: 01803 296277

BKS * Robert Brooks (Auctioneers) Ltd, 81 Westside, London SW4 9AY. Tel: 0171 228 8000

BlA • Brightwell Antiques, The Swan Antiques Centre, Tetsworth, Oxfordshire OX9 7AB. Tel: 01844 281777

Bne • Bourne Gallery Ltd, 31-33 Lesbourne Road, Reigate, Surrey RH2 7JS. Tel: 01737 241614

Bon * Bonhams, Montpelier Galleries, Montpelier Street, London SW7 1HH. Tel: 0171 584 9161

BOU • Boundary Gallery, 98 Boundary Road, London NW8 ORH. Tel: 0171 624 1126

BOX • Boxer, Henry, 98 Stuart Court, Richmond Hill, Richmond , Surrey, TW10 6RJ. Tel: 0181 948 1633

BRG •† Brandler Galleries, 1 Coptfold Road, Brentwood, Essex CM14 4BM. Tel: 01277 222269

BrS • Bruton Street Gallery, 28 Bruton Street, London W1Y 7DB. Tel: 0171 499 9747

BSG • Sinfield Gallery, Brian, Compton Cassey Galleries, Compton Cassey House, Nr Withington, Glos. GL54 4DE. Tel: 01242 890500

BuP •† Burlington Fine Paintings Ltd, 12 Burlington Gardens, London W1X 1LG. Tel: 0171 734 9984

BWe * Biddle and Webb Ltd, Ladywood Middleway, Birmingham, West Midlands, B16 0PP. Tel: 0121 455 8042

C * Christie, Manson & Woods Ltd, 8 King Street, St James's, London SW1Y 6QT. Tel: 0171 839 9060

C(S) * Christie's Scotland Ltd, 164-166 Bath Street, Glasgow, Scotland G2 4TB. Tel: 0141 332 8134

CAG * Canterbury Auction Galleries, 40 Station Road West, Canterbury, Kent CT2 8AN. Tel: 01227 763337

CASoc Contemporary Art Society, 20 John Islip Street, London, SW1P 4LL. Tel: 0171 821 5323

CAT • Catto Animation, 41 Heath Street, London, NW3 6UA. Tel: 0171 431 2892

CBL • Beetles Ltd, Chris, 8 & 10 Ryder Street, St. James's, London SW1Y 6QB. Tel: 0171 839 7551

CCG • O'Connor Gallery, Cynthia, 17 Duke Street, Dublin 2, Ireland. Tel: 00 353 679 2177/679 2198

CDL Lewis, Catherine D, 2427 East Avenue, Stevensville, Ontario, Canada L0S 1S0.

CE • Century Gallery, 100 Fulham Road, Chelsea, London SW3 6HS. Tel: 0171 581 1589

CG • Coltsfoot Gallery, Hatfield, Leominster, Hereford & Worcs. HR6 0SF. Tel: 01568 760277

CKG • Crane Kalman Gallery, 178 Brompton Road, London SW3 1HQ. Tel: 0171 584 7566/225 1931

CLG • Clare Gallery (Tunbridge Wells), Kent.

CNY * Christie Manson & Woods International Inc, 502 Park Avenue, (including Christie's East), New York, U.S.A. NY 10022. Tel: 001 212 546 1000

CON •† Contemporary Fine Art Gallery, The, 31 High Street, Eton, Windsor, Berkshire SL4 1HL. Tel: 01753 854315

CRO • Coronets & Crowns (Robert Taylor), Unit J12, Grays in the Mews, 1-7 Davies Mews, London W1Y 1AR. Tel: 0171 493 3448

CSK * Christie's South Kensington Ltd, 85 Old Brompton Road, London SW7 3LD. Tel: 0171 581 7611

CSKe • CSK Gallery, 55 Eton High Street, Windsor, Berkshire, SL4 6BL. Tel: 01753 840519

CW • Wood Gallery, Christopher, 141 Bond Street, London W1Y 0BS. Tel: 0171 499 7411

DA * Dee, Atkinson & Harrison, The Exchange Saleroom, Driffield, Yorkshire YO25 7LD. Tel: 01377 43151

DaD * Dockree, David, 224 Moss Lane, Bramhall, Stockport, Cheshire SK7 1BD. Tel: 0161 485 1258

Dag • Daggett Gallery, Charles, 153 Portobello Road, London W11 2DY. Tel: 0171 229 2248 Mobile 0374 141813

DMF • Miller Fine Arts, Duncan, 17 Flask Walk, Hampstead, London NW3 1HJ. Tel: 0171 435 5462

DN * Dreweatt Neate, Donnington Priory, Donnington, Newbury, Berkshire RG13 2JE. Tel: 01635 31234

Do • Liz Farrow T/As Dodo, Stand F037, Alfie's Antique Market, 13-25 Church Street, London NW8 8DT. Tel: 0171 706 1545

E * Ewbank, Welbeck House, High Street, Guildford, Surrey GU1 3JF. Tel: 01483 232134

EAG • Equus Art Gallery, Sun Lane, Newmarket, Suffolk CB8 8EW. Tel: 01638 560445

EDG • Edwards Gallery, Eley Place, Royal Victoria Place, Tunbridge Wells, Kent TN1 2SP. Tel: 01892 514164

EHL • Harvey-Lee, Elizabeth, Original 15th-20th Century Prints, 1 West Cottages, Middle Aston Road, North Aston, Oxfordshire OX6 3QB. Tel: 01869 347164

ELG •† Lawson Gallery, Enid, Antiques Centre, 36a Kensington Church Street, London W8 4DB. Tel: 0171 376 0552/0171 937 9559

FAS Fine Art Society Plc, The, 148 New Bond Street, London W1Y 0JT. Tel: 0171 629 5116

FCG • Flying Colours Gallery, 8/15 Chesham Street, London SW1X 8ND. Tel: 0171 235 2831

FdeL •† Fleur de Lys Gallery, 227A Westbourne Grove, London W11 2SE. Tel: 0171 727 8595

FT • Florence Trust, The, St Saviour's Church, Aberdeen Park, Highbury, London N5 2AR. Tel: 0171 354 0460

GCP • Clarke, Graham (Prints) Ltd, White Cottage, Green Lane, Boughton Monchelsea, Maidstone, Kent ME17 4LF. Tel: 01622 743938

GeC • Campbell, Gerard, Maple House, Market Place, Lechlade-on-Thames, Glos. GL7 3AB. Tel: 01367 52267

GG • Graham Gallery, 1 Castle Street, Tunbridge Wells, Kent TN1 1XJ. Tel: 01892 526695

GHI • Gandolfi House Interiors, 211-213 Wells Road, Malvern, Hereford & Worcs. WR14 4HF. Tel: 01684 569747

GK • Gallery Kaleidoscope, 64-66 Willesden Lane, London NW6 7SX. Tel: 0171 328 5833

GP •† Grosvenor Prints, 28-32 Shelton Street, Covent Garden, London WC2H 9HP. Tel: 0171 836 1979

Gra • Graham Gallery, Highwoods, Burghfield, Nr Reading, Berkshire, RG7 3BG. Tel: 01734 832320

HaG • Hart Gallery, The, 23 Main Street, Linby, Nottingham, Notts NG15 8AE. Tel: 0115 963 8707

HeG • Heath Galleries, Berkshire. Tel: 01491 875758

HFA •† Haynes Fine Art, The Bindery Gallery, 69 High Street, Broadway, Hereford & Worcs. WR12 7DP. Tel: 01386 852649

HHG • Hampton Hill Gallery, 203-205 High Street, Hampton Hill, Middlesex TW12 1NP. Tel: 0181 977 1379/5273

HJO • Oliver, H J & Sons, 17, St Georges Avenue South, Wolstanton, Newcastle, Staffordshire ST5 8DB. Tel: 01782 633248

HLG •† Hayloft Gallery, Berry Wormington, Broadway, Worcestershire WR12 7NH. Tel: 01242 621202

HO • Hone, Angela, The Garth, Mill Road, Marlow, Bucks., SL7 1QB. Tel: 01628 484170

HP • Potts, Henry, School House, Chillingham, Alnwick, Northumberland NE66 5NJ. Tel: 01668 215309

HSS * Henry Spencer and Sons, 20 The Square, Retford, Notts DN22 6BX. Tel: 01777 708633

HVM • Hutton Van Mastrigt Art, 26 North View Terrace, Mytholmes Lane, Haworth, Yorkshire BD22 8HJ. Tel: 01535 643882

JA • Asplund Fine Art, Jenny, Open by Appointment only, Surrey. Tel: 01372 464960/Mobile 0860 424448

JAd * Adam & Sons, James, 26 St Stephen's Green, Dublin 2, Ireland. Tel: 00 3531 676 0261/661 3655

JCFA • Colman Fine Art, James, The Tower, 28 Mossbury Road, London SW11 2PB. Tel: 0171 924 3860

JDG • Denham Gallery, John, 50 Mill Lane, London, NW6 1NJ. Tel: 0171 794 2635

JG •† Jerram Gallery, 7 St John Street, Salisbury, Wiltshire SP1 2SB. Tel: 01722 412310

JGG • George Gallery, Jill, 38 Lexington Street, Soho, London W1R 3HR. Tel: 0171 439 7343/7319

JN •† Noott Fine Paintings, John, 14 Cotswold Court, Broadway, Hereford & Worcs. WR12 7AA. Tel: 01386 852787

JNic *† Nicholson, John, The Auction Rooms, Longfield, Midhurst Road, Fernhurst, Haslemere, Surrey GU27 3HA. Tel: 01428 653727

JnM • Martin of London, John, 38 Albermarle Street, London W1X 3FB. Tel: 0171 499 1314

KG • Kilvert Gallery, Ashbrook House, Clyro, Hay-on-Wye, Hereford & Worcs. HR3 5RZ. Tel: 01497 820831

L * Lawrence Fine Art Auctioneers, South Street, Crewkerne, Somerset TA18 8AB. Tel: 01460 73041

L&E * Locke & England, Black Horse Agencies, 18 Guy Street, Leamington Spa, Warwickshire CV32 4RT. Tel: 01926 889100

LA • Llewellyn Alexander (Fine Paintings) Ltd, 124-126 The Cut, Waterloo, London SE1 8LN. Tel: 0171 620 1322

LFA • Lincoln Fine Art, 33 The Strait, Lincoln, Lincolnshire LN2 1LS. Tel: 01522 533029

LG • Lamont Gallery, 65 Roman Road, Bethnal Green, London E2 0QN. Tel: 0181 981 6332

LH •† Hallett, Laurence (LAPADA), London. Tel: 0171 798 8977

Lon Lonergan, Lolly, Kent. Tel: 01233 758617

LS • Lotus House Studios, 25 Station Road, Lydd, Romney Marsh, Kent TN29 9ED. Tel: 01797 320585

LyB Broberg, Lynne, Staffordshire. Tel: 01889 270234

M * Morphets of Harrogate, 4-6 Albert Street, Harrogate, Yorkshire HG1 1JL. Tel: 01423 502282

MAI • Andipa & Son, Maria, Icon Gallery, 162 Walton Street, Knightsbridge, London SW3 2JL. Tel: 0171 589 2371

Mar •† Marine Watercolours, Surrey. Tel: 01372 272374

MAT * Matthews, Christopher, 23 Mount Street, Harrogate, Yorkshire HG2 8DQ. Tel: 01423 871756

MBA • Fine Art & Antiques, 4 Miles Buildings (off George St), Bath, Avon, BA1 2QS.

MES • Messengers, 27 Sheep Street, Bicester, Oxfordshire OX6 7JF. Tel: 01869 252901

MGP Popple, Mark Grant, London NW2 2AR. Tel: 0181 455 5411

MI • Manya Igel Fine Arts Ltd, 21-22 Peters Court, Porchester Road, London W2 5DR. Tel: 0171 229 1669

MJB * Bowman, Michael J, 6 Haccombe House, Nr Netherton, Newton Abbott, Devon TQ12 4SJ. Tel: 01626 872890

MP •† Marine Prints, 21 Meadowcroft Road, The Ridings, Driffield, Yorkshire YO25 7NJ. Tel: 01377 241074

MTG •† Music Theatre Gallery, 1 Elystan Place, London SW3 3LA. Tel: 0171 823 9880

N * Neales, 192-194 Mansfield Road, Nottingham, Notts. NG1 3HU. Tel: 0115 962 4141

NAG • Apollo Gallery, 18 Duke Street (off Grafton Street), Dublin 2, Ireland. Tel: 00 353 1 671 2609

NBO • Bowlby, Nicholas, 9 Castle Street, Tunbridge Wells, Kent TN1 1XJ. Tel: 01892 510880

NEW • New Ashgate Gallery, Waggon Yard, Farnham, Surrey GU9 7PS. Tel: 01252 713208

NGG • New Grafton Gallery, 49 Church Road, London SW13 9HH. Tel: 0181 748 8850

NZ •† Zborowska, Nina, Damsels Mill, Paradise, Painswick, Glos. GL6 6UD. Tel: 01452 812460

OSh • O'Shea Gallery, 120a Mount Street, Mayfair, London W1Y 5HB. Tel: 0171 629 1122

P * Phillips, Blenstock House, 101 New Bond Street, London W1Y 0AS. Tel: 0171 629 6602

P(L) * Phillips (Leeds), Hepper House, 17a East Parade, Leeds, Yorkshire LS1 2BH. Tel: 0113 244 8011

P(M) * Phillips, Trinity House, 114 Washway Road, Sale, Gt. Manchester M33 1RF. Tel: 0161 962 9237

PC Private Collection.

PHG • Hedley Gallery, Peter, 10 South Street, Wareham, Dorset BH20 4LT. Tel: 01929 551777

PN •† Piano Nobile Fine Paintings, 26 Richmond Hill, Richmond, Surrey TW10 6QX. Tel: 0181 940 2435

Pol • Polak Gallery, 21 King Street, St James's, London SW1Y 6QY. Tel: 0171 839 2871

Q • Questor, 13/14 Margaret Place, Woburn, Bedfordshire MK17 9PZ. Tel: 01525 290658

RAA Royal Academy of Arts, Piccadilly, London, W1V ODS. Tel: 0171 439 5615

RAS Royal Academy Shop, Royal Academy of Arts, Piccadilly, London W1V 0DS. Tel: 0171 439 7438

RB • Billcliffe Fine Art, Roger, 134 Blythswood Street, Glasgow, Scotland G2 4EL. Tel: 0141 332 4027

RBB *† Russell, Baldwin & Bright, Fine Art Salerooms, Ryelands Road, Leominster, Hereford & Worcs. HR6 8NZ. Tel: 01568 611166

RCA Royal College of Art, The, Kensington Gore, London SW7 2EU. Tel: 0171 584 5020

RD * Deveau Galleries, Robert, Fine Art Auctioneers, 297-299 Queen Street, Toronto, Ontario, Canada M5A 1S7. Tel: 00 416 364 6271

RdeR• Rogers de Rin, 76 Royal Hospital Road, London SW3 4HN. Tel: 0171 352 9007

RGFA• Green Fine Art, Roger, Hales Place Studio, High Halden, Ashford, Kent TN26 3JQ. Tel: 01233 850794

RHF • Hossack Fitzrovia, Rebecca, 35 Windmill Street, London, W1P 1HH. Tel: 0171 436 4899

RHG • Hossack Gallery, Rebecca, 35 Windmill Street, London W1P 1HH. Tel: 0171 436 4899

RIC • Rich Designs, 1 Shakespeare Street, Stratford-upon-Avon, Warwickshire CV37 6RN. Tel: 01789 261612

RMG • Miles Gallery, Roy, 29 Bruton Street, London W1X 7DB. Tel: 0171 495 4747

ROY • Royall Fine Art, 52 The Pantiles, Tunbridge Wells, Kent TN2 5TN. Tel: 01892 536534

S * Sotheby's, 34-35 New Bond Street, London W1A 2AA. Tel: 0171 493 8080

S(A) * Sotheby's Australia, 13 Gurner Street, Paddington, Australia NSW2021. Tel: 00 02 332 3500

S(Am)* Sotheby's Amsterdam, Rokin 102, Amsterdam, The Netherlands 1012 KZ. Tel: 00 31 20 627 5656

S(HK)* Sotheby's, 502-503 Exchange Square Two, 8 Connaught Place Central, Hong Kong. Tel: 00 852 2524 8121

S(NY)* Sotheby's, 1334 York Avenue, New York, U.S.A. NY 10021. Tel: 001 212 606 7000

S(S) * Sotheby's Sussex, Summers Place, Billingshurst, Sussex RH14 9AB. Tel: 01403 783933

S(Sc) * Sotheby's, 112 George Street, Edinburgh, Scotland EH2 4LH. Tel: 0131 226 7201

S(T) * Sotheby's Tai Pei, 1st Floor, No 79 Secl, An Ho Road, Tai Pei, Taiwan R.O.C. Tel: 00 886 2 755 2906

SFA • Savage Fine Art, The Gate House, Haselbech, Northampton, Northants. NN6 9LQ. Tel: 01604 20327

SG • Savannah Gallery, 45 Derbyshire Street, London E2 6HQ. Tel: 0171 613 0474

SHF • Hunter Fine Art, Sally, London. Tel: 0171 235 0934

SJG • St James's Gallery, 9 Margaret Buildings, Brock Street, Bath, Avon BA1 2LP. Tel: 01225 319197

SK * Skinner Inc, The Heritage On The Garden, 63 Park Plaza, Boston, U.S.A. MA 02116. Tel: 001 617 350 5400

SK(B)* Skinner Inc, 357 Main Street, Bolton, U.S.A. MA 01740. Tel: 001 508 779 6241

SOL •† Solomon Gallery, The, Powerscourt Townhouse Centre, South William Street, Dublin 2, Ireland. Tel: 00 353 1679 4237

SPE • Spectrum, Sylvie, Stand 372, Grays Market, 58 Davies Street, London W1Y 1LB. Tel: 0171 629 3501

SRAB• Russell, Sarah, Antiquarian Books and Prints, 11 Oxford Row, Lansdown Road, Bath, Avon BA1 2QW. Tel: 01225 427594

TAB • Tabor Gallery, The Barn, All Saints Lane, Canterbury, Kent CT1 2AU. Tel: 01227 462570

TAR • Tarrant Antiques, Lorraine, 7-11 Market Place, Ringwood, Hampshire BH24 1AN. Tel: 01425 461123

TAY * Taylors, Honiton Galleries, 205 High Street, Honiton, Devon EX14 8LF. Tel: 01404 42404

TBG • Barnes Gallery, The, 51 Church Road, Barnes, London SW13 9HH. Tel: 0181 741 1277

THG •† Hunt Gallery, The, 33 Strand Street, Sandwich, Kent CT13 9DS. Tel: 01304 612792 Tel/Fax: 01227 722287

TLB • Linda Blackstone Gallery, The, The Old Slaughter House, Rear of 13 High Street, Pinner, Middlesex HA5 5QQ. Tel: 0181 868 5765

Tr • Treadwell, Nicholas, Upper Park Gate, Bradford, Yorkshire BD1 5DW. Tel: 01274 306065/64

VAL • Valentyne Dawes Gallery, The, Church Street, Ludlow, Shropshire SY8 1AP. Tel: 01584 874160

VCG •† Vicarage Cottage Gallery, Preston Road, Northshields, Tyne & Wear NE29 9PJ. Tel: 0191 257 0935

VKY • Hawkins, Vicky, London.

WG • Walker Galleries, 6 Montpelier Gardens, Harrogate, Yorkshire HG1 2TF. Tel: 01423 567933

WHP • Patterson, W H, 19 Albermarle St, London W1X 3HA. Tel: 0171 629 4119

WiA • Witney Antiques, 96-100 Corn Street, Witney, Oxfordshire OX8 7BU. Tel: 01993 703902

WL * Wintertons Ltd, Lichfield Auction Centre, Wood End Lane, Fradley, Lichfield, Staffordshire WS13 8NF. Tel: 01543 263256

WO •† Wiseman Originals Ltd, 34 West Square, London SE11 4SP. Tel: 0171 587 0747

WOT • World of Transport, The, 37 Heath Road, Twickenham, Middlesex TW1 4AW. Tel: 0181 891 3169

WrG •† Wren Gallery, 4 Bear Court, High Street, Burford, Oxfordshire OX18 4RR. Tel: 01993 823495

WWG• Wilkins and Wilkins Gallery, 1 Barrett Street, London W1A 6DN. Tel: 0171 935 9613

WyG • Wyllie Gallery, 44 Elvaston Place, London SW7 5NP. Tel: 0171 584 6024

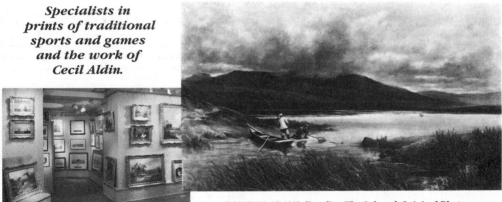

CONTENTS

HOW TO USE THIS BOOK

Miller's Picture Price Guide has been reorganised this year to make it even easier to use and it covers more areas of the art market than ever before.

Pictures have been classified by subject-matter and arranged alphabetically.
Each section allows you to compare pictures and prices within a specific field, providing a general view of the market within that area.

Many of the categories are set out chronologically (by century).
This enables the reader to see how a particular subject has been treated over the centuries, how styles have developed and how prices compare.

Larger categories have been broken down into specific topics and organised alphabetically.
For example, the Animals section is sub-divided into specific types (Cats, Dogs, Farmyard Animals, etc) whilst Landscapes includes a section devoted to pictures of named towns and famous views, catalogued by country (American, British, Dutch and Flemish Towns, etc).

To find an artist by name, consult the index at the back of book.
This will refer you to the page where his or her works are illustrated.

Where possible, each individual entry includes the name, dates and nationality of the artist, the title, medium and measurements of the picture, Miller's price range and finally the source code. The source code refers to the auction house or dealer that the picture comes from. The full selection of codes, catalogued in alphabetical order can be found in the Key to Illustrations on page 7.
The Key to Illustrations provides the full address and telephone numbers of contributing dealers, galleries, and auction houses, also offering a useful list of contacts for the reader and picture collector, including galleries and auction houses throughout Britain and covering salerooms across the world.

Many sections begin with helpful introductions, setting subjects in their historical and commercial context and offering practical advice to new

collectors from auctioneers, dealers and leading specialists in individual fields.
These introductions offer a general guide to collecting, whilst within the sections, caption footnotes give background history to individual pictures and painters.

The Glossary on page 382 explains the basic art terms used.
The additional subject matter covered in this year's edition means that Miller's is encompassing a wider range of media than ever before and the glossary has been expanded accordingly.

Price ranges have been carefully worked out by our experts to reflect the current state of the market place.
While Miller's offers a guide to values, no publication can claim to provide a definitive price list. As in any other business, the art market changes, painters and pictorial subjects go in and out of fashion, and prices fluctuate depending on a host of economic variables. Prices for auction house pictures include the auctioneers' commission (usually 10–15% of the bid price). Dealers' prices reflect the retail market.

No two pictures are ever the same.
The value of a picture depends on the artist, subject, rarity, quality and condition. Prices are also affected by who is selling a picture, how many people want to buy it and where and when it is sold.

Exchange rates used in this edition of Miller's Picture Price Guide:
£1 = $US 1.50
£1 = DFl 2.42 (Netherlands)
£1 = $T 44 (Taiwan)
£1 = A$ 2.12 (Australia)

The aim of all Guides is to be as comprehensive as possible. *Miller's Picture Price Guide* **covers pictures of every type and value from a wide range of sources. If you have any information to add or names and topics to suggest for the next edition, we would be delighted to hear from you.**

INTRODUCTION

Everyone fantasises about discovering a lost masterpiece and for some this dream comes true. Turn to page 31 and you will find the tale of the Inverness-shire lollipop lady who purchased a cat painting for 50p from a car boot sale. Bought for the price of a can of cat food, the painting subsequently fetched £22,000 at auction. The rhinoceros print, featured on this year's front cover, was found amongst a bundle of prints that had lain undisturbed for years in a trunk in a family's outhouse. To the owner's astonishment, it proved to be a rare work by Dürer, worth over £100,000.

Miller's Picture Price Guide gives you the stories behind the pictures and covers the whole range of the art market, from prints worth £10 to paintings valued at millions of pounds. Pictures are included from both art dealers and auction houses, giving a complete profile of how works of art are bought and sold and portraying a full range of picture prices in the 1990s.

This edition boasts several new categories, reflecting recent developments in the marketplace. The past season has seen the first ever sales in London auction houses devoted to architectural interiors and film posters. Both subjects are featured and each has its own particular fascination.

Many interiors were painted by amateur female artists in the 19thC and as the pictures and prices show, you did not have to be male or a professional painter to produce a fine and potentially valuable painting.

Film posters, long popular in the USA, are now becoming increasingly collectable in Great Britain. Record prices are being paid for British film posters – will future film fans be fighting in the salerooms for posters of *Four Weddings and a Funeral*? Watch this space, since we will be following the progress of posters in future guides.

Another new category is Russian painting. The break down of the Soviet block has brought a wealth of Russian paintings on to the British market, both at auction and in the galleries. Is Russia a land of opportunity for the art collector? Turn to our section on Russian painting (page 356) and judge for yourself. Auction houses are covered not only in Britain but across the world. We have included pictures from the London and provincial auction houses, Dutch paintings from Amsterdam, old and contemporary masters from the New York salerooms, Aboriginal art auctioned in Australia, and Chinese paintings sold in Hong Kong and Tai Pei.

Most categories include pictures from dealers. By covering works from galleries and private individuals, Miller's can tap into new areas of collecting – featuring artists who have not yet graduated to the auction salerooms, and prices that are still genuinely affordable.

Take Silver Paper Pictures, for example (page 361). These homemade images from the 1930s belong to a private collector with a self-confessed passion for kitsch. Picked up for pennies from jumble sales and church fêtes they are now worth pounds and are beginning to appear in antique shops. The relics of a pre-television age when people 'made their own fun', they will never be made again and their value can only rise.

As examples of a domestic and predominantly female craft, never intended for the saleroom, silver paper pictures can be compared with embroidered pictures and samplers, which have escalated hugely in value in recent years. Featured for the first time in *Miller's Picture Price Guide* on page 105, the section includes advice from a leading dealer, providing background history and tips for the new collector.

Throughout this edition we have consulted specialists in every field. The Marine section suggests how to start a collection and where to look for nautical bargains, whilst in the Animal section you can discover what are the most popular breeds in canine portraits. In Miniatures and Silhouettes (both new categories) experts explain their particular market, offering valuable advice and helpful words of warning to the purchaser. Buyers beware, these tiny and charming portable portraits are always the first thing to go in a burglary.

As well as covering the artists of the past, *Miller's Picture Price Guide* also looks to the future. Concluding the book the Twentieth Century Review: Contemporary Paintings section features the work of living artists, many young, most working in Britain, whose work is beginning to emerge into prominence. Next year we would like to expand this section. We are keen to hear from painters and art students working across the country.

Miller's Picture Price Guide sets collecting in context, examining the history behind pictures and the state of the market today. For anyone who owns pictures it gives a comprehensive review of market trends and values. For those who wish to collect it offers guidelines, contacts and a taste of what is available.

No other guide in this field offers such a broad range of subject matter, or of values, with prices beginning at well under £100. *Miller's Picture Price Guide* reflects the kind of pictures that you might have in your home already or that you may wish to purchase in the future.

ABORIGINAL ART

'Aboriginal art now commands an international market,' claims Rebecca Hossack, art dealer and Australia's Cultural Officer to Britain. 'There are some really great artists out there, doing works that contemporary artists such as Howard Hodgkin would die for!'

Aboriginal paintings are based on the symbolic patterns that the tribes people would paint on their bodies, scratch on weapons or draw in the sand (sand drawings could be up to 2 miles in length). Pictures vary in style depending on the individual tribe and are painted both on bark and canvas. As Hossack explains, the tradition of painting on canvas only emerged in the early 1970s, near Alice Springs, in Northern Territory, Australia, when a local art teacher encouraged the Papunya Aboriginals to translate their dream time stories into two-dimensional art. 'These early pictures sold for between A$20–50,' says Hossack, 'now they can be worth thousands.' At a recent sale of Aboriginal paintings at Sotheby's Sydney, estimates ranged between A$1,000–10,000, though bidding was selective with a number of pictures remaining unsold.

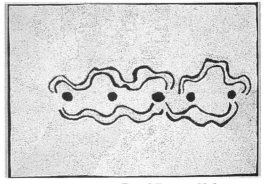

Beryl Barnes Nakamarra
Aboriginal (b1942)
Snake (Warna)
Acrylic on canvas
38 x 52½in (96.5 x 133.5cm)
£1,800–2,000 *RHG*

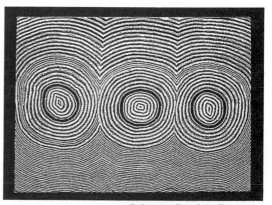

Johnny Gordon Downs
Aboriginal (b1939)
Malpuntilli, South of Balgo
Acrylic on canvas
32¾ x 44½in (83 x 113cm)
£900–1,100 *RHG*

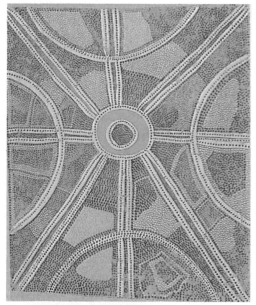

Unknown Pintubi Artist
Aboriginal (20thC)
Untitled, early 1970s
Acrylic on board
26 x 21¼in (66 x 54cm)
£2,000–2,500 *S(A)*

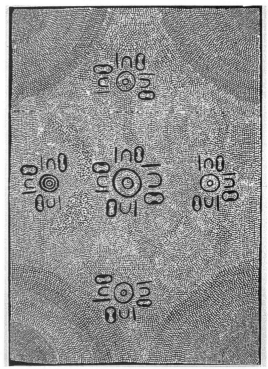

r. **Judy Napangardi Jigili**
Aboriginal (b1930)
Women (Karnta)
Acrylic on canvas, 1994
53½ x 39in (135 x 99cm)
£1,800–2,000 *RHG*

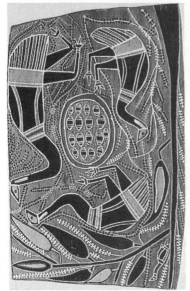

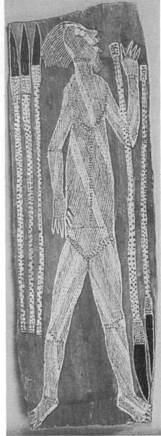

r. **Wally Mandarrk**
Aboriginal (20thC)
A bark painting from Western
Arnhem Land, depicting a
warrior with hunting spears
Old style bark, with hatchwork
designs in white, red and black
ochre, c1960s
35½ x 11½in (90 x 29cm)
£900–1,200 *S(A)*

l. **David Malangi**
Aboriginal (20thC)
Bird Fertility Scene
Earth pigments on bark
28 x 16½in (71.5 x 42cm)
£700–900 *S(A)*

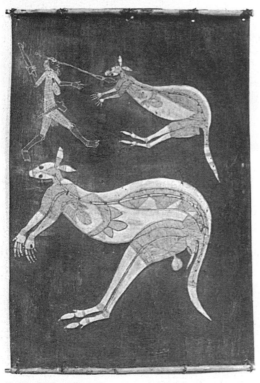

Lofty Nabardayal
Aboriginal (b1926)
Bininj Hunting Plains Kangaroo
Ochres on bark
28½ x 19in (72 x 48cm)
£1,200–1,600 *S(A)*

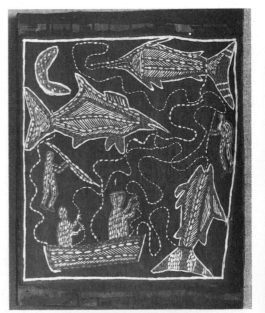

Groote Eylandt Nandubata
Aboriginal (20thC)
Sacred Place of the Shark and Dolphin
Ochre on bark
18¼ x 13¾in (46.5 x 35cm)
£1,000–1,400 *S(A)*

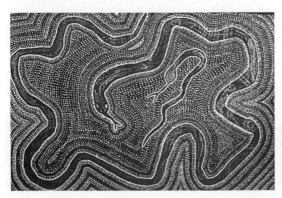

l. **Mirium Olodoodi**
Aboriginal (20thC)
Artist Country
Acrylic on canvas, 1985
24 x 36in (61 x 91.5cm)
£400–500 *RHG*

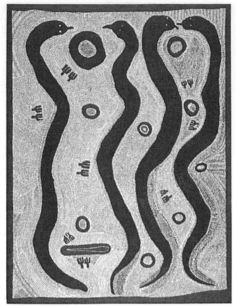

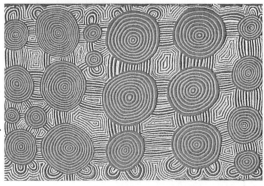

Billy Stockman
Aboriginal (b c1920)
Budgerigar Dreaming
Acrylic on canvas, c1985
120 x 144in (304.5 x 365.5cm)
£14,000–15,000 *RHG*

Jacko Jakamarra Tingiyari
Aboriginal (20thC)
Kurrlkurrlpa Jukurrpa
(Owl Dreaming) 1988
Acrylic on canvas
73½ x 54½in (187 x 138cm)
£2,000–2,500 *S(A)*

r. **Clifford Possum Tjapaltjarri**
Aboriginal (b c1935)
Water Dreaming, 1987
Acrylic on canvas
24in (61.5cm) square
£1,200–1,400 *RHG*

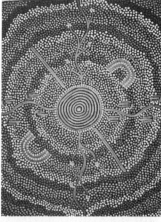

l. **Ronnie Lawson Tjakamarra**
Aboriginal (b c1930)
Water Dreaming
Acrylic on canvas, 1989
59 x 44½in (149.5 x 113cm)
£1,300–1,500 *RHG*

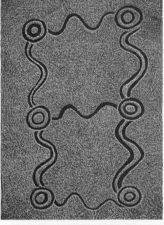

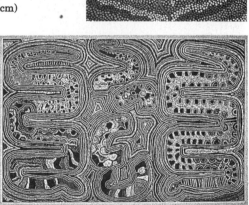

Old Mick Gill Tjakamarra
Aboriginal (b c1919)
Three Snakes Dreaming, Liltjin, Artist Country
Acrylic on canvas, 1989
47¼ x 71in (120 x 180cm)
£6,000–7,000 *RHG*

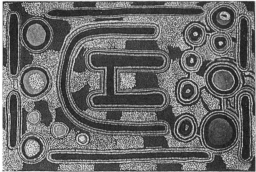

John Mosquito Tjanangari
Aboriginal (b c1910)
Puntukutjara, Artist's Country
Acrylic on canvas, 1989
240 x 358in (610 x 910cm)
£1,800–2,000 *RHG*

r. **Freddy Ward Tjungarrayi**
Aboriginal (20thC)
Tingari Men at Camp Sites near
Kiwirrkura, 1987
Acrylic and ochre on canvas
48 x 72in (122 x 183cm)
£1,500–1,800 *S(A)*

ABSTRACT & MODERN

The following section covers abstract and
modern pictures, many by the established
masters of the century and most sold at
auction in either the UK or the USA. As with
the Impressionists, the market for modern
pictures took a severe battering during the
recession. Prices have still not recovered and
demand remains extremely selective, with
buyers looking for good quality works and
reasonable estimates at auction. This section
includes some of the great pioneers of
modern art and the big names of the
American, European and Modern British
scene. Our '20thC Review: Contemporary
Painting' reviews paintings in Britain today,
concentrating on works by living artists,
many young, whose work tends to be sold
through galleries rather than auction houses.

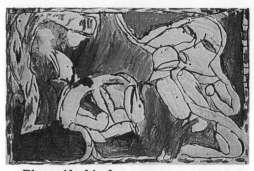

Pierre Alechinsky
Belgian (b1927)
Sans la Coquille
Signed, titled and dated '1978 NY' on reverse,
acrylic on paper mounted on canvas
39½ x 60½in (100 x 154cm)
£25,000–30,000 *C*

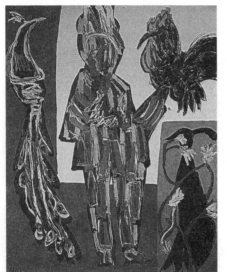

Karel Appel
Dutch (b1921)
The Birdsman
Signed, titled and dated '1986',
oil on canvas
96 x 76in (243.5 x 193cm)
£14,000–15,000 *CNY*

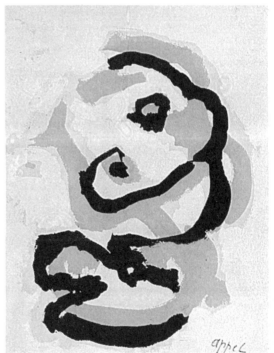

Karel Appel
Dutch (b1921)
Untitled
Signed, gouache on paper
12¾ x 9½in (32 x 24cm)
£2,500–3,000 *S*

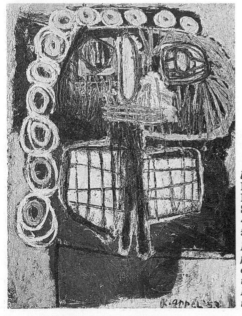

l. **Karel Appel**
Dutch (b1921)
La Femme aux Boucles Rouges
Signed and dated '53', oil on canvas
45½ x 35in (115 x 89cm)
£135,000–150,000 *C*

*In Paris in 1948 Appel and Alechinsky were both
founder members of COBRA, a group of artists
dedicated to exploring the expression of the
unconscious, uncontrolled by rational thought.
Primitive masks and children's drawings were a major
inspiration and a clear influence in the present work.*

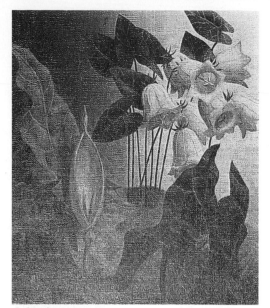

Jean Arp
French (1887–1966)
Deux Têtes
Oil and string on canvas, 1927
25½ x 31¾in (65 x 80.5cm)
£98,000–108,000 *S(NY)*

*From 1927–39, Arp created numerous string
reliefs, several being variations of the theme of
two heads engaged in some mysterious dialogue.*

John Armstrong
British (1893–1973)
Study for the City
Oil on canvas
12 x 10in (30.5 x 25cm)
£2,500–3,000 *NZ*

r. **Frank Auerbach**
British (b1931)
Reclining Figure II
Signed in pencil, original
screenprint, 1966,
numbered from an
edition of 70, published
by Marlborough Fine Art
Image 23 x 31½in
(59 x 80cm)
£800–850 *WO*

Grosvenor Gallery
Modern Masters

Grosvenor Gallery
18 Albemarle Street, London W1X 3HA
Telephone 0171-629 0891
Facsimile 0171-491 4391

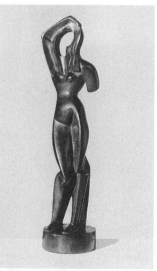

Alexander Archipenko
"Woman Combing her Hair"
1915, Bronze
35cm High

André Derain
"Tete de Femme" c.1918
Sanguine
60 X 42cm

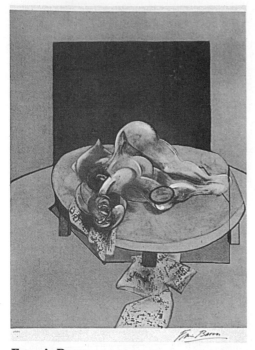

Francis Bacon
British (1909–92)
Triptych Studies for the Human Body
Signed and numbered '123/250' lithograph
printed in colours, by Marlborough Graphics,
Inc., New York, 1979
39¾ x 26in (101 x 66cm)
£3,000–4,000 *S(NY)*

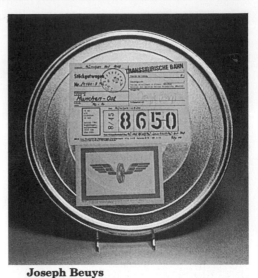

Joseph Beuys
German (1921–86)
Transiberian Rail
Signed in pencil, and stamp numbered '8/45',
multiple 16mm film in metal canister, with
railway sticker on the cover, published by
Edition der Galerie Heiner Friedrich, and
Edition Schellmann & Klüser, Munich, 1980
14½in (37cm) diam.
£1,500–1,600 *S(NY)*

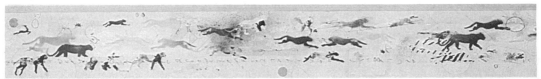

Alighiero e Boetti
Italian (1940–94)
Untitled
Inscribed 'Pensando ad Alessandra e all' immensa
confusione nel mio cuore mi sento drasticamente
cretino', signed and inscribed on reverse, spray
paint, pencil and gouache on paper mounted on
canvas laid down on wood, 1988-89
10 x 59¼in (25 x 150cm)
£3,500–4,000 *S*

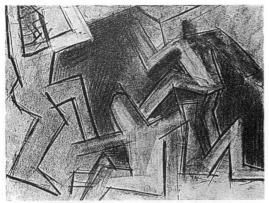

David Bomberg
British (1890–1957)
Study for in the Hold
Charcoal, c1912
9 x 11in (23 x 28cm)
£2,000–2,200 *BOX*

Les Brown
British (b1930)
The Sleeper
Oil and mixed media on board
26in (66cm) square
£225–275 *TAB*

Marcel Broodthaers
Belgian (1924–76)
Papa
Mirror
Signed and dated 'Pin 1963',
chair, eggshells, mirror, rope and chalk
Mirror 19¼in (49cm) diam.
Chair 35¼ x 16½ x 13½in (90 x 42 x 34cm)
The chair executed 1966
£60,000–70,000 *C*

Alexander Calder
American (1898–1976)
Du Haut des Pyramides
Signed and dated '70', gouache on paper
29½ x 42½in (75 x 108cm)
£3,000–3,500 *C*

Patrick Caulfield
British (b1936)
The Well
Signed, titled and dated '1966', oil on board
48 x 84in (122 x 213cm)
£15,000–17,000 *P*

Alexander Calder
American (1898–1976)
Escutcheon
Signed with initials and dated '76',
painted metal wall relief
25 x 17in (64 x 43cm)
£65,000–75,000 *C*

*In 1932 Marcel Duchamp coined the word 'mobile',
to describe Calder's moving sculptures, whilst artist
Jean Arp suggested the term 'stabile' for the
stationary constructions that Calder produced in
the same year. Calder was one of the first artists to
create moving sculptures, 'My moving Mondrians'
he called them. Significantly, early in his career
Calder not only studied mechanical engineering,
but worked producing mechanical and moving toys
for the Gould Manufacturing Company, U.S.A.*

Gaston Chaissac
French (b1910)
Personnages
Signed and dated '1962', gouache on paper
laid down on canvas
19 x 13½in (48 x 34cm)
£6,000–7,000 *C*

Sandro Chia
Italian (b1946)
Boy with Fish
Signed and dated '85', oil on paper
48½ x 35⅜in (123 x 91cm)
£17,500–20,000 *C*

Corneille
Dutch (b1922)
The Great Rock-Wall
Oil on board, 1961
9¾ x 6⅞in (25 x 17.5cm)
£5,800–7,000 *C*

Christo
Rumanian (b1935)
Package
Signed and dated '61', packages,
fabric, plastic and string
47¼ x 17¾ x 7in (120 x 45 x 18cm)
£28,000–32,000 *S*

r. **Joseph Cornell**
American (1903–72)
Cherubino: Prism Version Variant
Signed, titled and dedicated 'To Skip 3/11/67',
paper collage on masonite, c1960
12¼ x 9¾in (31 x 25cm)
£12,500–14,000 *S(NY)*

Walter Dahn
German (b1954)
Taxi
Signed and dated '1985' on reverse,
acrylic on canvas
78¾ x 62½in (200 x 159cm)
£4,750–5,750 *S*

Salvador Dali
Spanish (1904–89)
39 Tarot Cards
Each signed, collage of cut-out glossy reproductions
with added gouache and watercolour on board, 1970s
Each image approx. 9¾ x 6¼in (25 x 16cm)
£105,000–120,000 *S(NY)*

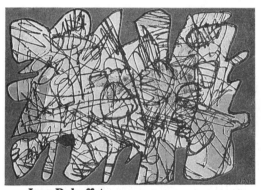

Jean Dubuffet
French (1901–85)
Parachiffre L II
Signed with initials and dated '75', vinyl paint
and acrylic on paper laid down on canvas
25½ x 36¼in (65 x 92cm)
£37,000–42,000 *C*

Jean Dubuffet
French (1901–85)
Cortège
Signed and dated '61', oil on canvas
45¾ x 35in (115 x 89cm)
£245,000–265,000 *C*

*In 1961, the date of the picture, Dubuffet
returned to Paris having spent 6 years in the
South of France. The dynamism of the city
inspired his art, 'I want to fill the site of the
painting with magic . . .', he wrote excitedly.
'I want my streets to be crazy, my pavements,
shops and flats to enter into a mad dance
which is why I transform the shapes and
colours.' To capture this vitality he used
fragmented shapes and jarring colours,
applied with brush, palette knife, sponge
and fingers. He was openly exhilerated by
this fresh approach. 'I feel a need that every
work of art should in the highest degree lift
one out of context, provoking surprise and
shock,' he wrote at the end of that year. 'A
painting does not work for me unless it is
completely unexpected.'*

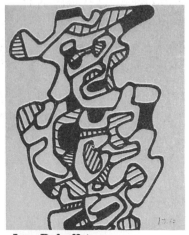

Jean Dubuffet
French (1901–85)
Personnage au Chapeau (mi-corps)
Signed with initials and dated '67',
black felt-tip pen on paper
10½ x 8½in (26 x 21cm)
£4,750–5,750 *C*

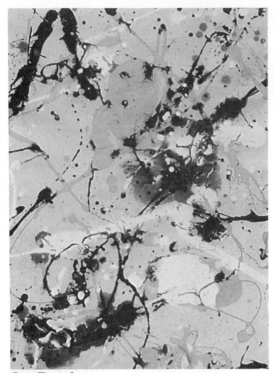

Sam Francis
American (b1923)
Untitled
Signed and dated '1989' on reverse,
acrylic on paper
18¾ x 13½in (47 x 34cm)
£12,750–14,000 *C*

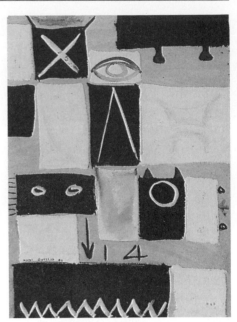

Adolph Gottlieb
American (1903–74)
Cryptic Tablets
Signed and dated '46', titled and
dated on reverse, gouache on paper
13¾ x 10¼in (35 x 25.5cm)
£8,500–9,000 *S(NY)*

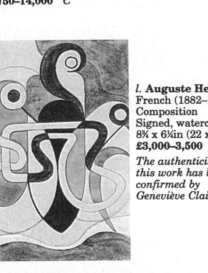

l. **Auguste Herbin**
French (1882–1960)
Composition
Signed, watercolour
8¾ x 6¼in (22 x 16cm)
£3,000–3,500 *S*

*The authenticity of
this work has been
confirmed by
Geneviève Claisse.*

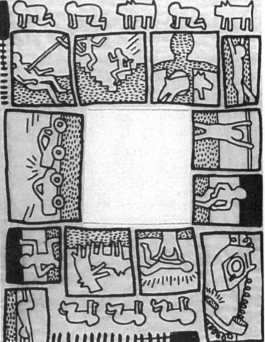

Keith Haring
American (1958–90)
Untitled
Signed and stamp dated 'Jan 15 1981',
ink on vellum
54 x 41½in (137 x 105)
£21,500–22,500 *S(NY)*

l. **Richard Hamilton**
British (b1922)
My Marylin (Waddington 59)
Signed in pencil, dated '66' and numbered '60/75', on
TH Saunders paper, silkscreen printed in colours,
published by Editions Alecto, London, with full margins
20¼ x 24¾in (52 x 63.5cm)
£3,000–4,000 *S(NY)*

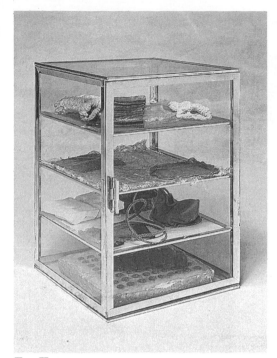

Eva Hesse
American (1936–70)
Untitled (Kardon Glass Case)
Latex rubber, plaster, wire mesh, burlap and
latex-coated gauze in glass and metal case
14½ x 10¼ x 10¼in (37 x 25.5 x 25.5cm) overall
£54,000–58,000 S(NY)

*Executed in 1968, this case is one of 3 made by
Eva Hesse in 1967 and 68.*

David Hockney
British (b1937)
An Etching and a Lithograph for Editions
Alecto (S.A.C. 129)
Signed in pencil, dated '72' and numbered
'25/100', etching, aquatint and lithograph
printed in colours, on English Mouldmade
paper, published by Editions Alecto, with
full margins, 1973
31 x 20in (79 x 51cm)
£1,700–2,000 S(NY)

Frances Hodgkins
British (1870–1947)
East Anglian Farm
Signed, dated '1939' and inscribed 'No. 3',
watercolour and pencil
15½ x 20in (39 x 51cm)
£8,500–9,500 P

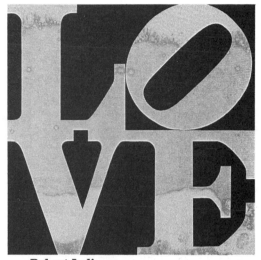

Robert Indiana
American (b1928)
Love No. 2
Signed, dated '66' and numbered '2' in stencil
on the reverse, oil on canvas
24in (61cm) square
£32,000–35,000 S(NY)

Asger Jorn
Danish (1914–73)
Gelbe Kippe
Signed and dated '71', gouache on paper
14 x 18¾in (36 x 47.5cm)
£7,000–8,000 C

Mark Lancaster
British (b1938)
Five Marilyn Monroe Paintings 1987–88
Each signed and variously dated on canvas overlap,
oil on canvas
Each 12 x 10in (30.5 x 25cm)
£2,200–3,000 C

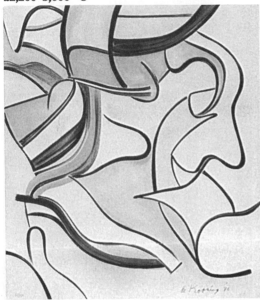

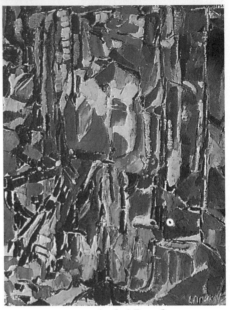

André Lanskoy
Russian/French (1902–76)
Untitled
Signed, oil on canvas
39½ x 28¾in (100 x 73cm)
£10,000–12,000 C

Willem de Kooning
American/Dutch (b1904)
A suite of 4 lithographs, printed in colours, each
signed in pencil, dated '86' and numbered '72/100',
from an edition of 180, on Arches paper, published
by Editions de la Différence, printed to the edges,
1987, in original portfolio
Each sheet 28¼ x 24¾in (72 x 63cm)
£7,000–7,500 S(NY)

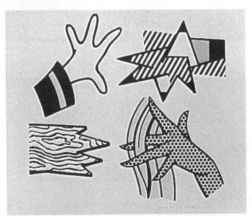

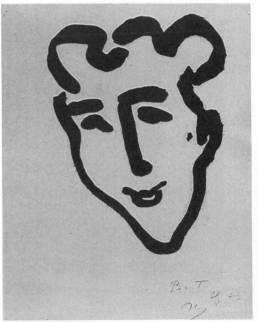

Roy Lichtenstein
American (b1923)
Study of Hands
Signed in pencil, dated and inscribed 'AP 12/24',
silkscreen printed in colours, one of 24 artist's
proofs, apart from the numbered edition of 100,
published by Castelli Graphics, New York
Each sheet 31½ x 32¾in (80 x 83cm)
£2,500–3,500 S(NY)

Henri Matisse
French (1869–1954)
Masque Aigu (D.791)
Initialled in pencil, inscribed 'B à T, 25 + 5', the
Bon à Tirer impression for the edition of 25 plus
5 artist's proofs, aquatint, on Lana wove paper,
with full margins, 1948
Image 9½ x 7in (24 x 17.5cm)
£3,500–4,500 S(NY)

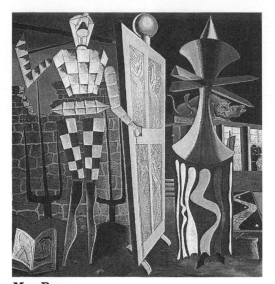

Man Ray
American (1890–1976)
Le Beau Temps
Signed, titled and dated 'Paris MCMXXXIX',
oil on canvas
82¾ x 78¾in (210 x 200cm)
£530,000–600,000 *S*

*Man Ray kept a sketchbook by his bed so that he
could draw his dreams upon waking. According
to the artist this picture, painted in 1939, was
the ultimately happy outcome of 8 separate
nightmares. 'Fair Weather is my most
representative work,' claimed Man Ray proudly,
'it constitutes the climax of my Surrealist
period.' Bidders clearly agreed at Sotheby's Man
Ray sale where the painting made a record price
for a work by the artist.*

Henri Michaux
Belgian (1899–1984)
Personnages Deformes
Signed with initials, Indian ink,
charcoal and pastel on paper
20¼ x 14in (51 x 35.5cm)
£4,500–5,500 *S*

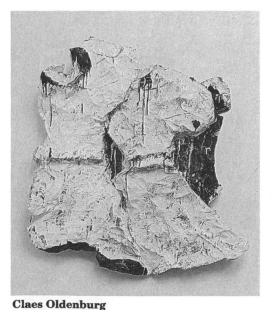

Claes Oldenburg
American (b1929)
Girls' Dresses blowing in the Wind
Signed with initials, dated '1961' on reverse,
muslin soaked in plaster over wire frames,
painted with enamel
44⅛ x 40¾ x 6in (113 x 103.5 x 15cm)
£135,000–150,000 *S(NY)*

*Girls' Dresses was created for Oldenburg's
Store, the 1961 installation of crafted objects
assembled in a Lower East Side storefront.*

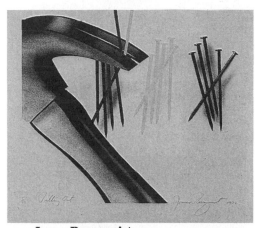

James Rosenquist
American (b1933)
Pulling Out
Signed in pencil, dated, titled and numbered
'6/39', lithograph printed in colours, 1972
25½ x 30½in (65 x 77.5cm)
£1,400–1,800 *S(NY)*

Edward Ruscha
American (b1937)
Jelly
Signed and dated '1971', gunpowder on paper
11¼ x 29in (29.5 x 73.5cm)
£7,000–8,500 *S(NY)*

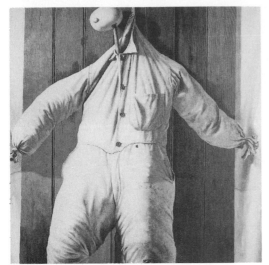

David Shan
British (1952–88)
Balcony Balloon
Signed, titled and dated '1981' on reverse,
acrylic on canvas
41 x 40in (104 x 101.5cm)
£120–150 *Bon*

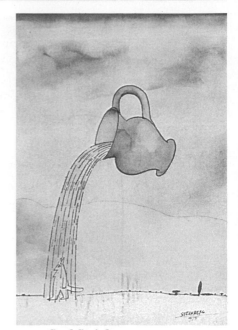

Saul Steinberg
American (b1914)
Rain on Cat (*New Yorker* Cover)
Signed and dated '1975', titled and
numbered '3' on reverse, Indian ink,
watercolour and crayon on paper
20 x 15in (51 x 38cm)
£6,000–7,000 *S(NY)*

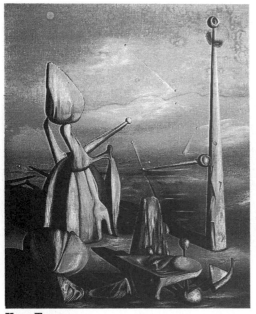

Yves Tanguy
French (1900–55)
Le Prodigue ne Revient Jamais (1)
Signed and dated '43', oil on canvas
11 x 9in (28 x 22.5cm)
£110,000–130,000 *S(NY)*

*Yves Tanguy's career as a painter began in 1922
shortly after the artist saw, through the window
of a Paris bus, an early surrealist work by
Giorgio de Chirico at Paul Guillaume's gallery.
Although few of Tanguy's early works survive,
those that do clearly allude to the 'Italian
squares' of de Chirico of the same period. It was
not until 1927 that Tanguy finally began to find
his way towards the dream-like landscapes
which would establish him as a major figure in
the Surrealist School. It is at this point that we
begin to see those elements – the deep foreground
plane, the blurring of the horizon and the
presence of objects floating in the silent air – that
distinguish works such as this as quintessential
surrealist landscapes.*

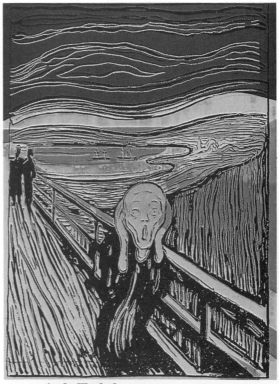

Andy Warhol
American (1928–87)
The Scream, after Edvard Munch
Signed and dated '84' on the overlap, synthetic
polymer silkscreened on canvas
52 x 38in (132 x 96.5cm)
£60,000–70,000 *S*

ANIMALS

A major event in the field of animal art was the Sotheby's sale of paintings, pastels and drawings from the studio of Arthur Wardle (1864–1949), one of Britain's favourite animal artists. Not only did every work sell, but the oil painting 'Leopards Resting' made a world record price of over £100,000. Although particularly famed for his portrayals of big game, Wardle, according to family tradition, rarely, if ever, left Britain and his studies of wild animals were made at London Zoo.

Sydenham Teak Edwards
British (1768–1819)
Porcupine and Cavy
Watercolour
8¾ x 7in (22 x 17.5cm)
£2,000–2,500 *CW*

Carl W. Broemel
American (b1891)
Landscape with Elephants
Signed, watercolour
14¼ x 19in (36.25 x 48.5cm)
£120–200 *SK*

Sean Harris
British (20thC)
King Batori the Vainglorious
Collograph
8¾ x 11in (22 x 28cm)
£65–75 *AwL*

Alison Guest
British (20thC)
English Spot Rabbit
Signed, oil on canvas
8 x 10in (20 x 25cm)
£400–500 *RGFA*

Robert Kretschmer
German (1818–72)
Felis Leo Capinies
Inscribed, watercolour and bodycolour
8½ x 11¼in (21 x 28.25cm)
£1,300–1,600 *CW*

r. Robert Hills, OWS
British (1769–1844)
Stags by a Highland Loch
Watercolour
6 x 4½in (15 x 11cm)
£950–1,150 *WrG*

Wilhelm Kuhnert
German (1865–1926)
A Buffalo in a Field
Signed and inscribed, oil on board
10¾ x 16½in (27 x 42cm)
£18,000–20,000 *C*

Edward Lear
British (1812–88)
Common Mouse, Mus Musculus
Signed and dated 'July 25 1832', watercolour
7¼ x 10¾in (18 x 27cm)
£4,000–5,000 *P*

l. **Arthur Wardle**
British (1864–1949)
Study of a Leopard
Signed and dated '1932', pastel
8¾ x 11¼in (22 x 28.5cm)
£300–400 *S(S)*

Thomas Landseer, ARA
British (1795–1880)
An African Lion
Signed and inscribed, pen
and black ink
4½ x 6½in (11.5 x 16.5cm)
£1,400–1,800 *C*

Sir Edwin Henry Landseer, RA
British, 1802–73
The Deer Family
Oil on canvas
54 x 39in (137 x 99cm)
£110,000–150,000 *S(NY)*

William Walls, RSA, RSW
British (1860–1942)
Jaguar in a Tree
Signed, oil on canvas
30 x 20½in (76 x 52cm)
£1,900–2,400 *S(Sc)*

Arthur Wardle
British (1864–1949)
Dromedary
Signed, pastel
9 x 11¼in (22.5 x 29cm)
£1,400–1,600 *CW*

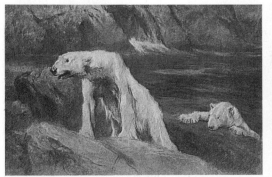

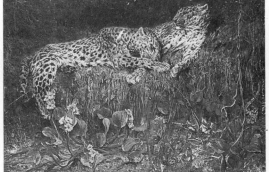

Arthur Wardle
British (1864–1949)
Polar Bears
Pastel
12¼ x 18in (31 x 45.5cm)
£900–1,400 *S(S)*

Arthur Wardle
British (1864–1949)
Leopards Resting
Signed, oil on canvas
41 x 61¾in (104 x 156cm)
£105,000–120,000 *S(S)*

Cats

Cat pictures are internationally popular and can command very impressive prices. Many of the artists are women, and queen of the feline painters is Henriette Ronner-Knip (1821–1909) who provided one of this year's most remarkable success stories. An Inverness-shire lollipop lady purchased a painting of cute little kittens at a car boot sale for 50p, the price of a can of cat food. It proved to be a fine Ronner-Knip and was subsequently sold at auction for over £22,000.

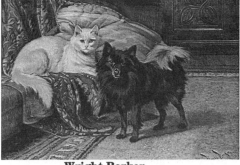

Wright Barker
British (1864–1941)
Kitty & Pip
Signed and inscribed, oil on canvas
26 x 36in (66 x 91.5cm)
£3,750–4,750 *Bon*

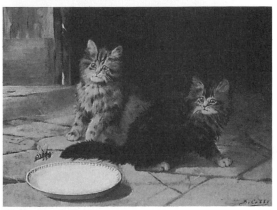

H. Bernard Cobbe
British (active 1868–83)
The Dangerous Intruder
Signed, oil on canvas
15 x 20in (38 x 50.5cm)
£2,000–2,500 *C*

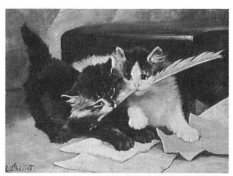

Lilian Cheviot
British (exh 1894–1902)
A Literary Dispute
Signed, oil on canvas
13 x 17¼in (33 x 44cm)
£5,500–6,500 *S*

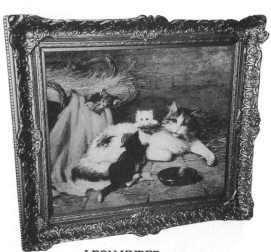

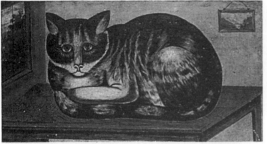

English Provincial School (c1860)
A Study of a Tabby Cat
Oil on paper
11 x 19in (28 x 48cm)
£5,500–6,500 *S(S)*

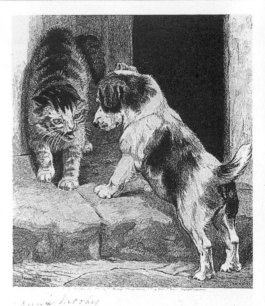

R. Wallace Hester, After Fannie Moody
British (1861–96)
No Way!
Signed, etching
9½ x 8½in (24 x 21cm)
£300–320 *GP*

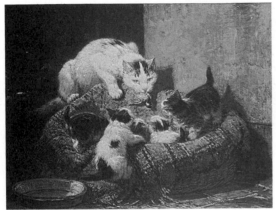

Henriette Ronner-Knip
Dutch (1821–1909)
A Feathered Gift
Signed, authenticated by the artist's
husband and stamped with artist's seal
on reverse, oil on panel
14½ x 18½in (37 x 47cm)
£9,500–12,000 *C*

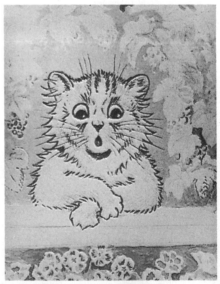

Louis Wain
British (1860–1939)
Cat among Vines and Geraniums
Coloured crayon and watercolour
9¼ x 7in (23.5 x 17.5cm)
£500–600 *Bon*

'Louis Wain,' said H. G. Wells, 'invented a
cat style, a cat society, a whole cat world.'
Wain is probably the most famous cat
painter of all time. Modelled on his wife's
pet kitten, Peter, Wain's anthropomorphised
cats first appeared in books and newspapers
in the 1880s, and by the turn of the century
the artist was a household name. A comic
genius, Wain had a sadly tragic life. His
wife died in 1886, after only 2 years of
marriage. The artist went bankrupt after
WWI, and in 1932 he was certified insane,
spending many of his final years in the
Royal Bethlem Hospital.

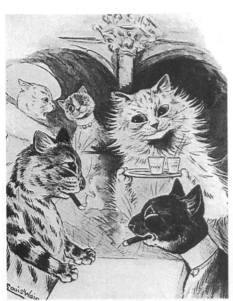

Louis Wain
British (1860–1939)
A Gathering at Florian's
Signed, watercolour, monochrome
16 x 13in (40.5 x 33cm)
£1,200–1,500 *Bon*

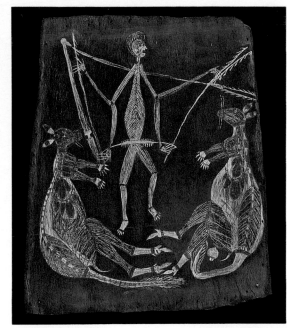

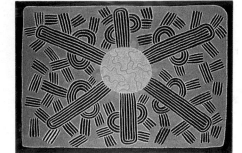

Dane Puerle Ross
Aboriginal (20thC)
Worm Dreaming
Acrylic on canvas, 1993
48 x 60in (122 x 152cm)
£800–1,000 *RHG*

Artist Unknown
North West Australian, 1950s
A Hunter with Spears
Brown, black and white ochre
painted on bark
25¼ x 13½in (64 x 34.5cm)
£4,000–4,500 *S(A)*

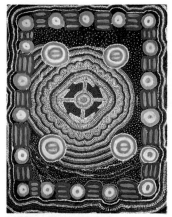

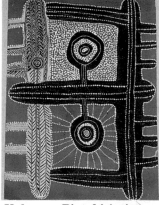

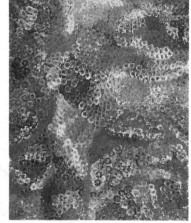

Unknown Pintubi Artist
Aboriginal (20thC)
Untitled 1972
Acrylic and ochre on board
'No.17, 26/9/72' inscribed on reverse
24¾ x 18⅛in (63.5 x 46cm)
£2,300–2,800 *S(A)*

Emily Kame Kngwarre
Aboriginal (b c1910)
Awele Dreaming
Acrylic on canvas, 1993
48in (122cm) square
£2,500–3,000 *RHG*

Milliga Napaltjarri
Aboriginal (b c1920)
Mullayurtju – Artists Country
Acrylic on canvas, 1989
39½ x 30in (100 x 76cm)
£1,800–2,000 *RHG*

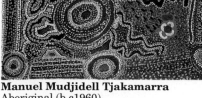

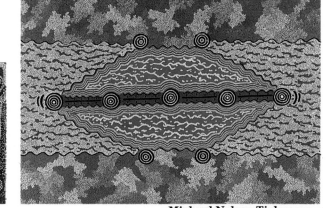

Manuel Mudjidell Tjakamarra
Aboriginal (b c1960)
Balgo Hills – Artists Country
Acrylic on canvas, 1989
24 x 35¾in (61 x 91cm)
£1,600–1,800 *RHG*

Michael Nelson Tjakamarra
Aboriginal (20thC)
Wayuta Dreaming at
Wantapirri, 1985
Acrylic on canvas
48 x 72¼in (122 x 183cm)
£3,000–3,500 *S(A)*

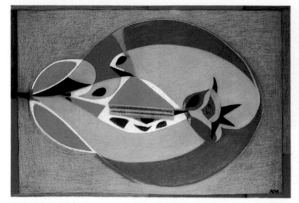

Eileen Agar
British (1904–91)
Oval Object 1953
Signed, oil and crayons on pulpboard
30 x 38in (76 x 96.5cm)
£2,500–3,000 *P*

Yacov Agam
Israeli (b1928)
Ambiance
Signed, painted wood and metal elements
39 x 47¾in (99 x 121cm)
£13,000–14,000 *C*

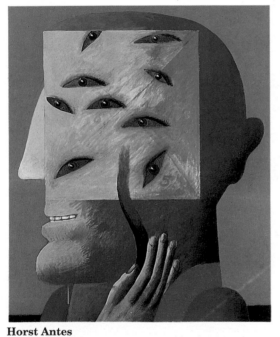

Horst Antes
German (b1938)
Kopf mit neun Augen
Signed, titled and dated '1971' on reverse, acrylic on canvas
47¼ x 39½in (120 x 100cm)
£60,000–70,000 *C*

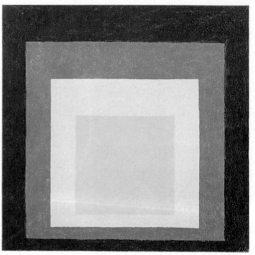

Josef Albers
American (1888–1976)
Homage to the Square No. 37
Initialled and dated '64', oil on masonite
16in (40.5cm) square
£14,000–16,000 *S(NY)*

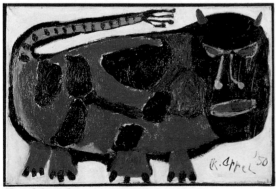

Karel Appel
Dutch (b1921)
Cat
Signed and dated '50', oil on canvas
18 x 26in (45.5 x 66cm)
£60,000–65,000 *C*

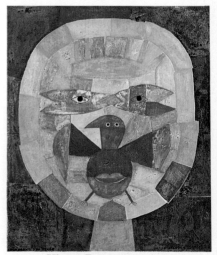

Victor Bruaner
French (1903–66)
Cosmogonie d'un Visage
Signed, titled and dated 'II.1961',
oil on canvas
25½ x 21¼in (65 x 54cm)
£55,000–60,000 *S(NY)*

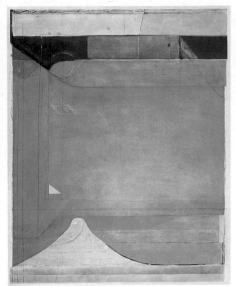

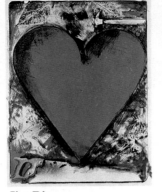

Jim Dine
American (b1935)
A Heart at the Opera
Signed in pencil, dated and
numbered '39/50', 1983,
lithograph printed in colours
50¼ x 38¾in (127.5 x 98cm)
£8,000–9,000 *S(NY)*

Jean Dubuffet
French (1901–85)
Site au Personnages
Signed with initials and
dated '67', coloured felt-
tip pens on paper
10¾ x 8½in (27 x 21.5cm)
£13,000–15,000 *C*

Richard Diebenkorn
American (b1922)
Green
Etching, aquatint and drypoint printed in
colours, 1986, initialled in pencil, dated and
numbered '14/60', on Somerset paper, with
blindstamp of Crown Point Press
45 x 35¼in (114 x 90cm)
£33,000–37,000 *S(NY)*

Peter Halley
American (b1953)
Two cells with Conduit
Dayglo acrylic and Roll-a-tex on canvas, 1985
64 x 108in (162.5 x 274cm)
£40,000–42,000 *S(NY)*

Al Held
American (b1928)
B-G-1
Signed and dated '78' on the reverse,
acrylic on canvas
36 x 48in (91.5 x 122cm)
£17,000–20,000 *S(NY)*

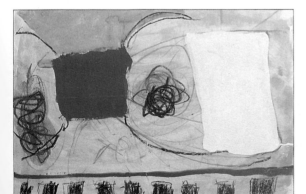

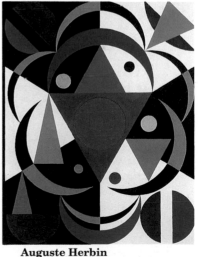

Roger Hilton
British (1911–75)
Abstract
Signature stamp to reverse, inscribed on reverse, 1967,
gouache and charcoal
14½ x 22in (37 x 55.5cm)
£2,000–3,000 *DL*

Auguste Herbin
French (1882–1960)
Rose II
Signed and dated '47', oil on canvas
36¼ x 28¾in (92 x 73cm)
£23,000–25,000 *S*

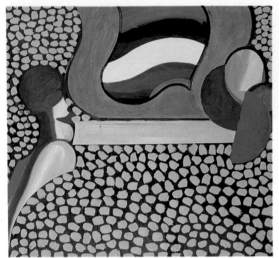

Howard Hodgkin
British (b1932)
Mr & Mrs P. Stringer
Signed, titled and dated '1966-8' twice,
oil on canvas
48 x 50in (122 x 127cm)
£57,000–60,000 *S*

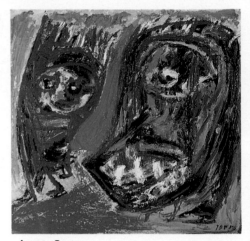

Asger Jorn
Danish (1914–73)
Skaenderi (Quarrelling)
Signed, signed, dated '1951-3' and titled twice
on the reverse, oil on board
23¾ x 24¼in (60.5 x 61.5cm)
£32,000–36,000 *C*

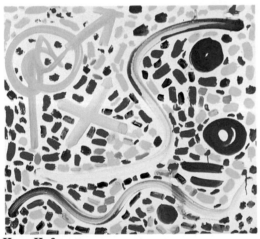

Hans Hofmann
American/German (1880–1996)
Purple and Blue Loop
Signed, oil on cardboard, 1955
31 x 34in (78.5 x 86cm)
£20,000–24,000 *S(NY)*

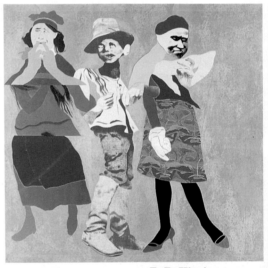

R. B. Kitaj
American (b1933)
Value, Price and Profit
Oil on canvas, 1963
60in (152cm) square
£245,000–275,000 *S*

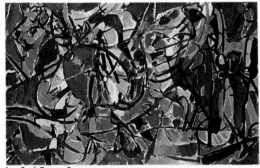

André Lanskoy
Russian/French (1902–76)
Le Refuge des Miserables
Signed, titled and dated '61' on reverse,
oil on canvas
37¾ x 57in (96 x 144.5cm)
£21,000–25,000 *S*

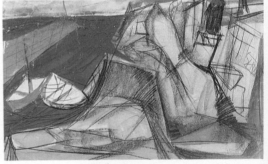

Peter Lanyon
British (1918–64)
Harbour
Signed and dated '51', mixed media
13 x 21in (33 x 53cm)
£3,000–4,000 *DL*

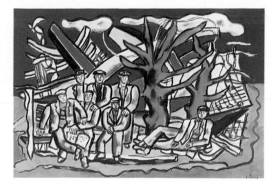

Fernand Léger
French (1881–1955)
L'Equipe au Repos
Signed and dated '51', also signed, titled and
dated on the reverse, oil on canvas
25¾ x 36¼in (65.5 x 92cm)
£320,000–350,000 *S(NY)*

Alfred Leslie
American (b1927)
Untitled
Signed and dated '1960',
oil on collage, various
materials
43½ x 51in (110 x 129cm)
£16,000–18,000 *S(NY)*

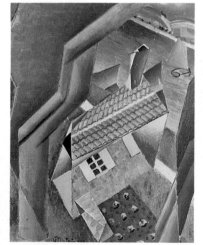

Man Ray
American (1890–1976)
Pêchage
Initialled, plastic peaches,
cotton wool and oil in a
wooden box
14½ x 9½in (37 x 24cm)
£50,000–55,000 *S*

Matta
Chilean (b1911)
Untitled
Signed, oil on canvas, 1975
38 x 39½in (96.5 x 100cm)
£18,500–20,000 *C*

Kenneth Noland
American (b1924)
Winds 82-20
Monotype printed in
colours, extensively
hand painted by the
artist, 1982
86½ x 32in
(220 x 81.5cm)
£5,000–5,500

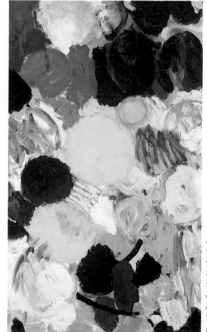

Jean Metzinger
French (1883–1956)
Maison et Champs de Choux
Signed, oil on panel
16 x 13in (40.5 x 33cm)
£15,000–18,000 *S*

l. **Ernst Wilhelm Nay**
German (1902–68)
Gelb und Silbergrau
Signed and dated '1961',
titled and dated '1961'
on the stretcher,
oil on canvas
79 x 49¼in (200 x 125cm)
£215,000–230,000 *S*

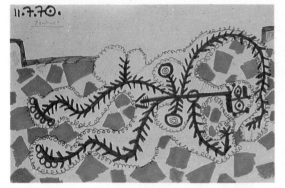

Pablo Picasso
Spanish (1881–1973)
Nu Couche
Signed and dated '11.7.70', felt-tip pen on buff paper
8¾ x 12¼in (22 x 31cm)
£16,000–20,000 *S*

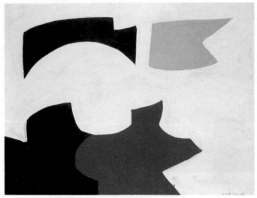

Serge Poliakoff
Russian (1900–69)
Composition Blanc, Rouge, Noir et Jaune
Signed, oil on canvas, 1967
25 x 31½in (64 x 80cm)
£20,000–25,000 *S*

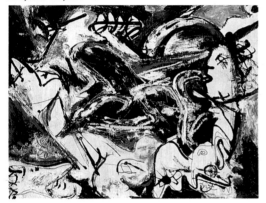

Jackson Pollock
American (1912–56)
Conflict
Signed and dated '43' on the reverse, oil on canvas
12 x 15in (30.5 x 38.5cm)
£240,000–250,000 *S(NY)*

Jean-Pierre Raynaud
French (b1939)
Sens Interdit
Signed and dated '1962' on reverse, oil on wood
36 x 45in (91.5 x 114cm)
£10,000–11,000 *S*

Gerhard Richter German (b1932)
Untitled
Signed, dated '69' and dedicated to Lucio
Winkler on reverse, oil on canvas
11¾ x 15¾in (30 x 40cm)
£17,500–20,000 *S*

Larry Rivers
American (b1923)
Black Jack
Signed and dated '89', acrylic
on canvas mounted on wood
construction
62 x 51¾in (157 x 131cm)
£24,000–26,000 *S(NY)*

l. **Bridget Riley**
British (b1931)
Scale Study
Signed, titled and
dated '1973', gouache
29 x 54¾in
(73.5 x 139cm)
£3,500–4,000 *P*

Richard Smith
British (b1931)
A Whole Year and Half a Day II
Signed, titled and dated '66' on stretcher,
acrylic on canvas
60 x 60 x 8in (152 x 152 x 20cm) shaped
£2,000–2,500 *P*

Mark Rothko
American (1903–70)
Untitled
Tempera on paper laid down on board, 1953
39½ x 26⅜in (100 x 67cm)
£200,000–250,000 *S(NY)*

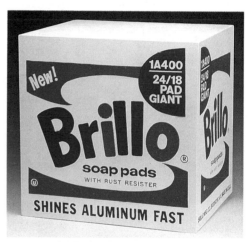

Andy Warhol
American (1928–87)
White Brillo Box
Synthetic polymer and silkscreen inks
on wood
17 x 17 x 14in (43 x 43 x 35.5cm)
£38,000–42,000 *C*

Bryan Wynter
British (1915–75)
Sea Journey No. 15
Oil on canvas
56 x 44in (142 x 111.5cm)
£12,000–18,000 *MtS*

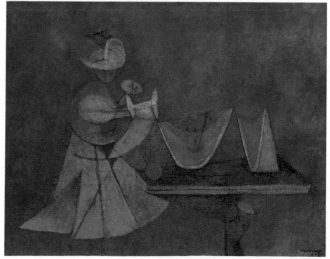

r. **Rufino Tamayo**
Mexican (1899–1991)
Niña Glotona
Signed and dated '0-51', oil
on canvas
31½ x 39in (80 x 99cm)
£520,000–550,000 *S(NY)*

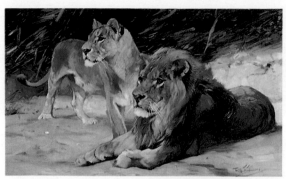

William Huggins
British (1820–84)
King of the Jungle
Signed and dated '1867', oil on canvas
28 x 36in (71 x 91.5cm)
£9,500–10,000 *S(NY)*

Wilhelm Kuhnert
German (1865–1926)
Löwenpaar
Signed, oil on canvas
17¼ x 27¼in (44 x 69.5cm)
£30,000–35,000 *S(NY)*

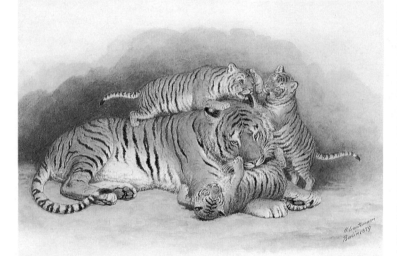

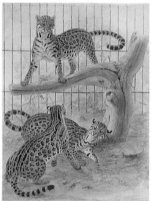

Joseph Wolf
German (1820–99)
Ocelots
Signed and dated '1874',
watercolour
17½ x 13½in (44 x 34cm)
£14,000–15,000 *CW*

*From an early age Joseph Wolf
liked to draw birds and wild
animals. His work was greatly
admired by bird artist John
Gould, Landseer and several
of the Pre-Raphaelites.*

Gottlob Heinrich Leutemann
German (1824–1905)
Tigermutter – A Tigress and her Cubs
Signed and dated 'Berlin 1879', watercolour
10¼ x 15in (26 x 38cm)
£3,000–3,500 *CW*

*In the 19thC demand for wildlife pictures was
stimulated by an interest in hunting and
coincided with the establishment of Europe's
public zoos. In the conservation conscious
1990s they are again popular and Christie's
now hold an annual sale of wildlife art, hosted
in conjunction with the World Wildlife Fund.*

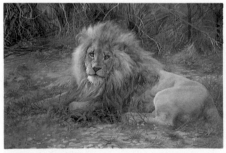

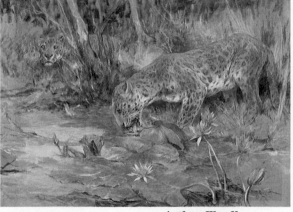

Spencer Roberts
British (20thC)
Atlas Lion
Gouache
19 x 23in (48 x 59cm)
£1,200–1,400 *RGFA*

Arthur Wardle
British (1864–1947)
A Leopard Drinking
Pastel
14¼ x 19¾in (36.5 x 50cm)
£4,000–5,000 *S(S)*

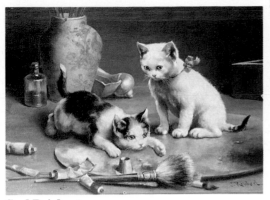

Carl Reichert
Austrian (1836–1918)
Studio Assistants
Signed, oil on panel
7½ x 10¼in (18.5 x 26cm)
£4,000–5,000 *Bon*

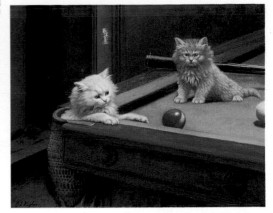

George Frederick Hughes
British (active 1873–79)
Snookered
Signed, oil on canvas
19¾ x 24in (50 x 61cm)
£5,500–7,000 *C*

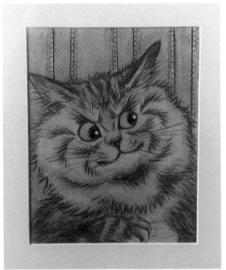

Louis Wain
British (1860–1939)
Untitled
Coloured chalk and crayon, c1932
11 x 9in (28 x 22.5cm)
£1,000–1,200 *BOX*

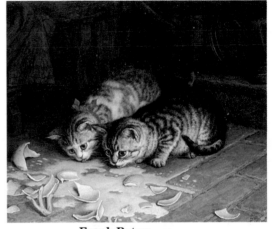

Frank Paton
British (1856–1909)
It's no use Crying over spilt Milk
Signed and dated '1880', oil on canvas
16½ x 19½in (42 x 49.5cm)
£6,500–8,000 *Bon*

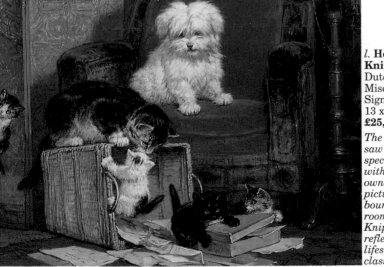

l. **Henriette Ronner-Knip**
Dutch (1821–1909)
Mischief
Signed, oil on panel
13 x 17½in (33 x 44cm)
£25,000–30,000 *C(S)*

*The Victorian period
saw the emergence of the
specialist cat painter,
with demand for the
ownership of pets and
pictures of them. The
bourgeois drawing
rooms in which Ronner-
Knip's kittens play
reflect the comfortable
lifestyle of her middle
class clientèle.*

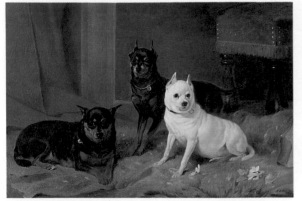

Richard Ansdell, RA
British (1815–85)
Two Manchester Terriers with an
Old English white Terrier
Signed, oil on canvas,
24 x 36in (61 x 91.5cm)
£10,500–12,500 *C*

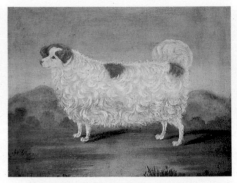

English Provincial School (mid-19thC)
'Rover', a study of a Dog
Inscribed with poem to Rover on label on
reverse, oil on panel
13¾ x 17¾in (35 x 45cm)
£1,500–1,800 *S(S)*

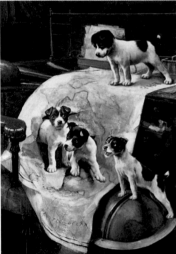

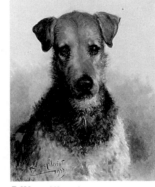

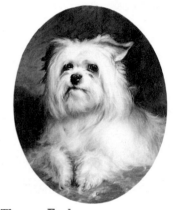

John Hayes
British (19thC)
Whilst the Master's Away
Oil on canvas
29 x 25in (74 x 63.5cm)
£16,500–17,500 *HFA*

Lilian Cheviot
British (exh 1894–1902)
A Wire-haired Fox Terrier
Signed and dated '1933',
oil on canvas
17¾ x 13¾in (45 x 35cm)
£1,800–2,400 *Bon*

Thomas Earl
British (active 1836–85)
A Winning Look
Signed and dated '64', oil on board
17 x 13in (43 x 33cm) oval
£6,500–7,500 *Bon*

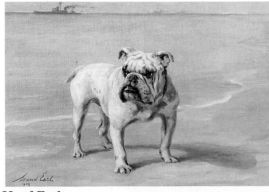

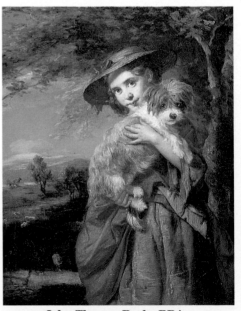

Maud Earl
British (1864–1943)
Dreadnought
Signed and dated '1919', oil on canvas
22 x 30in (56 x 76cm)
£6,000–7,000 *C*

John Thomas Peele, RBA
British (1822–97)
The new Puppy
Signed and dated '1868', oil on canvas
41½ x 31¾in (105 x 81cm)
£4,500–5,500 *C(S)*

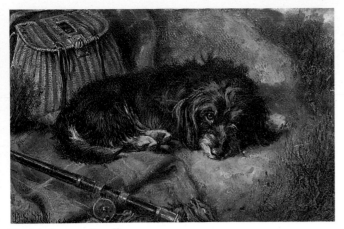

David George Steell
British (1856–1930)
On Guard
Signed and dated '1880', oil on board
14 x 20in (35.5 x 50.5cm)
£4,750–5,750 *Bon*

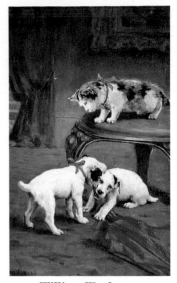

William Weekes
British (active 1864–1904)
A Tug o' War
Signed, oil on canvas
14 x 9in (35.5 x 22.5cm)
£1,800–2,200 *Bon*

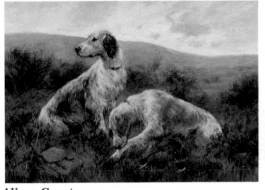

Alison Guest
British (20thC)
English Setters
Oil on canvas
9 x 12in (22.5 x 30.5cm)
£450–500 *RGFA*

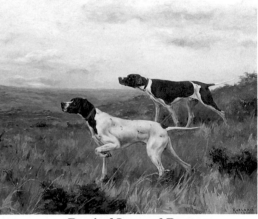

Percival Leonard Rosseau
American (1859–1937)
Two Pointers in a Landscape
Signed and dated '1909', oil on canvas
laid down on masonite
26 x 32¼in (66 x 82cm)
£18,000–20,000 *S(NY)*

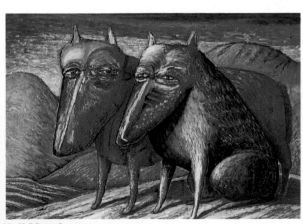

Neil Macpherson
Scottish (b1954)
Cobalt and Mimosa, 1989
Oil on card
32 x 47½in (81 x 120cm)
£4,400–4,800 *BOU*

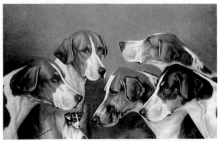

John Arnold Wheeler
British (1821–1903)
Five Knaves and a Jack
Signed, oil on canvas board
12 x 18½in (30.5 x 47cm)
£2,000–2,500 *Bon*

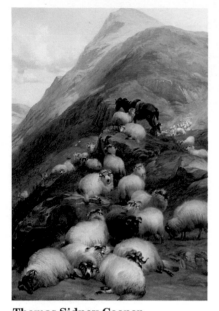

Thomas Sidney Cooper
British (1803–1902)
North
Oil on canvas
53 x 38in (134.5 x 96.5cm)
£38,000–42,000 *HFA*

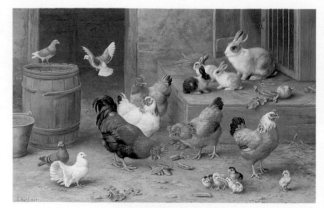

Edgar Hunt
British (1876–1953)
Farmyard Friends
Signed and dated '1937', oil on canvas
12 x 18in (30.5 x 45.5cm)
£15,000–18,000 *C*

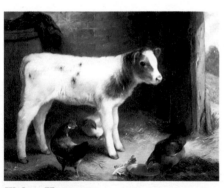

Walter Hunt
British (1861–1941)
Calf
Oil on panel
8 x 10in (20.5 x 25cm)
£4,400–4,800 *HFA*

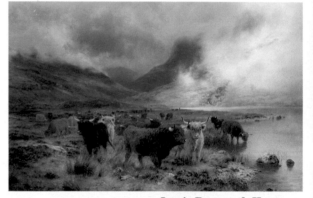

Louis Bosworth Hurt
British (1856–1929)
Through Glencoe, to the Tay
Oil on canvas
36 x 60in (91.5 x 152cm)
£45,000–49,000 *HFA*

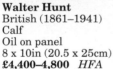

Sarah Hutton
British (20thC)
Pig in Mud
Black print, hand finished, on brown paper
9 x 12½in (22.5 x 32cm)
£80–90 *HVM*

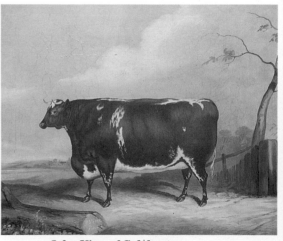

John Vine of Colchester
British (c1809–67)
A Brown and White Prize Bull in a Landscape
Signed, oil on canvas
19¾ x 23⅛in (49 x 59cm)
£4,750–5,750 *S(S)*

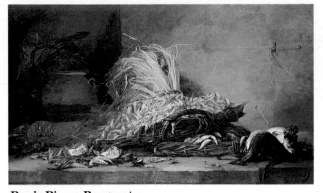

Denis Pierre Bergeret
French (1846–1910)
A Basket of Shrimps and Prawns with a Lobster, Oysters and
Fish on a Ledge
Signed, oil on canvas
33½ x 55in (85 x 139.5cm)
£3,750–4,750 *C*

J. W. Bennet & Couvier
British (19thC)
Tropical Fish
Print
20 x 16in (51 x 41cm)
£75–85 *EDG*

Jenny Webb
British (20thC)
Angel Fish
Pastel, 1994
110½ x 79in
(280 x 200cm)
£40–50 *LS*

r. **H. J. Oliver**
British (20thC)
Koi Carp
Oil on canvas
36 x 34in (92 x 86cm)
£2,500–3,000 *HJO*

Michael Scott
Scottish (b1946)
The Offering
Oil on canvas
24 x 20in (61 x 51cm)
£2,000–2,350 *CON*

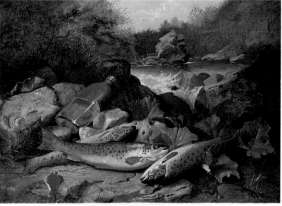

John Russell
British (mid-19thC)
Trout on a River Bank
Signed and dated '1871', oil on canvas
16 x 22in (41 x 56cm)
£7,500–8,500 *C*

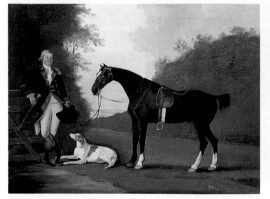

Henry Bernard Chalon
British (1770–1849)
Gentleman with Black Hunter
Signed, oil on canvas
27¾ x 35⅜in (70.5 x 91cm)
£14,500–16,000 *S(NY)*

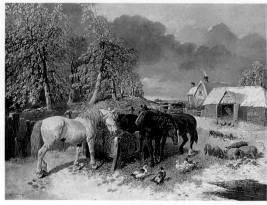

John Frederick Herring, Jnr
British (1820–1907)
The Farm in Winter
Signed, oil on canvas
28 x 36in (71 x 91.5cm)
£17,000–20,000 *S(NY)*

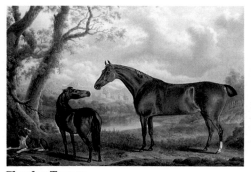

Charles Towne
British (1763–1840)
Horse and Foal
Oil on canvas
18 x 21in (46 x 53cm)
£15,000–18,000 *HFA*

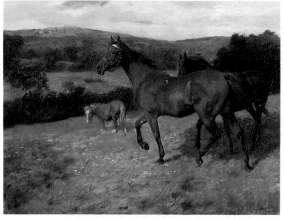

Lucy Elizabeth Kemp-Welch, RI, ROI
British (1869–1958)
Ladybird – My favourite Hunter
Signed and dated '1904', oil on canvas
30 x 40in (76 x 101.5cm)
£14,000–16,000 *C(S)*

Heywood Hardy
British (1843–1933)
A Chat with his Lordship
Signed, oil on canvas
25 x 37in (63.5 x 94cm)
£14,000–16,000 *C*

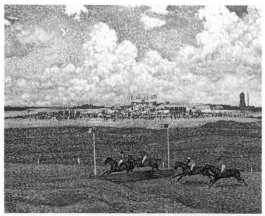

l. **Thomas Rowden**
British (1842–1926)
Blackhaven Brook,
Dartmoor
Signed, watercolour
8 x 14¾in
(20 x 37.5cm)
£700–800 *WrG*

Theo van Rysselberghe
Belgian (1862–1926)
Le Champ de Courses à
Boulogne-sur-Mer
Signed with monogram and
dated '1900', oil on canvas
30 x 34½in (76 x 87.5cm)
£126,500–140,000 *S(NY)*

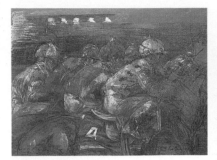

Claire Eva Burton
British (20thC)
Stall Start
Oil pastel
11 x 15½in (29.5 x 39cm)
£1,000–1,300 *RGFA*

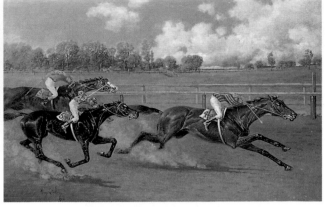

Henry Stull
American (1851–1913)
Ahead by a Length
Signed and dated '1910', oil on canvas
24 x 36in (61.5 x 91.5cm)
£20,000–25,000 *S(NY)*

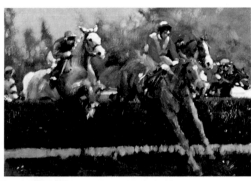

Anne Magill
Irish (20thC)
Over the First
Acrylic
12 x 15in (30.5 x 38cm)
£400–500 *EAG*

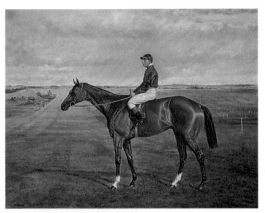

Allen Culpepper Sealy
British (active 1873–86)
Norman III, winner of the 1908 Guineas at
Newmarket, with Otto Madden up
Signed and dated and inscribed 'Allen C. Sealy
1908/copy', oil on canvas
20 x 25in (50.5 x 64cm)
£2,500–3,000 *C*

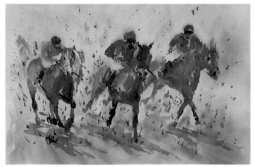

Glenn Wawman
British (b1955)
Three Way Photo
Signed, watercolour
12 x 20in (30.5 x 50.5cm)
£280–320 *HeG*

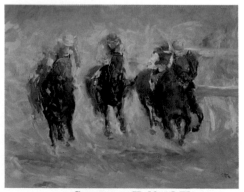

Constance Halford-Thompson
British (20thC)
Home Straight
Oil on canvas
24 x 29in (61.5 x 73.5cm)
£1,500-2,000 *AMC*

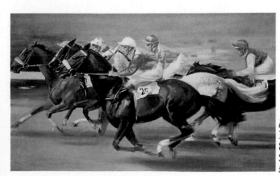

l. **Frank Wootton** British (b1911)
Early Restraint
Signed, oil on canvas
21¾ x 35⅜in (54 x 91cm)
£4,500–6,000 *S(S)*

French Provincial School (18thC)
The Stag Hunt
Oil on canvas
32 x 38½in (81 x 98cm)
£2,500–3,000 *S(S)*

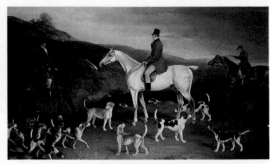

John Nost Sartorius
British (1759–1828)
Huntsmen and Hounds
Signed (heightened), oil on canvas
26 x 42½in (66 x 107cm)
£12,000–14,000 *S(S)*

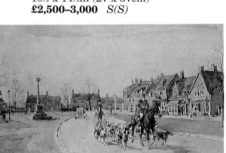

Richard Henry Brock
British (19th/20thC)
'There's many a slip twixt Cup and Lip'
Signed and dated '1897', oil on panel
10½ x 14½in (27 x 37cm)
£2,500–3,000 *S(S)*

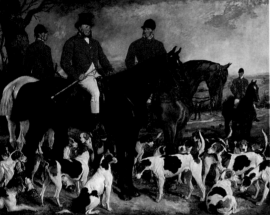

Sir Francis Grant, RA
British (1810–78)
Portrait of Gerard Leigh, Master of the Hertfordshire
Hounds at a Meet
Oil on canvas
115½ x 140½in (293.5 x 357cm)
£46,000–55,000 *S*

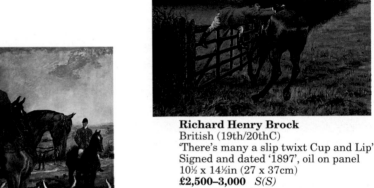

Lionel Dalhousie Robertson Edwards, RI
British (1878–1966)
The North Cotswold Hounds in Broadway
Signed and dated '1948', watercolour and pencil
13 x 19in (33 x 48cm)
£2,400–3,000 *S(S)*

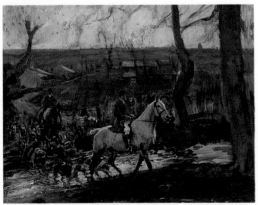

Sir Alfred Munnings, PRA
British (1878–1959)
Frosty Evening, returning Home
Signed and dated '1913', tempera
16¼ x 20¼in (41.5 x 51cm)
£24,000–30,000 *C*

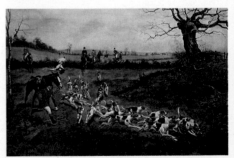

George Derville Rowlandson
British (b1861)
The final Chase
Oil on canvas
24 x 36in (61 x 91.5cm)
£6,000–8,750 *HFA*

Dogs

Dog pictures are ever-popular in the marketplace. Every year, Bonhams auction house hosts a sale of dogs in art, while, to coincide with Crufts, commercial galleries invariably hold their own pictorial dog shows. Pictures tend to fall into three main categories: canine portraits, accurately portraying a specific breed; sporting paintings showing hunting dogs in the field, and pet pictures, sweet and often sentimentalised portrayals of man's best friend. Collectors also tend to be dog owners and it is a field where the subject matters perhaps more than quality. A 'cute' image is all important stresses Bonham's expert, Charley O'Brien who notes that certain breeds will always do well at auction, particularly pugs and King Charles spaniels.

Cecil Charles Windsor Aldin, RBA
British (1870–1935)
Innocent M'Lord
Signed, inscribed in pencil, pen and ink and crayons over pencil on ivorine
13 x 10½in (33 x 26.5cm)
£3,000–3,500 *S(S)*

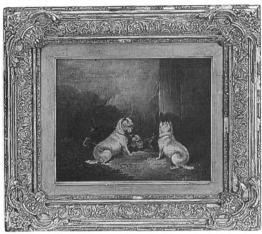

Attributed to George Armfield
British (active 1840–75)
Three Terriers at a Rat Cage
Oil on canvas
8 x 9in (20 x 22.5cm)
£900–1,200 *L&E*

Thomas Blinks
British (1860–1912)
Just Missed, Terriers Rabbiting
Signed and dated '95', oil on canvas
14 x 20in (35.5 x 50.5cm)
£10,000–12,000 *S(NY)*

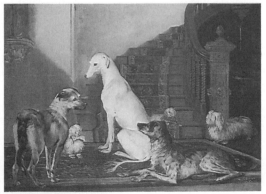

Henry Calvert
British (active 1813–69)
Waiting at the Foot of the Stairs
Signed and dated '1856', oil on canvas
34 x 46in (86 x 116.5cm)
£24,000–26,000 *CW*

Henry Calvert was born in Manchester, and exhibited pictures, mainly of horses, at the Royal Academy between 1826 and 1854. He also painted dogs, working mostly for private patrons in the north. It is not known who owned this curious group of dogs, or where the house was.

Edmund Caldwell
British (1852–1930)
A Stranger in our Midst
Signed and dated '1889', oil on canvas
24 x 36in (61 x 91.5cm)
£3,500–4,500 *C*

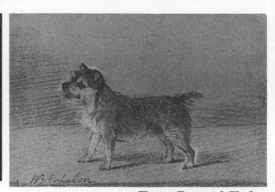

Henry Bernard Chalon
British (1770–1849)
Playful
Signed and inscribed, oil on canvas
33¾ x 52in (85.5 x 132cm)
£8,200–10,000 *S(S)*

Henry Bernard Chalon
British (1770–1849)
A Norfolk Terrier
Signed, coloured chalks
5 x 6in (12.5 x 15cm)
£250–350 *Bon*

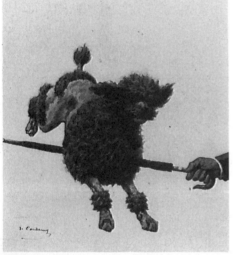

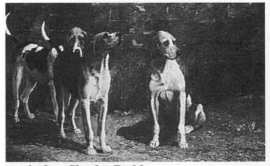

Marjorie Cox
British (20thC)
Sheila and Lizzie
Signed, inscribed and dated '1952', pastel
11¾ x 16¼in (30 x 41cm)
£200–300 *Bon*

Charles-Fernand de Condamy
French (19thC)
Favourite Tricks
A pair, signed, watercolour and pen and
ink on paper
6½ x 5½in (16.5 x 14cm)
£950–1,200 *S(NY)*

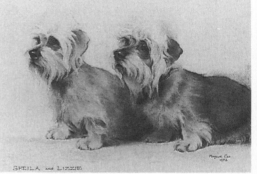

Arthur Charles Dodd
British (active 1878–1890)
A Study of Fox Hounds
Signed, inscribed and dated '1890', oil on canvas
15¾ x 23½in (40 x 60cm)
£1,000–1,200 *S(S)*

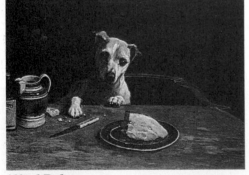

Alfred Duke
British (d1905)
Temptation
Signed, oil on canvas
10 x 14in (25 x 35.5cm)
£2,200–3,000 *Bon*

r. **John Emms**
British (1843–1912)
Study of a Beagle and a Dandie Dinmont
Signed, oil on canvas
21 x 29½in (53 x 75cm)
£2,200–3,000 *S(S)*

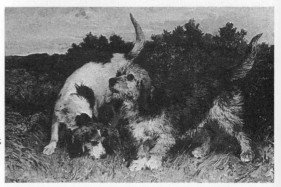

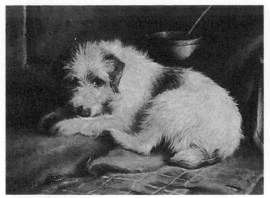

J. Fitzmarshall
British (1859–1932)
Waiting for Master
Signed, oil on canvas
11¼ x 15¾in (30 x 40cm)
£3,800–4,500 *Bon*

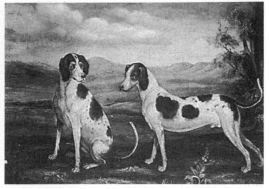

English Provincial School (c1860)
Two Liver and White Pointers in a Landscape
Oil on panel
13¾ x 17½in (35 x 44.5cm)
£1,200–1,500 *S(S)*

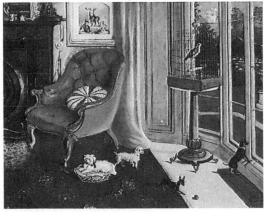

E. M. Fox
British (active 1860s)
Four Dogs and a Parrot
Signed and dated '1868', oil on canvas
15¾ x 20in (40 x 51cm)
£8,500–9,500 *CW*

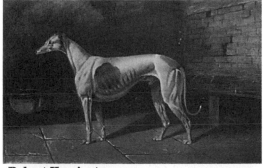

Robert Harrington
British (1800–82)
King Cob
Oil on board
11¾ x 18½in (30 x 46.5cm)
£1,000–1,500 *JNic*

King Cob belonged to Captain Daintree, c1838. He was sire of Magician, who won the Waterloo Cup in 1849, and is one of two main ancestors of the modern greyhounds.

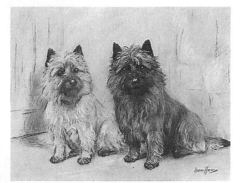

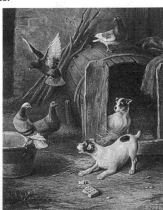

r. **Edgar Hunt**
British (1876–1953)
Taking the Biscuit
Signed and dated '1913',
oil on canvas
14 x 12in (35.5 x 30.5cm)
£9,000–10,000 *C*

Marion Rodger Hamilton Harvey
British (b1886)
Cairn Terriers
Signed, coloured chalks
15½ x 19½in (39.5 x 49.5cm)
£1,500–2,000 *S(Sc)*

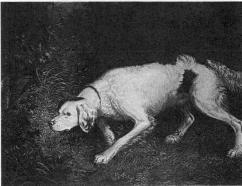

r. **Thomas Hewer Hinckley**
American (1813–96)
A Spaniel Pointing
Signed and dated '1843', oil on canvas laid
down on masonite
39 x 49in (99 x 124.5cm)
£5,500–6,500 *S(NY)*

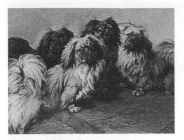

Fannie Moody
British (1861–97)
Spoilt Darlings
Signed, coloured chalks
24½ x 31½in (62 x 80cm)
£2,800–3,500 *C*

*Fanny Moody was the daughter
of Francis Wollaston Moody
(1824–86). She specialised in
scenes of animal behaviour.*

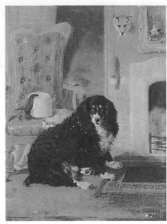

l. **William Malbon**
British (active 1834–69)
By his Master's Chair
Signed and dated 'Jan^y 23 1850',
oil on panel
21 x 16¼in (53 x 41.5cm)
£1,800–2,500 *Bon*

*Dog pictures often come with suitably
appealing titles. In many instances,
these were not devised by the artist,
but by the auctioneers or vendors
selling the work. Malbon's picture of a
dog sitting by a fez is a case in point.
'Like many paintings it came in
without a title so we had to think one
up,' explains Bonham's auctioneer,
Charley O'Brien. 'We wanted to call it
"Waiting for Tommy", but we didn't
think we would get away with it!'*

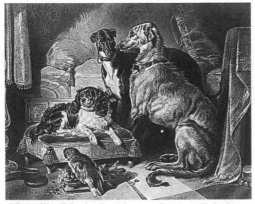

After Sir Edwin Landseer, George Zobel
British (1802–73)
Dash, Hector, Nero and Lory
Engraving on steel, March 15th, 1877
17½ x 20in (44 x 50.5cm)
£400–450 *GP*

*Queen Victoria did much to popularise the
owning of dogs as pets, as opposed to working
animals. When her favourite spaniel, Dash, died
in 1840, he was buried in the grounds of
Adelaide Lodge, with the following epitaph on
his tombstone: 'Here lies Dash . . . His
attachment was without selfishness / His
playfulness without malice / His fidelity without
deceit / Reader, if you would live beloved and die
regretted, profit by the example of Dash'.*

r. **M. Leckie**
British (19thC)
Peepo!
Signed and dated '1884',
oil on vellum
9½ x 7½in (24 x 19cm)
£400–600 *Bon*

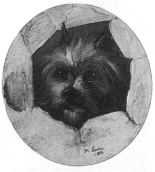

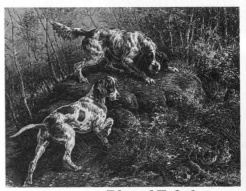

Edmund H. Osthaus
American (1858–1926)
Pointer, Setter and Grouse
Signed, oil on canvas
28½ x 36½in (72.5 x 93cm)
£26,000–32,000 *S(NY)*

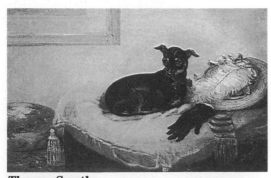

Thomas Smythe
British (1825–1907)
Her Favourite Pet - A Manchester Terrier
on a red Cushion
Signed, oil on canvas
11¼ x 17½in (29 x 45cm)
£2,000–3,000 *Bon*

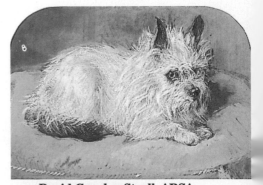

David Gourlay Steell, ARSA
British (1819–94)
A Terrier
Signed with initials, inscribed 'Sketch/DS',
watercolour and bodycolour
8½ x 11¾in (21.5 x 30cm)
£2,750–3,000 *CW*

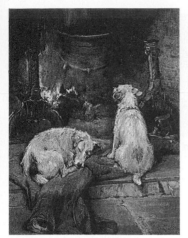

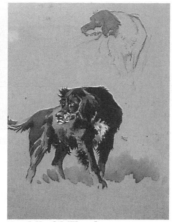

Philip Eustace Stretton
British (active 1884–1919)
By the Hearth
Signed and dated 1894,
oil on canvas
20 x 16in (51 x 41cm)
£7,500–9,000 *Bon*

Archibald Thorburn
British (1860–1935)
Studies of a Dog
Watercolour, pencil and wash
12¾ x 10in (32.5 x 25cm)
£1,300–1,600 *JNic*

Arthur Fitzwilliam Tait, NA
American (1819–1905)
Pointer and Quail
Signed, inscribed and dated '63',
oil on panel
8 x 9in (20 x 23cm)
£4,000–5,000 *S*

William Eddowes Turner
British (active 1858–62)
A Manchester Terrier in a Landscape
Signed, oil on canvas
9½ x 11¾in (24 x 30cm)
£550–750 *S(S)*

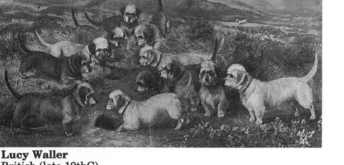

Lucy Waller
British (late 19thC)
Yorkshire Dandies
Signed and dated '1889', oil on canvas
36 x 66in (91.5 x 167.5cm)
£11,500–13,000 *Bon*

This picture was painted for Mrs Sage, a well-known breeder and judge of Dandie Dinmonts. History relates that Lucy Waller wanted one of her puppies but Mrs Sage refused to sell her one unless Lucy painted all Mrs Sage's champion dogs. This picture depicts those champions, and Lucy Waller got her puppy!

Arthur Wardle
British (1864–1949)
A Scottish Terrier
Pastel
14½ x 22in (37 x 55.5cm)
£1,700–2,000 *S(S)*

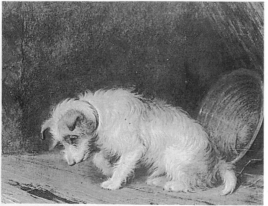

Martin Theodore Ward
British (1799–1874)
Waiting
Oil on board
7½ x 9½in (19 x 24cm)
£800–1,000 *Bon*

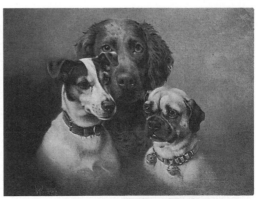

William Weekes
British (active 1864–1904)
Good Friends
Signed, oil on canvas
20 x 25½in (50.5 x 65cm)
£6,000–8,000 *Bon*

Farmyard Animals

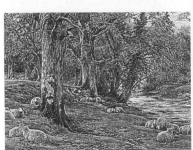

Charles J. Adams
British (1857–1931)
Sheep resting beneath Trees
on a River Bank
Signed, watercolour
10½ x 14½in (26.5 x 37cm)
£1,300–1,600 *BWe*

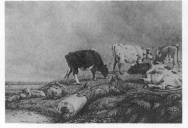

Thomas Baker of Leamington
British (1809–69)
Cattle Grazing
Signed and dated '1861',
watercolour
10 x 14½in (25 x 37cm)
£450–550 *S(S)*

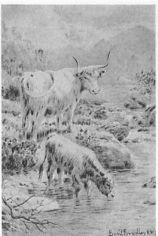

Basil Bradley, RWS
British (1842–1904)
Maternal Solitude
Signed and inscribed,
watercolour
10½ x 7¼in (26.5 x 18cm)
£900–1,150 *WrG*

r. **Arthur Batt**
British (19thC)
Stable Friends
Signed and dated '91',
oil on canvas
9½ x 13½in (24 x 34.5cm)
£500–600 *BWe*

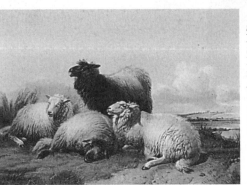

Thomas Sidney Cooper, RA
British (1803–1902)
Sheep on the Kent Coast
Signed, inscribed and dated '1869',
oil on panel
11¾ x 16in (30 x 40.5cm)
£6,750–8,750 *C*

r. **Jacob van Dieghem**
Dutch (19thC)
Sheep resting in a
Landscape and Sheep
in a Barn
A pair, both signed
and dated '82',
oil on panel
9 x 6¼in (22.5 x 15.5cm)
£2,500–3,000 *S(S)*

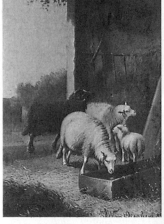

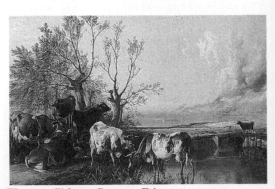

Thomas Sidney Cooper, RA
British (1803–1902)
Canterbury Meadows - A Cool Retreat
Signed and dated '1867', oil on canvas
48¼ x 72¼in (123 x 183cm)
£26,000–32,000 *C*

*The date of this picture, 1867, was a significant year
for Cooper. After 22 years as an Associate of the
Royal Academy, 1867 saw him elected a full member.
At the same time, he also founded the Sidney Cooper
Gallery of Art on the site of his birthplace in
Canterbury. Funded by the considerable fortune
earned from an endless stream of cow and sheep
pictures, the gallery was intended as an art school
where 'poor boys' received free tuition.*

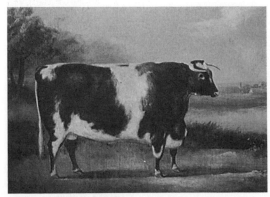

William Henry Davis
British (19thC)
A brown and white prize Bull in a Landscape
Signed and dated '1858', oil on canvas
20½ x 26½in (52 x 67.5cm)
£1,400–1,800 *S(S)*

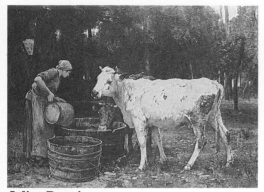

Julien Dupré
French (1851–1910)
A young Milkmaid with Cattle in a Landscape
Signed, oil on canvas
44½ x 59in (112 x 149.5cm)
£24,000–28,000 *P*

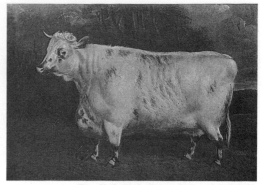

English Primitive School (19thC)
A Shorthorn Cow
Oil on canvas
20 x 27in (50.5 x 68.5cm)
£1,000–2,000 *DN*

English Primitive School (c1840)
A Study of a Pig in a Stable
Indistinctly inscribed 'Painted from Nature . .
May 20th . . 1840?', oil on canvas
24¾ x 30in (63 x 76cm)
£4,500–5,500 *S(S)*

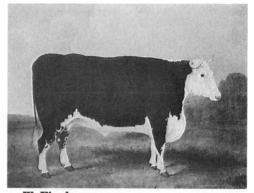

W. Fincher
British (19thC)
A brown and white prize Bull in a Landscape
Signed and dated '1861', oil on canvas
19 x 24½in (48 x 62.5cm)
£1,300–1,500 *S(S)*

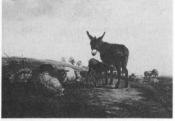

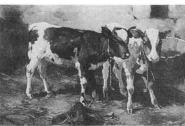

English School (19thC)
Donkey with a Foal and
Sheep in a Rural Setting
Oil on canvas
12 x 16in (30.5 x 40.5cm)
£300–400 *M*

David Gauld, RSA
British (1865–1936)
Calves
Signed, oil on canvas
20 x 30in (50.5 x 76cm)
£2,500–3,000 *P*

*Gauld specialised in painting
Ayrshire calves.*

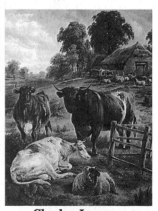

Charles Jones
British (1836–92)
A Pedigree Bull
Signed with monogram,
oil on canvas
44 x 34in (111.5 x 86cm)
£3,500–4,500 *S*

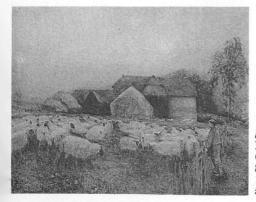

l. **Arthur J. Legge, RBA**
British (1859–1942)
Counting the Sheep
Signed and dated '08', watercolour
18½ x 23in (47 x 58.5cm)
£2,000–2,500 *WrG*

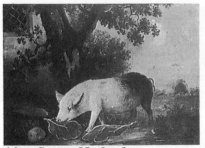

After George Morland
British (1763–1804)
Study of a Pig
Bears signature, oil on canvas
24½ x 29in (62.5 x 73.5cm)
£850–1,000 *S(S)*

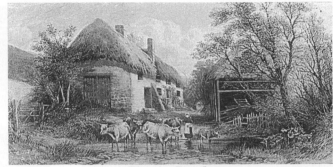

Thomas Rowden
British (1842–1926)
Girl and Cattle by a thatched Farmstead
Signed and dated '87', watercolour
10 x 20in (25 x 50.5cm)
£400–500 *TAY*

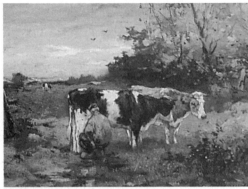

Johan Frederick Cornelis Scherrewitz
Dutch (1868–1951)
Milking Time
Signed, oil on canvas
12 x 16in (31.5 x 40.5cm)
£2,500–2,850 *Bne*

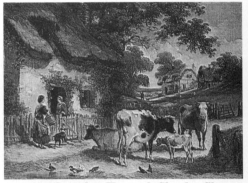

Attributed to Henry & Charles Shayer
British (19thC)
The Old Farmstead
Bears signature 'W. Shayer' dated '1841',
oil on canvas
12 x 15¾in (30.5 x 40cm)
£2,000–3,000 *Bon*

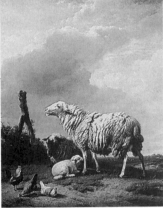

r. **Circle of
Thomas Weaver**
British (1774–1843)
A Landscape with a Farmer
with his Mare and Foal, a
prize Bull in the Foreground
Oil on canvas
22½ x 31½in (57 x 80cm)
£2,500–3,000 *S(S)*

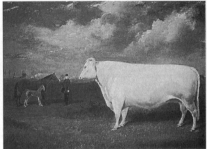

Eugene Verboeckhoven
Belgian (1798–1881)
Sheep and Poultry in a Landscape
Signed and dated '1856', oil on panel
29¼ x 23in (74 x 58.5cm)
£23,000–28,000 *Bon*

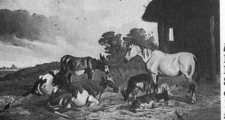

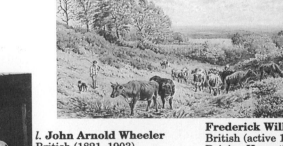

l. **John Arnold Wheeler**
British (1821–1903)
Livestock outside a Barn
Signed with monogram,
oil on canvas
15¼ x 23¼in (38.5 x 59cm)
£800–1,000 *S(S)*

Frederick Williamson
British (active 1856–1900)
Driving Home the Cattle
Signed, watercolour
10 x 18in (25 x 46cm)
£2,000–2,200 *Bne*

Fish

Over the centuries a small number of artists have specialised in fish pictures. These tend to fall into two main categories, the fish as a still life subject and as a sporting trophy. Dutch 17thC painters produced fish still lifes and as well as its visual importance the subject often had a religious significance; fish being regarded as suitable Lenten fare and being the symbol of Christ and Christianity. Sporting or angling pictures were a largely British phenomenon, with 19thC artists such as Roland Knight and Henry Leonidas Rolfe showing the fish being hooked in the water and the day's catch laid out on the bank.

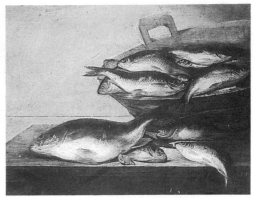

Jan de Bondt
Dutch (active c1650)
A Still Life of Fish
Signed, oil on panel
18¼ x 23¼in (46.5 x 59.5cm)
£2,300–3,000 *S(Am)*

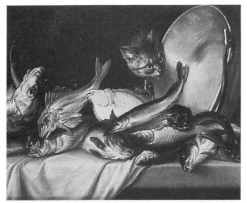

Manner of Willem Ormea
Dutch (17thC)
A Cat with Fish on a Table
Oil on canvas
20 x 24in (50.5 x 61.5cm)
£1,500–2,000 *C*

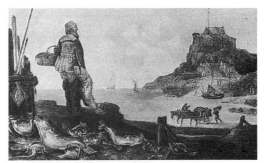

Abraham Willaerts & Pieter van Schaeyenborgh
Dutch (16th/17thC)
A Beach Scene with Fishermen and a Still Life of Fish in the Foreground
Signed, oil on panel
9 x 14in (22.5 x 35.5cm)
£4,000–5,000 *S(Am)*

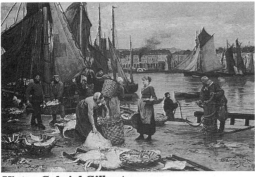

Victor-Gabriel Gilbert
French (1847–1933)
Unloading the Catch
Signed and dated '1881', oil on canvas
31 x 46in (79 x 116.5cm)
£35,000–40,000 *C*

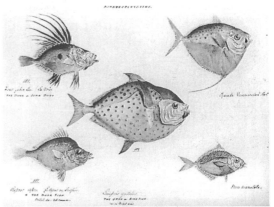

English School (19thC)
An Album of Watercolours of British Fishes, Studies of Eggs, Birds, Insects and other Animals, and 2 watercolours of Polar Expeditions
Inscribed and dated, watercolours
12 x 15in (30.5 x 38.5cm)
£500–600 *CSK*

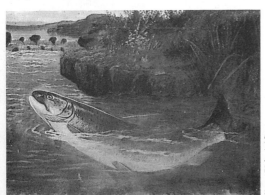

l. **A. Roland Knight**
British (late 19thC)
A Hooked Salmon
Signed, oil on canvas
17¾ x 24in (45.5 x 61cm)
£950–1,200 *S(Sc)*

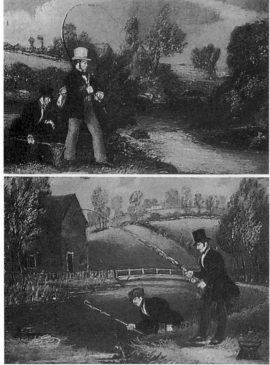

James Pollard
British (1792–1867)
Taking the Bait, Reeling in the Catch
A pair, oil on board
6¼ x 9in (15.5 x 22.5cm)
£9,000–10,000 C

W. Cecil Robinson
British (19thC)
An Album of Watercolours of Aranthopterygiens
and Malacopterygiens Studies
Inscribed, watercolours
11 x 15in (28 x 38cm)
£800–1,000 CSK

Henry Leonidas Rolfe
British (active 1847–81)
A Fisherman's Still Life
Signed and dated '1866', oil on canvas
18 x 29½in (45.5 x 75cm)
£2,000–3,000 S(S)

E. McDonald Stuart
British (19thC)
A Fisherman's Dream
Pastel
26½ x 38½in (67 x 98cm)
£1,000–1,200 CSK

Alfred Wallis
British (1855–1942)
Four Fishes
Pencil and gouache on board
6½ x 11¾in (16.5 x 30cm)
£3,500–4,500 C

l. **Fred Crayk**
British (b1952)
Nature
Oil on canvas
21 x 21in (53 x 53cm)
£650–750 LG

r. **H. J. Oliver**
British (20thC)
Safe Return
Watercolour
16 x 21in (40.5 x 53cm)
£400–500 HJO

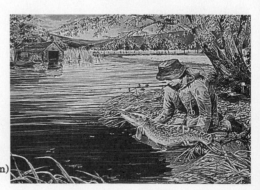

Horses

Demand for 19th–20thC horse pictures remains steady and not only for the big name painters such as Herring, Ferneley and Munnings. 'We have found that minor Victorian artists, in the £1,000–3,000 bracket, have been selling very well, as have early prints,' says Bill Jackson of the Heath Gallery, Ascot, dealers in equestrian art. 'A number of pictures in the Munnings style have also been coming on the market and are proving very popular; works that your grandmother might have bought from an exhibition for perhaps £15–20 in the 1930s–40s, and which are now being sold on by the grandchildren for considerably more.' Specialist dealers are at pains to stress that equestrian art does not only appeal to the 'horsey set', but equally to the general picture buyer. Nevertheless, like dog painters, artists who paint horses often tend to be marginalised. 'I don't think equestrian painters are properly respected by the fine art establishment,' laments Mrs Minahan, of the Equus Gallery in Newmarket, dealers in contemporary horse art. 'Until very recently, art schools have tended to look down on horse painting and on sporting art in general. Many of our artists worked with horses before becoming painters. A love of horses is essential to produce a good equestrian painting, whatever its period.'

18th Century

Attributed to John Boultbee
British (1745–1812)
A Study of a Chestnut Hunter in a Landscape
Bears signature, oil on canvas
27¼ x 35½in (69 x 90.5cm)
£2,000–2,500 *S(S)*

19th Century

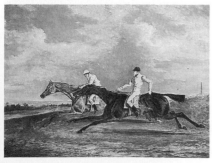

l. **Henry Thomas Alken**
British (1785–1851)
Neck and Neck
Oil on canvas
12¼ x 16in (31 x 40.5cm)
£23,000–28,000 *S(NY)*

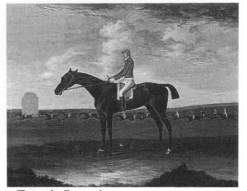

Francis Sartorius
British (1734–1804)
Minister
Signed, inscribed and dated '1774',
oil on canvas
40¼ x 50½in (103 x 128cm)
£32,000–40,000 *S(NY)*

Many horse pictures come inscribed with extensive notes, listing horses' pedigrees and victories in proud and meticulous detail.

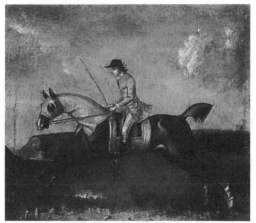

Attributed to Francis Sartorius
British (1734–1804)
Cardinal Puff
Oil on canvas
11 x 13in (28 x 33cm)
£3,600–4,500 *S(S)*

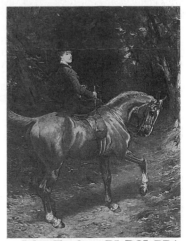

John Charlton, RI, ROI, RBA
British (1849–1917)
Hark! Back!
Signed with initials, inscribed and dated '1906', oil on canvas
71¼ x 53½in (181.5 x 136cm)
£35,000–45,000 *S(S)*

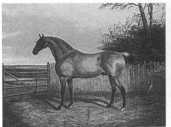

Albert Clark
British (19thC)
A Strawberry Roan Stallion
in a Landscape
Signed and dated '1884',
oil on canvas
19¾ x 23⅜in (50 x 60.5cm)
£1,750–2,500 *S(S)*

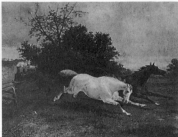

Follower of James Clark
British (1858–1943)
Running Scared
Bears another monogram,
oil on canvas
19¼ x 23¼in (49 x 59cm)
£700–900 *S(S)*

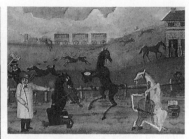

English Primitive School (c1840)
The Buskers
Oil on canvas
10½ x 13⅜in (26.5 x 35cm)
£900–1,200 *S(S)*

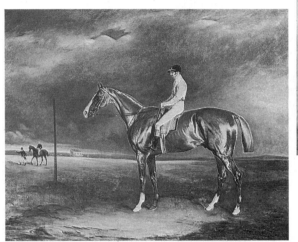

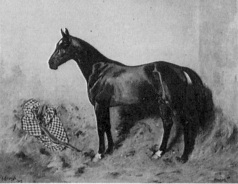

Alfred Grenville Haigh
British (1870–1963)
Mirdas
Signed and dated '1907', oil on canvas
16 x 20in (40.5 x 50.5cm)
£900–1,200 *RBB*

John E. Ferneley, Snr.
British (1782–1860)
Velocipede, winner of the
St. Leger, with W. Scott up
Signed 'Melton Mowbray',
dated '1829', oil on canvas
34 x 42in (86 x 106.5cm)
£68,000–78,000 *S(NY)*

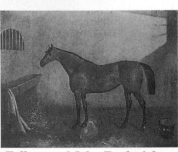

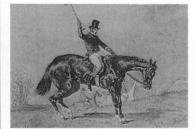

John Frederick Herring, Jnr.
British (1815–1907)
Pump'd Out
Signed with initials and inscribed,
watercolour over pencil
7½ x 10in (19 x 25cm)
£700–900 *S(S)*

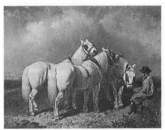

**Follower of John Frederick
Herring, Snr.**
British (1795–1865)
A Bay Hunter in a Stable
Oil on canvas
20 x 26in (50.5 x 66cm)
£650–850 *S(S)*

John Frederick Herring, Snr.
British (1795–1865)
Ploughteam Resting
Signed and dated '1846',
oil on canvas
27 x 35in (68.5 x 89cm)
£36,000–42,000 *S(NY)*

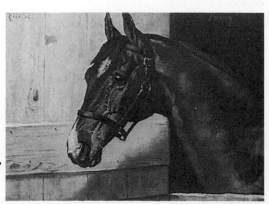

r. **George Paice**
British (1854–1925)
Tarry
Signed, inscribed and dated '81',
oil on canvas
13¾ x 17½in (35 x 44cm)
£1,500–1,800 *S(S)*

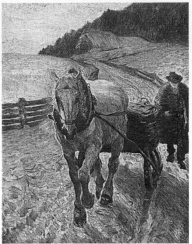

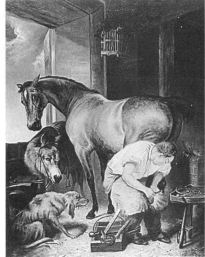

r. **William Widgery,
after Sir Edwin
Landseer**
British (1822–93)
Horse, Donkey and Dog
at the Blacksmith's
Signed and dated 1856,
oil on canvas
36 x 28in (91.5 x 71cm)
£350–450 *TAY*

Scandinavian School (c1890)
Untitled
Oil on canvas
24 x 18in (61.5 x 45.5cm)
£3,000–3,250 *HeG*

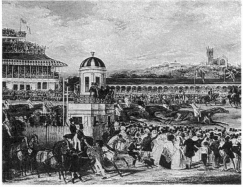

Francis Calcraft Turner
British (active 1782–1846)
The Wolverhampton Stakes, August 12, 1839
Signed and dated '1840', oil on canvas
28 x 36in (71 x 91.5cm)
£98,000–120,000 *S(NY)*

*A prolific equestrian artist, Turner was also a
keen hunter as he boasted, in a letter to* The
Sporting Magazine *in June 1825: 'I have rode
to more hounds and have been at the death of
more foxes, than any artist in existence – nay
more, my knowledge of racing, shooting,
coursing, etc. is alike.'*

Alfred Wheeler
British (1852–1932)
Flying Fox
Signed, inscribed and dated '1899'
20 x 24in (51 x 61.5cm)
£3,000–4,000 *S(S)*

*Flying Fox was bred and owned by the 1st Duke of
Westminster and trained by John Porter. His wins
included the 2,000 Guineas, the Derby and the
St. Leger all in 1899, and all ridden by Herbert
Mornington Cannon (1873–1962). Flying Fox came
up for sale in 1900 and was bought by M. Edmond
Blanc for 37,500 guineas, which was a vast sum at
the time.*

20th Century

Neil Cawthorne
British (b1940)
First Lot Lambourn
Signed, oil on canvas
18 x 24in (45.5 x 61.5cm)
£1,800–2,000 *HeG*

Letitia Marion Hamilton
British (1878–1964)
Punchestown Races
Signed with initials, oil on canvas
22 x 26in (55.5 x 66cm)
£9,000–10,000 *C*

Peter Lamberton
British (b1945)
Rainbow Quest
Signed, crayon
12 x 10in (30.5 x 25cm)
£200–250 *HeG*

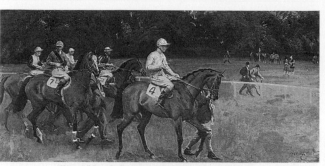

Sir Alfred James Munnings, PRA
British (1878–1959)
Parade to the Post, Kempton Park
Signed, oil on panel
18 x 36in (45.5 x 91.5cm)
£255,000–265,000 *S(NY)*

*'There is no better guide to Old England than A.J.,'
declared artist Laura Knight. Munnings loved the
British countryside and idolised horses, riding
untiringly and making his considerable fortune from
painting the horses of the rich and powerful. His
1947 exhibition, The English Scene, at the Leicester
Galleries, brought in £20,788, then a national record
for a living artist. His success is perhaps still more
remarkable when one considers that the painter had
only one eye, having lost the sight of his right eye
when it was pierced by a thorn in 1898.*

l. **John Lambie**
British (b1960)
Detail from a
Klodts Horse
Signed and dated
on reverse, crayon
11in (28cm) square
£200–225 *HeG*

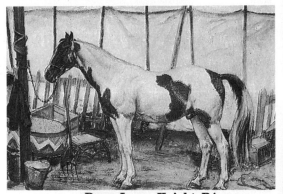

Dame Laura Knight, RA
British (1877–1970)
Pollux
Signed, watercolour and gouache
over charcoal
22½ x 30⅜in (57 x 78cm)
£4,000–5,000 *P*

*Painted c1930, Pollux and Apollo were
a pair of skewbald performing horses
belonging to Mr Carmo's circus.*

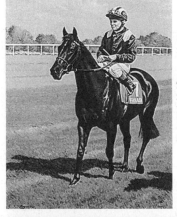

l. **Roy Miller**
British (b1938)
Erhaab
Signed, oil on canvas
35 x 27in (89 x 68.5cm)
£1,800–2,000 *EAG*

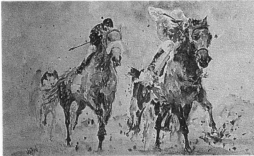

Glenn Wawman
British (b1955)
Opera House and Misil, Coral Eclipse 1993
Signed and dated on reverse, watercolour
12 x 20in (30.5 x 50.5cm)
£400–500 *HeG*

James Wright
British (b1935)
Ploughing the Field
Signed, oil on canvas
12 x 16in (30.5 x 40.5cm)
£400–500 *JN*

Hunting

Circle of Carel van Falens
Dutch (1683–1733)
A Hawking Party and A Hunting Party
at rest
A pair, oil on panel
6¾ x 9½in (17 x 24cm)
£6,000–7,000 *CSK*

George Denholm Armour
British (1864–1949)
Lord Heartycheer's Quiet Bye-day
Signed, watercolour over pen and ink
10½ x 8½in (26.5 x 21.5cm)
£800–1,000 *S(S)*

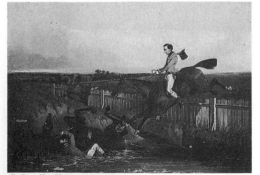

John Dalby of York
British (active 1826–56)
Over the Fence
Signed and dated '1850',
oil on canvas
11½ x 16½in (29.5 x 42cm)
£3,500–4,500 *S(S)*

Francis Stringer
British (active 1760–72)
Samuel Frith with Huntsman, Jackie
Owen, Out Hunting with his Pack,
Chapel-en-le-Frith, Derbyshire
Oil on canvas
60¾ x 94in (154 x 238cm)
£28,000–32,000 *S(NY)*

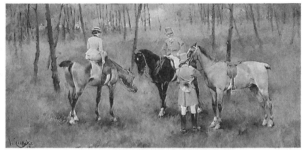

José Cusachs y Cusachs
Spanish (1851–1908)
The Hunting Party
Signed and dated '1903', oil on canvas
18½ x 38½in (47 x 98cm)
£40,000–45,000 *S*

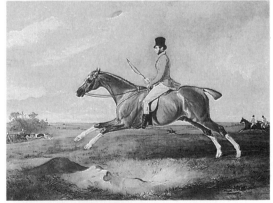

John E. Ferneley, Snr
British (1782–1860)
George Paine, Master of Foxhounds, on 'The
Clipper', out hunting with the Pytchley
Signed and dated '1827', oil on canvas
34 x 44in (86 x 111.5cm)
£65,000–75,000 *S(NY)*

*George Paine (1808–73) was twice Master of the
Pytchley hunt. His father was killed in a duel, and
at a very early age he inherited a large fortune.
However, due to his love of gambling, lack of success
with racehorses, and total involvement with life as a
country squire, he soon spent his fortune, as well as
two others subsequently left to him. He owned
racehorses for over 50 years, but had only one major
success – the 1,000 Guineas in 1847. Paine had
several notable racing failures; he lost the enormous
sum of 33,000 guineas on the 1824 St. Leger.*

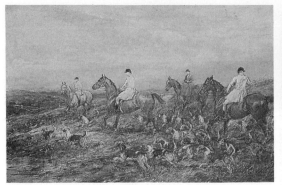

Heywood Hardy, ARWS, RPE
British (1843–1933)
Drawing Covert
Signed, oil on canvas
20 x 30in (50.5 x 76cm)
£6,000–7,000 *C(S)*

John Frederick Herring, Snr
British (1795–1865)
A Hunt in Full Cry
Signed and dated '1834', oil on canvas
13½ x 31¾in (34 x 80.5cm)
£60,000–70,000 *C*

Basil Nightingale
British (1864–1940)
The Chase
Signed and dated '1882', watercolour
over traces of pencil
15¼ x 22⅞in (39 x 58cm)
£1,000–1,400 *S(S)*

Ludwig Koch
Austrian (1866–1934)
A Hunting Scene
Signed and inscribed, oil on canvas
78 x 55in (198 x 139.5cm)
£12,000–14,000 *S*

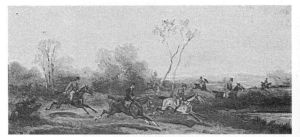

R. Stone
British (19thC)
Huntsmen approaching a Pond
Signed, oil on panel
6 x 12in (15 x 30.5cm)
£250–350 *DA*

Gilbert S. Wright
British (1880–1958)
The Runaway Horse
Signed and dated '97', oil on canvas
15¾ x 19⅜in (40 x 50cm)
£2,800–3,500 *S(S)*

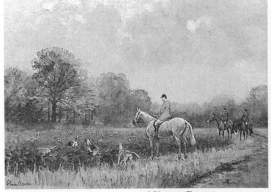

Alison Guest
British (20thC)
Drawing Kale
Signed, watercolour
12 x 16in (30.5 x 40.5cm)
£650–750 *RGFA*

ARCHITECTURE

'One of the great excitements about dealing in Victorian art is that there are still so many artists waiting to be discovered, particularly in watercolours and drawings,' enthuses dealer Christopher Wood. This is certainly true of paintings of interiors. As Wood explained to Miller's, architectural interiors were a popular subject throughout 19thC Europe, inspiring both professional artists and amateur painters, particularly women painting from home. Each nation has its idiosyncrasies. 'The British tended to include figures or pets,' says Wood, 'the Russians produced grand and empty interiors, whilst the Danish often included women, shown from the back.' In this highly decorative field, minor and amateur artists can produce both interesting and commercial pictures and it is not only the big names that are worth looking out for. In late 1994, Christie's first ever sale devoted to interiors was described by expert Andrew Clayton-Payne as a 'resounding success', many works exceeding their estimate, attracting enthusiastic bidding from dealers, private collectors and interior decorators.

Exteriors

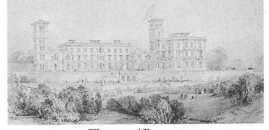

Thomas Allom
British (1804–72)
Osborne House, Isle of Wight
Engraving, pencil and brown wash, heightened with white
8¼ x 15¾in (20.5 x 40cm)
£2,000–2,400 *CW*

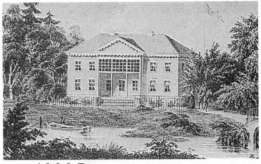

Adolph Besemann
German (b1806)
Russian Figures by a Classical Country Villa
Signed, watercolour
4¼ x 7in (11 x 17.5cm)
£350–450 *Bon*

William Busfield
British (1773–1851)
Esholt Hall, Yorkshire
Inscribed, watercolour over pencil
5½ x 9in (14 x 22.5cm)
£550–650 *HP*

'Esholt Hall, formerly a priory', is inscribed on the reverse. The hall was built 1706–09 for Sir Walter Calverley.

r. **John Chessell Buckler**
British (1793–1894)
The Abbey Gate at Malvern, Worcestershire
Signed and dated '1811', pencil and watercolour
6 x 9¼in (15 x 23cm)
£250–300 *CSK*

l. **Giuseppe Bernardino Bison**
Italian (1762–1844)
A Lady and Gentleman looking out of an ornate Window
Bears inscription, pen and brown ink and wash and pink and yellow and mauve wash
120 x 77¾in (305 x 197cm)
£22,500–26,500 *S(NY)*

The gentleman standing behind the lady's chair is probably her 'cicisbeo', the term used to describe the male companions who acted in Venetian 18thC society as 'walkers', devoted to the service of married ladies. 'They are obliged to wait on her to all public places,' noted Lady Mary Wortley Montagu (1689–1762), 'to wait behind her chair, take care of her fan and gloves if she plays, have the privilege of whispers . . . but the husband is not to have the impudence to suppose 'tis any other than a pure platonic friendship.'

Oliver Baker
British (1856–1939)
Timbered Houses by a River
Signed, pencil and watercolour
26½ x 19½in (67.5 x 49.5cm)
£300–400 *CSK*

After Colin Campbell
British (1676–1729)
Vitruvius Britannicus:
Prospect of the Royal
Hospital at Greenwich,
Castle Howard and
Umberslade from Volume III
Three engravings, by
H. Hulsbergh, pub. 1725
12¾ x 19½in (32.5 x 49.5cm)
£350–400 *CSK*

English School (c1820)
Design for a Classical Villa on a River Bank
Pencil, pen and ink, and watercolour
10¾ x 19in (27.5 x 48cm)
£650–750 *HP*

Thomas Greenhalgh
British (late 19thC)
An Exterior
Signed, watercolour
20 x 28in (50.5 x 71cm)
£350–500 *BWe*

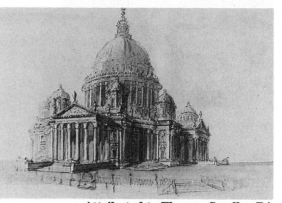

Attributed to Thomas Sandby, RA
British (1723–98)
Design for a Cathedral
Pencil, pen and grey ink, grey wash
8 x 10¾in (20 x 27.5cm)
£800–900 *HP*

William Rider
British (d1842)
Umberslade Hall, Warwickshire
Pencil
8½ x 12½in (21.5 x 31.5cm)
£200–250 *HP*

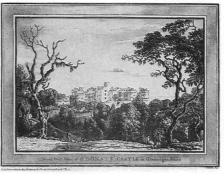

Paul Sandby
British (1725–1809)
Views in South Wales and Views in
North Wales
23 aquatints printed in sepia, 1775–77
12¼ x 18in (31 x 45.5cm)
£1,900–2,400 *S*

r. **John Sanderson**
British (d1774)
Design for additions to Britwell Court, Burnham,
Buckinghamshire
Signed and inscribed, pen and ink and watercolour
13 x 17¾in (33 x 45cm)
£1,000–1,200 *HP*

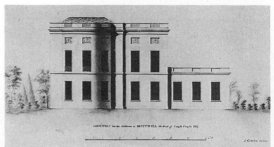

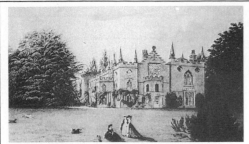

Gustav Ellinthorpe Sintzenich
British (active 1840–56)
Strawberry Hill, Middlesex
Watercolour over pencil, heightened
with bodycolour
10¾ x 15in (27.5 x 38cm)
£2,000–2,500 *HP*

*This view shows Horace Walpole's Gothic villa
c1840 in its completed state and before
Lady Waldegrave's additions of 1861.*

Henry Sargant Storer
British (1795–1837)
A Country House, possibly in Bedfordshire
Pen and ink, grey wash
4 x 6in (10 x 15cm)
£400-450 *HP*

John Varley
British (1778–1842)
Children in a Village Street
Signed and dated '1834', watercolour with
scratching out
7 x 10½in (17.5 x 26.5cm)
£350–450 *Bon*

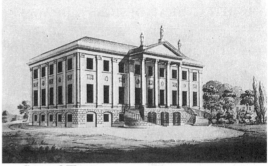

Samuel Wyatt
British (1737–1807)
An album of designs for a new house
at Mere, Cheshire
Contemporary tree calf gilt, red morocco label
tooled and titled 'Mere House 1783'
Pencil, pen and black ink with grey ochre washes
12½ x 18in (31.5 x 45.5cm)
£12,000–13,000 *HP*

Interiors

Austrian School (c1825)
Cabinet de ma Mère a Néapol en 1825
Signed and inscribed, pencil, pen and ink
and watercolour heightened with white
8½ x 12in (21.5 x 30.5cm)
£2,000–2,500 *C*

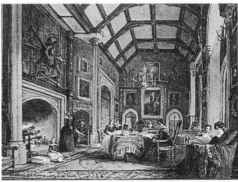

Lady Honoria Cadogan
British (1813–1904)
The Great Hall of a Gothic Country House
Watercolour over pencil, with bodycolour
9½ x 12¾in (24 x 32.5cm)
£4,000–4,500 *CW*

r. **G. B. Barborini**
Italian (19thC)
Figures in Santa
Sophia, Istanbul
Signed, inscribed, oil on canvas
43 x 31in (109 x 78.5cm)
£19,000–24,000 *S*

l. **Charles Candish**
British (c1885)
Hunting Lodge Interior
Signed and inscribed, pencil,
pen and ink and watercolour
14 x 21in (35.5 x 53cm)
£1,800–2,200 *C*

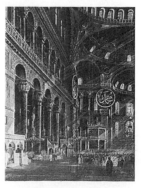

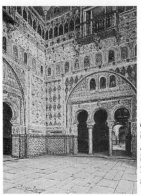

r. **English School** (19thC)
View of the Interior of the
Great Exhibition, 1851
Coloured lithograph, with
touches of white heightening
28 x 39in (71 x 99cm)
£450–550 *CSK*

l. **M. Lopez Cantero**
Spanish (19thC)
A Moorish Interior
Signed, oil on canvas
21¼ x 15½in (53 x 39.5cm)
£2,500–3,000 *S*

r. **Alma Burton Cull**
British (exh 1908–19)
The Passage of a
Country House
Signed and dated '08',
pencil and watercolour
with touches of white
heightening
14 x 10in (35.5 x 25cm)
£300–400 *CSK*

English School (c1840)
A Baronial Hall
Pencil and watercolour
12½ x 19¼in (31.5 x 48.5cm)
£1,300–1,600 *C*

l. **English School** (c1880)
Interior View of a Staircase
and Landing at Gower
House in Whitehall, opposite
the Horseguards
Pencil and watercolour
21 x 16in (53.5 x 40.5cm)
£900–1,200 *C*

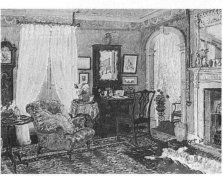

English School (20thC)
View of a Sitting Room decorated in the
18thC Style with Antique Furniture
Pencil and watercolour, with touches of
white heightening
15¾ x 21½in (40 x 54.5cm)
£2,000–2,500 *C*

Henri Evenepoel
Belgian (1872–99)
A Corner of the Studio
Stamped with the atelier mark,
dated '1899', oil on canvas
12¾ x 16in (32 x 40.5cm)
£8,000–10,000 *P*

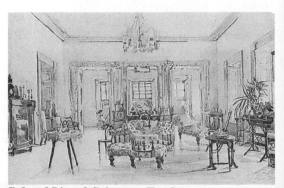

Colonel Lionel Grimston Fawkes
British (1849–1931)
The Drawing Room of Queen's House, Barbados, 1880
Watercolour over pencil
9¾ x 14½in (24.5 x 37cm)
£1,400–1,800 *P*

French School (c1790)
Design for a Bed Alcove for Empress Catherine II,
Catherine the Great of Russia
Pen and grey ink, and watercolour, watermark
Honig and Zoon
9 x 14½in (22.5 x 37cm)
£1,000–1,400 *C*

French School (c1860)
Interior of a doorway with a
windowbox, floral motif
wallpaper and curtains
Pencil and watercolour
9 x 7in (22.5 x 17.5cm)
£1,500–2,000 *C*

l. **Walter Gay**
American (1856–1937)
In a French Chateau
Inscribed 'John Singer Sargent',
pencil and watercolour
14 x 7½in (35.5 x 19cm)
£4,000–5,000 *C*

*This watercolour is by Sargent's
friend and fellow American, the
artist Walter Gay. Gay met
Sargent in about 1879, but it
was not until 1895, when he
started spending his summers
at the Chateau de Fortoiseau,
that he painted the first of the
empty interiors. These were to
become his trademark, the kind
of subject with which he is now
almost exclusively associated.*

Félix François Genaille
French (active 1830–60)
Vue du Salon de la Comtesse de Salverte
(née Daru) à Paris
Signed and dated '1857', pencil and
watercolour heightened with white
12½ x 16½in (31.5 x 42cm)
£20,000–25,000 *C*

George Goodwin Kilburne
British (1839–1924)
View of the Bedroom where Napoleon III died,
Camden Place, Chislehurst, Kent
Signed and dated '1873', pencil and
watercolour with touches of white heightening
9 x 13¼in (22.5 x 33cm)
£16,250–20,000 *C*

*After his disastrous defeat at Sedan in
September 1870, Napoleon III was held as a
prisoner-of-war by the Germans for more than
6 months. With the signing of the armistice by
the French Government the Emperor was
released and made immediate arrangements to
join his exiled wife and son in the house they
had taken at Camden Place, Chislehurst in
Kent. Queen Victoria had visited the Empress
Eugenie soon after she arrived and found the
house very small; she referred to 'the poor
Emperor's humble little rooms', but the
Emperor lived there contentedly until his
death in 1873.*

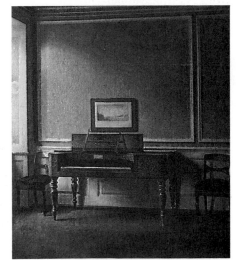

Vilhelm Hammershoi
Danish (1864–1916)
The Music Room
Signed with initials, oil on canvas
27 x 23½in (68.5 x 60cm)
£35,000–40,000 *P*

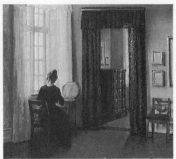

Gaetano Landi
Italian (18th/19thC)
Architectural Decorations: A
periodical work of original designs
invented from the Egyptian, The
Greek, The Roman . . . for exterior
and interior decoration, London:
Thomas King, 1810.
26 hand coloured engraved and
aquatint plates
15½ x 22in (40 x 56cm)
£3,500–4,500 *C*

*This is a very rare series of
unusual room designs in the Greek,
Roman, Egyptian, Etruscan and
Gothic manner. The work was
issued in parts from
January–March 1810 by Landi
from his address at the Sablonière
Hotel, Leicester Square, London.*

Conrad Leigh
British (20thC)
A Lady in an Interior
Signed, oil on canvas
25½ x 21½in (65 x 54.5cm)
£800–1,000 *CSK*

Aage Lund
Scandinavian (early 20thC)
At the Window
Signed and dated '18',
oil on canvas
23 x 25½in (58.5 x 65cm)
£2,500–3,000 *C*

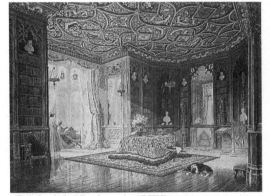

Frederick Mackenzie, OWS
British (1787–1854)
The Library of Stanmore Hall, the seat of Robert
Hollond, Esq
Signed, pencil, pen and black ink and watercolour
with touches of white heightening
26 x 35in (66 x 89cm)
£33,000–38,000 *C*

*This astonishing Gothic library was one of the
principal reception rooms in Stanmore Hall, a
large Tudor revival house built in London in 1847
for Robert Hollond, MP for Hastings, and
celebrated baloonist. The library was destroyed
when the house was devastated by fire in 1979.
This work was the top selling lot at Christie's sale
of interiors, more than quadrupling its
£6,000–8,000 estimate.*

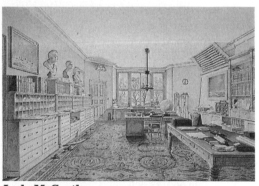

Lady McCarthy
British (active 1840–50)
Isambard Kingdom Brunel's Office at
No. 18 Duke Street, Westminster
Pencil, pen and ink and watercolour
with scratching out
14½ x 20½in (37 x 52cm)
£16,000–20,000 *C*

l. **Colonel Harold
Esdaile Malet**
British (1841–1918)
Interior at Woolwich
Pencil, pen and black
ink and watercolour
heightened with white
and scratching out
9¾ x 7in (24.5 x 17.5cm)
£1,000–1,300 *C*

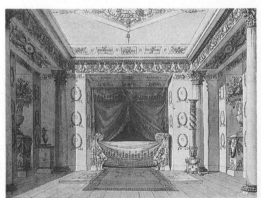

Circle of Charles Percier
French (1764–1838)
Interior Design for an Empire Bedroom, c1810
Inscribed, pencil, pen and black ink, grey wash
13¾ x 18in (35 x 45.5cm)
£6,500–7,500 *C*

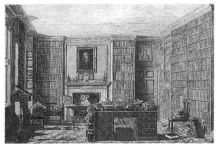

Luigi Ossipovitch Premazzi
Italian (1814–91)
A Salon Interior, Thought to be in the
Palace at Tsarkoe Seloe
Signed and dated '1870', watercolour
8½ x 12½in (21.5 x 31.5cm)
£800–1,000 *P*

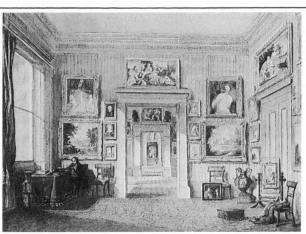

**Attributed to Miss Georgiana or Miss Harriet
Rushout-Bowles**
British (active 1843)
The Dining Room at Thirlestaine House
Pencil and watercolour heightened with gum arabic
and scratching out
13½ x 17½in (34.5 x 44.5cm)
£10,500–12,000 *C*

*Interiors frequently tended to be painted in
watercolours, sometimes mixed with opaque white, to
give body. Watercolour was the favourite medium of
amateur artists, including many women painters, for
whom interior views, like flower paintings, were
considered a suitably feminine subject.*

George Pyne
British (1860–84)
Study of an Academic or a Lawyer, c1840
Pencil and watercolour
8¾ x 13in (22 x 33cm)
£16,250–20,000 *C*

*It is very unusual to see a room
depicted in such a state of
disarray, with the desk and
every other surface – even the
chair seat – piled with books
and papers.*

r. **Diana Sperling**
British (1791–1862)
The Drawing Room at Tickford
Park, Buckinghamshire
Inscribed, pencil and
watercolour
8 x 6¾in (20 x 17cm)
£1,250–1,750 *C*

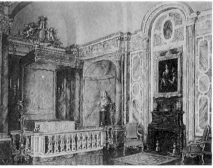

Alexandre Serebriakoff
Russian (b1907)
State Bedroom of Mr Arturo Lopez-
Willshaw, Hôtel Rodoconachi
Signed, inscribed and dated '1951',
pencil and watercolour with
touches of white heightening
and gum arabic
16 x 20¾in (40.5 x 53cm)
£3,750–4,750 *C*

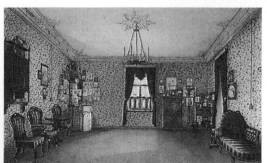

Ivan Petrovich Vol'skii
Russian (1817–68)
A Russian Living Room with an Icon Corner
Signed, pencil and watercolour with touches
of white heightening
7 x 11¼in (17.5 x 28.5cm)
£1,900–2,400 *C*

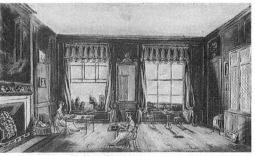

Harriet Yellowby
British (active 1830–40)
Interior Views of Woodton Hall, The Drawing
Room and The Oak Room
Two, both inscribed and dated '1835', pencil
and watercolour
7½ x 12½in (19 x 31.5cm), and smaller
£1,500–2,000 *C*

BEACH SCENES

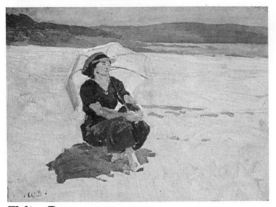

Walter Bayes
British (1869–1956)
Kitty on the Beach
Signed with initials, oil on board
11½ x 14½in (29 x 37cm)
£3,000–3,500 *C*

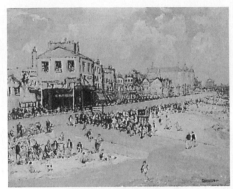

Godwin Bennett
British (active 1930–40)
Punch and Judy Show, Hastings
Signed, oil on canvas
20 x 24in (51 x 61cm)
£1,800–2,200 *C*

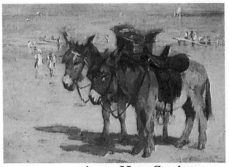

Agnes Mary Cowieson
British (active 1882–1940)
On the Beach, Portobello
Signed, signed and inscribed
on artist's label on the
reverse, oil on canvas
9¾ x 14in (24.5 x 35.5cm)
£4,000–4,500 *C(S)*

William Stephen Coleman
British (1829–1904)
The Sand Castle
Signed, pencil and watercolour
heightened with white
18½ x 10¼in (47 x 26cm)
£1,800–2,300 *CSK*

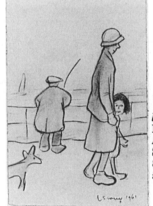

l. **Laurence Stephen Lowry, RA**
British (1887–1976)
A Walk on the Pier
Signed and dated '1961', pencil
8¾ x 5¼in (22 x 13cm)
£3,000–3,500 *S*

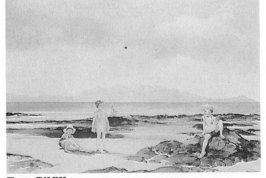

Tom Gilfillan
British (active 1930–40)
Children on the Beach, Isle of Skye
Signed, watercolour
21 x 28½in (53 x 72cm)
£1,650–1,850 *WrG*

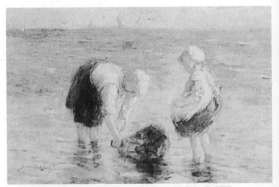

Robert Gemmell Hutchison, RSA, RSW
Scottish (1855–1936)
Children Playing in the Shallows
Signed, watercolour heightened with scratching out
8¾ x 11½in (22 x 29cm)
£6,500–7,000 *S(Sc)*

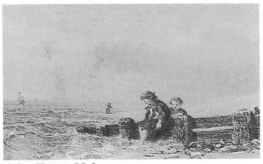

John Henry Mole
British (1814–86)
On the Breakwater
Signed and dated '1868', watercolour
heightened with white
7¾ x 11½in (19.5 x 29cm)
£900–1,200 *Bon*

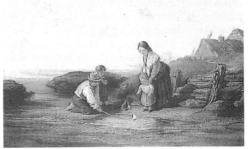

Attributed to Philip Hutchings Rogers
British (1786–1853)
A Day by the Sea
Oil on canvas
10 x 12in (25 x 30.5cm)
£600–800 *CSK*

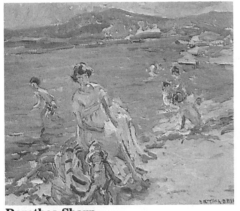

Dorothea Sharp
British (1874–1955)
Figures Bathing
Signed, oil on card
20 x 24in (51 x 61cm)
£3,000–4,000 *Bon*

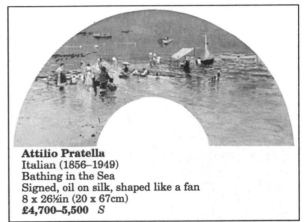

Attilio Pratella
Italian (1856–1949)
Bathing in the Sea
Signed, oil on silk, shaped like a fan
8 x 26½in (20 x 67cm)
£4,700–5,500 *S*

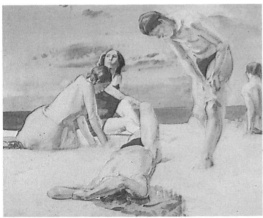

Harry Watson
British (1871–1936)
The Bathers
Watercolour
17½ x 21¼in (44 x 54cm)
£800–1,000 *Bon*

Frank Taylor
British (20thC)
Beach Huts, Berck-Plage
Watercolour
17 x 23in (43 x 58.5cm)
£750–800 *PHG*

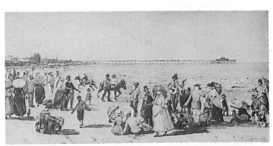

r. **Alexander Young**
British (active 1889–93)
On the Sands
Signed, watercolour
9 x 18¼in (23 x 46cm)
£500–700 *DN*

BIRDS

Auctions devoted to bird pictures tend to attract more private collectors than dealers. Such was the case at Sotheby's sale in London of watercolours from the Glenbow Museum, Calgary, Canada. The Glenbow foundation was set up in 1954 by oil magnate Eric Harvie. 'I want you to go out and collect like a bunch of drunken sailors,' Harvie informed his staff, whilst he himself embarked on eclectic global shopping sprees, bringing back to Canada everything from medieval armour to stuffed birds, to a pair of Queen Victoria's bloomers. When the museum decided to 'streamline' their collection in the cost conscious 90s, their fine selection of ornithological paintings was sold in London. Bird pictures are certainly popular with the British market and Britain has produced some of the finest artists in the field, such as John Harrison, George Edward Lodge and Archibald Thorburn. Interest in painting birds often went hand-in-hand with a love of shooting. Many bird artists were also keen sportsmen and today, their pictures still attract the country and sporting set.

17th–18th Century

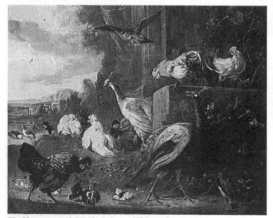

Follower of Melchior d'Hondecoeter
Dutch (1636–95)
A Peacock with Poultry, a Lapwing and a Bird of Prey in a Garden Setting
Oil on canvas
58in x 72in (148 x 182.5cm)
£8,200–10,000 *S*

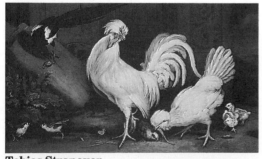

Tobias Stranover
Czechoslovakian (1684–1724)
A Cockerel, a Hen, Chicks, Robins and a Magpie taking a Snail
Oil on canvas
29 x 42½in (74 x 108cm)
£18,000–20,000 *C*

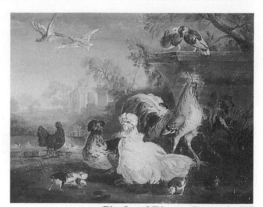

Circle of Pieter Casteels III
Flemish (1684–1749)
Fowl in a Park
Oil on canvas
28 x 37⅓in (71 x 94cm)
£7,000–8,000 *C*

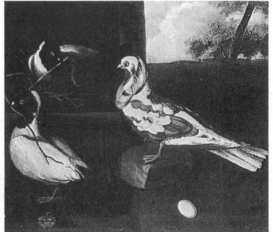

Follower of Marmaduke Craddock
British (1660–1717)
Pigeons in a Barn
Oil on canvas
18 x 20in (46 x 51cm)
£700–800 *CSK*

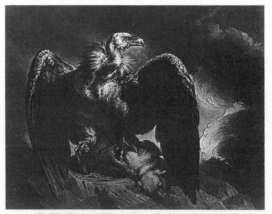

S. W. Reynolds, after J. Northcote, RA
British (1746–1831)
Vulture and Lamb
Mezzotint, published by James Dordell & Co., Great Charlotte Street, Blackfriars Road, London, June 24, 1799
19 x 23½in (48 x 60cm)
£2,500–3,000 *GP*

19th–20th Century

Attributed to Constant Artz
Dutch (1870–1951)
Ducks on a River Bank
Signed, oil on panel
7 x 11in (17.5 x 28cm)
£900–1,200 *CSK*

George Edward Collins
British (b1880)
Sleeping Chicks and Thirsty Chicks
A pair, one signed with initials 'GEC',
watercolours heightened with white
5 x 8in (12.5 x 20cm)
£550–650 *CSK*

Neil W. Cox
British (b1955)
The Grouse Moor
Signed, watercolour
17½in x 27in (44 x 69cm)
£1,350–1,550 *WrG*

Alexandré Defaux
French (1826–1900)
A Black and White Cock
Signed, oil on canvas
11½ x 15½in (29 x 39cm)
£1,000–1,200 *Bea*

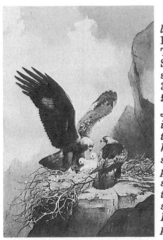

l. **John Cyril Harrison**
British (1898–1985)
The Rock Eyrie – Golden Eagles
Signed, watercolour heightened with
scratching out over traces of pencil
39 x 26in (99 x 66cm)
£11,000–12,000 *S*

*John Harrison first became interested
in birds as a child when he studied
taxidermy, giving him a profound
knowledge of the anatomy of his
subjects. His approach was always
pragmatic. Throughout his career he
spent many hours observing birds in
the field and he travelled the globe in
search of different species to portray.
Favourite subjects included birds of
prey, game birds and wildfowl.*

Roland Green
British (1896–1972)
Three Partridges
Signed, watercolour
heightened with white
15 x 10½in (38 x 26cm)
£300–350 *CSK*

l. **John Cyril Harrison**
British (1898–1985)
Pheasant – Solitary
Signed, inscribed with title on a label attached to the
backboard, watercolour heightened with bodycolour
8¾ x 12¾in (22 x 32.5cm)
£650–800 *S(Sc)*

Edgar Hunt
British (1876–1953)
Chicken and Chicks and Pigeons
A pair, oil on canvas
9 x 12in (23 x 30.5cm)
£20,000–25,000 *HFA*

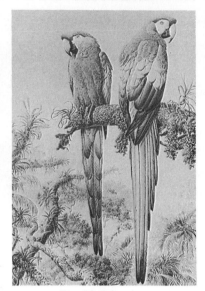

George Edward Lodge
British (1860–1942)
Southern Puffin
Signed and inscribed with title,
watercolour and bodycolour
11½ x 9in (29 x 23cm)
£2,500–3,000 *S*

*Lodge was born in the same year
as Archibald Thorburn and both
were perhaps the greatest bird
painters of their generation.
George Lodge's knowledge of
birds was extensive. He sketched
both in the field and at London
Zoo and kept, in his studio, an
enormous reference collection of
bird 'skins', which he prepared
himself. He was Vice President of
the British Ornithologists'
Union, an enthusiastic
sportsman, a keen shot at game
birds and above all loved
falconry, his favourite sport. His
home in Camberley, Surrey, was
fittingly entitled, 'Hawk House'.*

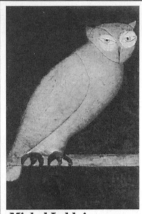

Michel Lablais
French (20thC)
Le Hibou
Signed and dated '55',
oil on board
33 x 25in (83.5 x 63.5cm)
£500–600 *Bea*

George Lance
British (19thC)
A Heron by Night
Signed and dated '1881', oil on panel
13½ x 17in (34 x 43cm)
£700–800 *CSK*

David Johnstone
British (20thC)
Scarlet Macaws
Signed and dated 'vii 1984',
watercolour
28 x 20in (71 x 51cm)
£1,200–1,600 *Bon*

Philip Rickman
British (1891–1982)
Ptarmigan
Signed and dated '1954',
watercolour and bodycolour
31 x 22¾in (78.5 x 58cm)
£5,200–6,000 *S*

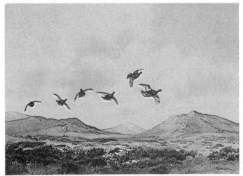

Robert W. Milliken
British (b1920)
Grouse in Flight
Signed, watercolour heightened with bodycolour
21¼ x 29in (54 x 74cm)
£1,000–1,400 *S(Sc)*

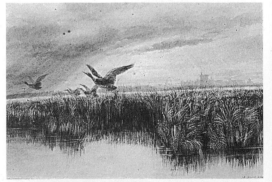

Andrew Nicholl, RHA
British (1804–86)
Ducks in Flight on the Thames, near Windsor
A pair, signed, watercolour
13 x 19in (33 x 48.5cm)
£1,500–2,000 *TAY*

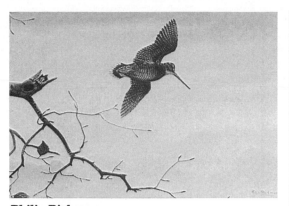

Philip Rickman
British (1891–1982)
A Woodcock in Flight
Signed, pencil and watercolour heightened with white
10 x 14in (25 x 36cm)
£500–600 *CSK*

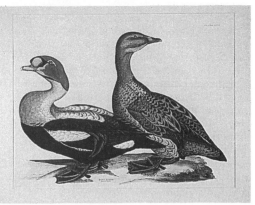

John Selby
British (1788–1867)
The King Eider
Hand coloured copperplate engraving
14½ x 21¾in (37 x 55cm)
£500–550 *OSh*

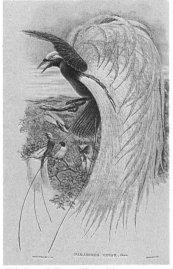

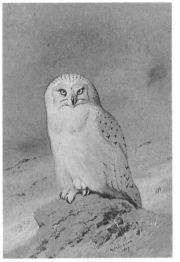

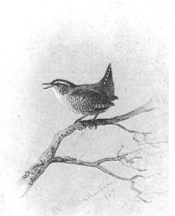

Richard Bowdler Sharpe
British (19thC)
Birds of Paradise and
Bower-birds
Two volumes containing
79 hand-coloured lithographic
plates by W. Hart after his
own work and that of J. Gould
and J.G. Keulemans, with
later hand-colouring
21in x 14in (54.5 x 36cm)
£10,000–12,000 *C*

Archibald Thorburn
British (1860–1935)
A Snowy Owl
Signed and dated '1917',
watercolour and bodycolour
10½ x 7¼in (26.5 x 18cm)
£8,000–9,000 *S*

Archibald Thorburn
British (1860–1935)
Study of a Wren
Signed and dated '1907',
watercolour and bodycolour
8¾ x 7in (22 x 17.5cm)
£1,500–2,000 *P*

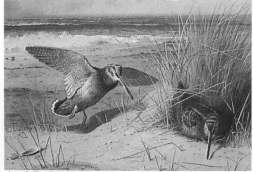

Archibald Thorburn
British (1860–1935)
Woodcock
Signed and dated '1903', monochrome bodycolour
13½ x 20in (34 x 51cm)
£3,000–4,000 *DN*

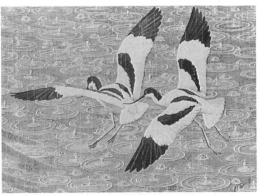

Charles Frederick Tunnicliffe
British (1901–79)
Arrival in the Rain
Signed, title on label on reverse, colour wash
15¾ x 22½in (40 x 56.5cm)
£3,500–4,000 *P(L)*

BOTANY

Botanical painting implies the exact,
scientific portrayal of flowers and plants,
often concentrating on a single bloom.
The following section, as well as covering
paintings, prints and watercolours, also
includes illustrated books, one of the
greatest sources of botanical images. As
early as the 15thC, illuminators were
including jewel-like portrayals of single
flowers and plants in the borders of
manuscripts. From there the science and art
of botany developed rapidly throughout the
16th and 17thC, with botanical artists
producing illustrations for herbals and
recording rare plants for royal and
aristocratic patrons. The 18thC was perhaps
the golden age of botanical painting, giving
birth to artists such as Pierre Joseph Redouté
(1759–1841), whose flower pictures are prized
around the world, and who also inspired a
whole generation of talented pupils. France
and England dominated the field of botanical
painting during this period and many of the
finest painters were women. Female
botanical artists have also produced some of
the most skilful work of the 20th Century.

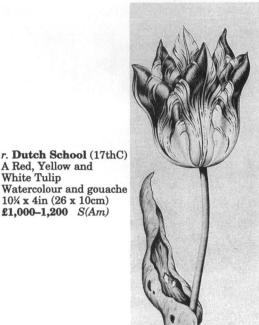

r. **Dutch School** (17thC)
A Red, Yellow and
White Tulip
Watercolour and gouache
10¼ x 4in (26 x 10cm)
£1,000–1,200 *S(Am)*

17th–18th Century

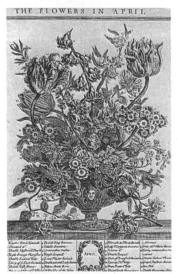

After Peter Casteels
Flemish (1684–1749)
The Twelve Months
of Flowers
Twelve coloured engravings
with etching, trimmed inside
the platemark, originally
published 1730, laid paper,
laid down on card
13¾ x 9½in (35 x 24cm)
£2,750–3,500 *CSK*

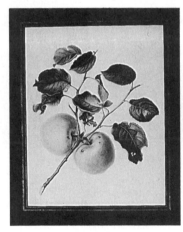

l. **Follower of
Georg-Dyonis Ehret**
German (1710–70)
Apples on Stalks with Leaves
Inscribed 'Gloucestershire
Pippins', watercolour, 19thC
14 x 11in (35.5 x 28cm)
£550–650 *LH*

r. **Dutch School** (17thC)
A Purple, Yellow and White Tulip
with a Ladybird and other Insects
Watercolour
13½ x 8½in (33.5 x 21cm)
£2,000–2,200 *S(Am)*

Crispin de Passe
Dutch (17thC)
Botanicals
Hand-coloured print
24 x 20in (61 x 51cm)
£110–130 *EDG*

19th Century

American School (19thC)
Lord Raglan and Gen'l J.A. Oqueminot Rose
A pair of lithographs, with original colour, published in New York, c1870
10½ x 7½in (26 x 19cm)
£100–120 *SRAB*

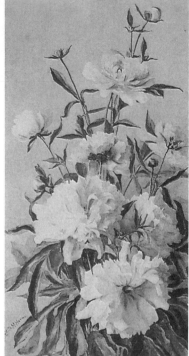

Edith Margaret Harms
British (exh 1897–1932)
White Peonies
Signed, watercolour
24¼ x 12¼in (62 x 31cm)
£1,300–1,500 *WrG*

Augustus Innes Withers
British (active 1829–65)
A Peony, A Rose and A Peony
Three watercolours
14½ x 11¾in (37 x 30cm)
£600–800 *Bon*

Horace van Ruith
British (1839–1923)
Flowers painted in Bombay
Signed, watercolour
12½ x 9½in (32 x 24cm)
£1,300–1,500 *WrG*

20th Century

Eliot Hodgkin
British (1905–87)
Two pale pink Poppies
Signed and dated 'May 52',
tempera on masonite board
10 x 6in (25 x 15cm)
£2,750–3,500 *CSK*

Marian Hebert
American (b1899)
Hymenocallis, Pecan Blossoms,
Flowers of the Tulip Tree,
A Wind Blew in Texas
Four numbered and titled
aquatints, 1948
9¾ x 7¾in (24.5 x 19.5cm)
£155–200 *SK*

William Tillyer
British (b1938)
Alpinia Purpurata
Signed, watercolour
60 x 30in (152 x 76cm)
£1,000–1,400 *Bon*

Illustrated Books

Henry Andrews
British (late 18thC)
The Botanist's Repository
Six volumes, one printed title
in vol. I and 6 engraved titles,
432 hand-coloured engraved
plates, 4 folding, some
damage, 1797
£5,000–6,000 *P*

Joseph Paxton
British (1801–65)
Magazine of Botany
Volumes 1–14, approx 661 hand-
coloured lithographed plates,
some folding, c5 plates part
coloured, some damage, 1834–48
£4,500–5,500 *P*

James Edward Smith and James F.L.S. Sowerby
British (18th/19thC)
English Botany or coloured
figures of British Plants, 36 vols.
bound as 18, and Supplements
1 and 2, with approx. 2500 hand-
coloured engravings, with
marbled boards, half calf with
some wear and foxing, London
1790–1814, the supplements
1831 and 1834
£1,400–1,800 *DN*

Pierre-Joseph Redouté
Belgian (1759–1840)
Les Liliacées
Text by Augustin-Pyramus de Candolle vols. I-IV, François
Delaroche vols. V-VI and Alire Raffeneau-Delile vols.
VII-VIII, Paris: Imprimerie de Didot jeune for the author,
1805–16, 8 volumes in four 21¼ x 14in (54 x 35.5cm)
Near contemporary French red half morocco spines in
6 compartments, with raised bands, lettered in one
compartment, the vol. numbers in a second, the others rules
in gilt and blind, occasional scuffing.
£90,000–100,000 *C*

*Redouté is probably the most famous of all flower painters. By
the age of 29 he was in the employment of Josephine Bonaparte,
an association that lasted until her death in 1814. The Empress
was passionate both about flowers and art and it was largely
thanks to her influence and patronage that Redouté was able to
publish his great series of botanical works of which Les Liliacées
was the first book.*

Christoph Jakob Trew
German (1695–1769) and
Benedict Christian Vogel
German (1745–1825)
Plantae Selectae
A set of plates to the first edition, ten
parts in one volume, 9 engraved titles
only, lettering in red, black and gold,
3 mezzotint portraits of Trew, G.D. Ehret
and J.J. Haid, 100 hand-coloured
engraved plates after Georg Dionysius
Ehret by Johann Jacob Haid, each with
the first word of caption heightened in
gold, bound in modern calf in imitation
of 18thC panelled calf
£15,000–17,000 *C*

Francesco Guardi
Italian (1712–93)
An Architectural Capriccio with an
Elaborate Archway
Pen and brown ink and wash over black
chalk
7½ x 5¼in (19 x 13cm)
£22,000–25,000 *S(NY)*

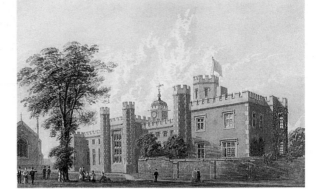

George Pyne
British (1800–70)
Rugby School, Warwickshire
Watercolour over pencil heightened with white
8¼ x 12¼in (21 x 31cm)
£2,750–3,000 *CW*

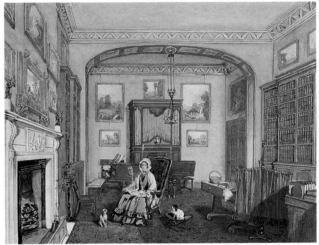

English School (c1830)
Library – Music Room with the Northwick
Bacchus and Ariadne after Titian
Pencil and watercolour heightened with white
and scratching out
13 x 17in (33 x 43cm)
£3,500–4,500 *C*

John Buckler
British (1770–1851)
The Staircase, Dodington,
Gloucestershire
Signed and dated '1824', watercolour
over pencil
12¾ x 18in (32.5 x 46cm)
£6,000–7,000 *CW*

Charles Harrington
British (d1943)
Arundel Castle from the Park
Signed, watercolour
10 x 14in (25 x 35.5cm)
£1,400–1,500 *Gra*

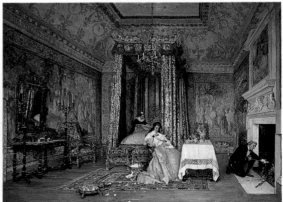

Claude Andrew Calthrop
British (1845–93)
Old Letters – A Scene at Knole
Signed and dated '1873', oil on canvas
36¼ x 50¾in (92 x 129cm)
£30,000–35,000 *CW*

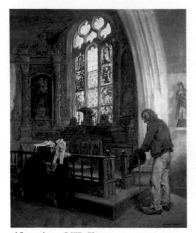

Aloysius O'Kelly
Irish (1853–1928)
Brittany: The Stained Glass Window
Signed and dated '1905', oil on
canvas
36½ x 29in (93 x 74cm)
£16,000–18,000 *CCG*

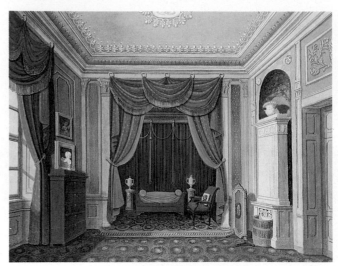

Wilhelm Kretschmer
German (1806–c1860)
Bedroom in a Royal Palace
Signed 'Kretschmer', pen and grey ink
and watercolour heightened with white
and gold
9½ x 12in (24 x 31cm)
£12,000–14,000 *C*

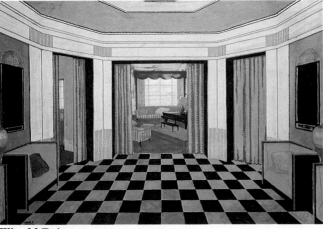

Winold Reiss
German (1886–1953)
Interior of a New York Flat
Signed 'Winold/Reiss', bodycolour
23 x 33¾in (59 x 85.5cm)
£3,750–4,750 *C*

Attrib. Alexandre Eugène Prinot
French (active 1840–80)
Ancestral Hall
Signed with initials and dated
'1858', pencil and watercolour with
touches of white heightening
8½ x 10¾in (21.5 x 27cm)
£900–1,200 *C*

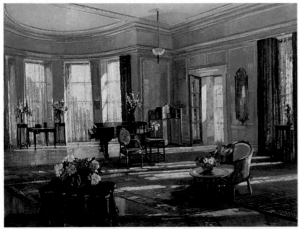

Herbert Davis Richter
British (1874–1955)
The Drawing Room
Signed, oil on canvas
28 x 36in (71 x 91.5cm)
£10,000–12,000 *BuP*

Attributed to Vasili Vasilievich
Russian (1842–1904)
The Interior of the Moscow Cathedral
of Christ the Saviour
Dated '1888', oil on canvas
59 x 52¾in (149.5 x 134cm)
£36,000–40,000 *S*

Terence Cuneo
British (b1907)
Lying in State of Sir Winston Churchill
Signed, dated 'January 29th 1965',
oil on canvas
40 x 50in (101.5 x 127cm)
£2,000–2,500 *Bon*

Michael John Hunt
British (b1941)
Paddledock Interior – Rug on Dresser
Signed, acrylic on canvas
24 x 36in (61 x 91.5cm)
£2,500–3,000 *THG*

David Hockney
British (b1937)
Tyler Dining Room
Signed and dated '84' in pencil, lithograph printed in colours
31¾ x 39⅝in (81 x 101cm)
£10,000–11,000 *S*

Trevor Neal
British (20thC)
Correale Triple Leo Monopodia, 1994
Oil on canvas
30 x 22in (76.5 x 56cm)
£3,000–4,000 *RMG*

Johnny Jonas
British (20thC)
Deck the Hall
Oil on canvas
30 x 22in (76 x 56cm)
£875–975 *ROY*

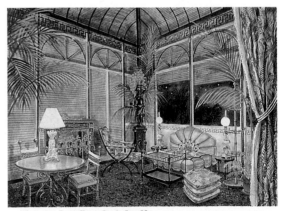

Alexandre Serebriakoff
Russian (b1907)
Madeleine Castaing's Stand
at the Salon des Antiquaires
Signed and dated '1948', pencil and watercolour with
touches of white heightening and gum arabic
12⅜ x 16¾in (31.5 x 43cm)
£15,000–18,000 *C*

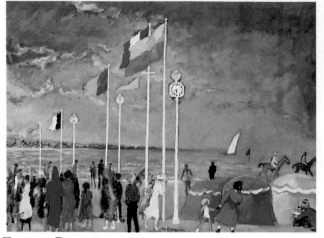

Kees van Dongen
French (1877–1968)
L'Horloge de la Plage de Deauville
Signed, oil on canvas
20 x 26in (50.5 x 66cm)
£185,000–200,000 *S(NY)*

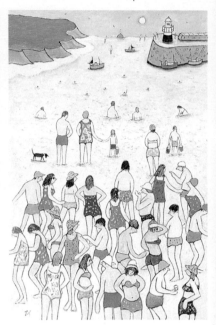

Joan Gillchrest
British (b1918)
Bathing Beauties
Oil on canvas
27 x 18in (68.5 x 45.5cm)
£800–900 *WrG*

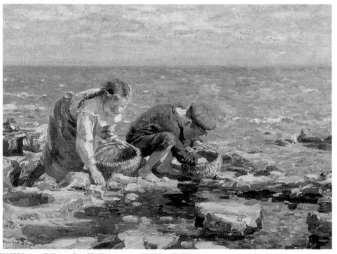

William Marshall Brown, RSA, RSW
British (1863–1936)
Gathering Shellfish
Signed, inscribed on reverse, oil on canvas
13 x 18in (33 x 46cm)
£7,000–8,000 *C(S)*

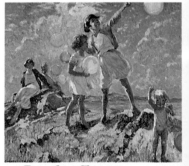

Dorothea Sharp
British (1874–1955)
Balloons on the Island, St. Ives
Signed, oil on canvas
32 x 36in (81 x 91.5cm)
£18,500–22,000 *C*

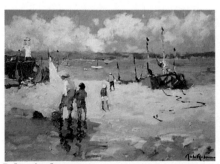

John Ambrose
British (20thC)
The Harbour, St. Ives
Oil on canvas
12 x 16in (30.5 x 40.5cm)
£500–600 *TBG*

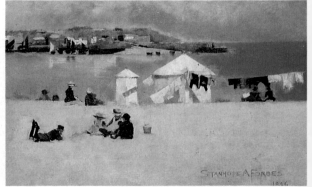

Stanhope Alexander Forbes, RA
British (1857–1947)
Children on the Beach, St. Ives
Signed and dated '1886', oil on canvas
laid on panel
12 x 16in (30.5 x 40.5cm)
£32,000–35,000 *C*

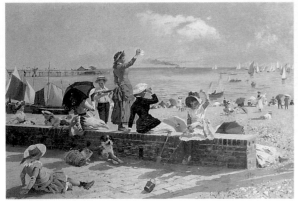

Alexander M. Rossi
British (active 1870–1903)
On the Seafront
Signed, oil on canvas
38 x 54¼in (96.5 x 138cm)
£46,000–50,000 *S*

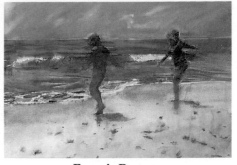

Francis Bowyer
British (20thC)
Throwing Pebbles, Walberswick
Watercolour
27 x 35in (68.5 x 89.5cm)
£1,000–1,250 *WHP*

Lolly Lonergan
British (20thC)
Lady with a parasol
Oil on canvas
16 x 20in (40.5 x 50.5cm)
£250–300 *Lon*

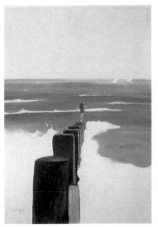

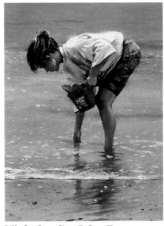

Janet Ledger
British (20thC)
The Dare
Oil on canvas
8 x 6in (20 x 15cm)
£400–450 *TLB*

Nicholas St. John Rosse
British (b1945)
In Shallow Water
Oil on canvas
24 x 18in (61.5 x 45.5cm)
£900–1,150 *AMC*

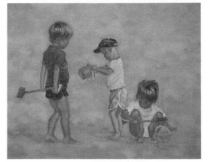

Sheila Tiffin
British (20thC)
Beach Fun
Oil on canvas
8 x 12in (20 x 30.5cm)
£300–350 *GeC*

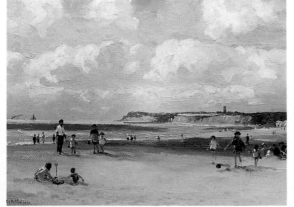

Campbell Mellon, RBA, ROI
British (1876–1955)
Beach Scene with Children, Gorleston
Signed, oil on canvas
12 x 16in (30.5 x 40.5cm)
£4,000–4,750 *BuP*

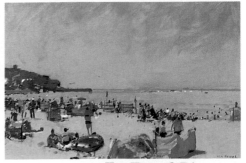

Ken Howard, RA
British (b1932)
Sennen, High Summer '92
Signed
20 x 24in (50.5 x 61.5cm)
£2,400–3,000 *CSK*

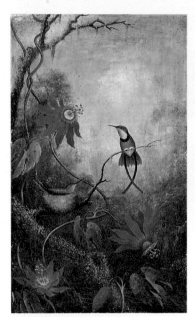

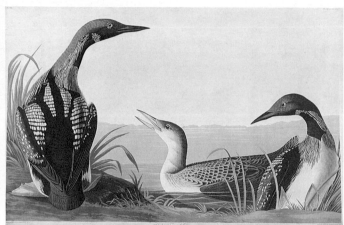

John James Audubon
American/French (1785–1851)
Black-throated Diver
Hand-coloured engraving by R. Havell
24½ x 38½in (63 x 97cm)
£4,200–5,000 *C*

Martin Johnson Heade
American (1819–1904)
Passion Flowers and Hummingbirds
Signed, oil on canvas
20 x 12in (50.5 x 30.5cm)
£480,000–500,000 *S(NY)*

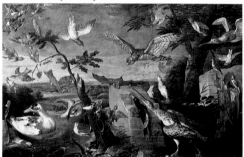

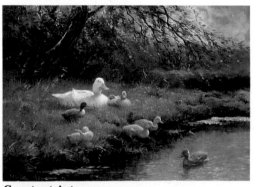

Flemish School (17thC)
An Assembly of Birds
Oil on canvas
44½ x 66¼in (112 x 168cm)
£15,000–18,000 *S*

Constant Artz
Dutch (1870–1951)
A Family of Ducks by a River
Signed, oil on panel
9 x 12⅝in (22.5 x 32cm)
£3,500–4,000 *Bon*

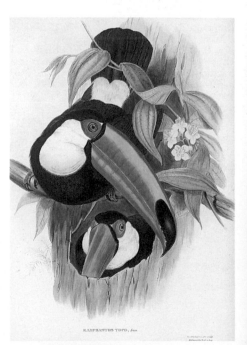

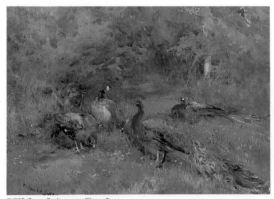

Mildred Anne Butler
British (1858–1941)
Fine Feathers
Signed and inscribed as title on reverse,
watercolour and bodycolour
10 x 14in (25 x 35.5cm)
£3,200–4,000 *CSK*

John Gould
British (1804–1881)
A Monograph of the Ramphastidae
An album containing 51 hand-coloured
lithographic plates by Gould and others
21¾ x 14½in (55 x 37cm)
£26,000–30,000 *C*

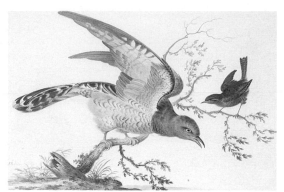

Johannes Bronckhorst Dutch (1648–1727)
A Cuckoo and a Wren
Signed with initials, inscribed, gouache on vellum
9½ x 13⅜in (24.5 x 34cm)
£6,000–7,000 *S(Am)*

Allen William Seaby
British (1867–1953)
Cuckoo
Signed, watercolour
14 x 18½in (35.5 x 47cm)
£1,200–1,500 *WrG*

Frank Southgate
British (1872–1916)
Shovelers – Spring
Signed, watercolour and bodycolour
15 x 22¼in (38 x 56.5cm)
£2,500–3,000 *S*

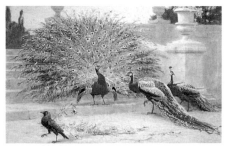

John Charles Dollman
British (1851–1934)
The borrowed Plume
Signed, watercolour
10 x 14⅜in (25 x 37.5cm)
£800–1,200 *Bon*

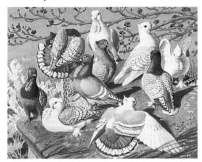

Charles Frederick Tunnicliffe, RA
British (1901–79)
Oriental Frills
Signed, watercolour over traces of pencil
18½ x 22¾in (47 x 58cm)
£3,500–4,000 *S*

Archibald Thorburn British (1860–1935)
Pheasants
Signed and dated '1929', watercolour and bodycolour
7 x 10¾in (17.5 x 27cm)
£2,750–3,750 *DN*

Veni Gligorova-Smith
Macedonian (20thC)
Cockerel's Celebration
Watercolour
11½ x 15in (29.5 x 39.5cm)
£450–550 *AMC*

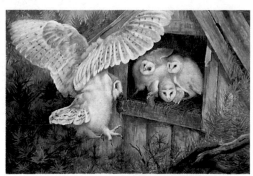

Spencer Roberts
British (20thC)
Tawny Owl with Young
Acrylic
22 x 30in (55.5 x 76cm)
£1,300–1,500 *RGFA*

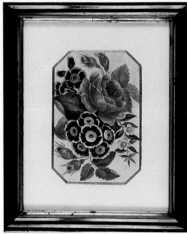

English School (19thC)
Roses and Auriculae
Watercolour, c1860
4½ x 3in (11.5 x 7.5cm)
£100–120 *SRAB*

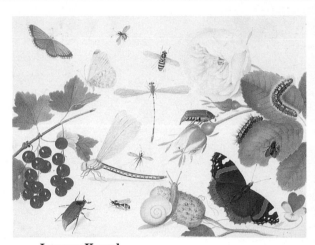

Jan van Kessel
Dutch (1626–29)
Still Life of Insects with Fruit and Flowers
Pen and black ink, watercolour and gouache on vellum
6 x 7¾in (15 x 19.5cm)
£35,000–40,000 *S(Am)*

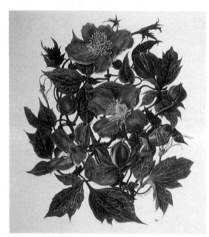

Lynne Broberg
British (20thC)
Clematis
Signed, ink on handmade paper
10 x 8in (25 x 20cm)
£1,800–2,000 *LyB*

Arthur Ellis
British (late 19thC)
Golden Gorse
Watercolour
14 x 21in (35.5 x 53.5cm)
£300–375 *MBA*

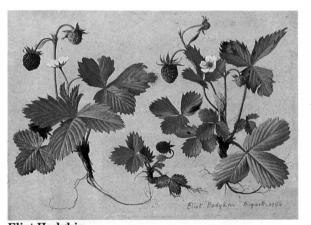

Eliot Hodgkin
British (1905–87)
Wild Strawberries
Signed and dated 'August 1954', tempera on panel
4½ x 6in (11.5 x 15cm)
£1,200–1,500 *CSK*

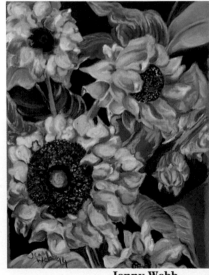

Jenny Webb
British (20thC)
Sunflowers
Pastel
9½ x 8in (23 x 20cm)
£45–65 *LS*

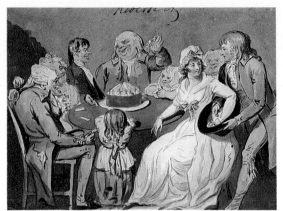

Isaac Cruikshank
British (1756–1811)
Twelfth Night
Inscribed, pen and ink with watercolour
6½ x 8¼in (16.5 x 21cm)
£2,000–2,250 *CBL*

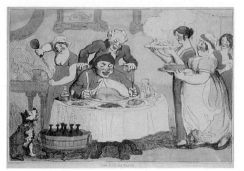

Thomas Rowlandson
British (1756–1827)
'The Man of Taste'
Hand coloured copper plate engraving,
published in London, 1807
9 x 13in (22.5 x 33cm)
£250–300 *OSh*

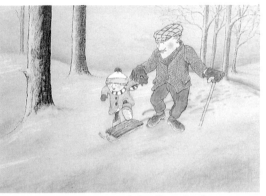

John Burningham
British (b1936)
Granpa in the Snowy Wood
Animation cel
10 x 13in (25 x 33cm)
£650–750 *CBL*

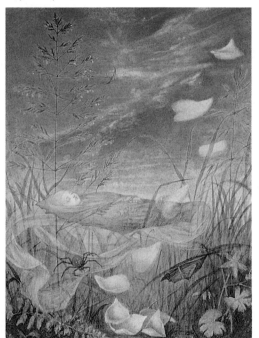

Eleanor Vere Boyle
British (1825–1916)
Death by a Sleep When the Spring begins
Watercolour heightened with white
6 x 4½in (15 x 11.5cm)
£6,000–7,000 *C*

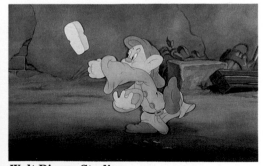

Walt Disney Studios
American (20thC)
Dopey (1937)
Animation cel on a watercolour production
background, used in *Snow White and the
Seven Dwarfs*
£13,000–14,000 *CAT* © *The Walt Disney Company*

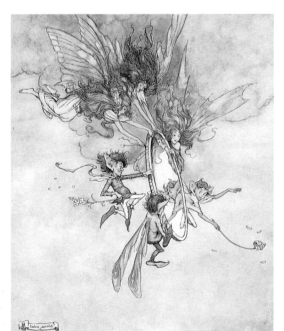

Helen Mary Jacobs
British (1888–1970)
The Magic Mirror
Signed, pen, ink and watercolour
9½ x 8in (24 x 20cm)
£2,000–2,500 *CBL*

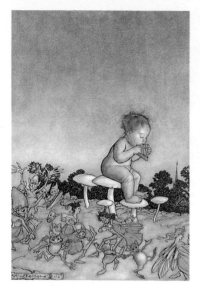

Arthur Rackham, RWS
British (1867–1939)
Peter Pan is the Fairies' Orchestra
Signed and dated '06', pen and ink
and watercolour
8¾ x 6in (22 x 15cm)
£16,000–18,000 *P*

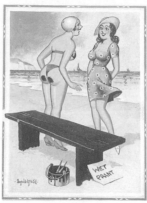

Donald McGill
British (1875–1962)
'I bet I touch bottom when I dive!'
Signed, watercolour and bodycolour
10½ x 7in (26 x 17.5cm)
£800–900 *CSK*

Peter Firmin
British (20thC)
Ivor the Engine - 'The Foxes'
Watercolour
8in (20cm) square
£200–250 *RGFA*

Norman Thelwell
British (b1923)
No Coaches
Signed, watercolour and
pen and ink over pencil
11 x 16in (28 x 40.5cm)
£9,000–10,000 *S(S)*

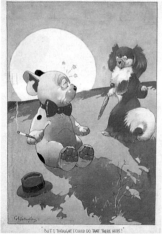

George Ernest Studdy
British (1878–1948)
'But I thought I could do that
there here!'
Signed, pencil and watercolour
14 x 9½in (35.5 x 24cm)
£850–1,200 *CSK*

Gerald Scarfe
British (b1936)
Teacher and Mincer
An original production cel
used in the Pink Floyd animation
for *The Wall*
£850–950 *CAT*

David Wright
British (20thC)
'Weekend at the Manor House'
Watercolour and gouache, artwork for
the front cover of a novel, 1940s
14 x 10½in (35.5 x 26.5cm)
£900–1,000 *JN*

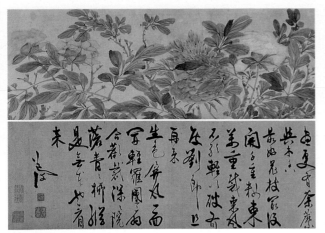

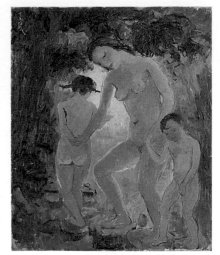

Chen Shun
Chinese (1483–1544)
Peonies and Poems
Handscroll in 2 sections, ink and colour on paper and ink on paper, the calligraphy signed and dated '1544'
Painting 10½ x 63⅜in (26.5 x 161cm)
£8,000–9,000 *S(NY)*

Pan Yuliang
Chinese (1895–1977)
Mother and Two Children
Signed, oil on canvas
18 x 15in (46 x 38cm)
£22,000–25,000 *S(T)*

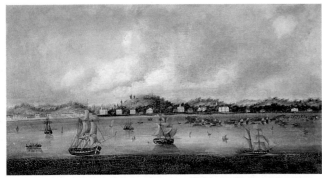

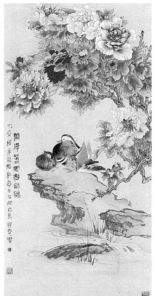

Chinese School (c1830)
The Waterfront, Singapore
Oil on canvas
16¾ x 30in (43 x 76cm)
£31,000–35,000 *S*

r. **Zheng Naiguang**
Chinese (b1911)
Mandarin Ducks and Peonies
Signed, entitled and 3 seals of the artist, ink and colour on paper, hanging scroll, 52 x 26½in (132 x 67.5cm)
£3,500–4,000 *S(HK)*

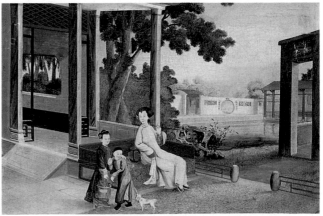

Liu Haisu
Chinese (b1896)
Landscape
Signed and dated '1989', ink and colour on paper, hanging scroll
53 x 26in (134.5 x 66cm)
£7,000–8,000 *S(NY)*

Chinese School (c1840)
A Chinese Woman and two Children in a Courtyard, a Garden beyond and Figures around a Table in an Interior, a Landscape beyond
A pair, oil on canvas
16¼ x 21¾in (41 x 55cm)
£8,000–10,000 *P*

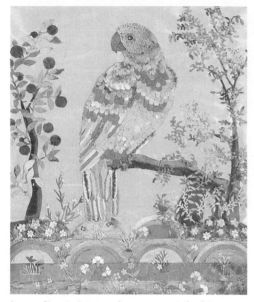

An appliqué picture of a parrot perched in an acacia tree above hillocks, with an orange tree to the left, worked in painted ribbed ribbons, worn, mid-18thC, 15 x 12in (38 x 30.5cm).
£7,500–8,500 *C*

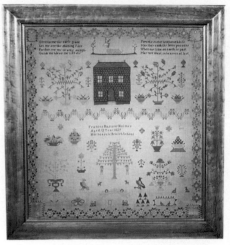

A pictorial sampler, worked in coloured silks, very good condition, dated '1829', 25 x 23in (64 x 59cm).
£900–1,200 *WiA*

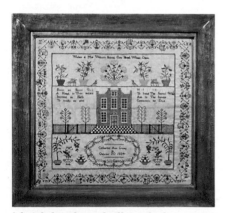

A brightly coloured silk worked sampler, depicting a school recording the maker, the name of the teacher, street and town, dated '1834', 21in (51cm) square
£1,000–1,500 *WiA*

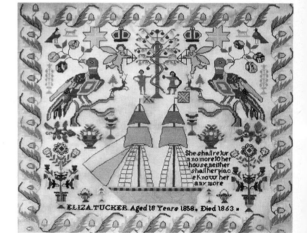

A woolwork sampler, depicting a sailing ship, birds, flowers and trees and inscribed 'Eliza Tucker Aged 18 Years 1838. Died 1863', 26 x 30½in (66 x 77.5cm)
£400–650 *WiA*

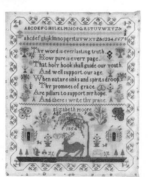

A sampler, worked in coloured silks, with alphabet, verse and 'Elizabeth Moore Age 9 1854', 15 x 12in (38 x 30.5cm).
£400–500 *WiA*

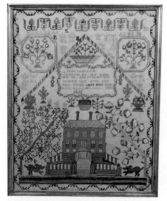

A Scottish sampler, worked in a variety of stitches showing a classical house with a verse and animals, dated '1815', 21 x 15½in (53 x 39.5cm).
£2,000–2,500 *WiA*

r. A Bristol Orphanage sampler, showing the alphabet, various geometric designs, coats-of-arms and animals, dated '1874', 18 x 12in (45.5 x 30.5cm).
£1,400–1,800 *WiA*

Edith Helena Adie
British (exh 1892–1930)
Villa Margherita – Lake Como
Signed, watercolour, c1900
13½ x 9½in (34.5 x 24cm)
£2,000–2,250 *ELG*

George Samuel Elgood, RI
British (1851–1943)
Ville d'Este, Rome
Signed, watercolour, c1910
9 x 13⅜in (22.5 x 34.5cm)
£2,000–2,450 *ELG*

Helen Allingham, RWS
British (1848–1926)
Posy for Grandma
Signed, watercolour
10½ x 14½in (26.5 x 37cm)
£14,000–15,000 *WrG*

William Affleck
British (1869–1908)
At the Garden Gate
Signed, pencil and watercolour
heightened with white
15½ x 11¾in (39.5 x 30cm)
£1,500–2,000 *C*

Henrick Jespersen
Danish (b1853)
The Rose Garden
Signed, oil on canvas
27 x 35in (68.5 x 89cm)
£2,800–3,500 *S*

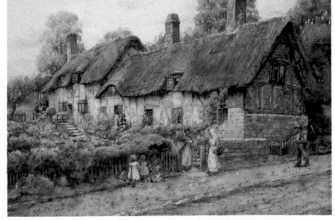

Ernest F. Hill
British (active 1896–1910)
Anne Hathaway's Cottage
Watercolour
11 x 18in (28 x 45.5cm)
£3,500–4,000 *HFA*

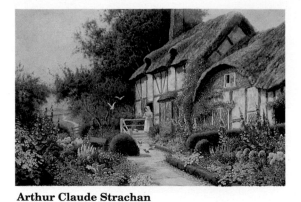

Arthur Claude Strachan
British (active 1885–1925)
Anne Hathaway's Cottage
Watercolour
15 x 21in (38 x 53.5cm)
£5,500–6,000 *HFA*

Ernest Arthur Rowe
British (1863–1922)
Near Canterbury
Signed, watercolour
10 x 14½in (25 x 37cm)
£2,500–3,000 *WrG*

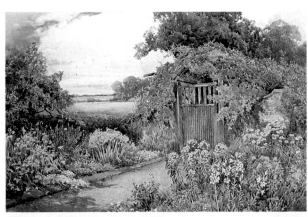

Theresa Sylvester Stannard
British (1898–1947)
Summer Garden and Landscape
Signed, watercolour
13¾ x 19¼in (34 x 49cm)
£2,500–3,500 *P*

J. W. Milliken
British (exh 1887–1930)
Cottage Garden, Fazackerley
Signed, watercolour
6 x 9in (15 x 22.5cm)
£1,000–1,300 *HO*

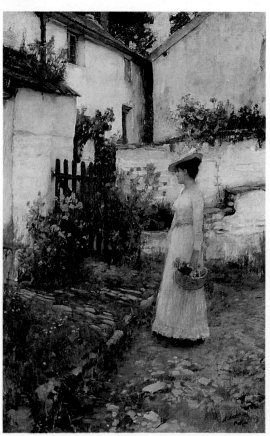

Cyril Ward
British (1863–1935)
The Herbaceous Border at Hampton Court
Signed, watercolour
12 x 18in (30.5 x 46cm)
£1,000–1,250 *HHG*

r. **John William Waterhouse, RA**
British (1849–1917)
Gathering Summer Flowers in a
Devonshire Garden
Signed, oil on canvas
30 x 20in (76 x 50.5cm)
£42,000–50,000 *C*

Jean Colyer
British (20thC)
Entrance to Tower, Sissinghurst, 1992
Pastel
11 x 16in (28 x 40.5cm)
£280–310 *RGFA*

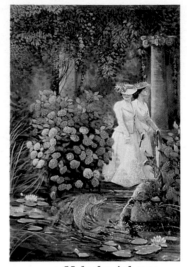

Malcolm Ashman
British (20thC)
Pisces
Acrylic
14½ x 10in (37 x 25cm)
£575–675 *SJG*

Fred Dubery
British (20thC)
Sunlight, Shade and Running Water
Oil on panel
18 x 14in (45.5 x 35.5cm)
£1,600–1,800 *WHP*

Ann Bolt
British (b1946)
Blue Shutters
Watercolour
20½ x 24¼in (52 x 62cm)
£400–475 *AMC*

Jenny Webb
British (20thC)
Wye Garden
Pastel, 1994
5¼ x 6¼in (13 x 16cm)
£45–65 *LS*

Royo
Spanish (b1944)
Los Geranios
Oil on canvas
29 x 36in (74 x 91.5cm)
£8,000–9,000 *BrS*

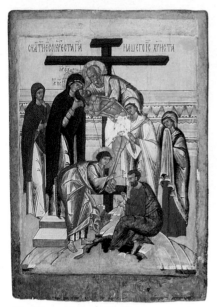

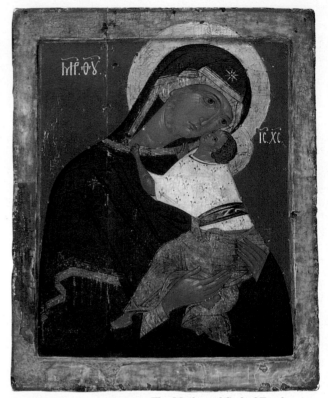

The Descent from the Cross
Novgorod, late 15thC
Joseph of Arimathea on the ladder, John
the Divine and Nicodemus pull out the
nails from Christ's feet
22½ x 15¼in (57 x 39cm)
£60,000–70,000 *S*

A Cretan Icon of Saint Basil
the Great
Russian, 16thC
Depicted bust length, against a
gold background
12½ x 10⅛in (32 x 27cm)
£18,000–20,000 *S*

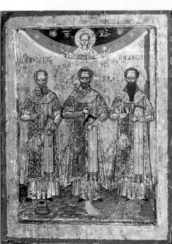

The Mother of God of Tenderness
Novgorod, late 15thC
The Child presses his cheek
against his Mother, red
background, fine calligraphy
21¾ x 17in (55 x 43cm)
£55,000–70,000 *S*

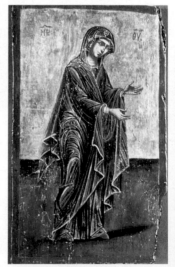

The Three Hierarchs
Greek, c1700
Depicted as Bishops, St. Gregorios,
St. Chrysostom and St. Basil, on
gold leaf ground and hollowed panel
15 x 11in (38 x 28cm)
£3,000–3,800 *MAI*

The Deisis Madonna
Greek, 17thC
Standing with her hands in
supplication, the background
faded green and chrysography
19 x 11in (48 x 28cm)
£16,000–18,000 *MAI*

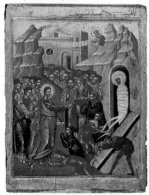

The Raising of Lazarus
Macedonia, 17thC
Depicting a figure emerging from
the mountain with a scroll
21¼ x 16in (54 x 40.5cm)
£16,000–18,000 *S*

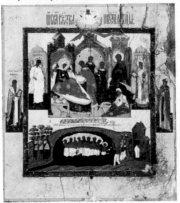

l. The Virgin's Nativity
Palech, 17thC
Depicting the baby Mary being
prepared for a bath and below the
Four Martyrs, tempera on panel
14 x 12in (36 x 30.5cm)
£10,000–12,000 *MAI*

CARTOONS & ILLUSTRATIONS

The market for cartoons and illustrations is a comparatively recent one. Illustrators used to be looked down upon compared to so-called 'fine artists', but today this is no longer the case. Demand is booming, the big names such as Arthur Rackham and William Heath Robinson can command five figure sums at auction. There is a wealth of good quality material available, both from the 19th and 20C and being produced today by contemporary illustrators. Dealer Chris Beetles has been the pioneer in this market. 'The demand between fine art and illustration has been blurred,' he notes with satisfaction. 'There are more collectors today than ever before.' Whilst a Rackham might cost you thousands of pounds, there is still, he stresses, plenty of fine work available at affordable prices, and it is not only in terms of value that drawings are accessible. 'People understand about cartoons and illustrations because they have absorbed them from books and magazines since childhood. You can buy on the pleasure of the eye alone. Look at the picture first and the name of the artist second. Buy what you like and you can't go wrong.'

18th Century

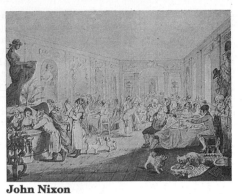

John Nixon
British (1750–1818)
Véry's Restaurant in the Palais Royal, Paris
Signed and dated 'J. Nixon/1803', pencil, pen and ink and watercolour
17 x 22¼in (43 x 56.5cm)
£2,800–3,500 *S*

Véry's was the most famous restaurant in Paris after the French Revolution. Nixon had taken advantage of the brief Peace of Amiens to visit Paris and make this drawing. There is a covert reference to the war with France, which was to continue for more than 10 years, in the confrontation between the poodle and the bulldog in the foreground. A bucolic Englishman is shown appealing for help with the unfamiliar menu, his appearance in great contrast to the ultra-fashionable French customers, many of whom are wearing large hoop earrings.

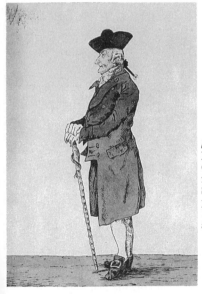

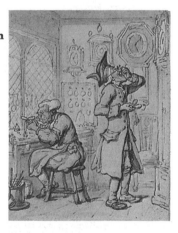

r. **Thomas Rowlandson**
British (1756–1827)
At the Watchmaker's
Pen and ink and wash
7¼ x 5½in (18 x 13cm)
£4,500–5,500 *P*

l. **Robert Dighton**
British (1752–1814)
General Donkin – A View from the Pump Room
Signed, watercolour over pen and ink
11¼ x 8in (29 x 20cm)
£350–450 *Bon*

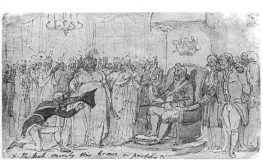

Thomas Rowlandson
British (1756–1827)
The Military Adventures of Johnnie Newcome
Two illustrations, inscribed, pencil, pen and brown ink and watercolour
4¼ x 7in (10.5 x 17.5cm)
£950–1,200 *C*

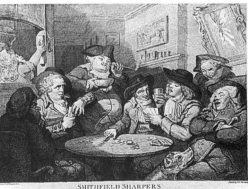

I. K. Sherwin after Thomas Rowlandson
British (1756–1827)
Smithfield Sharpers or the Countrymen Defrauded
Dated, etching
14¼ x 17in (36 x 43.5cm)
£200–220 *GP*

19th Century

Eleanor Vere Boyle
British (1825–1916)
In the Hut there was only a Bed –
the Sunbeam stole in to kiss him
Pencil and watercolour heightened
with white
6 x 5¼in (15 x 13cm)
£6,000–7,000 C

r. **Etheline E. Dell**
British (active 1885–91)
Midsummer Fairies
Signed and inscribed, pencil,
watercolour and bodycolour,
within a decorative arch
7½ x 6½in (19.5 x 16cm)
£3,500–4,500 C

*Etheline Dell specialised in
domestic and fairy subjects,
exhibiting at the Royal Academy,
the Royal Society of British Artists
and the New Watercolour Society.*

l. **Charles Edmund Brock**
British (1870–1938)
'Man's the creature of Habit,'
said Mr. Britain
Signed, inscribed and dated
'1907', pen and ink
5¼ x 6½in (13 x 15.5cm)
£300–350 CBL

English School (1826)
A Satirical View of a Regency Rout or Assembly
Dated '1826', pencil and watercolour
6 x 9in (15 x 22.5cm)
£650–750 S

*The 'rout' was a popular form of evening party
dating from the late 18thC, in which a large crowd
of people were asked to dancing and supper. In this
picture the musicians can be seen at the back of the
room. The crush was usually frightful and there
are numerous descriptions of the difficulty of
dancing in the squeeze or of securing any food at
tables occupied several deep on every side. For such
an occasion the furniture was removed and the
carpet rolled up. The paintings in this room,
seemingly portraits, suggest a private house.*

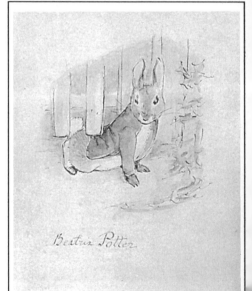

Helen Beatrix Potter
British (1866–1943)
Peter Rabbit entering the Vegetable Garden
Signed, pen and grey ink and watercolour
4¼ x 3¼in (10.5 x 8cm)
£21,000–25,000 CSK

*Beatrix Potter, the children's favourite, now
commands very adult prices at auction.
A signed first edition of* Peter Rabbit *made an
auction record of £55,000, whilst a set of six
lace table mats, handpainted with scenes from*
Jeremy Fisher, *recently fetched an
astonishing £16,000. Demand for original
illustrations is also extremely strong and the
present example more than tripled its top
auction estimate of £6,000.*

l. **Helen Beatrix Potter**
British (1866–1943)
Studies of Samuel Whiskers
Inscribed 'used' and 'not used', pencil
4¼ x 6½in (10.5 x 16cm)
£6,750–8,000 CSK

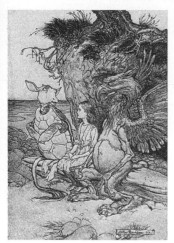

Arthur Rackham, RWS
British (1867–1939)
The Mock Turtle Drew a
long Breath and said 'That's
very Curious'
Signed and dated '07', pen and
ink and watercolour
10 x 7¼in (25 x 18.5cm)
£18,000–22,000 *P*

*This is the original illustration
facing page 132 of* Alice's
Adventures in Wonderland, *by
Lewis Carroll and published by
Heinemann. Illustrated by
Rackham, it proved to be one of
his most successful commissions.
Rackham is perhaps the most
admired and the most
collectable of all the great
British illustrators. When
Phillips recently offered a
collection of 30 Rackham
drawings, every lot found a
buyer. The present example was
the star piece, it more than
doubled its upper estimate of
£8,000, proving that top of the
range illustrators can match the
work of 'fine artists' both in
terms of quality and price.*

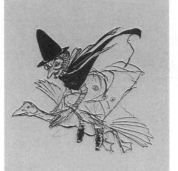

Arthur Rackham, RWS
British (1867–1939)
Mother Goose – A Study
Pen and ink and pencil
6¼in (16cm) square
£750–850 *P*

Sir John Tenniel
British (1820–1914)
Mistress Falstaff's Fix
Signed with monogram and dated
'1894', pencil
8 x 6in (20 x 15cm)
£550–650 *CBL*

Edward Tennyson Reed
British (1860–1933)
Prehistoric Shakespeare –
The Balcony Scene from
Romeo and Juliet
Signed, pencil
11 x 7¼in (28 x 18cm)
£450–550 *CBL*

Henry Meynell Rheam
British (1859–1920)
A Study for *The Mannikin*
Signed, inscription on reverse,
watercolour and gouache
20¼ x 14¼in (51.5 x 36.5cm)
£450–600 *Bon*

John Sloan
American (1871–1951)
Connoisseurs of Prints
Signed and titled in pencil and inscribed '100
proofs', also signed by the printer, Ernest Roth,
and inscribed 'imp.', with margins, etching, 1905
5 x 7in (12.5 x 17.5cm)
£2,000–2,500 *S(NY)*

Theophile Alexandre Steinlen
Swiss (1859–1923)
La Fête
Signed, coloured crayons and pen and ink
11½ x 9in (29 x 22.5cm)
£1,400–1,800 *S*

20th Century

Edward Ardizzone, RA
British (1900–79)
'You are Clever, Stig!' He Said
'You've made a Chimney!'
Pen and ink
4¼ x 6¾in (11 x 17cm)
£550–650 *CBL*

Janet Ahlberg
British (1944–95)
Oddbodds
Pen, ink and watercolour
9 x 6½in (22.5 x 16.5cm)
£550–650 *CBL*

*The untimely death of Janet Ahlberg has
deprived children's literature of one of its most
gifted and innovative illustrators. Janet Ahlberg
worked in tandem with her husband Alan
Ahlberg, he writing the stories and she providing
the pictures. Their children's books have become
contemporary classics. The Jolly Postman
(1986), which included envelopes containing
letters and paper toys, was one of the children's
book publishing successes of the decade.*

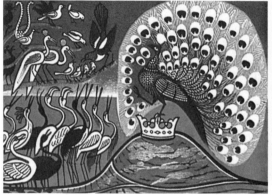

Edward Bawden
British (1903–89)
Aesop's Fables – Peacock and Magpies
Signed and inscribed with title and artist's
proof 37/50, colour linocut
16¾ x 22¾in (42.5 x 58cm)
£550–650 *CBL*

l. **Henry Mayo Bateman**
British (1887–1970)
'Poor George is so Shy'
Signed and dated '20',
inscribed below in another
hand and stamped on
reverse by S. H. Benson
Ltd, watercolour
12½ x 9½in (32 x 24cm)
£475–575 *Bon*

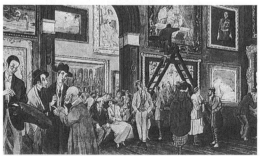

Molly Campbell
British (active 1915–37)
Varnishing Day – A satirical Drawing of the
Royal Acadamy
Signed and inscribed as title, pencil and watercolour
11½ x 18¾in (29 x 47.5cm)
£1,400–1,800 *S*

Harrison Cady
American (1877–1970)
Reddy Fox and Blacky the Crow
Signed, ink and ink wash on board
13 x 9¾in (33 x 24.5cm)
£4,000–4,500 *S(NY)*

*Cady illustrated the characters of Reddy
Fox and Blacky the Crow for the Thorton
W. Burgess' collection of bedtime stories.*

Rowland Emett
British (1906–90)
'Forget-me-Not'
Pen, ink and watercolour with bodycolour
16 x 25in (40.5 x 63.5cm)
£3,000–3,250 *CBL*

Annie French
British (1872–1965)
Conversation in a Garden
Signed 'A. French', watercolour and pen and ink
11½ x 15½in (29 x 38.5cm)
£1,200–1,600 *S(Sc)*

Cyril Walter Hodges
British (b1909)
'Holla! Ye Pampered Judges of Asia . . .'
Signed and dated '1948', pen and ink
10 x 7in (25 x 17.5cm)
£300–350 *CBL*

Paul Cox
British (b1957)
'Ooo-Ray-Oo-Ray-Oo-Ray-Ooray!'
Inscribed with title, pen, ink and watercolour
17 x 13in (43.5 x 33cm)
£750–850 *CBL*

Donald McGill
British (1875–1962)
'The comic postcards down here are positively disgusting! I must send you one!'
Signed, inscribed as title on the reverse, watercolour and bodycolour
10 x 7¼in (25 x 18cm)
£650–800 *CSK*

Donald McGill
British (1875–1962)
'I've landed here, but I've still got a feeling ash if I wash on the water!'
Signed, inscribed as title on the reverse, watercolour and bodycolour
9 x 7in (22.5 x 18cm)
£300–400 *CSK*

Sara Midda
British (b1951)
Menu L'Automne 1975
Signed, pen and ink
5¾ x 4¼in (14.5 x 11cm)
£650–750 *CBL*

Ida Rentoul Outhwaite
Australian (1888–1960)
The Witch's Sister on the Black Bat
Signed, watercolour over pen and ink
18 x 12¾in (46 x 32.5cm)
£3,500–4,000 *P*

l. **William Heath Robinson**
British (1872–1944)
He's a Regular Turk. Eastern
Luxury in the Home. The
Homemade Turkish Bath
Signed and inscribed with title,
pen, ink and monochrome
watercolour with bodycolour
14 x 10in (35.5 x 25cm)
£3,000–3,500 *CBL*

r. **George E. Studdy**
British (1878–1948)
'You Never Seem to Understand James,
that Times are Hard in the Wool Trade –
Why Didn't You Bring the TWENTY'
A pair, signed and dated '1928', colour
washes, heightened with white
14½ x 11in (37 x 28cm)
£1,500–2,000 *P(L)*

Paula Rego
South American (b1935)
Little Miss Muffet (2)
from *Nursery Rhymes* 1989
Coloured etching and aquatint,
from a limited edition of 50
17 x 24in (43.5 x 61cm)
£1,200–1,500 *CASoc*

Ronald Searle
British (b1920)
The Fourth Patient
Inscribed with title below mount,
pen and ink with watercolour
9 x 8½in (22.5 x 21.5cm)
£750–850 *CBL*

Margaret W. Tarrant
British (1888–1959)
Designs for Greetings Cards
Two, one signed with initials 'M.W.T',
the other 'from Margaret Tarrant',
pencil and watercolour
8 x 6½in (20.5 x 16.5cm)
£250–300 *CSK*

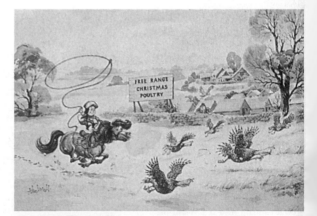

Norman Thelwell
British (b1923)
Free Range Christmas Poultry
Signed, watercolour and pen and ink over traces of pencil
11 x 16in (28 x 40.5cm)
£2,500–3,000 *S(S)*

CHINESE

Auction houses and dealers have been increasingly turning their attention to the Far East market, hoping to tap a rich vein of new collectors. Recent times have seen a number of auctions devoted to Chinese art concentrating not only on the traditional paintings of the past, but the new and Western influenced works being produced by China's contemporary artists.

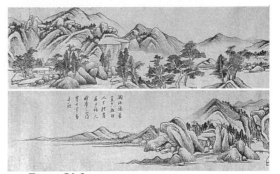

l. Liu Ji
Chinese (1311–1375)
Calligraphy in Li Shu (Clerical Script)
Signed, dated '1324', autumn, inscribed, and with 3 seals of the artist, and 8 collectors' seals, set of 12 hanging scrolls, ink on paper
each 72 x 18in (182.5 x 45.5cm)
£4,600–5,500 *S(NY)*

Dong Qichang
Chinese (1555–1636)
Landscape
Signed, inscribed, with one seal of the artist and 2 collectors' seals, handscroll, ink on paper
12¼ x 83¼in (31 x 211.5cm)
£14,000–16,000 *S(NY)*

Wu Li
Chinese (1632–1718)
Landscape Fan
Signed, dated '1710', inscribed, and with one seal of the artist, ink on paper
7 x 20½in (17.5 x 52cm)
£1,700–2,000 *S(NY)*

Wen Zhengming
Chinese (1470–1559)
Two Poems in Xing Shu (Running Script)
Signed, inscribed, and with 2 seals of the artist, fan painting, ink on gold paper
6½ x 19¾in (17 x 50cm)
£1,600–2,000 *S(NY)*

l. Fa Ruozhen
Chinese (1613–96)
Autumn Landscape
Signed, dated '1638', inscribed, hanging scroll, ink and colour on paper
31¼ x 15in (79.5 x 38.5cm)
£2,000–2,500 *S(NY)*

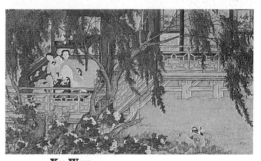

Xu Wen
Chinese (late 17th–early 18thC)
Album of Erotica
Album of 8 leaves, ink and colour on silk, each leaf with 2 seals of the artist
each 16½ x 28½in (42 x 72.5cm)
£62,000–70,000 *S(NY)*

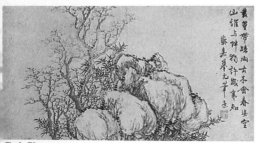

Cai Jia
Chinese (c1730–82)
Bamboo, Rock and Old Tree
Signed, inscribed, and with one seal of the artist, hanging scroll, ink on paper
12½ x 23½in (32 x 60cm)
£1,000–1,200 *S(NY)*

Wu Liting
Chinese (18thC)
Birds and Flowers of Spring and Summer
Signed, dated '1777', inscribed, and with one seal of the artist and 2 collectors' seals, handscroll, ink and colour on silk
18¾ x 305¼in (47.5 x 775cm)
£5,500–6,000 *S(NY)*

Zheng Xie
Chinese (1693–1765)
Bamboo
Signed, dated '1757', and
with 3 seals of the artist,
hanging scroll, ink on paper
70½ x 40½in (179 x 103cm)
£31,000–33,000 *S(NY)*

Fei Danxu
Chinese (1801–50)
Women and Children
at Home
Signed, dated '1887',
inscribed and with
2 seals of the artist,
hanging scroll, ink and
colour on silk
33 x 14in (83.5 x 35cm)
£1,700–2,000 *S(NY)*

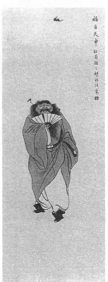

Hu Xigui
Chinese (1839–83)
Zhongkui
Signed, entitled,
inscribed and with one
seal of the artist,
hanging scroll, ink and
colour on paper
31⅛ x 12in (80 x 30.5cm)
£950–1,200 *S(NY)*

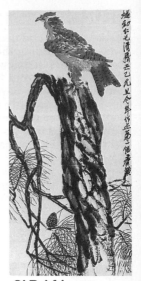

Qi Baishi
Chinese (1864–1957)
Eagle on a Pine Tree
Signed, dated '1929',
with a dedication and
one seal of the artist,
hanging scroll, ink and
colour on paper
52½ x 24in (133 x 61cm)
£11,500–12,500 *S(HK)*

Tang Yun
Chinese (1910–93)
Lotus
Signed, dated '1979',
inscribed, and with
3 seals of the artist,
hanging scroll, ink and
colour on paper
45 x 20⅝in (114 x 52.5cm)
£800–1,000 *S(NY)*

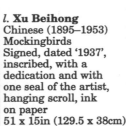

l. **Xu Beihong**
Chinese (1895–1953)
Mockingbirds
Signed, dated '1937',
inscribed, with a
dedication and with
one seal of the artist,
hanging scroll, ink
on paper
51 x 15in (129.5 x 38cm)
£8,500–10,000 *S(NY)*

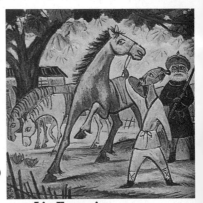

Lin Fengmian
Chinese (1900–91)
Bo Lo Inspecting the Horses
Signed in Chinese, oil on canvas
29½in (75cm) square
£23,000–25,000 *S(T)*

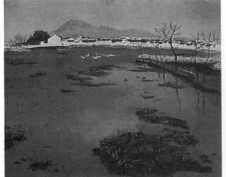

Wu Guanzhong
Chinese (b1919)
Shao Xing Lake
Signed in Chinese, dated '77', oil on board
18 x 24in (46 x 61cm)
£47,000–50,000 *S(T)*

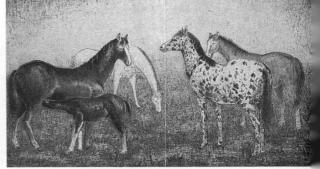

Pan Yuliang
Chinese (1895–1977)
Horses
Signed in Chinese, with one seal of the artist
dated '56', ink and colour on paper
38½ x 71½in (97.5 x 181.5cm)
£115,000–130,000 *S(T)*

EMBROIDERED PICTURES & SAMPLERS

For many years samplers were dismissed as little more than childhood embroideries, however, today their market is a strong one. Prices are extremely varied. According to Joy Jarrett of Witney Antiques, prices can range from as little as £50 at auction for the most basic alphabet or numeral sampler to four and five-figure sums for a fine example from the 17thC. The majority of works date from the 19thC where, notes Jarrett 'the more decorative the sampler, the finer the stitching, the brighter the silks and if the composition has an unusual subject – the more costly it becomes.' Condition is all important both with samplers and embroidered pictures: faded colours or moth holes will considerably reduce the value of a piece.

The attraction of a sampler is not only visual and technical, but also historical. Reading the texts you can learn about the lives of girls who stitched them, who they were, where they lived and what they learned. All levels of society worked samplers, from the most aristocratic young ladies, to the girls in orphanages for whom gaining proficiency with a needle was an essential skill for a future life in service. As Jarrett points out, you can even research the background of the maker by tracing her name through parish registers. 'There are very few antiques which bring us in such close personal contact with the past,' she concludes.

Embroidered Pictures

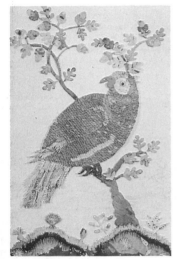

An appliqué picture of a parrot perched in an oak tree above hillocks, worked in painted silk on a ribbed silk ground, painted with a brown wash landscape, mid-18thC, 14 x 9½in (36 x 24cm).
£5,600–6,500 *C*

A silkwork picture, the silk ground embroidered with a family walking along a country road, a cottage in the background, c1780, 14½ x 18in (37 x 46cm).
£750–1,000 *S(S)*

A woolwork picture of a cottage interior with a dog and cat confronting each other across 2 fish laying on a table, and a parrot perched on a basket of fish, early 19thC, 20½ x 27in (52 x 68.5cm).
£900–1,200 *DN*

A silkwork and painted picture of a lady holding a sheaf of corn, with a cornfield, church and trees in the background, late 18thC, 9in (23cm) high.
£300–350 *DN*

A woolwork picture of a fully-rigged three-masted ship flying the Red Ensign, mid-19thC, 9½ x 12in (24 x 30.5cm).
£600–650 *DN*

A silk and chenille work picture of an exotic bird with a glass eye, perched on a tree, watching a butterfly, grassy mound below, ivory silk field, inscribed on reverse 'worked by Mary (?) born 16th April 1777, died unmarried 1802, only sister of Mrs Ellen Bancroft', slight damage, c1800, 17½ x 16in (44 x 40.5cm).
£300–350 *DN*

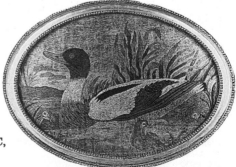

r. A woolwork picture of a duck and ducklings, early 19thC, 21in (53cm) wide.
£850–1,000 *DN*

Samplers

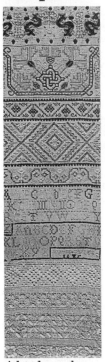

A band sampler,
with raised and cut
work, good condition,
dated '1685',
30 x 10in (76 x 25cm).
£2,500–4,000 *WiA*

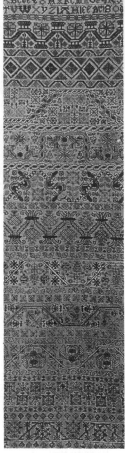

A sampler, worked in
green, pink and shades
of blue silks on a linen
ground, with an
alphabet and decorative
bands of geometric and
stylised floral designs,
late 17thC, 28½ x 8in
(72.5 x 20cm).
£1,000–1,200 *CSK*

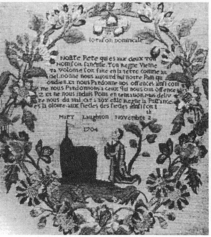

A silkwork sampler, worked by Mary
Laughton, depicting the Lord's Prayer or
'Le Raison Dominicale', above a kneeling
figure praying before a church, all within
a wreath of bold flowers, on a linen
ground, dated 'Novembre 2 1704',
9¾ x 8⅝in (24.5 x 22cm).
£500–600 *DN*

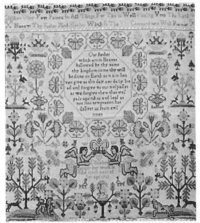

A sampler, worked in brightly
coloured silks, early 18thC,
16 x 15in (41 x 38cm).
£2,000–2,500 *WiA*

l. A needlework sampler, worked
by Elisabeth Cosham, with
religious text above a house
flanked by an avenue of trees, the
foreground with a flowering urn, a
bird, a dog and 2 cats, inside a
honeysuckle border, dated '1795',
16½ x 11¾in (42 x 30cm).
£850–1,000 *S(S)*

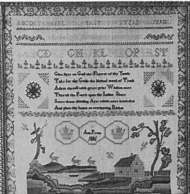

r. A needlework sampler,
with verse above a house,
trees, animals and 'Ann
Press 1801', 15½in
(40cm) square.
£400–500 *WL*

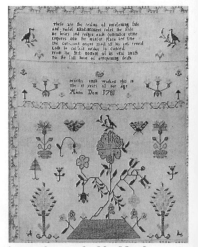

A sampler, worked by Martha
Smith in coloured silks, with a verse
flanked by birds and flowers, with
other birds and butterflies below,
within a stylised floral border, dated
'1781', 14 x 10½in (36 x 26cm).
£550–600 *CSK*

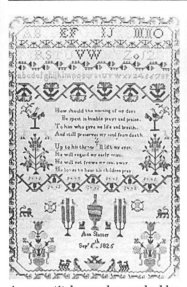

A cross stitch sampler, worked by Ann Slatter, with alphabet, numbers, a verse, animals and flowers, within a strawberry and chrysanthemum border, dated 'Sept. 5th 1825', some damage, 18½ x 12¼in (47 x 31cm).
£425–500 *DN*

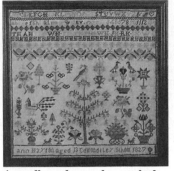

A needlework sampler, worked with the alphabet, trees, flowers, birds and 'Ann Mayron aged 13 Edmond Iley School 1827', 16in (41cm) square.
£750–900 *SK(B)*

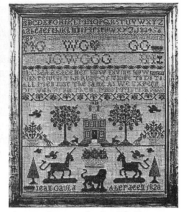

A sampler, worked with the alphabet, a house, trees, animals, birds and 'Jean Gauld Aberdeen 1828', 24½ x 20½in (62.5 x 52cm).
£1,000–1,200 *WiA*

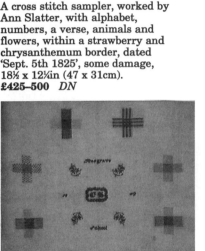

A darning sampler, worked on white linen with 8 darns in 2 colours each in the shape of a cross, 8 invisible whitework darns and decorated with 4 colourful motifs, the initials 'C.S.' and 'Kesgrave School', 19thC, 16in (41cm) square.
£650–800 *WiA*

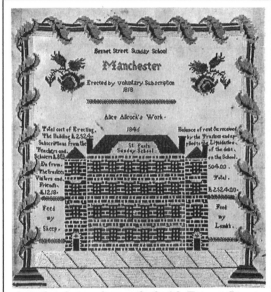

A woolwork sampler, worked with 'Bennet Street Sunday School, Manchester' and 'Alice Allcock's Work 1846', 24 x 20in (61 x 50.5cm).
£350–450 *WiA*

This sampler is particularly interesting because it records a wealth of local history. It celebrates the erection of Bennet Street Sunday School, Manchester, recording in exact detail the cost of the building and the amount received by various voluntary subscriptions, creating a fascinating, decorative and fiscal record.

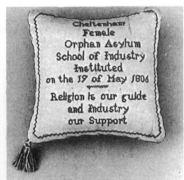

A cross stitch pincushion sampler, worked at the Cheltenham Female Orphan Asylum School of Industry, inscribed 'Instituted on the 19 of May 1806', the other side with the alphabet within a red zigzag border, on glazed cotton, 3¼in (8.5cm) square.
£300–350 *DN*

r. A school sampler, by Frances Wright, worked with the alphabet, numbers and verse, dated 'April 16 1861', 15 x 13in (38 x 33cm).
£150–300 *WiA*

The addition of a named school as here, Coughton School, can add interest and value to a sampler.

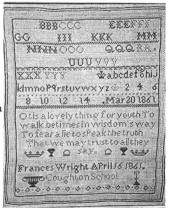

FRAMES

It is only in the last 15–20 years that old frames have become collectable. Before that they were often junked or burned to recycle the gold leaf on the gilded surrounds. Today, however, a frame can be worth more than the picture it contains and the major auction houses now hold sales specifically devoted to frames. Although the majority of early frames are anonymous, they can tell you about the culture that produced them. Seventeenth century Spanish and Italian pictures were often housed in poorly lit churches where their gilded frames with high relief carvings reflected the candlelight and drew attention to the pictures. Dutch frames of the period – simple and ebonised – were often designed for domestic subjects and more homely settings, their plainer style reflecting the tastes of a Protestant nation. In the late 18thC carved frames gradually gave way to compo (composition plaster) which enabled decoration to be moulded rather than carved and thus endlessly reproduced.

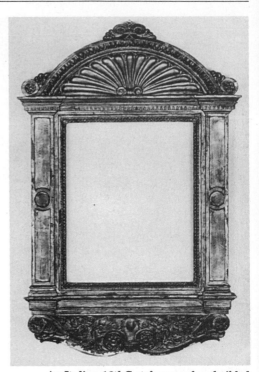

An Italian 16thC style carved and gilded tabernacle frame, with exhibition labels, 18½ x 14½in (47 x 37cm).
£1,000–1,200 *CSK*

A Continental carved, gilded and painted tabernacle frame, the dentil moulded broken pediment supported by 2 caryatid pilasters above a breakfront plinth base, part 16thC, with mirror glass, 15½ x 12in (40 x 30.5cm).
£1,700–2,000 *CSK*

An Italian carved and gilded frame, with raised scrolling foliate central plate, beaded and ovolo outer edge, flowerhead inner edge, 17thC, 16¼ x 23in (41.5 x 58.5cm).
£700–800 *CSK*

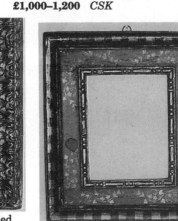

An Italian carved, gilded and painted frame, with raised black and gold outer edge, the cauliculi centres and corners on black ground, with bar-and-double beaded sight edge, 17thC, 9¾ x 7¼in (24.5 x 18cm).
£950–1,200 *CSK*

A carved and gilded frame, with raised oak leaf and flower central plate running to acanthus leaf corners, ribbon twist inner edge, foliate outer and sight edge, with mirror glass, 17thC, 47½ x 26½in (121 x 67cm).
£1,000–1,200 *CSK*

r. A Spanish carved, gilded and painted frame, with acanthus leaf corners and flowerhead centres, on blue ground, raised scrolling acanthus leaf sight edge, 17thC, 31 x 21in (79 x 53cm).
£3,600–4,500 *CSK*

A Spanish carved and gilded frame, with ovolo outer edge and raised imbricated leaf inner edge running from centres to corners, 18thC, 67¾ x 92½in (171 x 235cm). **£3,600–4,500** *CSK*

A Louis XIV carved and gilded frame, with anthemia corners, scallop shell centres, flanked by foliage and flowers, on cross-hatched ground and foliate sight edge, 31¼ x 24½in (79 x 62cm). **£450–550** *CSK*

An Italian 18thC style carved and gilded frame, with pierced borders cornered, quartered and centred by roundels, the inner edge with running flowerhead design, 17½ x 13½in (44.5 x 34.5cm). **£200–250** *CSK*

A carved giltwood frame, 18thC, 24¾ x 20½in (63 x 52cm). **£850–1,000** *Bea*

A French Regency carved and gilded frame, with anthemia centres and corners flanked by opposed C-scrolls and foliage on cross-hatched ground, foliate sight edge, 27 x 40½in (69 x 103cm). **£550–700** *CSK*

l. A Florentine carved and gilded frame, with pierced scrolling foliate border and raised sight edge, 19thC, 23½ x 29in (60 x 74cm). **£1,300–1,500** *CSK*

l. An Italian giltwood and gesso frame, decorated with masks, scrollwork, shells and foliage in high relief, bordered with formal foliage, the circular opening 11½in (29cm) diam. **£850–1,000** *HSS*

A French Empire style gilt composition frame, with raised outer edge decorated with honeysuckle and palmettes, beaded inner edge and lambs tongue sight edge, 40 x 34in (101.5 x 86cm). **£250–300** *CSK*

GARDENS & COTTAGES

One of the side effects of the Industrial Revolution was that gardening became the leisure occupation of the new middle classes. The 19thC saw the development of the flower garden, the invention of the lawn mower, hence the introduction of lawns into private as opposed to just stately homes, and the marketing of a new range of gardening tools deemed necessary for the Victorian villa garden. The growing popularity of gardens led to a flourishing demand for pictures of them and by the turn of the century an artist could make his or her fortune by specialising in decorative pictures of gardens and flower bedecked cottages. Leading exponents include such figures as Myles Birket Foster, perhaps the most celebrated Victorian cottage artist, Helen Allingham, whose depictions of Kent and Surrey dwellings were so faithful that the buildings may still be identified today, George Samuel Elgood who portrayed the grand and formal gardens of England and Italy and Beatrice Parsons, the supreme artist of the wild garden.

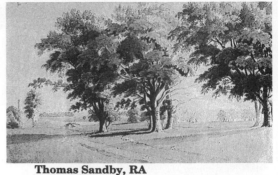

Thomas Sandby, RA
British (1723–98)
Windsor Great Park, with the Culloden Obelisk and the Obelisk Pond
Pen, grey ink and watercolour over pencil
10¼ x 17in (26 x 43cm)
£1,400–1,600 *HP*

Sandby was draughtsman to William Augustus, Duke of Cumberland, and Deputy Ranger of Windsor Great Park. The Culloden Obelisk was built to commemorate the Duke's victory of 1746.

17th–18th Century

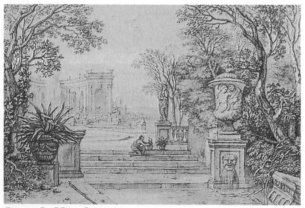

Isaac de Moucheron
Dutch (1670–1744)
Landscape with a formal Garden
Pen and black ink and grey wash
8 x 12¼in (20 x 31cm)
£2,200–3,000 *S(Am)*

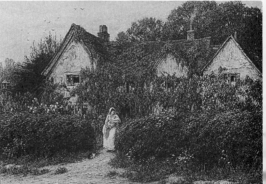

Isaac de Moucheron
Dutch (1670–1744)
An Arcadian Landscape with a Woman walking towards a Stream
Signed, gouache
8 x 6½in (20.5 x 16cm)
£7,600–8,500 *S(Am)*

19th–20th Century

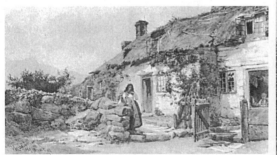

John Absolon, RI
British (1815–95)
Outside the Cottage
Signed and dated '1880', inscribed 'Salop',
watercolour over pencil, heightened with bodycolour
13¼ x 23¼in (34 x 59cm)
£750–850 *S(S)*

Helen Allingham, RWS
British (1848–1926)
An Old House – Middlesex
Signed and labelled, watercolour
13¾ x 18¾in (35 x 48cm)
£24,000–28,000 *HSS*

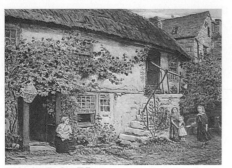

Edwin Bale, RI
British (1838–1923)
Playtime
Signed, dated '1871' and inscribed
on reverse, watercolour
14½ x 20in (37 x 50.5cm)
£2,000–2,500 *WrG*

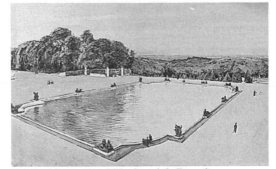

Alexander Nikolaevich Benois
Russian (1870–1960)
Pool of Neptune at Versailles
Signed and dated '1900', gouache over pencil
12¾ x 19in (32.5 x 48cm)
£4,200–4,500 *S*

Octavius T. Clark
British (1850–1921)
A Cottage on a country Lane
Signed, oil on canvas
12 x 18in (30.5 x 46cm)
£350–400 *CSK*

Joseph Hughes Clayton
British (exh 1891–1929)
Cottages on Anglesey
Signed and dated '1898', watercolour
15 x 25in (38 x 63.5cm)
£1,450–1,650 *WrG*

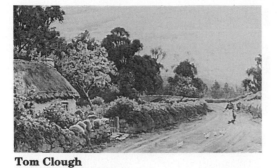

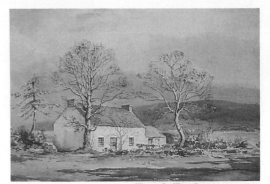

Tom Clough
British (c1867–1943)
A Woman and Geese by a Thatched Cottage
Signed, watercolour
15½ x 23¾in (39 x 61cm)
£700–900 *Bon*

Frank Egginton
British (1908–90)
A Cottage in Donegal
Signed, watercolour
21 x 29in (53.5 x 73.5cm)
£2,000–2,500 *WrG*

George Samuel Elgood
British (1851–1943)
A Herbaceous Border,
Penshurst
Signed and dated '1882',
pencil and watercolour with
scratching out
16½ x 13¾in (42 x 35cm)
£2,100–2,500 *C*

*George Elgood specialised in
painting English and Italian
gardens and architecture.*

Leyton Forbes
British (early 20thC)
Lady seated in a Cottage
Garden
Signed, dated label '3 Oct. 1912'
on reverse, watercolour
9 x 6in (23 x 15cm)
£450–550 *TAY*

John Mackintosh Mackintosh
British (1847–1913)
Picking Flowers
Watercolour
10 x 7in (25 x 17.5cm)
£1,000–1,500 *HFA*

Myles Birket Foster, RWS
British (1825–99)
At Sandhills, Surrey
Signed with monogram, watercolour heightened
with white
10 x 14in (25 x 36cm)
£8,500–9,000 *P*

r. **Beatrice Parsons**
British (1870–1955)
Summer Garden in Fairwarp, East Sussex
Signed and inscribed on the reverse, watercolour
9½ x 7in (24 x 17.5cm)
£1,900–2,400 *C(S)*

Benjamin D. Sigmund
British (active 1880–1904)
Picking Meadow Flowers
Signed and dated '97', watercolour
14 x 20½in (36 x 52cm)
£1,600–2,000 *Bon*

l. **Joseph Harold Swanwick, RI, ROI**
British (1866–1929)
Children playing with a Kitten
Signed, watercolour
14 x 10in (35.5 x 25cm)
£2,500–3,000 *WrG*

Lilian Stannard
British (1884–1944)
In Sweet September
Signed, watercolour
9¾ x 13⅜in (24.5 x 35cm)
£5,000–5,500 *CW*

Lilian Stannard was the daughter of landscape and sporting painter Henry Stannard (1844–1920), and her brothers, Henry and Alexander, and sisters, Emily and Ivy, were all artists. Lilian was one of the most successful of the brood. By the age of 30 she was one of the most celebrated garden painters in England. 'This lady's exact drawing and colouring should be of great value to publishers and men of science,' enthused the Bedfordshire Times in 1899, 'but there is also poetry in the notion and composition.'

ICONS

The word 'icon' comes from the Greek *'eikon'*, meaning likeness or image. The term signifies a picture by a Greek or Russian Orthodox believer, typically religious in subject matter and painted on panel. Themes were strictly prescribed by tradition, as was the manner of their presentation, and an icon of the 6th or 7thC may be identical in style to an example painted in the 17thC or even later. Similar formats are still followed in the 20thC.

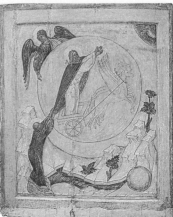

The Fiery Ascent of the Prophet Elijah to Heaven
Novgorod, late 15thC
Elijah ascends to heaven in a chariot of fire within a blazing whirlwind which is guided by Archangel Michael, below, his disciple Elisha, standing on the banks of the Jordan, clutches the hem of his master's fleece
20½ x 16½in (52 x 42cm)
£120,000–140,000 *S*

The subject first appears in Russia as a main theme on panel icons during the early 15thC. In Novgorod, Elijah was greatly revered as a visionary who saw God as a prophet, a miracle worker, and one who was able to control the elements, especially thunder, rain and fire.

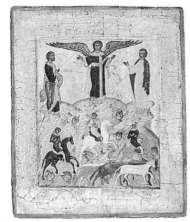

The Miracles of Saint Floros and Lavros
Novgorod, 16thC
Archangel Michael, his wings spread, stretches out his hands in blessing towards the martyrs Floros and Lavros, upon whom he confers the protection of horses, at the base of the panel a herd of horses is driven to a watering place by the Cappadocian grooms and horse doctors, the brothers Spevesippos, Elevesippos and Melevsippos
13 x 10¾in (33 x 27.5cm)
£35,000–40,000 *S*

The twins Floros and Lavros, second century stone masons from Illyria, gave all that they earned to the poor.
Commissioned to build a heathen temple, they preached the Gospel instead and built a church. In consequence, the twins were brought before the governor of Illyria who ordered them to be thrown down a deep dry well and covered with earth. Many years later, inhabitants of that place observed horses drinking at the spot and here the miraculously preserved bodies of the twins were uncovered. The water from the well was celebrated for its power to heal horses.

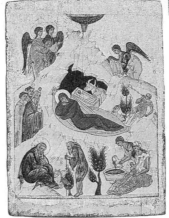

The Nativity of Christ
from the Festival Tier of the Iconostas of the Church of Saint Nicholas in the village of Gostinopol on the river Volkhov, near Novgorod, 1475–1500
23 x 17½in (58.5 x 44cm)
£80,000–100,000 *S*

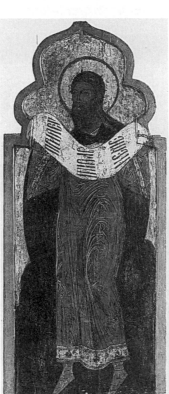

r. The Prophet Jeremiah
Russian, 17thC
Tempera on panel
31 x 20½in (79 x 52cm)
£14,000–15,000 *MAI*

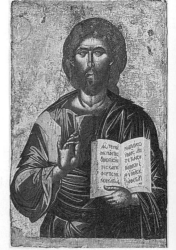

Christ Pantocrator
from the Despotic range of a Templon,
Cretan, 16thC
The flesh tones rendered through a series of white lines of equal strength, reminiscent of engraving running across the forms, over a base colour of a dark olive brown, the chiton of crimson, with an orange clavus picked out in gilt on his right shoulder
26¾ x 17in (68 x 43cm)
£24,000–28,000 *S*

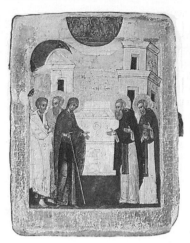

The appearance of the Mother of God accompanied by the Apostles Peter and John to Saint Sergei of Radonezh and his successor the Abbot Nikon, Moscow, probably from the workshop of the Trinity-Sergei Monastery, late 16thC
The Holy Trinity painted en grisaille on the upper border, gold background with cursive calligraphy
11¾ x 9½in (30 x 23.5cm)
£12,000–14,000 *S*

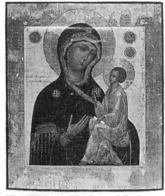

The Tikhvin Mother of God Russian, c1800
Painted against a gilt background and enriched with chrysography
12½ x 10in (31.5 x 25cm)
£900–1,200 *S*

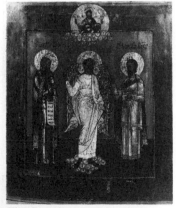

-The Guardian Angel and the Saints Sergei of Radonezh, Cosma, the Patron Saint of Doctors, with Christ above Russian, 19thC
12¾ x 10½in (31 x 26.5cm)
£275–350 *Bon*

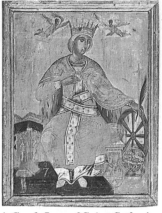

A Greek Icon of Saint Catherine, Great Martyr of Alexandria Late 17thC
Depicted wearing vestments of Imperial purple under a bejewelled golden stole, around her shoulders an ermine-lined mantle with the Paleologue Imperial eagle and at her feet attributes of her wisdom, books, scientific instruments and an armillary sphere, 2 angels holding a spiked crown on her head, signed 'Through the hand of John, Priest of Khios', and at the base a dedication to Saint Catherine
21 x 15½in (53 x 40cm)
£14,000–18,000 *S*

The Holy Trinity or the Hospitality of Abraham Russian, 19thC
With Saints Nicholas and Catherine on the border
12½ x 10½in (31 x 26.5cm)
£750–1,000 *S*

The Mother of God of Tenderness 19thC
12¾ x 10½in (31 x 26.5cm)
£550–650 *CSK*

The Deisis
Cretan, late 17thC
The Enthroned Christ majestically vested as Great Hierarch with a sakkos, Imperial mitre and stole and episcopal omophorion, gold background
23 x 17½in (59 x 44cm)
£8,500–10,000 *S*

St Paraskeva with geometric border Monastic Greek, c1750
Tempera on panel
12¼ x 8½in (31 x 21.5cm)
£1,000–1,200 *MAI*

Vladimirskaya with chased parcel oklad, silver oklad with gilt halos
Moscow, 1874
Tempera on panel
9 x 7in (22.5 x 17.5cm)
£1,600–1,800 *MAI*

LANDSCAPES

The following section devoted to landscape and topography is divided into two main parts. The first follows general landscape painting from the 16thC to the modern day and is organised by century. The second part 'Landscape Topographical Review', concentrates on pictures of towns, cities and, more specifically, topographical views, and is catalogued by country.

There are more landscapes sold at auction and through dealers than any other single category of painting. The majority of these date from the 19thC. As the Victorian population became increasingly urban, so demand for rural landscapes expanded and although more than a century has elapsed, the same pictures remain popular today. 'There will always be a market for 19thC traditionalist decorative landscapes – they are almost fashionless,' stresses James Lloyd of Burlington Paintings. Typically favourite subjects, both in the 19thC and today, include harvesting scenes, Highland views and continental beauty spots. 'Most of the painters we deal with were highly successful in their own lifetime,' explains Lloyd. 'They were very competent artists who understood both their subject matter and their clients' needs. Many painters hit upon a specific pictorial formula that worked for them and then stuck to it throughout their careers.' Examples of such artists included Alfred de Breanksi, famed for his Scottish loch scenes, Thomas Sidney Cooper, who regularly churned out landscapes with sheep and cattle until his death aged 99, and John Brandon 'Waterfall' Smith, renowned for his ability to paint rivers and waterfalls.

Whilst the majority of oil paintings from the period tend to be by established artists 'people with letters after their names,' says dealer Christopher Wood, many 19thC watercolour landscapes were painted by amateur or part-time painters. 'Pens and watercolours were portable and people took them with them on their travels in the same way that we would take a camera today. You will always come across artists you have never heard of before. The trick is to look at the picture first and the signature second. You don't have to look for a big name to buy a good picture.'

16th–17th Century

Attributed to Jan Frans van Bloemen, called Orizzonte
Flemish (1662–1749)
An extensive Italianate Landscape with a Shepherd and his Flock, a River and a Monastery beyond
Oil on canvas
33 x 39¾in (84 x 100.5cm)
£8,500–10,000 *C*

Follower of Anthonie Jansz. van der Croos
Dutch (1606–62)
River Landscapes with Fishing Boats
A pair, oil on panel
8 x 11in (20 x 28cm)
£3,000–4,000 *S*

Follower of Jan Brueghel
Flemish (17thC)
Wooded River Landscape with Peasants, and Cattle and a Cart on a Village Track
A pair, oil on panel
8 x 9½in (20 x 23cm)
£12,200–14,000 *CSK*

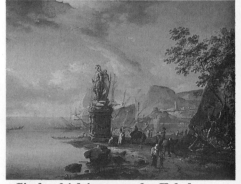

Circle of Adriaen van der Kabel
Dutch (1631–1705)
A Mediterranean Coast with Travellers by a Statue of a Warrior
Oil on canvas
18 x 23in (45.5 x 58cm)
£6,000–7,000 *C*

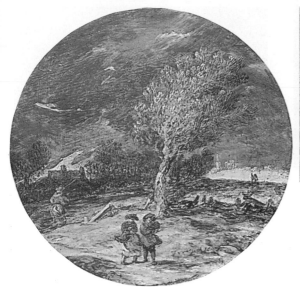

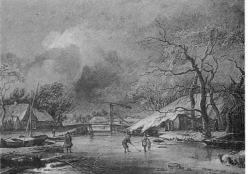

Jan van Kessel
Flemish (1641–80)
A Village in Winter with Peasants and a
Golf Player on a frozen Waterway
Signed, oil on canvas
19½ x 27in (49.5 x 68.5cm)
£38,000–42,000 *C*

Circle of Jan van Goyen
Dutch (1596–1665)
Figures Crossing a Heath, a Rider
approaching a Coppice with Houses
Bears signature 'J. v Goyen' and dated '1627',
oil on panel, tondo
4¾in (12cm) diam
£12,000–14,000 *Bon*

r. **Isaac Koene**
Dutch (1638–1713)
Landscape with Figures on
a Path and a Huntsman
with his Dog beyond
Oil on canvas
18 x 15½in (45.5 x 39.5cm)
£5,200–6,000 *S*

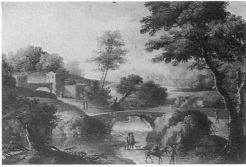

**Manner of Hendrik Frans van Lint,
called Studio**
Flemish (1684–1763)
An extensive Landscape with Figures on a
Track before a Ruined House and An
extensive Italianate River Landscape with
a Peasant and a Donkey
A pair, oil on copper
6 x 8½in (15 x 21.5cm)
£4,000–4,500 *CSK*

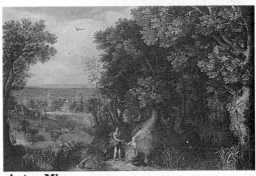

Anton Mirou
Flemish (before 1586–after 1661)
A wooded Landscape with Atalanta and Meleager
Signed, oil on copper
13¼ x 20½in (33.5 x 52cm)
£28,000–35,000 *C*

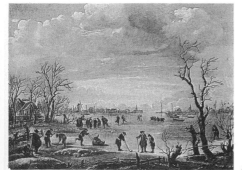

Follower of Aert van der Neer
Dutch (1603–77)
A Frozen Waterway with Golf Players and
Skaters by a Town
Monogrammed, oil on canvas
15½ x 20in (39 x 50.5cm)
£7,500–8,500 *C*

r. **Claes Molenaer**
Flemish (c1630–76)
A Frozen Waterway with
Peasants loading a
Sledge by a Cottage
Signed, oil on panel
20 x 15½in (50.5 x 39.5cm)
£15,000–17,000 *C*

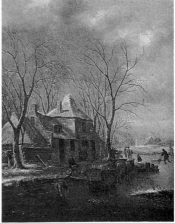

Gaspard Dughet, called Gaspard Poussin
French (1615–75)
A classical Landscape with 3 Shepherds by a
Lake, a Tower beyond
Oil on canvas
22¾ x 34in (58 x 86.5cm)
£26,000–30,000 *C*

Gillis Neyts
Flemish (1623–87)
A Mountainous wooded Landscape and Travellers
by a ruined Castle
Signed and dated '1680', oil on canvas
48 x 66¼in (122 x 168cm)
£19,000–25,000 *C*

Marco Ricci
Italian (1676–1730)
An extensive Mountainous Landscape with a
Herdsman and Cows Crossing a River
Pen and golden brown ink and wash
13¼ x 20⅜in (33.5 x 52.5cm)
£32,000–35,000 *S(NY)*

Attributed to Frederick van Valckenborch
Flemish (1570–1623)
Extensive Landscape with the Baptism of Christ
Oil on canvas
23 x 29in (58.5 x 73.5cm)
£4,200–5,000 *S*

Studio of David Teniers the Younger
Flemish (1610–90)
A Country Village with Peasants conversing
outside a Cottage and Topers outside an Inn
Oil on canvas
45½ x 65¼in (115.5 x 165.5cm)
£12,000–13,000 *P*

Dirck Verhaert
Dutch (1631–after 1664)
A Mediterranean Port with Peasants near
a Ruined Classical Temple
Signed with initials 'DVH', oil on canvas
26½ x 30½in (67.5 x 77.5cm)
£9,500–10,500 *C*

l. **Tobias Verhaecht**
Flemish (1561–1631)
Mountainous Landscape with a River
Pen and brown ink and brown and blue wash
9½ x 14¼in (24 x 36.5cm)
£11,500–15,000 *S(Am)*

18th Century

Dutch School (18thC)
Skaters on a Frozen Pond, Houses and a
Church beyond
Oil on panel
8 x 11¼in (20.5 x 28.5cm)
£1,500–2,000 *Bon*

Samuel Hieronymus Grimm
Swiss (1733–94)
Figures Working outside Cottages on
the Banks of a River
Signed and dated '1771', pen and ink
and watercolour
9¾ x 13½in (24.5 x 34.5cm)
£950–1,200 *P*

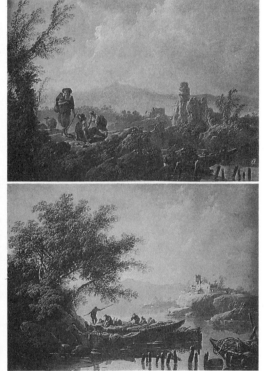

William Payne
British (1754–1833)
Ivy Bridge and On the River Tamar
A pair, signed, pencil, pen and brown ink
and watercolour
14 x 11½in (35.5 x 29.5cm)
£4,700–5,500 *C*

Jean Pillement
French (1728–1808)
Morning: A River Landscape with a Shepherd
and Shepherdesses and Evening: A River
Landscape with Fishermen mooring their Boats
A pair, one signed and dated '1785', the other
signed, oil on metal
12 x 16½in (30.5 x 42cm)
£35,000–40,000 *C*

*Born in Lyon, Pillement began his career as a
decorative draughtsman, especially of chinoiseries.
He was one of the most widely travelled artists of his
age. He left France for Madrid in 1745 at the age of
17 and visited Lisbon before spending the 1750s in
London where he turned to landscape painting. He
travelled Italy, Austria and Poland and founded a
drawing School in Portugal.*

Thomas Hearne, FSA
British (1744–1817)
Kensington Gardens
Signed, pencil and wash
7½ x 10¼in (19 x 26cm)
£3,000–3,500 *P*

r. **John 'Warwick' Smith**
British (1749–1831)
Vico Varo, near Tivoli
Watercolour
8½ x 11½in (21.5 x 29cm)
£1,400–1,800 *P*

19th Century

David Bates
British (1840–1921)
An Irish Lakeside Scene
Signed and dated '1900', watercolour
7 x 11in (17.5 x 28cm)
£900–975 *WrG*

Owen Bowen
British (1873–1922)
Extensive landscape with Shepherd and Flock
in the foreground
Signed, oil on canvas
17½ x 25½in (44.5 x 65cm)
£2,700–3,200 *AH*

Bolette Brandt
Continental (active late 19thC)
Stags resting in a river Landscape
Signed with initials and dated 'B.B.72',
oil on canvas
24½ x 35in (62.5 x 88.5cm)
£500–600 *CSK*

Newton Bennett
British (1854–1914)
The Village Street, Sutton Courtenay, Berkshire
Watercolour
13¼ x 20¼in (33.5 x 51.5cm)
£2,200–2,500 *Bon*

William Bradley
British (active 1872–89)
Haymaking
Signed and dated '1884', watercolour with
scratching out
22¾ x 34¾in (58 x 88cm)
£1,600–2,000 *Bon*

Alfred de Breanski, Snr
British (1852–1928)
Lodore, Derwentwater
Signed, inscribed on reverse, oil on canvas
15¾ x 21¾in (40 x 55.5cm)
£4,000–4,500 *Bon*

*A Highland scene by de Breanski, the
artist's speciality, tends to be more
desirable than an anonymous rural view.*

l. **Alfred de Breanski, Snr**
British (1852–1928)
At Cookham – Evening
Signed and dated '1878-9', indistinctly inscribed,
watercolour and bodycolour
15 x 22in (38 x 56cm)
£750–850 *S(S)*

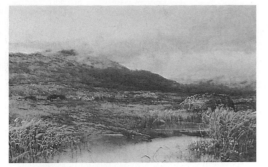

John Mallard Bromley
British (active 1876–1904)
Peat Bogs, North Wales
Signed, signed and inscribed as title on reverse
on artist's label, pencil and watercolour
19¼ x 29½in (48.5 x 75cm)
£750–950 *CSK*

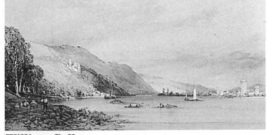

William Callow
British (1812–1908)
On the Rhine
Signed and dated '1861', watercolour
9¾ x 19¼in (24.5 x 49cm)
£3,000–3,500 *Bon*

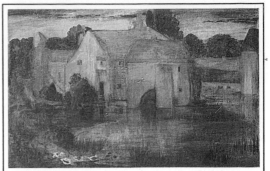

Sir Edward Coley Burne-Jones, Bt, ARA
British (1833–98)
The Watermill
Watercolour and bodycolour on wallpaper
laid down
31½ x 47½in (80 x 121cm)
£7,500–10,000 *S*

*Burne-Jones adored children and the present
picture was part of a watercolour mural painted
by the artist to decorate his grandchildren's
nursery in the mid-1890s. 'There was no story
about it,' his granddaughter later recalled, 'but
a child could invent an infinite number of
stories for itself and wonder what happened
round the furthest corner of the picture and
what monster might be lurking in the dark
archway under the mill.' One particular corner
of the nursery was where the children were
made to stand when they were naughty. One
day, Burne-Jones discovered his granddaughter
in this unfortunate position, and the following
morning he immediately painted a mural there
of animals and birds 'so that she might never be
unhappy or without company in the corner
again.' The murals were removed in the 1980s.*

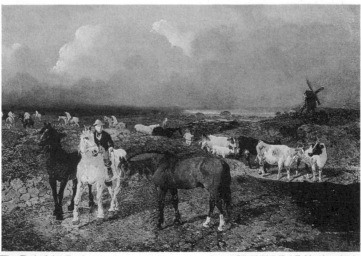

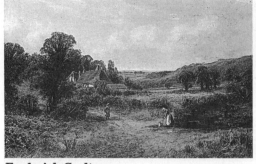

Frederick Carlton
British (19thC)
Landscape with Cottage in Background
Signed, oil on canvas
20 x 30in (50.5 x 76cm)
£1,600–2,000 *BWe*

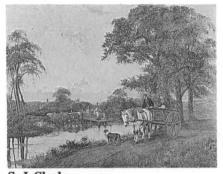

S. J. Clark
British (active 1880–90)
Idyllic Country Landscape
Signed and dated '1886', oil on canvas
36 x 46in (91.5 x 116.5cm)
£3,500–4,000 *CAG*

William Cook of Plymouth
British (exh 1870–80)
Drake's Island, Mount Edgecumbe from Oreston
Signed with monogram, dated '74' and inscribed
verso, watercolour
10 x 17in (25 x 43cm)
£850–1,050 *WrG*

Henry Cooper
British (19thC)
Swans on a River before a Cottage
Signed, oil on canvas
20 x 31in (51 x 78.5cm)
£450–650 *P*

Ivan Choultsé
Russian (19th/20thC)
Soir de Décembre pre de St. Moritz, Engadine
Signed, inscribed with title on reverse,
oil on board
9¼ x 12½in (23 x 31.5cm)
£3,750–4,500 *S*

Sir George Clausen, RA
British (1852–1944)
A Sheepfold, early Morning
Signed and dated '1890', signed with initials, dated
again and inscribed on reverse, oil on canvas
12½ x 14¼in (31 x 36cm)
£10,000–12,000 *C*

Jean Baptiste Camille Corot
French (1796–1875)
Le Pâtre dominant la Gorge rocheuse
Signed, dated '1859', and inscribed,
oil on cradled panel
16½ x 22½in (42 x 57cm)
£135,000–150,000 *C*

*Corot's landscapes anticipated the developments of
the Impressionist painters. 'In front of any site or any
object, abandon yourself to your first impression,' he
wrote in his notebook in 1856. 'If you have been truly
moved, you will communicate to others the sincerity
of your emotion.' According to contemporary reports,
his passion for painting lasted literally until his
dying day, expressed in his final words: 'I hope with
all my heart that there will be painting in heaven.'*

David Cox, Jnr
British (1809–85)
Cottages in an extensive Mountainous Landscape,
with Figures and Sheep
Signed and dated '1850', pencil and watercolour
11 x 15½in (28 x 39.5cm)
£450–550 *CSK*

Dutch School (early 19thC)
A Winter River Landscape with Skaters
Signed with initials and dated '1824', oil on panel
18 x 26in (46 x 66cm)
£4,200–5,000 *C*

Dutch School (19thC)
Figures by a Lakeside, a Windmill beyond
Oil on panel
4¾ x 10in (12 x 25cm)
£350–450 *CSK*

David Farquharson, ARA, ARSA, RSW
British (1839–1907)
A Summer's Afternoon near Blairgowrie
Signed and dated '1878', signed, inscribed with
title and artist's address on reverse, oil on canvas
10¼ x 13¾in (26 x 35cm)
£1,600–2,000 *Bon*

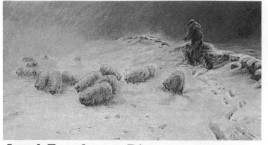

Joseph Farquharson, RA
Scottish (1846–1935)
The Joyless Winter Day
Signed, oil on canvas
20 x 36in (51 x 91.5cm)
£15,000–20,000 *S(Sc)*

r. **William Teulon
Blandford Fletcher**
British (1858–1936)
Summer Days
Signed, oil on board
10 x 7½in (25 x 19cm)
£3,000–3,500 *C*

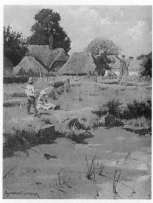

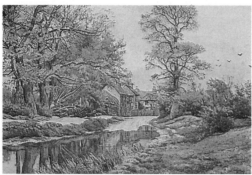

Garden William Fraser
British (1856–1921)
The Village Ford
Signed and dated '93', pencil and watercolour
8 x 11½in (20.5 x 29cm)
£2,500–3,000 *C*

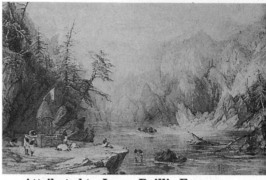

Attributed to James Baillie Fraser
British (1783–1856)
In the Himalayas
Watercolour heightened with white
8 x 12in (20.5 x 30.5cm)
£1,400–1,800 *P*

James Baillie Fraser was a merchant in Calcutta.

Robert James Winchester Fraser
British (1872–1930)
Near Bluntisham
Signed and dated' 97', watercolour
7 x 14½in (17.5 x 37cm)
£950–1,150 *WrG*

Alfred Augustus Glendenning
British (active 1861–1903)
Harvesting
Signed with initials and dated '98', oil on canvas
11½ x 15¼in (29.5 x 39cm)
£5,200–6,000 *S(S)*

John Glover
British (1767–1849)
An extensive Mountainous River Landscape with
Figures, Cattle and Sheep by a Bridge
Pencil, pen and brown ink and watercolour
11½ x 17¾in (29.5 x 45cm)
£850–1,200 *CSK*

Frederick E. J. Goff
British (exh 1891–1900)
Tewkesbury, Gloucestershire
Signed, watercolour
7 x 13in (17.5 x 33cm)
£650–750 *HO*

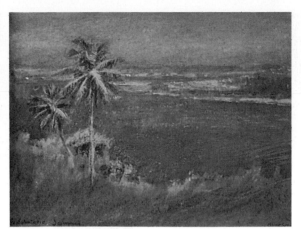

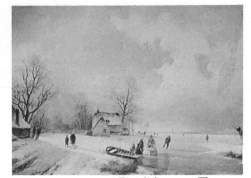

Remigius van Haanen
Dutch (1812–94)
A Winter Scene
Signed, oil on canvas
20 x 26in (50 x 66cm)
£7,000–8,000 *S*

Albert Goodwin, RWS
British (1845–1932)
Port Antonio, Jamaica
Signed and inscribed, pencil, pen and ink and
watercolour heightened with white on brown
paper, on the artist's original mount
7½ x 10in (19 x 25cm)
£3,000–3,500 *C*

*Goodwin visited Jamaica between March 7 and
April 10, 1902, his last disembarkation in the
West Indies before sailing on to Philadelphia. In
his diary he wrote of the view of Port Antonio:
'A more lovely look-out over this blue harbour
through coconut palms and all other wonderful
tropical trees I have never seen.'*

Edward Hargitt, RI
British (1835–95)
Highland Landscape
Signed and dated '1882', watercolour
10 x 18in (25 x 45.5cm)
£1,000–1,250 *HO*

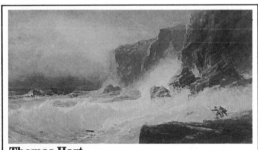

Thomas Hart
British (active 1865–80)
Stormy Day at the Lizard
Signed and dated '69', pencil and watercolour
heightened with white
13 x 23¾in (33 x 60.5cm)
£400–500 *CSK*

*Stormy pictures are often harder to sell than
happy sunny scenes, hence the comparatively
low price range of this picture.*

Claude Hayes, RI
British (1852–1922)
The Sussex Weald
Watercolour
19 x 29in (48 x 74cm)
£1,800–2,000 *NBO*

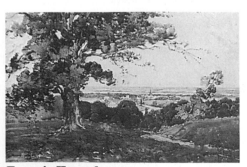

Eugenie Henard
French (19thC)
Environs de Melory
Signed and inscribed as title, pencil and
watercolour
15 x 22in (38 x 55.5cm)
£350–450 *CSK*

Edward Henry Holder
British (active 1864–1917)
Highland River Scene
Signed, oil on canvas
19 x 29in (48.5 x 73.5cm)
£1,500–2,000 *AH*

Tom Hunn
British (active 1878–1908)
September Morning, Somerford Mill, Nr. Cirencester
Signed, watercolour over pencil heightened with
touches of stopping out
15 x 24in (38 x 61.5cm)
£900–1,100 *Bon*

Henry John Yeend King, RBA, VPRI, ROI
British (1855–1924)
Wareham Quay
Signed, oil on canvas
23½ x 35½in (60 x 90.5cm)
£3,500–4,500 *S(S)*

Pieter Lodewijk Francisco Kluyver
Dutch (1816–1900)
An extensive panoramic Landscape
Signed, oil on panel
16 x 25¼in (41 x 64.5cm)
£18,000–20,000 *P*

Charles Parsons Knight
British (1829–97)
Boys on a River Bank
Signed and dated 'Jan^y 1858', watercolour
13 x 19in (33 x 48cm)
£450–550 *Bon*

F. E. Jamieson
Scottish (19thC)
Mountains at Loch Goil
Signed, oil on canvas
18 x 22in (45.5 x 55.5cm)
£300–380 *LH*

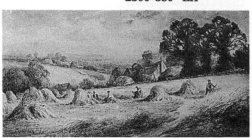

Henry John Kinnaird
British (exh 1880–1908)
Near Steyning, Sussex
Signed, watercolour
19½ x 39in (49.5 x 99cm)
£1,500–1,700 *JA*

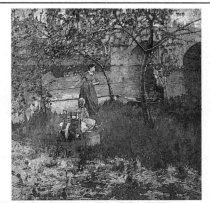

Sir John Lavery, RA, RSA, RHA
British (1856–1941)
On the Loing
Signed and dated '1884', signed again and
inscribed on the reverse, oil on canvas
31 x 30in (79 x 76cm)
£295,000–325,000 *C*

*Although the current market is extremely
selective, high prices are still being paid for
the best quality pictures. Lavery's 'On the
Loing' made an auction record for the artist
when it came up for sale at Christie's, more
than doubling its upper estimate of
£100,000. It was, claimed auctioneer John
Horwich, 'a truly remarkable picture,'
epitomising Lavery's 'plein air' style and
painted in 1884, when he was living at the
artistic community Grez-sur-Loing, in
France. The Grez laundresses were a
popular subject with both the artists and
writers who visited the community. They
'wash and wash all day among the fish and
water lilies,' wrote Robert Louis Stevenson
in 1876, 'it seems as if linen washed there
should be specially cool and sweet.'*

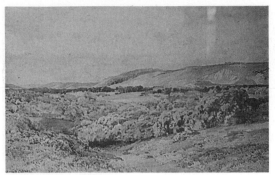

Harry Sutton Palmer
British (1854–1933)
The North Downs, Surrey
Watercolour
14 x 21in (36 x 53cm)
£900–1,150 *ROY*

Ernest Parton
American (1845–1933)
The Village Pond
Signed and dated '1879', oil on canvas
28 x 36in (71 x 91.5cm)
£2,500–3,000 *Bon*

Julio Ramos
Portuguese (b1868)
Promenade in the Countryside
Signed, oil on canvas
18 x 25in (46 x 64cm)
£5,500–6,500 *S*

Cornelius Pearson
British (1805–91)
Distant View of Windermere from
Troutbeck, Westmorland
Signed and dated '1855', watercolour
heightened with white
10 x 15in (25 x 38cm)
£550–750 *Bon*

Edward Harry Handley-Read, RBA
British (1870–1935)
The Village Pond
Signed and dated '90', watercolour
13 x 20in (33 x 51cm)
£1,000–1,250 *HO*

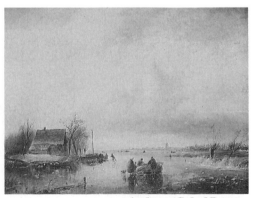

Andreas Schelfhout
Dutch (1787–1870)
On a frozen Lake
Signed, oil on panel
16½ x 21½in (42 x 55cm)
£7,500–9,000 *S*

l. **Vivian Rolt, RBA, NWS**
British (1874–1933)
Falmer Downs, 1926
Watercolour
10 x 15in (25 x 38cm)
£1,550–1,750 *NBO*

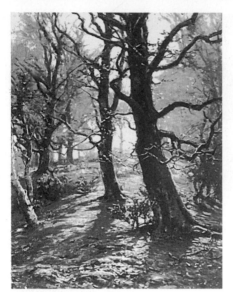

Frederick Golden Short
British (active 1882–1908)
An Autumn Afternoon
Signed and dated '1902', oil on canvas
20½ x 15½in (52 x 39.5cm)
£350–450 *CSK*

Henry John Sylvester Stannard
British (1870–1951)
The Woodgatherers
Signed, watercolour
10 x 14in (25 x 36cm)
£4,000–4,850 *HFA*

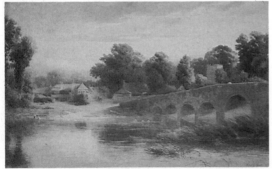

Howard Gull Stormont
British (exh 1884–1923)
Sonning upon Thames
Signed and dated '1893', watercolour
16 x 26in (41 x 66cm)
£1,750–1,950 *HO*

r. **John Syer**
British (1846–1913)
Richmond Castle
Signed and dated '1879', oil on canvas
23 x 35in (59 x 89cm)
£450–650 *AH*

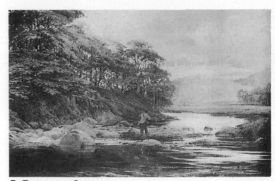

J. Somerscales
British (active 1893–98)
A Young Angler in an extensive River Landscape
Signed and dated '1894', pencil and watercolour with
scratching out
18 x 27¼in (46 x 69.5cm)
£600–800 *CSK*

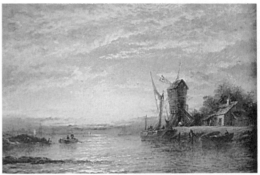

George Stainton
British (active 1860–90)
Evening on the Medway
Signed, oil on canvas
12 x 18in (30.5 x 45.5cm)
£2,800–3,200 *Bne*

Joseph Harold Swanwick, RI, ROI
British (1866–1929)
The Cuckmere Valley, Sussex
Signed, watercolour
9 x 13in (23 x 33cm)
£900–1,150 *WrG*

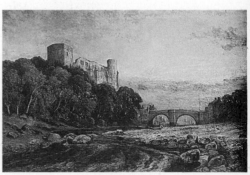

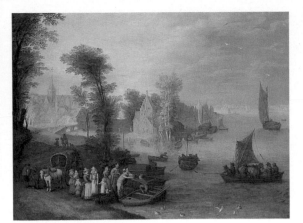

Joseph van Bredael
Flemish (1688–1739)
A River Landscape with Townsfolk disembarking from
a Ferry, a Village beyond
Signed with initials, oil on copper
9½ x 12¼in (24 x 31cm)
£50,000–55,000 *C*

Dutch School (c1780)
River Landscapes with Peasants
A pair, oil on canvas
77 x 49¾in (195.5 x 126.5cm)
£22,000–26,000 *C*

Attributed to Friedrich Brentel
German (1580–1651)
Fantastic Landscape with a Moated
Castle by the Sea
Tempera on vellum
3¾ x 8½in (9.5 x 21cm)
£8,500–10,000 *S(Am)*

Giovanni Battista Innocenzo Colombo
Italian (1717–93)
Mountainous Landscapes with Travellers,
Pilgrims and Beggars by Waterfalls
A pair, signed, oil on canvas
35 x 28in (89.5 x 71cm)
£30,000–35,000 *C*

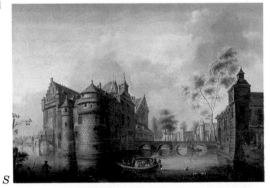

r. **Gerard-
Phillippe Colin**
Flemish (18thC)
Landscapes with
Chateaux
A pair, signed,
oil on panel
13¼ x 18½in
(33.5 x 47cm)
£13,000–15,000 *S*

Flemish School (17thC)
Hermits and Pilgrims in a
Rocky Landscape
Oil on canvas, laid on panel
12 x 10¾in (30.5 x 27cm)
£3,000–3,500 *S*

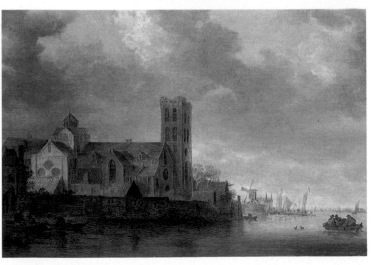

r. **Jan Josefsz van Goyen**
Dutch (1596–1656)
A Landscape of the
Mariakerk, Utrecht
Signed and dated '1642',
oil on panel
17 x 25¼in (43 x 64cm)
£22,000–30,000 *P*

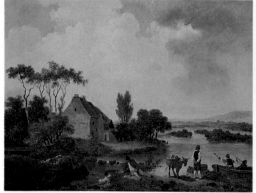

Jean Baptiste Leprince
French (1734–81)
An extensive Landscape with a Donkey and
Fisherfolk by a River Bank
Oil on panel
10¾ x 14in (27 x 35.5cm)
£5,000–6,000 *C*

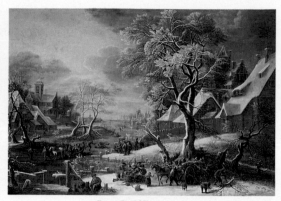

Jan Griffier
Dutch (1652–1718)
Figures in a frozen River Landscape
Oil on canvas
47½ x 66¼in (120 x 168cm)
£27,000–35,000 *S(Am)*

Follower of Andreas Vermeulen
Dutch (18th/19thC)
A Winter Landscape with Skaters on a
frozen River
Oil on canvas
18 x 24in (45.5 x 61cm)
£2,400–3,000 *CSK*

John Rathbone
British (1750–1807)
A Sportsman with his Dogs in a wooded
Landscape, a ruined Castle on the Hill beyond
Oil on canvas
18 x 24in (45.5 x 61cm)
£2,000–3,000 *P*

r. **Attributed to Willem
van Nieulandt II**
Flemish (1584–1635)
A rocky Mediterranean Coast
with the Temple of the Sibyl
at Tivoli
Oil on panel
12¾ x 16½in (32.5 x 42cm)
£6,000–8,000 *C*

Aert van der Neer
Dutch (1603–77)
A River Landscape with Fishermen near a
Village at dusk
Oil on canvas
24¼ x 34⅜in (62 x 88.5cm)
£18,000–20,000 *C*

Johannes Willem Tengeler
Dutch (active late 18thC)
An extensive Winter Landscape with
Skaters and Villagers on the Ice by a Booth
Signed and dated '1787–88', oil on panel
19¼ x 27⅜in (49 x 70.5cm)
£16,000–18,000 *C*

David Bates
British (1840–1921)
Collecting Firewood
Oil on canvas
14 x 18in (35.5 x 45.5cm)
£6,500–7,000 *HFA*

John White Abbott
British (1763–1851)
The Dart at Holne Chase, Devon
Watercolour over pen and ink
8¼ x 6in (21 x 15cm)
£4,500–5,500 *Bon*

Alfred de Breanski, Snr
British (1852–1928)
At Bowness, Windermere
Signed, inscribed on reverse, oil on canvas
24 x 36in (61 x 91.5cm)
£16,500–17,500 *BuP*

Thomas Baker of Leamington
British (1809–69)
Through the Ford
Oil on canvas
13 x 19in (33 x 48cm)
£4,500–5,000 *JN*

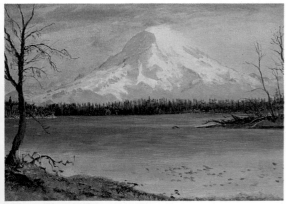

Albert Bierstadt
American/German (1830–1902)
Lake in The Rockies
Oil on paper
13¾ x 18½in (35 x 47cm)
£13,000–15,000 *S(NY)*

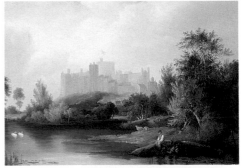

Henry John Boddington
British (1811–65)
Windsor Castle from the River
Oil on canvas
23 x 32in (58.5 x 81cm)
£12,500–13,500 *JN*

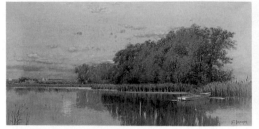

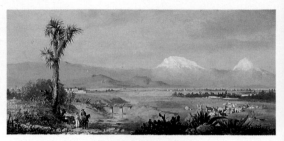

Alfred Thompson Bricher
American (1837–1908)
Borders of the North Sea, Southampton,
Long Island
Signed, watercolour on paper
18 x 34in (45.5 x 86cm)
£12,500–15,000 *S(NY)*

Conrad Wise Chapman
American (1842–1910)
Valle de México
Signed and dated '1882', oil on panel
7 x 14in (17.5 x 36cm)
£46,000–50,000 *S(NY)*

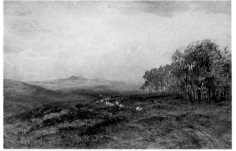

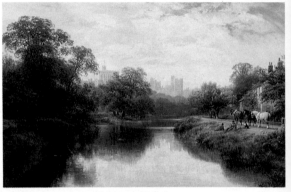

Arthur Henry Enock
British (exh 1892–1912)
A Breezy Moor
Signed, watercolour
14 x 21in (35.5 x 53cm)
£450–500 *HHG*

George Cole
British (1810–83)
Romney Lock House, Windsor
Signed and dated '1876', oil on canvas
19¼ x 29½in (49 x 75cm)
£8,000–10,000 *S(S)*

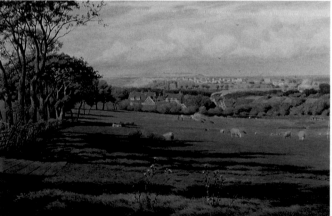

l. **William Sidney Cooper**
British (1854–1927)
View looking towards the Isle of
Sheppey from Herne Hill (?) a field
with sheep to foreground and group of
houses to centre
Signed and dated '1914', watercolour
13 x 19½in (33 x 49.5cm)
£800–1,000 *CAG*

David Cox, OWS
British (1783–1859)
Haymakers and Fishing in a Summer Landscape
Signed, watercolour and bodycolour
18½ x 29in (47 x 74cm)
£18,000–20,000 *P*

Jasper Francis Cropsey
American (1823–1900)
Evening
Signed with initials and dated '1859',
oil on canvas
6 x 8¾in (15 x 22cm)
£2,000–3,000 *Bon*

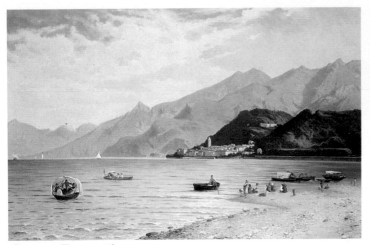

Gaetano Fasanotti
Italian (1831–82)
A View of Bellagio, Lago di Como
Signed and dated '79', oil on canvas
25½ x 39½in (65 x 100cm)
£18,000–20,000 *P*

Henry Charles Fox, RBA
British (b1860)
A Lane at Shepperton
Signed and dated '99',
watercolour
21 x 15in (53 x 38cm)
£900–1,200 *TAY*

Arthur Anderson Fraser
British (1861–1904)
Fisherman on the Ouse, Hemingford Abbots
Signed with initials and dated '1888', watercolour
16 x 27½in (40.5 x 70cm)
£1,750–1,950 *WrG*

Parker Hagarty
British (1859–1934)
Llantrithyd, Glamorganshire
Signed and dated '1913', watercolour
19 x 29in (48 x 74cm)
£1,750–1,950 *WrG*

Jan Jacob
Dutch (1837–1923)
Skaters on the Lake
Signed, oil on canvas
20 x 26in (50.5 x 66cm)
£6,750–7,500 *FdeL*

Thomas Hawthorn Hardman
British (active 1885–93)
An old Bridge near Bierton
Oil on canvas
16 x 24in (40.5 x 61cm)
£3,000–3,600 *HFA*

Joseph Horlor
British (active 1834–66)
Rosslyn Castle, Scotland
Signed, oil on canvas
12 x 19in (30.5 x 48cm)
£850–950 *GHI*

Georgina Laing
British (exh 1882–1922)
A sunny Corner in a Surrey Village
Signed, watercolour
14¼ x 21¼in (36 x 54cm)
£1,000–1,250 *JA*

l. **Henry John Kinnaird**
British
(exh 1880–1908)
Near Dalmally
Signed and inscribed,
watercolour, c1900
14 x 10in
(35.5 x 25cm)
£1,750–1,950 *ELG*

G. Lara
British (19thC)
Farmyard Scene
Signed, oil on canvas
9 x 14in (22.5 x 35.5cm)
£2,500–3,000 *HLG*

Benjamin Williams Leader
British (1831–1923)
A Surrey Sunset
Oil on canvas
12 x 18in (30.5 x 46cm)
£6,750–7,250 *HFA*

Harold Lawes
British (exh 1892)
Kirkstall Abbey
Signed, watercolour
10 x 15in (25 x 38cm)
£1,000–1,250 *WrG*

l. **Edward Lear**
British (1812–88)
The Pineta, Ravenna
Signed with
monogram and dated
'1866', oil on canvas
9¼ x 18½in
(23 x 47cm)
£40,000–50,000 *C*

Edwin Masters
British (active 1869)
Village Scene
Oil on canvas
12 x 16in (30.5 x40.5cm)
£3,000–3,700 *HFA*

Attributed to Albert Durer Lucas
British (1828–1918)
A Woodland Path and
A Woodland Lake
A pair, oil on canvas
30 x 20in (76 x 51cm)
£6,800–7,200 *HFA*

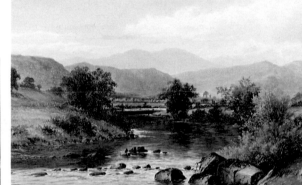

Charles Henri Joseph Leickert
Belgian (1818–1907)
A Winter Landscape with Figures on
a frozen River by a Tower
Signed, oil on canvas
14¼ x 19¼in (36 x 49cm)
£14,500–16,500 *S(Am)*

William Henry Mander
British (active 1880–1922)
The Vale of Ffestiniog
Signed, inscribed and dated '94',
oil on canvas
20 x 30in (51 x 76cm)
£8,000–8,750 *BuP*

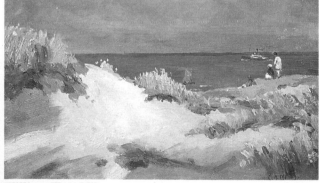

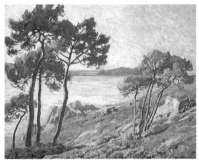

William Watt Milne
Scottish (1865–1949)
Haymaking on the Banks of the Great Ouse,
Huntingdonshire
Signed, oil on canvas
16 x 24in (40.5 x 61cm)
£5,000–5,500 *SFA*

Paul Madeline
French (1863–1920)
Pins au bord de la Mer
Signed, oil on canvas
24 x 29in (61 x 73.5cm)
£4,500–5,000 *S*

Rudolph Müller
Austrian (1816–1904)
Cattle in a Landscape
Watercolour
8 x 11in (20 x 28cm)
£2,700–3,300 *HFA*

William Mellor
British (1851–1931)
Jackdaw Crag Knaresborough, and another
A pair, signed, oil on canvas
7 x 11½in (17.5 x 29cm)
£3,000–4,000 *AH*

Edmund John Niemann
British (1813–76)
Richmond Bridge, North Yorkshire
Signed and dated '62', oil on canvas
11¾ x 19¾in (30 x 50cm)
£2,000–2,500 *CSK*

J. W. Milliken
British (exh 1887–1930)
Harvest Time at Halewood, Lancs
Signed, watercolour
9 x 14in (22.5 x 35.5cm)
£1,250–1,450 *HO*

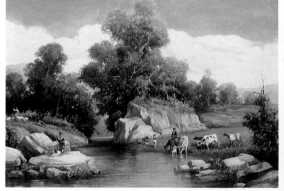

Peder Mork Monsted
Danish (1859–1941)
Haymaking at Sorup, 1937
Oil on canvas
16 x 23in (40.5 x 58.5cm)
£8,000–8,750 *JN*

Nicola Palizzi
Italian (1820–70)
Pastoral Scene
Signed, oil on canvas
36 x 47in
(91.5 x 119cm)
£55,000–70,000 *S*

l. **Edmund John Niemann**
British (1813–76)
A View near Ludlow on the
River Corve in Shropshire
Signed, oil on canvas
29 x 49in (74 x 124.5cm)
£5,500–6,000 *VAL*

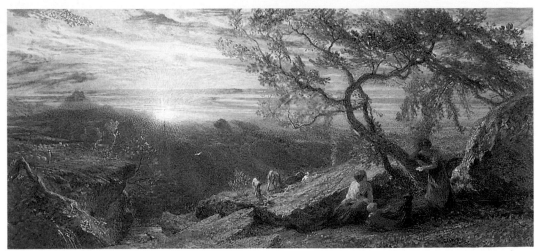

Samuel Palmer, OWS
British (1805–81)
Sunset
Pencil and watercolour heightened with bodycolour,
gum arabic and scratching out
7½ x 16¾in (19 x 42.5cm)
£65,000–80,000 *C*

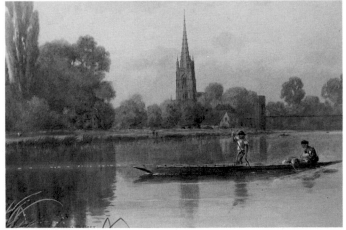

Harry Sutton Palmer
British (1854–1933)
A Punt on the River
Watercolour
10 x 15in (25 x 38cm)
£2,500–3,000 *HFA*

Charles James Parry
British (1824–94)
Washday
Signed, oil on canvas
13½ x 9½in (34 x 24cm)
£950–1,200 *GHI*

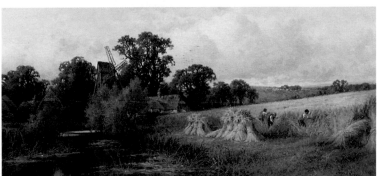

r. **Henry H. Parker**
British (1858–1930)
Streatley, Berkshire
Signed, inscribed and
dated '1895', oil on canvas
13¼ x 19in (33.5 x 48cm)
£16,500–17,500 *BuP*

l. **Henry H. Parker**
British (1858–1930)
Amongst the Surrey Hills
Signed and inscribed, oil on canvas
15 x 21in (38 x 53.5cm)
£500–700 *TAY*

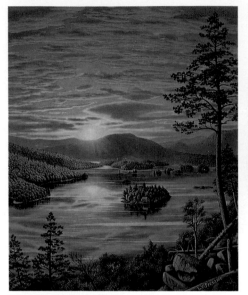

Levi Wells Prentice
American (1851–1935)
Sunset over Lake George
Signed, oil on canvas
20 x 16in (51 x 40.5cm)
£17,000–19,000 *S(NY)*

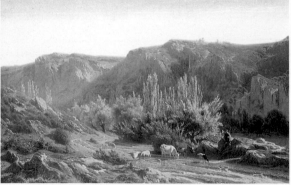

Jean François Xavier Roffiaen
Belgian (1820–98)
Herder with his Cattle in a mountainous Landscape
Signed and dated '1856', oil on canvas
22½ x 32½in (57 x 82.5cm)
£3,750–5,000 *P*

John Brandon Smith
British (active 1859–84)
On the Dee, North Wales
Signed and dated '1870', oil on canvas
20 x 30in (51 x 76cm)
£10,500–11,500 *BuP*

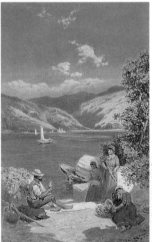

l. **Charles Rowbotham**
British (1858–1921)
Lake near Bracciano, Italy
Signed and dated '1908',
pencil and watercolour
heightened with bodycolour
17½ x 10¾in (44.5 x 27.5cm)
£1,500–2,000 *C*

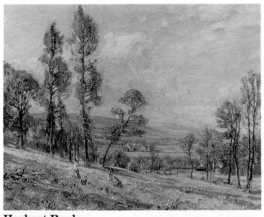

Herbert Royle
British (1870–1958)
Bluebell Woods Nessfield with Low Mill in
the distance
Signed, oil on canvas
19½ x 23½in (49.5 x 60cm)
£2,000–2,500 *AH*

Philip Wilson Steer
British (1860–1942)
Poplars at Montreuil, Picardy
Signed and dated '90', oil on canvas
30 x 20in (76 x 51cm)
£17,000–20,000 *P*

George Shepherd
British (19thC)
Family Outing
Signed, watercolour
10 x 14in (25 x 35.5cm)
£3,000–3,250 *BRG*

Joseph Thors
British (active 1863–1900)
Cottage by the Wood
Oil on panel
9 x 13in (22.5 x 33cm)
£2,500–3,000 *HFA*

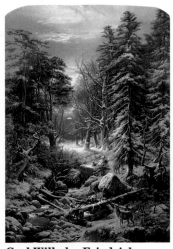

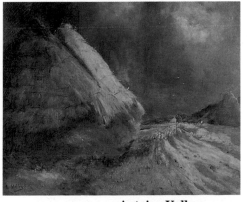

Carl Wilhelm Friedrich Trautschold
German (1815–77)
Deer in the Black Forest
at Sunset
Signed and dated '1870', pastel
42½ x 29½in (108 x 75cm)
£3,000–4,000 *P*

George Turner
British (1843–1910)
Old Oaks in South Derbyshire
Signed and dated '88', oil on canvas
23¾ x 36in (61 x 92cm)
£5,500–6,500 *P(M)*

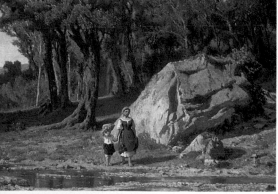

Serafino de Tivoli
Italian (1826–92)
The Promenade
Signed, oil on canvas
30 x 40in (76 x 101.5cm)
£17,000–20,000 *S*

Antoine Vollon
French (1833–1900)
Les Meules
Signed, oil on canvas
23 x 28½in (59 x 72.5cm)
£4,000–6,000 *Bea*

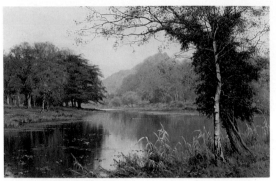

Edward Wilkins Waite
British (1854–1924)
A Woodland Pool in Autumn
Signed, oil on canvas
16 x 24in (40.5 x 61.5cm)
£11,500–12,250 *BuP*

George Stanfield Walters
British (1838–1924)
The Hay Barge
Oil on canvas
24 x 36in (61.5 x 91.5cm)
£12,000–12,500 *HFA*

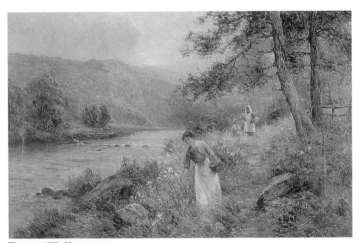

Ernest Walbourn
British (active 1897–1904)
A young Woman and two Children gathering
Flowers beside a River
Signed, oil on canvas
20 x 30in (51 x 76cm)
£5,500–6,500 *P(M)*

Walter Heath Williams
British (1835–1906)
A View in Surrey
Oil on canvas
12 x 10in (30.5 x 25cm)
£1,800–2,200 *HFA*

r. **William Tatton Winter**
British (1855–1928)
Horses and Figures
returning at the end of
the Day
Signed, oil on canvas
10 x 16in (25 x 40.5cm)
£550–650 *TAY*

Worthington Whittredge
American (1820–1910)
Deer in an Autumn Landscape
Signed and dated '1876', oil on canvas
17 x 12¾in (43 x 32.5cm)
£19,500–22,000 *S(NY)*

Heinrich von Zugel
German (1850–1941)
A Shepherd with his Flock before a
Cottage in a Landscape
Signed and inscribed, oil on panel
8 x 11¾in (20 x 30cm)
£36,000–42,000 *P*

Dr. Atl
Mexican (1875–1964)
Los Volcanes (Valle de México)
Oil on canvas, c1920
42½ x 78¾in (108 x 200cm)
£97,000–110,000 *S(NY)*

Brian Lemesle Adams
British (b1923)
Abbey Tapestry, Tresco
Watercolour
27½ x 19¼in (70 x 49cm)
£400–450 *SHF*

Bob Brown
British (20thC)
Morning walk, Trebarwith Strand
Oil on canvas
30 x 36in (76 x 91.5cm)
£1,650–1,850 *WHP*

David Blackburn
British (b1939)
Landscape – Australia
Signed and dated '1986', pastel on paper
23 x 19½in (59 x 49.5cm)
£1,300–1,500 *HaG*

Milton Avery
American (1885–1965)
Pink Dune
Signed and dated '1963', oil on canvas-board
22 x 28in (55.5 x 71cm)
£23,000–26,000 *S(NY)*

John Ambrose
British (20thC)
Worcestershire Winter Scene
Oil on board
10 x 13in (25 x 33cm)
£400–450 *GeC*

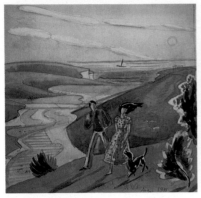

Peggy Angus
British (1904–94)
Walk on the Cliffs
Watercolour
10in (25cm) square
£250–300 *SHF*

Samuel John Lamorna Birch, RA
British (1869–1955)
Autumn green and gold, Inverlochy
Signed, oil on canvas
25 x 20in (63.5 x 50.5cm)
£7,000–8,000 *PN*

Stephen Brown
British (20thC)
The Ridge Path
Oil on canvas
10 x 8in (25 x 20cm)
£280–320 *TBG*

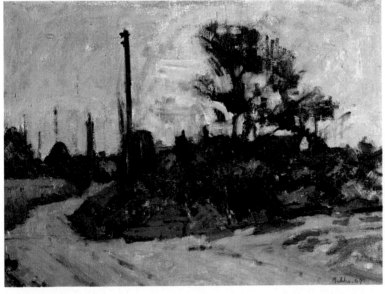

l. **Robert Buhler, RA, LG**
British (1916–89)
Outskirts of a Village
(Landermere, Essex)
Signed and dated '1949',
oil on canvas
14 x 18in (35.5 x 45.5cm)
£3,480–3,850 *PN*

*Robert Buhler trained in
Zurich and Basle before being
encouraged to study at
St. Martin's and the Royal
College of Art. This early
example of his work reflects
the influence of Sickert and
the Euston Road School.*

Peter Coker, RA
British (b1926)
Badenscallie
Signed with initials, oil on canvas
28 x 36in (71 x 92cm)
£3,500–4,000 *FCG*

Simon Cook
British (b1954)
Brean Sands
Acrylic
22½ x 24½in (57 x 62cm)
£800–1,000 *AMC*

Mary Burke
Irish (b1959)
Crooked Tree
Oil pastel
11 x 8½in (28 x 21cm)
£300–350 *SOL*

M. S. Elwes
British (active early 20thC)
Cactus on the North Shore at Shelly Bay
Signed, watercolour
7½ x 11½in (19 x 29cm)
£200–250 *MBA*

Jeffrey Camp, RA
Lovers at Pakefield
British (b1923)
Signed, oil on panel, c1985
14 x 18in (35.5 x 45.5cm)
£1,750–1,950 *BRG*

Patrick Cullen, PS
British (b1949)
Willow Trees, Tuscany
Pastel
18 x 27in (45.5 x 68.5cm)
£900–1,100 *TLB*

David Evans
British (b1950)
Poppy Field
Pastel
19¾ x 27½in (50 x 70cm)
£400–450 *AMC*

Gabriel Deschamps
French (b1919)
Paysage
Signed, oil on canvas
18¼ x 21½in (46 x 54.5cm)
£3,500–4,000 *BuP*

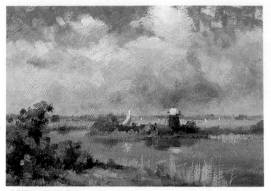

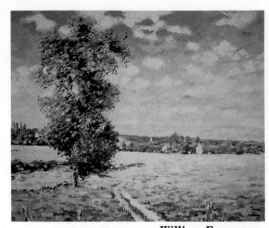

Miles Fairhurst
British (20thC)
A bend in the River
Oil on canvas
12 x 16in (30.5 x 40.5cm)
£550–650 *TBG*

William Foreman
British (b1939)
Fields near Giverny
Oil on canvas
24 x 28in (61 x 71cm)
£3,450–3,850 *BrS*

Klim Forster
British (20thC)
Cycling in Cornwall
Watercolour
12 x 15in (30.5 x 38cm)
£200–240 *RGFA*

Frederick Gore, RA
British (b1913)
Field of Flowers, St. Rémy
Signed and dated '55',
oil on canvas
24 x 32in (61 x 81cm)
£6,000–7,000 *C*

Marcel Gatteaux
French (b1952)
Farmhouse – Pròvence, 1990
Oil on canvas
20 x 25in (50.5 x 63.5cm)
£2,000–2,500 *CE*

James Joshua Guthrie
British (1874–1952)
The Sacred Mountain
Oil on board
12 x 15in (30.5 x 38cm)
£180–200 *MBA*

John F. Tennant
British (1796–1872)
A Chat by the Wayside
Oil on canvas
25½ x 36¼in (65 x 92cm)
£5,000–6,000 *S(S)*

Edward H. Thompson
British (active 1871–2)
Derwentwater with Falcon Crag beyond
Signed, pencil and watercolour with touches
of white heightening
11⅛ x 17½in (29 x 44cm)
£550–750 *CSK*

Circle of Edward Train
British (19thC)
An extensive River Landscape with Figures and
Cattle in the foreground
Oil on canvas
18 x 25½in (46 x 65cm)
£750–950 *S(S)*

Robert Thorne Waite, RWS, ROI
British (1842–1935)
Clayton, Sussex Downs
Signed, watercolour
10 x 14in (25 x 36cm)
£1,200–1,750 *WrG*

Howard Neville Walford
British (1864–1950)
A Sussex Landscape
Signed, watercolour
14 x 20in (36 x 50.5cm)
£1,250–1,450 *HO*

John Varley
British (1778–1842)
Figures resting on a Hillside with a
Church Spire beyond
Signed and dated '1825', watercolour
with scratching out
6 x 10¼in (15 x 26cm)
£2,500–3,000 *Bon*

l. **Ebenezer Alfred Warmington**
British (c1830–1903)
Crinkle Crags from Elterwater
Signed and dated '94', watercolour
10 x 20in (25 x 50.5cm)
£800–1,050 *WrG*

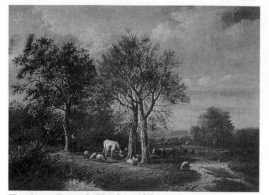

Eugène-Joseph Verboeckhoven
Belgian (1798–1881)
In the Meadows
Signed and dated '1867', oil on panel
26 x 34½in (66 x 88cm)
£15,000–18,000 *C*

*Like his pupil Thomas Sidney Cooper, the Belgian
artist Eugène Verboeckhoven specialised in
painting cows and sheep. His father was a
sculptor, and it was through modelling animals in
clay that Verboeckhoven gained his knowledge of
animal anatomy. He was extremely successful in
his own lifetime. 'Indeed he stands in the first
rank of cattle painters of the present day, and is so
full of commissions that it is difficult to get
anything from him without infinite patience,'
noted one contemporary, adding rather grumpily
that ever since Baron Rothschild had rashly paid
him 10,000 francs for a large landscape the artist
would not accept less for a work of a similar size.
Whilst Verboeckhoven always painted the animals,
the landscapes in his pictures were very often
produced in collaboration with another artist.*

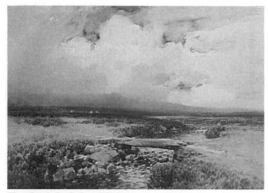

Frederick John Widgery
British (1861–1942)
Wallabrook Bridge, near Chagford
Signed, watercolour
14 x 20in (36 x 50.5cm)
£1,450–1,650 *WrG*

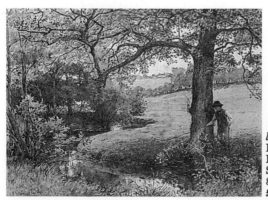

Sir Ernest Albert Waterlow, RA
British (1850–1919)
Winter near York
Signed, oil on canvas
23½ x 41½in (60 x 105cm)
£9,000–9,500 *CW*

Circle of Edward Williams
British (1782–1855)
Figures before a Cottage in a Landscape
Oil on canvas
28¼ x 35½in (72 x 90.5cm)
£2,500–3,500 *P*

*To the untrained eye, this picture might look a
complete, irretrievable wreck. Nevertheless, when
sold at Phillips it managed to double its upper
auction estimate of £1,200. Dirt can be cleaned,
damage can often be repaired and in general
dealers would far rather buy pictures in an
untouched state than works that have been,
possibly unsympathetically, restored. When
contemplating selling a painting, it is always
best to offer it in its original condition.*

Frederick William Woledge
British (active 1840–95)
A Shepherd watering his Flock
Signed, watercolour with scratching out
8½ x 12in (21 x 30.5cm)
£500–700 *Bon*

l. **Charles Edward Wilson**
British (active 1891–c1936)
Boy Fishing at a Wooded Stream
Signed, watercolour
8¾ x 11½in (22 x 29cm)
£350–550 *AH*

20th Century

Adrian Allinson
British (1880–1959)
Cotswold Farm
Signed, oil on board
20½ x 28in (52 x 71cm)
£1,000–1,500 *CSK*

Alois Arnegger
Austrian (1879–1967)
Sunset in the Mountains
Signed, oil on canvas
27 x 39in (69 x 99cm)
£1,900–2,500 *CNY*

r. **Stephen Bone**
British (1904–58)
Walton-on-Thames
Signed, oil on board
15¼ x 12in (39 x 30.5cm)
£400–600 *Bon*

l. **Martin Amies**
British (20thC)
Hill and Trees, Sussex
Oil on canvas
16 x 18in (41 x 46cm)
£700–800 *NEW*

Ashton Cannell
British (1927–94)
Wood and Undergrowth
Signed, watercolour
14 x 20in (36 x 50.5cm)
£240–280 *LH*

Pierre de Clausades
French (20thC)
Paysage de la Loire
Signed, watercolour
18 x 21½in (46 x 54.5cm)
£500–700 *CSK*

Montague J. Dawson
British (1895–1973)
Coastal views and fine Clouds
Signed, watercolour
13 x 19in (33 x 48cm)
£1,200–1,400 *LH*

Michael Fairclough
British (20thC)
The Big Field – Summer
Coloured aquatint
14 x 17in (36 x 43cm)
£150–175 *NEW*

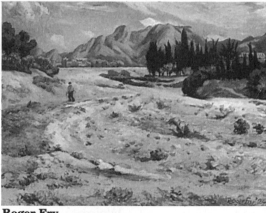

Roger Fry
British (1866–1934)
Provençal Landscape
Signed and dated '24', oil on canvas
20 x 25½in (50.5 x 65cm)
£2,100–2,600 *C*

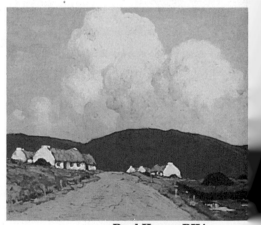

Paul Henry, RHA
Irish (1876–1958)
The Road to the Mountains
Signed, oil on board
13¾ x 16in (35 x 41cm)
£16,000–18,000 *P*

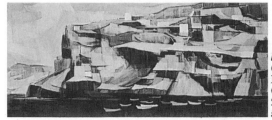

l. **Hilton Hassell**
Canadian (20thC)
Bay de Verde, Newfoundland
Oil on board
20 x 43in (50.5 x 109cm)
£300–400 *E*

Tristram Hillier, RA
British (1905–83)
The Brue, 1945
Signed, oil on canvas
7 x 9in (17.5 x 22.5cm)
£3,500–4,000 P

Born in Beijing, Tristram Hillier was a member of the British Surrealist avant-garde in the 1930s and his pictures remained Surrealist in style throughout his life. According to his family the crystaline precision that dominates his paintings also affected his private life. A dandy, he was always immaculately dressed and fastidious to a fault. His particular obsession was that cutlery should be placed with mathematical exactitude on the dining table, this insistence growing more intense and demanding if his mood blackened, as it frequently did.

Ivon Hitchens
British (1893–1979)
Felled Trees, Autumn
Signed, oil on canvas
20½ x 41½in (52 x 105cm)
£7,000–8,000 P

Jean Hugo
French (1894–1984)
Paysage
Signed, oil on canvas
13 x 21½in (33 x 54.5cm)
£4,000–5,000 S

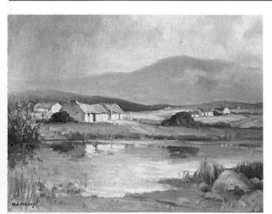

Frank McKelvey, RHA
Irish (1895–1974)
Donegal Landscape
Signed, oil on canvas
18 x 24in (45.5 x 61cm)
£5,500–6,500 P

John Nash, RA
British (1893–1977)
Valley near Nailsworth
Signed and annotated with colour notes, watercolour over pencil
14½ x 21in (37 x 53cm)
£2,000–2,500 P

Nash called himself an 'artist plantsman' and as well as being a painter and illustrator (entirely self-taught), he was an impassioned gardener and a keen botanist. 'The landscapes of John Nash are uncommon in that they are the work of a countryman,' wrote his friend Sir John Rothenstein. 'His brother Paul also loved landscape but he brought to . . . it a townsharpened and innately literary intelligence . . . John is a countryman by lifelong residence and in all his interests. Where Paul would write a manifesto or form a group, John transplants some roses; where Paul would cherish the works of Sir Thomas Brown or Blake, John consults a seed catalogue.'

l. **Sir John Lavery, RA, RHA, RSA**
Irish (1856–1941)
The Rising Moon, Tangier Bay (1912)
Signed, oil on canvas
34 x 44in (86 x 111.5cm)
£18,000–20,000 JAd

**Christopher Wynne
Nevinson, ARA**
British (1889–1946)
A Torrent
Signed, oil on canvas, 1924
36 x 24in (91.5 x 61cm)
£2,000–2,500 *C*

Howard Phipps
British (20thC)
Selborne
Wood engraving, 1988
5½ x 3¾in (13 x 9.5cm)
£40–50 *NEW*

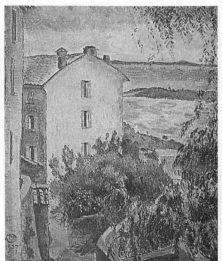

Lucien Pissarro, NEAC
British (1863–1944)
An Old Street, Bormes les Mimosa
Signed with monogram, dated '1927',
oil on canvas
18 x 15in (46 x 38cm)
£26,500–28,500 *DMF*

*The eldest son of famous impressionist
Camille Pissarro, Lucien was taught by
his father and in Paris, came under the
influence of the neo-impressionists Seurat
and Signac whose divisionist technique
was to have a lasting effect on his
painting. Partly to escape his father's
influence, Lucien emigrated to England in
1890 where he remained until his death.
He was a founder member of the Camden
Town Group and influenced many of his
British contemporaries providing a direct
link with artistic developments in France.*

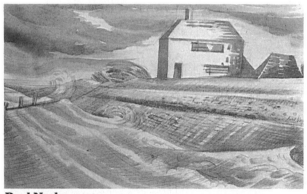

Paul Nash
British (1889–1946)
House by the Sea
Signed and dated '1922', watercolour over pencil
8 x 13in (20 x 33cm)
£3,000–3,500 *Bon*

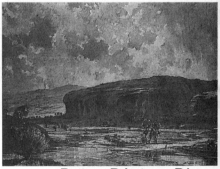

**Bertram Priestman, RA,
ROI, NEAC, IS**
British (1868–1951)
Sunshine after the Rain
Signed and dated, oil on canvas
39½ x 51¼in (100 x 131cm)
£2,800–3,500 *S(S)*

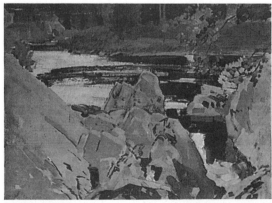

Harry Watson
British (1871–1936)
Evening by the River
Signed on reverse,
oil on panel
12 x 16in (30.5 x 40.5cm)
£1,200–1,500 *CW*

r. **Ethelbert White**
British (1891–1972)
Harvest Time, with a painting
of a Seated Lady on reverse
Signed, oil on canvas
35 x 42¾in (89 x 108cm)
£3,250–4,000 *C*

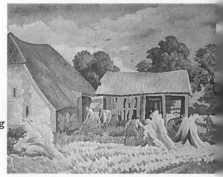

LANDSCAPES – TOPOGRAPHICAL REVIEW

Topographical views often perform well at auction, particularly the more exotic or unusual locations. Pictures of famous beauty spots, such as Venice and Naples, are one of the mainstays of the art market, appearing with relentless, if decorative, regularity in the salerooms.

American Towns

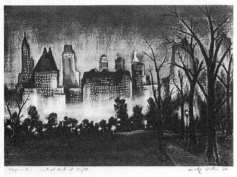

Adolf Dehn
American (1895–1968)
Central Park at Night, 20 Lithographs, 19 from the editions published by Associated American Artists, in the publisher's mats, with full margins, good condition, c1940
£2,000–2,500 *S(NY)*

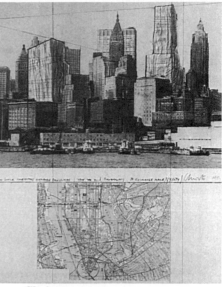

Christo
American/Bulgarian (b1935)
Two Lower Manhattan wrapped Buildings, Project for New York
Signed, lithograph printed in colours, with collage of fabric, thread and city map, on Arches Cover paper, published by Ediciones Poligrafa, Barcelona, 1980
22 x 27½in (55.5 x 70.5cm)
£3,750–4,750 *S(NY)*

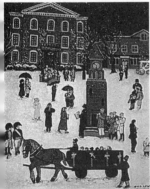

r. **Alphonse Jongers**
French (1872–1945)
Central Park, New York
Oil on canvas
14 x 17in (36 x 43cm)
£2,500–3,500 *Bon*

l. **Catherine D. Lewis**
Canadian (20thC)
Candlelight Walk Niagara on the Lake
Acrylic on board
18 x 14in (45.5 x 35.5cm)
£300–375 *CDL*

Charles Frederick William Mielatz
German/American (1864–1919)
Grand Central Station at Night (about 1892)
Titled, etching
7 x 10in (17.5 x 25cm)
£300–350 *SK*

Hayley Lever
American (1876–1958)
Flags
Signed and inscribed on a label attached to the stretcher, oil on canvas
25 x 30in (63.5 x 76cm)
£48,000–55,000 *S(NY)*

British Towns

Charles Frederick Allbon
British (1856–1926)
Durham Cathedral and River Wear
Signed, watercolour
5 x 6in (12.5 x 15cm)
£660–760 *LH*

Fred Brown
British (1851–1941)
Harwich Harbour
Pencil, watercolour and gouache
8¾ x 13in (22 x 33cm)
£650–750 *S*

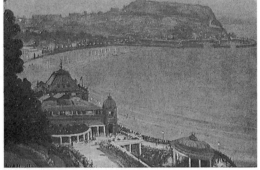

English School (19thC)
Castle, River, Town and Barges
Sepia coloured wash
7 x 11½in (17.5 x 29cm)
£280–380 *LH*

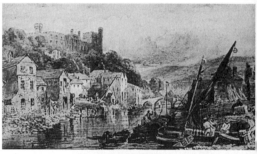

Frederick William Elwell, RA
British (1870–1958)
Scarborough South Bay at Twilight
Signed, oil on wood panel
14½ x 21¾in (37 x 55cm)
£3,000–4,000 *DA*

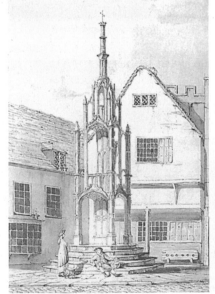

Charles Robert Cockerell
British (1788–1863)
Butter Cross, Winchester
Pencil and brown wash
12 x 10in (30.5 x 25cm)
£400–500 *CSK*

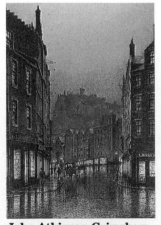

John Atkinson Grimshaw
British (1836–93)
The Grass Market from the
Royal Mile, Edinburgh
Signed, oil on artist's board
16½ x 11¾in (42 x 30cm)
£17,000–25,000 *C*

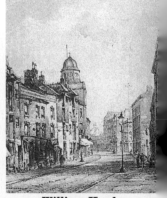

William Herdman
British (1805–82)
Park Lane, Liverpool
Signed with initials an
inscribed, pencil and
watercolour
13 x 10in (33 x 25cm)
£700–800 *HP*

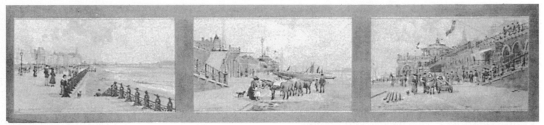

Clement Lambert
British (1855–1925)
Three Views of Brighton
Signed, watercolours heightened with
touches of bodycolour
6¾ x 10½in (17 x 26.5cm)
£1,200–1,500 *S(S)*

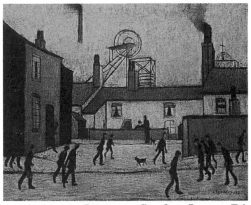

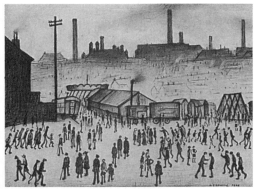

Laurence Stephen Lowry, RA
British (1887–1976)
Millworkers, 1948
Signed and dated, oil on canvas
16½ x 20in (42 x 50.5cm)
£45,000–50,000 *CKG*

Laurence Stephen Lowry, RA
British (1887–1976)
The Steam Fair
Signed and dated '1929', pencil drawing
10½ x 14½in (26 x 37cm)
£8,000–10,000 *S*

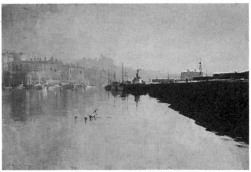

Edward Seago
British (1910–74)
Morning Haze, Ramsgate
Signed, oil on board
20 x 30in (50.5 x 76cm)
£18,500–22,000 *C*

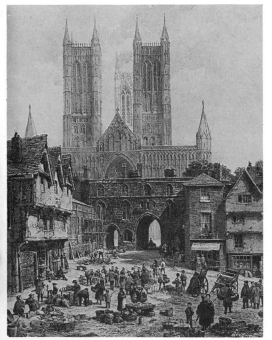

Louise J. Rayner
British (1829–1924)
Lincoln Cathedral
Signed, watercolour
20½ x 16in (52 x 41cm)
£16,000–18,000 *Pol*

William Page Atkinson Wells
British (1871–1923)
Teignmouth
Signed, oil on canvas
31½ x 39¼in (80 x 100cm)
£7,000–8,000 *S(S)*

London

With pictures of Paris, it is often the glamourous boulevards that take centre stage, but in portrayals of London, it is the Thames. Perhaps the most frequently encountered views include the royal buildings of Greenwich (often showing St. Paul's in the background) and the Houses of Parliament at Westminster. The Thames offered a vast array of subject matter, with marine artists being attracted by the shipping in the Port of London, while landscape painters were inspired both by the grand urban buildings and the rural, riparian views of Richmond and Mortlake. The novelist Henry James diagnosed 'the most general characteristic of the face of London' as its 'absence of style, or rather of the intention of style.' London is a city that has never had a proper plan, but one can follow the history of its idiosyncratic development through prints, which provide a fascinating topographical record of the city, often at comparatively affordable prices.

17th–18th Century

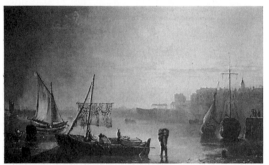

James Burnet
English (1788–1816)
View on the Thames
Signed and inscribed on a label on reverse, oil on panel
16¼ x 26½in (41.5 x 67.5cm)
£2,400–3,000 *Bon*

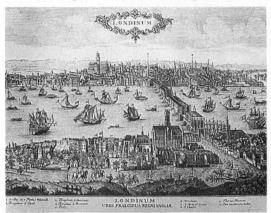

Artist Unknown (early 18thC)
Londinum – Urbs Praecipua Regni Angliae
Etching, c1700
15½ x 20in (39.5 x 50.5cm)
£1,300–1,500 *GP*

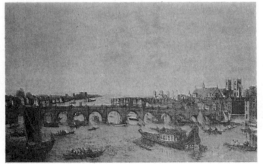

Follower of Samuel Scott
British (c1702–72)
A Royal Barge before Southwark Bridge and Cathedral
Oil on canvas
30 x 50½in (76 x 128cm)
£3,500–4,500 *P*

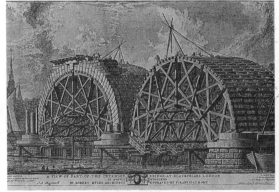

Robert Milne, after Piranesi
Italian (1720–78)
A View of Part of the intended Bridge at Blackfriars
Copper engraving, March 10, 1799
15½ x 23¼in (39 x 59.5cm)
£2,000–2,500 *GP*

l. **Circle of Vosterman**
Flemish (17thC)
A View from Greenwich Park towards St. Paul's, showing the Royal Observatory and Hospital
Oil on canvas
33 x 54in (84 x 137cm)
£2,750–3,500 *Bon*

19th–20th Century

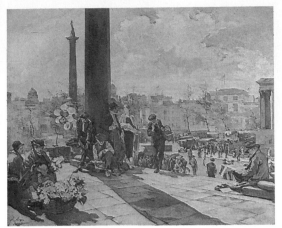

Anna Airy, RI, ROI
British (1882–1964)
Hawker's Noonday
Signed, oil on canvas
50 x 60in (127 x 152cm)
£23,000–28,000 *Bon*

A contemporary of Augustus John and William Orpen, Anna Airy trained at the Slade, exhibited widely in the first half of this century and achieved considerable popular success. 'Miss Airy is one of our most versatile artists: a consumately equipped observer of nature in all phases,' enthused Art & Reason in May 1946. Her traditionalist paintings fell from fashion in the post-war period, but their combination of strong draughtsmanship and decorative subject matter is well suited to the current market. The present work more than doubled its £5,000–8,000 when auctioned.

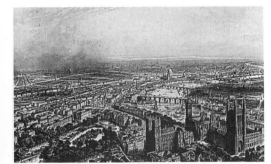

A. Appert after Chapius
French (19thC)
Aspect Général de Londres Vuc Prise De L'Abbaye de Westminster
Aquatint, c1860
25½ x 33½in (65 x 85cm)
£1,700–1,900 *GP*

Attributed to Sir Francis Barry
British (1883–1970)
The Thames at Sunset
Oil on canvas
14 x 21in (36 x 53cm)
£500–600 *Bon*

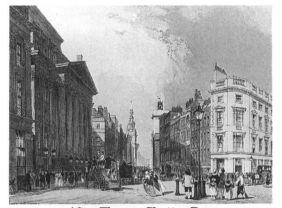

**After Thomas Shotter Boys,
by Thomas Shotter Boys**
British (1803–74)
Mansion House, Cheapside, from a series of 26 views of London
Lithograph, 1842
12¾ x 16¾in (32 x 43cm)
£450–550 *GP*

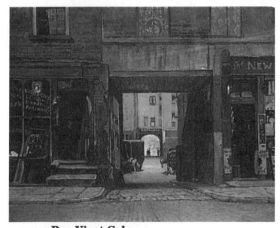

Rex Vicat Cole
British (1870–1940)
Tottenham Street, off Tottenham Court Road
Signed, oil on board
12 x 16in (30.5 x 41cm)
£4,000–4,500 *CW*

l. **Alfred Daniels, RBA, RWS**
British (b1924)
Royal Exchange and Bank of England
Signed and dated '1994', acrylic on board
16 x 20in (41 x 50.5cm)
£1,000–1,250 *MI*

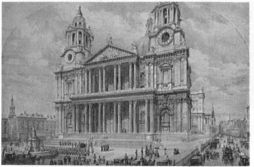

English School (19thC)
The Duke of Wellington's Funeral at
St. Paul's Cathedral
Pencil and watercolour heightened
with white
13¼ x 19½in (34 x 49.5cm)
£600–800 *CSK*

Louis H. Grimshaw
British (1870–1943)
Lambeth Palace, London
Signed and dated '8/95', oil on board
10½ x 17¾in (26.5 x 45cm)
£4,200–5,000 *C*

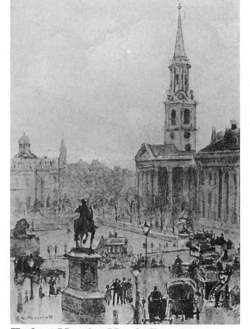

Herbert Menzies Marshall
British (1841–1913)
Trafalgar Square
Signed, pencil and watercolour with
touches of white heightening
7½ x 5in (19 x 12.5cm)
£500–600 *CSK*

Paul Gunn
British (20thC)
Large Crane, Victoria Embankment
Signed, oil on board
9 x 12in (23 x 30.5cm)
£500–560 *CW*

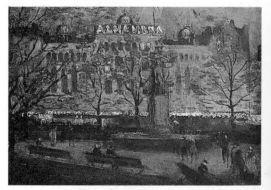

Albert Ludovici, Jnr, RBA
British (1852–1932)
The Alhambra, Leicester Square, 1905
Oil on panel
10 x 13½in (25 x 34.5cm)
£4,000–4,500 *PN*

The Rev Sir Hubert J. Medlycott
British (1841–1920)
The Thames at Limehouse
Signed and dated '1890', pencil and watercolour
8½ x 18½in (21.5 x 47cm)
£500–600 *CSK*

T. A. Prior
British (19thC)
Chelsea Bridge and Hospital
Steel engraving, c1860
8½ x 16¼in (21 x 41cm)
£200–250 *GP*

E. Angell Roberts
British (19thC)
A group of views of London
Signed and dated watercolours
7¼ x 5¼in (18 x 13cm)
£3,000–4,000 *L*

John Snelling, FSA
British (20thC)
Greenwich Park
Watercolour
11 x 14in (28 x 36cm)
£120–140 *CLG*

William Walcot, RBA, RE
British (1874–1943)
Site of Old London Bridge
Signed, watercolour
19 x 28in (48 x 71cm)
£3,400–3,800 *HO*

T. Picken, after E. Walker
British (19thC)
The New Houses of
Parliament
Lithograph, May 1, 1852
10½ x 16in (26 x 41cm)
£550–650 *GP*

Richard Henry Wright
British (1857–1930)
Southwark Bridge, over the Thames
Signed, inscribed 'Southwark Bridge' and
dated '1914', watercolour
10 x 14in (25 x 36cm)
£900–1,100 *LH*

Richard Henry Wright
British (1857–1930)
Greenwich Hospital and the River Thames
Signed and dated '96', watercolour
7 x 10in (17.5 x 25cm)
£1,200–1,500 *CSK*

r. **William Lionel Wyllie**
British (1851–1931)
Barges before the Houses of Parliament
Signed and dated '1909', pencil and
watercolour
6½ x 11in (16.5 x 28cm)
£700–900 *CSK*

Dutch & Flemish Towns

Dutch street scenes have always been a popular subject. Good quality 17thC Dutch landscapes, townscapes and market scenes, the more decorative the better, have been particularly in demand in the recent times. Nineteenth century Dutch townscapes are another staple of the marketplace, with artists such as Pieter Christian Dommersen (1834–1908) providing works that tend to be reliable in quality, subject matter and commercial appeal.

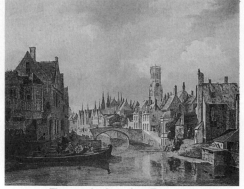

François Antoine Bossuet
Belgian (1798–1889)
A View in Bruges
Signed and dated '1883', oil on canvas
16 x 19½in (40.5 x 50cm)
£3,500–4,500 *P*

l. **Pieter Christian Dommersen**
Dutch (1834–1908)
A Dutch Market Square
Signed and dated '1870',
oil on canvas
30 x 25in (76 x 63.5cm)
£30,000–34,000 *BuP*

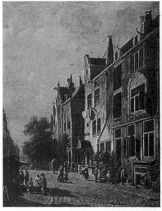

r. **Adrianus Eversen**
Dutch (1818–97)
A busy Street, Amsterdam
Signed, oil on panel
16 x 13in (40.5 x 33cm)
£12,000–15,000 *S(S)*

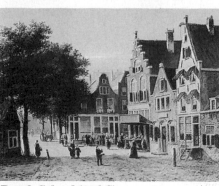

Dutch School (19thC)
Figures in a Town Square
Bears signature, oil on canvas
26 x 32½in (66 x 82.5cm)
£3,500–4,500 *P*

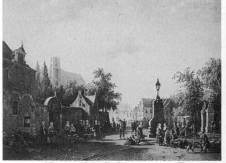

Alexander Salomon van Praag
Dutch (1812–1865)
Figures in the Town Square, Leiden
Signed, oil on canvas
16½ x 22¼in (41.5 x 56.5cm)
£6,000–8,000 *P*

Bartholomeus Johannes van Hove
Dutch (1790–1880)
Figures in a Street before a Dutch Town
Signed, oil on panel
17½ x 19¼in (44.5 x 48.5cm)
£3,500–4,500 *P*

r. **Cornelis Springer**
Dutch (1817–91)
A View of the Townhall
in Kampen
Signed and dated '1866',
oil on panel
24¼ x 20½in (62 x 52cm)
£127,000–150,000 *S(Am)*

French Towns

Eugène Boudin
French (1824–98)
La Seine à Quillebeuf
Signed and dated 'Quillebeuf 93', oil on canvas
19½ x 29in (49.5 x 74cm)
£90,000–100,000 *S(NY)*

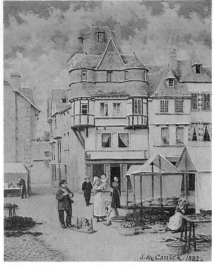

John Mulcaster Carrick
British (active 1854–78)
In the Market Square, Lannion, Brittany
Signed, dated and inscribed 'J.M. Carrick
1882', oil on board
10 x 8in (25 x 20cm)
£1,000–1,500 *C*

Continental School (19thC)
The Clockhouse in Rouen
Oil on canvas
25¼ x 17¾in (64 x 45cm)
£800–1,000 *CSK*

Charles Cundall, RA
British (1890–1971)
Dieppe Harbour
Signed and inscribed 'Dieppe Harbour', oil on canvas
16 x 24in (40.5 x 61cm)
£1,200–1,500 *C*

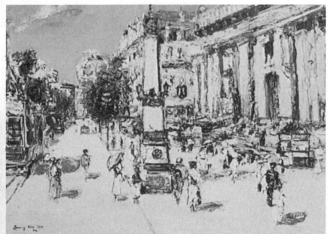

James Kay, RSA, RSW
British (1858–1942)
Boulevard Strasbourg, Le Havre
Signed, oil on card
10 x 14in ((25 x 36cm)
£4,000–5,000 *C(S)*

Thomas Colman Dibdin
British (1810–93)
Abbeville
Signed, inscribed and dated '1872',
pencil and gouache
29¼ x 20½in (74 x 52cm)
£1,800–2,200 *Bon*

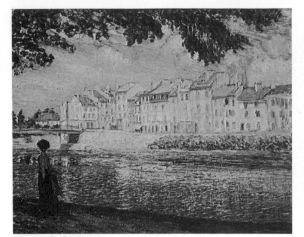

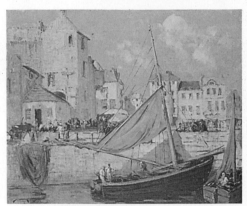

William Lee-Hankey
British (1869–1952)
The Harbour at Honfleur
Signed 'W Lee Hankey', oil on canvas
21½ x 25½in (54.5 x 65cm)
£6,500–8,000 *C*

Henri Lebasque
French (1865–1937)
Promenade au Bord de la Rivière
Signed, oil on canvas
19½ x 24¼in (49.5 x 62cm)
£45,000–50,000 *S(NY)*

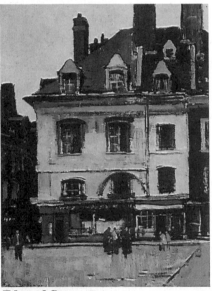

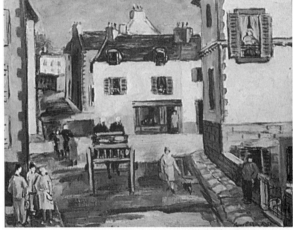

Anne Estelle Rice
American (1877–1959)
Figures in a French Street
Signed, oil on panel, c1925
13 x 16in (33 x 40.5cm)
£1,000–1,400 *C(S)*

Edward Seago
British (1910–74)
White House, Dieppe
Signed, oil on board
24 x 18in (61 x 46cm)
£5,500–6,500 *C*

> **Miller's is a price GUIDE
> not a price LIST**

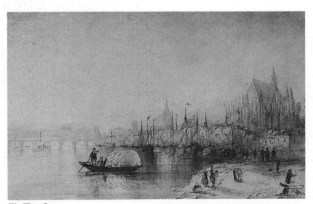

E. Tucker
British (c1830–1909)
Boulogne
Signed, watercolour
11½ x 17½in (29 x 44.5cm)
£700–1,000 *AH*

**Walter Richard Sickert,
RA, PRBA, NEAC**
British (1860–1942)
Place St Remy, Dieppe
Signed, oil on canvas
16 x 11½in (40.5 x 29cm)
£12,000–15,000 *Bon*

Paris

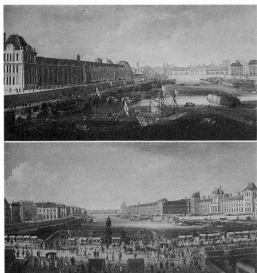

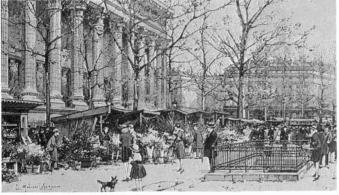

French School (c1668)
Views of Paris and the Seine
A pair, oil on canvas
27 x 49in (69 x 124.5cm)
£70,000–80,000 *C*

*These two pictures record the appearance of Paris
after its transformation in the first years of the
reign of Louis XIV. The last vestiges of the
medieval city, the Tour de Bois, the Tour de Nesle,
the Hôtel de Nevers and the last remains of the
medieval castle of the Louvre, have all been
replaced by modern classical buildings, notably
Louis Le Vau's south wing of the new courtyard of
the Louvre and his Collège des Quatre Nations.*

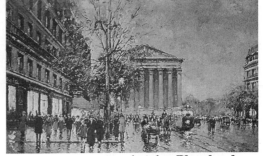

Antoine Blanchard
French (1910–88)
The Opera House
Signed, oil on canvas
22¾ x 35½in (58 x 90.5cm)
£5,500–7,000 *S(S)*

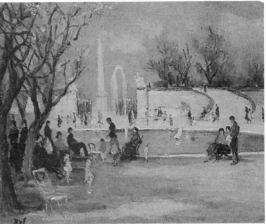

Marcel Dyf
French (1899–1985)
Place de la Concorde
Signed, oil on canvas
15 x 18in (38 x 46cm)
£3,500–5,000 *S(S)*

Eugène Galien-Laloue
French (1854–1941)
The Flower Market, Place de la Madeleine, Paris
Signed, gouache
10½ x 17¾in (27 x 45cm)
£12,500–14,500 *S*

John Duncan Fergusson
British (1874–1961)
Paris 1903
Signed and dated, oil on panel
9½ x 7½in (24 x 19cm)
£14,000–15,000 *DMF*

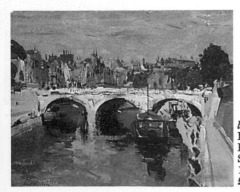

l. **Konstantin Alexeivich Korovin**
Russian (1861–1939)
Paris
Signed, oil on canvas
11¼ x 14in (29 x 36cm)
£4,800–6,000 *S*

Greek Views

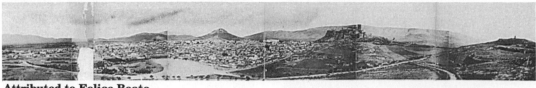

Attributed to Felice Beato
Italian (19thC)
Panorama of Athens
Eight albumen prints, c1857
6¼ x 44⅜in (16 x 113cm)
£1,000–1,400 *S*

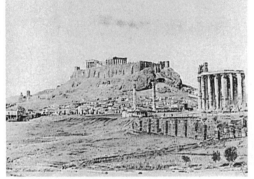

**Attributed to Dimitrios
Konstantinou, Petro Moriates,
James Robertson and others** (19thC)
View of Athens
A collection of 20 albumen and silver
prints, mostly 1855–70
13 x 14¾in (33 x 37.5cm) largest
£600–800 *S*

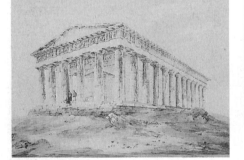

William Page
British (1794–1872)
Temple of Theseum, Athens
Signed and dated 'W. Page 1820', pencil
and watercolour
19 x 25½in (48 x 64.5cm)
£5,000–6,000 *C*

*William Page, who was a successful
drawing master, attended the RA Schools
in 1812 and 1813 and his first exhibits at
the RA in 1816 were of North Wales. He
probably first went to Greece and Turkey
in 1818. This temple is on the hill of
Kolonos Agoratos overlooking the
Athenian Agora and was dedicated to
Hephaestus 499–444 BC.*

r. **Hugh William 'Grecian' Williams**
British (active 1820)
Brenthe (Karytaena) on the
Alphaeus, Arcadia
Signed and inscribed, watercolour over pencil
heightened with bodycolour and stopping out
20 x 31in (51 x 79cm)
£12,000–15,000 *S*

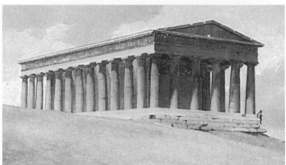

Louis Dupré
French (19thC)
The Theseum, Athens
Oil on paper
10¾ x 16in (27 x 40.5cm)
Together with a framed landscape by an unknown artist
Dated 'June 15th 72', oil on board
£2,000–2,500 *S*

Vasili Dimitrevich Polenov
Russian (1844–1927)
A View of the Acropolis
Signed, oil on canvas laid down on board
10¼ x 16in (26 x 40.5cm)
£7,500–8,500 *S*

*Born of a noble family in St. Petersburg, Polenov studied
at the Imperial Academy while also studying law.
Instrumental in the organisation of Mamontov's colony of
artists at Abramtsevo, he lived and painted in Greece and
the Near East between 1881 and 1882.*

Italian Towns

From the 18thC onwards, the Grand Tour was an essential part of a gentleman's education. The young 'milord' (the stock title for any wealthy Englishman) would set off in his own coach, accompanied by a tutor and servants and would then spend between two and five years visiting the sites of Europe. Italy was the most important country on his agenda and the serious traveller followed an established route endeavouring to be in Naples for the winter months, Rome for the Easter ceremonies at St. Peter's and the Sistine Chapel and in Venice for the Doge's Ascension Day ceremony in May. Initially the Grand Tour was reserved for the aristocracy, but after the Napoleonic wars and with the advent of steamships and the railways, the Continent was opened up to a more middle class tourist. Irrespective of class, everyone wanted to bring back a souvenir of their trip, hence the massive industry in Italian views. In many cases, these decorative portrayals remain as popular with today's market as they were in the 18th and 19thC.

Ernesto Bensa
Italian (19thC)
The Ponte Vecchio, Florence
Signed, watercolour
14 x 19½in (35.5 x 49.5cm)
£900–1,200 *Bon*

William Crouch
British (19thC)
Italian Lakeside Landscapes with Ruins
A pair, signed, watercolour over pencil
12½ x 19in (32 x 48cm)
£1,000–1,500 *S(S)*

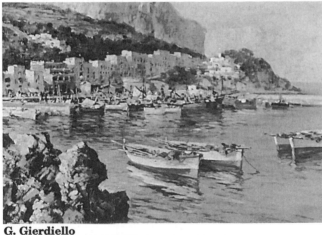

G. Gierdiello
Italian (active early 20thC)
Italian coastal Town with fishing Boats moored in a Harbour
Signed, oil on canvas
22 x 31in (55.5 x 78.5cm)
£500–700 *CSK*

Konstantin Alexeivich Korovin
Russian (1861–1939)
Milan
Inscribed, oil on canvas board
8 x 4¼in (20 x 11cm)
£2,500–3,000 *S*

l. **Charles Rowbotham**
British (1858–1921)
Verona
Signed and dated '1906', pencil and watercolour heightened with bodycolour
6¼ x 9in (15.5 x 22.5cm)
£1,400–1,800 *C*

Naples & Neapolitan Views

Naples provided a variety of attractions for both the artist and the tourist, offering the sunny pleasures of the Neapolitan coast and the more dramatic lure of Vesuvius. The volcano erupted in 1707, 1737, 1760, 1766, 1769 and 1794. Local artists took every opportunity to paint the phenomenon, which became a popular subject for pictures, prints and souvenir fans. Another fashionable artistic theme was the Neapolitan locals; fishermen and pretty, brightly dressed peasant girls.

Consalvo Carelli
Italian (1818–1900)
Villa Isabella a Capodimonte,
Palazzo Reale, Naples
Signed and inscribed, oil on panel
10¼ x 17½in (26 x 44.5cm)
£4,500–5,500 S

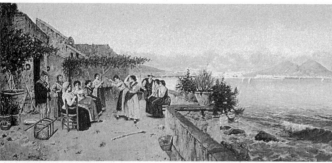

Giuseppe Giardiello
Italian (19th/20thC)
A Neapolitan Celebration
Signed, oil on canvas
19 x 40in (48 x 101.5cm)
£6,000–8,000 S

Carlo Brancaccio
Italian (1861–1920)
Bagni alla Marinella, Naples
Signed and inscribed, oil on canvas
13¾ x 18in (35 x 46cm)
£9,000–10,000 C

Guglielmo Giusti
Italian (19thC)
Figures on the Italian Coast above Naples
and Castello D'Ischia
A pair, one signed 'G. Giusti', bodycolour
13 x 18½in (33 x 47cm)
£2,800–3,500 CSK

Posillipo School (19thC)
Views of the Bay of Naples
Three, oil on board
7½ x 10½in (19 x 27cm)
£3,750–4,750 S

Attilio Pratella
Italian (1856–1949)
Fishermen with their Nets in the Bay of Naples
Signed, oil on panel
9 x 13¾in (22.5 x 35cm)
£8,750–10,000 S

Charles Rowbotham
British (1858–1921)
Figures on a Terrace above the Bay of Naples
Signed, pencil and watercolour heightened with
bodycolour and scratching out
11 x 16¼in (28 x 42cm)
£2,000–2,500 C

Rome & Roman Ruins

Johannes Lingelbach
German (1622–74)
Rome, The Piazza del Popolo with a
Shoemaker and other Figures
Signed, oil on canvas
30¼ x 26¼in (77 x 66.5cm)
£40,000–50,000 *S*

**Follower of Gaspare Vanvitelli,
called Wittel**
Dutch (1653–1736)
An elegant Group before a Capriccio of the
Colosseum, Rome
Oil on canvas
22 x 28½in (55.5 x 72.5cm)
£4,500–5,500 *CSK*

Franz Knebel, Jnr
A View of the Claudian Aquaduct
in the Roman Campana
Signed, oil on canvas
11½ x 20¼in (29 x 51cm)
£2,500–3,000 *Bon*

r. **Ebenezer Wake Cook**
British (1843–1926)
Il Vaticano da Castel Sant Angelo, Roma
Oil on paper laid down on canvas
7¾ x 13¼in (19.5 x 33.5cm)
£8,000–10,000 *CSK*

Follower of Giovanni Paolo Panini
Italian (1691–1765)
Figures resting amongst a classical Ruin
Oil on canvas
44½ x 58½in (113 x 148.5cm)
£5,500–7,000 *CSK*

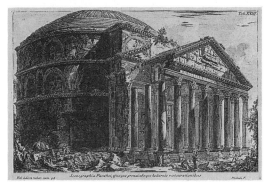

Giovanni Battista Piranesi
Italian (1720–78)
Il Campo Marzio Dell'antica Roma
A volume containing fifty-four etchings
and engraved plates, Rome, 1762
Folio
£10,000–12,000 *S*

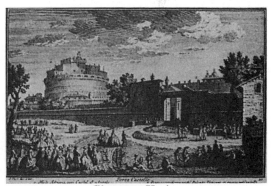

Giuseppe Vasi
Italian (18thC)
Vedute delle Porte e Mura di Roma
Twenty-two etchings, 1747
7¾ x 11½in (19.5 x 29cm)
£600–800 *P*

Venice

Few subjects are more obviously commercial than Venice. Perhaps the first and undoubtedly the greatest artist to capitalise on this fact was Canaletto, who was hugely sought after for his magnificent Venetian pictures. 'The fellow is whimsical and varies his prices everyday . . . He has more work than he can do in any reasonable time,' wrote Owen McSwiney, a disgruntled British client in 1727, adding that the only way he had managed to have his commission completed was by bribing the artist. From the 18thC onwards, the popularity of Venetian views has not waned. In spite of the restraint of the current market, a number of the following works went well over estimate at auction. Nevertheless, even in this endlessly fashionable field, buyers can still be selective. A pair of oval-shaped Canaletto views failed to sell at a Sotheby's sale of Old Masters, largely because of their upright shape, as opposed to the more traditional horizontal format.

17th–18th Century

Luca Carlevarijs
Italian (1665–1731)
Le Fabriche e Vedute di Venezia
One hundred and three etchings, 1703
Quarto
£16,000–20,000 *S*

Circle of Giuseppe Heinz II
Italian (17thC)
The Bacino di San Marco, Venice
Oil on canvas
45¼ x 71½in (115 x 181.5cm)
£10,500–12,500 *C*

Manner of Francesco Tironi
Italian (d1800)
The Grand Canal, Venice
Oil on canvas
29 x 41½in (73.5 x 105.5cm)
£18,000–20,000 *CSK*

Venetian School (18thC)
The Riva degli Schiavoni looking West and
The Piazza San Marco looking South, Venice
A pair, oil on canvas
22½ x 45in (57 x 114cm)
£30,000–35,000 *C*

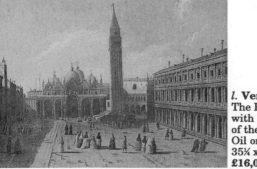

l. **Venetian School** (c1800)
The Piazza di San Marco, Venice,
with a Puppet Show at the Foot
of the Campanile
Oil on canvas
35¼ x 42½in (90 x 107.5cm)
£16,000–18,000 *C*

19th–20th Century

Frederick James Aldridge
British (1850–1933)
View of the Grand Canal, Venice
Watercolour
14 x 21in (35.5 x 53.5cm)
£800–1,000 *CAG*

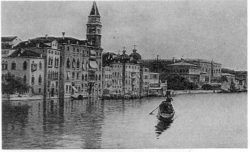

Emilio Benvenuti
Italian (19th/20thC)
The Grand Canal, Venice
Signed, pencil and watercolour
9½ x 15½in (24 x 39.5cm)
£250–350 *CSK*

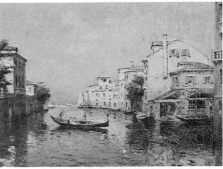

l. **Walter Bayes**
British (1869–1956)
Arches by the Grand
Canal, Venice
Signed, oil on canvas board
14¼ x 14½in (36 x 36.5cm)
£1,500–2,000 *C*

Antoine Bouvard, Snr
French (1840–1920)
Evening in Venice
Signed, oil on canvas
20 x 25in (51 x 63.5cm)
£7,500–8,500 *Bne*

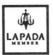
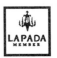

Antoine Bouvard
French (d1956)
A Venetian Canal
Signed, oil on canvas
19 x 25in (48 x 63.5cm)
£3,000–4,000 *S(S)*

Hercules Brabazon Brabazon
British (1821–1906)
The Zattere, Venice
Signed with initials, pencil and gouache
8¾ x 10½in (22 x 26.5cm)
£3,000–4,000 *Bon*

l. **Antonietta Brandeis**
Bohemian (b1849)
Figures in the Piazetta, Venice
Signed, oil on canvas
9½ x 13in (24 x 33cm)
£12,000–15,000 *P*

Antonietta Brandeis
Bohemian (b1849)
The Bridge of Sighs, Venice
Signed with monogram, oil on board
9 x 6½in (22.5 x 16.5cm)
£3,500–4,500 *P*

Myles Birket Foster, RWS
British (1825–99)
Rio des Santi Apostoli, Venice and
The Colleoni Monument, Venice
A pair, signed, watercolour
3¾ x 5¼in (9 x 13cm)
£17,500–18,500 *Pol*

G. de Colle
Italian (19th/20thC)
Palazzo Cavalli Franchetti
Signed and dated '1898', watercolour
10½ x 18in (26.5 x 45.5cm)
£500–700 *MJB*

Sir William Russell Flint, RA
British (1880–1969)
November Twilight, Piazza San
Marco, Venice
Signed, watercolour and bodycolour
14¼ x 22½in (36 x 57cm)
£9,000–11,000 *C*

Pietro Gabrini
Italian (1865–1926)
On the Lagoon, Venice
Oil on canvas
21¼ x 33in (54 x 83.5cm)
£5,500–6,500 *C*

Giovanni Grubacs
Italian (1829–1919)
A Venetian Festival
Signed, oil on canvas
26½ x 36in (67 x 91.5cm)
£8,000–10,000 *S*

*It is not only dealers and collectors who are
attracted by pictures of Venice. In recent
months, a set of four Grubacs' Venetian views
were stolen from a private house. The former
owners sensibly tipped off Sotheby's and sure
enough, a few weeks later, two of the pictures
were offered to the auction house by a vendor
who had bought them for £2,000 at Portobello
Road. The police moved in, tracked down all
four paintings and returned them to their
rightful owner. As the* Antiques Trade Gazette
*reported, rather than going through the worry
of trying to keep them on his walls, he decided
to sell them, understably choosing Sotheby's
(Billingshurst) where the pictures nearly
doubled their estimate to fetch a hammer price
of £19,200 – a happy ending for both parties.*

Henri Joseph Harpignies
French (1819–1916)
A Landscape at Dusk
Signed and dated, oil on cradled panel
11¾ x 19¾in (30 x 50cm)
£3,500–4,500 *S*

James Holland
British (1799–1870)
Venetian Capriccio
Signed with monogram and
dated '1853', inscribed and dated
'1857'on reverse, oil on board
12½in (32cm) diam
£600–800 *CSK*

l. **Italian School** (19thC)
Venetian Canal Scene
Watercolour
10 x 18in (25 x 45.5cm)
£300–390 *LH*

Antonio Maria de Reyna Manescau
Spanish (1859–1937)
La Giudecca, Venice
Signed and inscribed, oil on canvas
14 x 30¼in (35.5 x 77cm)
£12,000–15,000 C

r. **Robert McInnes**
Scottish (1801–86)
A Fiesta Scene on the
Lido, near Venice
Signed and dated '1848',
oil on canvas
21 x 36¾in (53 x 93.5cm)
£11,000–15,000 C

Sydney Mortimer Laurence
British (b1865)
Venice
Signed and inscribed, watercolour
31 x 16in (78.5 x 40.5cm)
£1,400–1,600 HO

Antonio Paoletti
Italian (1834–1912)
The Young Anglers, Venice
Signed, oil on canvas
16¼ x 22½in (41.5 x 57.5cm)
£21,000–25,000 C

E. Massoni
Italian (19thC)
Santa Maria della Salute, Venice
Signed and inscribed, oil on panel
5½ x 8¼in (14 x 21cm)
£850–1,000 CSK

Ludwig Pasini
Italian (19thC)
Venetian Gossip
Signed, inscribed and dated '1878'
20¼ x 33¾in (51 x 85.5cm)
£2,000–3,000 S(S)

Alfred Pollentine
British (active 1847–50)
The Grand Canal
Signed, oil on canvas, laid down on board
16 x 24in (40.5 x 61cm)
£2,500–3,000 CSK

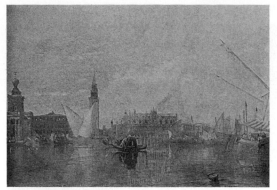

James Baker Pyne
British (1800–70)
Doges Palace, Venice
Signed, inscribed and dated '1867',
oil on canvas
14 x 20in (36 x 51cm)
£2,200–3,000 *P(L)*

Luigi da Rios
Italian (1844-92)
Venetian Fruit Sellers
Signed and dated '1884', watercolour
24 x 44in (61 x 111.5cm)
£12,000–15,000 *S*

B. Salviatiz
Italian (19thC)
The Lagoon, Venice
Signed, pencil and watercolour
6¾ x 9½in (17 x 24cm)
£300–400 *CSK*

E. Romani
Italian (late 19thC)
The Bacino, Venice
Signed, oil on canvas
19¾ x 24in (50 x 61cm)
£1,800–2,400 *C*

r. **Rubens Santoro**
Italian (1859–1942)
A Venetian Canal with the
Campanile of the Frari in
the Distance
Signed, oil on canvas
19 x 13¾in (48 x 35cm)
£50,000–60,000 *C*

l. **F.W. Simon**
British (19thC)
A Quiet Backwater, Venice
Signed and dated '87',
pencil and watercolour
18 x 7½in (45.5 x 19cm)
£200–300 *CSK*

r. **Circle of Felix
François Georges
Philibert Ziem**
French (1821–1911)
The Rialto Bridge, Venice
Oil on canvas
21 x 28½in (53 x 72.5cm)
£1,000–2,000 *CSK*

Towns General

Mstislav V. Doboujinsky
Russian (1875–1957)
Outskirts of Moscow
Watercolour over pencil
8 x 10½in (20 x 27cm)
£1,300–1,600 *S*

Luigi M. Galea
Maltese (1847–1917)
The Grand Harbour, Valletta
Signed, oil on board
8¼ x 21in (21 x 53.5cm)
£2,400–3,000 *Bon*

M. Gianni
Italian (19thC)
Valetta Harbour – Moonlight
Signed and dated '1901', watercolour
5 x 11in (12.5 x 28cm)
£550–750 *TAY*

l. **Alfred Montague**
British (19thC)
Continental Street
Scene with
Numerous Figures
Signed, oil on canvas
18 x 14in (45.5 x 35.5cm)
£1,200–1,600 *BWe*

Henry Foley
British (19thC)
Continental Town Street
scene with Figures
Signed, oil on board
22 x 20in (56 x 50.5cm)
£400–500 *BWe*

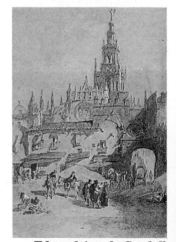

Edward Angelo Goodall
English (1819–1908)
Seville
Signed, pencil and
watercolour heightened
with white
7 x 4⅝in (17.5 x 12cm)
£400–500 *CSK*

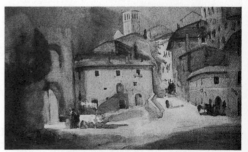

Robert Herdman-Smith, ARWA
British (b1879)
After the Siesta
Watercolour
10 x 14in (25 x 36cm)
£400–450 *GHI*

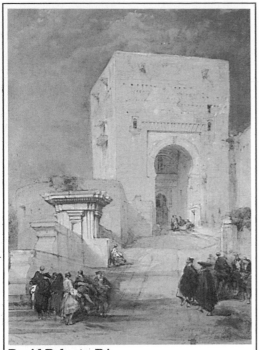

David Roberts, RA
British (1796–1864)
Entrance to the Alhambra
Signed, inscribed and dated '1833', pencil,
watercolour and bodycolour
13½ x 9½in (34 x 24cm)
£7,000–8,000 *Bon*

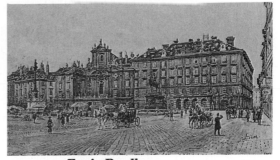

Erwin Pendl
Austrian (b1875)
Platz am Hof, Vienna
Signed, inscribed and dated '1912', pencil
and watercolour heightened with white
7 x 12in (17.5 x 30.5cm)
£2,750–3,750 *CSK*

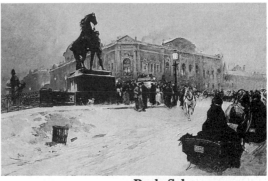

Paolo Sala
Italian (1859–1929)
Twilight, St. Petersburg
Signed, oil on canvas
48½ x 68in (123 x 172.5cm)
£28,000–35,000 *S*

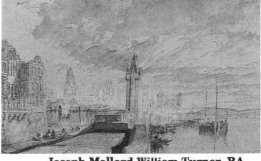

Joseph Mallord William Turner, RA
British (1775–1851)
Mainz on the Rhine
Pencil and watercolour with scratching out
7½ x 12¼in (19 x 31cm)
£60,000–70,000 *C*

Gregory Shishko
Ukranian (1923–94)
Noontime, Illyn Church, 1970
Oil on canvas
17 x 14in (43.5 x 35.5cm)
£1,450–1,650 *CE*

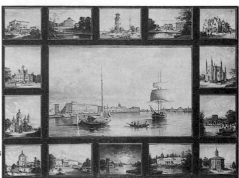

r. **Joseph Andreas Weiss**
German (1814–87)
A View of the Palace Embankment in
St. Petersburg and 14 smaller views of Imperial
residences on the outskirts of St. Petersburg
Signed with initials and dated '1872', oil on canvas
37¼ x 51in (94.5 x 129.5cm)
£100,000–150,000 *S*

MAPS

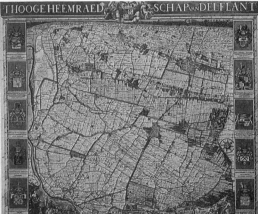

Jacob & Nicolas Kruikius
T Hooghe Heemraedschap van Delflant, 1712
Engraved wall map of Delftland comprising a hand
coloured general map heightened in gold, the
uncoloured wall map on 25 sheets, later morocco
backed boards, worn.
20½ x 23½in (52 x 60cm)
£3,500–4,000 *C*

*The Kruikius brothers of Delft were both surveyors,
Nicolas (1678–1754) being supervisor of sluices and
dams. He was also the first surveyor to use contours
on his map of the Merwede River, 1729.*

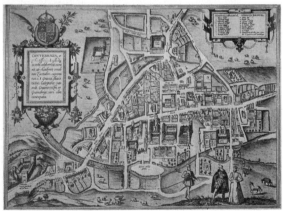

Braun & Hogenberg
Cambridge, 1575
Copper engraving, original hand colouring
15 x 20in (38 x 51cm)
£550–650 *APS*

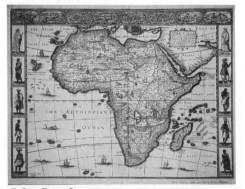

John Speed
Africa, 1627
First edition, copper engraving
16 x 22in (40.5 x 55.5cm)
£4,000–4,200 *APS*

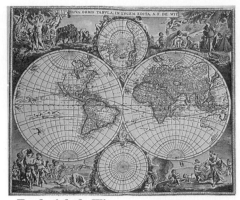

Frederick de Wit
Dutch (1610–1698)
Amsterdam, c1680, hand coloured engraved
title with Atlas on the top of the world
holding up the heavens, printed index on
verso, 100 hand coloured double-page
engraved maps, later vellum, lightly spotted
12½ x 21in (32 x 53cm)
£22,000–25,000 *C*

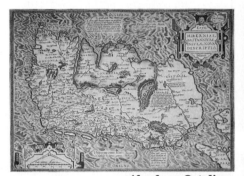

Abraham Ortelius
Ireland, 1570
Copper engraving
15 x 20in (38 x 51cm)
£1,000–1,300 *APS*

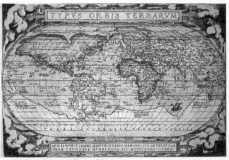

Abraham Ortelius
Typus Orbis Terrarum, 1570
Original hand colouring, copper engraving
10 x 20in (25 x 51cm)
£5,500–6,500 *APS*

r. **John Speed,**
Kent, 1616
Copper engraving
15 x 20in (38 x 51cm)
£750–850 *APS*

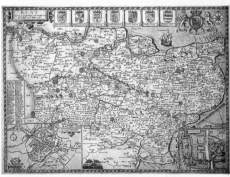

MARINE

As in every other area of the market today, demand for marine pictures is extremely selective. 'If a rare work, in good condition by a leading name comes up then prices can be substantial,' explains dealer Bernard Reed, 'but there is a very high casualty rate at auction for drab, run of the mill material.'

Marine watercolours can still represent good value for money and with the advantage of modern conservation techniques, a watercolour can be a durable investment. But what is the best way to start collecting? 'Soak up as much knowledge as you can before you buy,' advises Reed. 'Attend auctions, visit dealers and look at reference books. When making a purchase, the first rule is always to buy what you really like. Next, check that it is in good basic condition, foxing is no problem but fading is irreversible. Finally,

make sure that the picture is firmly attributed to a known artist – a work by a recognised name is much more likely to maintain or increase its value than a watercolour by an anonymous artist.'

Some areas of the market are still comparatively cheap in price, 18th century marine watercolours, more academic and less obviously decorative than 19th century examples, and pictures of the more unpopular subjects such as wrecks and storms. 'Preparatory sketches for larger works and working drawings of parts of ships can also be tremendous value for money. You will often come across these in folios of bundled drawings at auction houses. They can be both historically interesting and charming to look at,' adds Bernard Reed.

17th–18th Century

Attributed to William Anderson
British (1757–1837)
Boats in an Estuary
Oil on panel
5¾ x 8¾in (14.5 x 22cm)
£2,000–2,500 *S(S)*

Samuel Atkins
British (c1765–1810)
Evening Gun off Shakespeare Cliff
Watercolour
9¾ x 13½in (25 x 34.5cm)
£2,000–2,300 *Mar*

John Cleveley, The Elder
British (c1712–1777)
Dutch Fishing Vessels
Signed, watercolour
9¼ x 14½in (23.5 x 37cm)
£2,200–2,800 *Mar*

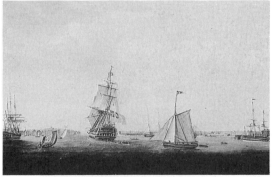

Thomas Elliot
British (active 1790–1800)
Panorama of Portsmouth Harbour
and Dockyard
Oil on canvas
20 x 30in (50.5 x 76cm)
£6,000–7,000 *CSK*

Site of the first naval dock in Britain in 1540, Portsmouth, home to the Royal Navy for many centuries, was the largest naval station in the world for much of the period of British supremacy at sea.

l. **Pieter Idserts**
Dutch (active 1721–1770)
River Scene by Durkerdam
Bears signature, pen and grey ink and wash,
over black chalk
7¾in x 13in (19.5 x 33cm)
£4,000–5,000 *S(Am)*

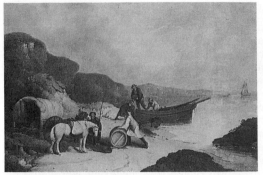

After George Morland
British (1762–1804)
Smugglers on the Coast
Oil on canvas
36¾ x 49¼in (93 x 125cm)
£1,300–1,800 *P*

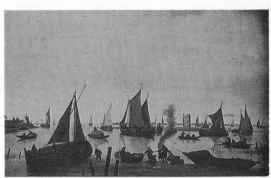

Hendrick de Meyer
Dutch (c1637–83)
Fishermen lighting a Brazier on the
Banks of the River Maas before the
'Huis Termerwede' near Dordrecht
Oil on panel
33½ x 49in (85 x 124.5cm)
£7,500–10,000 *P*

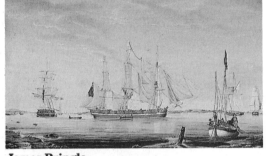

James Pringle
British (active 1770–1818)
'A Calm' – An armed vessel flying a Royal Navy
blue ensign in 2 positions, lying in an estuary,
possibly the Medway
Signed and dated '1811', oil on canvas
28 x 49in (71 x 124.5cm)
£11,000–15,000 *CSK*

*James Pringle, ship draughtsman in HM
Dockyard at Deptford, exhibited marine paintings
at the Royal Academy 1800–1818.*

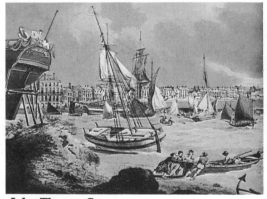

John Thomas Serres
British (1759–1825)
The Harbour at Weymouth
Signed and dated '1805', pen, ink and watercolour
17¼ x 21½in (43.5 x 54.5cm)
£3,000–4,000 *Bon*

*Son of Dominic Serres (1722–93), John Thomas
succeeded his father as marine painter to George III.
Although his professional life was extremely
successful, his private life was not. According to
marine expert Teddy Archibald, he married a
Miss Olivia Wilmot, 'an extravagant and immoral
woman with notorious delusions of grandeur'. She
claimed to be the illegitimate daughter of HRH the
Duke of Cumberland, calling herself Princess Olive
of Cumberland, and her bad behaviour and debts
ruined Serres who lost his position at court and
sadly died in a debtor's prison.*

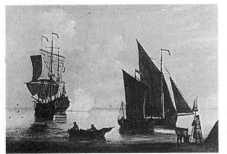

Attributed to Francis Swaine
British (1740–82)
An English Frigate firing a Salute
off the Dutch Coast
Oil on canvas
19 x 25in (48 x 64cm)
£1,000–1,500 *Bon*

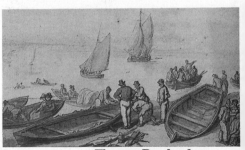

Thomas Rowlandson
British (1756–1827)
Boating Parties, on a Beach
Pen and ink and watercolour
5½ x 9in (14 x 22.5cm)
£2,000–2,500 *P*

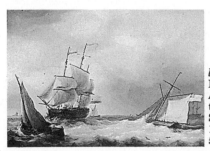

l. **Martinus Schouman**
Dutch (1770–1838)
A Dutch Man o' War heaving
to for a Royal Navy Cutter
Signed, oil on panel
18 x 25¼in (46 x 64.5cm)
£13,500–15,000 *CSK*

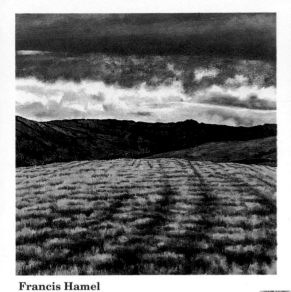

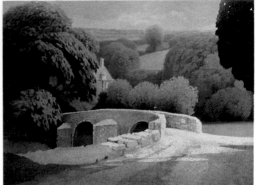

Kevin Hughes
British (20thC)
Altarnun Bridge, Cornwall
Watercolour
12 x 16in (30.5 x 40.5cm)
£350–400 *SJG*

Francis Hamel
British (b1963)
South West Cork
Oil on canvas
24in (61.5cm) square
£1,800–2,200 *JnM*

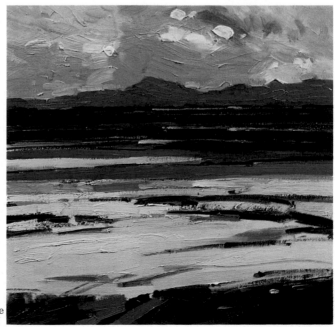

Gertrude Harvey
British (20thC)
My Garden
Oil on panel
13 x 16in (33 x 40.5cm)
£1,600–1,800 *NZ*

Duncan Harris
British (20thC)
Canal du Midi
Oil on canvas
24in (61.5cm) square
£500–550 *AMC*

Cecil Arthur Hunt, RBA, RWS
British (1873–1965)
Lake Thun with Eiger, Münch
and Jungfrau
Signed, inscribed and dated '1948',
watercolour
10 x 14in (25 x 35.5cm)
£1,200–1,400 *HO*

r. **Robert Kelsey**
Scottish (20thC)
Towards Iona
Oil on canvas
12in (31.5cm) square
£1,500–1,900 *JnM*

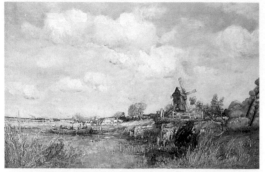

Campbell A. Mellon, RBA, ROI
British (1876–1955)
Caister Sandhill
Signed, inscribed on reverse, oil on board
9 x 12in (22.5 x 30.5cm)
£1,600–1,900 *SFA*

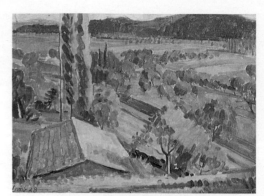

Henry Lamb, RA, LG
British (1883–1960)
View across the Dordogne
Signed and dated, oil on board
12 x 16in (30.5 x 40.5cm)
£3,500–3,900 *PN*

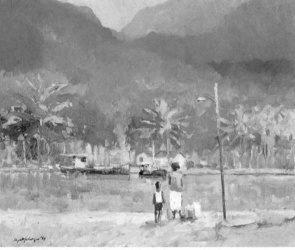

Hugh McNeil McIntyre, DA
Scottish (1943)
The River Crossing near Sao Sebastitao
Signed, oil on canvas
24 x 20in (61.5 x 50.5cm)
£900–1,050 *CON*

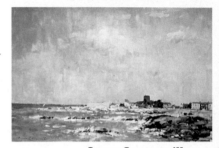

James Longueville
British (b1942)
Fresh Day, Joyce's Tower
Signed, oil on panel
20 x 30in (50.5 x 76cm)
£1,500–1,700 *SOL*

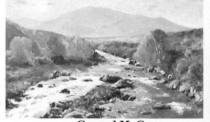

Gerard McGann
Irish (b1968)
Autumn on the Gaddagh
Oil on canvas
24 x 36in (61.5 x 91.5cm)
£1,000–1,300 *SOL*

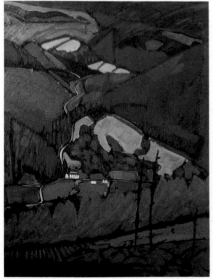

Bob Lynn
Scottish (b1940)
Crossroads, Glenmalure
Oil on canvas
36 x 30in (91.5 x 76cm)
£1,000–1,300 *SOL*

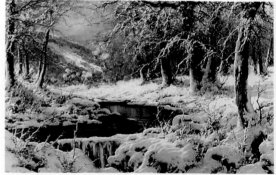

Laszlo Neogrady
Hungarian (b1900)
The Forest – Deep Snow
Signed, oil on canvas
38 x 58in (96.5 x 147cm)
£14,500–15,500 *BuP*

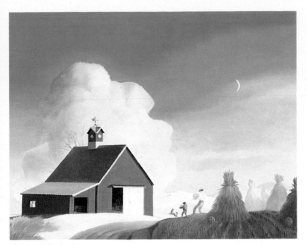

David Prentice
British (20thC)
Willow Herb on Summer Hill, Malvern
Watercolour
23 x 34in (58.5 x 86cm)
£1,200–1,500 *AMC*

Dale Nichols
American (b1904)
Evening before the Witches Ride
Signed and inscribed, oil on canvas
24 x 30in (61.5 x 76cm)
£7,000–8,000 *S(NY)*

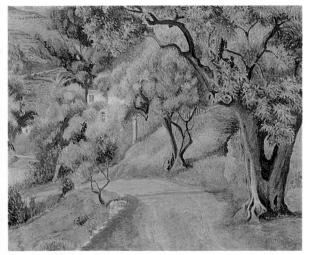

Victor Richardson
Irish (b1952)
The Water Garden
Pastel
10 x 12in (25.5 x 30.5cm)
£300–350 *SOL*

Lucien Pissarro
British (1863–1944)
Chemin de l'Hubac, Toulon
Signed with a monogram and dated '1929',
oil on canvas
21½ x 25¾in (54.5 x 65.5cm)
£38,000–48,000 *C*

R. C. Riseley
British (active 1920s)
Corn Stooks
Signed and dated '1923',
watercolour
10 x 14in (25.5. x 35.5cm)
£300–350 *Gra*

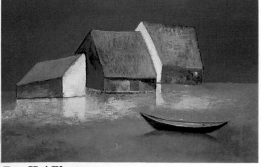

Dao Hai Phong
Vietnamese (20thC)
Tranquil Evening
Mixed media on paper
21 x 28in (53.5 x 71cm)
£2,400–2,800 *RMG*

René Charles Edmond His
French (1877–1960)
A Peaceful Lake
Signed, oil on canvas
20 x 24¼in (50.5 x 62cm)
£5,500–6,250 *BuP*

Leonard Rosoman
British (b1913)
Country Garden in Sunlight
Oil on canvas
20 x 30in (50.5 x 76cm)
£7,000–7,500 *FAS*

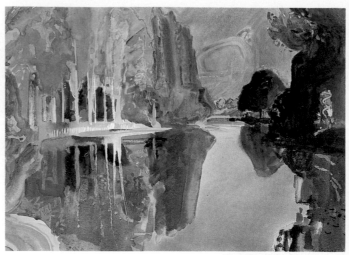

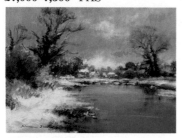

Bob Rudd
British (b1944)
Normandy River
Watercolour
21½ x 29in (54.5 x 74cm)
£900–1,100 *JnM*

Norman Smith
British (b1949)
The Frozen Canal
Oil on canvas
9 x 12in (22.5 x 30.5cm)
£340–380 *TBG*

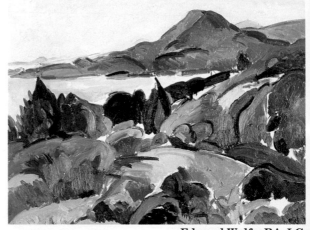

David Smith
British (20thC)
River Chelmer at Little Beddow
Oil on canvas
16 x 24in (40.5 x 61.5cm)
£2,500–3,000 *ROY*

Edward Wolfe, RA, LG
British (1897–1982)
North Wales
Signed, oil on board
20 x 24in (50.5 x 61.5cm)
£8,000–8,500 *PN*

David Tress
British (b1955)
Red Field Pen Caer
Mixed media, 1994
22 x 30in (56 x 76cm)
£850–950 *BOU*

Ruth Stage
British (20thC)
Tuscany
Signed, egg tempera
10 x 8in (25.5 x 20cm)
£500–1,000 *BRG*

Samuel Austin, OWS
British (1796–1834)
Seacombe Slip, Liverpool
Pencil and watercolour with scratching out
5¾ x 7¼in (14 x 18.5cm)
£3,300–4,000 *C*

Myles Birket Foster, RWS
British (1825–99)
Edinburgh from Calton Hill
Signed with monogram, watercolour
6 x 8in (15 x 20cm)
£9,000–9,750 *WrG*

John Atkinson Grimshaw
British (1836–93)
Whitby Harbour from Station Quay
Signed and dated '1876', oil on board
12 x 18in (30.5 x 45.5cm)
£42,000–50,000 *S*

Louise Rayner
British (1832–1924)
St. Michael's Church, Chester
Signed and inscribed, watercolour
12 x 6¾in (30.5 x 17cm)
£6,000–8,000 *C(S)*

Noel Harry Leaver
British (1889–1951)
Chipping Campden
Watercolour
14 x 10in (35.5 x 25.5cm)
£2,500–3,250 *HFA*

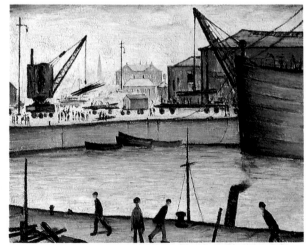

Laurence Stephen Lowry, RA
British (1887–1976)
Glasgow Docks
Signed and dated '1949', oil on board
18 x 22in (45.5 x 56cm)
£28,000–35,000 *C*

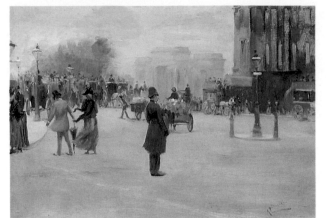

Mark Popple
British (b1968)
Tower Bridge
Egg tempera on panel
35 x 53½in (89 x 136cm)
£3,000–3,500 *MGP*

Albert Ludovici, Jnr
British (1852–1932)
Hyde Park Corner
Signed, oil on panel
10 x 14in (25.5 x 35.5cm)
£9,500–11,000 C

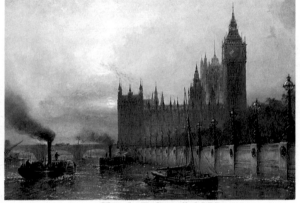

Claude T. Stanfield Moore
British (1853–1901)
Houses of Parliament from the Thames
Embankment
Signed, signed and dated '1884' on the
reverse, oil on canvas
30 x 44in (76 x 111.5cm)
£10,500–12,000 *S*

Bernard Dunstan, RA, NEAC
British (b1920)
Painting at Richmond
Signed, oil on canvas, c1946
30 x 36in (76 x 91.5cm)
£8,000–8,500 *BRG*

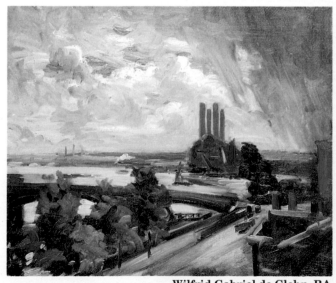

Debra Manifold
British (20thC)
Riverside at Wapping
Pastel/oil
20½ x 15in (52 x 38.5cm)
£500–600 *TLB*

Wilfrid Gabriel de Glehn, RA
British (1870–1951)
Battersea Bridge from Cheyne
Walk, Chelsea
Signed, oil on canvas
24 x 30in (61.5 x 76cm)
£24,000–26,000 *PN*

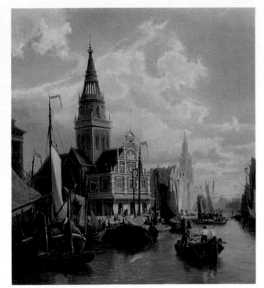

Peiter Christian Dommersen
Dutch (1834–1908)
A Dutch Waterfront
Signed and dated '1870', oil on canvas
30 x 25in (76 x 64cm)
£30,000–34,000 *BuP*

Johann Frederick Hulk
Dutch (1855–1913)
Dutch Quay Scene
Oil on panel
16 x 12in (40.5 x 30.5cm)
£7,000–8,000 *HFA*

Adam Edwin Proctor, RBA, RI, ROI
British (1864–1913)
The Voorstraatshaven, Dordrecht
Signed and dated '08', watercolour
14 x 10in (35.5 x 25.5cm)
£1,000–1,250 *HO*

Jan de Beijer Swiss (1703–80)
A View of the Schans
Signed and dated '1756', pen and brown
ink and watercolour over black chalk
9¼ x 15½in (23 x 39cm)
£6,200–7,000 *S(Am)*

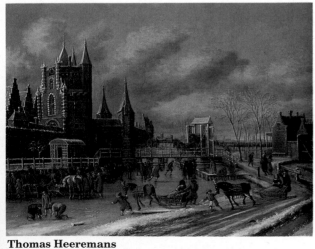

Thomas Heeremans
Dutch (active 1660–97)
The Amsterdam or Spaarnwouder Gate, Haarlem,
with Townsfolk on a frozen Canal
Signed with monogram, oil on canvas
19¾ x 25½in (50 x 65cm)
£9,000–10,000 *C*

Michael John Hunt
British (b1941)
South Church, Amsterdam
Acrylic on canvas
40 x 32in (101.5 x 81cm)
£7,000–8,000 *THG*

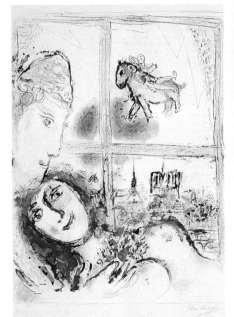

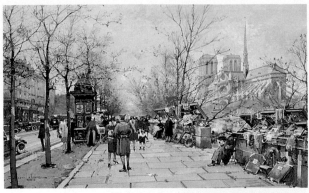

Eugène Galien-Laloue
French (1854–1941)
Sur les Quais, Paris
Signed, gouache
10⅝ x 17¾in (27 x 45cm)
£10,000–12,000 *S*

Marc Chagall
French/Russian (1887–1985)
Paris from my Window
Signed in pencil, lithograph, c1969
32½ x 24in (83 x 61.5cm)
£16,000–17,000 *S(NY)*

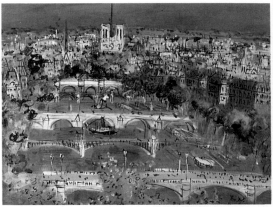

Jean Dufy
French (1888–1964)
La Seine, Paris
Signed, oil on canvas
19 x 25in (48 x 63.5cm)
£32,000–35,000 *S(NY)*

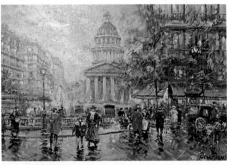

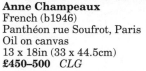

Anne Champeaux
French (b1946)
Panthéon rue Soufrot, Paris
Oil on canvas
13 x 18in (33 x 44.5cm)
£450–500 *CLG*

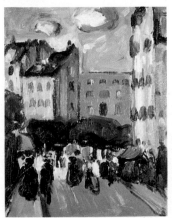

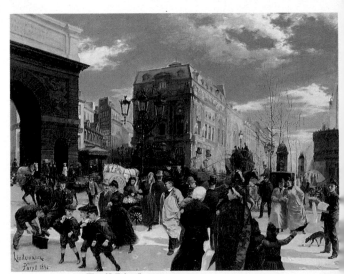

John Duncan Fergusson
British (1874–1961)
Boulevards Edgar Quinet and Raspail
Signed and dated '1907',
oil on panel
14 x 11in (35.5 x 28cm)
£30,000–32,500 *DMF*

Emil Lindemann
German (?) (1864–1939)
Les Grands Boulevards, la Porte St. Martin, Paris
Signed and dated '1891', oil on canvas
23 x 29in (58.5 x 73.5cm)
£12,000–14,000 *C*

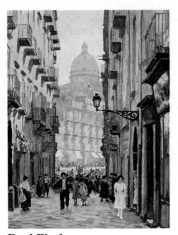

Paul Fischer
Danish (1860–1934)
A Neapolitan Street Scene
Signed, oil on canvas
20 x 14½in (50.5 x 37cm)
£4,500–5,500 *S*

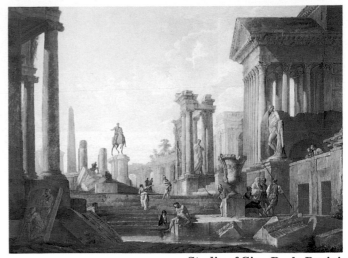

Studio of Gian Paolo Panini
Italian (c1691–1765)
A Capriccio of Roman Ruins
with the Statue of
Marcus Aurelius
Oil on canvas
39½ x 53in (100 x 134.5cm)
£27,000–32,000 *S*

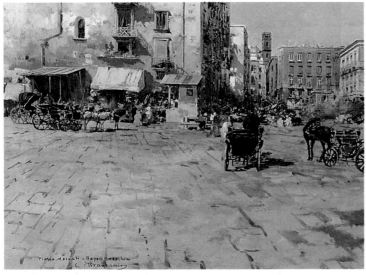

l. **Carlo Brancaccio**
Italian (1861–1920)
Piazza Mercato, Naples
Signed and inscribed,
oil on canvas
13¾ x 18in (35 x 46cm)
£14,000–16,000 *C*

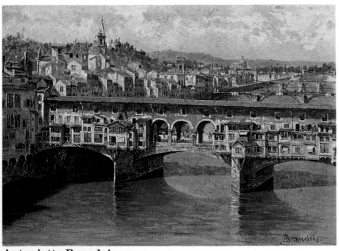

Antonietta Brandeis
Bohemian (b1849)
Ponte Vecchio, Florence
Signed, oil on board
6½ x 9½in (16.5 x 24cm)
£6,000–8,000 *C(S)*

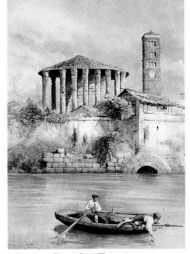

Ettore Roesler Franz
Italian (1845–1907)
The Temple of Vesta from the
Tiber, Rome
Signed and inscribed, watercolour
30¼ x 21½in (77 x 54.5cm)
£9,000–11,000 *Bon*

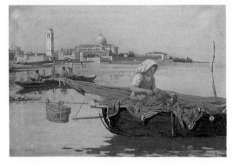

Sylvius D. Paoletti
Italian (1864–1921)
A Fisherwoman repairing her Nets on the
Mincio, Mantua
Signed, oil on canvas
16 x 22¾in (40.5 x 58cm)
£5,000–6,000 *C*

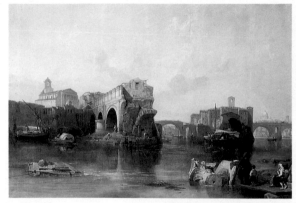

Clarkson Stanfield, RA
British (1793–1867)
Il Ponte Rotto, Rome
Signed, oil on canvas
35¾ x 50½in (91 x 128cm)
£14,000–16,000 *S*

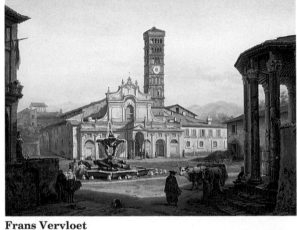

Thomas Charles Leeson Rowbotham
British (1823–75)
An Italian Fishing Port
Signed and dated '1868', watercolour
3½ x 6in (8.5 x 15cm)
£800–875 *WrG*

Frans Vervloet
Belgian (1795–1872)
Santa Maria in Cosmedin, Rome
Signed and dated '64', oil on canvas
24 x 32in (61 x 81.5cm)
£7,000–8,000 *S*

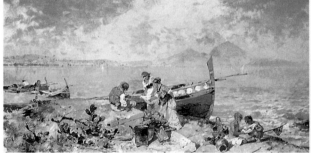

Franz Richard Unterberger
Belgian (c1838–1902)
The Bay of Naples
Oil on panel
10½ x 19¾in (26 x 50cm)
£9,000–12,000 *Bon*

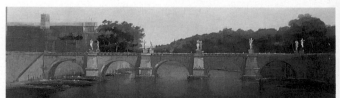

F. Donald Blake, RI, RSMA
British (20thC)
Afternoon in Tuscany
Signed, watercolour
23 x 16in (58.5 x 40.5cm)
£650–750 *TLB*

Martin Mooney
Irish (b1960)
St. Angelo Bridge, Rome
Oil on panel
12 x 40in (30.5 x 101.5cm)
£2,400–2,600 *SOL*

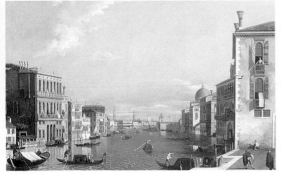

William James
British (active 1754–71)
A View on the Grand Canal, Venice
Oil on canvas
16¼ x 26⅛in (41 x 67cm)
£8,500–10,000 *Bon*

Antonietta Brandeis
Bohemian (b1849)
Figures before St Mark's, Venice
Signed, oil on canvas
9¾ x 13in (24.5 x 33cm)
£10,500–12,500 *P*

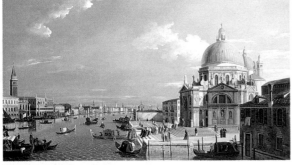

Manner of Canaletto
Italian (1697–1768)
The Grand Canal, looking East
Oil on canvas
30 x 50½in (76 x 128cm)
£29,000–35,000 *S*

Federico del Campo
Peruvian (19thC)
A View of a Venetian Canal
Signed and dated '1912',
oil on canvas
23 x 16in (59 x 41cm)
£30,000–40,000 *S*

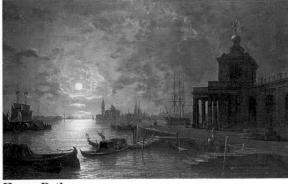

Henry Pether
British (1828–65)
San Giorgio Maggiore and the Campanile
Signed, oil on canvas
24 x 36in (61 x 91.5cm)
£10,500–12,000 *CSK*

l. **Antoine Bouvard**
French (d1956)
Gondolas
Oil on canvas
20 x 25in (50.5 x 64cm)
£8,000–9,000 *HFA*

Vincenzo Chilone
Italian (1758–1839)
The Piazza San Marco,
Venice
Oil on canvas
20½ x 27⅛in (52 x 70cm)
£30,000–35,000 *C*

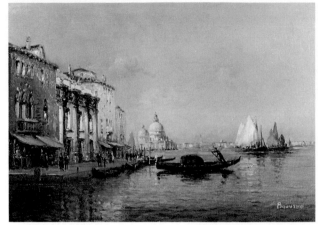

Jane Corsellis
British (20thC)
Gondoliers on the Piazella, Venice
Oil on canvas
7 x 10½in (17.5 x 26cm)
£750–850 *BSG*

Antoine Bouvard
French (d1956)
Venice
Signed, oil on canvas
9½ x 13in (24 x 33cm)
£7,750–8,250 *BuP*

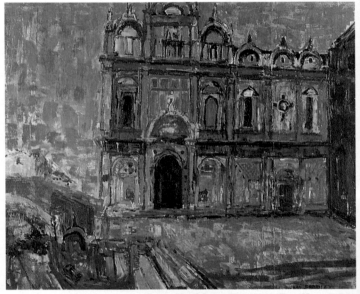

F. C. B. Cadell, RSA, RSW
Scottish (1883–1937)
The Grand Canal, Santa Maria
Della Salute, c1910
Signed and inscribed, oil on board
17¾ x 14¾in (45 x 37.5cm)
£29,000–32,500 *DMF*

Joan Kathleen Harding Eardley, RSA
British (1921–63)
Venetian Piazza
Signed, oil on canvas
31½ x 38¾in (80 x 98.5cm)
£10,500–12,000 *C(S)*

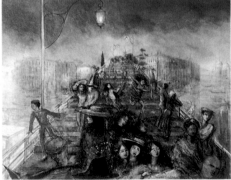

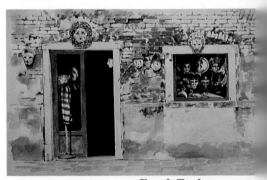

Charles Newington
British (b1950)
Uscita (Venice 1991)
Mixed media on paper
22 x 28in (55.5 x 71cm)
£685–725 *RGFA*

Frank Taylor
British (20thC)
Mask Shop, Venice
Watercolour
14 x 19in (35.5 x 48cm)
£500–550 *PHG*

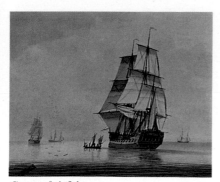

Samuel Atkins
British (c1765–1810)
Frigate Hove-to
Signed, watercolour
6¾ x 7¾in (17 x 20cm)
£2,400–2,800 *Mar*

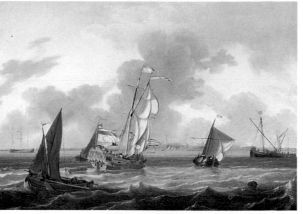

Ludolf Backhuyzen
Dutch (1631–1708)
A Dutch States Yacht and other Vessels
Signed with initials, oil on canvas
16½ x 22in (42 x 55.5cm)
£30,000–35,000 P

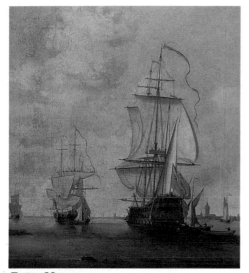

Peter Monamy
British (1681–1749)
A Squadron of the Red preparing to put to Sea
Oil on canvas
27½ x 23in (70 x 58.5cm)
£9,000–10,000 *CSK*

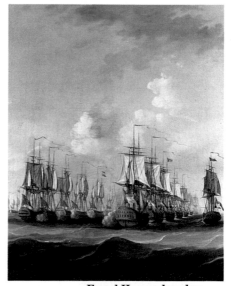

Engel Hoogerheyden
German (1740–1809)
The Battle of Dogger Bank
Oil on canvas
43¼ x 34½in (110 x 87.5cm)
£9,000–11,000 P

Dominic Serres
British (1722–93)
Squadrons of the Fleet at Anchor
A pair, signed, one dated '1780' (?),
oil on panel
10½ x 16in (26.5 x 40.5cm)
£6,000–8,000 *Bon*

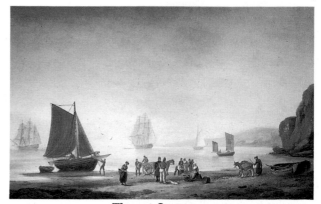

Thomas Luny
British (1759–1837)
Teignmouth Beach with the Ness beyond
Signed and dated '1827', oil on canvas
33¼ x 50in (84.5 x 127cm)
£20,000–25,000 *CSK*

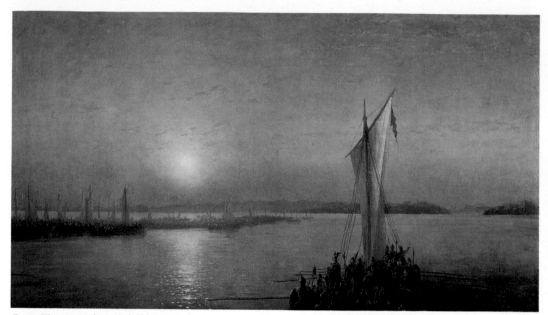

Ivan Konstantinovich Aivazovsky
Russian (1817–1900)
Varangian Saga: The Waterway from the Varangians to the Greeks
Signed and dated '1876', oil on canvas
52 x 92½in (132 x 235cm)
£225,000–275,000 *S*

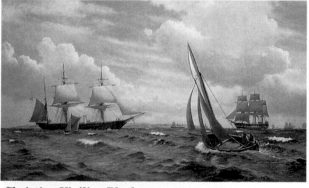

Christian Vigilius Blache
Danish (1836–1920)
A Danish Steam Frigate and other Shipping off the White Cliffs
Signed and dated '1883', oil on canvas
34¼ x 55½in (87.5 x 141cm)
£8,500–10,000 *CSK*

John William Buxton-Knight, RBA
British (1843–1908)
Dover Harbour with Castle in Distance
Signed, inscribed and dated
'1895', watercolour
13 x 10in (33 x 25cm)
£275–400 *TAY*

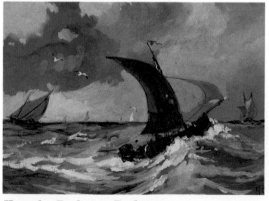

Hercules Brabazon Brabazon
British (1821–1906)
Fishing Boats off Newhaven, Sussex
Signed with initials, gouache
6 x 10in (15 x 25cm)
£225–325 *TAY*

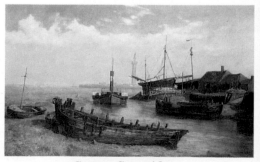

George Cammidge
British (active 1814)
Mouth of the River Freshney, near
Grimsby, Lincs
Signed and dated '1874', oil on panel
8 x 13¼in (20 x 33.5cm)
£1,200–1,600 *Bon*

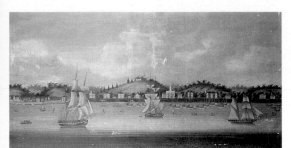

Chinese School (c1830)
A View of Singapore
Oil on canvas
16¾ x 30in (43 x 76cm)
£35,000–40,000 *Bon*

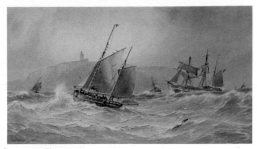

George Gregory
British (1849–1938)
Pilot Cutter, Paddle Tug and Merchantman off Lundy
Signed and dated '1899', watercolour
12¼ x 20¾in (31 x 53cm)
£1,500–2,000 *Mar*

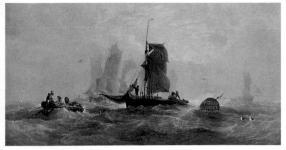

Edward Duncan
British (1803–82)
Fishing Fleet off Grain Spit
Signed and dated '1870', watercolour
15¼ x 27¼in (39 x 69cm)
£10,000–11,500 *Mar*

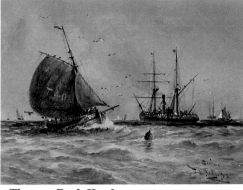

Thomas Bush Hardy
British (1842–97)
Off Scarboro'
Signed, inscribed and dated '1895', watercolour
9¾ x 12¼in (24.5 x 31.5cm)
£2,500–3,000 *Mar*

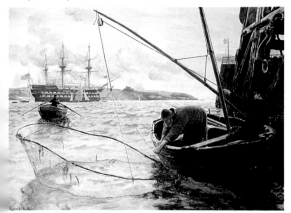

Charles Napier Hemy
British (1841–1917)
A Smelt Net
Signed and dated '1886', oil on canvas
36 x 48in (91.5 x 122cm)
£20,000–30,000 *Bon*

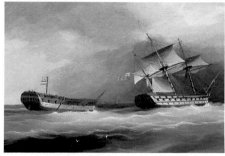

J.M. Huggins
British (active 1827–42)
The Prize
Signed and dated '1836', oil on canvas
19½ x 28in (49.5 x 71cm)
£7,000–7,750 *VAL*

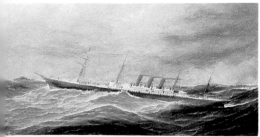

Antonio Nicolo Gasparo Jacobsen
American (1850–1921)
SS *City of Rome*
Signed, inscribed and dated '1885', oil on canvas
22 x 36in (55.5 x 91.5cm)
£5,000–6,000 *CSK*

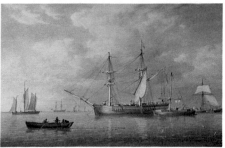

William Joy
British (1803–67)
Brig at Anchor
Watercolour
11¼ x 16¼in (29 x 41cm)
£4,600–5,400 *Mar*

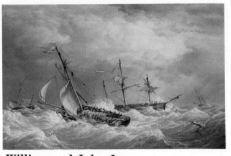

William and John Joy
British (1808–67 and 1806–66)
Cutter in a Squall
Signed and dated '1855', watercolour
12¾ x 18¼in (32 x 47cm)
£6,000–7,000 *Mar*

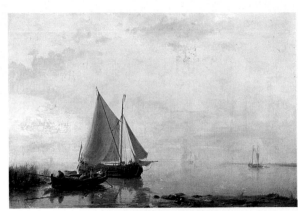

Hermanus Koekkoek
Dutch (1815–82)
Shipping in a Calm at Sunset
Signed and dated '62', oil on canvas
15 x 21½in (38 x 54.5cm)
£10,500–12,500 *P*

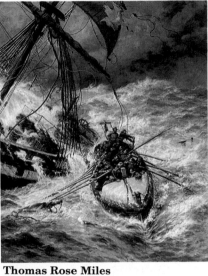

Thomas Rose Miles
British (active 1869–91)
Saved
Signed, signed and inscribed on reverse,
dated 'July 14th 1887', oil on canvas
36 x 28in (91.5 x 71cm)
£8,500–9,500 *CSK*

Egidius Linnig
Belgian (1821–60)
Shipping in a Calm
Signed and dated '1846',
oil on panel
16½ x 22½in (42 x 57cm)
£9,500–10,500 *P*

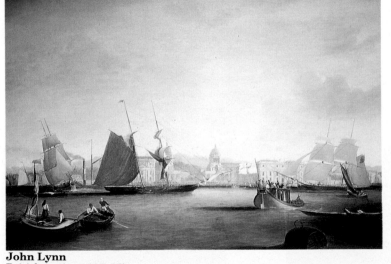

John Lynn
British (active 1828–38)
Distinguished Visitors arriving at Greenwich Palace by ceremonial Barge
Signed and dated '1839', oil on canvas
38½ x 56½in (98 x 143.5cm)
£40,000–50,000 *CSK*

William Alister Macdonald
British (active 1884–1936)
Boats on the Thames
Signed, watercolour, c1890
14 x 10in (35.5 x 25cm)
£625–725 *ELG*

François Etienne Musin
Belgian (1820–88)
Shipping off a Coastline in a Calm
Signed, signed and inscribed on reverse, oil on canvas
20¼ x 30in (51 x 76.5cm)
£10,000–12,000 *P*

Thomas Pyne
British (1843–1935)
Sandwich
Signed and dated '1888', oil on canvas
29¼ x 40½in (74 x 102.5cm)
£6,000–6,750 *BuP*

Henry Redmore
British (1820–87)
Shipping offshore at Sunset
Signed and dated '1878', oil on canvas
18 x 34in (45.5 x 86.5cm)
£13,500–14,500 *BuP*

Thomas Miles Richardson, Jnr, RWS
British (1813–90)
A Fisherman by an Italian Lake
Signed and dated '1857', watercolour
13 x 27in (33 x 68.5cm)
£4,750–5,250 *WrG*

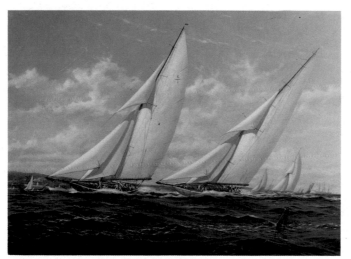

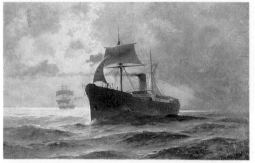

Emilios Prosalentis
Greek (1859–1926)
Ships at Sea
Signed, oil on canvas
31 x 47in (78.5 x 119cm)
£17,000–20,000 *S*

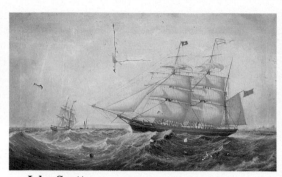

John Scott
British (active 1840–72)
The Barque *Lizzie Leslie,* thought to be off Whitby
Signed and dated '1867', oil on canvas
25¼ x 64½in (65 x 164cm)
£10,000–12,000 *CSK*

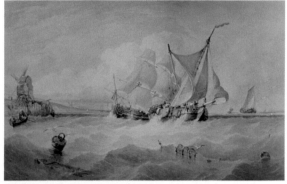

George Clarkson Stanfield
British (1828–78)
Smalschip and Merchantman
Signed, watercolour
15¾ x 24½in (40 x 62cm)
£2,700–3,200 *Mar*

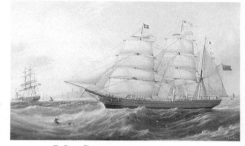

John Scott
British (active 1840–72)
The Barque *Egmont* off Tynemouth
Signed and dated '1871', oil on canvas
26¼ x 41½in (67 x 105.5cm)
£7,500–9,000 *CSK*

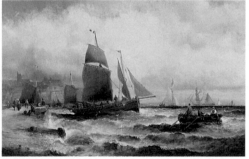

William Thornley
British (19th/20thC)
French Fishing Boats – Outward bound
Signed, inscribed on reverse, oil on canvas
16 x 24in (40.5 x 61.5cm)
£5,250–5,750 *BuP*

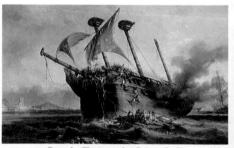

Louis François Joseph Trouville
French (exh 1835–70)
Abandoning the Prize
Signed, oil on canvas
40¾ x 63⅜in (103.5 x 161cm)
£9,000–10,000 *CSK*

George Stanfield Walters
British (1838–1924)
Sunset on the Medway
Signed and inscribed verso, watercolour
10 x 16½in (25 x 42cm)
£850–1,050 *WrG*

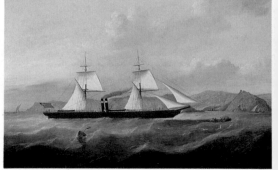

Circle of Samuel Walters
British (1811–82)
A Troop Transport arriving off Balaklava
during the Crimean War, 1854–5
Oil on canvas
23 x 35in (58.5 x 89cm)
£5,000–6,000 *CSK*

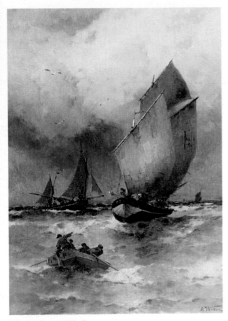

Théodore Weber
French (1838–1907)
A stormy Day
Signed, oil on canvas
18¾ x 13in (47.5 x 33cm)
£5,000–5,750 *BuP*

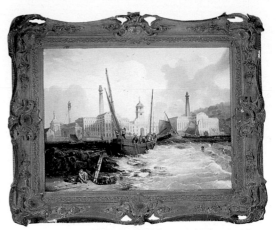

William Williams of Plymouth
British (active 1841–76)
The Royal William Victualling Yard
at Plymouth
Oil on canvas
28 x 36in (71 x 91.5cm)
£9,500–10,500 *CSK*

James Webb
British (1825–95)
On the Rotter, Rotterdam
Signed, oil on panel
14 x 20in (35.5 x 51cm)
£7,000–7,800 *WG*

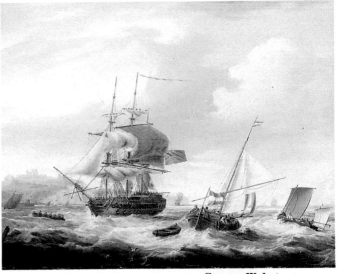

George Webster
British (active 1797–1832)
Shipping off Dover
Signed, oil on canvas
17 x 21in (43.5 x 53.5cm)
£6,750–8,000 *CSK*

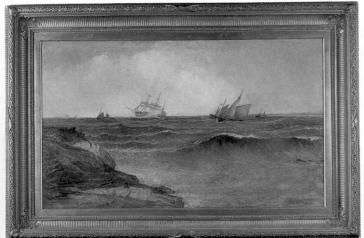

l. **Thomas Webster, RA**
British (1800–86)
Shipping off a rocky Headland
Signed and dated '1880',
oil on canvas
28 x 46in (71 x116.5cm)
£2,500–3,500 *CSK*

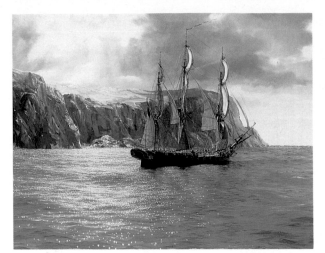

Jonathan Christie
British (20thC)
Port Isaac Harbour
Mixed media on board
9 x 11in (22.5 x 28cm)
£300–375 *KG*

John Russell Chancellor
British (1925–84)
The Frigate *Pallas* off a rocky Headland
Signed, oil on canvas
27¼ x 35¼in (69 x 90cm)
£14,000–16,000 *CSK*

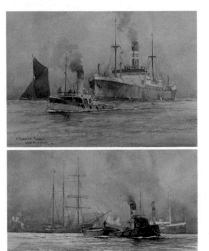

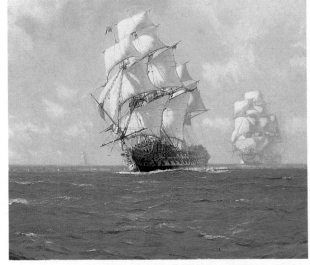

Montague J. Dawson, RSMA, FRSA
British (1895–1973)
The Old Superb
Signed, oil on canvas
28 x 32⅜in (71 x 83cm)
£9,000–11,000 *C(S)*

William Minshall Birchall
American (b1884)
Off Blackwall and A Thames Trader, c1910
A pair, signed and inscribed, watercolour
4½ x 5½in (11 x 14cm)
£1,000–1,250 *ELG*

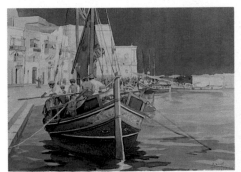

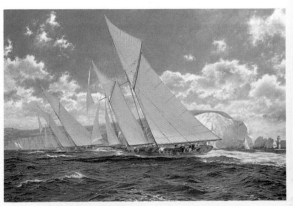

R. C. Dingli
Maltese (19th/20thC)
Maltese fishing Boat in a Harbour
Signed, watercolour
9 x 13in (22.5 x 33cm)
£1,400–1,600 *TAY*

John Steven Dews
British (b1949)
Susanne racing *Westward* off the Needles, c1910
Signed, oil on canvas
20 x 30in (51 x 76.5cm)
£14,000–18,000 *Bon*

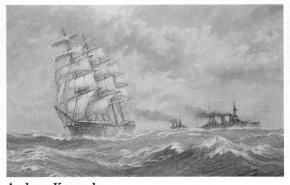

Andrew Kennedy
British (b1941)
HMS *Invincible* and HMS *Inflexible* passing *Pinmore*
Signed, oil on canvas
24 x 30in (61.5 x 76.5cm)
£200–250 *CLG*

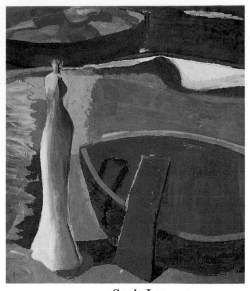

Sonia Lawson
British (b1934)
Shore, 1994
Oil on canvas
74½ x 66½in (189 x 169cm)
£12,000–13,000 *BOU*

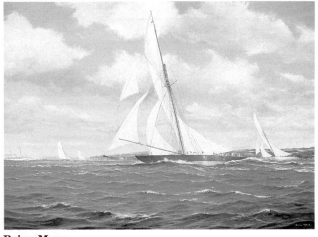

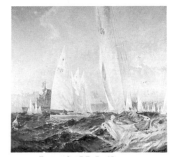

Brian Mays
British (20thC)
Preparing for the Challenge
Signed and inscribed, oil on canvas
30 x 40in (76.5 x 101.5cm)
£4,000–5,000 *CSK*

Leonio Melnikov
Ukranian (b1927)
Sevastopol Regatta, 1979
Signed, oil on canvas
40 x 43in (101.5 x 109cm)
£4,000–4,750 *CE*

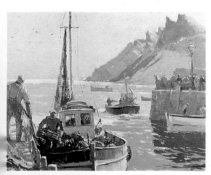

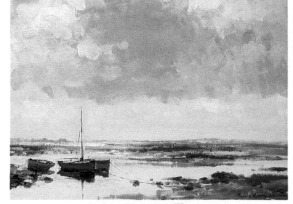

Jack Merriott
British (1901–68)
Polperro Harbour
Signed, oil on canvas
18 x 22in (45.5 x 55.5cm)
£550–700 *TAY*

James Longueville
British (b1942)
Boats at Ballyconneely Bay, Connemara
Signed, oil on panel
16 x 24in (40.5 x 61.5cm)
£800–1,000 *SOL*

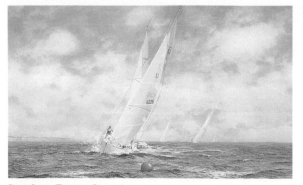

Stephen Renard
British (b1947)
Rounding the Buoy
Signed and dated '88', oil on canvas
20 x 30in (51 x 76.5cm)
£2,400–3,000 *CSK*

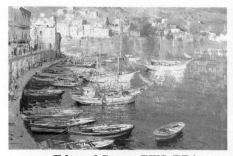

Edward Seago, RWS, RBA
British (1910–74)
Fishing Schooners, Ponza Harbour
Signed, oil on board
20 x 30in (51 x 76.5cm)
£12,000–14,000 *Bon*

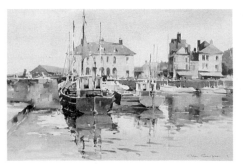

Alan Simpson, RSMA
British (20thC)
Honfleur
Signed, watercolour
14½ x 21½in (37 x 54.5cm)
£300–325 *TLB*

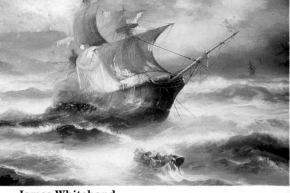

James Whitehand
British (20thC)
The Wreck of the *Eugenie* off Boscastle, Cornwall, 1865
Oil on canvas
24 x 36in (61.5 x 91.5cm)
£2,000–2,500 *MP*

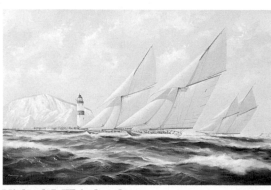

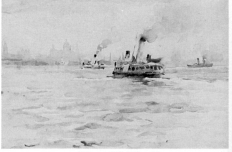

Mary McNicoll
British (early 20thC)
Steamers crossing the Mersey
Watercolour
10 x 13½in (25 x 34cm)
£250–300 *MBA*

Michael J. Whitehand
British (b1941)
Shamrock, Britannia and *Westward* off
The Needles
Signed, oil on canvas
38 x 59½in (96.5 x 150.5cm)
£4,000–6,000 *MP*

r. James Whitehand
British (20thC)
The Frigate *United States* and British
Frigate *Macedonian*, 1812
Oil on canvas
24 x 36in (61 x 91.5cm)
£2,000–2,500 *MP*

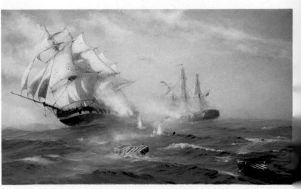

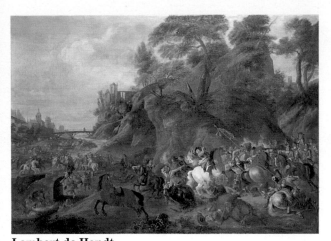

Lambert de Hondt
Flemish (17thC)
A Cavalry Ambush in a Ravine, Troops crossing a
River in a Valley beyond
Bears initials, oil on canvas
47½ x 66½in (120 x 168.5cm)
£8,000–9,000 *P*

John Anthony Park, ROI, RBA
British (1880–1962)
Royal Artillery Memorial
Signed, oil on canvas
24 x 30in (61.5 x 76.5cm)
£5,000–5,500 *PN*

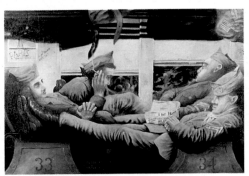
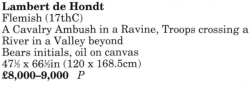

Attributed to Norman Rockwell
American (1894–1978)
Four American Soldiers travelling in a
French Train
Signed, oil on canvas
24 x 36in (61.5 x 91.5cm)
£2,000–2,500 *TAY*

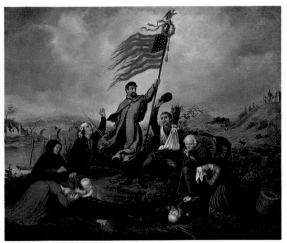

Henry Machen
American (1832–1911)
After the Battle
Signed and dated '1864', oil on canvas
25¼ x 30¼in (64 x 77cm)
£2,300–3,000 *S(NY)*

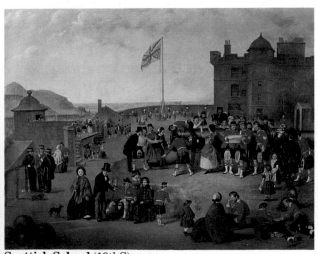

Scottish School (19thC)
A Day at Home
The 78th Highlanders celebrating their Return from the
Indian Mutiny, Edinburgh Castle, 1860
Oil on canvas
40 x 50in (101.5 x 127cm)
£12,000–14,000 *CAG*

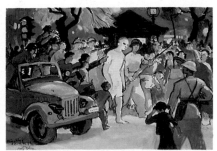

Professor Nguyen Thu
Vietnamese (b1930)
Paraded American Prisoner, 1966
Signed, watercolour on paper
11 x 15in (28 x 38.5cm)
£400–500 *RMG*

Frederick Buck
British (1759–1833)
A portrait of Richard Deasy
2¾in (7cm) high
Gold frame, the reverse with
gold monogram 'RD' on
plaited hair
£375–475 *Bon*

George Chinnery
British (1774–1852)
A portrait believed to be the
Earl of Sheffield
Gilt mounted papier mâché frame
3½in (8.5cm) high
£3,500–4,000 *Bon*

Richard Cosway, RA
British (1742–1821)
A portrait of Mrs. Phillipson
Gold frame with paste border
2in (5cm) high
£1,500–1,800 *Bon*

Pierre Adolphe Hall
Swedish (1739–93)
A Lady, c1785
3in (7.5cm) high
Ormolu frame
£6,000–7,000 *S*

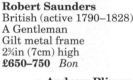

Robert Saunders
British (active 1790–1828)
A Gentleman
Gilt metal frame
2¾in (7cm) high
£650–750 *Bon*

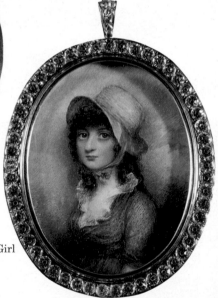

r. **Andrew Plimer**
British (1763–1837)
A portrait of a young Girl
Silver gilt frame with
paste border
3¼in (8cm) high
£4,500–5,000 *Bon*

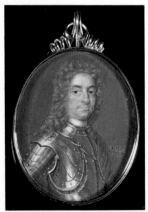

Heinrich Jacob Pohle
Danish (active 1729–47)
A portrait of a Nobleman
Signed and dated '1720',
on parchment
2¼in (6cm) high
£1,600–2,000 *Bon*

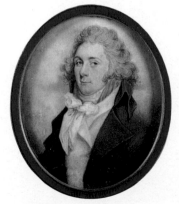

William Singleton
British (d1793)
A portrait of a Gentleman
Signed and dated '1793'
Gilt metal mount
3in (7.5cm) high
£1,500–2,000 *Bon*

**After Feodor
Stepanov Rokotov**
Russian (1735–1808)
Portrait of the Empress
Catherine II Alexeievna, c1790
4in (10cm) high
£4,000–5,000 *S*

Annie Dixon
British (d1901)
Two Young Girls
Signed and dated '1862' on reverse
4in (10cm) wide, gilt metal frame
£1,900–2,400 *S*

James Heath-Millington
British (1799–1872)
Lady Anne Hudson
Signed and dated '1818'
Silver gilt frame
3in (8cm) high
£1,400–1,600 *Bon*

Guglielmo Faija
French (19thC)
A Lady, wearing a black dress, with lace collar and a lace trimmed bonnet
Ormolu frame
4½in (11.5cm) high
£650–750 *Bon*

German School (early 19thC)
An Officer
Gold mount, with glazed reverse
2½in (6cm) high
£1,300–1,600 *Bon*

Continental School
(early 19thC)
A Watercarrier
4¼in (11cm) high
£300–350 *CSK*

Savinien-Edome Dubourjal
French (c1795–1853)
A Gentleman, wearing a blue Coat with black Collar
Signed and dated '1828', ormolu frame
4in (10cm) high
£1,400–1,800 *Bon*

W. P. Mundy
British (20thC)
Jade
Watercolour on ivorine
3¾in (9.5cm) high
£1,450–1,650 *LA*

Kathleen Nelson
British (20thC)
Two Bantam Hens
Watercolour
1¾in (4.5cm) diam
£120–130 *LA*

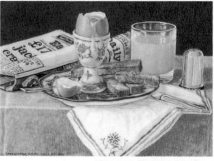

Elizabeth Meek
British (20thC)
Woman from Rajasthan, India
Oil on ivorine
3 x 4½in (7.5 x 11.5cm)
£1,000–1,250 *LA*

Dianne Branscombe
British (20thC)
Breakfast time
Signed, watercolour
2½ x 3½in (6.5 x 8.5cm)
£165–185 *LA*

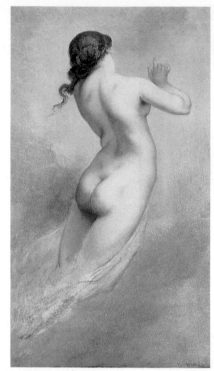

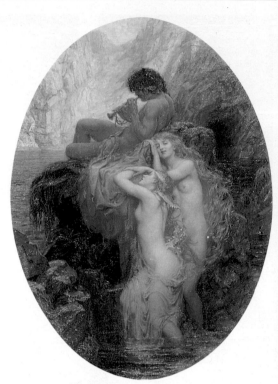

Narcisse Virgile Diaz de la Peña
French (1807–76)
A Study for *The last Tears*
Signed, oil on panel
18 x 10in (45.5 x 25cm)
£10,500–12,500 *C*

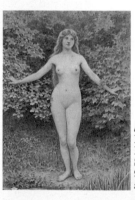

Herbert James Draper
British (1864–1920)
Sea Melodies
Signed, oil on canvas laid down on board
35½ x 26in (90.5 x 66cm)
£24,000–28,000 *S*

l. **Henry John Johnstone**
British (active 1881–1900)
Innocence
Signed, watercolour
9¾ x 7in (24.5 x 17.5cm)
£3,750–4,750 *S*

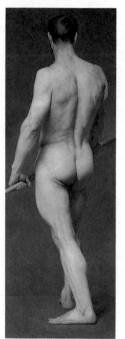

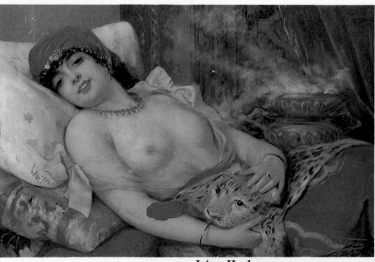

Edouard Joseph Alexander Agneesens
Belgian (1842–85)
A standing Male Nude
Signed and dated '1870',
oil on canvas
78 x 27½in (198 x 70cm)
£4,750–6,000 *S*

Léon Herbo
Belgian (1850–1907)
A Harem Beauty
Signed and inscribed, oil on canvas
28 x 41½in (71 x 105.5cm)
£11,000–15,000 *C*

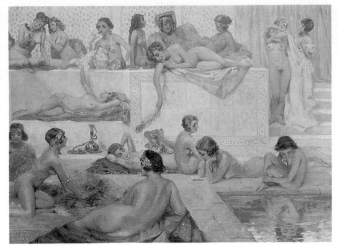

Hugo Vilfred Pedersen
Danish (1870–1959)
At the Baths
Signed, oil on canvas
35¼ x 47in (89.5 x 119cm)
£18,500–22,000 *C*

John DeAndrea
American(?) (b1941)
Man leaning against the Wall
Polyester, resin and fibreglass,
polychromed in oil, 1976
69 x 27 x 17in (175 x 68.5 x 43cm)
£13,000–14,500 *S(NY)*

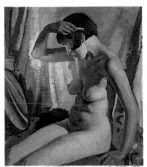

**Bernard Fleetwood-Walker,
RA, RWS, RP, ROI, NEAC,**
British (1893–1965)
The Toilet
Oil on canvas
24 x 20in (61 x 51cm)
£6,000–7,000 *JN*

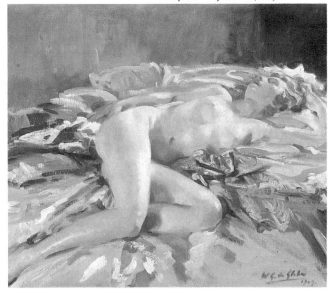

Wilfrid Gabriel de Glehn, RA, RP, NEAC
British (1870–1951)
A Nude Female Figure reclining on a draped Couch
Signed and dated '1927', oil on canvas
20 x 24in (51 x 61cm)
£16,000–20,000 *Bon*

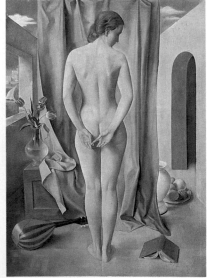

Creten-Georges
Belgian (1887–1966)
A standing Nude
Signed, oil on canvas
34½ x 25½in (88 x 65cm)
£16,000–18,000 *S*

Peter McGrath
British (20thC)
Reclining Figure with Mirror
Acrylic
11 x 15½in (28 x 39.5cm)
£1,500–1,750 *PN*

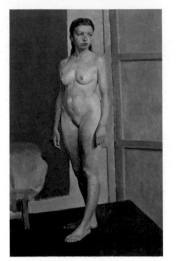

Aubrey Claude Davidson-Houston
Irish (b1906)
Study of a Young Girl
Monogrammed, oil on canvas, 1925
24 x 16in (61.5 x 41cm)
£2,000–2,400 *VAL*

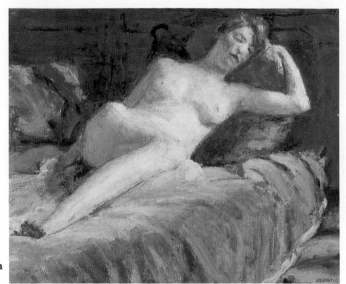

Roderic O'Conor, RHA
Irish (1860–1940)
Reclining Nude on a Chaise Longue
Bears stamped signature, oil on canvas
18 x 21½in (46 x 54.5cm)
£30,000–35,000 *P*

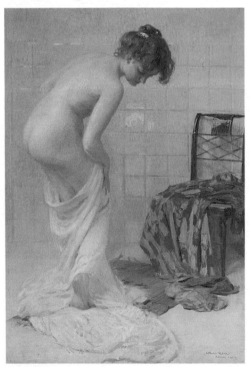

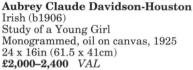

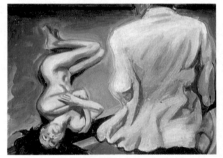

Guy Noble
British (b1959)
Victim Series: Man and Woman
Oil on board
9 x 12in (22.5 x 30.5cm)
£615–715 *LG*

Arturo Noci
Italian (1875–1953)
The Bath
Signed and dated '1909', oil on canvas
43¼ x 39½in (110.5 x 100cm)
£45,000–50,000 *C*

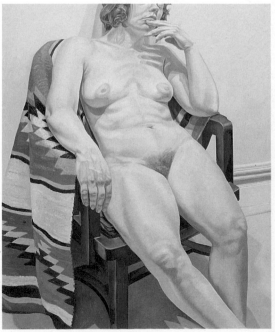

r. **Philip Pearlstein**
American (b1924)
Female Model on Chair with Indian Rug
Signed and dated '72', oil on canvas
48 x 39¼in (122 x 99.5cm)
£13,500–14,500 *S(NY)*

Yasushi Tanaka
Japanese (b1886)
The Artist in his Studio
Signed and dated '1935',
oil on canvas
107 x 87in (271.5 x 221cm)
£12,000–14,000 *Bon*

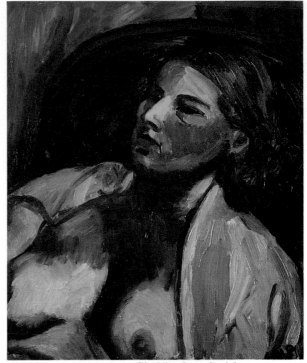

Sir Matthew Smith
British (1879–1959)
Nude in Pink Jacket
Signed with initials, oil on canvas
18in (46cm) square
£17,000–18,000 *PN*

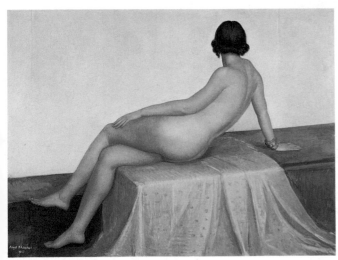

Angel Zárraga
Mexican (1886–1946)
La Pose du Modèle
Signed and dated '1937',
oil on canvas
35 x 45¾in (89 x 116cm)
£142,000–150,000 *S(NY)*

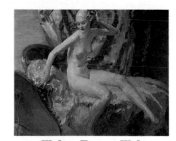

Walter Ernest Webster
British (1878–1959)
Venus
Oil on canvas
24 x 30in (61 x 76cm)
£4,000–5,000 *JN*

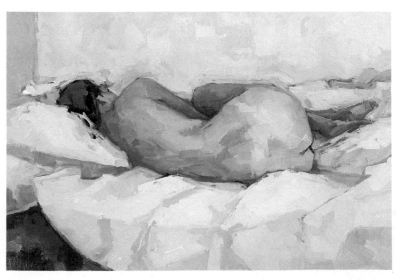

r. **Sarah Spackman**
British (b1958)
Curled Nude on Bed
Oil on canvas
11 x 22in (28 x 56cm)
£1,000–1,450 *SOL*

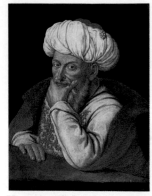

Venetian School (early18thC)
Portrait of a Turk
Oil on canvas
29¾ x 22⅛in (75.5 x 56.5cm)
£6,750–7,750 *S*

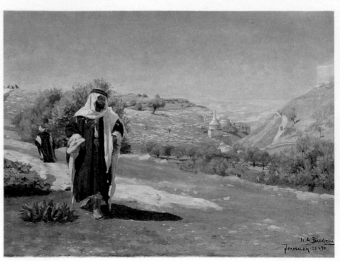

Hans-Andersen Brendekilde
Danish (1857–1920)
Overlooking Jerusalem's Valley
Signed and dated '25.4.90', oil on canvas
laid on board
20 x 27⅛in (51 x 69.5cm)
£4,750–5,750 *C*

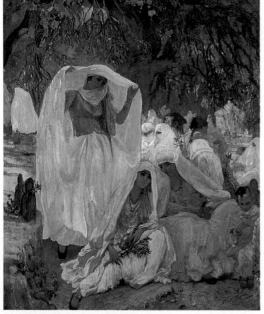

Frederick Arthur Bridgman
American (1847–1928)
The Day of the Prophet Blidah, Algeria
Signed and dated '1900', oil on canvas
25¾ x 21¼in (65.5 x 54cm)
£31,000–36,000 *C*

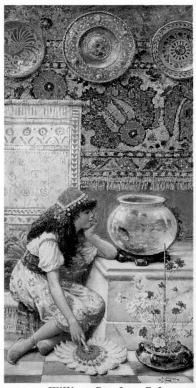

William Stephen Coleman
British (1829–1904)
The Goldfish Bowl
Signed, oil on canvas
31½ x 16½in (81 x 42cm)
£8,000–10,000 *C*

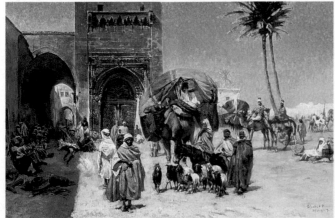

l. **Ferencz Eisenhut**
Hungarian (1857–1903)
An Arab Scene
Signed and dated '91', oil on panel
15 x 24½in (38.5 x 62.5cm)
£12,000–13,000 *S*

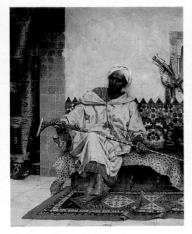

Albert Joseph Franke
German (1860–1924)
The Palace Guard
Signed and dated '89',
oil on canvas
25¼ x 20in (64 x 51cm)
£35,000–40,000 *C*

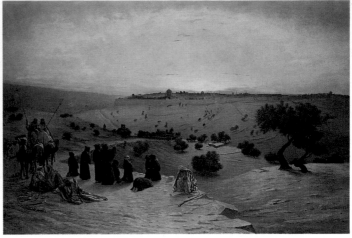

Charles Théodore Frère
French (1814–88)
Pilgrims worshipping
outside Jerusalem
Signed and inscribed,
oil on canvas
56 x 80¼in (142 x 204cm)
£135,000–150,000 *C*

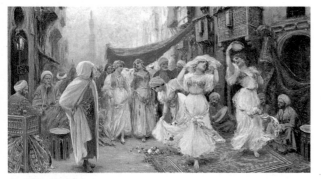

Fabbio Fabbi
Italian (1861–1946)
The Belly Dancers
Signed, oil on canvas
26½ x 46½in (67.5 x 118cm)
£21,000–26,000 *P*

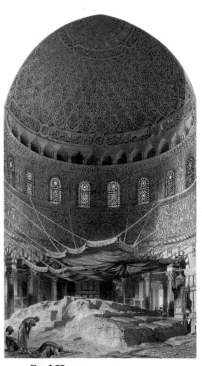

Carl Haag
German (1820–1915)
The Holy Rock, Summit of Mount
Moriah, Jerusalem
Signed, inscribed and dated
'1891', pencil and watercolour
heightened with white, on paper
laid down on canvas, arched top
40¼ x 22½in (102 x 57cm)
£160,000–180,000 *C*

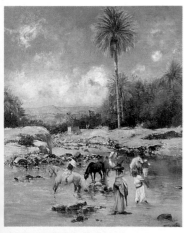

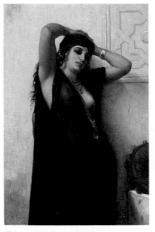

Victor Pierre Huguet
French (1835–1902)
El Kantara, l'Oued
Signed, oil on canvas
24¼ x 19½in (61.5 x 49.5cm)
£10,200–11,000 *C*

Charles Landelle
French (1812–1908)
An Odalisque
Signed, oil on canvas
17¼ x 11½in (44 x 29cm)
£13,000–15,000 *C*

Eugène Alexis Girardet
French (1853–1907)
An Arab Encampment
Signed and dated '1888',
oil on canvas
10½ x 16in (26 x 41cm)
£3,500–4,500 *C*

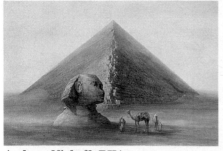

Andrew Nicholl, RHA
British (1804–86)
The Sphinx and Great Pyramid
Signed, watercolour
19 x 28in (48.5 x 71cm)
£6,500–7,500 *S*

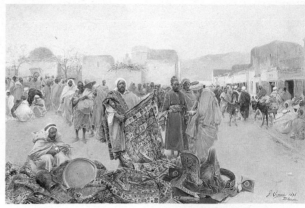

Gustavo Simoni
Italian (b1846)
The Carpet Seller
Signed and dated '1896',
watercolour
22½ x 34½in (57 x 87.5cm)
£10,500–11,500 *S*

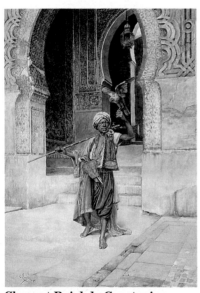

Clement Pujol de Guastavino
French (c1850–1905)
The Falconer
Signed and inscribed, pencil and
watercolour heightened with white
and gum arabic, on paper laid down
on board
29¼ x 20½in (74.5 x 52cm)
£17,500–20,000 *C*

Clive McCartney
British (b1960)
Covered Exchanges
Signed, acrylic on board
8 x 11in (20 x 28cm)
£500–600 *GG*

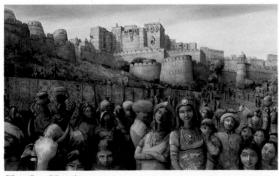

Charles Newington
British (b1950)
Jaisalmer
Watercolour
30 x 48in (76 x 122cm)
£1,750–2,000 *RGFA*

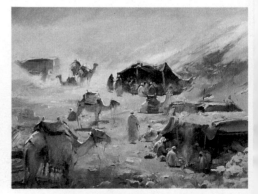

Trevor Chamberlain, ROI, RSMA
British (b1933)
Bedouin Encampment, Nr. Cairo
Oil on canvas
26 x 34in (66 x 86cm)
£3,750–4,250 *PN*

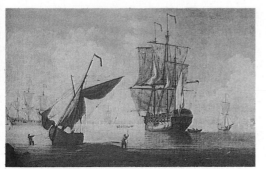

Circle of Monamy Swaine
British (active 1760–70)
A Man o' War and other Shipping in a Calm
Oil on canvas
14¾ x 22in (37.5 x 56cm)
£1,100–1,500 *P*

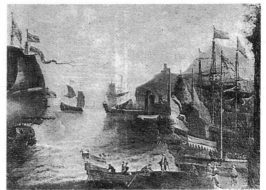

Circle of Pieter van den Velde
Flemish (1634–87)
Figures at a Mediterranean Port,
with Shipping Offshore
Oil on canvas laid on panel
36 x 44in (91.5 x 111.5cm)
£1,600–2,000 *Bon*

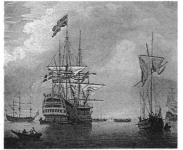

r. **Thomas Whitcombe**
British (c1752–1824)
HMS *Constance*
Oil on canvas
24¾ x 30in (63 x 76cm)
£2,800–3,400 *Bon*

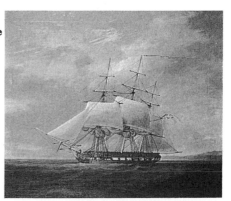

Follower of William van de Velde
Dutch (1611–93)
The Flagship at Anchor with other
Vessels beyond
Oil on canvas
23¾ x 28¾in (61 x 73cm)
£3,500–4,500 *CSK*

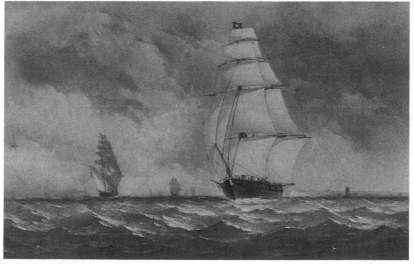

19th Century

As Bernard Reed explains, a distinction can be drawn between the marine watercolourists of the 18th and 19thC. The leading artists of the 18thC had often served at sea. Their clients tended to come from a similar professional, nautical background and wanted pictures that were accurate in detail. Many Victorian painters, however, came from a more shore-based tradition. Their patrons were the new middle classes who wanted something attractive to hang on the wall and the growing availability of different pigments meant that works could be far more colourful than in the previous century. 'Eighteenth century watercolours tend to be academic in style and muted in tone,' concludes Reed. 'Nineteenth century pictures are often more decorative, designed to appeal to the general picture buyer and not just the sailor.'

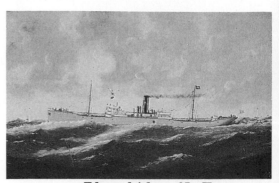

Edouard Adam of Le Havre
French (1847–1929)
SS *Henry R. James*
Signed and dated '1911', oil on canvas
24 x 36in (61 x 91.5cm)
£2,500–3,000 *CSK*

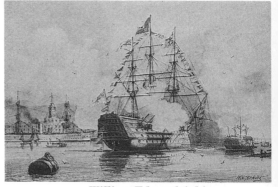

William Edward Atkins
British (1842/3–1910)
HMS *Victory* at Portsmouth
Signed, pen and ink and watercolour
with scratching out
7½ x 11in (19 x 28cm)
£600–800 *P*

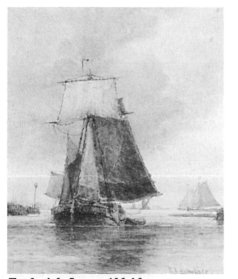

Frederick James Aldridge
British (1850–1933)
Barges on a Dutch Waterway
Signed, watercolour
10 x 8in (25 x 20cm)
£850–950 *Bne*

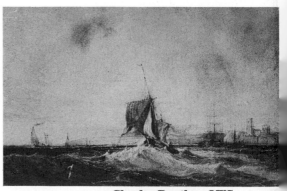

Charles Bentley, OWS
British (1806–54)
Fishing Vessels off Margate, 1828
Watercolour
6 x 8¾in (15 x 22cm)
£1,800–2,300 *Mar*

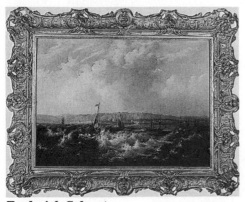

Frederick Calvert
British (active 1815–44)
A Channel Port from
the Sea, thought
to be Dover
Oil on canvas
18 x 24½in (46 x 62cm)
£3,500–4,500 *CSK*

r. **John Wilson Carmichael**
British (1800–68)
Firing a Salute to the
Guard-Ship
Signed and dated '1867',
oil on canvas
14 x 24in (35.5 x 61.5cm)
£1,800–2,200 *Bon*

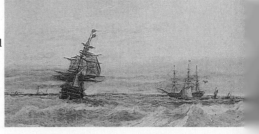

John Chambers
British (1852–1928)
A Three-master under Tow
Signed, watercolour
23 x 36in (59 x 91.5cm)
£700–800 *Bon*

Joseph Newington Carter
British (1835–71)
Scarborough Lighthouse
Signed and dated '1868', watercolour
12 x 18in (30.5 x 46cm)
£1,550–1,750 *Gra*

Ebenezer Colls
British (1812–86)
Coastal Shipping under Sail
in a Choppy Sea
Signed, oil on canvas
12½ x 19½in (31.5 x 49.5cm)
£2,000–2,500 *LH*

Nicholas Matthew Condy
British (1816–51)
The *Jane* off the Eddystone Lighthouse
Signed and dated '1833', oil on panel
6½ x 8in (16.5 x 20cm)
£4,500–6,000 *CSK*

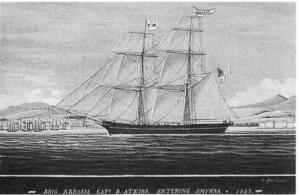

Raffaele Corsini
Italian (19thC)
The American Brig *Abrasia*, Capt.
B. Atkins, entering Smyrna, 1849
Signed and inscribed with title, gouache
15½ x 22½in (39.5 x 57cm)
£6,000–8,000 *S*

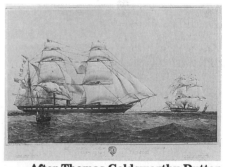

**After Thomas Goldsworthy Dutton
by T. G. Dutton**
British (c1819–91)
The General Screw Steam Shipping
Comp^y's Screw Steam Ship *Croesus*
Lithograph, published by H.J. Buchan,
Southampton, January 1854
16 x 25in (40.5 x 64cm)
£1,250–1,450 *GP*

l. **Thomas Goldsworthy Dutton**
British (c1819–91)
The Paddlesteamer *Harwich*, in two
Positions, with the Port of Harwich
beyond her Bow
Signed and dated '56', pencil and
watercolour heightened with white
13½ x 27¾in (34.5 x 70.5cm)
£4,750–5,750 *CSK*

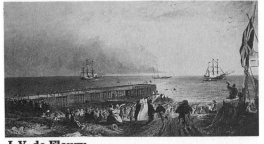

J. V. de Fleury
British (19thC)
Ships conveying Princess Alexandra of Denmark,
arriving off the Kent Coast prior to her Marriage
to the Prince of Wales in March 1863
Signed, oil on canvas
18 x 32in (46 x 81cm)
£3,500–4,500 *Bon*

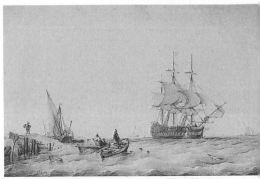

Anthony Vandyke Copley Fielding
British (1787–1855)
A Frigate making Sail from a South Coast Port,
thought to be Newhaven
Signed and dated '1842', pencil and watercolour
heightened with white
29½ x 44¼in (75 x 112.5cm)
£8,000–10,000 *CSK*

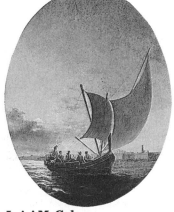

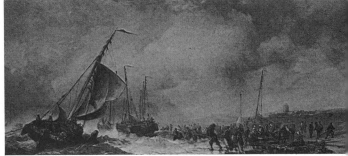

Luigi M. Galea
Maltese (1847–1917)
A Luzzu off Valletta
Oil on board, oval
13 x 10in (33 x 25cm)
£1,000–1,200 *Bon*

Alfred Herbert
British (c1820–61)
Unloading the Boats
Signed, watercolour heightened with whit
18¾ x 38½in (47.5 x 97.5cm)
£3,000–4,000 *P*

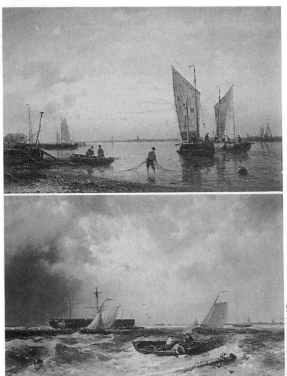

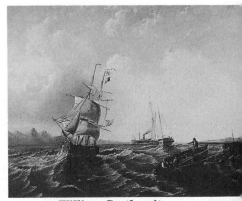

William Garthwaite
British (1821–99)
Shipping off the Coast
Signed and dated '1850', oil on canva
34 x 42in (86 x 106.5cm)
£9,000–11,000 *CSK*

l. **Abraham Hulk**
Dutch (19thC)
Fishing Boats in a calm Estuary
and Retrieving Wreckage
A pair, signed, oil on panel
6¾ x 9½in (17 x 24cm)
£6,000–7,000 *Bon*

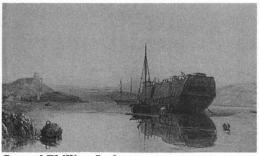

Samuel Phillips Jackson
British (1830–1904)
Hulk in Plymouth at Sunset
Signed and dated '1856', watercolour
18 x 29in (46 x 74cm)
£2,800–3,300 *LH*

Roger Joseph Jourdain
French (1845–1918)
The Boat House
Signed, oil on canvas
32 x 43⅜in (81 x 111cm)
£20,000–25,000 *C*

Jennens & Bettridge
Canadian (19thC)
A pair of papier mâché panels painted with a view of the Customs
House, Dublin and Holyhead Harbour, c1860
16¼ x 36¼in (41.5 x 92cm)
£900–1,200 *Bon*

*It is believed that these panels came from the Beaumaris home of the
Buckley's. The family ran the Holyhead to Dublin Steampacket Co. in
the mid-19thC and it is possible that the panels were removed from one
of the company's vessels. Jennens & Bettridge were the foremost
makers of papier mâché objects at this period, specialising in utility
objects such as trays and table tops. it is unusual to see pictures of this
type which were clearly produced for decorative purposes rather than
serving any function.*

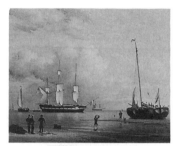

William Joy
British (1803–67)
Beach Scene, a Vessel
taking on Provisions,
Man o' War at Anchor
Signed, oil on canvas
15¼ x 20in (39 x 50.5cm)
£22,000–24,000 *BuP*

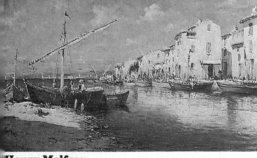

Henry Malfroy
French (19th/20thC)
A Mediterranean Harbour
Oil on canvas
21 x 32in (53 x 81cm)
£4,000–5,000 *JN*

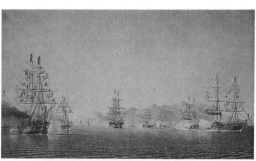

Antoine-Léon Morel-Fatio
French (1810–71)
L'Arrivée sur la Rade de Toulon du Prince
Président (Napoléon III), le 27 Sept 1852
Signed, oil on canvas
51 x 89½in (129.5 x 227cm)
£24,000–28,000 *C*

l. **Arthur Joseph Meadows**
British (1843–1907)
Figures and Boats on the Coast
Signed and dated '1893', oil on canvas
14 x 24in (36 x 61cm)
£3,500–4,500 *P*

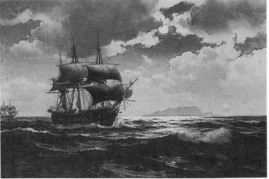

Eduardo Federico de Martino
Italian (1838–1912)
HMS *Vanguard* in 1798
Signed, oil on canvas
25 x 37in (64 x 94cm)
£4,750–5,750 *CSK*

*A former Italian naval officer, Martino achieved his
first artistic success in South America. In 1876, he
moved to England where his love of yachting
brought him into close contact with Edward, Prince
of Wales, figurehead of a fantastically wealthy
yachting fraternity that included such figures as
Thomas Lipton, the tea magnate. Employed by many
of the crowned heads of Europe, Martino received a
vast number of commissions. At the turn of the
century, after a stroke had left him with permanent
damage to his right arm, he used another artist,
John Fraser, to paint or rather 'ghost' a number of
his pictures, apparently doing little more himself
than adding a couple of final touches and the all
important signature.*

Lavin Pascoe
British (19thC)
Fishing Boats at Mount's Bay, St. Michael's
Mount beyond
Signed with monogram, oil on canvas
5 x 8in (12.5 x 20cm)
£150–250 *TAY*

Circle of Charles Martin Powell
British (active 1807–21)
Shipping off the West Coast of Africa
Signed, oil on canvas
16½ x 21in (42 x 53cm)
£1,200–1,600 *CSK*

T. Mortimer
British (19thC)
Low Tide, near Beachy Head and Seaford, Sussex
A pair, both signed, pencil and watercolour
heightened with bodycolour
9 x 20½in (23 x 51cm)
£450–600 *CSK*

Arthur Wilde Parsons
British (active 1867–1904)
A squally Day off the South Coast
Signed and dated '1880', oil on canvas
20 x 30in (50.5 x 76cm)
£1,700–2,000 *CSK*

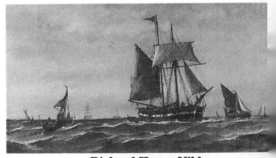

Richard Henry Nibbs
British (1816–93)
A Trading Brig and Thames Barges
Oil on canvas
16½in x 24in (42 x 61cm)
£1,000–1,500 *Bon*

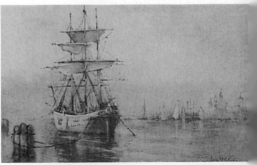

Emily Murray Paterson, RSW, ASW.
British (1855–1934)
A Schooner at Anchor, Venice
Signed, watercolour
10½ x 14½in (26 x 37cm)
£1,200–1,600 *C(S)*

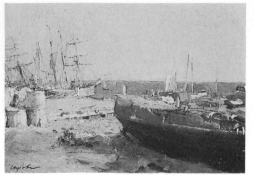

Valentin Alexandrovich Serov
Russian (1865–1911)
Fishing Boats at Archangel
Signed and dated '1894', oil on board
8¼ x 12¾in (21 x 32.5cm)
£23,000–30,000 *S*

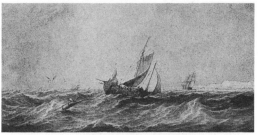

Thomas Sewell Robins
British (c1809–80)
Fishing Boat off Shakespeare Cliff
Signed and dated '74', watercolour
7 x 13½in (17.5 x 34.5cm)
£1,800–2,200 *Mar*

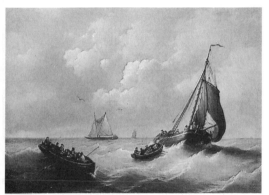

Henri Adolphe Schaep
Dutch (1826–70)
Shipping in Choppy Seas
Signed and dated '1860', oil on canvas
22½ x 31½in (57 x 80cm)
£3,750–5,000 *P*

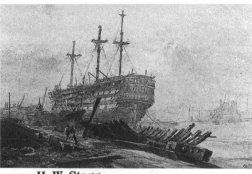

H. W. Stagg
British (19th/20thC)
Breaking up *The Caledonia*, Charlton, Kent
Signed and dated '1910', watercolour
14 x 21in (36 x 53cm)
£1,300–1,600 *BWe*

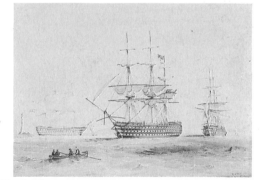

Mark Thompson
British (1812–75)
A Squadron of the Blue coming to Anchor
at Plymouth
Signed, oil on canvas
23 x 35in (59 x 89cm)
£10,000–12,000 *CSK*

Believed to have been introduced in the reign of Queen Elizabeth I, the sub-division of the English battle fleet into three distinct squadrons lasted throughout the age of sail and was only finally discontinued in 1864. The earliest surviving instructions laying down the wearing of coloured flags to denote the three squadrons date from 1617 and under these, the Admiral's squadron flew a red ensign, the vice-Admiral's a white and the rear-Admiral's a blue. As fleets grew in size and the squadrons became correspondingly larger, it gradually became impossible for the commanding Admiral to control the movements of an entire fleet. Thus, command of each constituent part devolved upon the Admirals of the squadrons which were ranked in order of red, white and blue. Likewise Admirals took their rank according to the colour of their squadron and promotion was granted using the same progression of colours.

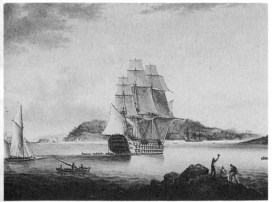

Robert Strickland Thomas
British (1781–1853)
HMS *Britannia*, 120 guns, setting out from
Plymouth and passing Mount Edgecumbe
Oil on canvas
19½ x 26in (49.5 x 66cm)
£4,000–6,000 *CSK*

Launched in 1820, the Britannia was one of the largest ships of her day measuring 205 feet in length with a 53ft 6in beam. She served in Malta and in the Crimean war but is most famous for her non-combative role. In 1859 she was re-commissioned as the first training ship exclusively for the education of naval cadets. Eventually moored in Dartmouth, the ship was to become familiar to generations of young naval officers.

Louis Timmermans
Belgian (1846–1910)
Shipping in a Dock at Dusk and Whitby
from the Station
A pair, signed with initials, oil on panel
5¾ x 10in (14.5 x 25cm)
£1,000–1,500 *P*

Miles Walters
British (1773–1855)
The New York Packet Ship *Hudson*, portrayed in
two Views off Dover, inward bound for London
Oil on canvas
20 x 34in (50.5 x 86cm)
£9,000–12,000 *CSK*

William Edward Webb
British (1862–1903)
Beach Scene with Figures and Fishing Vessels
anchored in the Foreground
Signed, watercolour
13 x 23in (33 x 59cm)
£900–1,200 *WL*

William Henry Williamson
British (active 1853–75)
Fishing Boat and other Shipping off the Coast in
a Squall
Signed and dated '1851', oil on canvas
17 x 29in (43 x 74cm)
£2,000–2,500 *L&E*

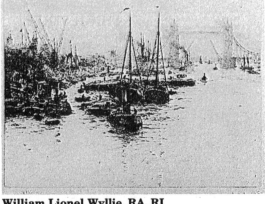

William Lionel Wyllie, RA, RI
British (1851–1931)
Dutch Eel Schuits moored upstream of Tower
Bridge at Billingsgate
Signed artist's proof, drypoint etching
8 x 10in (20 x 25cm)
£450–550 *WyG*

*William Wyllie was a leading English marine artist
of the late 19th and early 20th century. He was the
complete sailor/artist, seldom out of a boat and
never without a sketch pad at hand. From 1907
until his death he lived at Tower House, Portsmouth
Harbour. He worked in three mediums, oil,
watercolour and etching. Between 1868 and 1931 he
exhibited 200 works at the Royal Academy. That
W. L. Wyllie was recognised as a paramount artist
of his time was made clear when the Art Journal in
1907 devoted the whole of its Christmas issue to
his work.*

John Wilson
British (1774–1855)
Fishing Smacks off a Harbour and
Shipping off the Coast
A pair, both signed, oil on panel
8 x 12in (20 x 30.5cm)
£5,000–5,500 *BuP*

20th Century

r. **Robert Craig-Wallace**
British (exh 1829–40)
Racing
Signed, oil on canvas
21 x 24¼in (53 x 62cm)
£2,500–3,000 S(Sc)

William Minshall Birchall
British (b1884)
The End of the Voyage off Tilbury
Signed and dated '1925', watercolour
14 x 20in (36 x 50.5cm)
£1,300–1,500 E

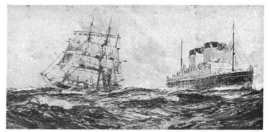

Charles Edward Dixon
British (1872–1934)
Across the Atlantic
Signed and dated '1922', watercolour
5½ x 11½in (14 x 29cm)
£400–600 DaD

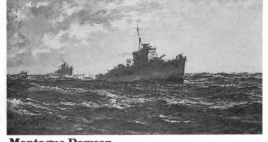

Montague Dawson
British (1895–1973)
Evening Patrol – Hunt Class Destroyers
Signed, oil on canvas
23 x 42in (58.5 x 106.5cm)
£6,000–7,000 Bon

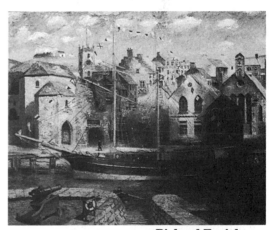

Richard Eurich
British (1903–92)
At the Quay, 1936
Oil on canvas
24 x 30in (61 x 76cm)
£11,500–12,500 FAS

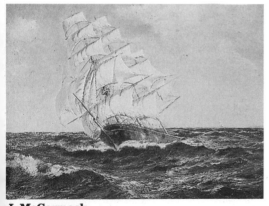

J. McCormack
British (20thC)
Two Clippers racing Home
Signed, oil on canvas
39 x 47in (99 x 119cm)
£4,200–5,000 CSK

Although the two ships are unrecognisable, the scene portrayed above is very reminiscent of the heyday of the so-called 'China Clippers'. Their annual races to bring the new season's tea home from China caught the British public's imagination throughout the 1860's and often huge sums were wagered on the best favoured vessels as if they were thoroughbred racehorses. The most famous race of them all took place in 1866 when Ariel and Taeping raced neck and neck across the world for a hundred days and docked in London within a half-hour of each other on 6 September. These breathtaking runs have inspired many artists over the years.

Charles A. Hannaford
British (1863–1955)
An unspoilt corner of Norfolk
Watercolour
9 x 14in (23 x 36cm)
£600–665 ROY

l. **Paul Maze**
French (1887–1979)
Early Morning, Cowes
Signed, pastel
20½ x 29in (52 x 73.5cm)
£6,000–7,000 *Bon*

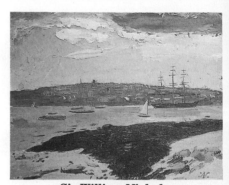

Sir William Nicholson
British (1872–1949)
Trefusis Point
Signed with initials, oil on panel
13 x 16in (33 x 40.5cm)
£6,500–7,500 *Bon*

Girgori Andreivitch Shpoinko
Russian (b1926)
Fishermen in a Boat on icy Waters
Signed, oil on board
19⅛ x 27in (49 x 69cm)
£400–600 *JNic*

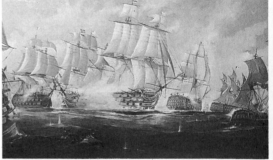

Michael J. Whitehand
British (b1941)
Battle of Trafalgar
Oil on canvas
40 x 60in (101.5 x 152cm)
£8,500–9,500 *MP*

*Son of a painter and brother of marine artist James
Whitehand, Michael Whitehand grew up by the sea
in Bridlington and has devoted his life to painting
ships. 'There is nothing more beautiful or more
majestic than a ship in full sail,' he claims
passionately. The craft that Michael Whitehand
portrays are unlikely to be found sailing in today's
waters, since his speciality is the great vessels of the
past. 'My great loves are the ships from Nelson's
period from c1750 to the Battle of Trafalgar in 1805,
great yachts from the 1880s–1920s and the
J-Class yachts of the 1930s.' Michael Whitehand's
pictures are the result of artistic imagination
combined with careful historical research. His
sources include the great marine painters of the past,
with photography and film from the 20thC, although
he laments that there is so little contemporary footage
from this period. 'You would have thought with all
the yacht racing at Cowes, someone would have had
a cine camera,' he says regretfully.*

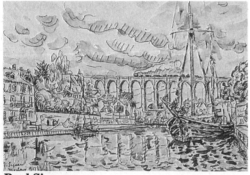

Paul Signac
French (1863–1935)
Morlaix
Signed, titled and dated '1927',
watercolour and pencil
11¾ x 16½in (30 x 42cm)
£24,000–26,000 *S*

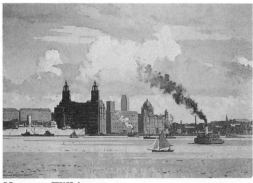

Norman Wilkinson
British (1878–1971)
Wartime Camouflage – a large Merchantman
Anchored in the Mersey off the Royal Liver
Building, Liverpool
Signed, oil on canvas
29 x 44in (74 x 111.5cm)
£5,000–6,000 *CSK*

Alfred Wallis
British (1855–1942)
Houses and Ships
Pencil and gouache on board
12 x 25in (30.5 x 63.5cm)
£5,000–6,000 *C*

MILITARY
17th–18th Century

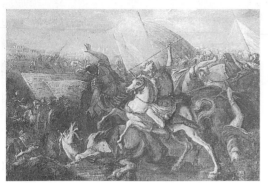

Circle of Pietro Berretini, called Pietro da Cortona
Italian (1596–1669)
A Cavalry Skirmish
Oil on canvas
38¾ x 53in (98 x 134.5cm)
£5,500–6,500 *P*

19th Century

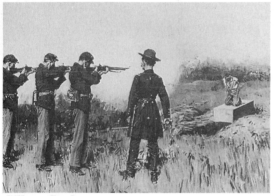

Gilbert Gaul
American (1855–1919)
The Deserter
Signed, oil on board, en grisaille
18½ x 24⅛in (47 x 62.5cm)
£1,200–1,600 *S(NY)*

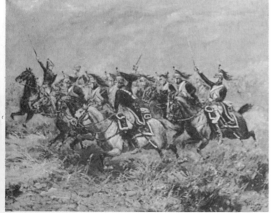

Paul Emile Leon Perboyre
French (b1826)
Charge of the Napoleonic 3rd Dragoons
Signed, oil on canvas
21 x 25½in (53 x 65cm)
£1,700–2,200 *P*

Follower of Jacques Courtois, il Borgognone
French (1621–76)
A Cavalry Skirmish between Turks and Crusaders
Oil on canvas
23¼ x 37½in (59 x 95cm)
£8,500–9,500 *C*

Benjamin West, PRA
British (1738–1820)
Two Officers and a Groom in a Landscape
Signed and dated '1777', oil on canvas
39 x 49in (99 x 124.5cm)
£27,000–35,000 *P*

Robert Alexander Hillingford
British (1825–1904)
Storming the Battlements
Signed and with inscription, oil on canvas
18 x 24¼in (45.5 x 62cm)
£6,500–7,500 *C*

The battle is presumably the siege of Liège, 14–23 October 1702, after which the House of Commons declared that John Churchill had 'singularly retrieved the ancient honour of his nation.' The Queen of her own accord offered him a Dukedom and on 14th December 1702 he was created Marquis of Blandford and Duke of Marlborough.

Domenico Induno
Italian (1815–78)
The Innocent Bystander
Signed and dated '1852', oil on canvas
28 x 23in (71.5 x 58.5cm)
£60,000–65,000 S

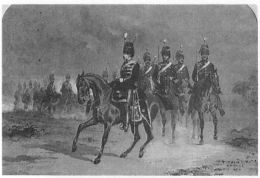

Alfred F. de Prades
British (active 1844–83)
A mounted Troop of the Eleventh Hussars
Signed and dated '1858', watercolour,
12¾ x 19in (32.5 x 48cm)
£1,000–1,200 L

20th Century

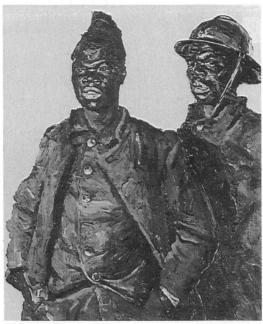

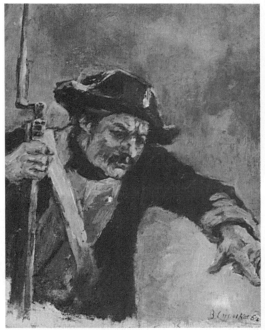

Vassily Ivanovich Surikov
Russian (1848–1916)
Study of a Figure for the Painting of 1899 entitled
'Suvorov Crossing the Alps'
Signed, oil on canvas laid down on board
13¾ x 11½in (35 x 29cm)
£7,000–8,000 S

Thomas Baumgartner
German (1892–1962)
Two Senegalese Soldiers
Signed and dated '1917',
oil on canvas
37 x 29in (94 x 74cm)
£2,900–3,500 S(Am)

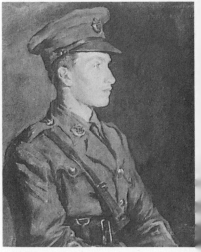

r. **Stanhope Alexander Forbes, RA**
British (1857–1947)
Portrait of William Alexander
Stanhope Forbes
Signed and dated '1916', oil on canvas
24 x 20in (61 x 51cm)
£3,000–3,500 P

*Alec Forbes was the artist's only son
and his death in the Great War was a
substantial blow. This painting was
completed posthumously.*

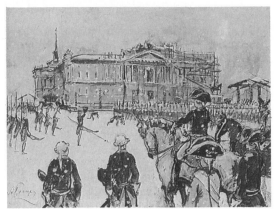

Alexander Nikolaevich Benois
Russian (1870–1960)
Emperor Paul Reviewing his Troops outside the
Michael Castle in St. Petersburg
Signed, gouache over pencil
10⅜ x 14in (26.5 x 35cm)
£6,800–7,500 *S*

*From 1907, Benois worked on a series of pictures
on themes from Russian history which were to
be published by the Moscow Publishing House,
I. Knebel. Reproductions of the pictures were to
be hung in schools. The theme of Paul drilling
his troops was the first in the series. It is
interesting that at the same time Nicholas II had
ordered a photographer to take photographs of
landscapes and fine town architecture which
were to be enlarged and hung in schools using
modern technology to cultivate a stronger sense
of patriotism in school children.*

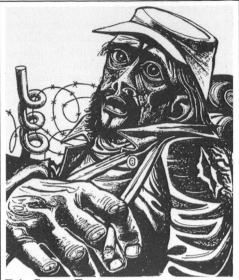

Eric George Fraser
British (1902–83)
Under Fire
Inscribed with title and author on reverse,
pen and ink
7¼ x 6⅛in (18.5 x 16cm)
£300–350 *CBL*

*From 1926 until his death in 1983, Fraser
drew for The Radio Times and his drawings
helped to formulate the visual identity of the
magazine. In the post-war period he produced
dust jacket designs (including the present
example) for the Everyman library. The
intention of Everyman was to bring the
classics of world literature to the ordinary
reader and Fraser's powerful drawings made
a significant contribution.*

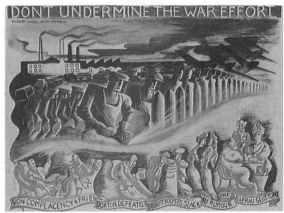

Olga Lehmann
British (exh 1932–33)
Don't Undermine the War Effort
Signed, gouache over pencil
16 x 21in (40.5 x 53cm)
£450–550 *P*

Harold Septimus Power, RI, ROI
British (1878–1955)
Gun Horses, France
Signed and inscribed, oil on card
19 x 24½in (48 x 62cm)
£1,300–1,600 *DN*

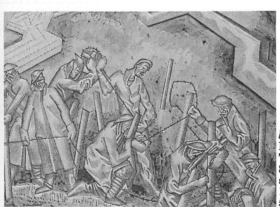

l. **William Roberts, ARA**
British (1895–1980)
The Wiring Party
Signed, black ink wash and red pastel,
squared for transfer
11 x 15in (28 x 38cm)
£12,000–14,000 *S*

MINIATURES

'The market for miniatures is very strong at the moment,' claims Bonham's miniature expert Claudia Hill, 'particularly, as in every other field, for fine works that are fresh to the market. Probably the most crucial factors in miniatures are rarity, quality, condition and an attractive image. It can be an added advantage if the work is signed and dated, and a named sitter can also help, but a good quality portrayal of an unknown figure will fetch more than a poor quality picture of an identified subject.'

According to Hill, certain areas of the market remain under-valued. 'I don't understand why enamel miniatures are not more popular,' she says in puzzled tones, 'they show great technical skill, they don't fade and are less susceptible to damage.' Other than enamels, really good quality

19thC miniatures can still be picked up for under £1,000 and as the 21stC approaches, these are likely to become ever more desirable. For the new collector, Hill recommends looking at miniatures from the 1760s–90s, specifically: 'Pictures from the 'Modest School', so-called because they are modest in size and restrained in technique. Prices can be as low as £200–400, which is relatively cheap for a work of that date.'

The attraction of miniatures lies in their meticulous, jewel-like quality and their romantic appeal. Many were painted as love tokens and often include personal inscriptions or locks of hair set in the back. But collectors beware, as Hill warns, these uniquely personal, portable little portraits are always the first thing to go in a burglary.

17th Century

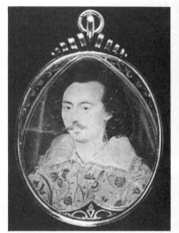

John Hoskins
British (17thC)
Sir Thomas Peyton,
2nd Bart., c1648
Signed with initials, ivory
2¼in (5.5cm) high
Gold frame with scroll surmount
£8,500–9,000 *S*

Samuel Cooper
British (1609–72)
A Lady, with low Landscape and Sky background, pigment on vellum, c1645
3¼in (8.5cm) high
Gilt metal frame with scroll surmount
£90,000–100,000 *S*

Samuel Cooper's freely painted portrait vastly exceeded its estimate of £20,000–25,000 to make a world record price for the artist when it was sold at Sotheby's.

Nicholas Hilliard
British (1547–1614)
A Young Gentleman, against a black background, pigment on vellum, c1600
2in (5cm) high
Silver frame with scroll surmount, foliate engraved reverse
£22,000–27,000 *S*

The sensitive delineation of the young man's features, and the use of the apparently unique form of the inverted heart frame, render the miniature as a pictorial parallel of the melancholic humour explored by poets of the period.

18th Century

l. **Baron Girolamo Pompeo Batoni**
Italian (1708–87)
Horace Walpole, in Grand Tour Winter Coat
Inscribed on reverse, watercolour on ivory
2½in (6cm) high
Gilt metal frame with beaded border
£10,000–11,000 *Bon*

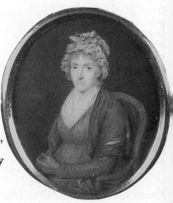

r. **Pierre-Louis Bouvier**
Swiss (1766–1836)
Jeane-Madelaine Le Double, the artist's mother
Signed, watercolour on ivory
3¼in (8cm) high
In gilt metal mount
£8,000–9,000 *Bon*

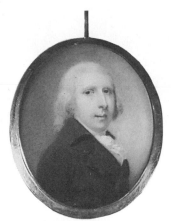

Joseph Daniel
British (1760–1803)
A Gentleman in a blue Coat
Watercolour on ivory
With gold frame
2¾in (7cm) high
£750–950 *Bon*

Thomas Hargreaves
British (1774–1846)
Henry Thomas Carr, with
powdered Hair, Cloud and
Sky background
Watercolour on ivory
3in (8cm) high
£1,500–1,800 *P*

William Armfield Hobday
British (1771–1831)
A Lady, with Curled Dark Hair,
Sky background, c1805
Ivory
2½in (7cm) high
Gold frame with gilt metal reverse
£2,500–2,750 *S*

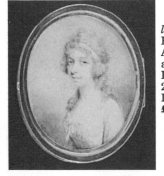

l. **Philip Jean**
British (1755–1802)
A Lady, her powdered Hair tied with
a Bandeau, Sky background
Ivory
2¾in (7cm) high
In fitted gold-mounted ivory case
£700–800 *S*

r. **Peter Paillou**
British (18th/19thC)
A Gentleman, with short Hair,
wearing a black Coat
Ivory
2½in (6.5cm)
In gold frame, glazed hair reverse
set with gold monogram 'JEP'
£750–850 *S*

Louis Lié Périn-Salbreux
French (1753–1817)
A Maid of Athens, with Garland
of Flowers in her Hair
Watercolour on ivory
2½in (6.5cm) diam
In gold mount, set in the lid of a
gold lined tortoiseshell
bonbonnière
£13,000–15,000 *Bon*

*The rim of the gold box is
engraved 'This bonbonnière and
portrait of a "Maid of Athens"
was left in the charge of The
British Consul at Genoa in 1822
by Lord Byron on his departure
for Greece and transmitted on his
death in 1824 to Mr. Hobhouse
(afterwards Lord Broughton) his
executor, whose property it
became. It was inherited in 1869
by Lady Dorchester from her
father, Lord Broughton.'*

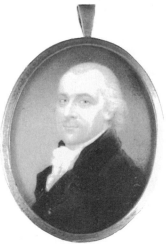

Sampson Towgood Roche
Irish (1759–1847)
A Gentleman in black Coat
and tied white Cravat
Watercolour on ivory
In gilt metal mount
2¼in (5.5cm) high
£500–600 *Bon*

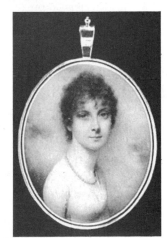

William Wood
British (1769–1810)
A Lady, with curled brown Hair,
wearing a white Dress and coral
Necklace
Signed and inscribed, ivory
2¾in (7cm)
In gilt metal frame
£6,500–7,500 *S*

19th Century

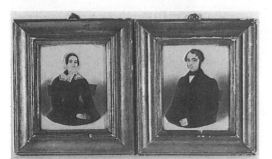

American School (19thC)
Mr and Mrs Rains
A pair, watercolours on paper
5 x 4in (12.5 x 10cm)
£250–300 *SK(B)*

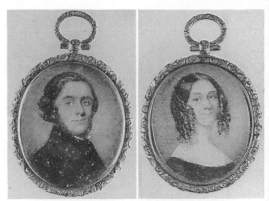

English School (c1840)
A Couple, identified as Robert Browning and
Elizabeth Barrett Browning
A pair, watercolours on ivory
2in (5cm) high
Gilt metal frames with chased and engraved
foliate borders
£325–425 *CSK*

*The English poets, Robert Browning and
Elizabeth Barrett met after Miss Barrett
published* Poems *in 1844. They married two
years later.*

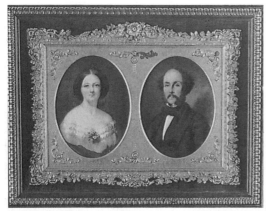

English School (19thC)
Lord and Lady Bolton
A pair, watercolours on ivory
5¾in (14.5cm) high
£900–1,200 *CSK*

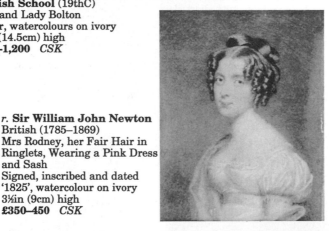

r. **Sir William John Newton**
British (1785–1869)
Mrs Rodney, her Fair Hair in
Ringlets, Wearing a Pink Dress
and Sash
Signed, inscribed and dated
'1825', watercolour on ivory
3½in (9cm) high
£350–450 *CSK*

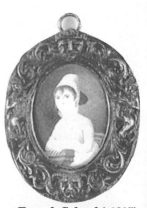

French School (c1815)
A Lady Wearing a White
Dress with Lace Collar
Watercolour on ivory
2½in (6.5cm) high
£150–200 *CSK*

20th Century

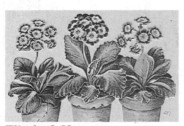

Elizabeth Norman
British (20thC)
The Three Graces
Watercolour and gouache
3 x 4½in (7.5 x 11cm)
£200–220 *LA*

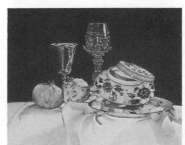

Elaine Fellows
British (20thC)
Stealing from Proserpine
Watercolour on vellum
3½ x 4½in (9 x 11.5cm)
£1,400–1,600 *LA*

Eric Morton
British (20thC)
Entrance to the Temple Church
Watercolour on vellum
3½ x 2½in (9 x 6cm)
£350–400 *LA*

NUDES

'If the subject allows it let there be a few nude figures and others partly nude and partly draped, but always observe decency and modesty. Let the shameful parts and any others that happen to lack grace be covered with drapery, with foliage or with the hand.' Leon Baptista Alberti, *Treatise on Painting, 1436*.

How to portray nudity is a subject that has preoccupied artists over the centuries. In addition to using convenient leaves and wisps of material to conceal any potentially offending organs and removing all traces of bodily hair, until the 20thC artists often had to find a suitable subject to justify their portrayal of the naked figure. Religion and mythology provided endless excuses to portray the nude. Oriental themes (harems and slave markets) and scenes from Roman life (bath houses) were another alternative. The nude was acceptable as long as it was nominally distanced from everyday life. 'Every young sculptor seems to think that he must give the world some specimen of indecorous womanhood, and call it Eve, Venus, a nymph, or any name that may apologise for a lack of decent clothing,' noted Nathaniel Hawthorne in 1860.

16th–18th Century

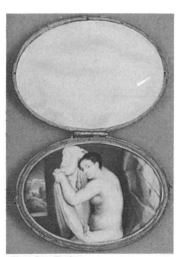

Charles Boit
Swedish (1663–1727)
A Lady, c1700
Signed, enamel
3¼in (8cm) oval
£650–850 *S(S)*

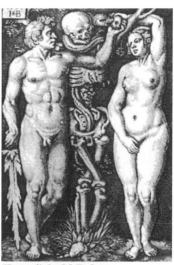

Hans Sebald Beham
German (1500–50)
Adam and Eve with a Skeleton
Engraving, 1543
3 x 2¼in (7.5 x 5.5cm)
£900–1,000 *P*

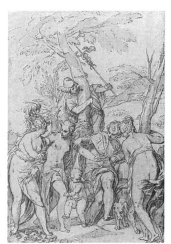

Paolo Farinati
Italian (1524–1606)
The Judgement of Paris
Pen and brown ink, brown and grey wash heightened with white over traces of black chalk, on paper washed yellow
16 x 11in (40.5 x 28cm)
£5,200–6,000 *S(NY)*

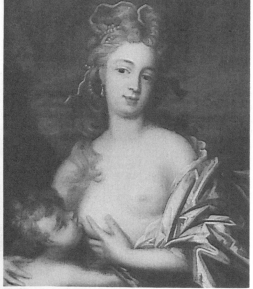

Follower of Antoine Pesne
French (1683–1757)
Portrait of a Lady, bust length, in a blue Dress with a lace Collar
Oil on canvas
19 x 14½in (48 x 37cm)
£2,500–3,000 *CSK*

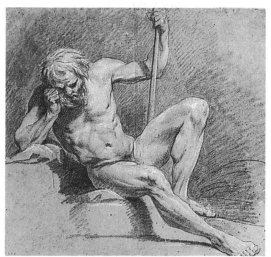

Louis de Boullogne, the Younger
French (1654–1733)
Reclining Male Nude with a Staff
Black chalk heightened with white chalk on blue paper
17½ x 18¼in (44.5 x 46.5cm)
£1,300–1,500 *S(NY)*

19th Century

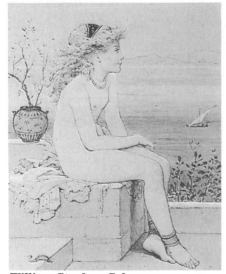

William Stephen Coleman
British (1829–1904)
Reflections by the Sea
Signed, pencil and watercolour
with touches of white heightening
12 x 9¼in (30.5 x 23cm)
£500–600 *CSK*

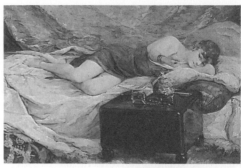

Emile Deckers
Belgian (b1860)
Femme Alongé
Oil on canvas
24 x 34in (61 x 86cm)
£7,000–8,000 *JN*

r. **Raphael Kirchner**
Austrian (1876–1917)
The Favourite of the Harem
Signed with monogram,
charcoal heightened with
white, with an arched top
16¾ x 11¾in (42.5 x 30cm)
£3,000–3,500 *P*

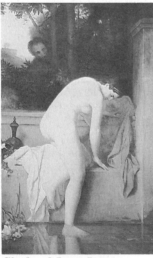

Circle of Jean-Jacques Henner
French (1829–1905)
Susannah and the Elders
Signed, oil on canvas
59 x 37¼in (149.5 x 95cm)
£4,750–5,750 *P*

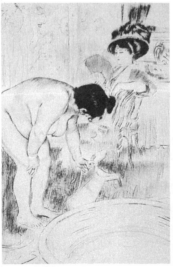

Louis Legrand
French (1863–1951)
Le Tub
Stamped and dated '1909',
numbered '48/65', drypoint and
pencil on laid watermarked paper
8¼ x 5¾in (20.5 x 14.5cm)
£550–650 *EHL*

Sir Edward John Poynter, PRA, RWS
British (1836–1919)
The Cave of the Storm Nymphs
Signed with monogram
and dated, oil on canvas
58¼ x 44¼in (148 x 112cm)
£550,000–700,000 *S*

*In 1969, Poynter's 'The Cave of the
Storm Nymphs' sold at auction for
just £3,518. In 1981, it fetched
£180,000 at Sotheby's and in 1988,
when prices were at their peak it
was bought for £400,000 from
Christie's. Back at Sotheby's in
late 1994, the picture sold for
£500,000, a world record auction
price for the artist.*

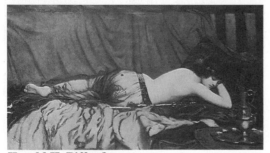

Harold H. Piffard
British (active 1895–99)
The sleeping Model
Signed, oil on canvas
38½ x 66½in (97.5 x 168.5cm)
£11,500–13,500 *S*

Jean Auguste Dominique Ingres
French (1780–1867)
Odalisque
Dated '1825', lithograph on wove paper
5¼ x 8⅛in (13 x 20.5cm)
£3,250–3,500 *EHL*

*An 'Odalisque' (from the Turkish ōdaliq) was
a female slave in an oriental harem. In art, it
refers to the style of voluptuous nudes
portrayed by Ingres and Matisse. Ingres never
visited the Middle East, but choosing an
orientalist subject matter gave him the
freedom to experiment with painting the nude.
His coolly, sensuous pictures received a mixed
response when they were exhibited at the
Paris salons, with some critics objecting to the
fashion in which he distorted the bodies of his
models, as in the present example, where he
elongated the arm and spine to suit the
composition. Ingres refused to be tied by mere
physical exactitude. 'Anatomy, that dreadful
science!' he responded testily. 'If I had had to
learn anatomy, I would never have made
myself a painter!'*

Wilhelm Ferdinand Souchon
German (1825–76)
Imogen from Shakespeare's *Cymbeline*
Signed and dated '1872', oil on canvas
32¾ x 44½in (82 x 113cm)
£6,000–7,000 *C*

Fritz Zuber-Buhler
Swiss (1822–96)
La Rêverie
Signed, oil on canvas
28¾ x 36¼in (73 x 92cm)
£5,500–6,500 *C*

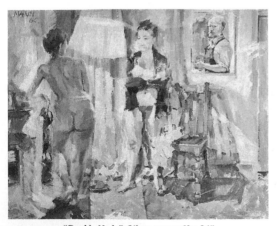

20th Century

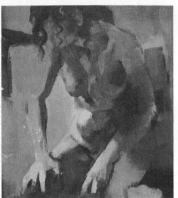

Karl Barrie
British (20thC)
Red Flower Nude
Signed and dated, oil on canvas
12 x 24in (30.5 x 61cm)
£800–1,000 *GK*

l. **Crawford Adamson**
Scottish (b1953)
Seated Woman
Dated '1994', oil on canvas
16 x 14in (40.5 x 35.5cm)
£1,400–1,600 *JGG*

Andrew Christian
British (20thC)
Pin-up
Signed, watercolour
12 x 18in (30.5 x 45.5cm)
£500–600 *GK*

Maurice Cockrill
British (b1936)
Venus & Mars – Edge of Town
Signed and dated '1985',
oil on canvas
30 x 28in (76.5 x 71cm)
£1,500–2,500 *Bon*

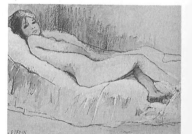

Tom Durkin
British (1928–90)
Nude on the Bed
Acrylics on board
12 x 16in (30.5 x 40.5cm)
£550–650 *WG*

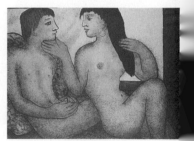

Albert Henry Collings
British (d1947)
Life's Ambitions
Indistinctly dated '1920'(?),
oil on canvas
78¾ x 56¼in (200 x 143cm)
£57,000–70,000 *C*

Sir William Russell Flint, RA
British (1880–1969)
The tall Model – Jennifer
Signed, also signed and titled
on backboard, red chalk on
grey paper
16 x 10in (40.5 x 25cm)
£3,750–4,500 *P*

Francyn
French (20thC)
Innocence
Oil on canvas
18 x 24in (45.5 x 61cm)
£600–700 *GK*

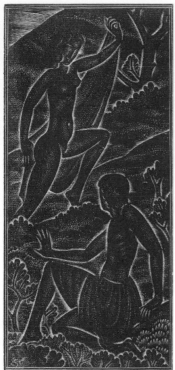

Eric Gill
British (1882–1940)
Vadam ad Montem
Signed and dated '1931',
numbered '12/20', woodcut
on thin laid
5¾ x 2½in (14.5 x 6.5cm)
£350–400 *P*

Harry Holland
Scottish (b1941)
Eyrie
Oil on canvas
54 x 48in (137 x 122cm)
£6,500–7,000 *JGG*

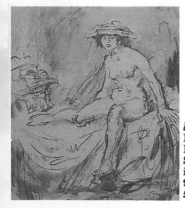

l. **Augustus John, OM, RA**
British (1878–1961)
Ida seated on a Bed
Signed, pen, brush, brown
ink and wash
9¾ x 8¼in (24.5 x 21cm)
£5,500–6,500 *C*

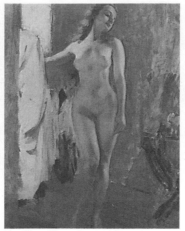

Lucien Grandgerard
French (1880–1970)
Nude
Signed and dated '1944',
oil on canvas
29 x 20in (73.5 x 50.5cm)
£3,000–3,500 *JN*

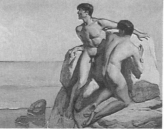

Marcel René von Herrfeldt
French (1890–1965)
Male Nudes on a Rock
Signed, oil on canvas
46 x 58½in (116.5 x 148cm)
£3,750–4,500 *S*

Willem de Kooning
American/Dutch (b1904)
Woman
Signed and dedicated 'To Harold
from Bill', oil and India ink on
paper, c1949
19 x 16½in (48.5 x 42cm)
£79,000–85,000 *S(NY)*

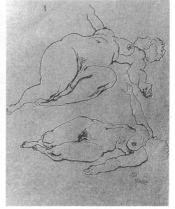

George Grosz
German (1893–1959)
Nude Studies, 1915
Signed and dated '15',
pen and ink
16 x 13½in (40.5 x 34cm)
£2,650–3,000 *BOX*

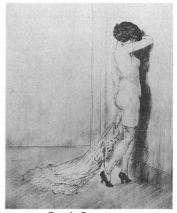

Louis Icart
French (1888–1950)
Nude
Drypoint engraving
18 x 12in (45.5 x 30.5cm)
£1,200–1,500 *GK*

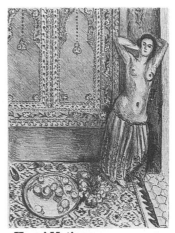

Henri Matisse
French (1869–1954)
Odalisque Debout au Plateau
de Fruits
Signed in pencil and numbered
32/50, lithograph, 1924
14¾ x 10½in (37.5 x 26.5cm)
£16,500–17,000 *S(NY)*

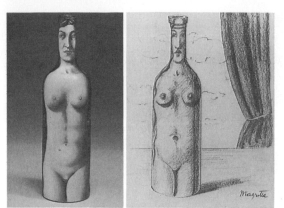

René Magritte
Belgian (1898–1967)
Femme-bouteille and Etude pour Femme-bouteille
The Bottle
Signed, oil on wine bottle
11½in (29cm) high
The Drawing
Signed, pencil on paper
7 x 5½in (17.5 x 14cm)
£83,000–90,000 *S(NY)*

*Magritte started painting bottles during the autumn of
1940 and is known to have painted at least 25, although
the exact number is undetermined. Both this bottle and
the related drawing were executed c1941, making the
bottle one of the earliest works in this series.*

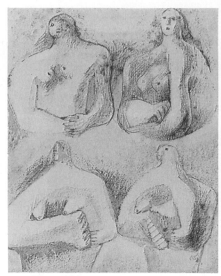

Henry Moore
British (1898–1986)
Study of four Sculptures
Signed and dated '31', grey wash and
charcoal on paper laid down on board
15½ x 12¼in (39.5 x 31cm)
£9,500–10,500 *S(NY)*

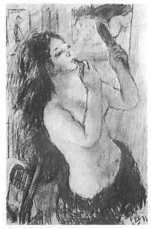

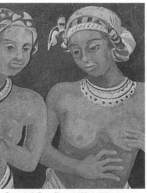

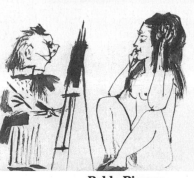

Pablo Picasso
Spanish (1881-1973)
Peintre et Modèle
Signed and dated '23.1.54',
Indian ink on paper
9¼ x 12½in (23 x 32cm)
£27,000–30,000 *S(NY)*

Robert Philipp
American (1895-1981)
Woman putting on Lipstick
Signed, pastel
28½ x 20in (72.5 x 50.5cm)
£300–400 *SK*

Orovida Camille Pissaro
Anglo-French (1893–1968)
Two brown skinned Dariais
28½ x 23½in (72.5 x 60cm)
Oil on canvas
£3,000–3,500 *JN*

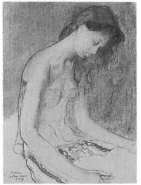

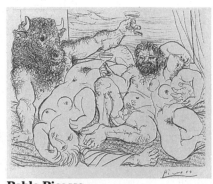

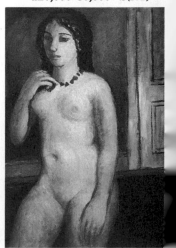

John Ward, CBE, RA
British (20thC)
Gillian
Pastel
12¼ x 9¼in (31 x 23cm)
£2,500–3,000 *BSG*

Pablo Picasso
Spanish (1881-1973)
Scene Bacchique au Minotaure
Signed in pencil, etching, 1933
11¾ x 14¼in (30 x 36cm)
£8,500–9,000 *S(NY)*

Roy Spencer
British (b1918)
Nude
Oil on board
36¼ x 24in (92 x 61cm)
£1,000–1,250 *SHF*

ORIENTALIST

The 19thC saw many artists travelling to the Orient in search of new and exotic subject matter, often at the risk of their own lives. Arthur Bridgman disguised himself in Arab clothing to paint a Moslem feast but was forced to flee when his haik slipped to reveal his European dress. Richard Dadd became insane after suffering from sunstroke in Egypt and Thomas Seddon died of dysentery in Cairo. Edward Lear braved 'rats, mice, cockroaches . . . big frizzly moths . . . and all lesser vermin' in Tirana, was stoned by Albanian peasants who thought he was a devil, and was twice robbed and beaten up by Arab brigands at Petra. 'The landscape painter has two alternatives,' commented Lear philosophically, 'luxury and inconvenience on the one hand, liberty, hard living, and filth on the other; and of these two I choose the latter, as the most professionally useful, although not the most agreeable.'

Lear and his fellow artists were creating views of the Near and Middle East for the Western picture buyer. Today, many of these same views are being bought up by Arab purchasers and returned to the countries that inspired them. In November 1994, Christie's held a sale of Oriental art, their first uniquely devoted to this subject since the 1970s. The auction was a great success, attracting strong Arabian bidding, and setting several world record prices for artists including Gustav Bauernfeind and Carl Haag.

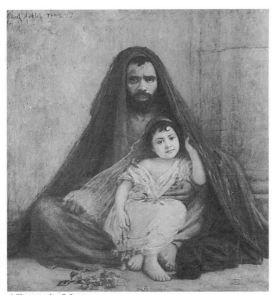

Albert Aublet
French (1851–1938)
Le Mendiant
Signed and dated '1909', oil on canvas
46¼in (117.5cm) square
£19,000–22,000 *C*

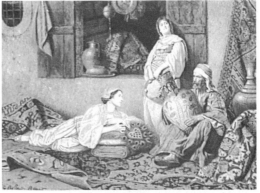

Gian Ballesio
Italian (19thC)
The Harem Scene
Signed and inscribed, oil on canvas
18 x 25in (45.5 x 63.5cm)
£10,500–12,000 *S*

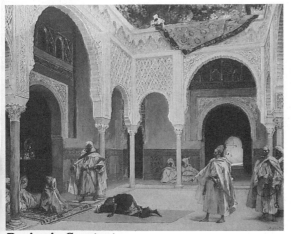

Benjamin Constant
French (1845–1902)
Before the Caid
Signed, oil on canvas
28¼ x 34¼in (72 x 87cm)
£42,000–45,000 *S*

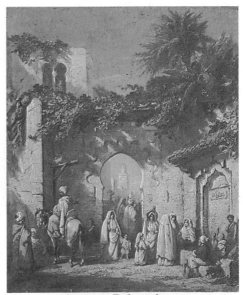

Auguste Delacroix
French (1809–68)
Une Rue de Tétouan
Signed and inscribed, oil on canvas
25¾ x 21¾in (65 x 55cm)
£12,750–14,000 *C*

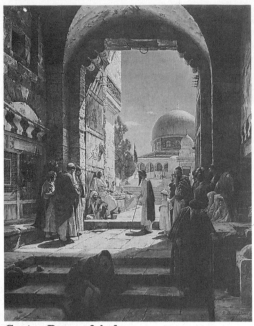

Gustav Bauernfeind
Austrian (1848–1904)
At the Entrance to the Temple
Mount, Jerusalem
Signed and dated '1886', oil on canvas
61¼ x 48½in (155.5 x 123.5cm)
£380,000–400,000 *C*

*Painted during Bauernfeind's second journey to
the Middle East, 1884–7, the present picture set a
new auction record for the artist when it was sold
at Christie's. The painter himself was not entirely
happy with its execution. His client, Englishman
Arthur Sulley, preferred small pictures.
Bauernfeind felt, however, that if this picture was
to create a 'proper stir' when exhibited, it should
be at least 3m square. 'In the event, I am
compelled to squander this happy concept on a
small format in order to earn my living. My
picture measures 120 x 150cm,' he concluded with
resignation. Sulley was more than satisfied and
paid the artist £500.*

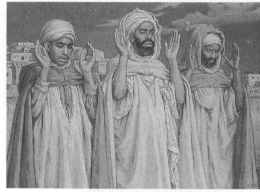

Alphonse-Etienne Dinet
French (1861–1929)
Prière à l'Aube; Première Phase de
la Prière: et Tekbir
Signed, oil on canvas
33½ x 45¼in (85 x 115cm)
£52,000–60,000 *C*

*Dinet's involvement with Algeria
spanned a period of 45 years and the
artist converted to Islam in 1913.*

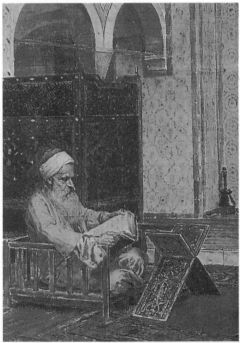

Rudolf Ernst
Austrian (1854–1920)
Reading the Koran
Signed, oil on panel
16 x 12¾in (40.5 x 32cm)
£44,000–50,000 *C*

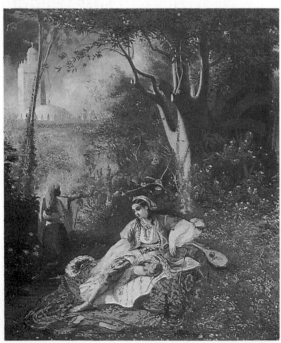

l. **Charles Théodore Frère**
French (1814–88)
An Algerian Woman and her Servant
in a Garden
Signed and dated '1844', oil on canvas
25¾ x 21½in (65.5 x 54.5cm)
£16,000–18,000 *C*

Carl Goebel
Austrian (1824–99)
Turkish Street Urchins
Signed and inscribed, watercolour and pencil
12¼ x 13¾in (32 x 35cm)
£850–1000 *S*

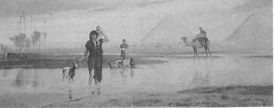

Frederick Goodall, RA
British (1822–1904)
Overflow of the Nile
Signed with monogram, oil on canvas
25¼ x 60¼in (64 x 152.5cm)
£14,000–16,000 *C*

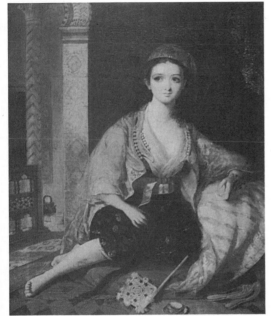

Attributed to Frederick Goodall, RA
British (1822–1904)
An Odalisque
Monogrammed and dated '1877', oil on canvas
24 x 20in (61 x 51cm)
£5,000–6,000 *C*

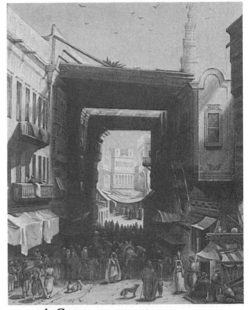

A. Green
British (19thC)
A Turkish Bazaar
Signed with monogram and dated '1872',
oil on board
19 x 15in (48 x 38cm)
£3,500–4,000 *S*

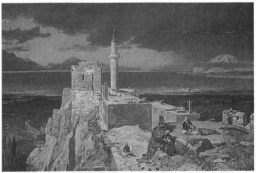

Jules Joseph Augustin Laurens
French (1825–1901)
Van Lake and Fortress, Armenia
Signed, oil on canvas
33 x 49¼in (83.5 x 125cm)
£24,000–25,000 *C*

*In 1846 Laurens left France for the Orient,
accompanied by geographer Xavier Hommaire
de Hell. The artist undertook an arduous
journey to Persia; a route rarely taken by
Westerners. He endured unbelievable hardships,
thirst, starvation and sickness and his
companion died of fever. Negotiating dangerous
and almost impassable routes, at each perilous
stop Laurens sketched the people and landscape
of the East.*

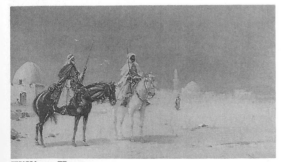

William Knox
British (20thC)
A Sheikh with his Son on Horseback by a
Desert Town
Signed, watercolour heightened with white
11½ x 19in (29 x 48cm)
£450–600 *CSK*

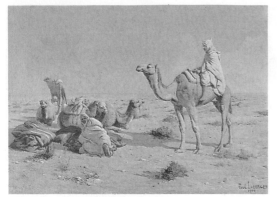

Jean Baptiste Paul Lazerges
French (1845–1902)
The Halt
Signed and dated '1909', oil on canvas
28¼ x 35½in (72 x 90.5cm)
£11,000–12,000 *C*

Lazerges specialised in painting camels.

August Loeffler
German (1875–1955)
Bethlehem
Signed, oil on canvas
41¼ x 57½in (104.5 x 146cm)
£11,500–12,500 *S*

John Frederick Lewis, RA, POWS
British (1805–76)
Turkish Smoker
Inscribed, watercolour and
black chalk
16¼ x 10¾in (41 x 27cm)
£2,800–3,500 *P*

*Lewis was another artist who
according to his contemporaries 'went
native'. He spent some 10 years in the
Orient, adopting Arab clothing and
customs. According to the writer
Thackeray, who visited him in 1844,
Lewis resided in Oriental splendour
in Cairo 'a dreamy, hazy, lazy,
tobaccofied life', and when he wearied
of languid luxury retired to the desert
to live under canvas and the stars.*

Clive McCartney
British (b1960)
Ksour near Sahara, Evening
Acrylic on board
8 x 11in (20 x 28cm)
£500–600 *GG*

*Inspired by Orientalist painters from Delacroix to
Matisse and writers such as Albert Camus and
T. E. Lawrence, artist Clive McCartney made two
successive journeys to the remote regions of Morocco.
'I travelled with lightweight easel, watercolours,
drawing materials and a camera,' he writes. 'In the
South I discovered a people still largely untouched by
the sophistication of the northern cities. Living in
mud-brick ksoucks, grinding (by hand) the wheat of
their bread and inscribing their doorways and bodies
with magical signs to ward off evil spirits.'*

r. **Rappini**
Italian (20thC)
Arabian desert Scene
Signed, watercolour
14 x 10½in (35.5 x 26.5cm)
£375–475 *BWe*

Henri Emilien Rousseau
French (1875–1933)
Arab Horseman with Hound
Signed, oil on canvas
26 x 21in (66 x 54cm)
£10,000–11,000 *S*

David Roberts, RA
British (1796–1864)
Jerusalem from the South-East
Oil on canvas
48 x 84in (122 x 213cm)
£125,000–145,000 *C*

*'I begin to be very tired of Jerusalem,' wrote
Roberts in April 1839, 'surely there cannot be
any city more wretched. How has the mighty
fallen! I have wandered over the hills today
in the burning sun, to find a good view of the
once mighty city, but without success, the
walls being almost all that is visible; within
them all is misery . . .'*

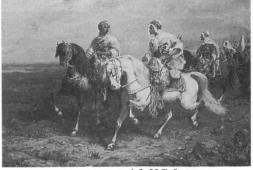

Adolf Schreyer
German (1828–99)
Arab Horsemen
Signed, oil on panel
15 x 21½in (38 x 54.5cm)
£21,000–25,000 *C*

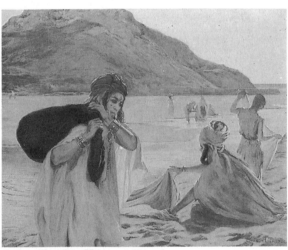

Jules Charles Clément Taupin
French (1863–1931)
Washing Clothes in the Wadi
Signed, oil on canvas
18¼ x 21¾in (46 x 55cm)
£6,500–8,000 *C*

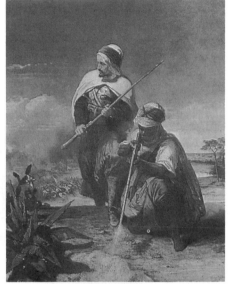

Ernest Slingeneyer
Belgian (1820–94)
Deux Arabes en Embuscade
Signed and dated '52', oil on canvas
36¼ x 28¾in (92 x 73cm)
£8,000–10,000 *C*

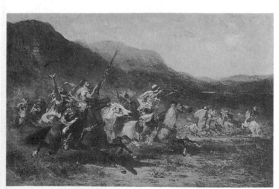

Georges Washington
French (1827–1910)
The Attack
Signed, oil on panel
9 x 13in (22.5 x 33cm)
£7,000–8,000 *C*

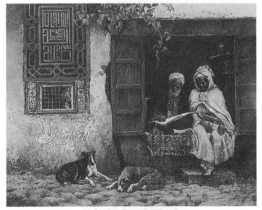

Edwin Lord Weeks
Anglo/American (1849–1903)
A Visit to the Scribe
Signed and inscribed, oil on canvas
19¾ x 25in (50 x 63.5cm)
£18,000–20,000 *C*

PEOPLE

'Of all things the perfection is to imitate the face of mankind,' claimed the great miniatuarist and portrait painter Nicholas Hilliard in 1598. Portraiture is one of the few branches of art in which the British have excelled and for which there has always been a continuous demand – 'The cursed face business,' bemoaned Gainsborough who was forced to earn his living as a portraitist. 'I'm sick of portraits and wish very much to . . . walk off to some sweet village where I can paint landscapes.'

Because of the huge number of portraits painted over the centuries, many still come on the market today, particularly from the 17th and 18thC. 'I think portraits from this period are still very undervalued,' says Andrew McKenzie from the Old Master paintings department at Phillips. 'In the early 20thC such portraits were the height of fashion, but this is no longer the case. Today's collectors often seem to prefer either more academic old masters (religious or mythological scenes) or decorative subjects such as landscapes or still lifes.'

But what makes a desirable portrait? 'Quality and artist is all important,' says McKenzie. 'Obviously an outstanding painting by an important painter will always sell, but even a dull portrait by a major name will have a significant value. For more run-of-the-mill portraits by lesser known painters, an attractive image is all important. A pretty woman is far easier to sell than an old man, and a decorative setting can also help: the inclusion of animals, a parrot, fruit, flowers – anything that enhances the look of the picture.'

Also crucial is the identity of the sitter. Finding out about the person behind the portrait not only brings it to life but also provides a means to market it, as McKenzie explains. 'If we have a picture of a soldier, we will contact the regiment to which he belonged, with a portrait of a nobleman we might get in touch with family descendants; museums and academic institutions will often purchase portraits of scientists, writers or other notable figures.'

Nineteenth and 20thC portraits appear less frequently on the market and often tend to fetch comparatively low prices unless the artist or sitter is particularly well known. 'People sometimes worry about hanging someone else's great-grandmother on their wall and can shy away from buying early 20thC portraits which is quite wrong,' says dealer Christopher Wood. 'There are some really magnificent portraits from this period, pictures that are great art and not just a miscellaneous relative.'

Men & Women 16th–17th Century

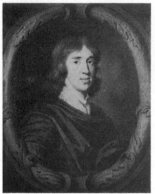

Circle of Mary Beale
British (1633–99)
Portrait of John Hough, later Bishop of Worcester
Oil on canvas
31 x 25½in (79 x 65cm)
£1,900–2,200 P

Mary Beale could be seen as a rare example of a 17thC feminist. While her husband managed the household, undertaking much of the care of their 2 sons, Mary Beale was a successful portrait painter. The daughter of a rector, she specialised in painting the clergy, charging £5–10 for a portrait and enjoying a flourishing practice in London. The use of an oval surround, painted to simulate carved stone, was typical of her work.

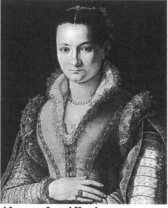

Alessandro Allori
Italian (1535–1607)
Portrait of a young Lady
Oil on canvas
26 x 21¼in (66 x 54cm)
£35,000–37,000 S(NY)

One of the great charms of portraits, is the dramatic stories lying behind the sitters. The young lady in the present portrait has been identified as Bianca Capello de'Medici, member of a wealthy Venetian family. At 17, she eloped with Piero Bonaventura an impoverished Florentine. A bounty of 2000 ducats was put on Piero's head, but the couple escaped to Florence where they lived in abject poverty. Their fortunes changed when Francesco de'Medici, son of the Grand Duke of Tuscany, saw Bianca doing her laundry and fell instantly in love with her. He used his influence to give her husband high office and when Piero was conveniently murdered, Bianca became Francesco's mistress and married him after the death of his first wife in 1578. Nine years later, they both died after a banquet, presumably poisoned.

r. **Quiringh Gerritsz. van Brekelenkam**
Dutch (1620–68)
Interior with a Man dressing, behind him a Boy in attendance
Signed with initials and dated '1661', oil on canvas
27¾ x 21in (71 x 53cm)
£30,000–35,000 S

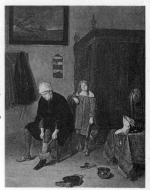

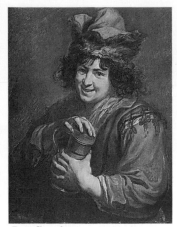

Jan Cossiers
Flemish (1600–71)
A young Man holding a
Tankard
Oil on panel
29¼ x 22½in (74 x 57cm)
£16,000–18,000 *S*

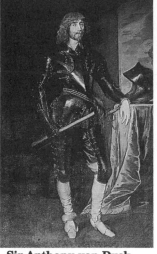

Sir Anthony van Dyck
Flemish (1599–1641)
Portrait of George Hay,
2nd Earl of Kinnoull
Oil on canvas
86 x 52in (218.5 x 132cm)
£85,000–90,000 *S*

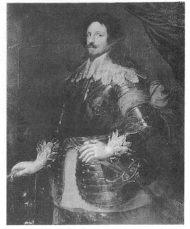

**Follower of Sir Anthony
van Dyck**
Flemish (1599–1641)
Portrait of Prince Thomas of Savoy
Oil on canvas
53 x 39½in (134.5 x 100cm)
£10,000–12,000 *CSK*

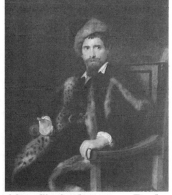

After Sir Anthony van Dyck
Flemish (1599–1641)
Portrait of a Gentleman,
thought to be an Actor
Oil on canvas
19½ x 15¾in (49.5 x 40cm)
£600–800 *CSK*

Circle of Lavinia Fontana
Italian (1552–1614)
Portrait of a Lady
Oil on canvas
17¾ x 14¼in (45 x 36cm)
£2,300–2,800 *P*

Follower of Gortzius Geldorp
Flemish (1553–1618)
Portrait of a Lady wearing a
lace Cap and a Ruff
Oil on panel
17½ x 14½in (44 x 37cm)
£600–800 *Bea*

Circle of Thomas Gibson
British (1680–1751)
Portrait of an Artist
Oil on canvas
29¾ x 24¼in (74.5 x 62cm)
£1,200–1,500 *CSK*

**Follower of Gerrit
van Honthorst**
Dutch (1590–1656)
Portrait of a Gentleman
possibly Prince Rupert,
Count Palatine
Oil on canvas
30 x 25in (76 x 63.5cm)
£1,200–1,500 *P*

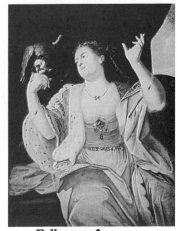

**Follower of
Abraham Janssens**
Flemish (1575–1632)
A Lady with a Parrot
Oil on canvas
47½ x 35¾in (120.5 x 91cm)
£4,000–5,000 *S*

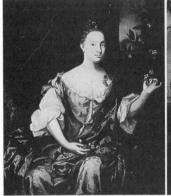

Circle of Johann Kerseboom
British (active 1680s–1708)
Portraits of Admiral McCulloch
and his Wife
A pair, oil on canvas
48 x 39½in (122 x 100cm)
£4,500–5,500 *S*

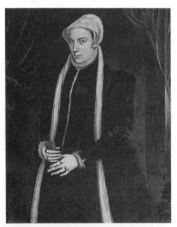

Follower of Willem Key
Flemish (1520–68)
Portrait of a Lady holding Gloves
Oil on canvas
44 x 33⅓in (111.5 x 85cm)
£2,000–2,500 *C*

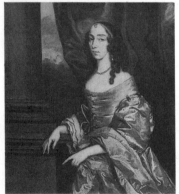

Circle of Sir Peter Lely
British (1618–80)
Portrait of a Lady
Oil on canvas
50 x 40in (127 x 101.5cm)
£1,200–1,500 *Bon*

Sir Peter Lely
British (1618–80)
Portrait of Lady Elizabeth Percy,
later Wife of Charles, 6th Duke
of Somerset
Oil on canvas
50 x 40in (127 x 101.5cm)
£28,000–33,000 *S*

*By the age of 15 Lady Elizabeth
had already had three husbands.
The first died of illness, the
second Thomas Thynne was
assassinated and she eventually
married the handsome and
arrogant courtier Charles
Seymour, 6th Duke of Somerset
(1662–1748), known as 'the Proud
Duke'. The couple were great
favourites of Queen Anne,
although they were less than
popular with many of their
contemporaries. In 1711, writer
Jonathan Swift published a
celebrated lampoon on Lady
Elizabeth, satirising her red hair,
'beware of carrots from
Northumberland', and
accusing her of murdering her
second husband.*

r. **Nicolaes Maes**
Dutch (1634–93)
Portrait of a Gentleman
Oil on canvas
29 x 25¾in (74 x 65.5cm)
£4,000–5,000 *C*

**Studio of Sir Godfrey
Kneller**
British (1646–1723)
Portrait of Lady Mary Wortley
Montagu
Oil on canvas
30¾ x 25½in (78 x 65cm)
£5,000–6,000 *P*

*Lady Mary Wortley Montagu
(1689–1762) was a remarkable
character. Traveller, writer and
society figure she was famed for
her published letters, her
flamboyant character, and
perhaps most importantly for
introducing the practice of
smallpox inoculation to
England, thus saving
thousands of lives (she herself
had lost her eyelashes and been
disfigured by the disease).
Kneller was commissioned to
paint Lady Mary by the poet
and satirist Alexander Pope.
Pope idolised her until they had
a disastrous quarrel – he then
attacked her viciously in verse
and the pair conducted a long
and bitter feud both in private
and in print.*

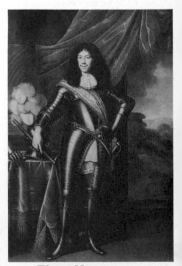

Pieter Nason
Dutch (1612–88)
Portrait of a Gentleman,
possibly a Member of the
Hohenzollern Family
Signed and dated '1674',
oil on canvas
89½ x 59in (227 x 149.5cm)
£16,500–18,000 *C*

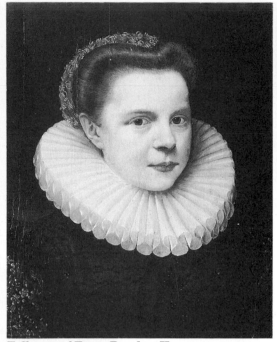

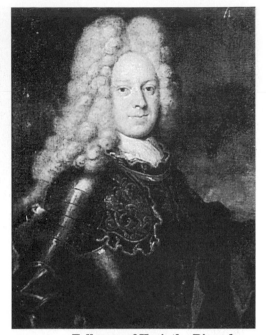

Follower of Frans Pourbus II
Flemish (1570–1622)
Portrait of a young Lady
Dated '1584', oil on panel
19 x 16in (48 x 40.5cm)
£6,500–7,500 *C*

Follower of Hycinthe Rigaud
French (1659–1743)
Portrait of Colonel William Congreve
Oil on canvas
31½ x 25¾in (80 x 65.5cm)
£1,300–1,600 *P*

The National Portrait Gallery, London (0171 306 0055)
and the Royal Society of British Portrait Painters at
the Mall Galleries, (0171 930 6844) both hold files of
portraits by contemporary painters and offer a contact
service between artist and sitter.

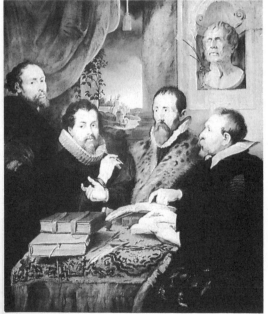

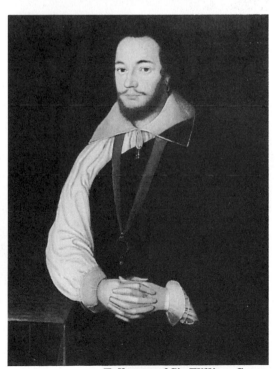

After Sir Peter Paul Rubens
Flemish (1577–1640)
The four Philosophers – Rubens, his
brother Philip, Justus Lipsius and
Jan van de Wouwere
Oil on canvas
66 x 55in (167.5 x 139.5cm)
£5,500–6,500 *CSK*

After the picture in the Pitti Palace, Florence.

Follower of Sir William Segar
British (16th/17thC)
Portrait of a Gentleman
Oil on panel
34¼in x 27in (87 x 68.5cm)
£1,400–1,800 *CSK*

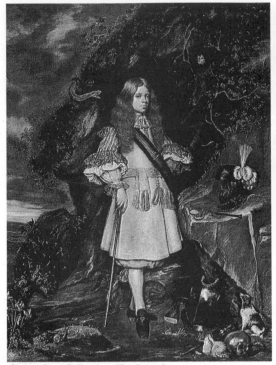

Gerard and Gesina Terborch
Dutch (1617–81 and 1631–90)
Posthumous Portrait of
Moses Terborch
Oil on canvas
30 x 22¼in (76 x 56.5cm)
£230,000–250,000 *S(NY)*

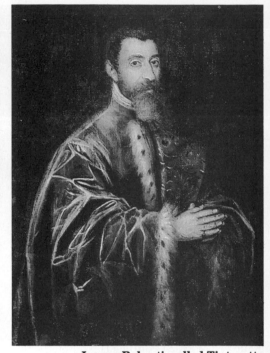

Jacopo Robusti, called Tintoretto
Italian (1518–94)
Portrait of a Venetian Senator
Oil on canvas
45¼ x 33in (115 x 83.5cm)
£8,000–9,000 *P*

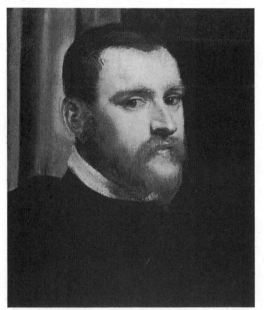

Jacopo Robusti, called Tintoretto
Italian (1518–94)
Portrait of a Gentleman
Oil on canvas
19¼ x 16in (49 x 40.5cm)
£68,000–75,000 *S(NY)*

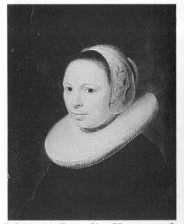

Johannes Cornelisz Verspronck
Dutch (1597–1662)
Portrait of a Lady
Oil on panel
12½ x 9⅝in (32 x 24.5cm)
£5,500–6,500 *P*

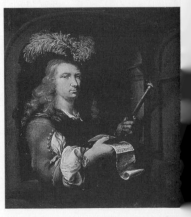

r. **Circle of Adriaen van
der Werff**
Dutch (1659–1722)
Portrait of a Gentleman
Signed and dated '1660',
oil on canvas
38 x 33¾in (96.5 x 86cm)
£4,000–5,000 *C*

**Miller's is a price GUIDE
not a price LIST**

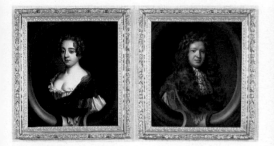

Mary Beale
British (1633–99)
Portraits of Richard Beavis and his wife Margaret
Oil on canvas
29 x 24in (74 x 61cm)
£3,750–4,000 *WWG*

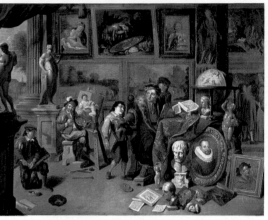

Follower of Balthasar van den Bossche
Flemish (1681–1715)
An Artist's Studio
Oil on canvas
34½in x 47½in (87.5 x 120cm)
£6,750–7,750 *CSK*

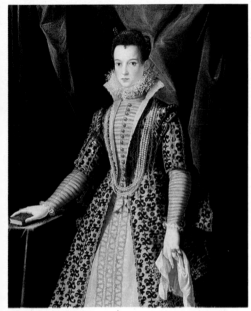

Florentine School (c1575)
Portrait of a young woman in an Embroidered
Dress and Pearls
Oil on canvas
52 x 40½in (132 x 102cm)
£85,000–90,000 *S(NY)*

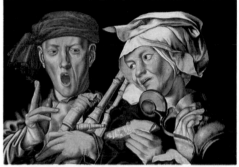

Follower of Jan Sanders van Hemessen
Flemish (1504–66)
A Piper with a Peasant Woman
Oil on panel
18 x 25in (45.5 x63.5cm)
£7,000–8,000 *S*

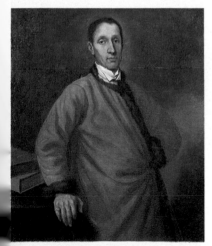

**Studio of Vittore Ghislandi, called
Fra Galgario**
Italian (1655–1743)
Portrait of a Gentleman
Oil on canvas
40½in x 32½in (102 x 82.5cm)
£22,000–25,000 *P*

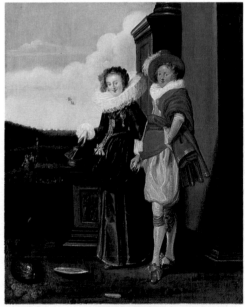

Dirck Hals
Dutch (1591–1656)
Elegant couple
Oil on panel
14½in x 11¼in (37 x 28.5cm)
£21,000–25,000 *S(NY)*

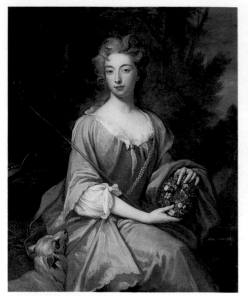

Sir Godfrey Kneller
British (1646–1723)
Portrait of a Lady
Signed, oil on canvas
48 x 39in (122 x 99cm)
£16,000–18,000 *S*

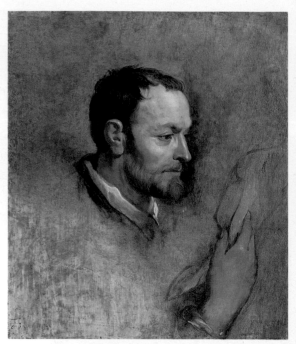

Attributed to Sir Peter Paul Rubens
Flemish (1577–1640)
Study of the Head and right Hand
of Nicolaas Rock-ox
Oil on oak panel
26¼ x 22¼in (66.7 x 56.5cm)
£290,000–300,000 *S(NY)*

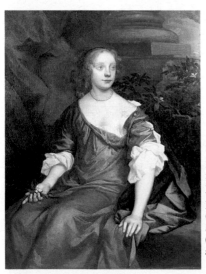

**Studio of
Sir Peter Lely**
British (1618–1680)
Portrait, said to be of
the Countess of
Rochester
Oil on canvas
50 x 40in
(127 x 101.5cm)
£3,500–4,000 *P*

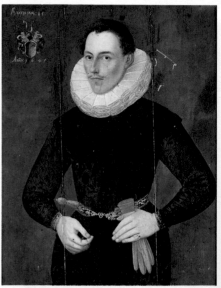

Pieter Pietersz.
Flemish (1540–1603)
Portrait of a Gentleman
Inscribed and dated '1605',
bears coat-of-arms, oil on panel
34¾ x 26in (88 x 66cm)
£3,000–3,500 *P*

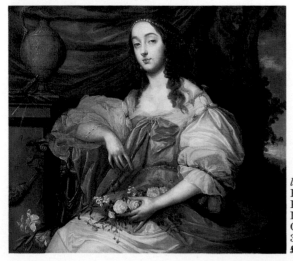

l. **John Michael Wright**
British (1623–1700)
Portrait of a Lady, possibly Lady Anne Somerset,
Duchess of Norfolk
Oil on canvas
39 x 43¼in (99 x 110cm)
£9,500–10,500 *S*

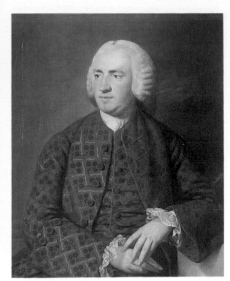

Sir Nathaniel Dance, RA
British (1734–1811)
Portrait of Peter Delmé
Oil on canvas
36 x 27½in (91.5 x 70.5cm)
£5,000–6,000 *C*

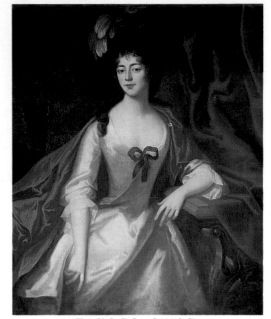

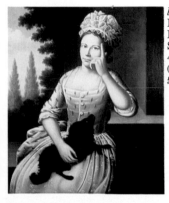

l. **J.H. Kramer**
British (18thC)
Primitive portrait of a lady
Signed, oil on canvas
43½ x 39½in
(110 x 100cm)
£5,000–5,500 *RdR*

English School (18thC)
Portrait of a lady, said to be Charlotte
Fitzroy, wife of Edward Henry Lee,
Earl of the City of Lichfield
Oil on canvas
49¼ x 39¼in (125 x 99.5cm)
£6,000–6,500 *S*

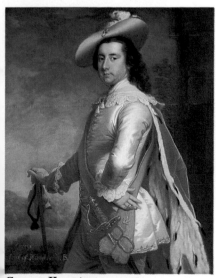

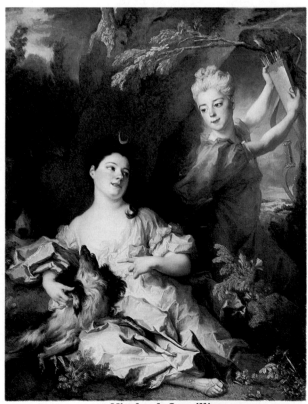

George Knapton
British (1698–1778)
Portrait of George Montague Dunk,
2nd Earl of Halifax
Inscribed, oil on canvas
50⅛ x 40in (128 x 101.5cm)
£8,750–9,750 *C*

Nicolas de Largillierre
French (1656–1746)
Portrait of the Comtesse de Montsoreau
and her sister
Inscribed on reverse, oil on canvas
56¾ x 44¼in (144 x 112cm)
£290,000–300,000 *S(NY)*

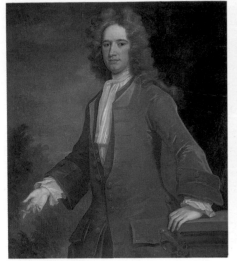

Charles Jervas
British (1675–1739)
Portrait of Edward Wortley Montagu
Oil on canvas
48¾ x 39⅜in (124 x 101cm)
£8,750–10,000 *S*

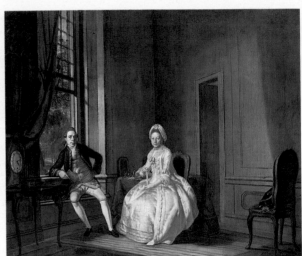

Hermanus Numan
Dutch (1744–1820)
Portrait of the Poet Johannes Nomsz and his
Wife in their Sitting Room, Amsterdam
Oil on canvas
27¼ x 32⅜in (69 x 83cm)
£14,500–15,500 *S(NY)*

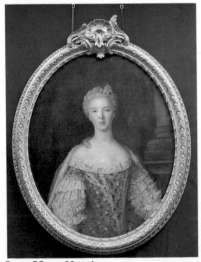

Jean Marc Nattier
French (1685–1766)
Portrait of Princess Victoire
Oil on canvas
37½ x 29½in (95 x 75cm)
£5,750–6,750 *DN*

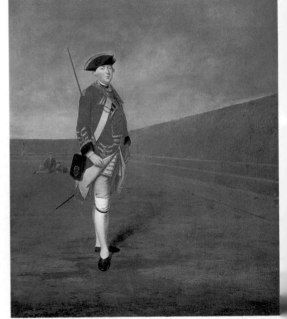

Edward Penny, RA
British (1714–91)
Portrait of an Officer of the Cornwall Militia, c1760
Oil on canvas
29¼ x 24½in (74 x 62cm)
£32,000–36,000 *S*

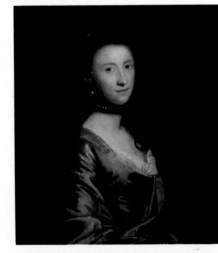

l. **Sir Joshua Reynolds**
British (1723–92)
My favourite Lady
Oil on canvas, 1740
30 x 25in (76 x 64cm)
£17,500–18,500 *BRG*

r. **Thomas Pope-Stephens**
Irish (active 1771–80)
Portrait of John Reilly,
MP of Scarvagh
Oil on canvas
48½ x 39in (123 x 99cm)
£6,500–7,500 *S*

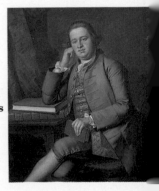

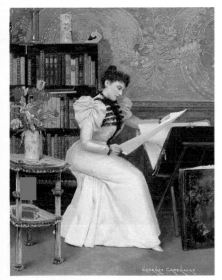

Frederico Andreotti
Italian (1847–1930)
An Interesting Letter
Signed, oil on canvas
29½ x 23½in (75 x 60cm)
£54,000–58,000 *BuP*

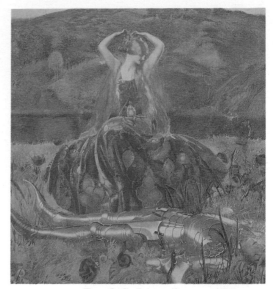

Frank Cadogan Cowper, RA
British (1877–1958)
La Belle Dame Sans Merci
Signed and dated '1946', watercolour
30 x 28½in (76 x 72.5cm)
£18,500–19,500 *CW*

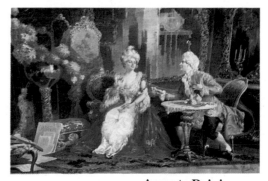

Augusto Daini
Italian (19thC)
A Gift of Flowers
Oil on canvas
15 x 23in (38 x 58.5cm)
£3,000–3,800 *HFA*

Georges Croegaret
French (1848–1923)
The Elegant Connoisseur
Signed, oil on panel
13 x 9½in (33 x 24cm)
£5,750–6,750 *P*

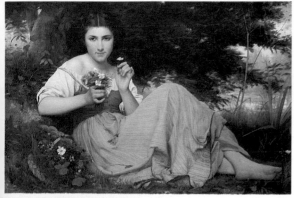

François-Alfred Delobbe
French (1835–1920)
A Moment's Rest
Signed and dated '1871', oil on canvas
35¾ x 50in (91 x 127cm)
£6,500–7,500 *C*

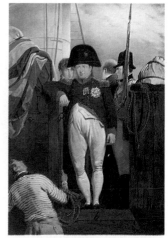

Sir Charles Lock Eastlake, PRA
British (1793–1865)
Napoleon on board
HMS *Bellerophon*
Oil on canvas
23½ x 16¼in (59.5 x 42cm)
£13,500–14,500 *S*

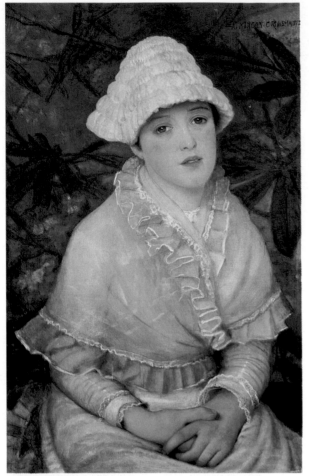

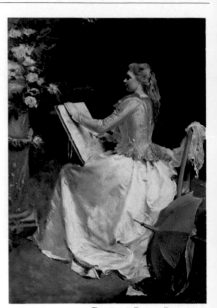

Gustav Jean Jacquet
French (b 1846)
Flowers Study
Oil on panel
13 x 10in (33 x 25cm)
£18,500–19,000 *HFA*

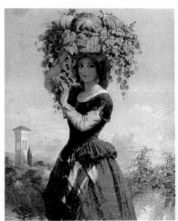

John Atikinson Grimshaw
British (1836–93)
My Wee White Rose
Signed and dated '1882',
oil on canvas
30 x 19in (76 x 48.5cm)
£26,000–30,000 *C*

r. **John Adam Houston, RSA**
British (1812–84)
An Italian Fruit Seller
Signed, oil on canvas
24½ x 19½in (63 x 49.5cm)
£3,000–4,000 *Bon*

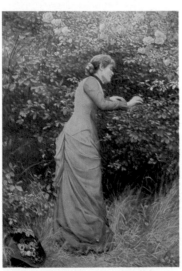

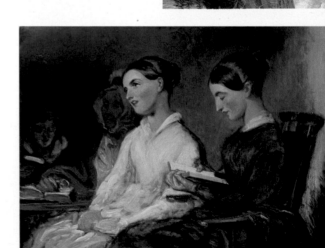

Edward Killingworth Johnson, RWS
British (1825–1923)
The Bird's Nest
Signed and dated '1878', watercolour
and gouache
27 x 18½in (69 x 47cm)
£16,000–16,750 *Pol*

Sir Edwin Landseer
British (1802–73)
My Wife
Signed and inscribed on reverse,
oil on panel
14 x 18in (36 x 46cm)
£16,500–17,500 *BRG*

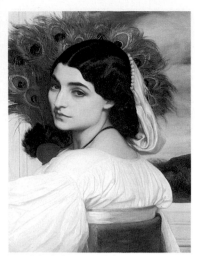

Lord Leighton, PRA
British (1830–96)
Pavonia
Oil on canvas
21 x 16½in (53 x 42cm)
£240,000–250,000 *CW*

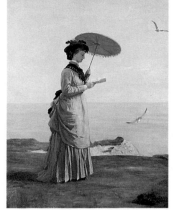

Valentine Cameron Prinsep, RA
British (1838–1904)
Lady Tennyson
Oil on canvas
34½ x 26in
(87 x 66cm)
£30,000–35,000 *CW*

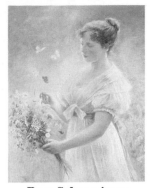

Rosa Schweninger
Austrian (19thC)
Arranging the Bouquet
Signed, pastel
37 x 27in (94 x 69cm)
£2,000–2,500 *S*

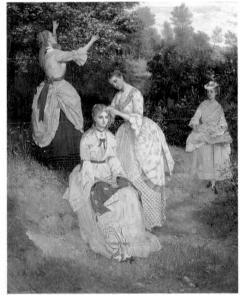

William Oliver
British (1804–53)
A Springtime Idyll
Signed and dated '1871',
oil on canvas
50½ x 40½in (128 x 102cm)
£13,000–14,000 *P*

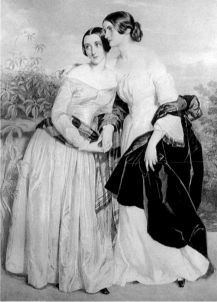

George Richmond
British (1809–96)
Mrs Partridge and her Sister
Watercolour, heightened with white
39½ x 26in (100 x 74cm)
£1,500–2,500 *Bon*

Franz Xavier Winterhalter
German (1806–73)
Untitled
Oil on canvas
30 x 25in (76 x 63.5cm)
£3,250–3,750 *FdeL*

Giuseppe Signorini
Italian (1857–1932)
Madrigale
Signed and inscribed, pencil
and watercolour
13½ x 9½in (34.5 x 24cm)
£1,700–2,000 *C*

Wilhelm Trautschold
German (1815–1877)
Portrait of a young Man
Signed and dated '1862',
oil on canvas
24 x 20in (60 x 50.8cm)
£4,750–5,500 *C*

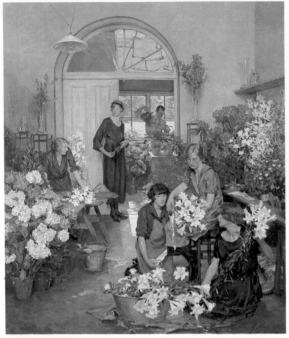

Anna Airy
British (1882–1964)
The Flower Shop
Signed and dated '1922'
Oil on canvas
71 x 60in (180 x 152cm)
£55,000–65,000 *Bon*

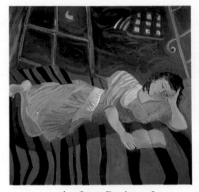

Anthea Craigmyle
British (b1933)
Girl Reading by a Window
Oil on canvas
24in (61cm) square
£550–600 *SHF*

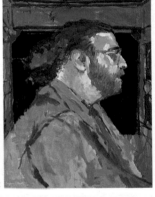

r. **Eugène Fisk**
British (b1938)
Matthew Epstein
Oil on board
22 x 17in
(56 x 43cm)
£1,300–1,500 *KG*

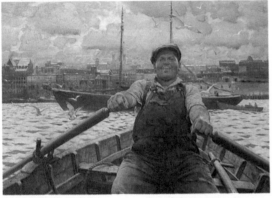

Franklin Arbuckle
Canadian (b1909)
St John's Harboour
Newfoundland
Oil on canvas
24 x 32in (61 x 81cm)
£2,000–2,500 *E*

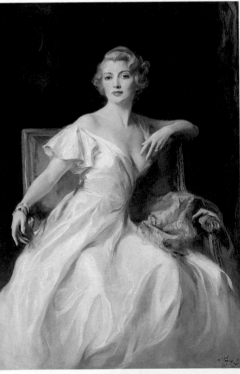

Imre Goth RP
Hungarian (1893–1982)
Judy
Signed verso
Oil on canvas
20 x 16in (51 x 41cm)
£2,250–2,450 *JN*

Catherine Arnold
British (20C)
Portrait of Bob Lucy
Oil on canvas
16 x 12in (41 x 31cm)
£450–500 *VCG*

Philip Alexius de Laszlo
British (1869–1937)
The White Dress
Oil on canvas
50 x 40in (127 x 101.5cm)
£30,000–35,000 *CW*

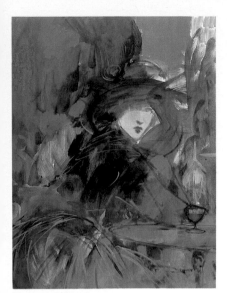

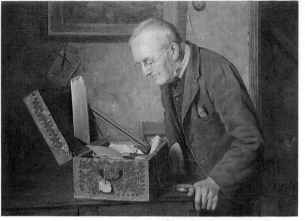

Charles Spencelayh
British (1865–1958)
Treasures
Signed, oil on canvas
15½ x 19½in (39.5 x 49.5cm)
£32,000–36,000 *S(S)*

Robert Plisnier
British (20thC)
At the Café
Oil on card
32 x 22in (81.5 x 56cm)
£800–1,000 *BSG*

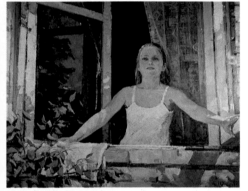

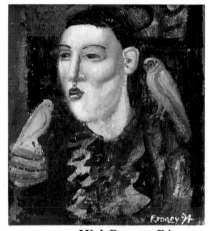

Vitali Shepetovsky
Ukranian (1927–88)
Morning, 1962
Oil on canvas
38 x 45in (96.5 x 114cm)
£12,000–12,500 *CE*

Mick Rooney, RA
British (20thC)
Boy with two Birds
Signed, oil on panel, 1994
10 x 8in (25 x 20cm)
£1,450–1,650 *BRG*

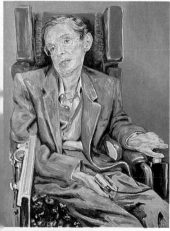

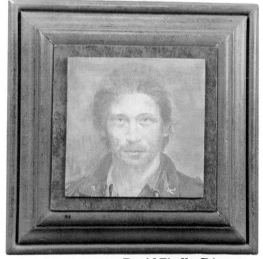

Ursula Wieland
German (b1939)
Portrait of Stephen Hawking
Oil on canvas
32 x 23½in (81.5 x 60cm)
£1,200–1,500 *C*

David Tindle, RA
British (b1932)
Kenny Jones
Signed, egg tempera, c1980
6in (15cm) square
£2,200–2,250 *BRG*

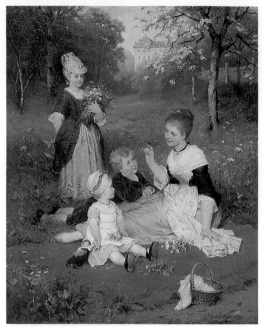

Julius Robert Beyschlag
German (1838–1903)
Maikäfer flieg!
Signed, oil on canvas
28¼ x 22½in (72 x 56cm)
£11,500–12,500 *C*

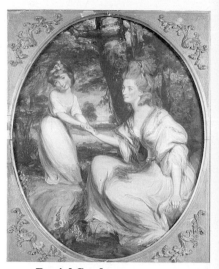

Daniel Gardner
British (1750–1805)
Portrait of a Lady and her Daughter
Gouache and pastel
30 x 24in (76 x 61cm)
£4,500–5,500 *DN*

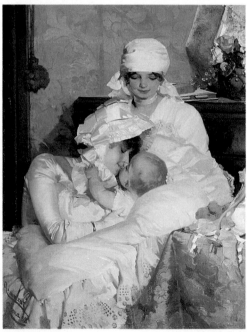

Ferenc Innocent
Hungarian (b1859)
Motherly Love
Signed and dated '83', oil on canvas
39½ x 30in (100 x 76cm)
£17,500–18,500 *C*

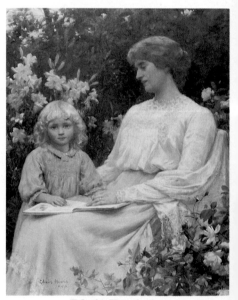

Edwin Harris
British (1855–1906)
Study of a Mother and Child
Signed and dated, oil on canvas
51½ x 39½in (130 x 100cm)
£7,500–8,500 *WL*

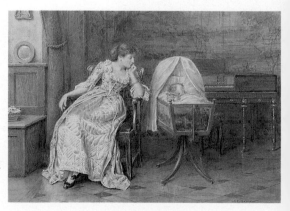

r. **George Goodwin Kilburne**
British (1839–1924)
An Interior with a Mother and Child
Signed, pencil and watercolour
10 x 14in (25 x 36cm)
£2,800–3,500 *C*

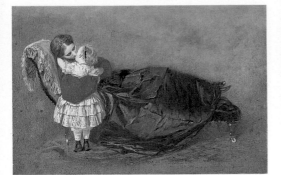

George Elgar Hicks, RA
British (1824–1914)
Good Night
Signed and dated '1863', oil on paper
16½ x 23in (42 x 59cm)
£13,500–14,500 *CW*

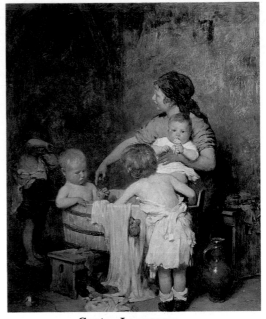

Gustav Laeverenz
German (1851–1909)
Saturday Night
Signed and dated '1876', oil on panel
15½ x 12½in (39 x 32cm)
£10,500–11,500 *C*

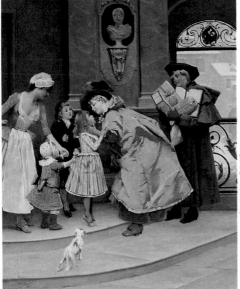

l. **Emile August Pinchart**
French (1842–1924)
The Homecoming
Signed, oil on canvas
36½ x 28½in (92 x 72cm)
£12,000–13,000 *C*

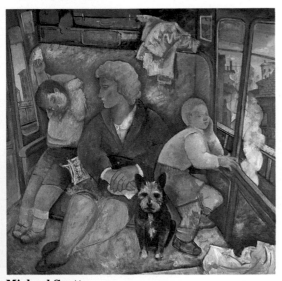

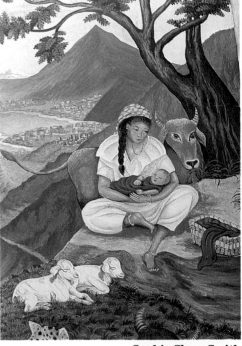

Michael Scott
Scottish (b1946)
The Journey
Oil on canvas
48in (122cm) square
£4,000–4,500 *CON*

Sophie Shaw-Smith
Irish (b1967)
Peaceful Kingdom
Gouache
22 x 31in (56 x 79cm)
£800–900 *SOL*

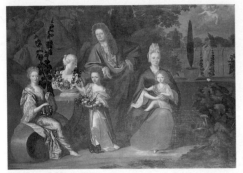

Richard Van Bleeck
Dutch (1670–1733)
A Family Portrait
Signed, oil on canvas laid down on panel
37¼ x 49in (95 x 124.5cm)
£3,700–4,500 *P*

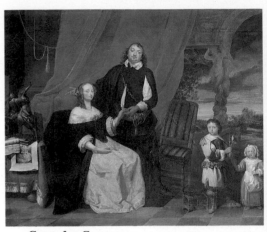

Gonzales Coques
Flemish (1618–84)
A portrait of David Ryckaert III and his Family
Oil on panel
25 x 29in (64 x 73.5cm)
£17,500–18,500 *C*

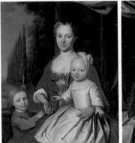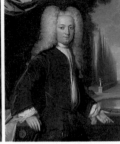

Gerrit Alberts
Dutch (1690–1750)
A Portrait of Christoffel van de Berghe and
his Wife, Anna Maria van Benthem
A pair, inscribed, oil on canvas
28 x 23¼in (71 x 59.5cm)
£3,700–4,500 *P*

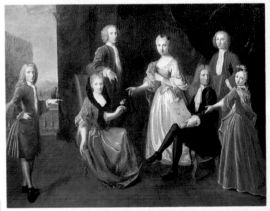

Anglo-Dutch School (early 18thC)
A portrait of a Lady and Gentleman
with three Sons and two Daughters
Oil on canvas
30 x 38½in (76 x 97cm)
£3,200–5,000 *Bon*

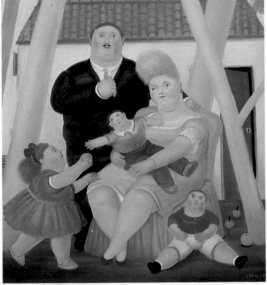

Fernando Botero
Columbian (b1932)
La Familia
Signed and dated '79', oil on canvas
35½ x 32in (90 x 81cm)
£185,000–200,000 *S(NY)*

Maude Goodman
British (active 1874–1901)
And they lived Happily ever After
Signed and dated '94', oil on canvas
24 x 36in (61 x 91.5cm)
£10,000–12,000 *C*

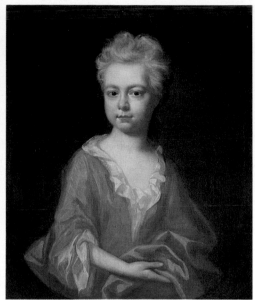

Attributed to John Clösterman
German (1670–1711)
Portrait of the Daughter of William Congreve
Oil on canvas, in a painted oval
30 x 25in (76 x 63.5cm)
£3,300–3,800 *P*

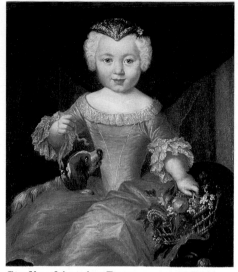

Studio of Antoine Pesne
French (1683–1757)
Portrait of a Young Girl, holding a Basket of
Flowers in one Hand and a Spaniel in the other
Oil on canvas
27 x 23in (69 x 59cm)
£7,000–9,000 *P*

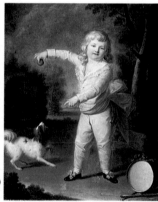

r. **Joseph Hickel**
Austrian (1736–1807)
Portrait of a Young Boy
standing in a Landscape,
with his Drum and his
Dog by his Side
Signed, oil on canvas
51½ x 42in (131 x 106.5cm)
£3,500–4,500 *S*

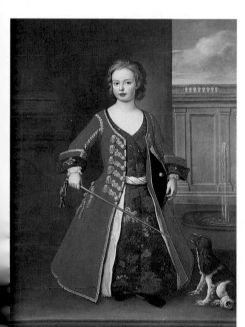

Thomas Gibson
British (c1680–1751)
Portrait of a Young Boy, a member of the
Strathmore Family, holding a Cane and a
Tricorn, with a Spaniel by his Side
Oil on canvas
57 x 42in (144.5 x 106.5cm)
£9,500–10,500 *C*

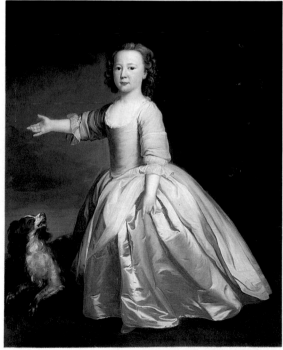

r. **Thomas Hudson**
British (1701–79)
Portrait of Theodore Hodshon,
standing in a Landscape
Oil on canvas
49¾ x 39in (125 x 99cm)
£9,000–10,000 *S*

Bernard Jean Corneille Pothast
British (1882–1966)
The Three Little Sisters
Signed, oil on canvas
25 x 30in (63.5 x 76cm)
£26,500–28,500 *BuP*

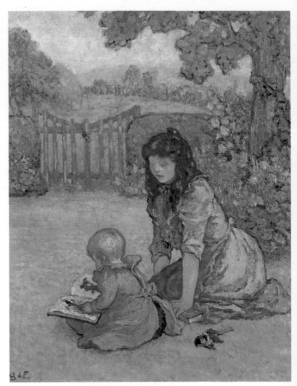

Georges d'Espagnat
French (1870–1950)
La Lecture au Jardin
Signed with monogram, oil on canvas, 1898
55½ x 42in (141 x 106.5cm)
£31,000–35,000 *S(NY)*

Thomas Cooper Gotch
British (1854–1931)
Young Girl in Renaissance Costume
Signed, oil on panel
9½ x 6¼in (23.5 x 16cm)
£2,500–3,000 *P*

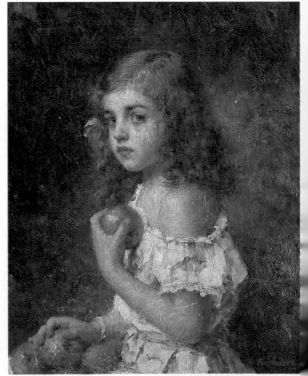

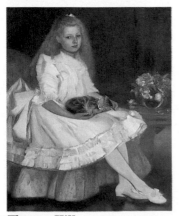

Thomas Hill
British (1852–1926)
Portrait of a Young Girl Nursing
a Tabby Kitten
Oil on canvas
50 x 40in (127 x 101.5cm)
£11,000–11,750 *JN*

Alexis Harlamoff
Russian (1842–1915)
A Young girl with Apples
Signed, oil on panel
16¼ x 12½in (41 x 32cm)
£20,000–25,000 *C*

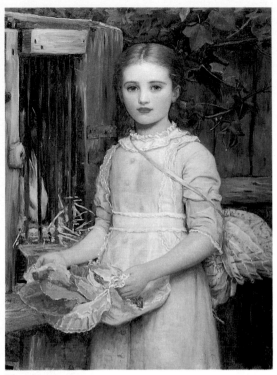

Kate Perugini
British (1839–1929)
Feeding the Rabbit
Signed with initials, oil on canvas
30 x 22in (76 x 56cm)
£10,000–12,000 *Bon*

Erskine Nicol, ARA, RSA
British (1825–1901)
Looking out for a safe Investment
Signed and dated '1876', oil on canvas
43½ x 32in (110 x 81cm)
£36,000–38,000 *BuP*

Samuel Sidley
British (1829–96)
Primroses and Bluebells
Signed, oil on canvas
30 x 25in (76 x 63.5cm)
£17,500–20,000 *C*

Charles Victor Thirion
French (1833–78)
The Apple Girl
Signed, oil on canvas
46¼ x 29½in (117.5 x 75cm)
£12,000–13,000 *C*

Frank Jameson
British (20thC)
Portrait of Daughter
Signed, oil on canvas
19 x 15in (48 x 38cm)
£1,500–2,000 *HLG*

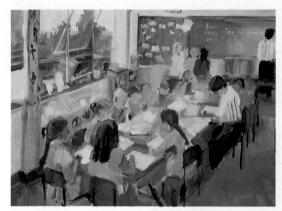

Carl Lazzari
British (20thC)
In Miss O'Connor's Class
Oil on canvas
26 x 30in (66 x 76cm)
£600–700 *VCG*

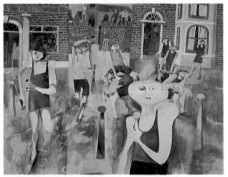

George Large, RI
British (b1936)
London Kids
Oil on canvas
24 x 36in (61 x 91.5cm)
£2,000–2,200 *Q*

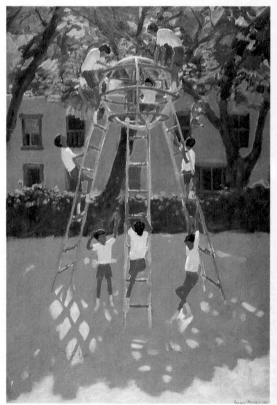

Andrew Macara, RBA, NEAC
British (b1944)
Climbing Frame, Panjim, Goa
Oil on canvas
40 x 26in (101.5 x 66cm)
£2,250–2,450 *CON*

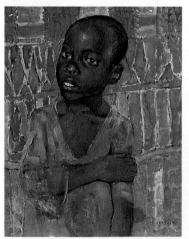

Kuzma Sergeivich Petrov-Vodkin
Russian (1878–1939)
African Boy
Incribed, dated '1907', oil on canvas
19 x 14½in (48 x 37cm)
£7,000–8,000 *S*

r. **Charlie Mackesy**
British (20thC)
Fixing the Boat
Watercolour
12 x 16in
(30.5 x 40.5cm)
£400–465 *TBG*

18th Century

Thomas Bardwell
British (1704–67)
Portrait of a Gentleman
Signed and dated '1744',
oil on canvas
25½ x 22½in (65 x 57cm)
£1,400–1,800 *AH*

Rosalba Carriera
Italian (1675–1757)
Portrait of Anton Maria Zanetti
Pastel
9 x 7in (22.5 x 17.5cm)
£35,000–40,000 *S(NY)*

John Constable, RA
British (1776–1837)
Portrait of Jane Inglis
Oil on canvas
30 x 25in (76 x 63.5cm)
£34,000–38,000 *C*

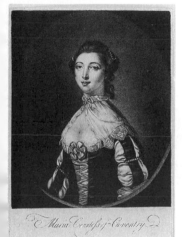

After Francis Cotes
British (1725–70)
Maria Countess of Coventry
Mezzotint, by James McArdell
unrecorded state, published 1752
10¾ x 9in (27.5 x 22.5cm)
£170–190 *GP*

Maria was regarded as one of the most beautiful women of her day. Born in Ireland, when she and her sister Elisabeth came to London in 1751 they were pronounced the 'handsomest women alive', attracting crowds of admirers whenever they appeared in public. At one stage Maria even employed a guard of 14 soldiers in order to avoid being mobbed. Maria was not renowned for her intelligence, although undeniably lovely, she was generally considered foolish and her principal interest was always her looks. Her early death from consumption was said to have been accelerated by her addiction to the white lead with which she blanched her flawless complexion. This work exemplifies the high quality of mezzotint portraits produced during the 18thC. The greatest painters of the day collaborated with engravers to produce these highly collectable images and famous beauties were a particularly popular subject.

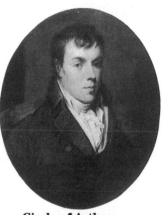

Circle of Arthur William Devis
British (1763–1822)
Portrait of George Cooper
of Wraes
Signed with initials,
oil on canvas
27½in (70cm) diam
£350–450 *CSK*

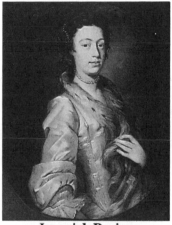

Jeremiah Davison
British (c1695–1745)
Portrait of a Lady, said to
be Kitty Clive, the Actress
Oil on canvas
29 x 23in (74 x 58.5cm)
£5,250–6,500 *S*

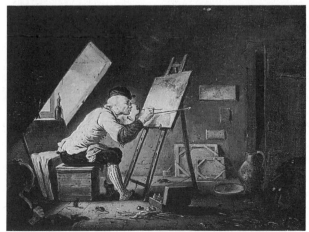

Alexandré-Joseph Desenne
French (1785–1827)
An Artist in a Garret Studio
Oil on panel
7¼ x 9½in (18 x 24.5cm)
£14,000–16,000 *C*

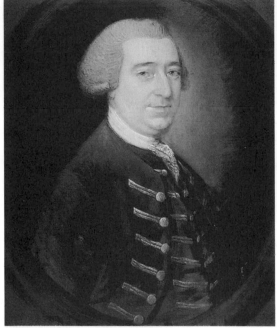

Thomas Gainsborough, RA
British (1727–88)
Portrait of the Hon. John Shirley
Oil on canvas
29 x 24in (74 x 61.5cm)
£15,000–17,000 *S*

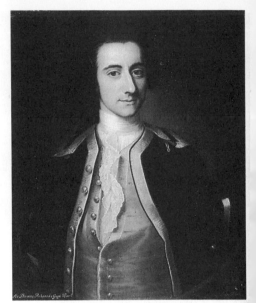

John Theodore Heins
British (1732–71)
Portrait of Sir Thomas Rookwood
Gage of Hengrave
Signed and dated '1748', oil on canvas
29¼ x 24¼in (74.5 x 62cm)
£5,000–6,000 *P*

> **Did you know?**
> *MILLER'S* Picture Price Guide *builds*
> *up year-by-year to form the most*
> *comprehensive picture photo-reference*
> *library available.*

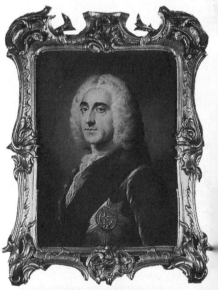

William Hoare of Bath, RA
British (1707–92)
Portrait of Philip Dormer Stanhope,
4th Earl of Chesterfield
Pastel
26¼ x 19in (67 x 48cm)
£24,000–28,000 *C*

Philip Dormer Stanhope Chesterfield,
who gave his name both to an overcoat
and a couch, was a politician and
writer. His most famous publications
were his letters to his natural son,
Philip, and to his godson and heir, also
named Philip. Witty and finely written
the letters contained advice on
behaviour and good breeding but were
roundly condemned (and extremely
popular) for their liberated attitude to
sexuality: 'They teach the morals of a
whore, and the manners of a dancing
master,' fulminated Samuel Johnson.

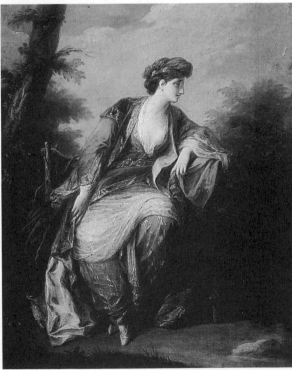

Angelica Kauffmann, RA
Swiss (1741–1807)
A Lady in Turkish Dress
Oil on canvas
29½ x 24¾in (75 x 63cm)
£40,000–45,000 *S*

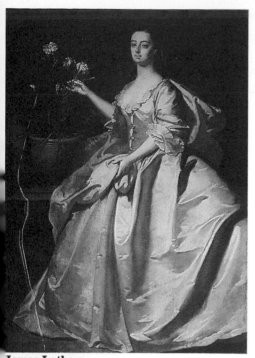

James Latham
British (1696–1747)
Portrait of Mary, Wife of Edward,
9th Duke of Norfolk
Oil on canvas
75 x 53in (190.5 x 134.5cm)
£22,000–27,000 *S*

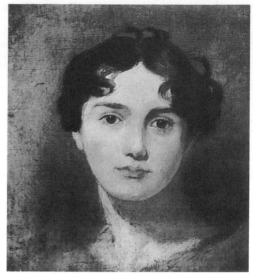

Attributed to Sir Thomas Lawrence
British (1769–1830)
Portrait sketch of a young Lady's Head
Oil on canvas
14¼ x 12⅜in (36 x 32.5cm)
£750–1,000 *CSK*

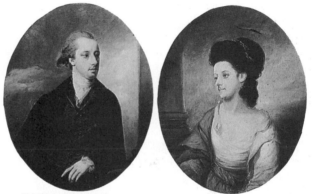

Richard Livesay
British (1753–1823)
A set of 6 Portraits of the Rev. Samuel Brewer, Elizabeth
Mary Brewer, Mr Samuel Brewer, Mrs Samuel Mary
Brewer and Mr and Mrs William Killbinton
Oil on copper
7¼ x 6in (18 x 15cm)
£9,000–10,000 *S*

l. **Louis-Michel van Loo**
French (1707–71)
Portrait of a Lady
Signed and dated '1761',
oil on canvas
26 x 21in (66 x 53.5cm)
£2,750–3,500 *Bon*

l. **Pietro Antonio Novelli**
Italian (1729–1804)
An elegant Couple walking
under a Parasol, handing a
Coin to an old Woman
Bears inscription, pen and
black ink and grey wash
over black chalk
6½ x 9½in (17 x 24.5cm)
£4,000–5,000 *S(NY)*

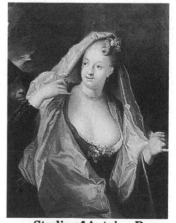

Studio of Antoine Pesne
French (1683–1757)
La Trompetina
Oil on canvas
43 x 33½in (109 x 85cm)
£5,000–6,000 *P*

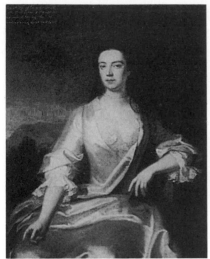

Attributed to Charles Philips
British (1708–47)
Portrait of a Lady said to be Cecelia Scott
Bears inscription, oil on canvas
50 x 40in (127 x 101.5cm)
£1,400–1,600 *P*

r. **Thomas Pope**
Irish (d1775)
Portrait of Lady Travers,
with a Parrot perched on
her Finger
Signed and dated '1762',
oil on canvas
29½ x 24in (75 x 61cm)
£4,000–4,500 *Bon*

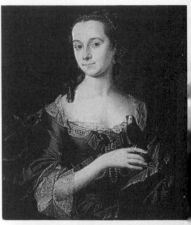

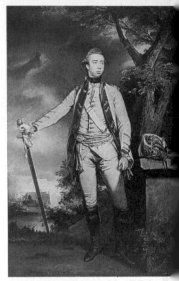

Sir Joshua Reynolds, PRA
British (1723–92)
Portrait of George Townshend,
Lord de Ferrars
Oil on canvas
94 x 56½in (238 x 143cm)
£467,000–475,000 *CNY*

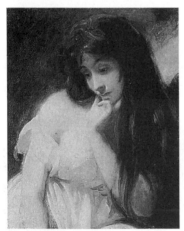

George Romney
British (1734–1802)
Portrait of Emma Hamilton
Oil on canvas
25¼ x 20in (64.5 x 50.5cm)
£18,000–20,000 *S*

*Emma Hamilton, wife of Sir
William Hamilton and mistress
of Admiral Horatio Nelson,
bewitched her many admirers
with her beauty. On first seeing
her Hamilton claimed that she
was far more lovely 'than
anything found in nature; and
finer in her particular way
than anything that is to be
found in antique art.' She sat
for many of the leading artists
of the day and was the
particular muse of Romney who
painted her repeatedly.*

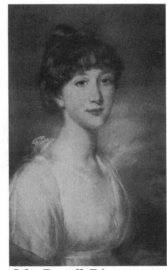

John Russell, RA
British (1745–1806)
Portrait of Miss Glover
Signed and dated '1802', pastel
23½ x 17½in (60 x 44.5cm)
£2,500–3,000 *P*

*This portrait reflects the recent
vagaries of art market fashion. I
1986 it was sold at auction in
London for £270,000. Some time
later it was purchased by ballet
star Rudolf Nureyev for $850,00
(£550,000) from a New York
dealer. After Nureyev's death his
collection was sold at Christie's
New York where the picture ma
$700,000 (£466,600), an auction
record for the artist perhaps but
still $150,000 (£97,500) less tha
Nureyev had paid for it privatel*

r. **Thomas Stothard, RA**
British (1755–1834)
The Departure of the Sons of Tipu
Sultan from the Zenana on May 4, 1799
Oil on panel
19¾ x 28in (50 x 71cm)
£19,500–22,500 *S(NY)*

19th Century

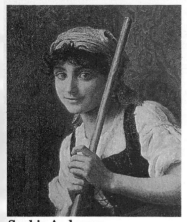

Sophie Anderson,
British (1823–1903)
Music hath Charms
Signed, oil on canvas
13¾ x 12in (35 x 30.5cm)
£3,000–4,000 *S(S)*

l. **John White Alexander**
American (1856–1915)
Portrait of Lady Thankerton
Signed, oil on canvas
80 x 43in (203 x 109cm)
£24,000–28,000 *CAG*

*Lady Thankerton's portrait vastly
exceeded its £3,000–5,000 estimate when
offered by Canterbury Auction Galleries.
Pretty though she was, the attraction was
not so much the lady herself but the
Pennsylvanian portrait painter, whose
other sitters had included such American
luminaries as Walt Whitman. The
painting inspired considerable US
interest and sold to an American buyer.*

r. **Edwin Bale, RI**
British (1838–1923)
Gertrude, a Portrait
Signed, watercolour
31 x 19½in (78.5 x 49.5cm)
£2,000–2,500 *P*

Follower of Charles Baxter
British (1809–79)
Portrait of a Lady
Oil on canvas
30¼ x 25in (77 x 63.5cm)
£1,600–1,800 *CSK*

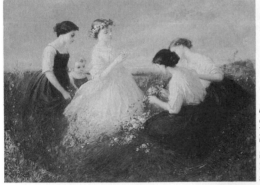

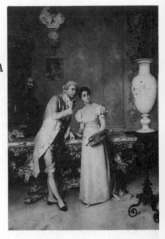

r. **Francesco Beda**
Dutch (1840–1900)
The Final Touches
Oil on canvas
36 x 26in (92 x 66cm)
£16,500–17,500 *HFA*

l. **Charles Edouard
de Beaumont**
French (1812–88)
The Flower Garland
Signed, oil on canvas
22½ x 29⅜in (57 x 76cm)
£9,000–11,000 *C*

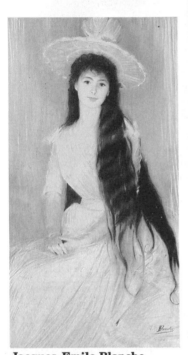

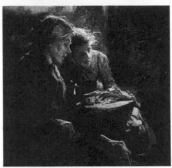

Frank Bramley, RA
British (1857–1915)
Fireside Tales
Signed and dated '1896',
oil on canvas
23 x 24in (58.5 x 61.5cm)
£20,000–22,500 *VAL*

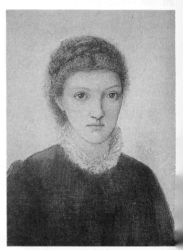

Jacques–Emile Blanche
French (1861–1942)
Portrait of an elegant
young Woman
Signed and dated '88' twice,
pastel on canvas
60½ x 31in (154 x 78.5cm)
£26,000–30,000 *P*

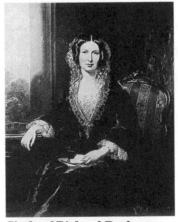

Circle of Richard Buckner
British (active 1830–97)
Portrait of a Lady holding a
Letter in her left Hand
Oil on canvas
50 x 40½in (127 x 102cm)
£2,500–3,000 *Bon*

**Sir Edward Coley
Burne-Jones, ARA**
British (1833–98)
Portrait of Frances Graham
Signed with initials and dated
'1879', oil on canvas
23½ x 17½in (60 x 44.5cm)
£180,000–200,000 *C*

*Born in 1858, Frances Graham
was the daughter of William
Graham, a wealthy India
Merchant and one of Burne-
Jones staunchest clients. From
childhood she visited the artist's
studios with her father. Burne-
Jones drew her repeatedly and
her close relationship with him
led to her being dubbed the High
Priestess of the Souls, the group
of intellectuals of which Burne-
Jones was mentor.*

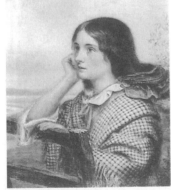

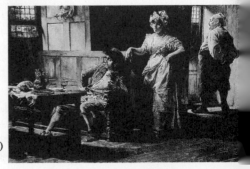

John Watkins Chapman
British (19thC)
Distant Thoughts
Signed, oil on panel
8¾ x 7½in (22 x 19cm)
£550–700 *CSK*

r. **Edgar Bundy**
British (1862–1922)
A watchful Eye
Oil on canvas
30 x 40in (76 x 101.5cm)
£14,000–15,000 *HFA*

Sir George Clausen, RA
British (1852–1944)
A Toiler Still; an old Woman, North
Lincolnshire
Signed and dated '1887', oil on canvas
30 x 25in (76 x 63.5cm)
£38,000–45,000 *C*

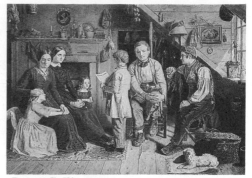

James Collinson
British (1825–81)
The Emigration Scheme
Signed, oil on panel
22 x 30in 55.5 x 76cm)
£170,000–200,000 *S*

*Collinson was one of the seven founding
members of the Pre-Raphaelite Brotherhood in
1848, and this painting reflects directly the
Pre-Raphaelite belief that pictures should deal
with contemporary life and ordinary people.
Emigration was a major concern of the period.
Between 1841–51, 1.5 million Britons
emigrated to the new worlds of North America,
Australia and New Zealand, the figure rising to
some 2 million in the following decade.
Government grants were offered to incite 'men
of good character' and their families to make
the move to Australia, and it is just such a
respectable working family that Collinson
portrays. Pre-Raphaelite pictures have been
performing strongly in the marketplace and
when sold by Sotheby's, the present work
achieved an auction record for the artist.*

l. **Vittorio Matteo Corcos**
Italian (1859–1933)
A Portrait of a Lady with
a Hat
Signed, oil on canvas
24 x 13½in (61 x 34.5cm)
£37,000–42,000 *S*

Thomas Faed, RA, HRSA
British (1826–1900)
Morning Girl doing her Hair
Signed and dated '1871',
oil on canvas
30¾ x 21¼in (78 x 54cm)
£13,000–14,000 *C(S)*

William Erley
British (19thC)
Ye Queen of Ye Roses
Signed and dated '1875',
oil on canvas
18¼ x 14¼in (46.5 x 36.5cm)
£1,000–1,300 *CSK*

**Nikolai Nikanorovich
Dubovskoi**
Russian (1859–1918)
Portrait of a Girl reading
in Spring
Signed and dated '95',
numbered '696', oil on canvas
34½ x 26in (87.5 x 66cm)
£1,500–2,000 *S*

r. **Albert Joseph Franke**
German (1860–1924)
A good Story
Signed, oil on panel
6¾ x 9in (17 x 22.5cm)
£4,750–5,750 *C*

Friedrich Friedlander
Austrian (1825–1901)
Die Weinprobe
Signed, oil on panel
16¾ x 12¼in (43 x 31.5cm)
£5,000–6,000 *Bon*

**Alfred Augustus
Glendening, Jnr, RBA**
British (1861–1907)
In the Poppy Field
Monogrammed and dated
'1880', watercolour
18 x 8in (46 x 20cm)
£3,000–3,200 *GG*

Henry Gillard Glindoni
British (1852–1913)
Crossing the Threshold,
the new Bride
Signed and dated '1886',
watercolour heightened
with white
27 x 20in (69 x 50.5cm)
£1,000–1,400 *Bon*

Maude Goodman
British (exh 1880–1920)
The Garland Maker
Indistinctly signed, watercolour
heightened with bodycolour and
gum arabic
12 x 9in (30.5 x 22.5cm)
£800–1,000 *CSK*

Charles Joseph Grips
Belgian (1825–1920)
A Girl grinding Coffee
in a Kitchen
Signed and dated '1863',
oil on panel
12 x 10in (30.5 x 25cm)
£8,500–9,000 *DaD*

Paul César Helleu
French (1859–1927)
Madame Helleu au Chapeau
Signed, coloured chalks on paper
25½ x 17¾in (65 x 45cm)
£14,000–16,000 *C*

Eva Hollyer
British (active 1891–98)
The pink Ribbon
Signed and dated '1892',
oil on canvas
13 x 11in (33 x 28cm)
£2,900–3,200 *Bne*

r. **William Holyoake, RBA**
British (1834–94)
Rebecca – The Jew's Daughter
Signed and inscribed,
oil on board
12 x 10in (30.5 x 25cm)
£2,500–2,750 *VAL*

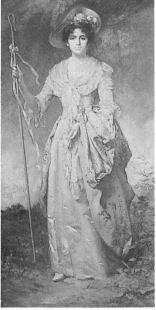

Edward Hopley
British (19th)
Portrait of John Ruskin
Signed and dated '1863',
oil on canvas
21 x 18in (53 x 46cm)
£475–575 *CSK*

Hermann Kern
Hungarian (1839–1912)
Der Blumenzüchter and Der Gemüsezüchter
A pair, signed and stamped with the artist's seal,
oil on panel
18½ x 12¼in (47 x 31.5cm)
£9,000–10,000 *C*

Carl Kronberger
Austrian (1841–1921)
A good Smoke
Signed, oil on panel
6¼ x 4¾in (16 x 12cm)
£2,800–3,400 *C*

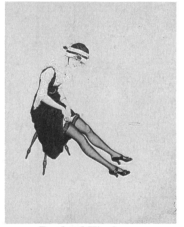

Raphaël Kirchner
Austrian (1876–1917)
The Garter
Signed, pencil, watercolour,
bodycolour and blue chalk
on paper laid down on card
23½ x 18¼in (60 x 46.5cm)
£3,000–3,500 *C*

**Thomas Benjamin
Kennington, RBA, NEAC**
British (1856–1916)
A Shepherdess
Signed and dated '01',
oil on canvas
78 x 39in (198 x 99cm)
£6,000–7,000 *C(S)*

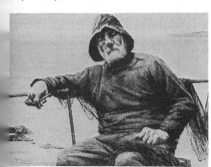

Walter Langley
British (1852–1922)
An idle Hour
Signed, watercolour
10½ x 13½in (26 x 34cm)
£1,300–1,600 *P*

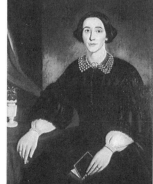

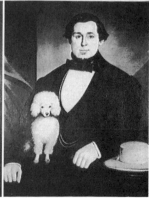

T. Lang
American (?) (19thC)
A Lady and a Gentleman
A pair, oil on canvas
44 x 34in (111.5 x 86cm)
£3,750–4,500 *P*

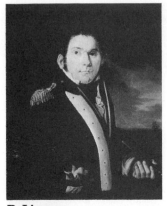

R. Livesay
British (d1823)
Portrait of a Naval
Lieutenant
Oil on board
11 x 9in (28 x 22.5cm)
£800–840 *LH*

Charles Frederick Lowcock
British (active 1878–1922)
A Portrait of a seated
young Woman
Signed, oil on panel
18 x 11in (46 x 28cm)
£1,500–1,800 *RD*

Harrington Mann
British (1864–1937)
Portrait of Dolly, the
Artist's Wife
Signed and dated '1892',
oil on canvas
58 x 45in (147 x 114cm)
£4,000–5,000 *C*

*The artist painted this portrait
to mark his engagement to
Dolly. She later became an
interior designer.*

Mortimer Menpes
British (1860–1938)
Two Faces of Whistler
Signed, drypoint, c1880, laid
paper, laid down onto card
7¼ x 5¼in (18.5 x 13.5cm)
£600–700 *CSK*

Edouard Menta
Swiss (b1848)
La Repasseuse
Signed and dated '1896',
oil on canvas
63¾ x 39¾in (162 x 101cm)
£16,000–18,000 *S*

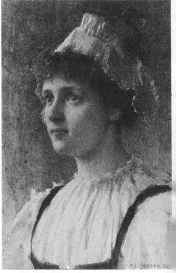

R. E. Morrison
British (1852–1925)
Portrait of a Girl in white Cap
Signed and dated '1897',
watercolour
9½ x 6½in (24 x 16.5cm)
£750–850 *MJB*

Cecil Watson Quinnell, RBA
British (1868–1932)
Janette
Signed, oil on board
14½ x 10½in (37 x 26.5cm)
£3,250–3,500 *CW*

r. **George Patten, ARA**
British (1801–65)
Perdita
Oil on canvas
10 x 8¼in (25 x 21cm)
£4,500–5,000 *CW*

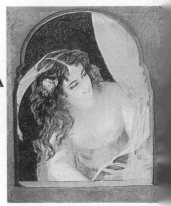

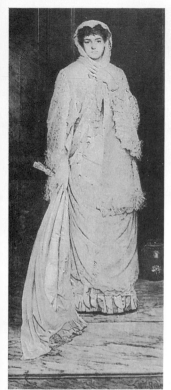

Guilo Rosati
Italian (1853–1917)
The Patient Model
Oil on canvas
16 x 13in (40.5 x 33cm)
£7,000–7,500 *HFA*

Eighteenth century genre pictures were extremely popular with 19thC patrons. These were essentially costume dramas showing richly dressed aristocratic ladies and gentlemen, in elegant and luxurious interiors. Typically, the scenes portrayed are romantic and anecdotal: flirting lovers, bustling maids and card-playing beaux, a view of history that finds its literary equivalent in the novels of Barbara Cartland. Such paintings were prized for their technical expertise and their painstaking attention to decorative detail.

Matthew White Ridley
British (1837–88)
Portrait of Mrs M.W. Ridley
Signed, oil on canvas
84 x 36¼in (213 x 92.5cm)
£18,000–20,000 *P*

Edwin Roberts
British (1840–1932)
A Gypsy Girl
Signed and dated '1890',
oil on canvas
24 x 16in (61 x 40.5cm)
£400–500 *CSK*

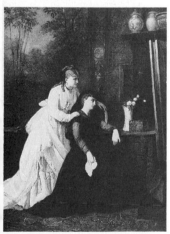

Charles Runciman
British (active 1825–1867)
The Widow
Signed, oil on canvas
30 x 23in (76 x 58.5cm)
£1,600–1,800 *AH*

Lucio Rossi
Italian (1846–1913)
The Love Token
Signed, watercolour
17 x 11¾in (43 x 30cm)
£600–700 *P*

Enrico Tarenghi
Italian (b1848)
A sympathetic Critic
Signed, watercolour over pencil
20¼ x 15¾in (51 x 40cm)
£850–1,000 *S(S)*

l. **Marcus Stone, RA**
British (1840–1921)
A Gambler's Wife
Signed, oil on paper laid on linen
14 x 18¾in (35.5x 47.5cm)
£3,000–3,500 *CW*

Edward Tayler
British (1828–1906)
Portrait of an elegant Woman in
white Dress
Signed, pencil and watercolour
with touches of white heightening
16 x 13in (40.5 x 33cm)
£800–1,000 *CSK*

Henry Terry
British (active 1879–1920)
Documentary Evidence
Signed, watercolour
21¾ x 15in (55 x 38cm)
£1,000–1,200 *P*

Cesare Tiratelli
Italian (b1864)
The Vintage
Signed and inscribed,
oil on panel
26 x 22in (66 x 55.5cm)
£70,000–80,000 *S*

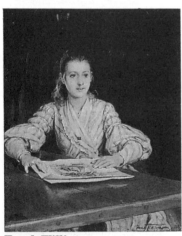

**Frank William
Warwick Topham**
British (1838–1924)
The young Collector
Signed and dated '1889',
oil on canvas
19 x 13½in (48 x 34.5cm)
£2,400–3,000 *C*

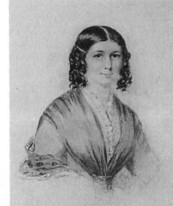

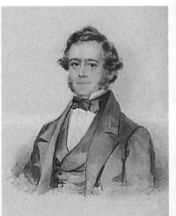

Marion Walker
British (exh 1870–1880)
Portraits of a Lady
and Gentleman
A pair, signed and dated '1852',
watercolour and pencil
12¼ x 9¾in (31 x 24.5cm)
£1,000–1,350 *WrG*

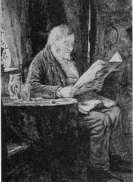

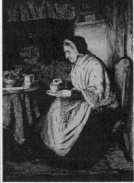

Robert Wright
British (active 1871–89)
Quiet Moments
A pair, oil on panel
10 x 8in (25 x 20cm)
£10,750–11,750 *HFA*

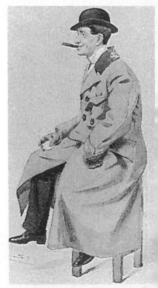

Sir Leslie Ward (Spy)
British (1851–1922)
A portrait of the
illustrator Phil May
Signed and dated '1895'
watercolour heightened
with white
13 x 7¼in (33 x 18cm)
£1,800–2,000 *Bon*

20th Century

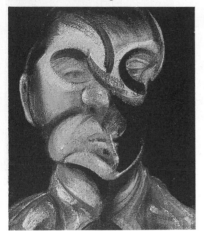

Francis Bacon
British (1909–92)
Self Portrait
Signed, titled and dated '1972',
oil on canvas
14 x 12in (35.5 x 30.5cm)
£365,000–385,000 *S*

*In an interview with David
Sylvester, Bacon once
remarked, 'I loathe my own face
but I go on painting it only
because I haven't got any other
people to do . . .' One of the
nicest things that Cocteau said
was: "Each day in the mirror I
watch death at work." This is
what one does oneself.'*

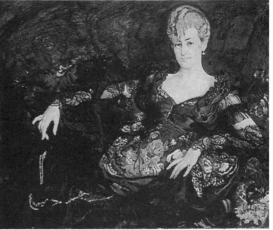

Isaac Israelovich Brodsky
Russian (1883–1939)
Portrait of a Lady said to be
Madame Rosenelle-Lunacharskaya
Signed and dated '1916',
oil on canvas
34 x 41¾in (86 x 106cm)
£10,000–11,000 *S*

*The sitter was a well-known
actress and film star, the lover of
A. V. Lunacharsky, the future
Soviet Commissar of Propaganda
and the Arts.*

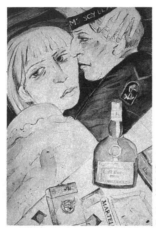

l. **Joyce W. Cairns**
British (20thC)
Kiss the Boys goodbye
Watercolour
33 x 31in (83.5 x 78.5cm)
£500–600 *LG*

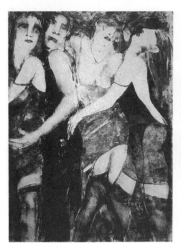

Inge Clayton
Austrian (20thC)
Cabaret
Oil on paper
28 x 22½in (71.5 x 57cm)
£1,300–1,500 *GeC*

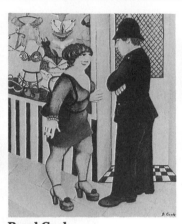

Beryl Cook
British (b1926)
A Fine Pair
Signed, oil on board
18 x 15in (45.5 x 38cm)
£2,500–3,500 *Bon*

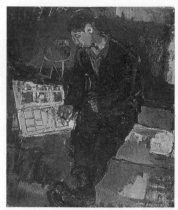

Joan Kathleen Harding Eardley, RSA
British (1921–63)
Boy with a Comic
Signed, inscribed and dated '1957', oil on canvas
30½ x 25in (77.5 x 63.5cm)
£20,000–25,000 *C(S)*

Leonard Fuller, ROI
British (1891–1973)
Joy in Black and Green
Oil on canvas
24 x 20in (61.5 x 50.5cm)
£4,750–5,250 *CE*

James Dickson Innes
British (1887–1914)
Euphemia Lamb
Watercolour over pencil
10¼ x 8½in (25.5 x 21.5cm)
£2,200–2,600 *P*

Augustus John, OM, RA
British (1878–1961)
Woman with Flowers in her Hair
Signed in pencil, etching
8 x 4¾in (20 x 12cm)
£300–350 *CSK*

William Kennedy
British (1860–1918)
Portrait of a Man, thought to be Ignatius Alexander Roche
Signed, inscribed and dated '81', oil on panel
9½ x 7in (24 x 17.5cm)
£400–600 *S(Sc)*

Augustus John, OM, RA
British (1878–1961)
The Snowdrop – Portrait of Gwen John
Signed and indistinctly dated, red chalk
9¼ x 5¾in (23 x 14.5cm)
£3,750–4,500 *P*

Dame Laura Knight, RA
British (1877–1970)
Make-Up (catalogue raisonné 33)
Signed in pencil, etching and drypoint, 1925
9¾ x 7¾in (24.5 x 19cm)
£425–525 *CSK*

Charles Lamb, RHA, RUA
Irish (1893–1965)
Girl in a red Shawl, c1935
Signed, oil on canvas
25 x 19in (63.5 x 48cm)
£5,500–6,500 *JAd*

Karen Ray
British (20thC)
Girl Against a Lace Curtain
Oil on canvas
50 x 40in (127 x 101.5cm)
£1,800–2,000 *AMC*

r. **Sir Matthew Smith**
British (1879–1959)
Richard Smart
Signed, inscribed and dated,
oil on canvas
30 x 25in (76.5 x 63.5cm)
£2,000–3,000 *C*

Percy Wyndham Lewis
British (1882–1957)
Study for a Portrait of T.S. Eliot
Signed and dated '1949', black
and coloured chalks
15 x 11¼in (38.5 x 28.5cm)
£6,000–7,000 *C*

*Having one's portrait painted by
Lewis could be a testing
experience as Edith Sitwell
recalled: 'When one sat to him in
his enormous studio, mice
emerged from their holes, and
lolled against the furniture,
staring in the most insolent
manner. At last when Tom Eliot
was sitting to him, their
behaviour became intolerable.
They climbed on to his knee,
and would sit staring up at his
face. So Lewis bought a large
gong which he placed near the
mouse-hole and, when matters
reached a certain limit, he
would strike this loudly, and the
mice would retreat.'*

l. **Austin Osman Spare**
British (1888–1956)
The Astrologer, 1947
Monogrammed, watercolour
and pencil
11½in (29.5cm) square
£900–1,100 *BOX*

Ken Moroney
British (20thC)
Five Minute Break
Signed and dated '77',
oil on board
9 x 7in (22.5 x 17.5cm)
£1,000–1,400 *GK*

William Roberts, RA
British (1895–1980)
Portrait of
Mr Christopher Milford
Signed, oil on canvas
17 x 14in (43 x 35.5cm)
£950–1,200 *P*

**John Singer Sargent, RA,
RWS, HRSA**
British (1856–1925)
Portrait of the Hon. Clare
Stuart Wortley
Signed and dated '1923', charcoal
24½ x 19in (62.5 x 48cm)
£10,000–11,000 *P*

John Strevens
British (1902–92)
Rose
Oil on canvas
16 x 12in (40.5 x 30.5cm)
£2,250–2,450 *JN*

Linda Sutton
British (b1949)
Fire Fairies
Mixed media
42 x 34½in (106.5 x 87.5cm)
£2,500–3,000 *LG*

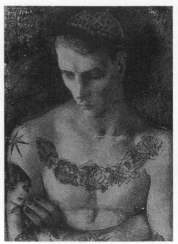

Pavel Tchelitchew
American/Russian (1898–1957)
Le Collier de Roses
Signed, dated '31', oil on board
23¼ x 21in (59 x 53cm)
£44,000–48,000 *S*

*The sitter is Charles Vincent, the
artist's favourite male model in
Paris. Tchelitchew's various
depictions of Vincent made much
of his elaborately tattooed chest
and shoulders. The artist's
interest in tattooing grew out of
his fascination with the circus, a
theme which recurs in his work
from the late 1920s onwards.*

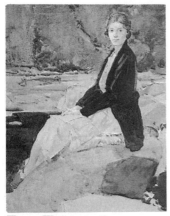

Harry Watson
British (1871–1936)
A young Lady in a white
Dress and black Coat
sitting upon Rocks
Signed, watercolour
15 x 11¼in (38 x 28.5cm)
£800–1,000 *Bon*

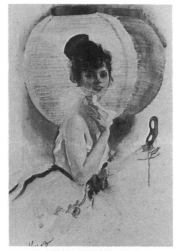

Walter Ernest Webster
British (1878–1959)
Masquerade
Signed, watercolour
22½ x 16½in (57 x 42cm)
£950–1,200 *P*

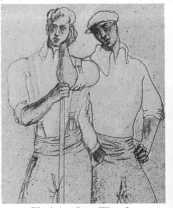

Christopher Wood
British (1901–30)
French Workmen
Pencil and coloured chalks
13½ x 11¼in (34.5 x 28.5cm)
£2,500–3,000 *P*

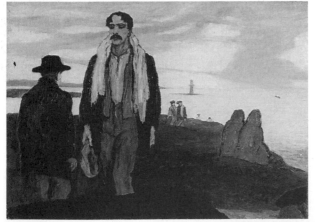

Jack Butler Yeats, RHA
Irish (1871–1957)
The Bather, 1918
Signed, oil on canvas
18 x 24in (45.5 x 61.5cm)
£62,000–65,000 *JAd*

r. **Robert Wraith**
British (b1952)
Six o'Clock
Oil on board
15½ x 11½in (39 x 29.5cm)
£2,200–2,500 *BSG*

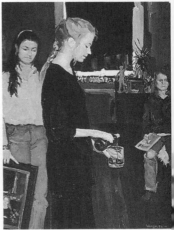

Mothers & Children
18th–19th Century

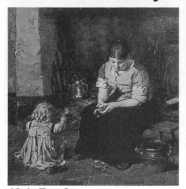

Alois Boudry
Belgian (1851–1938)
Preparing Vegetables
Signed, oil on panel
9¼in (23cm) square
£4,500–6,000 *Bon*

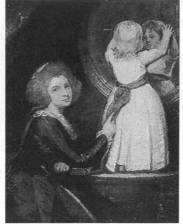

George Romney
British (1734–1802)
Portrait of Mrs Russell
with her Son, Henry
Oil on board
18¼ x 14¼in (46 x 36cm)
£7,000–8,000 *S*

Léon Emile Caille
French (1836–1907)
Her Pride and Joy
Signed and dated '1866',
oil on panel
12½ x 9½in (31.5 x 24cm)
£7,500–8,500 *C*

Luigi Crosio
Italian (1835–1915)
The Family Reunion
Signed, oil on canvas
34 x 24in (86 x 61cm)
£4,000–5,000 *S*

William Collins, RA
British (1788–1847)
The Morning Lesson
Signed and dated '1834',
oil on canvas
30 x 25in (76 x 63.5cm)
£30,000–35,000 *P*

English School (19thC)
Mother and Child eating
Grapes at a Table
Oil on panel
20 x 24in (50.5 x 61cm)
£450–550 *P(S)*

r. **Théodore Gérard**
Belgian (1829–95)
The Happy Family
Signed and dated '1865',
oil on panel
22 x 28in (55.5 x 71cm)
£22,000–25,000 *S*

English School (c1800)
Portrait of a Woman with her
Twins, seated by a Window
Oil on canvas
30 x 25in (76 x 63.5cm)
£3,500–4,000 *C(S)*

l. **William Hemsley**
British (active 1848–93)
The Cherry Tart
Signed and dated '1873',
oil on panel
6½ x 7¾in (16.5 x 19cm)
£2,500–3,500 *C*

Bernard de Hoog
Dutch (1866–1943)
A Present for Mother
Signed, oil on canvas
23½ x 19½in (60 x 49.5cm)
£4,750–5,750 *P*

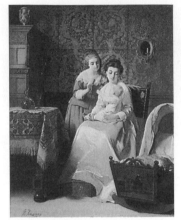

**Petrus Renier
Hubertus Knarren**
Belgian (b1869)
The New Toy
Signed, oil on panel
27¼ x 21¼in (69 x 54cm)
£12,000–13,000 *C*

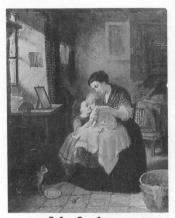

John Locker
British (active 1862–75)
Playing with Baby
Signed and dated '1872',
oil on canvas
21 x 17¼in (53.5 x 44cm)
£1,300–1,500 *CSK*

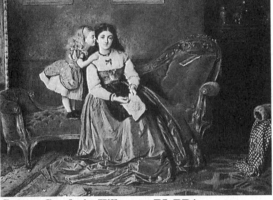

George Goodwin Kilburne, RI, RBA
British (1839–1924)
Secrets
Oil on canvas
18 x 24in (45.5 x 61cm)
£12,500–14,500 *JN*

The models were the artist's wife and daughter.

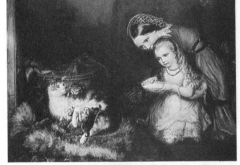

Edward William John Hopley
British (1816–69)
Feeding the Cats
Signed and dated '1860', oil on board
18 x 24in (45.5 x 61cm)
£15,000–16,000 *CW*

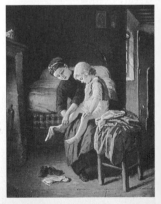

r. **Guillaume Seignac**
French (19thC)
Dressing for School
Signed, oil on panel
12 x 8¼in (30.5 x 20.5cm)
£6,500–7,500 *S*

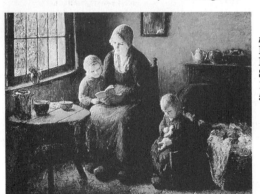

Bernard Pothast
Dutch (1882–1966)
A Family Interior
Signed, oil on canvas
27½ x 36in (69.5 x 91.5cm)
£13,000–15,000 *S*

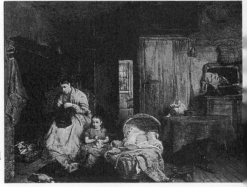

r. **George Smith**
British (1829–1901)
A sewing Lesson by the Fire
Signed and dated '1867', oil on panel
13¾ x 18in (35 x 45.5cm)
£6,750–7,750 *C*

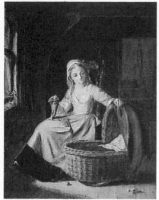

Coke Smythe
British (exh 1842–67)
Watching the Baby
Signed, oil on canvas
19¾ x 15in (50 x 38cm)
£1,000–1,400 *CSK*

Frederick Walker, ARA
British (1840–75)
The New Boy
Signed and dated '1860', pencil
and watercolour heightened with
white and gum arabic and with
scratching out
11¾ x 12¾in (30 x 32cm)
£8,500–10,000 *C*

Adolphe Weisz
French (b1838)
Watching the Kittens
Signed and dated '1868',
oil on panel
16½ x 11¼in (42 x 28.5cm)
£3,250–4,000 *C*

Robert W. Wright
British (active 1880–1900)
A Feather in the Breeze
Signed and dated '1900', oil on board
7½ x 9½in (18.5 x 24cm)
£1,200–1,500 *S(S)*

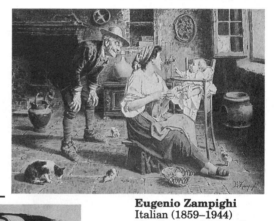

Eugenio Zampighi
Italian (1859–1944)
The Centre of Attraction
Signed, oil on canvas
22¼ x 30½in (56 x 77.5cm)
£8,500–9,500 *C*

20th Century

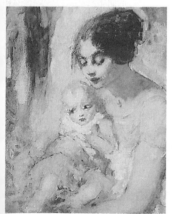

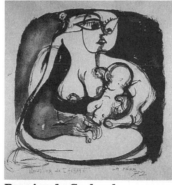

Bouvier de Cachard
French (b1929)
La Mére *(sic)*, 1972
Signed, watercolour
20 x 18in (50.5 x 45.5cm)
£850–950 *CE*

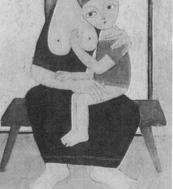

Louis Kronberg
American (1872–1965)
Mother and Child
Signed, oil on canvas
20 x 16in (50.5 x 40.5cm)
£400–600 *CSK*

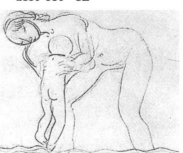

r. **Sir Jacob Epstein**
British (1880–1959)
Study for Mother and
Child, 1905–7
Pencil
8½ x 11in (22 x 28cm)
£850–1,000 *P*

Michel Lablais
French (20thC)
Mère et Enfant
Signed and dated '54', mixed media
38¾ x 26¾in (98.5 x 68cm)
£800–1,000 *Bea*

Children

Few subjects are more popular than children. Until the second half of the 18thC, children were portrayed as miniature adults, mirroring their parents in both dress and pose, in formal portraits that tended to reflect their social status rather than their childhood state. By the late 1700s, fashions in child rearing and consequently child painting had changed. Philosophers such as John Locke and Emile Rousseau recommended that children should be comfortably dressed and lead a 'natural' life, advocating breast-feeding, plenty of fresh air, exercise, plain food and sensible instruction. It was no longer considered essential for babies to be swaddled, and children were allowed to wear looser fitting, more childish clothes. The simple white muslin frocks that had been worn by both sexes only up until the age of three or four, were now maintained by girls throughout childhood and into their teens. 'The white dresses are certainly the prettiest at your age,' wrote one mother in 1786 to her 15 year old daughter 'and are worn here by young people with sashes.' Family portraits chart this growing freedom, mothers are shown playing with their children and with the turn of the century artists concentrated increasingly on portraying childish pleasures, genre pictures rather than specific portraits.

'That the 19thC spectator could be reduced to a state of treacly ecstasy by the depiction of the antics of adorable little children was a weakness well-understood and exploited by artists,' note Philip Hook and Mark Poltimore, specialists in popular 19thC painting. Innumerable pictures of children were produced in the Victorian period: pretty little girls, naughty little boys, winsome peasant children, a sanitised and sentimental portrayal of childhood innocence, popular then and still highly commercial in our own century.

17th–18th Century

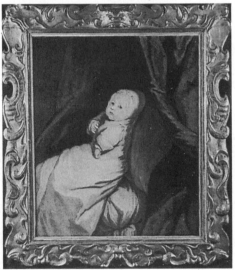

Circle of Mary Beale
British (1632–97)
Portrait of a Baby, wearing white Robes
Oil on canvas
30 x 25in (76 x 63.5cm)
£2,400–3,000 *P*

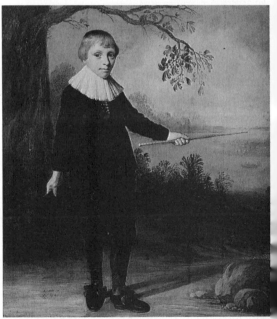

Jacob Gerritsz Cuyp
Dutch (1594–after 1651)
Portrait of a Boy holding his Hat in a
River landscape
Signed, inscribed and dated '1640', oil on panel
35½ x 30¼in (90.5 x 77cm)
£16,000–18,000 *S*

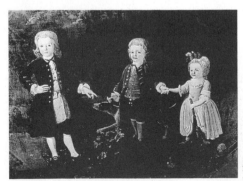

English School (18thC)
Portraits of 3 Children in an
open Landscape
Oil on canvas
64 x 84in (162.5 x 213cm)
£35,000–45,000 *HSS*

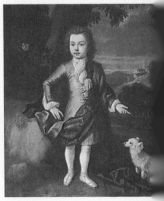

r. **Circle of Charles D'Agar**
French (1669–1723)
Portrait of a Boy in a purple
Coat and a green Wrap with
his Dog beside him
Oil on canvas
49¾ x 40in (126.5 x 101.5cm)
£3,500–4,000 *C*

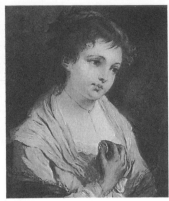

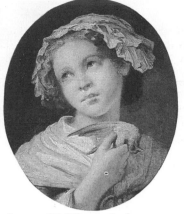

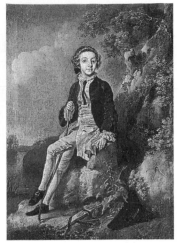

Manner of Jean-Baptiste Greuze
French (1725–1805)
A young Girl in a blue
Dress holding a Locket
Oil on canvas
23½ x 19in (60 x 48cm)
£900–1,100 *CSK*

Jeanne Philiberte Ledoux
French (1767–1840)
Lost Innocence
Oil on canvas
20 x 15in (50.5 x 38.5cm) oval
£6,000–8,000 *P*

Francis Hayman, RA
British (1708–76)
Portrait of William Honywood,
Son of Sir John Honywood
Oil on canvas
23½ x 16½in (60 x 42cm)
£57,000–65,000 *S*

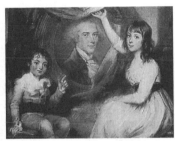

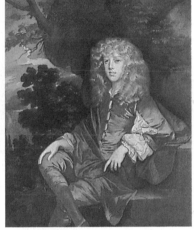

John Russell, RA
British (1745–1806)
Portrait of Judge William
Garrow with two Children
Dated '1792', pastel
35 x 43¼in (89 x 110cm)
£2,500–3,500 *P*

l. **Circle of Sir Peter Lely**
British (1618–80)
Portrait of a Youth in
a Landscape
Oil on canvas
50 x 40½in (127 x 102.5cm)
£4,700–6,000 *C*

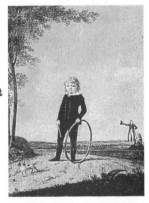

r. **Jean François Sablet**
Swiss (1745–1819)
Portrait of Charles
Gruy with his Dog,
his Parents beyond
Signed and dated '1796',
oil on panel
9½ x 7in (24 x 17.5cm)
£8,500–9,000 *S(NY)*

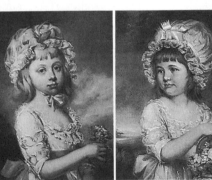

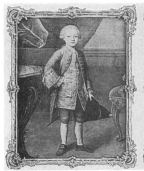

After John Russell, RA
British (1745–1806)
Emil Wehrschmidt (active 1900–20)
Portraits of Lady Georgiana Cavendish and
Lady Harriet Cavendish
A pair with inscriptions on backboard, pastel
23½ x 17¼in (60 x 44cm)
£2,500–3,000 *C*

*The inscriptions on the backboard confirm that
the pastel drawings are, in fact, copies after
John Russell. The originals were last recorded in
the collection of the Hon. F. Leveson Gower. The
technical virtuosity of these drawings attest to
Wehrschmidt's ability and similar copies were
exhibited at the Royal Academy 1905–15 when
there was a revival of interest in this medium
and 18thC portraits were extremely fashionable.*

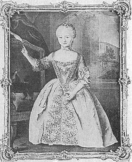

Circle of Guillaume de Spinney
Flemish (1721–85)
Portraits of a Boy and Girl
A pair, oil on canvas
43¼ x 33½in (109.5 x 85cm)
£11,500–12,500 *S(Am)*

19th Century

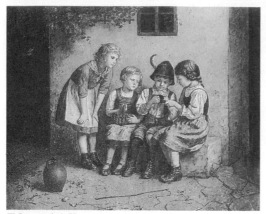

Edmund Adler
German (1871–1957)
The Knitting Lesson
Signed, oil on canvas
22 x 27in (55.5 x 69cm)
£14,000–16,000 C

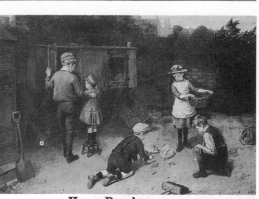

Harry Brooker
British (1848–1940)
Feeding Time
Signed and dated '1890', oil on canvas
27¼ x 35¼in (69 x 90cm)
£13,000–15,000 Bon

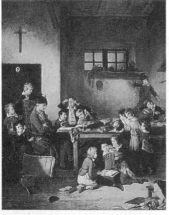

l. **Joseph Beaume**
French (1796–1885)
Le Maître d'École
endormi
Signed, oil on canvas
32½ x 26⅜in (82.5 x 68cm)
£8,000–9,000 C

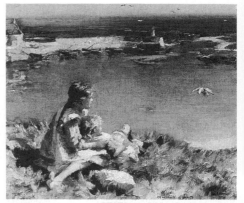

William Marshall Brown
British (1863–1936)
Above the Harbour, Braes
Signed, oil on canvas
12 x 14in (30.5 x 35.5cm)
£13,500–14,500 BuP

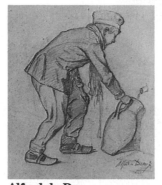

Alfred de Dreux
French (1810–60)
Study of a Boy with a Pitcher
Signed, pencil on paper
8¼ x 7in (20.5 x 17.5cm)
£700–900 C

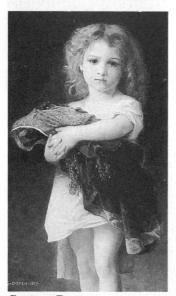

Gustave Doyen
French (b1837)
Portrait of a young Girl
in a white Dress
Signed and dated '1877',
oil on canvas
34 x 21in (86 x 53.5cm)
£45,000–50,000 S

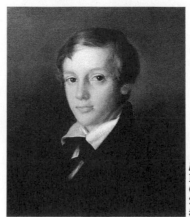

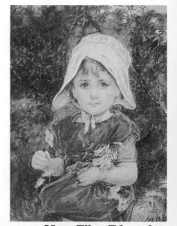

Mary Ellen Edwards
British (1839–c1908)
My Poppy
Signed with initials and
inscribed, watercolour
11½ x 8½in (29 x 21.5cm)
£2,800–3,200 WrG

l. **English School** (c1830)
Portrait of a Boy
Oil on canvas
20 x 16in (50.5 x 40.5cm)
£1,800–2,200 Dag

William Powell Frith, RA
British (1819–1909)
The Crossing Sweeper
Signed and dated '1858',
oil on canvas
9 x 7½in (22.5 x 18.5cm)
£17,000–20,000 *S*

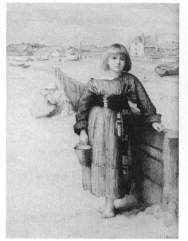

Minnie J. Hardman
British (b1867)
On the Beach
Signed, watercolour
14¼ x 10in (36 x 25cm)
£1,375–1,575 *JA*

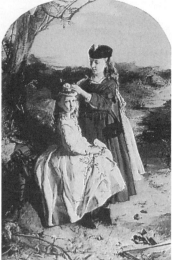

**Robert Inerarity Herdman,
RSA, RSW**
Scottish (1829–88)
Highland Sisters
Signed with monogram and
dated '1868', oil on canvas
56½ x 36½in (143.5 x 92.5cm)
£15,000–17,000 *S(Sc)*

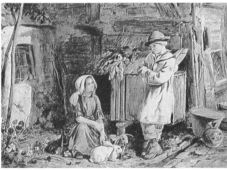

r. **Edward Hughes**
British (1832–1908)
Christmas Greetings
Signed, oil on canvas
63½ x 49in (161 x 124.5cm)
£14,000–16,000 *S*

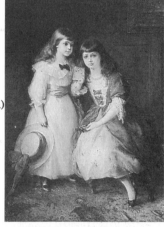

James Hardy, Jnr
British (1832–89)
The Dawn of Love
Signed and dated '63', watercolour
13 x 18in (33 x 45.5cm)
£6,000–6,750 *WrG*

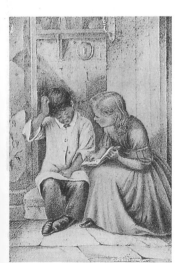

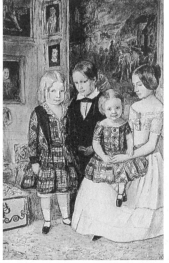

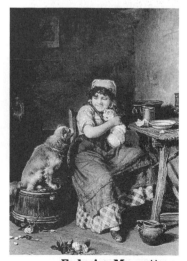

J. Lipscombe
British (19thC)
The Reading Lesson
Signed and dated '1868',
pencil and watercolour
12 x 8in (30.5 x 20cm)
£175–250 *CSK*

Sir John Everett Millais, PRA
British (1829–96)
Portrait of 4 children of the
Wyatt Family
Signed and indistinctly dated
'1849', bears signature and date
'1846' on reverse, oil on board
18 x 12in (45.5 x 30.5cm)
£70,000–75,000 *P*

Federico Mazzotta
Italian (19thC)
A New Pet
Oil on canvas
23 x 17in (58.5 x 43cm)
£9,000–10,000 *HFA*

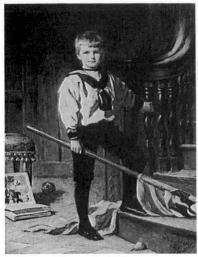

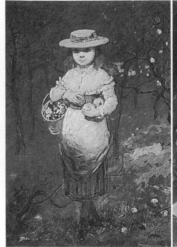

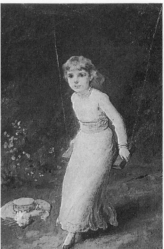

William Edwards Miller
British (active 1873–1903)
The young Patriot
Signed and dated '1892',
oil on canvas
61½ x 46¼in (156 x 117cm)
£6,750–7,750 *C*

James Sant, RA
British (1820–1916)
Gathering Apples and The Swing
A pair, both signed with
monogram, oil on board
17¼ x 11½in (44 x 29cm)
£7,500–8,000 *CW*

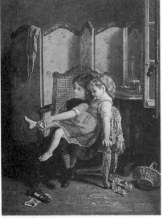

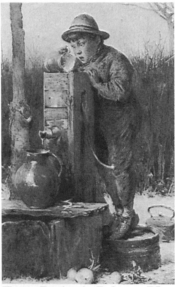

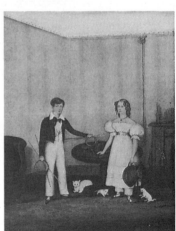

Paul Seignac
French (1826–1904)
The young Nursemaid
Signed, oil on panel
13¾ x 10¼in (35 x 25.5cm)
£15,000–17,000 *P*

Henry Benjamin Roberts, RI
British (1832–1915)
The frozen Pump
Signed and dated '76',
watercolour and bodycolour
21¾ x 14¼in (55 x 36cm)
£3,600–4,000 *P*

John Vine
British (1809–67)
Ready for Games
Signed and inscribed, pencil and
watercolour heightened with
bodycolour and gum arabic
22 x 17½in (56 x 44.5cm)
£2,400–3,000 *S*

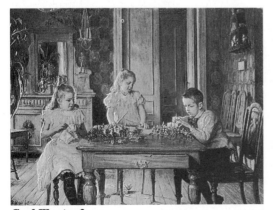

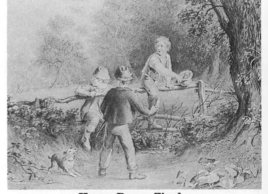

Carl Wentorf
Danish (1863–1914)
The Battle
Signed and dated '1900', oil on canvas
31 x 40in (79 x101.5cm)
£25,000–30,000 *C*

Henry Bryan Ziegler
British (1798–1874)
Scrumping – A quick Escape
Signed and dated '1870', watercolour
14½ x 19in (37 x 48cm)
£800–1,000 *P*

20th Century

Rose M. Barton
British (d1929)
At the Garden Gate
Signed, watercolour
4 x 7in (10 x 17.5cm)
£2,600–2,800 *HO*

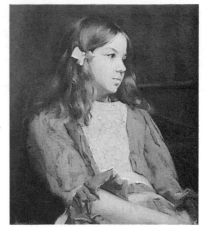

Francis Edward Colthurst
British (b1874)
Dorothy
Signed and inscribed, oil on canvas
24 x 20in (61 x 51cm)
£9,000–9,500 *CW*

Thérèse Lessore
French (1884–1945)
Children in a Perambulator
Signed, watercolour
7in (17.5cm) square
£450–550 *CSK*

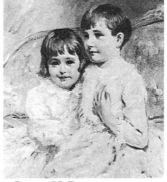

James McBey
British (1883–1959)
Portrait of Juliette and
Una Brander Dunbar
Signed and dated '1927',
oil on canvas
30 x 25in (76 x 63.5cm)
£2,200–2,600 *P*

Dod Proctor, RA
British (1891–1972)
Month old Baby
Signed, oil on canvas
11½ x 12in (29 x 30.5cm)
£1,000–1,500 *P*

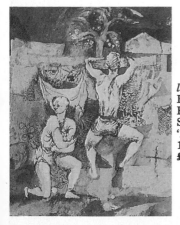

l. **Keith Vaughan**
British (1912–77)
Boys stealing Apples
Signed and dated
'1944', gouache
11½ x 9in (29 x 22.5cm)
£2,750–3,250 *P*

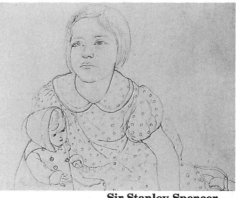

Sir Stanley Spencer
British (1891–1959)
Portraits of Pauline, 1940
and of a Girl with a Doll
A pair, pencil
14 x 18½in (35.5 x 47cm)
£700–800 *CSK*

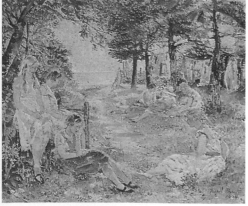

l. **Margaret Fisher Prout**
British (20thC)
The Path to the Shore
Signed and dated '1934', oil on panel
30 x 36in (76 x 91.5cm)
£2,750–3,250 *CSK*

Cardinals & Monks

One of the archetypes of 19thC popular painting, monks and cardinals are invariably portrayed enjoying the pleasures of the material rather than the spiritual world. Scarlet-gowned cardinals inhabit luxurious apartments glittering with gilt and porcelain. Monks more modestly dressed, but no less self-indulgent, enjoy glasses of wine and pipes of tobacco. A vein of humour runs through these glamourous pictures decoratively debunking the clerical world.

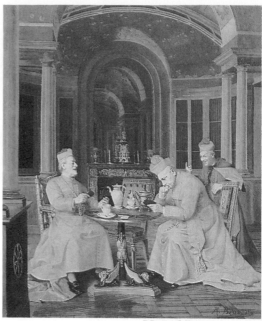

Marcel Brunery
French (19/20thC)
An unfair Advantage
Signed, oil on canvas
25½ x 21¼in (65 x 54cm)
£9,500–10,500 *P*

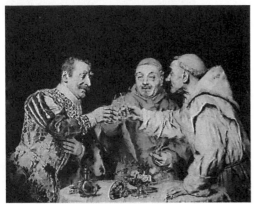

Antonio Casanova y Estorach
Spanish (1847–96)
The Holy Alliance
Signed and dated '1894', oil on canvas
12¾ x 16in (32.5 x 40.5cm)
£5,000–6,000 *C*

r. **Georges Croegaert**
French (1848–1923)
La Dictée
Signed and inscribed,
oil on panel
15¼ x 12in (39 x 30.5cm)
£15,000–17,000 *S*

Victor Marais-Milton
French (1872–1968)
The Cardinal's favourite Melody
and A Word in Confidence
A pair, signed, oil on canvas
23½ x 28¾in (60 x 73cm)
£4,750–5,750 *P*

r. **German School** (19thC)
The Confession
Oil on canvas
16½ x 13½in (42 x 34.5cm)
£900–1,200 *CSK*

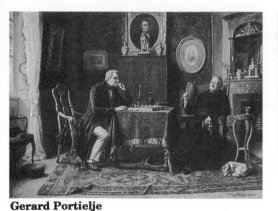

Gerard Portielje
Belgian (1856–1929)
An interesting Game
Signed and inscribed, oil on canvas
23 x 30½in (58.5 x 77.5cm)
£16,000–18,000 *C*

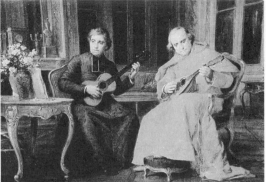

Charles Baptiste Schreiber
French (d1903)
A difficult Note
Oil on canvas
14 x 18in (35.5 x 45.5cm)
£8,500–9,000 *HFA*

l. **Walter Dendy Sadler**
British (1824–1923)
The Magpie
Signed and dated '79',
oil on canvas
24¼ x 12¼in (62 x 31cm)
£1,200–1,800 *Bon*

Giuseppe Signorini
Italian (1857–1932)
A Cardinal taking Tea with
two other Figures
Signed and dated '1897', colour
washes heightened with white
17½ x 23in (44.5 x 59cm)
£1,700–2,000 *P(L)*

r. **Euginio Zampighi**
Italian (1859–1944)
A dubious Vintage
Signed, oil on canvas
11½ x 8½in (29 x 21cm)
£2,500–3,000 *S(S)*

A. Staniek
German (19thC)
Teasing the sleepy Friar
Signed, inscribed and
dated '1883', oil on canvas
21¾ x 18in (55 x 45.5cm)
£1,700–2,000 *P*

l. **Umberto Zini**
Italian (b1878)
The Cardinal's Portrait
Signed, watercolour heightened with white
13½ x 21in (34.5 x 53cm)
£1,000–1,200 *CSK*

Cavaliers

The cavalier was a favourite subject with Victorian artists. Pictorial inspiration came from the painters of the 17th and 18thC, in particular 17thC Dutch portrayals of officers, handsomely dressed and generally portrayed in a domestic rather than a warlike setting. Similarly, the cavaliers in 19thC paintings are more likely to be seen romancing beautiful ladies, playing cards or enjoying a quiet smoke, than fighting bloody battles.

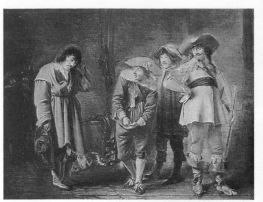

Circle of Jan Olis
Dutch (c1610–76)
Officers mocking a Peasant
Signed, oil on panel
21¾ x 28in (55 x 71cm)
£10,500–11,500 *C*

l. **Edgar Bundy, ARA**
British (1862–1922)
A Glass of Ale
Signed and dated '1887',
oil on canvas
28 x 36in (71 x 91.5cm)
£3,300–4,000 *S*

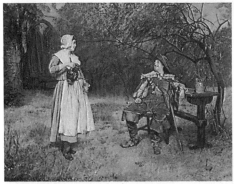

Joaquin Miro
Spanish (19thC)
Gamblers in a Courtyard
Signed, oil on canvas
11¾ x 9in (30 x 22.5cm)
£1,800–2,000 *P*

Follower of Robert Alexander Hillingford
British (1828–1902)
A Cavalier smoking a Pipe and A Good Brew
A pair, oil on panel
9 x 7in (22.5 x 17.5cm)
£450–550 *CSK*

F. H. Mols
Belgian (1848–1903)
A Family Concert and The Card Players
A pair, signed, oil on panel, late 19thC
9 x 13in (22.5 x 33cm)
£1,200–1,500 *MJB*

Alessandro Sani
Italian (19thC)
The Hungry Guest
Oil on canvas
15 x 19in (38 x 48cm)
£4,000–4,600 *HFA*

l. **John Seymour Lucas**
British (1849–1923)
A Good Smoke
Signed and dated '1881',
oil on canvas
11 x 13in (28 x 33cm)
£750–850 *CSK*

Classical Genre

Classical genre pictures provided a popular and accessible vision of the antique world. Unlike mythological pictures which portrayed the legends of gods and goddesses, Victorian classical genre painters set out to tell the everyday story of Roman folk, a domestic picture of antiquity. The scenes, costumes and settings might have been researched with the utmost fidelity, but the figures themselves are always eminently 19thC – Victorians in togas, or as one commentator put it, 'Maidens from the St. John's Wood vicinity dressed up in sheets.'

l. **After Sir Hubert von Herkomer, RA, RWS**
British (1849–1914)
Ivy
Photogravure, 1896
20¾ x 16in (52.5 x 40.5cm)
£600–700 *C*

Follower of George Lawrence Bulleid
British (1858–1933)
Classical Maidens
Oil with gold paint on canvas
10½ x 39¾in (26 x 100cm)
£1,000–1,500 *S(S)*

Sir Edward John Poynter, PRA, RWS
British (1836–1919)
Study for Idle Fears
Signed with monogram and dated '1893' and '1913', oil on panel
12¾ x 9¼in (32.5 x 23cm)
£3,500–4,500 *S*

Louis Fairfax Muckley
British (1862–1926)
Autumn
Oil on canvas
81¼ x 32½in (206 x 82.5cm)
£15,000–20,000 *C*

Sir Edward John Poynter, PRA, RWS
British (1836–1919)
Idle Fears
Signed with monogram and dated '1893', oil on canvas
40½ x 28½in (102.5 x 72.5cm)
£112,000–125,000 *S*

r. **Henry Ryland**
British (1856–1924)
When the Heart is Young
Signed, watercolour
13½ x 10in (34 x 25cm)
£1,400–1,800 *N*

l. **Joseph Edward Southall**
British (1861–1944)
Lady kneeling
Signed with an initial and dated '1893', pencil and white chalk
10¾ x 9¼in (27 x 23cm)
£400–450 *CSK*

Circus & Fairground

Nicholas Africano
American (b1948)
The High Wire, No.2
Oil, wax, acrylic, string and wood, 1979
9½ x 54 x 1in (24 x 137 x 2.5cm)
£3,000–3,500 S(NY)

Mary Fedden, LG, PRWA
British (b1915)
Clowns and Charcoal Burners
Signed and dated '1954', oil on canvas
24 x 30in (61 x 76cm)
£3,000–4,000 Bon

Yasuo Kuniyoshi
American (1893–1953)
Before the Act
Signed and dated in pencil '1932'
and inscribed '40 prints', lithograph
13¼ x 9½in (34 x 24cm)
£3,000–3,500 S(NY)

r. **Paul Monaghan**
British (20thC)
Waiting to go On
Signed, oil on canvas
18 x 24in (45.5 x 61cm)
£200–300 GK

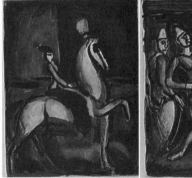

George Rouault
French (1871–1958)
Cirque
Eight aquatints, 1930, from total edition of 270
17½ x 13¼in (44.5 x 33.5cm)
£21,000–24,000 S(NY)

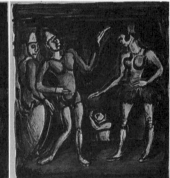

r. **Ben Sunlight**
British (20thC)
Variation on a Theme
of Tintoretto
Oil on canvas
30 x 20in (76 x 51cm)
£600–800 GK

l. **Edward Seago**
British (1910–74)
Circus Studies
Pencil, pen, brush,
black and red ink
11½ x 8in (29 x 20cm)
£500–600 CSK

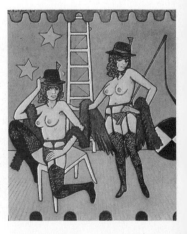

Cowboys & Indians

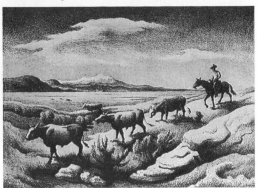

Thomas Hart Benton
American (1889–1975)
Wyoming Autumn
Signed, lithograph, 1974, from edition of 250
17 x 23¼in (43 x 59.5cm)
£1,000–1,200 *S(NY)*

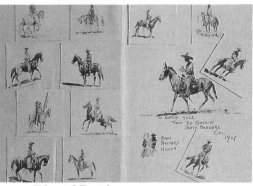

Edward Borein
American (1872–1945)
Mounted Cowboy with a Lasso
A set of 12, signed, watercolour, with a copy
of *The Phantom Bull* by Charles E. Perkins,
1932, illustrated with a vignette and
inscribed, 'To Gladis Yule from Ed Borein
Santa Barbara Cal 1937'
2¼ x 2½in (6 x 6.5cm)
£6,500–7,500 *P*

*These watercolours were used as place cards
on board* Nahlin, *the yacht belonging to
Lady Anne Yule.*

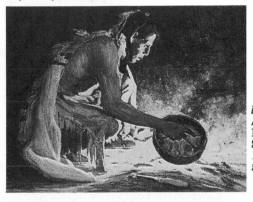

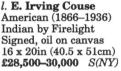

l. **E. Irving Couse**
American (1866–1936)
Indian by Firelight
Signed, oil on canvas
16 x 20in (40.5 x 51cm)
£28,500–30,000 *S(NY)*

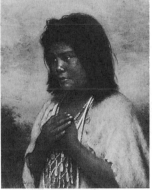

Grace Carpenter Hudson
American (1865–1937)
The Betrothed (Ta-Le-A)
Signed and dated '22',
oil on masonite
20¾ x 16¾in (52.5 x 42.5cm)
£11,000–12,000 *S(NY)*

Gaspard de Latoix
British (active 1882–1903)
North American Indians
Signed with initials, pencil
11 x 15in (28 x 38cm)
£350–450 *Bea*

l. **Olaf Wieghorst**
American (1899–1988)
Cowboys on a Hilltop
Signed, oil on canvas
20 x 24in (50.5 x 61cm)
£9,500–10,500 *S(NY)*

Rex Whistler
British (1905–44)
Indians
Signed, c1917, mixed media,
3 sketches
6 x 8in (15 x 20cm)
£1,250–1,500 each *BRG*

Music & Dance

In old master pictures, musical instruments often had an allegorical significance. In paintings depicting the 'five senses', musical instruments traditionally represented hearing and they were frequently associated with love and lust. Bagpipes for example appear frequently in 17thC Dutch and Flemish 'low life' scenes. They were not only portrayed because they were a popular folk instrument, but often had a deliberately phallic implication, enhanced by the shape of the instrument. The lute, with its long neck and pear-shaped body was a familiar attribute of the lover. In 19thC paintings, music was often the excuse for romance, bringing young lovers together over the piano.

Pieter Brueghel III
Flemish (1589–1639)
The Egg Dance
Oil on panel
26 x 41¼in (66 x 104.5cm)
£145,000–160,000 C

r. **Jan Verkolje**
Dutch (1650–93)
An elegant Couple with musical Instruments in an Interior
Signed and dated '1671' or '1674', oil on canvas
38 x 32¼in (96.5 x 81.5cm)
£720,000–750,000 S

l. **Jan Tilius**
Italian (1660–1719)
A young Man with Bagpipes
Oil on panel
9¾ x 8in (24.5 x 20cm)
£12,500–14,000 S(NY)

r. **Guido R. Bach, RI**
British (1828–1905)
Italian Shepherd Boy
Signed and dated '1872', watercolour heightened with white
24½ x 18in (62.5 x 45.5cm)
£3,500–4,000 P

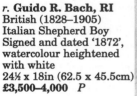

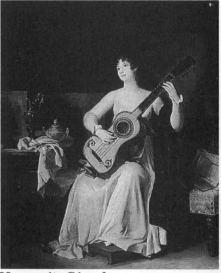

Marguerite Gérard
French (1761–1837)
La jeune Guitariste
Signed, oil on canvas
17½ x 14½in (44.5 x 37cm)
£33,000–35,000 S(NY)

Marguerite Gérard is generally regarded as responsible for the reinvention of the small scale, finely painted genre picture in the manner of Gabriel Metsu and Caspar Netscher, this despite the ever present example of her brother-in-law Jean-Honoré Fragonard (she lived with her sister and the great master, probably from 1775 onwards). This picture is a perfect example of the type of work that made her famous, successful, and wealthy enough to support the entire Fragonard / Gérard household.

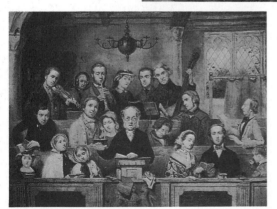

John Watkins Chapman
British (active 1853–1903)
The Village Choir
Signed, oil on canvas
28 x 36¼in (71 x 92cm)
£7,200–8,000 C

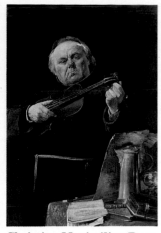

Christian Maximilian Baer
German (1853–1911)
A false String
Signed, oil on panel
24⅛ x 17in (62.5 x 43cm)
£2,200–2,500 *C*

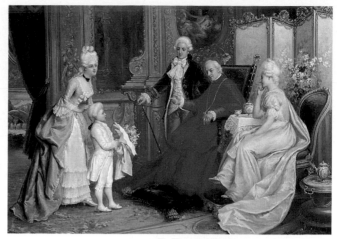

T. Ferranti
Italian (19thC)
A Bouquet for the Cardinal
Signed and inscribed, oil on canvas
18 x 24¼in (45.5 x 62cm)
£3,500–4,500 *P*

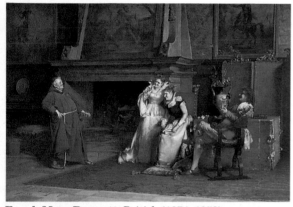

Frank Moss Bennett British (1874–1953)
Good Campanions
Oil on canvas
21 x 30in (53.5 x 76cm)
£10,000–11,000 *JN*

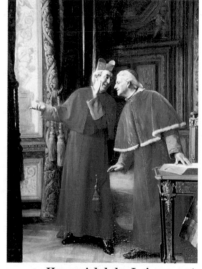

Henry Adolphe Laissemont
French (1854–1921)
An amusing Story
Oil on panel
18 x 15in (45.5 x 38cm)
£12,000–13,000 *HFA*

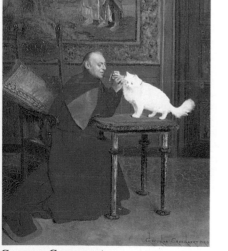

Georges Croegaert
French (1848–1923)
A Final Adjustment
Signed and inscribed, oil on panel
10½ x 8⅓in (27 x 21cm)
£4,200–5,000 *P*

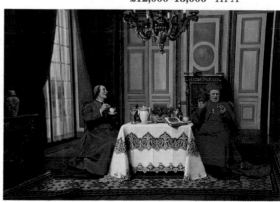

Marcel Brunery
French (19th/20thC)
An acquired Taste
Oil on board
20 x 24in (51 x 61.5cm)
£20,000–21,000 *HFA*

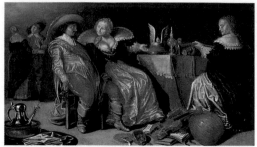

Herman Mijnerts Doncker
Dutch (c1620–56)
Elegant Figures in an Interior
Signed, oil on panel
11¼ x 19in (28.5 x 48.5cm)
£8,750–9,750 *S*

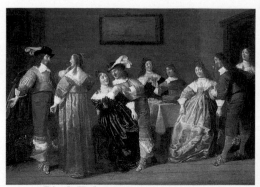

Dirck Hals
Dutch (1591–1656)
Elegant Company in an Interior
Signed with a monogram and dated '1645',
oil on panel
16¼ x 20¾in (41 x 52.5cm)
£9,000–10,000 *S*

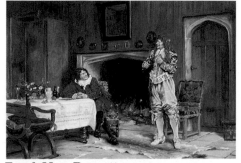

Frank Moss Bennett
British (1874–1953)
Good Companions
Oil on canvas
21 x 30in (53 x 76cm)
£18,500 19,500 *JN*

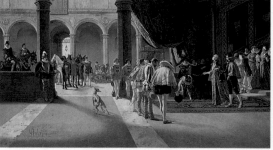

Pietro Gabrini
Italian (1865–1926)
The Arrival
Signed and dated '1882', oil on canvas
33½ x 59¼in (84 x 150cm)
£12,000–13,000 *C*

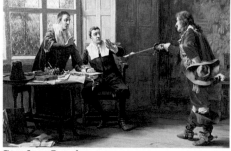

Stephen Lewin
British (active 1890–1910)
The Denial
Oil on canvas
24 x 30in (61.5 x 76cm)
£14,000–15,000 *HFA*

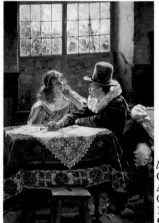

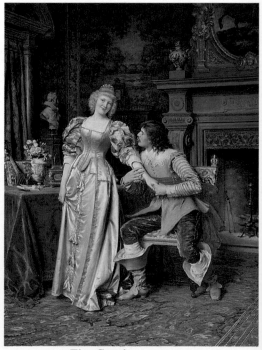

l. **Albert Friedrich Schroder**
German (b1854)
A handsome Visitor
Oil on panel
16 x 11in (40.5 x 28cm)
£13,000–14,000 *HFA*

Tito Conti
Italian (1842–1924)
The Proposal
Signed and dated '1896', oil on canvas
42¼ x 31¾in (107 x 80.5cm)
£42,000–46,000 *C*

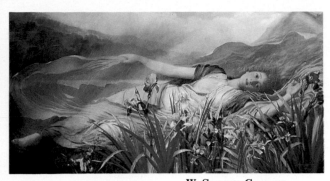

W. Savage Cooper
British (active 1882–1903)
Iris
Signed and dated '1893',
oil on canvas
40¼ x 76in (102 x 193cm)
£20,000–25,000 *S*

l. **Reginald Arthur**
British (active 1881–96)
The Bridesmaid
Signed and dated '1890', oil on panel
12½ x 9in (32 x 22.5cm)
£3,500–4,000 *S*

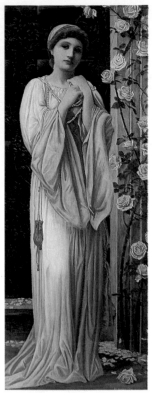

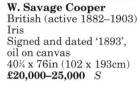

Henry Ryland
British (1856–1924)
The Dreamer
Signed and dated '1901',
oil on canvas
57 x 22in (144.5 x 56cm)
£21,000–26,000 *S*

l. **W. Anstey Dolland**
British (active 1879–89)
The Altar of Venus and
At the Fountain
A pair, signed, watercolour
13 x 9in (33 x 22.5cm)
£2,200–3,000 *TAY*

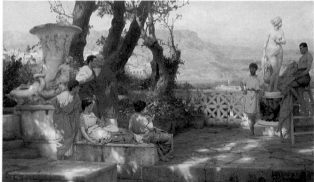

John William Godward
British (1861–1922)
The new Perfume
Signed and dated '1914', oil on canvas
40 x 20in (101.5 x 51cm)
£90,000–100,000 *C*

Hendrik Siemiradzki
Polish (1843–1902)
The Connoisseurs
Signed and dated 'AD.MDXXXXCVIII', oil on canvas
36½ x 60¾in (92.5 x 154.5cm)
£39,000–45,000 *C*

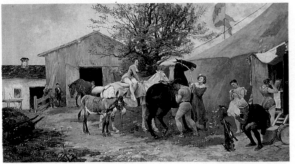

Julius von Blaas
Austrian (1845–1922)
The Circus
Signed and dated '1896', oil on canvas
31½ x 55in (80 x 139.5cm)
£16,000–18,000 *S*

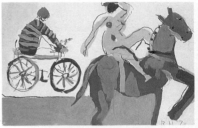

Roger Hilton British (b1911)
The Circus Act
Signed and dated '73', black chalk
and gouache
14¼ x 21½in (36 x 54.5cm)
£4,000–4,500 *S*

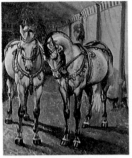

**Dame Laura Knight,
DBE, RA, RWS**
British (1877–1970)
Haifa and Hassan
Signed, oil on canvas
24 x 20in (61.5 x 51cm)
£10,500–11,500 *S*

Carlos Enríquez
Latin American (1901–57)
Circo
Signed and dated '55',
oil on canvas
26½ x 22½in (67 x 57cm)
£11,500–12,500 *S(NY)*

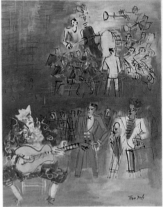

Jean Dufy
French (1888–1964)
Le Cirque
Signed, gouache on paper
26 x 20½in (66 x 52cm)
£10,000–11,000 *S(NY)*

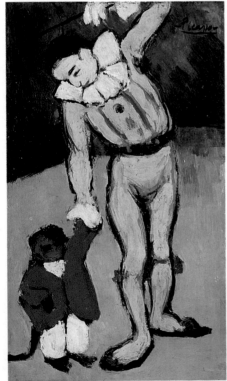

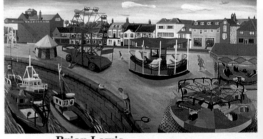

Brian Lewis
British (20thC)
The Fairground, Wells-next-the-sea
Oil and polymer wash on gessoed board
18 x 24in (45.5 x 61.5cm)
£650–750 *JCFA*

Pablo Picasso
Spanish (1881–1973)
Le Clown au Singe
Signed, oil on canvas
13 x 7½in (33 x 18.5cm)
£552,000–560,000 *S(NY)*

Jack Butler Yeats, RHA
Irish (1871–1957)
The Circus, 1921
Signed, oil on canvas
14 x 18in (35.5 x 45.5cm)
£60,000–65,000 *JAd*

Mattheus van Helmont
Flemish (1623–after 1679)
A young Man playing a Lute with a Lady reading Music
Signed, oil on panel
11¾ x 11in (30 x 28cm)
£47,000–52,000 *S(NY)*

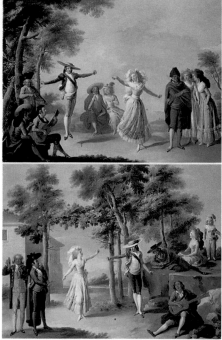

José Camarón y Boronat
Spanish (1731–1803)
Elegant Couples dancing the *Bolero*
A pair, oil on canvas
17½ x 22in (44 x 55.5cm)
£90,000–100,000 *C*

John Bagnold Burgess
British (1830–1897)
Pensioned Off
Oil on canvas
36 x 50in (91.5 x 127cm)
£4,000–5,000 *HFA*

Italian School (late 19thC)
La Tarantella
Signed, pencil and watercolour on
paper laid down on board
27¼ x 39¾in (69 x 101cm)
£5,000–6,000 *C*

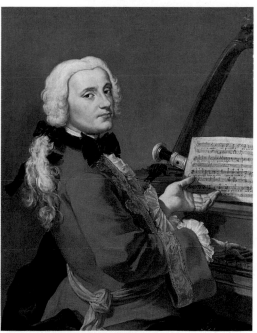

Italian School (c1740–50)
Portrait of a Musician or Composer
at a Harpsichord
Inscribed, oil on canvas
38 x 29in (96.5 x 73.5cm)
£120,000–130,000 *S(NY)*

l. **Filippo Falciatore**
Italian (1718–68)
An Ornamental Garden with
active people
Oil on canvas
16 x 39½in (40.5 x 100cm)
£28,000–30,000 *P*

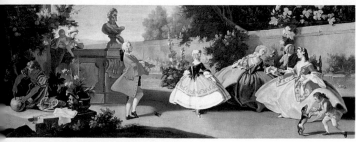

Kees van Dongen
French (1877–1968)
L'Enregistrement
Signed, watercolour, Indian ink
and gouache on paper
12¼ x 9½in (31 x 24cm)
£9,500–10,500 *S(NY)*

Maxilimien Lenz
Austrian (1860–1948)
Fruhlingsreigen
Signed, oil on canvas
63¼ x 79in (161 x 200.5cm)
£32,000–36,000 *S*

**Lord Methuen, RA, RWS, RBA,
NEAC, PRWA**
British (1886–1974)
The BBC Symphony Orchestra
Signed, oil on canvas
24 x 34in (61.5 x 86.5cm)
£1,000–1,400 *Bon*

Everett Shinn
American (1876–1953)
Ballet Dancer
Signed and dated '1929', pastel on paper
15½ x 11¼in (39 x 28.5cm)
£50,000–55,000 *S(NY)*

Louis Adolphe Tessier
French (early 20thC)
La Danse des Poupées
Signed and dated '1905', oil on canvas
39¼ x 31½in (100 x 80cm)
£8,000–9,000 *C*

Charles William Sharpe
British (d1953)
A Tune after Supper
Oil on canvas
19 x 23in (48.5 x 59cm)
£11,500–12,500 *JN*

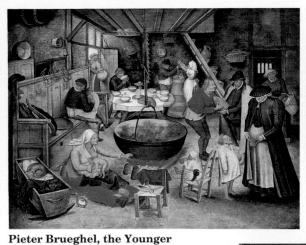

Pieter Brueghel, the Younger
Flemish (1564–1637)
The visit to the Farm
Signed, oil on panel
17½ x 22½in (44.5 x 57cm)
£240,000–260,000 *S(NY)*

Gerrit Donck
Flemish (c1610–40)
A Peasant Woman with a Vegetable Seller
Signed and dated '1639', oil on panel
14 x 24¾in (35.5 x 63cm)
£14,000–15,000 *S(NY)*

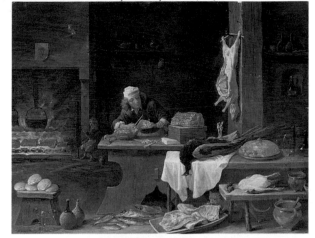

David Teniers II
Flemish (1610–90)
A Peasant preparing a Lamb in a Kitchen
Signed and dated '1668', oil on panel
18¾ x 24in (48 x 61.5cm)
£53,000–55,000 *CNY*

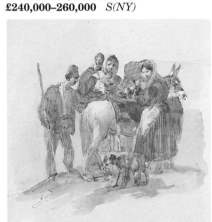

Giuseppe Bernardino Bison
Italian (1762–1844)
A Peasant Family loading a Donkey
Pen and brown ink and watercolour over black chalk
7 x 6½in (18.5 x 16cm)
£5,000–6,000 *S(NY)*

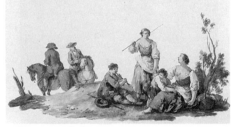

Giuseppe Zais
Italian (1709–84)
A pastoral Scene with Women and Children
Watercolour, brown ink and gouache
9½ x 13¾in (24 x 34.5cm)
£11,500–12,500 *S(NY)*

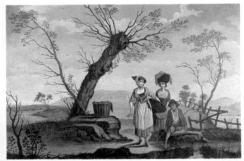

French Provincial School (18thC)
Washerwomen and a Young Man by a
Pollarded Tree on the Banks of a River
Oil on canvas
38½ x 58½in (98 x 148.5cm)
£2,500–3,000 *Bon*

r. **Bernardus Johannes Blommers**
Dutch (1845–1914)
Landing the Catch
Signed, oil on canvas
25 x 48in (63.5 x 122cm)
£80,000–90,000 *C(S)*

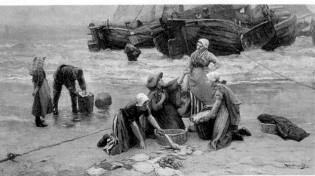

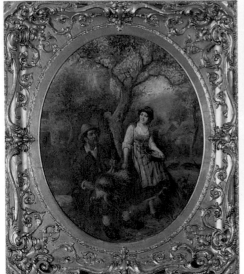

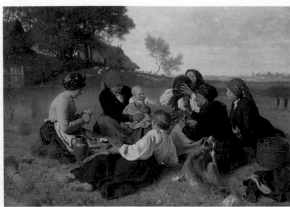

Friedrich Kraus
German (1826–94)
A rest from the Harvest
Signed, oil on canvas
28¾ x 40½in (73 x103cm)
£7,500–8,500 *C*

Trevor Haddon, RBA
British (c1864–1941)
Countryman and Girl
Oil on canvas
30 x 28in (76 x 71cm)
£1,700–1,900 *MAT*

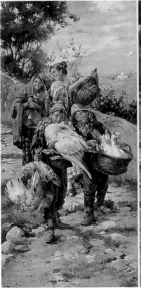

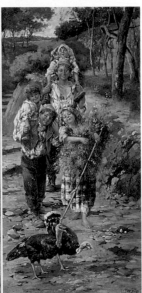

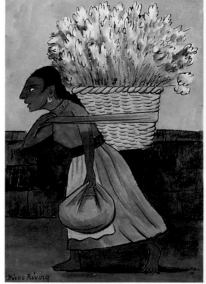

L. Pernett (late 19thC)
Going to Market
A pair, signed, oil on canvas
41½ x 20¾in (105.5 x 52.5cm)
£8,000–9,000 *C*

Diego Rivera
Mexican (1886–1967)
Mujer con Canasta de Flores
Signed, watercolour on rice paper, 1940
15¼ x 10½in (39 x 26.5cm)
£75,000–85,000 *S(NY)*

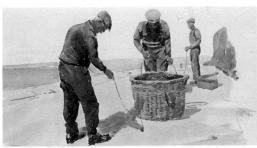

Rowland Fisher
British (1885–1969)
Fishermen unloading, Mevagissey Harbour
Signed, oil on canvas
24 x 36in (61.5 x 91.5cm)
£3,500–4,000 *SFA*

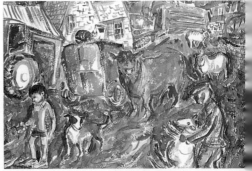

Robert Macdonald
British (20thC)
Bull at Wernfawr
Watercolour
22½ x 29½in (57 x 74.5cm)
£700–800 *KG*

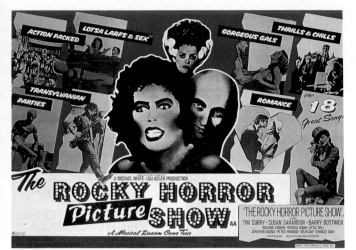

The Rocky Horror Picture Show, 1975,
TCF, British Quad, art by John Pasche,
linen-backed, fine condition, 26½ x 36½in
(67.5 x 92.5cm).
£650–750 *CSK*

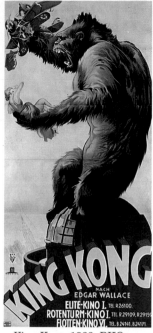

King Kong, 1933, RKO,
lithograph, Austrian, linen-
backed, very fine condition,
110 x 49in (279 x 124.5cm).
£16,000–16,500 *S(NY)*

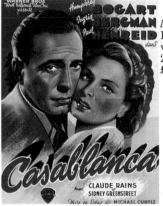

l. Casablanca, 1943, Warner
Bros, Belgium, linen-backed,
very fine condition,
22 x 14in (56 x 35.5cm).
£2,300–2,600 *CSK*

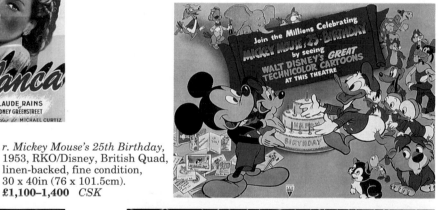

r. Mickey Mouse's 25th Birthday,
1953, RKO/Disney, British Quad,
linen-backed, fine condition,
30 x 40in (76 x 101.5cm).
£1,100–1,400 *CSK*

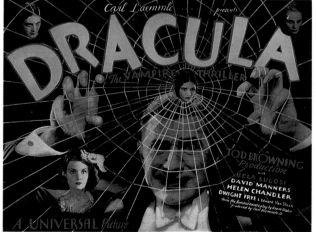

Terminator, 1984, Orion,
US, one sheet, linen-backed,
fine condition, 41 x 27in
(104 x 68.5cm).
£400–450 *CSK*

Dracula, 1931, Universal, title lobby card,
paper-backed, good condition, 11 x 14in
(28 x 35.5cm).
£7,000–8,000 *CNY*

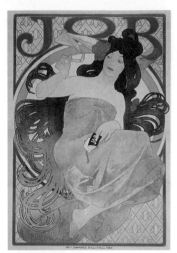

Job, Rennert/Weill,
lithograph, printed,c1899, by
Alphonse Maria Mucha, linen-
backed, good condition,
59½ x 39¾in (150.5 x 101cm).
£5,500–6,000 *S(NY)*

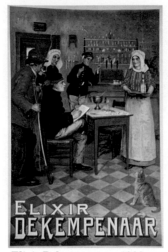

Elixir Dekempenaar, c1930,
paper, 34 x 23in (86.5 x 59cm).
£100–120 *Do*

*London and South
Western Railway,*
lithograph, c1900, by
Douglas Snowdon,
printed by F. Nash &
Co, excellent condition,
39½ x 26in (100 x 66cm).
£1,000–1,500 *CSK*

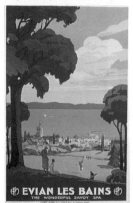

Evian Les Bains, PLM,
c1930, lithograph by Geo
François, French, linen-
backed, excellent condition,
39 x 25in (99 x 63.5cm).
£800–900 *CSK*

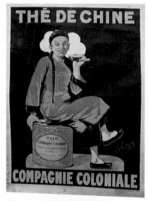

Thé de Chine, c1920s,
French, by D'Ezy, paper,
55 x 38in (139.5 x 96.5cm).
£275–325 *Do*

Heinz, c1940, USA, paper,
20 x 12in (50.5 x 30.5cm).
£20–40 *Do*

Tip Top Polishers, c1930,
British, paper, 16 x 10½in
(40.5 x 26.5cm).
£40–50 *Do*

Raisin Girl, c1920,
Spanish, paper, 16 x 9in
(40.5 x 22.5cm).
£55–65 *Do*

Power, London Underground,
1931, lithograph by E. M.
Kauffer, backed on japan,
39 x 25in (99 x 63.5cm).
£9,000–9,500 *CSK*

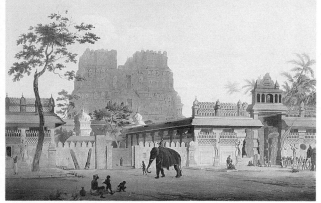

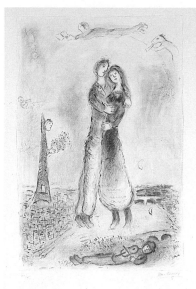

After Henry Salt
British (1780–1827)
Twenty-four views in St. Helena, the Cape, India, Ceylon,
Abyssinia and Egypt
Set of 24 plates, coloured aquatints, by D. Havell
21¼ x 29¼in (54 x 74cm)
£11,500–12,500 *S*

Marc Chagall
French/Russian (1887–1985)
La Joie
Signed, lithograph
45½ x 29½in (115 x 75cm)
£16,250–17,250 *S*

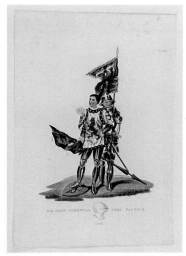

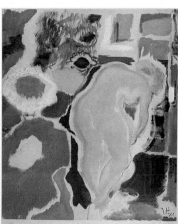

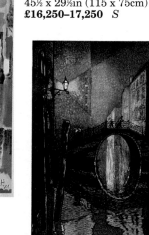

Unknown British (19thC)
Sir John Cornwall and
Lord Fanhope
Published by Sir Samuel Rush,
1824, hand-coloured aquatint
heightened with gold
12½ x 9½in (32 x 24cm)
£8–10 *SRAB*

Ivon Hitchens
British (1893–1979)
Early Morning
Signed, limited edition
24 x 20in (61.5 x 51cm)
£365–385 *BRG*

Joshijiro Urushibara
Japanese (1888–1953)
Ponte S. Paternina, Venice
Signed and inscribed
'No.66', woodcut
10¾ x 7½in (27.5 x 19cm)
£325–350 *EHL*

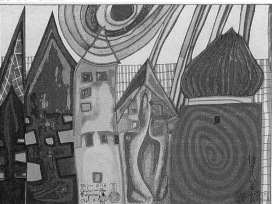

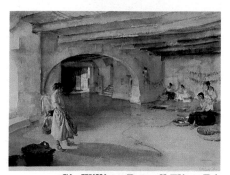

Friedensreich Hundertwasser
Austrian (b1928)
Nana Hyaku Mizu
Set of 7, signed and dated '1973', woodcuts
21¼ x 26¾in (68 x 54cm)
£16,250–17,250 *S*

Sir William Russell Flint, RA
British (1880–1969)
Festal preparations, Manosque
Signed, published by Medici,
limited edition of 756
17 x 22in (43.5 x 55.5cm)
£460–520 *P(B)*

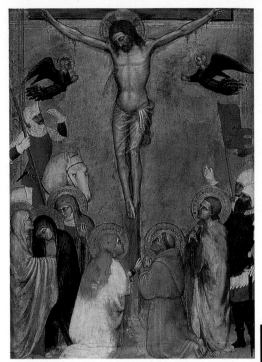

Giovanni di Jacopo di Guido da Caversaccio or da Como, called Giovanni da Milano
Italian (1345–70)
Crucifixion with the Virgin, the Holy Women, Saints John and Francis of Assisi and Roman Soldiers
Inscribed, gold ground, tempera on panel
15½ x 11in (39.5 x 28cm)
£650,000–700,000 *S(NY)*

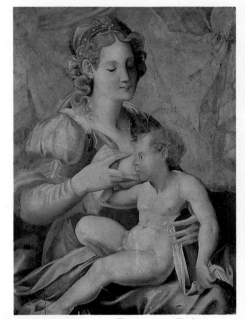

Francesco Brina
Italian (c1540–85)
The Madonna and Child
Oil on panel
34 x 25in (86 x 63.5cm)
£9,250–10,250 *P*

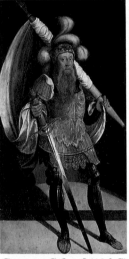

German School (16thC)
Portrait of a Gentleman, possibly Godfrey de Bouillon
Oil on panel
36½ x 19½in (92 x 48cm)
£27,000–30,000 *S(NY)*

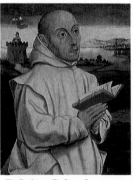

Belgian School
(early 16thC)
A Carthusian with a Book
Inscribed, oil on panel
10½ x 8½in (26.5 x 21cm)
£7,000–8,000 *C*

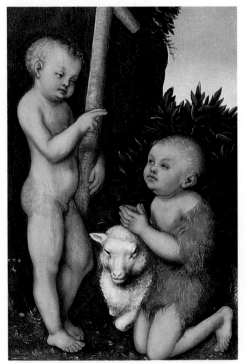

Lucas Cranach, the Elder
German (1472–1553)
The Young Jesus adored by St John the Baptist
Signed and dated '1534', oil on panel
13¾ x 9in (35 x 22.5cm)
£120,000–130,000 *S(NY)*

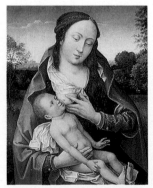

Circle of Joost van Cleve
Dutch (1485–c1540)
Madonna and Child
Oil on panel
17¾ x 14¼in (45 x 36cm)
£13,000–14,000 *S(Am)*

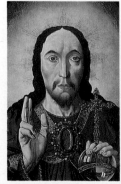

Flemish School
(late 15thC)
Christ as Salvator Mundi
Oil on panel
21¼ x 14in (54 x 35.5cm)
£1,800–2,200 *S*

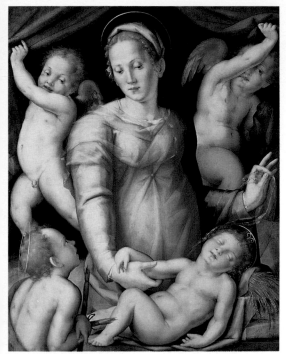

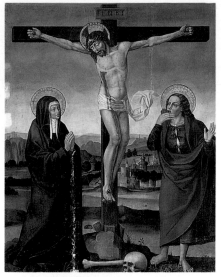

Antonio Vázquez
Spanish (c1485–after 1563)
Christ on the Cross with the Madonna
and St John the Evangelist
Oil on panel
41¼ x 32½in (104.5 x 82.5cm)
£11,000–12,000 *C*

Pier Francesco di Jacopo Foschi Italian (1502–67)
The Madonna and Child with St John the Baptist and Angels
Oil on panel
44¾ x 34¾in (113.5 x 88.5cm)
£125,000–140,000 *S*

r. **Bernardino di Betto da Perugia, called
Pintoricchio** Italian (c1454–1513)
The Madonna and Child with the infant
St John, Andrew and Jerome
Oil on panel, 24¼in(61.5 diam)
£120,000–130,000 *CNY*

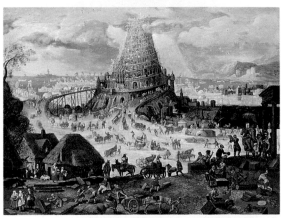

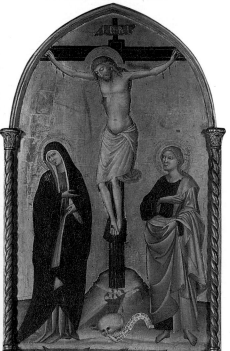

Tuscan School (c1400)
The Crucifixion with the Virgin Mary
and St John
Tempera on panel and gold ground
34¼ x 20¼in (87 x 51.5cm)
£30,000–35,000 *S*

Circle of Marten van Valckenborch
Flemish (16thC)
The Tower of Babel
Oil on copper
17½ x 23½in (44.5 x 60cm)
£48,000–53,000 *S*

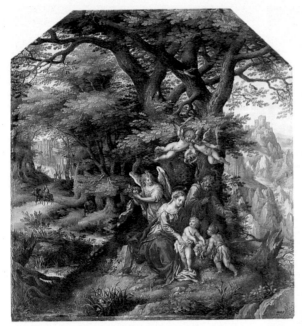

Denis van Alsloot and Hendrick de Clerck
Flemish (1570–1628 and 1570–1629)
The Holy Family with the Infant St John and
attendant Angels in a Wooded Landscape with the
Flight of Egypt beyond
Bears date '1611', oil on panel
41¼ x 37in (104.5 x 94cm)
£134,000–150,000 *S*

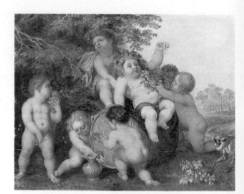

Jan van Balen
Flemish (1611–54)
The Triumph of Bacchus
Oil on panel
7½ x 9in (18.5 x 22.5cm)
£4,000–5,000 *P*

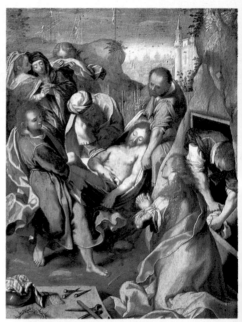

Flemish School, after Federico Barocci
Flemish (c1600)
The Entombment
Oil on copper
19½ x 14¼in (49.5 x 36cm)
£4,000–5,000 *CSK*

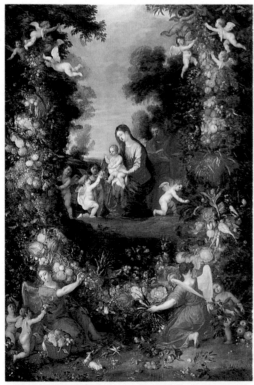

**Jan Brueghel, the Younger, and
Hendrick van Balen**
Flemish (1601–78 and 1575–1632)
The Holy Family with Cherubs in a Landscape,
set in a Wreath of Fruit and Vegetables
Oil on panel
42 x 28in (106.5 x 71cm)
£88,000–95,000 *S(Am)*

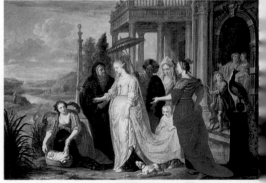

William van Herp
Flemish (1614–77)
The finding of Moses
Oil on canvas
52 x 71¼in (132 x 180.5cm)
£10,500–11,500 *S*

Mexican School (Mid-18thC)
Virgen de Guadalupe
Oil on copper
26½ x 20½in (67.5 x 52cm)
£25,000–28,000 *S(NY)*

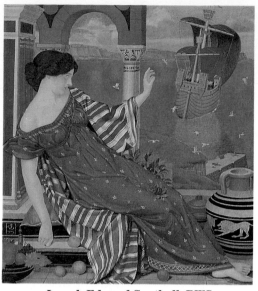

Joseph Edward Southall, RWS
British (1861–1944)
Ariadne
Signed and dated '1903', tempera on panel
14 x 13in (35.5 x 33cm)
£17,500–18,500 *C*

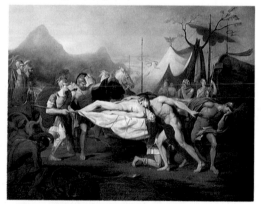

Thomas Douglas Guest
British (b1781)
Bearing the dead Body of Patroclus to the Camp
Signed, oil on canvas
39½ x 49¼in (100.5 x 125cm)
£8,750–9,750 *S*

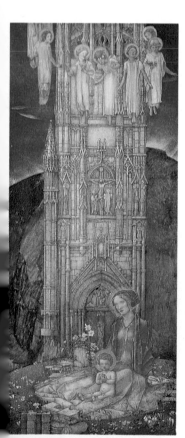

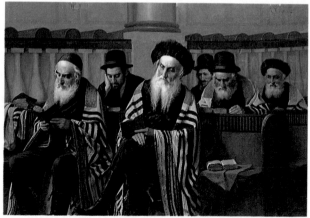

Edward Reginald Frampton
British (1872–1923)
The Gothic Tower
Signed, watercolour and bodycolour
36½ x 15½in (93 x 39.5cm)
£10,500–11,500 *C*

Alois Heinrich Priechenfried
German (1867–1953)
Reading the Scriptures
Signed, oil on panel
23 x 31in (59 x 79cm)
£35,000–40,000 *Bon*

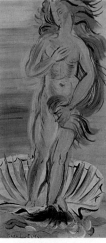

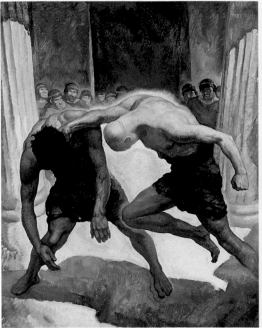

Leon Underwood
British (1890–1975)
The Fiery Angel
Signed and dated '27',
oil on canvas
23 x 13in (59 x 33cm)
£1,900–2,200 *P*

Raoul Dufy
French (1877–1953)
La Naissance de Venus
Signed, oil on panel
11½ x 5in (29 x 12.5cm)
£12,500–13,500 *S(NY)*

N. C. Wyeth
American (1882–1945)
The Beggars Fight
Signed, oil on canvas
48¼ x 38¼in (122.5 x 97cm)
£13,000–14,000 *S(NY)*

l. **Marc Chagall**
French/Russian (1887–1985)
Moses receiving the
Tablets of the Law
Signed, gouache, Indian
ink and pencil on paper
15 x 11in (38.5 x 28cm)
£19,500–20,500 *S(NY)*

Kate Rose
British (20thC)
Detail from the Expulsion from the Garden
Acrylic
46 x 31½in (116.5 x 80cm)
£2,000–2,250 *AMC*

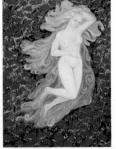

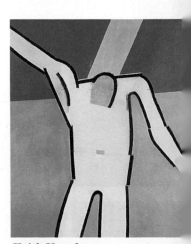

Pamela Mussen
Irish (20thC)
Roses (Erin re-born)
Signed, oil on panel,
completed 1994
30 x 20in (76 x 51cm)
£550–650 *Art*

l. **Carel Weight, RA**
British (b1908)
They are all looking the
wrong Way
Signed, oil on panel
48 x 36in (122 x 91.5cm)
£14,000–15,000 *BRG*

Keith Vaughan
British (1912–76)
Adam
Signed, dated '1976', oil on canvas
50¼ x 40in (127.5 x101.5cm)
£4,750–5,250 *S*

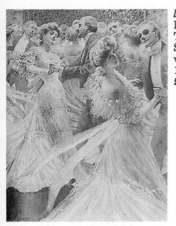

l. **Lucien Davis**
British (1860–1941)
The Mistletoe Dance
Signed, watercolour and
wash heightened with white
12 x 9in (30.5 x 22.5cm)
£450–550 *CSK*

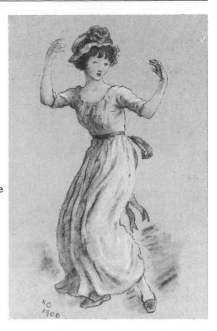

r. **Kate Greenaway, RI**
British (1846–1901)
Study of a dancing Girl
Signed with initials and
dated '1900', pencil and
wash heightened with white
8¼ x 4¾in (20.5 x 12cm)
£1,200–1,500 *P*

Leopold Franz Kowalsky
French (1856–1931)
Dancing Maidens
Signed, oil on canvas
41 x 63in (104 x 160cm)
£10,500–11,500 *S*

l. **Frédéric Soulacroix**
French (b1825)
Anxiously waiting
Signed and inscribed,
oil on canvas
27½ x 16in (70 x 40.5cm)
£21,000–26,000 *S*

Alexander MacKenzie
Scottish (1850–90)
Out of Tune
Signed and dated '1886', oil on canvas
20 x 30in (50.5 x 76cm)
£4,750–5,750 *C(S)*

l. **Victor Ambrus, ARCA, RE**
British (20thC)
Dancer Resting
Signed, pastel and conté
26 x 18½in (66 x 47.5cm)
£550–650 *BSG*

Jules de Vignon
French (1815–85)
Vivanti, Italian Dance
Oil on canvas
50¼ x 78in (127.5 x198cm) oval
£22,000–25,000 *S*

Lewis Baumer
British (b1870)
Ballerina
Etching
12 x 10in (30.5 x 25cm)
£400–500 *GK*

Rudolf Bonnet
French (1895–1978)
Balinese Dancers
Signed, inscribed and
dated '1934', pastel
38 x 28½in (99.5 x 72.5cm)
£33,500–36,000 *S(Am)*

Alan J. Bowyer
British (exh 1929–31)
Girl playing the Piano
Oil on canvas
36 x 28in (91.5 x 71cm)
£1,000–1,200 *CSK*

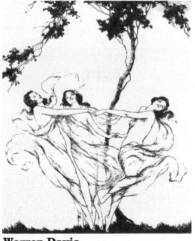

Warren Davis
British (active 1940s)
The Three Graces
Etching
11 x 9in (28 x 22.5cm)
£400–500 *GK*

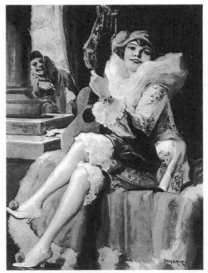

Richard Geiger
American (1870–1945)
Columbine
Signed, oil on canvas
39 x 29in (99 x 73.5cm)
£1,000–1,200 *CSK*

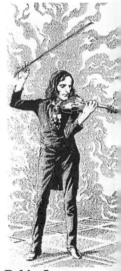

Robin Jacques
British (b1920)
Paganini
Pen and ink
11½ x 5in (29 x 12.5cm)
£200–250 *CBL*

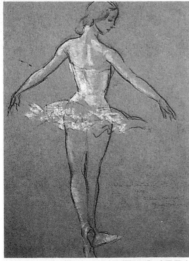

Vernon de Beauvoir Ward, ARBA
British (b1905)
Ballerina
Signed and dated '1953', pastel
23 x 16½in (58.5 x 42cm)
£1,000–1,250 *JN*

Maria Szantho
Hungarian (b1898)
Three Dancers
Signed and numbered '944', oil on board
27 x 38in (68.5 x 96.5cm)
£3,200–3,800 *DN*

Peasants & Country Life
17th–18th Century

Andries Both
Dutch (c1612–41)
A Tavern Interior
Signed and dated '1634', oil on panel
12¾ x 16¾in (32.5 x 42.5cm)
£10,000–11,000 S(Am)

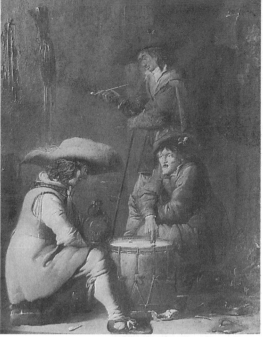

Benjamin Gerritsz. Cuyp
Dutch (1612–52)
Men playing Dice
Oil on panel
11 x 9in (28 x 22.5cm)
£7,500–8,500 S(Am)

Pietro Antonio Novelli
Italian (1729–1804)
Peasants eating a Picnic under the Shade
of a Tree
Signed, pen and black ink and grey wash
over black chalk
6¾ x 9½in (17 x 24cm)
£3,800–4,200 S(NY)

Pieter Snyers
Flemish (1681–1752)
Two Months of the Year; June and November
A pair, signed, oil on canvas
33¼ x 26½in (84.5 x 67.5cm)
£42,000–45,000 CNY

*The present paintings form part of the series of the
Twelve Months of the Year executed in 1727.
Each painting can be identified with the month it
represents through the personification of the signs of
the zodiac, by the appropriate actions of the people
depicted and the inclusion of produce pertinent to the
corresponding month.*

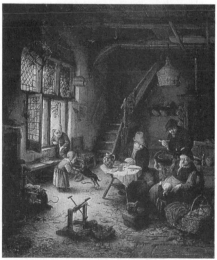

Adriaen Jansz. Van Ostade
Dutch (1610–85)
A Peasant Family in the Interior
of a Cottage
Signed and dated '1661', oil on panel
13½ x 12in (34 x 30.5cm)
£1,500,000+ CNY

*Dutch and Flemish old master paintings
have been performing strongly at auction
and none more so than the current work,
which created a new auction record for the
artist when sold by Christie's, New York.
The son of a weaver and a pupil of Frans
Hals, Ostade specialised in peasant scenes.
He was extremely prolific, with over 800 of
his paintings known. His drawings are
found in collections across the world.
Highly successful in his own day, Ostade
was also extremely popular with collectors
in the 18thC, when he was esteemed as
highly as Rembrandt.*

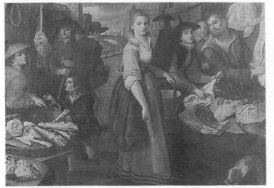

Attributed to Jean Baptiste de Saive
Flemish (1540–1624)
The Butcher's Stall
Oil on canvas
72 x 100¾in (182.5 x 256cm)
£6,000–7,000 *Bon*

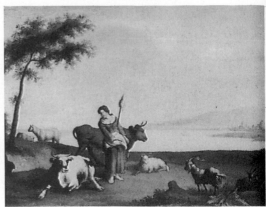

Manner of Adriaen van der Velde
Dutch (1636–72)
A Shepherdess with Sheep, a Cow and Goat
in a River Landscape
Oil on panel
10¼ x 12½in (25.5 x 32cm)
£600–800 *CSK*

19th–20th Century

l. **Adriaen Pietersz.
van de Venne**
Dutch (1589–1662)
A Brawl amongst
Peasants
Inscribed and dated
'1636', oil on panel
20 x 15½in (51 x 39.5cm)
£5,200–6,000 *S*

Charles James Adams
British (1857–1931)
A Logging Team returning Home
Signed, watercolour
20 x 30in (51 x 76cm)
£2,000–2,500 *Bon*

Francesco Bergamini
Italian (1815–83)
Behind Granny's Back
Signed and inscribed, oil on canvas
17½ x 26½in (44 x 67.5cm)
£8,750–10,000 *S*

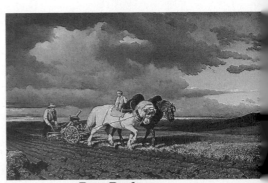

Rosa Bonheur
French (1822–99)
Le Labourage
Signed and dated '1844', oil on canvas
29 x 43½in (73.5 x 110.5cm)
£45,000–50,000 *S(NY)*

l. **William Bromley**
British (19thC)
There's a Hole in my Bucket
Signed and dated '1858', oil on canvas
28 x 36in (71 x 91.5cm)
£2,500–3,000 *Bon*

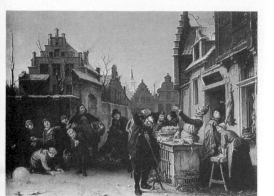

David Col
Belgian (1822–1900)
The Market Stall
Signed, inscribed and dated '1861',
oil on panel
29½ x 38in (75 x 96.5cm)
£35,000–40,000 *P*

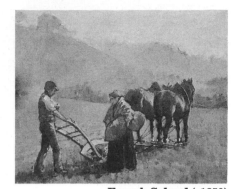

French School (c1850)
Ploughing Scene
Oil on canvas
12 x 15in (30.5 x 38cm)
£500–550 *HeG*

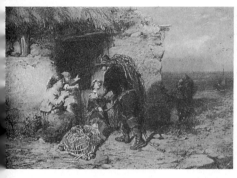

l. **James John Hill**
British (1811–82)
The Fisherman's Return
Signed, oil on canvas
10½ x 14½in (26.5 x 37cm)
£4,000–4,500 *P*

r. **David Haddon**
British (active 1884–1914)
The Fisherman
Signed, oil on canvas
13 x 9¼in (33 x 23cm)
£550–600 *BCG*

Joseph John Jenkins, RWS
British (1811–85)
Shrimpers – on the Coast of France,
near Boulogne
Signed, inscribed and dated '1849', watercolour
15¾ x 20½in (40 x 52cm)
£750–850 S(S)

*It was not just a large body of
paintings and engravings that
Jenkins left to posterity. As secretary
of the Old Watercolour Society he
inaugurated the custom of private
press views for exhibitions.*

Arthur Henry Knighton-Hammond
British (1875–1970)
Man with a Scythe
Signed, watercolour and bodycolour
22 x 30½in (56 x 77.5cm)
£1,600–1,800 JG

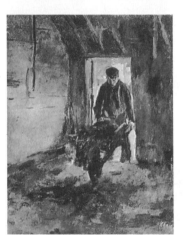

Jacob Simon Hendrik Kever
Dutch (1854–1922)
Figure with a Wheelbarrow
in a Barn Interior
Bears signature, oil on card laid
down on panel
17¾ x 13¾in (45 x 35cm)
£1,200–1,500 P

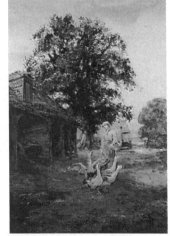

**Henry John Yeend King,
VPRI, RBA**
British (1855–1924)
Farmyard Scene
Signed, watercolour
21 x 14in (53.5 x 35.5cm)
£1,400–1,600 HO

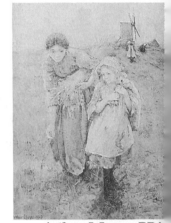

Arthur J. Legge, RBA
British (exh 1883–1920)
The Gleaners
Signed and dated '1913'
watercolour
24 x 18in (61 x 45.5cm)
£2,750–3,000 HO

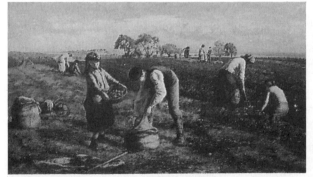

William Darling McKay, RSA
British (1844–1924)
Digging Potatoes
Signed and dated '70/71', oil on canvas
21¼ x 35½in (54 x 90.5cm)
£6,750–7,750 S(Sc)

Jean François Millet
French (1814–75)
Le Départ pour le Travail
Etching printed in brownish-black
1863, final state
15 x 12in (38.5 x 30.5cm)
£4,500–5,000 S(NY)

Bengt Nordenberg
Swedish (1822–1902)
The Visitor
Signed and dated '63', oil on canvas
22 x 26¼in (56 x 67cm)
£10,500–11,500 *P*

Attributed to Paul Falconer Poole
British (1807–79)
A Gipsy Family on a Mountain Track
Oil on canvas
40 x 34in (101.5 x 86cm)
£1,900–2,300 *Bon*

The son of a grocer and a self-taught painter, Poole became involved in a celebrated matrimonial scandal. An associate of artist Francis Danby, Poole moved in with Danby's wife, while Danby eloped to the continent with his mistress, his own 7 children and 3 of hers. After Danby's death in 1861, Poole married his widow. Poole was not renowned for his technical ability: 'He is deficient in power of drawing, careless in modelling, and demonstrates a singular neglect of the very elements of painting,' noted his contemporaries Richard and Samuel Redgrave. 'Yet there are perhaps few painters whose works show such a delightful combination of art and poetry.' The combination of landscape and peasant women was typical of his work.

William Shayer, Snr
British (1788–1879)
In the New Forest
Oil on canvas
25 x 30in (63.5 x 76cm)
£8,000–8,500 *JN*

Based in Southampton, Shayer painted many pictures in the nearby New Forest.

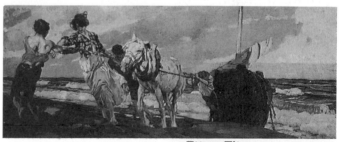

Ettore Tito
Italian (1859–1941)
Pulling the Boat on the Beach
Signed, oil on canvas
27 x 68in (68.5 x 172.5cm)
£42,000–46,000 *S*

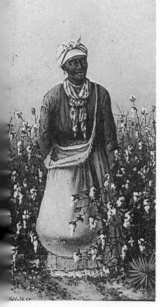

l. **William Aiken Walker**
American (1839–1921)
Cotton-picking Mammy
Signed and inscribed,
oil on board
11¾ x 6in (30 x 15cm)
£2,100–2,500 *S*

r. **Ralph Todd**
British (active 1880–93)
Mending Nets
Signed, watercolour
10½ x 14½in (26.5 x 37cm)
£900–1,100 *Bea*

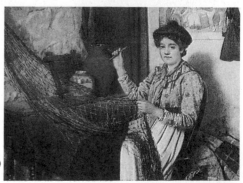

Royalty

Portraits of royalty appear regularly in the salerooms. They can be worth anything from a king's ransom for an original royal portrait, to under £1,000 for an indifferent, later copy of a famous royal prototype. Such portraits were regularly copied, both for private collectors and as diplomatic gifts. They were also used as art school exercises.

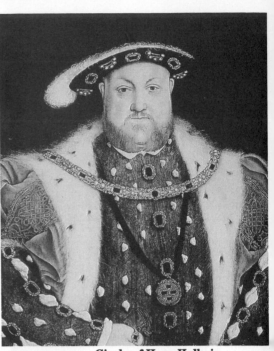

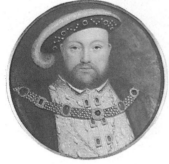

l. **Henry Bone,**
after Holbein
British (1755–1834)
King Henry VIII
Miniature, enamel
3½in (8.5cm) diam
£1,800–2,100 *Bon*

Circle of Hans Holbein
German (1497–1543)
Portrait of Henry VIII
Oil on panel
25½ x 20in (65 x 51cm)
£300,000–325,000 *S*

From 1836 until his premature death from the plague in 1543, Holbein was court painter to Henry VIII. IIis masterpiece during this period was a life-size dynastic portrait of the King, painted for Whitehall Palace in 1537 (destroyed by fire 1698), from which all subsequent portraits of the King were derived. Holbein established a prototype for royal portraiture, a powerful full frontal image of regal authority.

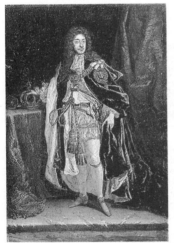

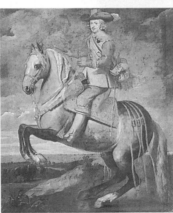

After Sir Godfrey Kneller
British (1646–1723)
Portrait of James II
Inscribed, oil on canvas
17 x 12⅛in (43 x 31.5cm)
£950–1,100 *CSK*

Caspar de Crayer
Flemish (1584–1669)
An Equestrian Portrait of Ferdinand, Cardinal-Infante of Spain
Oil on canvas
8½ x 7in (21 x 17.5cm)
£17,000–18,000 *S(Am)*

Miller's is a price GUIDE not a price LIST

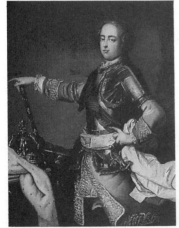

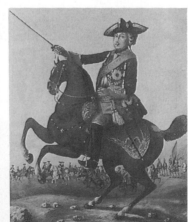

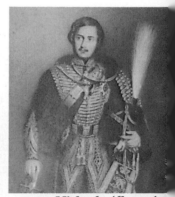

After Carle van Loo
French (1705–65)
Portrait of Louis XV
Oil on canvas
50 x 36in (127 x 91.5cm)
£5,500–6,500 *CSK*

Follower of David Morier
Swiss (1705–70)
George III on his Charger
Oil on canvas laid down on board
28¾ x 22¾in (73 x 58cm)
£1,300–1,500 *S(S)*

Michaelo Albanesi
after John Partridg
Italian (1816–78)
Prince Albert, Consort of England
Miniature, signed and dated '1862', oil on can
5in (12.5cm) high
Gilt gesso frame
£800–1,000 *Bon*

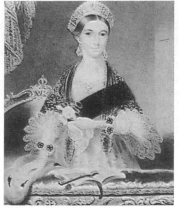

After Franz Kruger
German (1797–1857)
Portrait of Czar Nicholas I
Oil on canvas
36 x 28in (91.5 x 71cm)
£2,400–2,800 *P*

Edmund Thomas Parris
British (1793–1873)
Her Majesty at the Opera
Signed and dated '1837',
watercolour
12 x 10in (30.5 x 25cm)
£1,400–1,600 *HO*

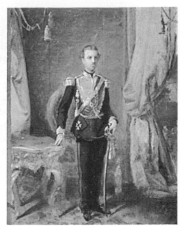

Spyros Prosalentis
Greek (1830–95)
A Portrait of King George I
Oil on board
13 x 10in (33 x 25cm)
£2,100–2,400 *S*

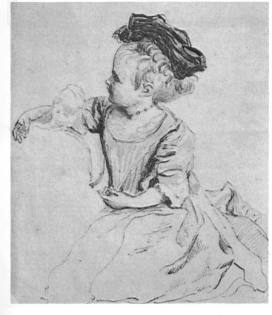

l. **HRH Queen Victoria**
British (1819–1901)
Princess Sophia
Inscribed, pen and ink
8 x 6in (20 x 15cm)
£1,200–1,400 *HO*

Queen Victoria loved drawing and, as a child, she was taught by Sir Richard Westall (1766–1836). She drew and painted with enjoyment and some skill throughout her life. Prince Albert taught her engraving and together they both experimented with lithography.

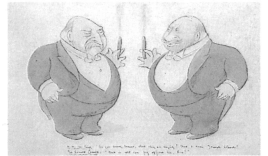

Sir Max Beerbohm
British (1872–1956)
HM The King and Sir Ernest Cassell
Inscribed, pencil, pen, black ink, coloured crayon
and watercolour
7½ x 12¼in (19 x 31cm)
£4,750–5,250 *C*

A caricature of HRH King Edward VII (1841–1910) and the financier Sir Ernest Cassell (1852–1921).

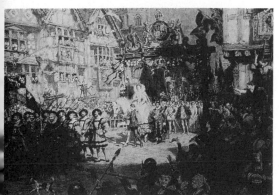

Frank Moss Bennett
British (1874–1953)
The Visit of Mary
Queen of Scots
Oil on canvas
15 x 20in (38 x 50.5cm)
£6,500–7,000 *HFA*

r. **Raoul Dufy**
French (1877–1953)
The Coronation of
King George
Signed, oil on canvas
or board, 1937
8 x 12in (20 x 30.5cm)
£18,000–18,750 *BRG*

PHOTOGRAPHY

The word photography, from the Greek *photos* 'light' and *graphein* 'to draw', was first coined in 1839. Nineteenth century subjects currently popular in the market include topographical studies, in particular views of India and the Near and Far East. Like artists, photographers travelled extensively in the Orient in the 19thC, producing pictures for the Western market. As with other Victorian photographs, such pictures are often sold in period albums. Some of these travel albums were compiled picture by picture by their original owners, others were created as a complete entity by professional photographers for the tourist market. Within the 20thC field the best prices tend to be reserved for famous images by famous names. Sotheby's sale of works from Man

Ray's studio fulfilled both these criteria, including portrait photographs of famous artists such as Picasso, as well as Man Ray's distinctive surrealist photographs.

The market for photography is dominated by American collectors. London is the principal auction centre for vintage 19thC photography while New York provides the main selling location for 20thC material (1995 saw Sotheby's New York celebrating their 20th anniversary of photographic auctions). As with pictures, the market for photographs today is extremely selective. Serious buyers are concentrating only on the rarest most important works, while more ordinary, run-of-the-mill material has been failing to sell at auction.

19th Century

Unknown
India (19thC)
An album containing over 105 photographs of India, including a portrait of the King of Siam, c1865
Album size 12½ x 16¼in (31.5 x 41cm)
£4,000–4,500 *P*

Francis Edmund Currey
British (1814–96)
Flower Studies, 1860s
A pair, albumen prints, mounted on card
8½ x 6¼in (21.5 x 16cm)
£425–525 *S*

Julia Margaret Cameron
British (1815–79)
A Study, c1865
Albumen print from copy negative, mounted on card
5½ x 4¼in (14 x 10.5cm)
£600–700 *S*

Percy Lund
British (19th/20thC)
An album containing photographs, including 'Sunny Memories' of the Bournemouth area, published by Humphries & Co Ltd, c1900
13 x 11in (33 x 28cm)
£80–100 *TAR*

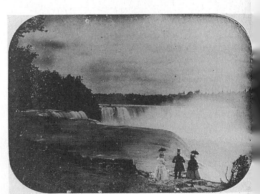

Attributed to Platt D. Babbitt
American (active 1850–70)
Niagara Falls
Whole plate daguerreotype, c1855
Whole plate
£5,800–6,000 *S(NY)*

The view is from Prospect Point on the American side of the Falls, where Babbitt's camera was located.

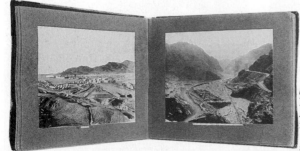

l. **R. B. Holmes**
British (19th/20thC)
An album containing photographs including the Khyber Pass, 1900
13½ x 16in (34 x 40.5cm)
£100–150 *TAR*

Henry White
British (1819–1903)
Country Cottage with Couple, 1856
Lightly albumenised salt print,
mounted on card
7¾ x 9¾in (19.5 x 24.5cm)
£1,100–1,500 *S*

20th Century

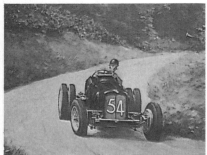

Anon (20thC)
A Study of Ken Wharton driving the
Ex-Mays ERA R4D at The Esses
Oil painted photograph, c1953
20 x 23in (50.5 x 58.5cm)
£160–200 *BKS*

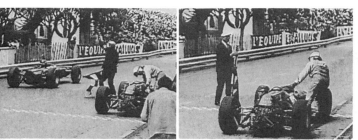

Anon (20thC)
Monaco 1965 – BRM and Ferrari
A pair of unpublished photographs
15 x 19in (38 x 48cm)
£200–240 *BKS*

John Surtees runs out of fuel on the penultimate lap after a race-long battle for the lead and pushes over the line for 4th, as Graham Hill takes the chequered flag.

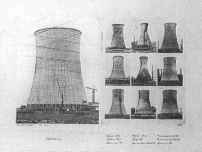

l. **Bernd and
Hilla Becher**
German (b1931 and 1934)
Kühltürme
Signed, titled and
dated '1973'
24¾ x 33½in (63.5 x 85cm)
£7,000–8,000 *S*

James F. Ryder
American (1826–1904)
Photographic Views of the Atlantic and Great Western
Railway, Volumes I and II
Albumen prints
7¼ x 9¼in (18.5 x 23cm)
£32,500–35,000 *S(NY)*

*Two albums containing 129 photographs, all studies of
'the Excavations, Cuts, Bridges, Trestles, Stations,
Buildings, and General Character of the Country' along
the Atlantic and Great Western Railway Lines from
Salamanca, New York, to Akron, Ohio, and from
Meadville to Oil City, Pennsylvania. In the spring of
1862, the Cleveland photographer James F. Ryder was
hired to provide a series of views of the railroad, to
inspire future investors. A special train car was outfitted
for Ryder, with a darkroom, water tank, developing sink,
and other necessities. With an engine, a tender and the
special car, Ryder and his little crew travelled the rails
as they chose, their only restrictions being as Ryder noted,
'to keep out of the way of all other trains.'*

David Bailey
British (b1938)
Marianne Faithfull, printed 1990
Signed in pencil, No. '1/25',
silver print
28¾ x 21½in (73.5 x 54.5cm)
£350–450 *S*

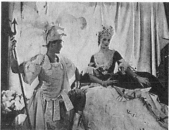

Cecil Beaton
British (1904–79)
Oliver Messel in costume for the
role of Paris from *Helen* and his
sister Anne, early 1932
Silver print mounted on card
7 x 9in (17.5 x 22.5cm)
£650–750 *S*

Edouard Boubat
French (b1923)
Woman with Goose, France, 1964
Dated '1964', silver print
15½ x 10½in (39.5 x 26cm)
£475–575 *S*

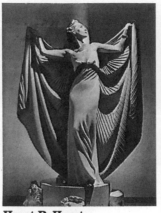

Horst P. Horst
German (b1906)
Helen Bennett
Platinum palladium print,
signed in pencil on border,
the reverse signed in pencil
and numbered 'Ed. 7/25',
1930s, printed later
26 x 22½in (66 x 56.5cm)
£2,000–2,300 *S*

l. **Karl Lagerfield**
Swedish (20thC)
Nadége à Plage, 1980s
Signed in ink on the
border, the reverse
numbered '4' in pencil,
silver print, mounted
on card
19¾ x 23½in (50 x 60cm)
£675–775 *S*

Margaret Bourke-White
American (1904–71)
George Washington Bridge
Signed, warm toned, mounted,
matted, 1933
13¼ x 8¾in (34 x 22cm)
£31,000–35,000 *S(NY)*

*'The George Washington Bridge over
the Hudson is the most beautiful
bridge in the world,' enthused Le
Corbusier. 'Made of cables and steel
beams, it gleams in the sky like a
reversed arch. It is blessed. It is the
only seat of grace in the disordered
city. When your car moves up the
ramp, the two towers rise so high
that it brings you happiness; their
structure is so pure, so resolute, so
regular that here, finally, steel
architecture seems to laugh.'*

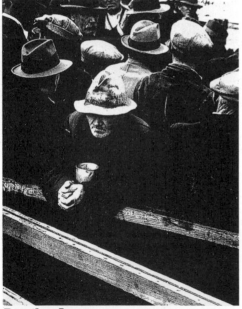

Dorothea Lange
American (1895–1965)
White Angel Breadline, San Francisco
Inscribed with printing notations by the
photographer in pencil with studio stamp on
reverse, matted, 1933
13½ x 10½ in (34 x 26.5cm)
£50,000–55,000 *S(NY)*

*This photograph is one of the most celebrated
images of the American Depression.*

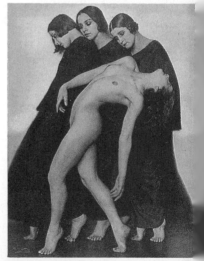

Prof. Rudolf Koppitz
Austrian (1884–1936)
Bewegungsstudie
Warm-toned carbon print, the
photographer's name blindstamped on
the image, double-mounted, signed in
pencil on the inner mount, 1926
14¾ x 11in (37.5 x 28cm)
£75,000–80,000 *S(NY)*

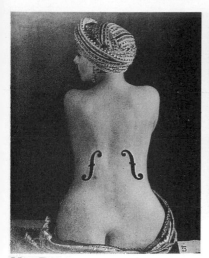

Man Ray
American (1890–1976)
Le Violon d'Ingres, 1924
Signed and dated on the original
image 'E.A. Man Ray 1924' and
signed and annotated in pencil,
silver copy print, printed c1971
15¾ x 11⅝in (40 x 29.5cm)
£66,000–72,000 S

*This is probably Man Ray's most
famous photograph. The title is a
pun. The French expression 'Violon
d'Ingres' means 'artistic hobby',
deriving from Ingres' own passion
for playing the violin. Man Ray has
transformed Kiki, his model and
mistress, into an Ingres' like
odalisque, adding f- stops to her
curvaceous back to evoke the violin.
The title also implies that Man
Ray's own artistic hobby was
beautiful women.*

Man Ray
American (1890–1976)
Pablo Picasso, Profile, 1932
Stamped in ink on the reverse
with photographer's credit, and
ADAGP agency credit, silver
print, mounted on card
11½ x 9in (29.5 x 22.5cm)
£14,000–15,000 S

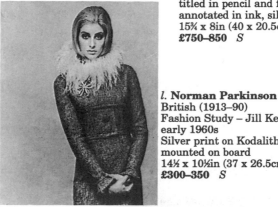

l. **Norman Parkinson**
British (1913–90)
Fashion Study – Jill Kennington,
early 1960s
Silver print on Kodalith paper,
mounted on board
14½ x 10½in (37 x 26.5cm)
£300–350 S

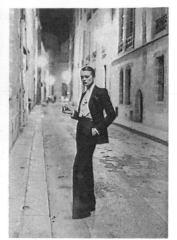

Helmut Newton
Australian (b1920)
'Vibeke photographed in
Paris', fashion by Yves Saint
Laurent, 1975
Stamped in ink on the reverse
with Condé Nast Paris credit,
titled in pencil and further
annotated in ink, silver print
15¾ x 8in (40 x 20.5cm)
£750–850 S

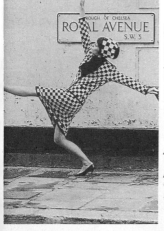

l. **Norman Parkinson**
British (1913–90)
Fashion Study for
Life, 1963
Silver print, the reverse
annotated in pencil
20¼ x 16in (51 x 40.5cm)
£1,300–1,500 S

*This is a variant of the
image selected for the
publication in* Life,
*October 18, 1963, within a
feature 'Brand New Breed
of British Designers'. The
suit is by Sambo and the
hat by James Wedge.*

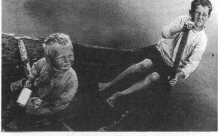

Alexander Rodchenko
Russian (1891–1956)
Catching Worms for Bait
Initialled by the photographer in the
negative, the photographer's stamps and
inscribed and dated by the photographer's
daughter, Varvara Rodchenko, in Russian,
in pencil on the reverse, matted, 1933
11½ x 18¼in (29 x 47cm)
£19,500–21,000 S(NY)

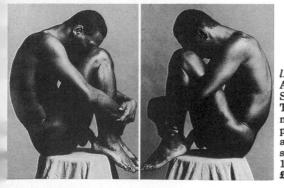

l. **Robert Mapplethorpe**
American (1946–1989)
Selected Images of Ajitto
Two photographs, each signed, dated and
numbered '4/15' and '8/15' respectively, by the
photographer in ink in the margin, each signed
and dated in ink with his copyright reproduction
stamps on the reverse, matted, 1981
18 x 14½in (45.5 x 37cm)
£11,500–12,000 S(NY)

Film & Entertainment Personalities

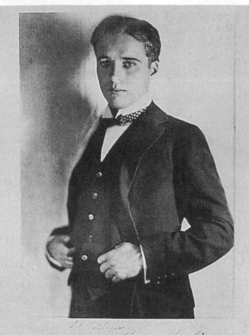

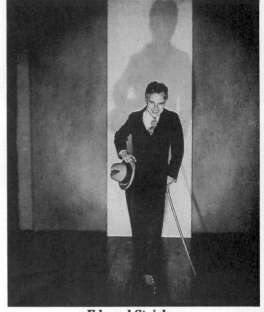

Edward Steichen
American (1876–1973)
Charlie Chaplin
Warm-toned gelatin bromide print,
mounted, matted, 1925
9½ x 7½in (24 x 19cm)
£14,500–15,500 S(NY)

Unknown (20thC)
Charlie Chaplin
Publicity photograph, signed and inscribed in ink
'To Wyn From Charlie', c1920
8¾ x 6in (21.5 x 15.5cm)
£200–250 CSK

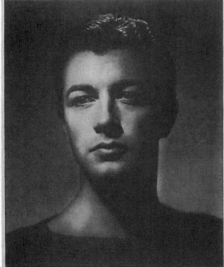

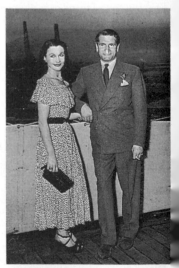

r. **Unknown**
Laurence Olivier and
Vivien Leigh
A photograph album
containing approx. 580
photographs from the
1948 Australian Tour
8 x 6in (20 x 15cm)
£675–775 CSK

George Hurrell
American (b1904)
Robert Taylor
Signed, edition of 250, unmatted
20 x 16in (50.5 x 40.5cm)
£620–680 SK(B)

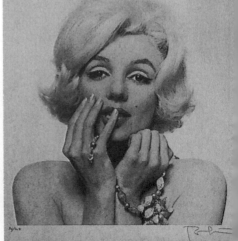

r. **Bert Stern**
American (b1929)
Marilyn Monroe
'What's it all About' from the Marilyn Monroe
portfolio *The Last Sitting,* 1962, signed in
pencil, unmatted
23½in (59.5cm) square
£850–950 SK(B)

POSTERS

In 1995, Christie's, South Kensington, launched their first sale devoted entirely to film posters. The auction was a near sell-out, inspiring extensive media coverage, attracting many new buyers and resulting in some record prices. Its success underlined the wide appeal of film posters, which extends far beyond the general poster collector interested in the design and decorative qualities of the image.

Cinema posters attract film fans including followers of individual stars, specific films and movie genre. Posters in general appeal to specialist collectors' markets: psychedelic posters attract rock and pop enthusiasts, railway buffs buy train travel posters, food and drink posters will often be purchased by wine bars, restaurants and related commercial companies.

The market for posters is, therefore, extremely broad, fuelled by nostalgia and filled with images designed from the onset to be attractive and accessible. At the top end of the range, prices can run into thousands of pounds, as the following selection shows, but poster collecting does not have to be an expensive hobby and you can still buy a wide variety of period posters for under £50.

Film Posters

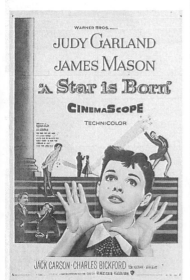

A Star is Born, 1954, Warner Bros, US, one sheet, 41 x 27in (104 x 69cm).
£750–850 *CSK*

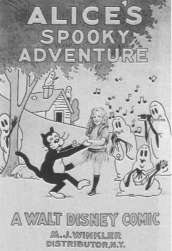

Alice's Spooky Adventure, 1924, Walt Disney, US, one sheet, linen-backed, 41 x 27in (104 x 69cm).
£16,000-17,000 *CSK*

Alice's Spooky Adventure *produced early in 1924, soon after Disney's 22nd birthday, is one of the last films ever to be animated by Disney personally. By May of that year Walt had given up drawing his own cartoons for ever. It is also the last time on record that Walt's brother Roy Disney, the financial genius behind the Disney organization, served as cameraman.*

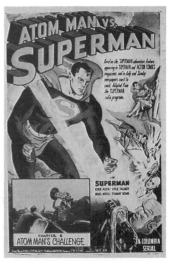

Atom Man vs Superman, 1950, Columbia, one sheet, linen-backed, very fine condition, 41 x 27in (104 x 69cm).
£1,200–1,400 *S(NY)*

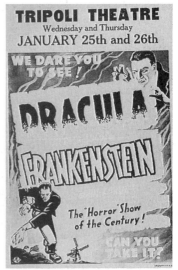

Dracula and Frankenstein, re-issue 1938, Universal, window card, very fine condition, 22 x 14in (56 x 36cm).
£600–650 *S(NY)*

Cage of Gold, 1950, Ealing, one sheet, linen-backed, 40 x 27in (101.5 x 69cm).
£200–220 *CSK*

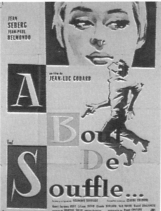

l. A Bout de Souffle / Breathless, 1959, French, one-panel art by Clement Hurel, very fine condition, 63 x 47in (160 x 119cm).
£700–750 *S(NY)*

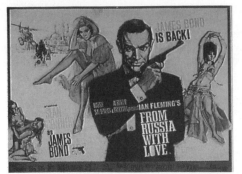

From Russia with Love, 1964, United Artists,
linen-backed, very fine condition, 30 x 40in
(76 x 101.5cm).
£1,500–1,700 *S(NY)*

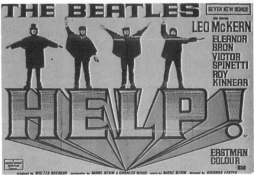

Help!, 1965, United Artists,
30 x 40in (76 x 101.5cm).
£650–750 *CSK*

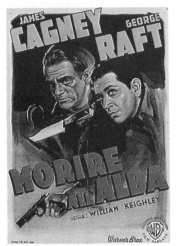

*Morire All'Alba / Each Dawn
I Die*, 1939, Warner Bros,
Italian, by Luigi Martinati,
39½ x 26¼in (100 x 67cm).
£400–500 *CSK*

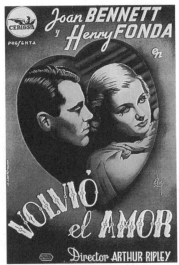

*Volvio el Amor / I Met My Love
Again*, 1938, United Artists,
Spanish, one sheet,
36¾ x 34½in (93.5 x 87.5cm).
£325–375 *CSK*

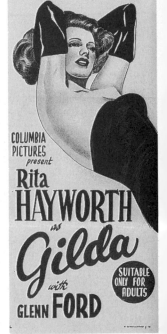

Gilda, 1946, Columbia,
Australian, 30 x 13in
(76 x 33cm).
£800–900 *CSK*

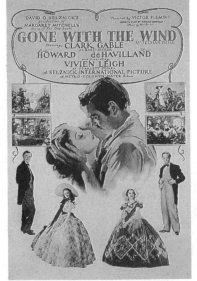

Gone With The Wind, 1939, MGM,
linen-backed, very fine condition,
65 x 43in (165 x 109cm).
£48,000–52,000 *S(NY)*

The Gone With The Wind
*pressbook extols the poster's
seven-colour printing as a
singular achievement.*

r. Island of Lost Souls,
1932, Paramount,
lithograph, one sheet,
very fine condition,
41 x 27in (104 x 69cm).
£11,500–12,000 *S(NY)*

*Island of Lost Souls, is
the H. G. Wells novel
filmed with Charles
Laughton as the mad
Dr Moreau, who
experiments with the
quick evolution of animals
into humans, including
The Panther Woman.*

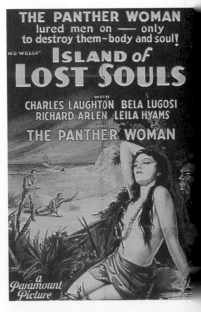

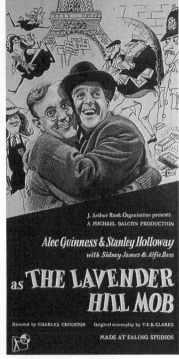

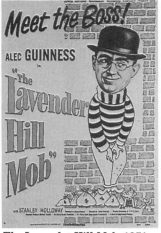

The Lavender Hill Mob, 1951,
Ealing, US, one sheet, linen-
backed, 41 x 27in (104 x 69cm).
£700–800 *CSK*

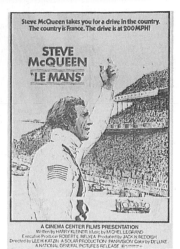

Le Mans, 1971, General Pictures,
41 x 27in (104 x 69cm).
£85–100 *BKS*

The Lavender Hill Mob, 1951,
Ealing, linen-backed, artwork by
Ronald Searle, slight damage,
81 x 41in (205.5 x 104cm).
£6,200–7,000 *CSK*

*This poster, when sold by
Christie's, South Kensington, set
an auction record for a British
film poster. It is the most sought-
after of all the Ealing Comedy
posters, and includes artwork by
Ronald Searle, of St Trinians and
Molesworth fame, as well as the
photographic image of Alec
Guinness and Stanley Holloway.
Whereas previously Americans
have dominated film poster
collecting, recent trends show an
increasing number of European
and British collectors, paving the
way for a rise in prices for British
film posters.*

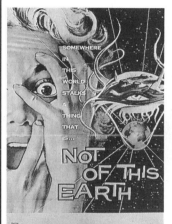

Not of this Earth, 1957,
Allied Artists, US, one sheet,
41 x 27in (104 x 69cm).
£250–300 *CSK*

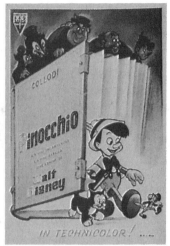

Pinocchio, 1940, Disney, Italian,
paper backed, very fine condition,
14 x 10in (36 x 25cm).
£400–450 *S(NY)*

| Miller's is a price GUIDE |
| not a price LIST |

West Side Story, 1961, United Artists,
artwork by Bob Peak, 30 x 40in
(76 x 101.5cm).
£375–475 *CSK*

Road to Morocco, 1942,
Paramount, 3 sheet,
linen-backed, very fine
condition, 81 x 41in
(205.5 x 104cm).
£300–350 *S(NY)*

Shanghai Express, 1932,
Paramount, French, artwork
by Roger Soubie, 31½ x 23¼in
(80 x 60cm).
£9,250–10,000 *CSK*

Food & Drink

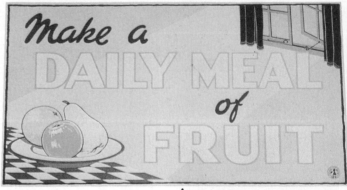

American School (19th/20thC)
Schrafft's Ice Cream Drops and
Try Schrafft's Ice Cream Drops
A pair of posters, one signed
13¾ x 10½in (35 x 26.5cm)
£300–350 *SK*

Anon
British (1930s)
Make a Daily Meal of Fruit, paper
10 x 18in (25 x 46cm)
£15–25 *Do*

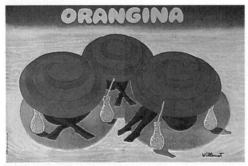

l. **Bernard Villemot**
French (b1911)
Orangina
Lithograph in colours,
1984, printed by Visées,
Paris, on 2 sheets, linen-
backed, minor defects
63 x 92in (160 x 234cm)
£800–1,000 *CSK*

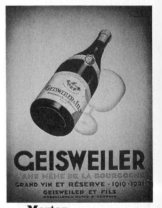

Marton
French (1920s)
Geisweiler
63 x 47½in (160 x 120cm)
£400–450 *Do*

Travel

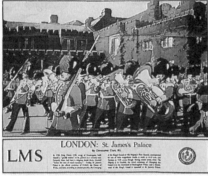

Christopher Clark, RI
British (1875–1942)
LMS, London: St. James's Palace
Lithograph, in colours, c1930, printed by
McCorquodale & Co Ltd, London, stains
and minor defects
39 x 50in (99 x 127cm)
£300–325 *CSK*

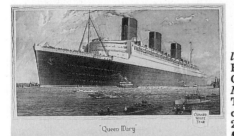

Norman Wilkinson, PRI
British (1878–1971)
Ireland for Holidays
Lithograph, in colours, c1947,
printed by Stafford & Co Ltd,
London, minor defects
40 x 25in (101.5 x 64cm)
£300–350 *CSK*

l. **William McDowell**
British (20thC)
*Cunard White Star, Queen
Mary, SS Rex* and *Mauretania*
Three offset lithographs, in
colours, 1930s, tears and stains
22½ x 35in (57 x 89cm)
£475–325 *CSK*

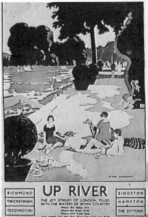

George Sheringham
British (1884–1937)
*Up River, By Tram from
Hammersmith or Shepherds
Bush Station*
Lithograph, in colours, 1926,
printed by Vincent Brooks,
Day & Son, London, tears,
surface dirt and creases
40 x 25in (101.5 x 64cm)
£275–325 *CSK*

General

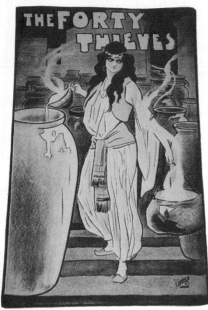

Anon
British (c1920)
The Forty Thieves
Paper
30 x 20in (76 x 50.5cm)
£40–50 *Do*

Anon (1930s)
Rhodian No 2 Cigarettes
Paper
22 x 18in (55.5 x 45.5cm)
£120–150 *Do*

l. **Anon**
British (c1940)
Carnival and Fun Fair
Paper
40 x 30in (101.5 x 76cm)
£30–40 *Do*

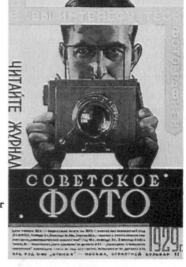

r. **Anon**
Russian (20thC)
Soviet's Photo
Lithograph, in colours,
1929, printed by The
Workers Business, minor
creases and losses
21 x 14in (53 x 36in)
£1,350–1,500 *CSK*

r. **Frank Newbold**
British (20thC)
*Daily Mail Ideal Home
Exhibition,* c1935
Paper
40 x 25in (101.5 x 64cm)
£150–200 *Do*

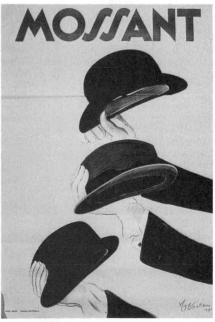

S. Cappiello
French
Mossant, 1938
Paper
63 x 47in (160 x 119cm)
£350–400 *Do*

PRINTS

Prints appear throughout the Price Guide, but this year we have decided to devote a specific section to a field of collecting that can appear both vast and confusing to the uninitiated.

A print is an image on paper, printed from the inked surface of an engraved wood block, metal plate or stone, from which multiple copies (impressions) can be taken. The term can be applied to anything from an old master engraving to a modern-day bookplate.

The prints in the following section run from the 15th to the 20thC. They cover numerous techniques (for an explanation of terms consult the glossary), reflect a huge variety of subject matter and range in price from thousands of pounds to under £10. When faced by such a variety of choice, where should the new collector start?

'Fix on a subject you like: dogs, ships, a picture of your local town, whatever appeals to you and take it from there,' advises Joslyn McDiarmid from Grosvenor Prints, a leading British dealer in the field. 'As you look for your image, you will come across prints of different styles, periods and price and also learn something along the way about condition and technique. You might eventually give up on your chosen subject, fall in love with the medium itself and decide

to collect 18thC stipple engravings or aquatints whatever their topic – but initially, focusing on a single theme gives you a way in.'

As in every other area, it is only through experience that one can recognise quality and understand why with two prints of an identical image, one could be worth £1,000 and the other less than £100. 'Look, look and look again,' stresses McDiarmid. 'As you develop your eye you will recognise the difference between a good crisp early impression and a tired later copy and learn to evaluate rarity and condition.'

According to McDiarmid, a fine quality print of an interesting subject in good condition will always keep its value. 'Interest', however, is in the eye of the beholder and some subjects are harder to sell than others, notably scenes of death, crying girls and images that lack that 'feel-good factor'. But perhaps the greatest thing about the prints is that they can encompass any taste and any pocket providing something for everybody. 'Remember that before photography, prints were the main medium for disseminating visual information,' concludes McDiarmid. 'We mystify them too much. At the end of the day they are quite simple things, there to give us information.'

15th–17th Century

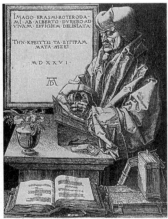

Albrecht Dürer
German (1471–1528)
Erasmus of Rotterdam
Engraving, 1526, a fine early impression, printed with plate tone, minor defects, traces of foxing
10 x 7½in (25 x 19cm)
£15,000–16,000 *S*

r. **After Nicholas Poussin**
French (1594–1665)
Le Printemps, L'Esté, L'Automne and L'Hiver
Four etchings, by J. Pesne, laid paper, laid down on to card, slight defects and repairs
18 x 23in (46 x 59cm)
£1,550–1,700 *CSK*

Prints were often produced in sets and when complete now command the highest prices.

After Andrea Mantegna
Italian (c1430–1506)
The Triumph of Caesar; Soldiers carrying Trophies
Engraving, good impression, on laid, stains and thin patches
11 x 10½in (28 x 26cm)
£275–325 *P*

r. **Joannes Meyssens after Van Dyck**
Dutch (1612–70)
Maria Clara . . .
Copper plate engraving, c1660
10½ x 8in (26 x 20cm)
£40–45 *SRAB*

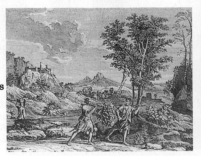

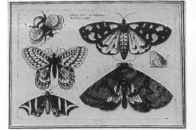

Weceslaus Hollar
Hungarian (1606–77)
Muscarum Scarabeorum Varmiumque variae Figura et Formae
Five etchings, fine impressions, on laid with part watermarks, minor foxing, 1646
3 x 5in (8 x 12.5cm)
£700–800 *P*

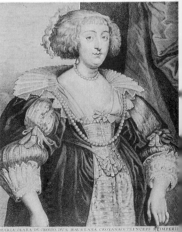

18th Century

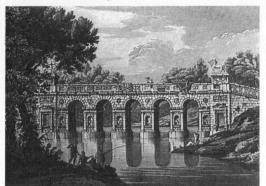

After Robert Adam
British (1728–92)
Design of a Bridge in imitation of the Aquaducts of the Ancients proposed to be built over the Lake at Bowood Park, Wiltshire
Copper engraving, by Bened, 1778
16¼ x 22in (41.5 x 56cm)
£370–400 *GP*

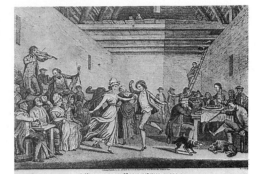

A SCOTTISH PENNY WEDDING.

After David Allan
British (1744–96)
A Scottish Penny Wedding and a Highland Marriage
Stipple engravings, published by R. Scott, discolouration, tears and surface abrasions
14 x 17¾in (36 x 45.5cm)
A stipple engraving by F. Bartolozzi together with a quantity of etchings and engravings
£300–350 *CSK*

At auction, prints are often sold in mixed bundles. The picture illustrated was part of a lot of ten, making an average price of approximately £30 an item.

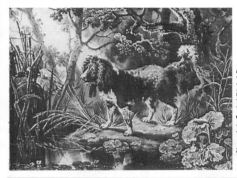

l. **After George Barret, RA**
British (1728–84)
Spaniel and Wild Duck
Mezzotint, a scratch letter proof, by J. Watson, published by J. Boydell, laid paper, faint spotting, 1768
17¼in x 21in (44 x 53cm)
£675–775 *CSK*

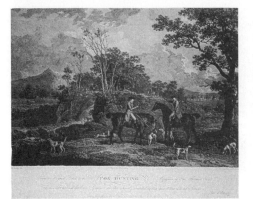

After Gilpin & Barret
British (18thC)
Fox Hunting
Engraving, by T. Morris and
F. Bartilozzi, published Jan 1, 1783
14½ x 20¼in (37 x 51.5cm)
£350–375 *CG*

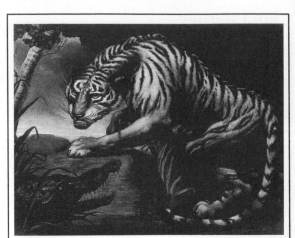

After J. Northcote, RA
British (1746–1831)
Tiger & Crocodile
Mezzotint, by C. Turner, published by
James Dordell & Co., December 7, 1799
18½ x 23½in (47.5 x 60cm)
£4,000–5,000 *GP*

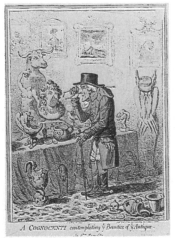

James Gillray
British (1757–1815)
A Cognoscenti contemplating
the Beauties of ye Antique
Etching, hand coloured, good
impression, narrow margins,
published Feb 11, 1801
14¼in x 10in (36 x 25cm)
£950–1,100 *S*

*Sir William Hamilton is
depicted as a cuckolded
antiquary peering myopically
at an array of grotesque
antiquities. Nelson's liaison
with Lady Hamilton had
become notorious by 1800 and
their daughter Horatia was
born on January 30, 1801.*

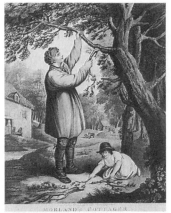

After George Morland
British (1763–1804)
Morland's Cottager
Coloured aquatint and stipple
engraving part printed in colour,
finished by hand, by
T. Williamson, trimmed just
inside the platemark,
originally published 1805 by
T. Williamson, wove paper, faint
water stain lower title area
21 x 17in (53 x 43cm)
£120–150 *CSK*

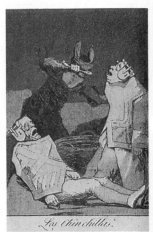

**Francisco José de
Goya y Lucientes**
Spanish (1746–1828)
Los Chinchillas
Etching and aquatint, very
good impression, with
margins, slight foxing, plate
50 from the 1st edition of 1799
8 x 6in (20 x 15cm)
£875–1,000 *S*

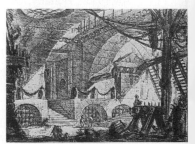

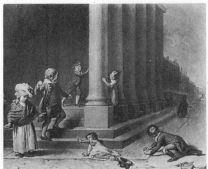

l. **Richard Morton Paye**
British (d1821)
Children throwing Snowballs
Mezzotint, by W. Ward, laid
paper, with margins, some
foxing, originally published
by J.R. Smith, 1785
17¾ x 21¾in (45 x 55cm)
£180–220 *CSK*

Giovanni Battista Piranesi
Italian (1720–78)
The Saw Horse
Etching, a fine impression of the
4th state of 6, fleur-de-lys with
double circle watermark, full
margins, minor staining
16¼ x 22in (41 x 56cm)
£1,750–2,000 *P*

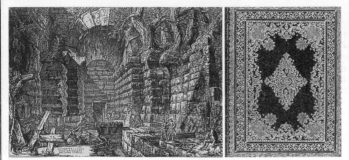

Giovanni Battista Piranesi
Italian (1720–78)
Dimostrazioni Dell'Emissario, Del Lago Albano
One of 54 etched and engraved plates, of Rome 1762 and 1764,
from a volume containing 3 complete series bound together
£20,000–24,000 *S*

*This set of Piranesi prints is contained in a magnificent tooled
leather rococo binding. This was produced in Rome in the late
18thC, by a shop that specialised in binding architectural works,
often as diplomatic gifts for visiting princes and dignitaries. The
present volume belonged to Russian Tsar Paul I (assassinated
1801), who presumably acquired it when he and his wife made a
celebrated and supposedly anonymous visit to Rome in 1782,
travelling under the pseudonyms of Comte and Comtesse du Nord.*

After Pu-Qua of Canton
Chinese (18thC)
Chinese Holyman
Hand engraved aquatint by
Dadley, published May 4,
1799, by W. Miller
12½in x 10in (31.5 x 25cm)
£15–20 *SRAB*

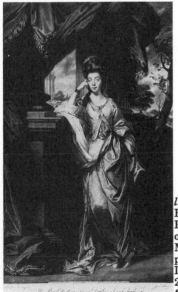

r. **After Sir Joshua Reynolds**
British (1723–92)
Hebe
Mezzotint, by John Jacobe,
published by John Boydell,
August 1, 1780
22½ x 15in (57 x 38cm)
£275–300 *GP*

*Mezzotint portraits were
hugely valued in the 18thC.
Every grand house had its
collection of prints and in
many instances such images
cost less today than when they
were originally produced.*

l. **After Sir Joshua Reynolds**
British (1723–92)
HRH Anne, Duchess
of Cumberland
Mezzotint by James Watson,
published by James Watson,
December 1, 1773
24¼in x 15in (62 x 38cm)
£540–580 *GP*

After George Stubbs, ARA and Amos Green
British (18thC)
Game Keepers
Mezzotint, laid paper, with margins, final state
of 4, surface abrasions, by H. Birche, published
by B. B. Evans
17¼ x 26in (44 x 66cm)
£610–660 *CSK*

After Joseph Wright of Derby
British (1734–97)
An Iron Forge
Mezzotint, 1773, by Richard Earlom, on
wove, published by J. Boydell, trimmed
to narrow margins and laid at sheet
edge, minor tears
19 x 23¼in (48 x 59cm)
£450–600 *P*

19th Century

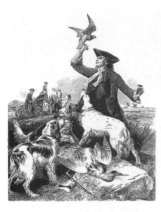

l. **After Richard Ansdell, RA**
British (1815–85)
Hawking
Mixed method, by
T. O. Barlow, published
by the Art Union of
Glasgow, 1871
25½ x 19¾in (65 x 50cm)
£400–450 *GP*

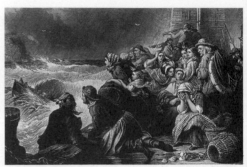

After T. Brooks
British (1818–91)
The Life Boat
Mezzotint, by W. H. Simmons, published by
B. Brooks & Sons, September 1, 1864
20 x 31in (51 x 79cm)
£275–300 *GP*

Commemorative engravings were extremely popular in the 19thC. The present example celebrates William Darling, lighthouse keeper on the Farne Islands, and his daughter Grace. On Sept 7, 1838, the steamboat Forfarshire *was wrecked and William and Grace Darling braved death and the most perilous seas to row out and rescue survivors. The event captured the public imagination and Grace Darling became a national heroine. She sat for her portrait seven times in twelve days, received so many requests for locks of hair that she was in danger of baldness and was even invited to star in Batty's circus, a request that this religious and sensible girl turned down. Grace died of consumption just before her 27th birthday.*

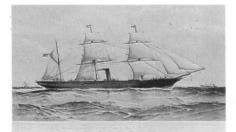

Herbert Dicksee, RE, after Herbert Dicksee
British (1853–1928)
A Sleeping Pekinese
Etching, published by Frost & Reed Ltd., c1920
5 x 10½in (12.5 x 26.5cm)
£400–450 *GP*

T. G. Dutton, after T. G. Dutton
British (d1891)
The Iron Steamship *Mooltan*
Lithograph, published by Wm Foster, c1860
15¼ x 24¼in (39 x 61.5cm)
£1,000–1,200 *GP*

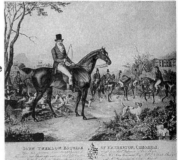

r. **J. W. Giles**
British (19thC)
John Twemlow Esquire
of Hatherton, Cheshire
Lithograph, 1842
17 x 21in (43 x 53cm)
£275–300 *CG*

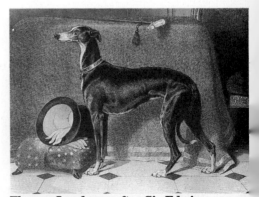

Winslow Homer
American (1836–1910)
Yachting Girl
Lithograph, extensively enhanced with white heightening, printed on buff wove paper mounted on layered card, slight discolouration in the margins, 1880
8 x 12½in (20 x 31.5cm)
£4,300–5,000 *S(NY)*

Thomas Landseer, after Sir Edwin Landseer
British (1802–73)
Eos, HRH Prince Consort's favourite Greyhound
Mezzotint, 1843
19¾ x 23½in (50 x 60cm)
£720–820 *GP*

William Lee-Hankey, RE
British (1869–1952)
Moonrise in the Clearing
Signed in pencil and with the artist's
blind monogram stamp, colour soft-
ground etching and aquatint, printed in
brown, green and 2 shades of blue from
multiple plates, on strong textured
oatmeal paper, faintly mount-stained,
one of only 12 impressions, 1911
6 x 7½in (15 x 19cm)
£500–525 *EHL*

l. **James Tissot**
French (1836–1902)
Le Banc de Jardin
Signed in pencil and
inscribed '1st state',
mezzotint, a rich
impression, 1st state of
3, foxed in margins
16½ x 22in (42 x 56cm)
£1,200–1,400 *P*

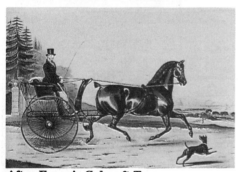

After Francis Calcraft Turner
British (c1782–1846)
Artaxerxes
Coloured aquatint by R. G. Reeve, with
margins, originally published by I. W. Laird,
1838, backboard staining and surface dirt
19½ x 24in (49.5 x 61cm)
£575–675 *CSK*

James Abbott McNeill Whistler
American (1834–1903)
Billingsgate
Etching, 8th and final state, on laid,
with full margins, good condition, 1859
6 x 8½in (15 x 21.5cm)
£400–450 *P*

r. **L. Haghe, after
David Roberts**
Belgian (1806–85)
Great Sphinx,
Pyramids of Gizeh
Lithograph, published
by F.G. Moon,
London, 1846
13¼ x 21in (33.5 x 53cm)
£325–350 *GP*

Henri de Toulouse-Lautrec
French (1864–1901)
Miss Loïe Fuller
Lithograph, printed in colours, with
powdered gold, a fine, fresh
impression, from the edition of 50,
good condition, 1893
15 x 11in (38 x 28cm)
£40,000–45,000 *S(NY)*

*In one of Lautrec's most experimental
prints he depicted the American born
dancer Loïe Fuller in the midst of her
danse de feu, a dance she performed
with wide, flowing skirts that became
so popular that she had the dance
patented in 1894. Fuller achieved
tremendous effects through the
combination of her costume,
choreography and special lights
installed for each performance.
Lautrec sprinkled the print with gold
dust to capture the effect of light.*

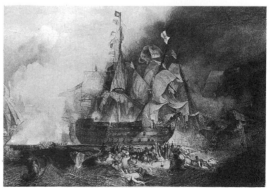

After J. M. W. Turner
British (1775–1851)
The Battle of Trafalgar, Nelson's Ship
Engraving by J. Burnet, published by
H. Graves & Co., London, April 8, 1858
25½ x 35in (65.5 x 89.5cm)
£450–500 *GP*

20th Century

Thomas Hart Benton
American (1889–1975)
Huck Finn
Signed in pencil, lithograph, 1936,
from the edition of 100, published
by Associated American Artists,
with margins, good condition
16¼ x 21¾in (41 x 55cm)
£4,000–4,250 *S(NY)*

Horace Brodzky
Australian (1885–1969)
Self Portrait
Signed in pencil, drypoint,
1919, on heavy wove, slight
mount staining
4⅞in x 3¾in (12 x 9.5cm)
£325–375 *P*

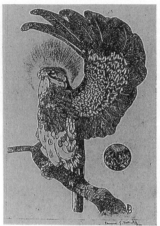

Edward J. Detmold
British (1883–1957)
Phoenix
Signed and dated in pencil,
engraving, 1900, printed in
black and gold, 2nd state, on
tissue thin laid, foxing to lower
margin, minor paper losses
11 x 7¾in (28 x 19.5cm)
£350–400 *P*

Claude Flight
British (1881–1955)
Employed and Unemployed
A pair, signed, linocuts, c1935,
printed in blue and red, on grey laid
japan, each numbered from the
edition of 50, each with artist, title
and price written in ink on the
margin, very good condition
8½ x 10½in (21 x 26.5cm)
£1,100–1,500 *P*

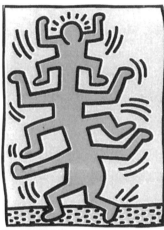

Keith Haring
American (1958–90)
Growing Suite
Signed and dated in pencil,
numbered '5/100', set of
5 screenprints, in colours, 1988,
published by Martin Lawrence
Limited Editions, California,
with their blindstamp, on Lenox
Museum Board, the full sheets
in excellent condition
40 x 30in (101.5 x 76cm)
£7,500–8,500 *S*

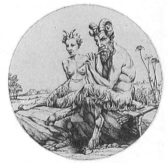

Stephen Gooden, RA
British (1892–1955)
Satyrs
Signed, dated '1937' and
numbered '42/109' in pencil,
engraving, 5th and final
state, laid paper with deckle
edge 2 sides, hinged top edge,
very good condition
6¼in (16cm) diam.
£180–210 *CSK*

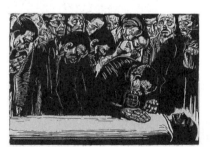

Käthe Kollwitz
German (1867–1945)
Gedenkblatt für Karl Liebknecht
Signed in pencil, inscribed
'Handdruck' and numbered '96' from
the edition of 100, woodcut, c1920,
3rd state of 4, also signed by the
printer 'Voigt', on heavy wove paper,
with margins, good condition
14 x 19¾in (36 x 50cm)
£2,350–2,750 *S(NY)*

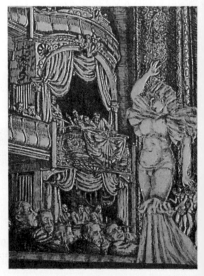

r. Reginald Marsh
American (1898–1954)
Star Burlesk, 1933
Etching on paper,
numbered '2/100',
from the Whitney
Museum edition of
100, 1969, matted,
very good condition
12 x 8¾in (30.5 x 22cm)
£350–380 *SK(B)*

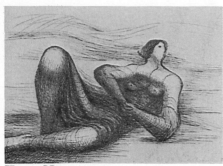

Henry Moore
British (1898–1986)
Reclining Figure
Etching, c1977, inscribed 'Pl.6', numbered
'G22/25', from an edition of 65, printed by
Atelier Lacourière and Frélaut, Paris,
published by Ganymede Original Editions,
1978, on Richard de Bas paper, with full
margins, good condition
9 x 11⅜in (22.5 x 30.5cm)
£2,200–2,700 *S*

Walter J. Phillips
Canadian (1884–1963)
Morning
Woodcut, 1924, with monogram and date,
signed in pencil entitled and numbered
'145/150', printed in shades of blue, pink,
purple, green, brown and black, on japan
18 x 19in (45.5 x 48cm)
£900–1,000 *EHL*

*Born in Britain, Phillips emigrated to
Canada in 1913 and became a leading
member of the Canadian Group of Seven
who pioneered a national school of
modernist painting, with regional
Canadian landscape as its principal
theme. In printmaking, Phillips
abandoned etching soon after his arrival
in Canada and was inspired by Japanese
prints to experiment with colour woodcut.
He integrated motifs of Canadian
landscape with Japanese composition and
technique and his own personal rich soft
colour schemes.*

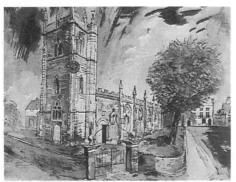

John Piper
British (1903–92)
Alchester Church
Signed in pencil, numbered
'60/100', screenprint
19¾ x 25½in (50 x 65cm)
£440–500 *Bon*

Frederick Whiting, RBA, RI
British (1874–1962)
Untitled
Etching
12 x 18in (30.5 x 45.5cm)
£225–250 *GK*

Edward Wadsworth
British (1889–1949)
Still Life
Woodcut, 1920, printed in
black, on wove, published by
Herbert Furst, good condition
6 x 4in (15 x 10cm)
£275–300 *P*

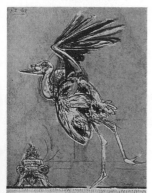

Graham Sutherland
British (1903–80)
Bird about to take Flight
Signed and numbered in
pencil '38/70', lithograph,
1968, from *A Bestiary and
Some Correspondences*, on
Arches, printed in colours,
printed by Mourlot,
published by Marlborough
Fine Art, backboard
staining, good condition
26¼ x 19in (67 x 48cm)
£400–450 *P*

r. **Tom Wesselmann**
British (b1931)
Monica reclining on Back,
Knees up
Lithograph, 1991, from the
album *Memoire de la
Liberté*, printed in grey and
black, signed in pencil,
numbered '28/100', on wove,
the full sheet printed to the
edges, good condition
39½in x 57in (100 x 144.5cm)
£800–1,000 *S*

Japanese Prints

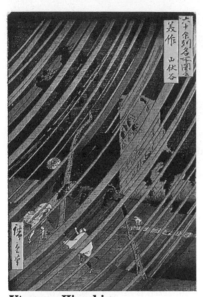

Utagawa Hiroshige
Japanese (1791–1858)
Yamabushi Gorge in Mimasaka Province
Woodblock, signed, good impression,
colour and condition
14 x 9½in (36 x 24cm)
£1,000–1,250 *S(NY)*

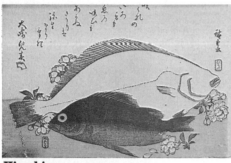

Hiroshige
Japanese (18th/19thC)
A Flat Fish and a Mebaru with
Cherry Blossom
Oban yoko-e, hirame, mebaru, sakura-bana,
with a kyoka poem by Oshima Nishun,
from the 2nd series *Large Fish* published by
Yamadaya Shojiro, signed 'Hiroshige ga',
good impression and colour, slightly soiled
and rubbed
£1,275–1,375 *S*

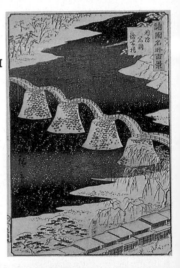

r. **Utagawa Hiroshige II**
Japanese (1826–69)
Iwakuni Kintai Bridge
Woodblock, signed
'Hiroshige ga', with
publisher's seal 'Uo-Ei',
censor's seal, very good
impression and colour,
good condition
13¾ x 9⅛in (35 x 23cm)
£2,000–2,200 *S(NY)*

Anon
Japanese (18thC)
Still Life, Saya-e
Surimono, a saya-e depicting Daikoku and Ebisu's
attributes and takaramono, such as a hat, mallet,
sack, fish, lobster and a koban, 4 poems on the left,
unsigned, good impression, slightly rubbed
and soiled
£825–1,000 *S*

*An inscription on this rare surimono states that this
is a saya-e and suggests that one should look at this
picture through the tsuba of a wakizashi (short
sword) placed against a koban (old Japanese gold
coin). Saya-e (literally 'pictures of a sheath') became
popular during the Kansei period (1789–1800). It is
a design which appears in normal proportions only
when viewed with a curved mirror.*

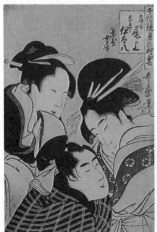

l. **Kitagawa Utamaro**
Japanese (1754–1806)
Onoe and Idahachi
Woodblock, signed
'Utamaro hitsu',
publisher's seal
'Yamaguchi-ya',
good impression
15 x 9½in (38 x 24cm)
£2,000–2,200 *S(NY)*

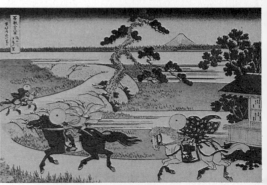

Katsushika Hokusai
Japanese (1760–1849)
Sekiya Village on the Sumida River
Woodblock, signed 'zen Hokusai Iitsu hitsu'
very good impression, colour and condition
10 x 14¾in (25 x 37.5cm)
£6,500–7,250 *S(NY)*

RELIGIOUS & MYTHOLOGICAL

In the 1980s it was Impressionist and modern pictures that grabbed the headlines and achieved record prices. The 1990s, however, is seeing a healthy demand for old master pictures, with new buyers being converted to religious and mythological paintings. 'A growing number of collectors . . . perceive old masters as offering better value for money and a more stable investment than their late 19th and 20thC equivalents,' commented Scott Reyburn in *The Antiques Trade Gazette,* reporting on a spate of highly successful old master sales in the USA.

The most controversial of these was Sotheby's auction of old master pictures from the New York Historical Society. The decision to sell part of their collection resulted in a major scandal and an unsuccessful legal challenge to prevent the sale by a descendant of patron and philanthropist, Thomas Jefferson Bryan, who formed the collection during the 19thC.

Matters were further complicated by the threat of state intervention in the purchase of major pictures, most notably Giovanni di Simone's circular salver celebrating the birth of Lorenzo de'Medici in 1449 *(see p334).* The painting was sold at the auction to a London dealer, but the Metropolitan Museum of Art then exercised its legal right to pre-empt its sale, matched the price, and obtained the work which is currently on display in their collection.

14th–16th Century

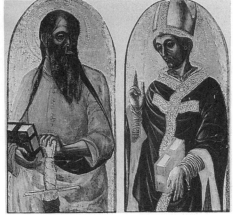

Attributed to Nicola di Maestro Antonio da Ancona
Italian (active late 15thC)
Saint Paul and a Bishop Saint
A pair, tempera on panel, gold ground, arched tops
20¾ x 10⅜in (53 x 27.5cm)
£15,000–16,000 *S*

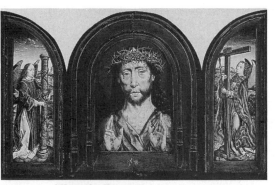

Albrecht Bouts
Dutch (1454–1549)
Christ as the Man of Sorrows with an Angel holding the Column and Scourges on the left and an Angel with the Cross and Spear on the right
A portable triptych, oil on panel
Central panel 15 x 10½in (38 x 26cm)
£150,000–165,000 *S(NY)*

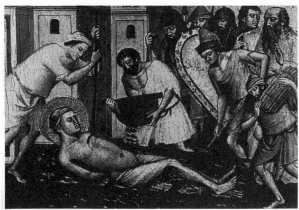

Niccolò di Pietro Gerini
Italian (1368–1415)
The Martyrdom of St Lawrence
Tempera on panel
8¾ x 12½in (22 x 32cm)
£35,000–38,000 *S(NY)*

The Christian martyr St. Lawrence died in Rome in 258AD. According to tradition he was killed by being roasted on a gridiron, a horrific fate that he accepted with saintly courage, remarking calmly to his torturers, 'See, I am done enough on one side, now turn me over and cook the other.' Contemporary historical research suggests that this story owes more to drama than historical fact, since at the period, the main instrument of capital punishment was the sword.

Paulus Moreelse
Dutch (1571–1638)
The Supper at Emmaus
Oil on canvas
61 x 78¾in (155 x 200cm)
£2,200–2,700 *P*

After Raphael
Italian (1483–1520)
The Madonna and Child with
St Elizabeth and the Infant
St John the Baptist
Oil on canvas
29¾ x 25in (75.5 x 63.5cm)
£900–1,200 *CSK*

*Raphael has inspired countless
imitators over the centuries.
His paintings were often used
as art school exercises and
copies of his works appear
regularly in the salerooms.*

**Giovanni di ser Giovanni di Simone, called Lo Scheggia,
formerly known as the Master of the Adimari Cassone and
the Master of Fucecchio**
Italian (1407–86)
Recto – The Triumph of Fame; a birth Salver (desco da parto)
honouring the Birth of Lorenzo de' Medici, il Magnifico and
Verso – The Medici and Tornabuoni coats-of-arms flanking the
Impresa of Lorenzo il Magnifico
Tempera, silver and gold on wood, in original frame decorated
with 12 Medici feathers
24½in (62.5cm) diam
£1,500,000+ *S(NY)*

*Such salvers were traditionally commissioned to celebrate major
events such as marriages or births. The verso of this tondo bears
the coats-of-arms of the Medici and Tornabuoni families and the
picture marks the birth of Lorenzo de' Medici on January 1, 1449.*

17th Century

Hendrick Bloemaert
Dutch (1601–72)
The Adoration of the Shepherds
Signed and dated '1654', oil on canvas
60 x 50½in (152 x 128cm)
£14,000–16,000 *S*

Attributed to Giulio Carpioni
Italian (1613–79)
Jacob's Ladder
Oil on canvas
36 x 29½in (91.5 x 75cm)
£1,600–2,000 *P*

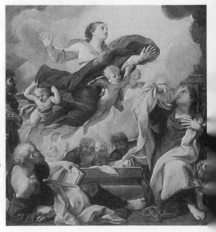

r. **Guillaume Courtois, called
Guglielmo Cortese, il Borgognone**
French (1628–79)
The Assumption of the Virgin
Oil on canvas
29½ x 27in (75.5 x 68.5cm)
£6,000–7,000 *S*

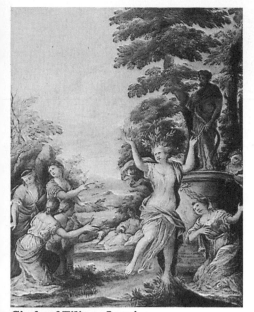

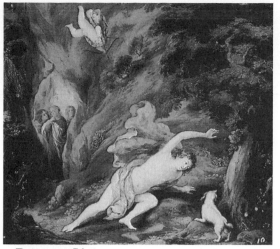

Circle of Filippo Lauri
Italian (1623–94)
The Sisters of Phaëthon
Oil on canvas
18½ x 14¼in (47 x 36cm)
£2,750–3,250 *S*

Son of Helios, the sun god, Phaëthon forced his father to let him drive his chariot across the skies. Unable to control the horses, Phaëthon caused the earth to catch fire and Zeus struck him down with a thunderbolt, saving the world from extinction. Phaëthon's sisters as they came to mourn over his grave were transformed into poplars and their tears turned to amber. Phaëthon is the symbol of those who aspire to that which they can never achieve, representing hubris followed by Nemesis.

Peter van Lint
Flemish (1609–90)
Narcissus
Signed with monogram and dated '1648', oil on copper
15 x 17in (38 x 43.5cm)
£7,000–8,000 *C*

Narcissus fell in love with his own reflection in a pool of water and, unable to tear himself away from the image, pined away. On his death he was turned into the flower that bears his name.

l. **Manner of Guido Reni**
Italian (1575–1642)
The Madonna at Prayer
Oil on canvas
22½ x 17½in (57 x 44.5cm)
£550–650 *CSK*

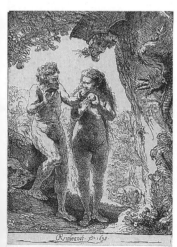

Rembrandt Harmensz. van Rijn
Dutch (1606–69)
Adam and Eve
Etching, 1638, a fine impression of the 2nd (final) state, some foxing and small patches of surface dirt
6½ x 4½in (16.5 x 11.5cm)
£16,000–18,000 *S*

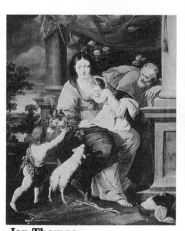

Jan Thomas
Flemish (1617–78)
The Holy Family and the Infant St John holding a Basket of Fruit
Signed, oil on canvas
60 x 50in (152 x 127cm)
£12,000–14,000 *S*

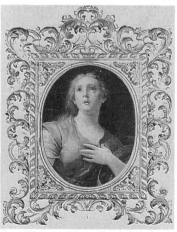

Giovan Gioseffo dal Sole
Italian (1654–1719)
A Female Saint
Oil on panel
21¼ x 16½in (54 x 41.5cm)
£3,000–4,000 *P*

Old master pictures often come in decorative period frames which can contribute considerably to their value.

18th Century

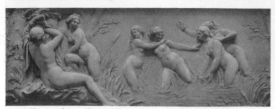

Attributed to Jean Jacques de Boissieu
French (1736–1810)
Six Nymphs bathing in a Forest Pool
Oil on canvas
24 x 59in (61.5 x 149.5cm)
£17,500–18,500 *S(NY)*

Gaspare Diziani
Italian (1689–1767)
Three Putti playing with Trophies of War
Signed, pen and brown ink and wash over
red chalk within brown ink framing lines
4 x 11½in (10 x 29.5cm)
£4,750–5,750 *S(NY)*

After François Boucher
French (1703–70)
The Infant Christ blessing
the Infant St John
the Baptist
Oil on canvas
21½ x 18¼in (54.5 x 46cm)
£1,400–1,600 *CSK*

Charles Coypel
French (1694–1752)
St Thaïs in her Cell
Oil on canvas
33 x 24in (84 x 61.5cm)
£39,000–44,000 *C*

*The legend of St Thaïs appears to
have no historical basis and is
rarely depicted. The saint, who
had been promiscuous, as well as
wealthy and beautiful, was
converted to the path of
righteousness by St Paphnutius.
She burned her clothes and
jewellery and, once taken to a
nunnery, began a course of prayer
in solitary confinement. As shown
in the present picture, Saint
Thaïs sat facing East repeating
the simple prayer, 'Oh my
Creator, have pity on me.' At the
end of three years she rejoined the
daily life of the nunnery but died
two weeks later.*

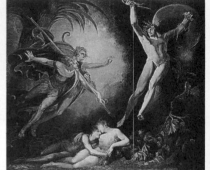

Johann Heinrich Fuseli, RA
Swiss (1741–1825)
Satan starting from the Touch of
Ithuriel's Lance
Oil on canvas
90¾ x 108¾in (230.5 x 276cm)
£475,000–500,000 *CNY*

*Fuseli painted many works
inspired by Milton. The subject for
the present painting is taken from
Book IV of Milton's Paradise Lost.
Pursuing his evil schemes to
seduce mankind from God and
bring about their downfall, Satan
slinks into the Garden of Eden,
where he disguises himself as a
toad and creeps up on Adam and
Eve as they sleep. However, before
he can taint 'the Organs of (Eve's)
Fancy', he is seen by Ithuriel, one
of the angelic guards entrusted
with the safety of Paradise, who
reveals him in his true guise.*

**Follower of François
Lemoine**
French (1688–1737)
Venus and Adonis
Oil on canvas
31 x 25½in (78.5 x 65cm)
£2,750–3,250 *CSK*

r. **Hubert Robert**
French (1733–1808)
The Hermit of the Colosseum
Signed and dated '1790',
oil on canvas
23¼ x 19½in (59 x 50cm)
£28,000–34,000 *P*

*Hubert Robert painted several
paintings depicting a hermit
at his prayers while girls steal
his flowers*

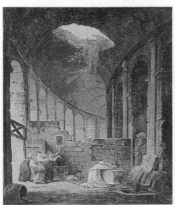

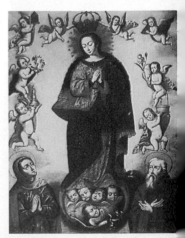

Spanish Colonial School (18thC)
The Madonna in Glory
Oil on canvas
47 x 36in (119 x 91.5cm)
£1,700–2,000 *CSK*

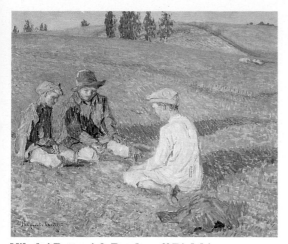

Nikolai Petrovich Bogdanoff-Bjelski
Russian (1868–1945)
Three Boys in a Meadow in the Springtime
Signed, oil on canvas
26½ x 30½in (67.5 x 77.5cm)
£8,100–9,000 *S*

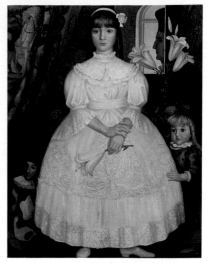

Oleg Bogmarov
Russian (b1962)
Girl with Lily
Oil on canvas
31½ x 24¾in (80 x 63cm)
£3,750–4,250 *ALG*

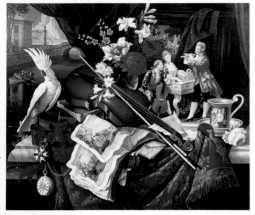

Genrich Khozatsky
Russian (b1931)
Still Life, 1994
Oil on canvas
32¾ x 38¼in (83 x 97cm)
£5,250–5,750 *ALG*

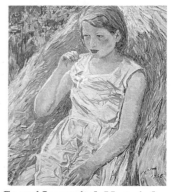

Georgi Ivanovitch Magmiedov
Russian (b1921)
The Artist's Daughter
Monogrammed and dated '1956',
oil on canvas
24¾ x 23¼in (63 x 59.5cm)
£650–800 *JNic*

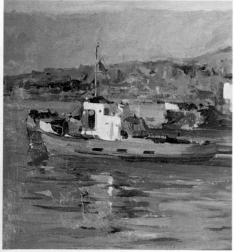

Vladimir Filiponov
Russian (20thC)
Trawler 144, 1958
Oil on board
24 x 20in (61.5 x 51cm)
£1,550–1,750 *CE*

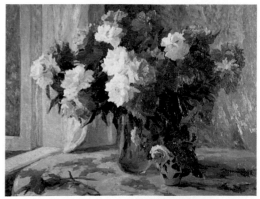

Pavel Markov
Russian (20thC)
Peonies and Roses, 1962
Oil on canvas
36 x 45in (91.5 x 114cm)
£5,500–6,000 *CE*

Kuzma Sergeievich Petrov-Vodkin
Russian (1878–1939)
Still Life; a Glass of Water, a Box of Matches, a Letter
in an Envelope and a red Blotter
Signed with initials and dated '1925', oil on canvas
21¼ x 25½in (54 x 65cm)
£43,000–46,000 *S*

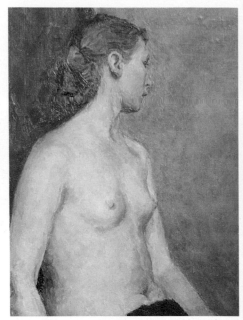

Nikolai A. Plastov
Russian (b1922)
Young Seated Nude Girl, 1950
Oil on canvas
24 x 16in (61.5 x 40.5cm)
£2,500–2,750 *CE*

Varvara Shavrova
Russian (b1968)
In front of the Window
Oil on canvas
15 x 20in (38.5 x 51cm)
£400–600 *FT*

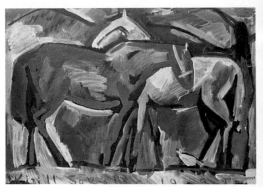

Kirill Sokolov
Russian (b1930)
Spetsos Horses I
Signed, oil on card laid on board
18 x 25in (46 x 63.5cm)
£500–600 *VCG*

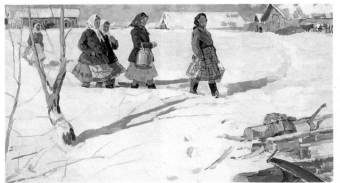

Valeri S. Semenov
Russian (b1928)
A Sunny Day
Signed and dated '1967', oil on canvas
29 x 53¼in (74 x 135cm)
£5,800–7,000 *P*

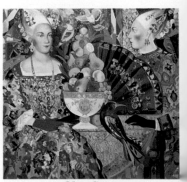

Olga Suvorova
Russian (b1966)
Two Ladies with a Fan
Oil on canvas
38½in (98cm) square
£2,000–2,350 *ALG*

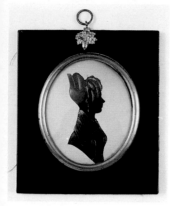

Anon
British (c1835)
Unknown Woman
Cut out paper and bronzed
3½ x 2¾in (8.5 x 7cm)
£80–150 *BlA*

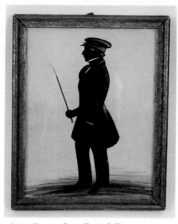

Attributed to Lord Byron
British (c1860)
Unknown Man
10½ x 8½in (26 x 21cm)
£150–200 *RdeR*

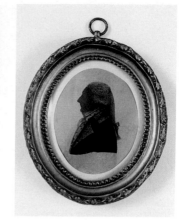

Attributed to W. W. Cracknell
British (active 1796)
Unknown Man
Painted on paper
2½ x 3in (6 x 7.5cm)
£150–300 *BlA*

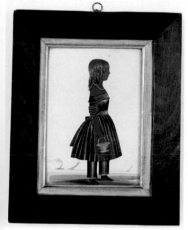

G. Walker
British (active 1840s)
Louisa Walker on Blackpool Sands
Cut out paper and bronzed
6¼ x 4⅓in (15.5 x 11cm)
£300–600 *BlA*

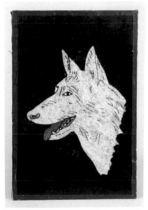

A Dog
Stencil, silver paper
9½ x 6in (24 x 15cm)
£10–15 *Lon*

A Parrot
Stencil, silver paper
12 x 10½in (30.5 x 26cm)
£20–25 *Lon*

Crinoline Lady with full Moon
Stencil, silver paper
8½ x 7in (21 x 17.5cm)
£15–20 *Lon*

A Galleon
Stencil, silver paper
10½ x 8in (26 x 20cm)
£20–25 *Lon*

A Dutch Girl
Stencil, silver paper
11½ x 8½in (29 x 21cm)
£20–25 *Lon*

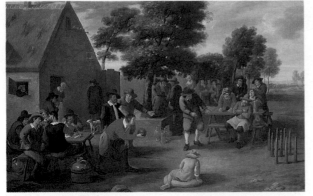

Matheus van Helmont
Flemish (1623–after 1679)
Boors playing Skittles and drinking outside an Inn
Signed, oil on canvas
30¼ x 46¼in (77 x 117cm)
£22,000–25,000 *C*

John Corbet Anderson
British (19thC)
Hillyer at Lords
Signed and dated '1850', watercolour
14½ x 10¼in (37 x 25.5cm)
£3,400–4,000 *CSK*

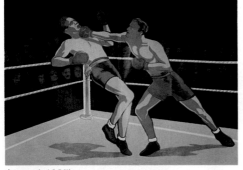

Anon (c1935)
Boxers
Linen backed poster
30 x 40in (76 x 101.5cm)
£120–150 *Do*

Bob Godfrey
British (b1921)
W. G. Grace in action
Cel
8½ x 12in (21 x 30.5cm)
£350–400 *CBL*

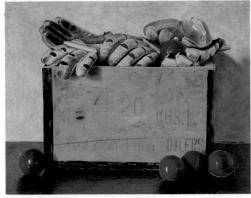

Liam Bradshaw
British (20thC)
Cricketing Things
Pastel
19 x 25in (48 x 63.5cm)
£1,600–1,800 *BSG*

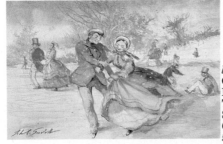

l. **John Strickland
Goodall, RI, RBA**
British (b1908)
The Novice
Signed, watercolour
6¾ x 9¾in (17 x 24.5cm)
£800–900 *WrG*

Arthur Maderson
British (20thC)
Lismore River Pool, Co. Waterford
Oil on board
43in (109cm) square
£2,400–2,800 *JnM*

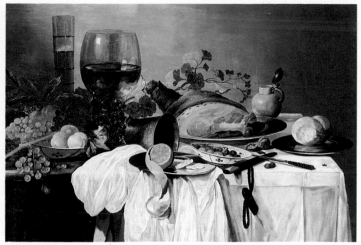

Cornelis Kruys
Dutch (died before 1660)
A Breakfast Still Life
Oil on panel
29 x 41in (73.5 x 104cm)
£31,000–35,000 *S(NY)*

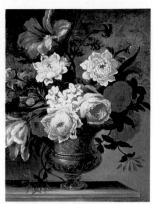

Circle of Pieter Hardime
Flemish (1677–1758)
Still Life of Flowers
Oil on canvas
15 x 11in (38 x 28cm)
£4,500–5,500 *CSK*

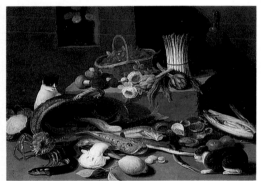

Jan van Kessel the Younger
Flemish (1654–1708)
Still Life of Fish, Vegetables, a Basket of wild
Strawberries and Cats, all on a stone Ledge
Oil on copper
8 x 11in (20 x 28cm)
£24,000–28,000 *S*

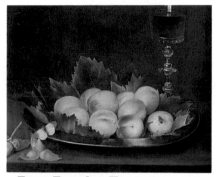

Frans Francken II
Flemish (1581–1642)
Apricots on a Pewter Plate
Signed and monogrammed, oil on panel
12¾ x 15¼in (32.5 x 39cm)
£65,000–70,000 *C*

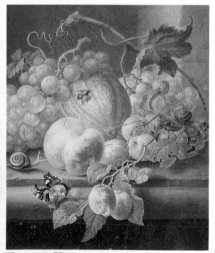

Herman Henstenburgh
Dutch (1667–1726)
Still Life of Fruit on a Ledge, with
Snails and Insects
Signed and dated '1689', watercolour
and gouache on vellum
12¼ x 10¼in (31 x 25.5cm)
£20,000–22,000 *S(Am)*

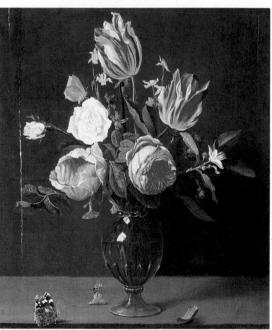

Jan Philips van Thielen, called Rigoults
Flemish (1618–67)
A Still Life of Roses, Tulips, Bluebells, Narcissi and
other Flowers in a Glass Vase, with a Bee and a Red
Admiral Butterfly, on a wooden Ledge
Signed, oil on panel
22½ x 17¾in (57 x 45cm)
£56,000–65,000 *P*

Vincent Clare
British (c1855–1930)
Still Life
Signed, oil on canvas
6¾ x 8¾in (17 x 22cm)
£3,500–4,000 *CW*

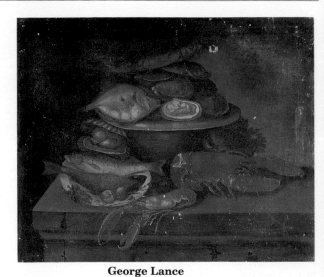

George Lance
British (1802–64)
Still Life with Lobster, Trout and Oysters
Signed and dated '1824', oil on canvas
24 x 29in (61.5 x 73.5cm)
£5,300–6,300 *S*

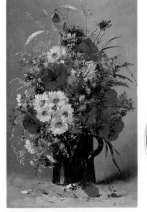

Eugène-Henri Cauchois
French (1850–1911)
Summer Flowers
A pair, signed, oil
on canvas
16 x 10½in (40.5 x 27cm)
£6,000–7,000 *C*

William Hough
British (active 1857–94)
Grapes and a Strawberry
by a mossy Bank
Signed, watercolour
6 x 8in (15 x 20in)
£1,200–1,400 *TAY*

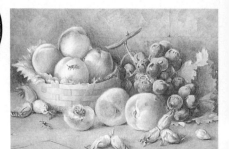

Agnes Louise Holding
British (c1890)
Peaches, Grapes and Nuts
Signed, watercolour
10 x 13½in (25 x 34cm)
£1,000–1,200 *WrG*

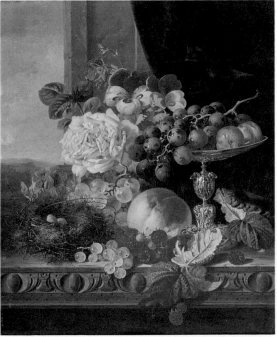

Edward Ladell
British (1821–86)
Still Life with Fruit, Flowers, a Bird's Nest and a Tazza
Signed with monogram, oil on canvas
17 x 14in (43 x 35.5cm)
£26,000–30,000 *S*

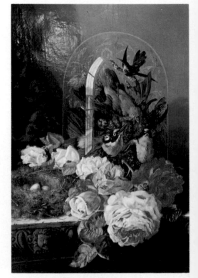

Ellen Ladell
British (19thC)
Still Life with a Bird's Nest
Oil on canvas
17 x 13in (43 x 33cm)
£13,000–14,000 *HFA*

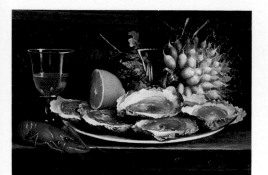

Aurelie Leontine Malbet
Austrian/French (exh 1868)
Still Life of Oysters, Radishes, a Lobster and a
Wine Glass
Signed, oil on canvas
10½ x 16½in (26.5 x 42cm)
£4,000–4,500 *BuP*

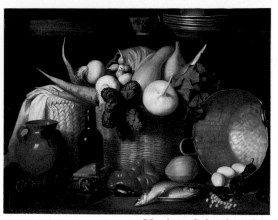

Mexican School (19thC)
Bodegón
Oil on canvas
32 x 38½in (81.5 x 98cm)
£42,000–45,000 *S(NY)*

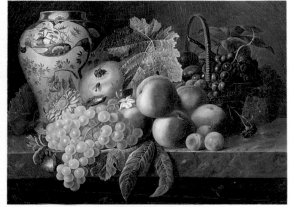

Monginot
French (19thC)
Still Life with an Oriental Vase, Fruits and Flowers
on a marble Ledge
Signed and dated '1877', oil on canvas
17 x 23½in (43.5 x 60cm)
£5,500–6,500 *P*

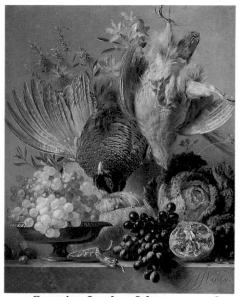

Georgius Jacobus Johannes van Os
Dutch (1782–1861)
A dead Pheasant, a Partridge, Grapes, a
Cabbage and other Fruit and Flowers on
a Ledge
Signed, oil on canvas
25¾ x 21½in (65.5 x 55cm)
£14,000–15,000 *C*

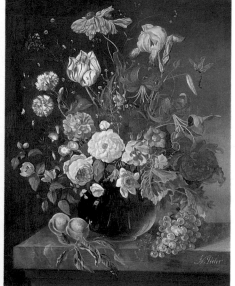

Franz Xavier Pieler
Austrian (1879–1952)
Lilies, Roses, Carnations, a Tulip, Iris and
other Flowers in a Vase on a Ledge with
Peaches, Grapes and a Dragonfly
Signed, oil on canvas
27¼ x 21½in (69 x 54.5cm)
£4,100–4,600 *C*

Benjamin Walter Spiers
British (active 1875)
A Connoisseur's Corner
Pencil and watercolour with
touches of white heightening
13 x 23½in (33 x 60cm)
£28,000–30,000 *S*

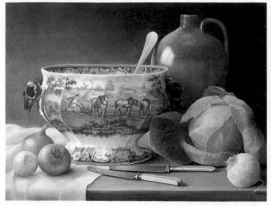

Edna Bizon
British (20thC)
The blue Tureen
Oil on canvas
20 x 26in (51 x 66cm)
£4,000–4,500 *LA*

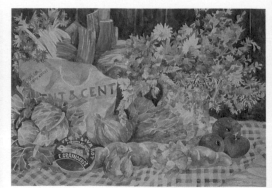

Jenny Abbott
British (20thC)
Shopping Still Life
Watercolour
21 x 30in (53 x 76.5cm)
£500–550 *AMC*

Helen Dyson
British (20thC)
Pomegranates on Chintz
Oil on board
41 x 57in (104 x 144.5cm)
£885–985 *AMC*

Norman Edgar, RGI
Scottish (20thC)
Still Life in red and yellow
Oil on canvas
41 x 39in (104 x 99cm)
£4,500–5,000 *RB*

Mary Fedden
British (b1915)
The chequered Cloth
Oil on canvas
12 x 16in (30.5 x 40.5cm)
£2,000–2,200 *NZ*

Darrell Gardner
British (20thC)
White Peaches
Oil on canvas
20 x 24in (51 x 61.5cm)
£800–900 *RGFA*

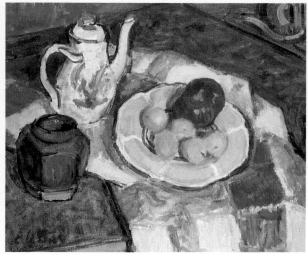

Edward Le Bas, CBE, RA, LG
British (1904–66)
Still Life
Signed, oil on canvas
16 x 20in (40.5 x 51cm)
£9,000–9,500 *PN*

Judith K. Living
American (20thC)
Three Baskets
Watercolour
12 x 14in (30.5 x 35.5cm)
£400–450 *NBO*

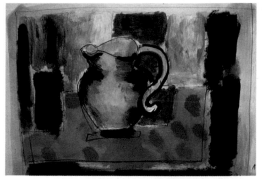

Jacqueline Mair
British (20thC)
Spotted Jug, 1994
Mixed media
4 x 5in (10 x12.5cm)
£150–175 *CSKe*

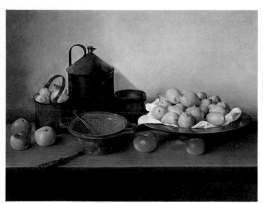

Andrew Hemingway
British (b1955)
Still Life reflections with a 17thC Colander
Pastel
38 x 50½in (96.5 x 128cm)
£15,000–16,000 *BSG*

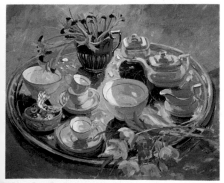

Elizabeth Jane Lloyd
British (b1928)
Still Life with Iris and Hellebore
Oil on canvas
20 x 24in (51 x 61cm)
£600–700 *SHF*

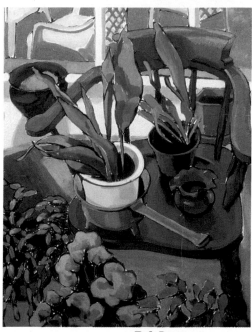

Bob Lynn
Scottish (b1940)
Conservatory Chair
Oil on canvas
30 x 24in (76.5 x 61cm)
£850–930 *SOL*

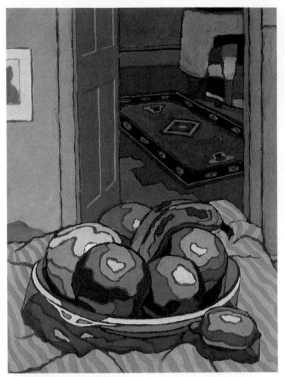

Cyril Mann
British (1911–80)
Interior with Fruit
Gouache
21 x 15in (53.5 x 38.5cm)
£2,000–2,500 *PN*

Walter Nessler
German/British (20thC)
Still Life, 1959
Oil and sand
18 x 22in (45.5 x 55.5cm)
£650–750 *JDG*

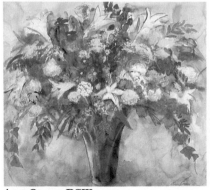

Ann Oram, RSW
Scottish (20thC)
Spring Flowers
Watercolour
38 x 42in (96.5 x 106.5cm)
£1,850–1,950 *RB*

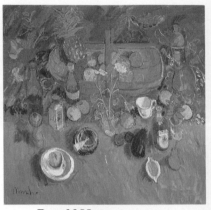

Donald Manson
Scottish (20thC)
Still Life with Bottles and Basket
Oil on panel
35in (89.5cm) square
£1,750–1,950 *RB*

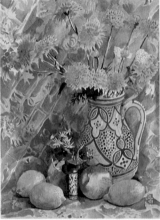

r. **Sara Philpott**
British (b1963)
Ulswater Blue
Watercolour
28 x 21½in (71 x 54.5cm)
£500–550 *AMC*

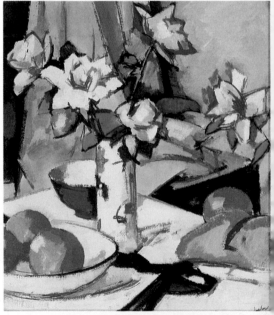

Samuel John Peploe, RSA
Scottish (1871–1935)
Still Life with Roses and Oranges
Signed, oil on canvas
18 x 16in (45.5 x 40.5cm)
£58,000–64,000 *S(Sc)*

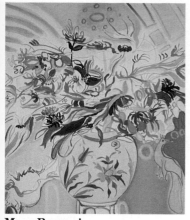

Mary Ruggeri
British (b1951)
Persian Vase with Flowers
Oil on canvas
24 x 20in (61.5 x 51cm)
£400–450 *AMC*

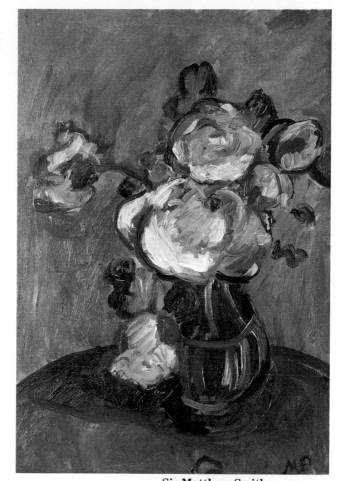

Sir Matthew Smith
British (1879–1959)
Peonies, 1926
Signed with initials, oil on canvas
22 x 15in (55.5 x 38cm)
£25,000–28,000 *PN*

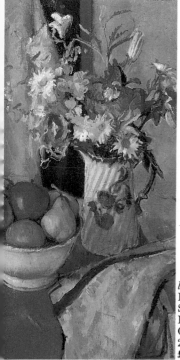

l. **Richard Smith**
British (b1957)
Still Life with Summer
Flowers and Fruit
Oil on canvas
26 x 14in (66 x 35.5cm)
£1,800–2,000 *BSG*

Vernon de Beauvoir Ward
British (1905–88)
A Bowl of Roses
Signed, oil on canvas
22 x 26in (55.5 x 66cm)
£5,000–6,000 *TG*

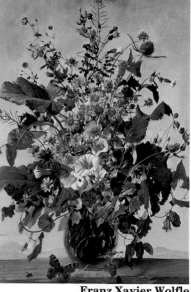

Franz Xavier Wolfle
Austrian (1896–1989)
Still Life of Flowers
Oil on panel
26 x 20in (66 x 51cm)
£15,950–16,950 *HFA*

Chris Brown
British (20thC)
Blondes have more Fun
Acrylic on canvas
18 x 20in (45.5 x 51cm)
£850–950 *Tr*

Julian Bailey
British (b1963)
The Hat Stall, night Market
Oil on board
22 x 25in (55.5 x 63.5cm)
£1,000–1,200 *NGG*

John Boyd
British (20thC)
Figure and Pot
Oil on card laid on board
18 x 22in (45.5 x 55.5cm)
£1,000–1,100 *VCG*

Harriet Brigdale
Dutch (20thC)
Man with Kite
Pastel
9½ x 10in (24 x 25cm)
£225–265 *AMC*

Martyn Brewster
British (b1952)
Square Variations 3-95
Oil on canvas
17in (43.5cm) square
£500–575 *JGG*

Brendan Stuart Burns
British (20thC)
Easter – Newport Road, 199
Oil on board
4¾ x 6½in (12 x 16cm)
£300–365 *KG*

Melanie Comber
British (20thC)
Nodule, 1994
Oil, sand, PVA and pigment on canvas
56in (142cm) square
£700–750 *CASoc*

P. J. Crook
British (20thC)
Weekend
Acrylic on canvas
40 x 52in (101.5 x132cm)
£4,250–4,750 *MES*

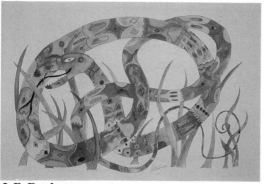

J. P. Donleavy
American/Irish (20thC)
Anaconda
Watercolour
14½ x 20⅜in (37 x 53cm)
£850–950 *AMC*

Liza Gough Daniels
British (b1962)
Four Quarter Panel
Egg tempera on gesso panel
79in (200.5cm) square
£1,000–1,500 *FT*

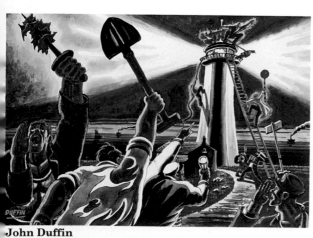

John Duffin
British (20thC)
The Revolutionaries: taking the Lighthouse
Watercolour and ink
22 x 30in (56 x 76cm)
£300–400 *GK*

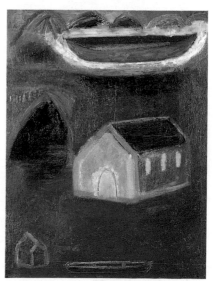

Maryclare Foa
British (20thC)
Gold Boat passing
Oil on board
35 x 28in (89.5 x 71cm)
£750–850 *KG*

Jonet Harley-Peters
British (20thC)
Hot Landscape
Pastel on constructed paper
38in (96.5cm) square
£600–665 *FT*

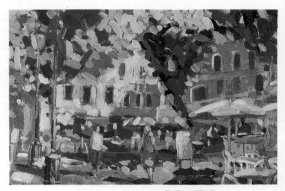

John Holt
British (20thC)
Aix-en-Provence
Acrylic
24 x 30in (61.5 x 76cm)
£550–650 *WG*

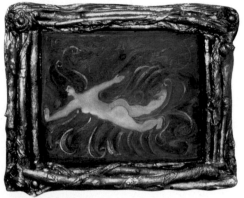

Vicky Hawkins
British (20thC)
Splish, Splosh
Oil on wood and driftwood frame
15½ x 19in (39.5 x 48cm)
£450–500 *VKY*

Kim Marsland
British (20thC)
Viennese Horse
Oil on paper
8 x 9in (20 x 22.5cm)
£300–360 *KG*

Graham Knuttel
Irish (20thC)
Fish, 1992
Signed, acrylic
48 x 72in (122 x 182.5cm)
£10,000–12,000 *NAG*

Graham Knuttel was born in Dublin of German and English parents. Among his mother's family were several noted artists and architects, including Thomas Cooper Gotch who co-founded the Newlyn School of painting, whilst movie star Gary Cooper was his great uncle. Graham Knuttel first became known for his large mechanically animated sculptures but today works both as a painter and sculptor. His work is represented in collections in Europe and the USA.

Charles Newington
British (b1950)
Ice and Fire (Beasts Series)
Pastel, sfumato
6 x 9in (15 x 22.5cm)
£150–175 *RGFA*

Colum McEvoy
Irish (20thC)
Carlingford Harbour
Signed and dated '1995', watercolour
14 x 21in (35.5 x 53.5cm)
£300–330 *Art*

Robert Nixon
British (b1955)
A King at Paddington
Oil on canvas
16 x 20in (40.5 x 51cm)
£200–300 *WOT*

Sean Read
British (20thC)
The Artist woos his Client, 1995
Fibreglass, acrylics and wood
77¼ x 73½in (196 x 186cm)
£2,250–2,500 *Tr*

Dorothy Lee Roberts
Australian/British (20thC)
The new Beginning
Oil on canvas
16 x 12in (40.5 x 30.5cm)
£600–700 *LFA*

l. **Carey Mortimer**
British (b1962)
Untitled
Fresco on stucco
33 x 24in (83.5 x 61.5cm)
£400–500 *FT*

John Boydell Rogers
British (20thC)
Homage to Georgie P. – Icarus Series '93
Acrylic, oil and collage on board
8½ x 13½in (21 x 34cm)
£600–700 *KG*

Christopher Wood
British (20thC)
Beyond the Eastern Hill
Oil on canvas
24 x 26in (61.5 x 66cm)
£900–1,100 *VCG*

Robert Soden
British (20thC)
Oil Rig, River Tyne
Watercolour
30 x 41in (76 x 104cm)
£550–650 *VCG*

Colin G. Thomason
British (20thC)
Jungle Mooning
Oil on board
24 x 18in (61.5 x 45.5cm)
£600–800 *GK*

Dominic E. W. Wright
British (b1970)
Bump in the Night
Oil and wax on canvas
63in (160cm) square
£500–700 *GK*

Ruth Stage
British (20thC)
Boathouse at Serpentine
Tempera on panel
13 x 17⅛in (33 x 44cm)
£650–750 *BRG*

19th Century

F. Carabini after
Guido Reni
Italian (1575–1642)
L'Aurora
Inscribed and dated '1873', oil on canvas
37½ x 74¼in (95 x 188.5cm)
£2,500–3,000 *P*

Reni's 'L'Aurora' was frequently copied. It was
one of the more popular pictures with visitors to
Rome and in the 19thC was reproduced in
paintings, prints and on fan leaves destined for
the tourist market.

Edward Clifford
British (1844–1907)
Some have entertained Angels unawares
Signed and dated '1871', watercolour and
bodycolour, heightened with gum arabic
25¼ x 38⅛in (64 x 97cm)
£7,500–8,500 *S*

The work takes its title from the Epistle of
St Paul to the Hebrews 13:1 'Let brotherly love
continue. Be not forgetful to entertain strangers;
for thereby some have entertained angels
unawares.' Clifford was an intensely religious
man. He had considered taking holy orders and
regularly treated biblical subjects.

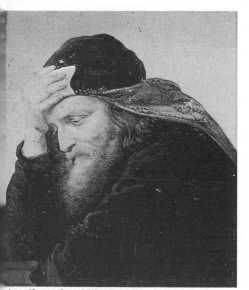

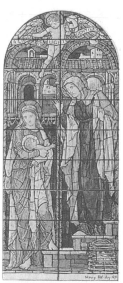

r. **Henry Holiday**
British (1839–1927)
A stained Glass Window
Design for the Holy
Trinity, Philadelphia:
The Prophetess Anna
Signed and dated '1890',
pen and brown ink
and watercolour
8½ x 3⅓in (21.5 x 8.5cm)
£400–500 *CSK*

Attributed to Nikolai Nikolaievich Ge
Russian (1831–94)
Head of a Rabbi
Oil on board
6¾ x 5⅜in (17 x 14.5cm)
£9,500–10,500 *S*

r. **William Holman Hunt, ARSA, RWS, OM**
British (1827–1910)
The Shadow of Death
Signed with initials, inscribed and dated '1873',
oil on panel
41 x 32¼in (104 x 82cm)
£1,900,000+ *S*

This painting is the third version of 'The Shadow
of Death' (original version in Manchester City Art
Gallery), one of Hunt's most famous compositions,
showing Christ as a young carpenter, stretching
out his arms, giving thanks to God for the day's
labour and prefiguring the crucifixion. Auctioned
by Sotheby's, it made a world record price for a
Pre-Raphaelite painting and also achieved the
third highest price paid to date for any Victorian
work. Reports after the auction revealed that the
painting was destined for the collection of
Andrew Lloyd-Webber.

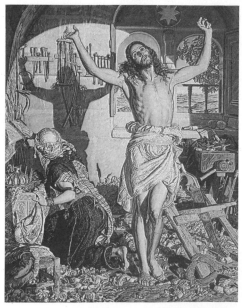

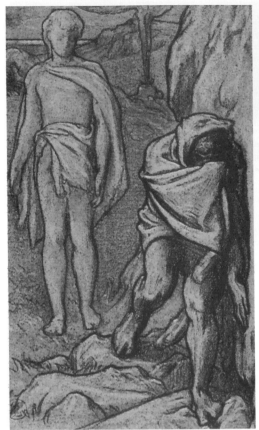

Lord Frederic Leighton, PRA, RWS
British (1830–96)
Cain
Black and white chalk on grey blue paper
5½ x 3¼in (14 x 8.5cm)
£600–800 *C*

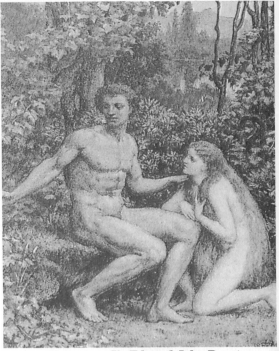

Sir Edward John Poynter
British (1836–1919)
An illustration to *Paradise Lost*
Signed with monogram and dated
'1888', watercolour
6 x 4½in (15 x 11cm)
£1,500–1,800 *CSK*

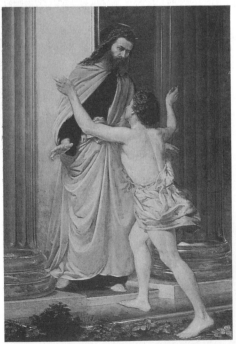

William Cave Thomas
British (active 1838–84)
The Return
Signed with monogram, oil on canvas
38½ x 32½in (97.5 x 82.5cm)
£3,500–4,000 *C*

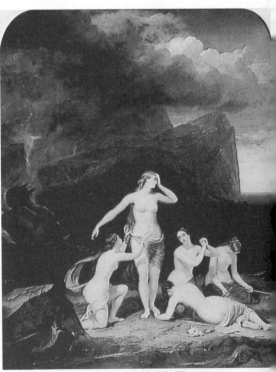

Jacob Thompson
British (1806–79)
Galatea
Signed, inscribed and date
'1849' oil on canvas
36½ x 28½in (92.5 x 72.5cm
£3,750–4,750 *S*

20th Century

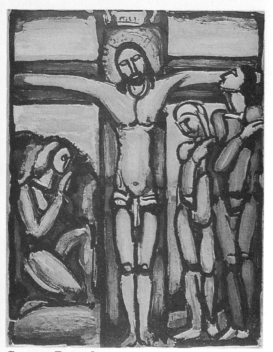

Georges Rouault
French (1871–1958)
Christ en Croix
Signed and numbered '53/175', aquatint
printed in colours, on Montval laid paper
with full margins, good condition, 1936
25½ x 19in (65 x 48cm)
£9,000–10,000 *S*

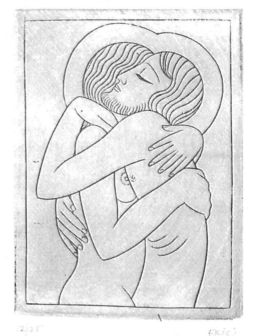

Eric Gill
British (1882–1940)
Divine Lovers
Signed and numbered 12/25, wood engraving,
printed with tone on wove, 1926
4 x 3in (10 x 7.5cm)
£500–600 *P*

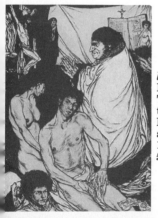

l. **Austin Spare**
British (1888–1956)
The Sacred and
the Profane
Dated '1907', pen and ink
and watercolour
15 x 11in (38 x 28cm)
£1,750–1,950 *BOX*

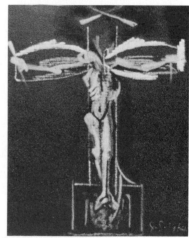

Graham Sutherland
British (1903–80)
Crucifixion
Signed and dated '1964', mixed media
8½ x 6in (21 x 15cm)
£3,900–4,250 *BRG*

l. **Sir Stanley Spencer, RA**
British (1891–1959)
The Paralytic being let into the Top of the
House on his Bed
Oil on panel
11¾ x 13in (30 x 33cm)
£21,000–25,000 *C*

*An illustration of the Miracle of Capernaeum,
Luke 5: 17–20. In common with other religious
paintings of the 1920s the events take place at
Cookham and the paralytic is being lowered
through the roof of Spencer's next door
neighbours, at The Nest. The ladders belong to
Fairchild, the Cookham builder.*

RUSSIAN

Ever since *glasnost,* an increasing number of
works by Russian artists, (predominantly
20thC and contemporary) has been appearing
on the market. In recent times, Phillips,
Christie's, Sotheby's and John Nicholson have
all held auctions devoted to Russian paintings
and several galleries have hosted special
exhibitions of Russian art. Why are these
painters suddenly proving so popular on the
Western market? 'Well, to begin with they can
actually paint,' says Timothy Bruce-Dick,
proprietor of the Alberti Gallery, dealers in
contemporary Russian art. 'Many of them
were trained at the Repin Academy in
St Petersburg, where they studied "old
fashioned" subjects, like composition, drawing
and technique, that we chose to ignore in
Britain.' For sellers and buyers of Russian
paintings the attractions appear to be good
technique, traditionalist subject matter, a
style that is often very decorative and for the
moment at least, moderately priced compared
with many European works of a similar date.
Russia is currently seen as a land of
opportunity for entrepreneurs in every field
and the art market is no exception.

Sergei Besedin
Russian (b1901)
Still Life with Roses, 1963
Oil on board
20 x 12in (51 x 30.5cm)
£2,000–2,500 *CE*

Mariana S. Davidson
Russian (b1926)
Cadet Victor
Signed and dated '1963', oil on canvas
22½ x 24½in (57 x 62cm)
£1,100–1,300 *P*

Vladimir Isayevitch Erlikh
Russian (b1921)
Three young Boys sitting and
lying on a Quay
Signed, oil on canvas
19½ x 31½in (49.5 x 80cm)
£550–650 *JNic*

Anatoli Nikiforovitch Fomin
Russian (b1925)
Extensive ploughing with Tractors in
the Fields
Signed, oil on canvas
32 x 43in (81.5 x 109cm)
£800–1,000 *JNic*

r. **Ilia Savvich Galkin**
Russian (1860–1915)
Flower Girl
Signed and dated '94',
oil on canvas
33 x 25¼in (84 x 64cm)
£9,500–10,500 *S*

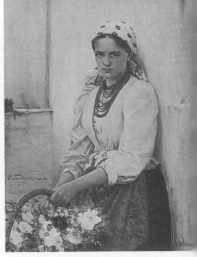

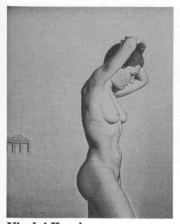

Nicolai Karajov
Russian (b1950)
The New Moon
Signed and dated '94',
oil on canvas
17¾ x 13¾in (45 x 35cm)
£750–850 *ALG*

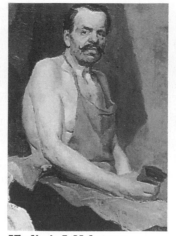

Vladimir I. Nekrasov
Russian (b.1924)
Worker
Signed and dated '1948',
oil on canvas
27½ x 19½in (70 x 49.5cm)
£3,000–3,500 *P*

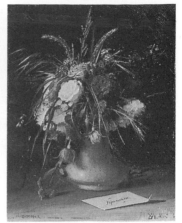

Ivan Nikolaevich Kramskoy
Russian (1837–87)
Vase of Flowers and a
Visiting Card
Signed and dated '84',
oil on panel
9½ x 7½in (24 x 19cm)
£7,000–8,000 *S*

'Strangers are expected to make the first call, which is returned either in person or by call. In leaving cards on persons who are not at home, one of the edges of the card should be turned up. It is necessary to leave a card the next day on any person to whom the stranger may have been introduced at a party. Those who are introduced to the stranger will observe the same politeness. Great punctuality is exacted in St. Petersburg in the matter of leaving cards after entertainments and introductions . . . The hours for calling are 3 to 5pm . . .' (J. Murray, Handbook for Travellers in Russian, Poland and Finland, *London 1865, p46).*

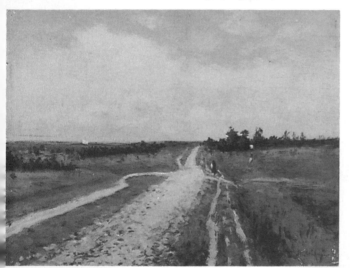

Isaac Illich Levitan
Russian (1860–1900)
Study for the Painting of the Road to Vladimir
Signed, oil on artist's panel
6¾ x 8½in (17 x 21.5cm)
£9,500–10,000 *S*

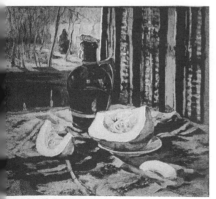

Mikhail Lizagoup
Russian (20thC)
Still Life with Jug and Melon
Oil on canvas, 1950
29 x 31in (74 x 78.5cm)
£3,000–3,250 *CE*

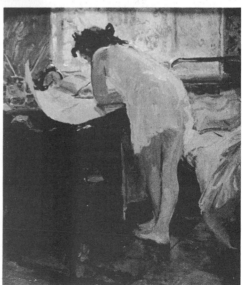

Nikolai Obriynba
Russian (b1913)
Young Girl Painting, 1952
Oil on canvas
24 x 16in (61.5 x 40.5cm)
£3,000–3,500 *CE*

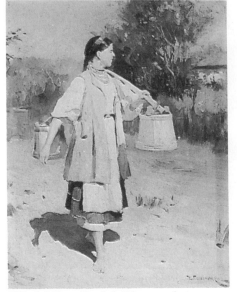

Nikolai Kornilovich Pimonenko
Russian (1862–1912)
Little Russian Peasant Girl returning
from the Well
Signed, oil on canvas
21 x 15¾in (53 x 40cm)
£2,400–3,000 *S*

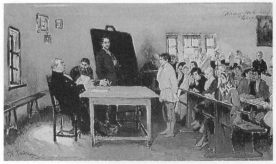

Ilia Efimovich Repin
Russian (1844–1930)
An Examination in a Village School
Signed and dated '1878', oil on canvas
21 x 35in (53.5 x 89.5cm)
£30,000–35,000 *S*

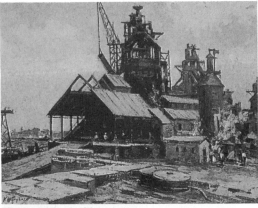

Konstantin A. Shurupov
Russian (1910–85)
Mill in Kiev
Signed and dated, oil on canvas
19 x 31in (48.5 x 78.5cm)
£5,000–5,500 *P*

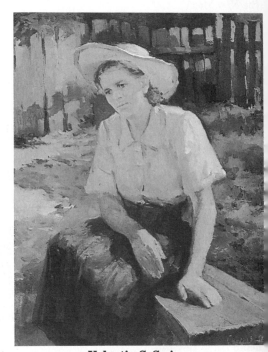

Valentin S. Smirnov
Russian (b.1917)
In the Garden
Signed and dated '51', oil on canvas
30½ x 23¼in (77.5 x 59cm)
£22,000–25,000 *P*

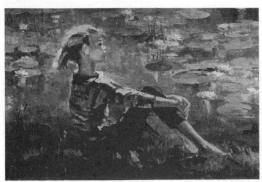

Ksenia Uspenskaya
Russian (b1922)
Lilies
Signed and dated '70', oil on canvas,
26 x 38in (66 x 96.5cm)
£11,000–12,000 *CE*

Mikhail Alexandrovich Vrube
Russian (1856–1910)
A Study of two Heads
Watercolour and ink over pencil
3½ x 5¼in (9 x 13cm)
£3,750–4,250 *S*

SILHOUETTES

In 1758, the French Finance Minister, Etienne de Silhouette, introduced harsh financial measures. Artists took their revenge by satirising these deeply unpopular restraints and produced 'silhouette' portraits, reducing their subjects to a black shadow in profile. A contemporary publication the *Tableau de Paris* noted: 'Everything appeared "a la silhouette" and his name soon became ridiculous.'

Silhouettes became fashionable in Europe and the United Kingdom and according to specialist dealer Martin Riley of Brightwell Antiques, the great period for silhouettes was from c1780–1820. 'London was, of course, the major centre, with many silhouette artists based in Covent Garden and the Strand, but artists would also travel around the country, advertising their services in local newspapers, and offering sittings at prices ranging anywhere from 2s 6d to two guineas.' Silhouettes were produced in various media. 'Painted' silhouettes were painted on paper, plaster, glass or ivory. 'Cut-out' silhouettes were snipped from black paper and laid down on white paper, whilst with 'hollow cut' silhouettes (far rarer), the portrait was cut out of white paper, the central part discarded, and the white stencil placed on a black background.

Collectors should proceed with great care. 'There are some very good modern-day fakes of Victorian silhouettes,' warns Martin Riley. 'Original condition is all-important,' he continues, 'many silhouettes were cut down from rectangular into oval shape and a contemporary frame is crucial to the value and interest of a silhouette.'

Anon (18thC)
Louis XVI, King of France
Silhouette print, c1791
9¼ x 7¼in (23 x 18cm)
£55–65 *STA*

Anon
British (c1825)
Unknown Man
Cut out paper and bronzed
2½ x 2¼in (6.5 x 6cm)
£80–150 *BlA*

**Attributed to
George Atkinson**
British (active 1806–26)
Unknown Woman
Painted on paper and
bronzed, c1820
3¼ x 2¾in (8 x 7cm)
£200–400 *BlA*

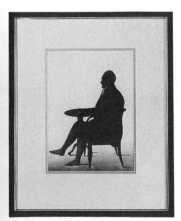

Beale
British (active 1840s)
Dr. Jowett
Painted, c1840
9¼ x 6¾in (23 x 17cm)
£300–500 *BlA*

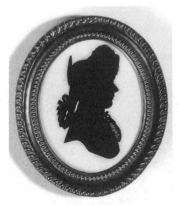

Mrs Isabella Beetham
British (18thC)
A Member of the Bowen family
of Dripsey Castle, Co Cork
A set of 4, cut-outs on plaster
3½in (8.5cm) high
£1,050–1,250 *CSK*

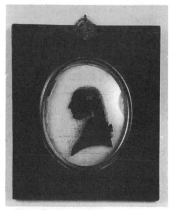

Mrs Burtram
British (active 1760–98)
Unknown Man
Signed, needlepointed on glass
5½ x 4½in (13.5 x 11cm)
£125–150 *SPE*

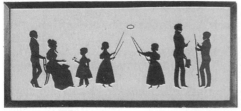

r. Richard Jorden
British (active c1779–85)
Unknown Man
Cut-out paper, c1785
3½ x 2¾in (8.5 x 7cm)
£200–300 *BlA*

Augustin Edouart
British (19thC)
A full length Group, Mrs John Nash, with
her children and Master Deane Horre
Dated '1835', cut-outs on card
10½in (26.5cm) high overall
£450–600 *CSK*

Samuel Metford
British (1810–96)
Lady knitting
Signed, cut-out paper
and bronzed, c1845
9¾ x 7in (24.5 x 17.5cm)
£200–400 *BlA*

John Miers
British (c1758–1821)
Mrs. Markey
Painted on plaster, c1790
3¼ x 2¼in (8 x 6cm)
£250–500 *BlA*

Charles Rosenberg
British (1745–1844)
Unknown Boy
Painted on glass, c1795
3 x 2in (7.5 x 5cm)
£250–500 *BlA*

l. Unknown Artist
British (c1840)
A Man
Cut-out paper and bronzed
11¼ x 7⅛in (28.5 x 18cm)
£450–650 *BlA*

Mr Seville
British (19thC)
Unknown Person
Signed, cut-out
silhouette, c1840
4¾ x 4in (12 x 10cm)
£100–150 *RdeR*

r. Baron Scotford
American (20thC)
A Woman
Signed and dated '1930',
cut-out paper
13 x 4in (33 x 10cm)
£50–100 *BlA*

Enid Elliott Linder
British (20thC)
HRH Princess Anne and
Captain Mark Phillips, 1973
A pair, cut-out paper
6 x 5in (15 x 12.5cm)
£65–100 *CRO*

SILVER PAPER PICTURES

The majority of the silver paper pictures illustrated below were made during the 1930s. Using a commercial stencil, the image was traced on to a sheet of glass, after which the background was masked out with black or coloured ink. When the surface dried, pieces of silver paper were stuck in the spaces not filled in with ink. The back was concealed by a sheet of cardboard which was secured to the glass by passé-par-tout tape, the forerunner of Sellotape. Many pictures were incorporated into trays. Popular images include Dutch boys and girls, galleons, crinoline ladies, flowers and animals. Rarely did the makers create their own designs.

Crinoline Lady Tray
Stencil, silver paper
14 x 20in (35.5 x 50.5cm)
£40–50 *Lon*

Chickens
Stencil, silver paper
7 x 5½in (17.5 x 14cm)
£15–20 *Lon*

Parrot Tray
Stencil design painted over silver and gold paper
16 x 11in (40.5 x 28cm)
£1–5 *PC*

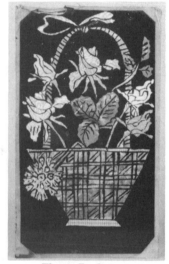

Flower Basket
Stencil, silver paper
14½ x 8½in (37 x 21.5cm)
£30–35 *Lon*

l. Dutch Scenes
A pair, stencil, same image, stencil reversed on one picture, silver paper
10½ x 12½in (26.5 x 31.5cm)
£35–40 *Lon*

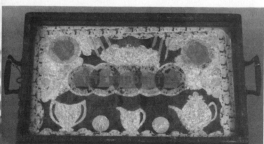

Afternoon Tea Tray
Original design, not stencil, silver paper
10 x 16in (25 x 40.5cm)
£35–40 *Lon*

Tray with Galleon and desert Island
Stencil, silver paper
12 x 18in (30.5 x 45.5cm)
£30–35 *Lon*

SPORTS & GAMES
17th–18th Century

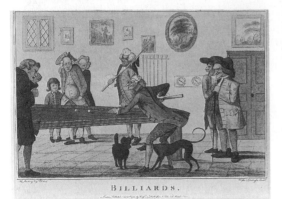

After H. Bunbury
British (1750–1811)
Billiards
Stipple engraving by Watson & Dickinson and
published by Watson & Dickinson, 158 New
Bond Street, London, 1780
10 x 14¾in (25 x 37.5cm)
£550–650 *GP*

Thomas Rowlandson
British (1756–1827)
A Dog Fight, probably at the Westminster Pit
Watermark '1798 Russell', pencil, pen and grey
ink and watercolour
8½ x 12½in (21.5 x 32cm)
£2,800–3,300 *C*

*'The scene of this cruel sport, since made
unlawful, is probably the Westminster Pit, where
these spectacles attracted people of rank and
fashion as well as the dregs of the sporting and
dog fancying fraternities. It was at the
Westminster Pit that the famous dog Billy won
the vermin killing, by despatching a hundred
rats at a time,' writes J. Grego in* Rowlandson
the Caricaturist.

19th Century

James Warren Childe
British (1778–1862)
Two young Cricketers
Signed, oil on ivory
7¼ x 5⅜in (18 x 14cm)
£1,250–1,500 *CSK*

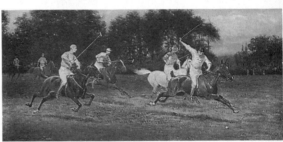

John Alexander Harrington Bird
(British 1846–1936)
The Polo Match
Signed and dated '1898', oil on canvas
15 x 30in (38 x 76cm)
£29,000–31,000 *S(NY)*

r. **English School** (early 19thC)
A Cricketer at the Crease
Oil on canvas
12 x 10in (30.5 x 25cm)
£12,000–13,000 *C*

*Up until the mid-19thC, cricketers had worn tall
hats and buckled shoes. But with the rising
popularity of the game, dress began to change to
take into account the need for easier movement. The
hats were replaced by caps of varying kinds, and the
shoes with buckles, which dangerously interfered
with the sweep of the bat on occasions, were
replaced with boots. The player in the present
picture is still wearing the shoes with buckles; boots
were not worn until the 1860s.*

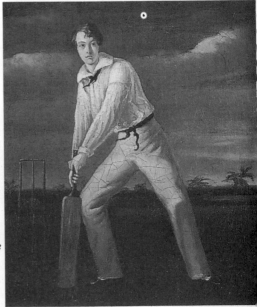

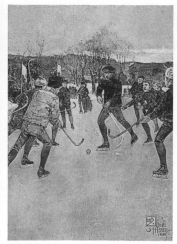

Childe Hassam
American (1859–1935)
Skating
Signed and dated '1886',
watercolour and gouache on
paper, en grisaille
13 x 9in (33 x 22.5cm)
£22,500–25,000 *S(NY)*

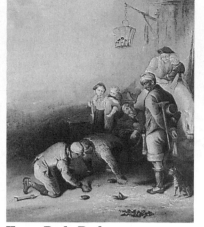

Henry Perle Parker
British (1795–1873)
Pitmen playing Quoits
Oil on canvas
30 x 25in (76 x63.5cm)
£3,000–3,500 *C*

r. **Charles Tichon**
French (19th/20thC)
'Cycles Rochet'
Lithograph poster, c1900, printed by
J. Kossuth & Cie., Paris, generally
in excellent condition,
backed on linen
61 x 22½in (155 x 57cm)
£360–450 *CSK*

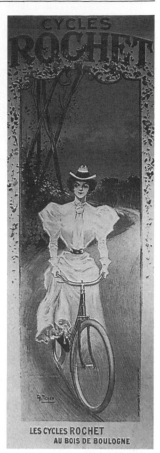

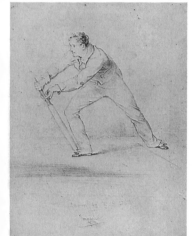

George Frederick Watts
British (1817–1904)
Forward
Signed, charcoal drawing
13 x 9½in (33 x 24cm)
£2,750–3,250 *CSK*

20th Century

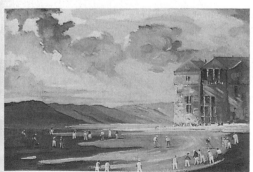

Gordon Barlow
British (b1913)
The 17th Green at St. Andrews
Signed and inscribed, oil on board
18 x 26in (45.5 x 66cm)
£700–800 *CSK*

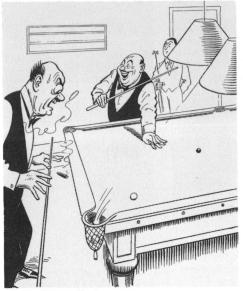

Henry Mayo Bateman
British (1887–1970)
The Snooker Player
Pen and ink
12¼ x 8½in (31 x 21.5cm)
£2,500–2,750 *CBL*

Gill & Lancaster
British (20thC)
Lords, 1937
Poster
10 x 12½in (25 x 32cm)
£75–95 *Do*

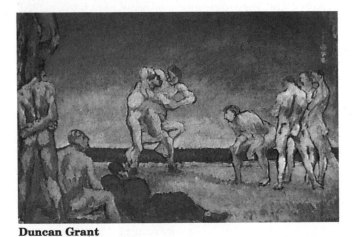

Duncan Grant
British (1885–1975)
The Wrestlers
Signed, oil on board
22 x 32in (55.5 x 81.5cm)
£7,500–8,500 *S*

Yaroslav Titov
Russian (b1906)
The Winner
Signed and dated '1986',
oil on canvas
39½ x 31½in (100 x 80cm)
£750–850 *CSK*

Larry (Terence Parkes)
British (b1925)
Score Cards
Pen ink and watercolour
5½ x 6¾in (14 x 17cm)
£175–200 *CBL*

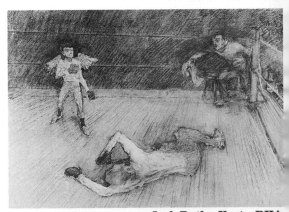

Jack Butler Yeats, RHA
Irish (1871–1957)
Out
Signed, watercolour
20 x 27in (50.5 x 68.5cm)
£2,600–2,800 *JAd*

STILL LIFE

'Today we witness the victory of the inanimate, or, to put it another way, those who can only paint still and dead things, and with such things achieve fame among the common people,' wrote the Italian artist Francesco Albani (1578–1660) scornfully in his *Treatise on Painting*. As far as 17thC academic artistic circles were concerned, still life ranked at the lowest end of the scale in terms of artistic merit, the highest position invariably being occupied by 'history' painting (portrayals of religious, mythological and grand historical scenes). Such critical distinctions however, mattered very little to contemporary picture buyers. In Holland still lifes were hugely valued and flower painters were amongst the highest paid artists of the day. According to reports, Flemish painter Ambrosius Bosschaert (1573–1621) could command 1,000 guilders for a flower painting, an astonishing sum of money, at a time when the average price of a portrait on the Dutch market was only 60 guilders.

The Netherlands was the home of the still life, and artists, or indeed whole families of artists, often concentrated on specific still life subjects, specialising in flower pieces, fruit baskets, breakfast scenes, banqueting tables or dead game paintings. Although in one sense these pictures were an ultimate celebration of the material world, many also carried religious and symbolic overtones, reminding collectors of the vanity of earthly pleasures. Above all, however, they were admired for their decorative qualities and the same is true today with old master still lifes commanding strong prices in the current market.

17th–18th Century

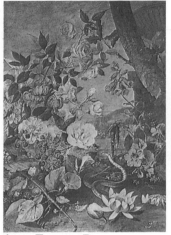

Anne Frances Byrne
British (1775–1837)
Flowers
Signed and inscribed, watercolour heightened with white and gum arabic
32 x 23½in (81 x 60cm)
£1,750–2,250 *CSK*

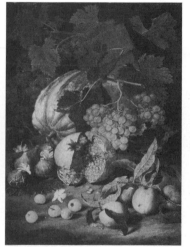

Christian Berentz
German (1658–1722)
Peaches, Crab apples, Figs, Grapes, a Pomegranate and a Melon on a Bank
Oil on canvas
26 x 19½in (66 x 50cm)
£20,000–25,000 *C*

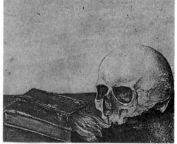

Attributed to Giovanna Garzoni
Italian (1600–70)
A Vanitas Still Life of a Tulip on a Book beside a Skull
Gouache on vellum
5¼ x 6½in (13 x 16.5cm)
£1,600–1,900 *Bon*

A 'Vanitas' still life was a collection of objects selected to signify the transience of life and the vanity of all material possessions. Traditional elements included a skull, an hourglass, an overturned cup, coins, books and an extinguished candle. Vanitas symbols were often incorporated into other still lives, a watch on a breakfast table was there to remind the observer of the passing of time, a butterfly in a flower piece was not only a decorative detail but symbolised the brevity of life and the resurrection of the Christian soul.

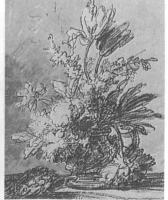

Jan van Huysum
Dutch (1682–1749)
Study of a Vase of Flowers
Pen and black ink, black chalk and grey wash
15½ x 11¾in (39 x 30cm)
£7,200–8,000 *S(Am)*

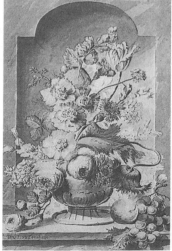

l. **Pieter van Loo**
Dutch (1731–84)
A Still Life with a Vase of Flowers, Grapes and a Peach in a stone Niche
Signed and dated '1774', watercolour over black chalk
18½ x 12½in (47 x 32cm)
£3,600–4,000 *S(Am)*

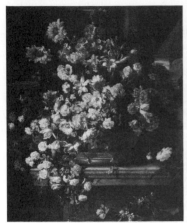

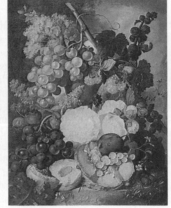

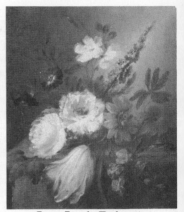

Jean Baptiste Monnoyer
French (1634–99)
Still Life of Flowers in a large
Basin on a stone Ledge in the
Out-of-doors before a draped
Column, a Landscape beyond
Oil on canvas
73½ x 61½in (186.5 x 156cm)
£170,000–180,000 *S(NY)*

*The present painting may be
datable to the artist's final decade
when he moved to England at the
request of the 1st Duke of
Montagu. His greatest
achievement during this period
was a series of flower decorations
for Montagu House, Whitehall,
which are today in the collection
of the Duke of Buccleuch.*

Follower of Jan van Os
Dutch (1744–1808)
Still Life of Flowers with Grapes,
a Peach, a Melon and Plums
Signed, oil on panel
15 x 11½in (38 x 29cm)
£15,000–16,000 *S*

Jean Louis Prévost
French (c1760–1810)
A Still Life of Roses, a Tulip,
Passion Flowers and other
Flowers on a stone Ledge
Oil on canvas
14 x 12in (36 x 31cm)
£5,750–6,750 *Bon*

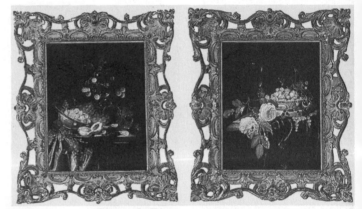

Pieter de Ring
Dutch (1615–60)
Still Life of Fraises de Bois in a blue and white
Porcelain Bowl, a Roemer, Cherries, Peaches on a
Pewter Plate, all on a stone Pedestal, partly draped
with a brown Cloth and,
Still Life of Fraises de Bois in a blue and white
porcelain bowl, a façon de Venise Goblet, Roses,
Cherries and Berries, all on a stone Pedestal, partly
draped with a green Cloth
A pair, oil on panel
18½ x 14¼in (47 x 36.5cm)
£35,000–40,000 *S*

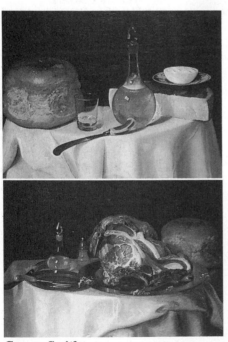

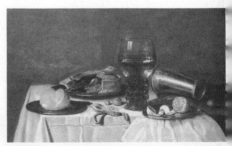

George Smith
British (1714–76)
Still Life with Bread and Cheese and
Still Life with Meat and Bread
A pair, oil on canvas
24½ x 29in (62 x 73.5cm)
£13,500–15,500 *Bon*

Hans van Sant
Dutch (active c1620)
A Roemer, an overturned Beaker, a peeled Lemon
on a Pewter Plate, a Fruit Pie, a Bread Roll and a
Knife on a Pewter Plate, a Watch, Walnuts and a
Hazelnut on a partly draped Table
Signed with monogram, oil on canvas
20¼ x 33in (51.5 x 83.5cm)
£20,000–22,000 *C*

19th Century

Many Victorian still life painters followed the artistic patterns laid down in 17thC Holland. In Britain, William Henry 'bird's-nest' Hunt (1790–1864) originated a native genre of still life in which fruit, blossom and bird's nests were portrayed on a moss-covered bank rather than in an interior. His works were extremely successful and spawned a host of imitators, including the Clare family (father George and brothers Vincent and Oliver), whose 'mossy bank' still lifes remain equally popular today.

Owen Bowen
British (1873–1967)
Still Life with Flowers
Signed, oil on canvas
25 x 31in (63.5 x 78.5cm)
£1,300–1,600 *AH*

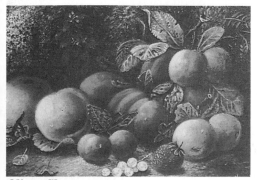

Oliver Clare
British (c1853–1927)
Plums, Peaches, Apples, Greengages,
White Currants and a Strawberry on a
mossy Bank
Signed, oil on board
8¼ x 12in (20.5 x 30.5cm)
£900–1,200 *CSK*

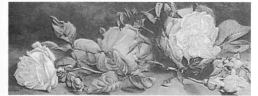

Thomas Frederick Collier
British (exh 1850–74)
A Spray of Pink Roses
Signed, watercolour
6 x 15¼in (15 x 39cm)
£850–950 *WrG*

Vincent Clare
British (1855–1930)
Still Life of Plums and Grapes
Signed, oil on canvas
10 x 12in (25 x 30.5cm)
£950–1,250 *P*

Joshua Cook
British (active 1852–54)
A Silver Ewer, Grapes, a Gourd,
Peaches, Plums, an Apple and a
Pineapple on a marble Top with an
extensive River Landscape beyond
Signed and dated '1852', oil on panel
15¼ x 20in (39 x 51cm)
£3,750–4,750 *C*

William Cruickshank
British (active 1866–79)
A Still Life of Pineapple, Strawberries
and Apples on a mossy Bank
Signed, watercolour and bodycolour
on ivorine
5½ x 6½in (14 x 16.5cm)
£400–500 *Bon*

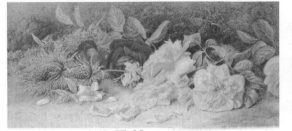

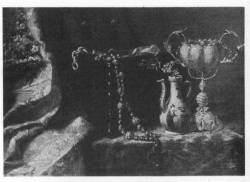

Mary Elizabeth Duffield
British (1819–1914)
Mossy Bank with Yellow and Red Roses
Signed, watercolour
9½ x 18¾in (24 x 47.5)
£1,700–1,900 *WrG*

English School (19thC)
A Still Life of a Jewel Casket, Vase and
gilt Ewer
Signed with initials, oil on canvas, 1877
15 x 19in (38 x 48.5cm)
£1,200–1,400 *Dag*

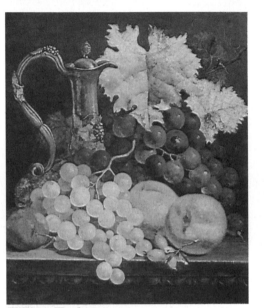

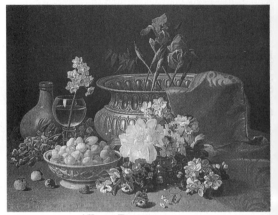

William Hughes
British (1842–1901)
Grapes, Peaches, Rosehips, a Plum and
a silver Claret Jug on a wooden Ledge
Signed and dated '65', oil on canvas
11¾ x 10in (30 x 25cm)
£3,750–4,750 *C*

Albert Raoux
French (19thC)
Still Life with Strawberries & Flowers
Oil on canvas
27 x 33in (68.5 x 83.4cm)
£4,500–5,000 *JN*

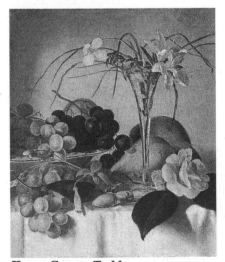

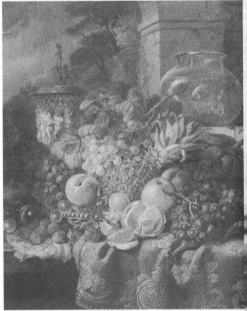

Henry George Todd
British (1846–98)
An Apple, Grapes, Pears, Hazelnuts, a
Glass and a Camelia on a Table
Signed and dated '1876', oil on canvas
12¼ x 10¼in (31 x 25.5cm)
£2,600–3,200 *C*

John Wainwright
British (19thC)
Still Life of Fruit with Goldfish in a Bowl
Signed and dated '1876', oil on canvas
30 x 25in (76 x 63.5cm)
£5,800–6,800 *P*

20th Century

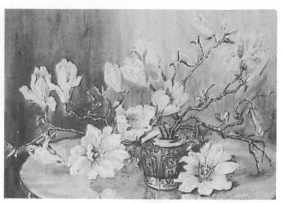

Marion Broom, BWS
British (exh 1897–1940)
Magnolia
Signed, watercolour
21 x 29in (53.5 x 73.5cm)
£1,200–1,500 *HO*

Diana Armfield, RA, NEAC
British (b1920)
Spring Flowers
Signed, oil on panel, 1992
10 x 8in (25 x 20cm)
£3,550–3,750 *BRG*

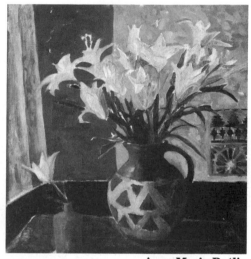

George Ayling
British (1887–1960)
Chrysanthemums in a blue Vase
Signed, watercolour
14½ x 20in (37 x 50.5cm)
£500–600 *LH*

Anne-Marie Butlin
British (20thC)
Red Lilies
Oil on canvas
24in (61cm) square
£585–685 *AMC*

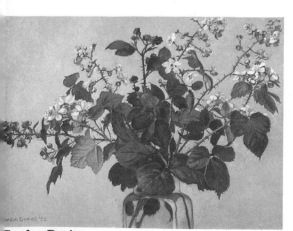

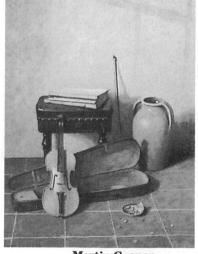

Gordon Davies
British (b1926)
Blackberries, 1993
Signed and dated '93', oil on board
11½ x 15¾in (29 x 40cm)
£800–1,000 *SHF*

Martin Cooper
British (20thC)
The Music Maker
Oil on canvas
16 x 13½in (40.5 x 34cm)
£2,400–2,800 *BSG*

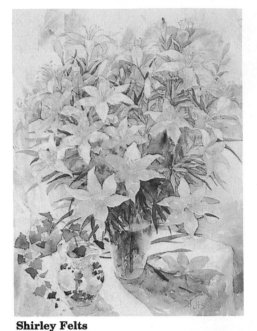

Shirley Felts
American (20thC)
Lilies
Watercolour
29 x 21½in (73.5 x 54cm)
£800–1,000 *PHG*

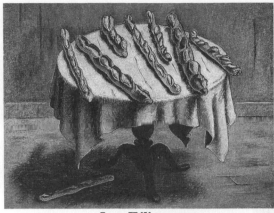

Jean Hélion
French (1904–87)
Les Pains
Signed and dated '51', oil on canvas
28¼ x 35⅞in (72 x 91cm)
£24,000–26,000 *C*

Edith Victoria Hogarth
British (exh 1936–40)
Summer Flowers
Signed, watercolour
13in (33cm) square
£1,000–1,250 *HO*

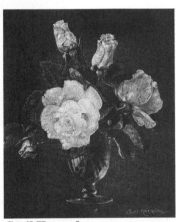

Cecil Kennedy
British (b1905)
Roses in a glass Vase
Signed, oil on canvas
11½ x 9½in (29.5 x 24cm)
£6,750–7,750 *Bea*

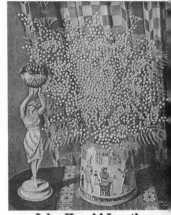

John Harold Lowther
British (20thC)
Leguminosae
Signed and dated '1947',
oil on canvas
21½ x 16⅜in (54.5 x 42.5cm)
£200–250 *DA*

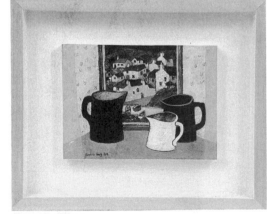

Brenda King
British (20thC)
Three Jugs
Signed and dated '94', oil on board
6 x 8in (15 x 20cm)
£175–200 *NEW*

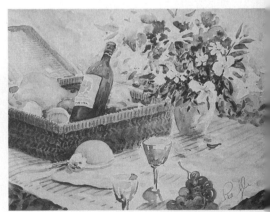

Patrick Livingstone
Irish (b1956)
Spring Picnic
Signed, watercolour
22¼ x 30in (56 x 76cm)
£550–650 *AMC*

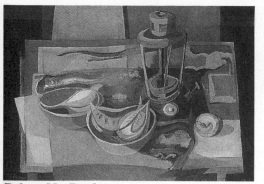

Robert MacBryde
British (1913–66)
The Hurricane Lamp
Signed, oil on canvas
16 x 22in (40.5 x 55.5cm)
£3,750–4,250 *C*

June Miles
British (20thC)
Honesty
Oil on canvas
24 x 18in (61.5 x 45.5cm)
£850–950 *NZ*

l. **Freda Marston**
British (1895–1949)
Apples in glass Bowl on Table
Signed, oil on canvas
12 x 16in (30.5 x 40.5cm)
£400–480 *LH*

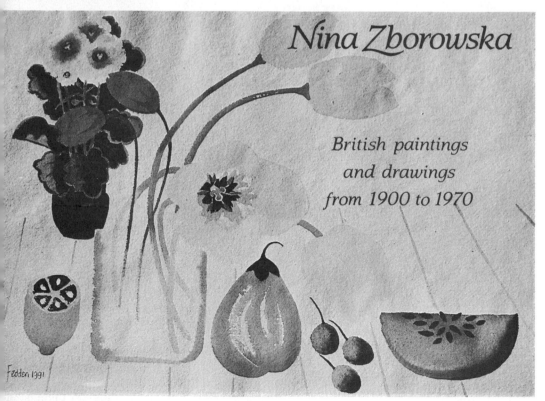

Charles Rennie Mackintosh
Scottish (1868–1928)
Yellow Tulips
Signed, watercolour, c1922
19½in (49.5cm) square
£185,000–200,000 *C(S)*

Born in Glasgow, the son of a
police superintendent, architect
and painter Charles Rennie
Mackintosh was one of the
originators of the Art Nouveau
style. His most famous work was
carried out in Glasgow at the turn
of the century including the
design for the Glasgow School of
Art and Mrs Cranston's tea
rooms. Ironically, notes the
Dictionary of National Biography,
though Mackintosh was famed on
the continent as founder of the
Jugendstil movement, 'the first
British architect since Robert
Adam whose name was a
household word abroad,' in
Britain he was almost completely
unknown. His architectural
practice virtually dried up before
WWI and moving to England, he
turned to painting and decorative
design work in order to make his
living. Mackintosh died from
cancer in 1928, a forgotten figure.

Pippa Mills
British (20thC)
Still Life with Plants
Gouache
13 x 9in (33 x 22.5cm)
£250–300 *TBG*

Max Papart
French (20thC)
Still Life with Fish
Oil on canvas
18 x 24in (45.5 x 61.5cm)
£1,800–2,000 *GK*

Paul Nash
British (1889–1946)
Mirror and Window, 1924
Signed and dated '24',
oil on canvas
30 x 22in (76 x 56cm)
£38,000–42,000 *P*

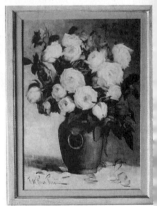

John W. Ross Perrin
British (19th/20thC)
Roses in Vase
Signed, oil on canvas
20½ x 14in (52 x 35.5cm)
£850–950 *LH*

l. **Anne Redpath, RSA**
British (1895–1965)
Mainly grey and white
Signed, oil on board
30½ x 38½in (77.5 x 97.5cm)
£18,500–20,000 *P*

Salliann Putman
British (20thC)
Flower Study
Signed, oil on canvas
8 x 7in (20 x 17.5cm)
£300–350 *TBG*

r. **Leonard Richmond,**
RBA, RI, ROI, PS
British (1886–1965)
Study of Flowers
Signed and dated '1945',
oil on board
21½ x 17½in (54.5 x 44.5cm)
£4,000–4,500 *PN*

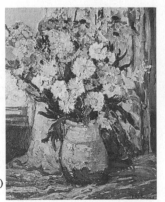

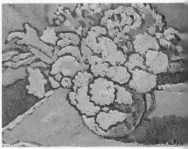

Louis Valtat
French (1869–1952)
Vase de Fleurs sur Fond rouge
Signed and dated '43', oil on board
8½ x 10½in (21 x 26cm)
£6,250–7,250 *S*

THEATRE, FILM & FASHION DESIGNS

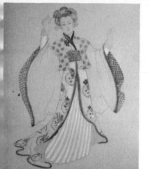

British School (c1920–30s)
Costume design
Unsigned, pencil
and watercolour
16 x 13in (40.5 x 33cm)
£40–50 *MBA*

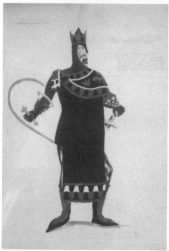

Frederick Crooke
British (1908–91)
Costume design for Philip, King
of France in *King John,* for the
Old Vic Touring Company, 1941
Gouache
22 x 15in (56 x 38cm)
£240–280 *SHF*

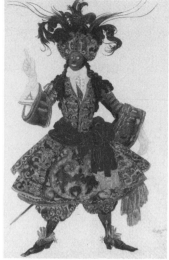

Lev Samoilovich Bakst
Russian (1866–1924)
Costume design for a
Blackamoor in the production
of *La Belle au Bois dormant*
Signed and dated '1921',
gouache over pencil heightened
with gold and silver paint
18¾ x 12½in (47.5 x 32cm)
£25,000–30,000 *S*

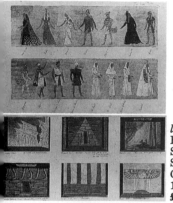

l. **John Armstrong**
British (1893–1973)
Sadler's Wells Opera Costumes and
Set designs, for *The Magic Flute*, 1942
Gouache
19¾ x 15¾in (50 x 40cm)
£1,700–2,000 *MTG*

> **Miller's is a price GUIDE
> not a price LIST**

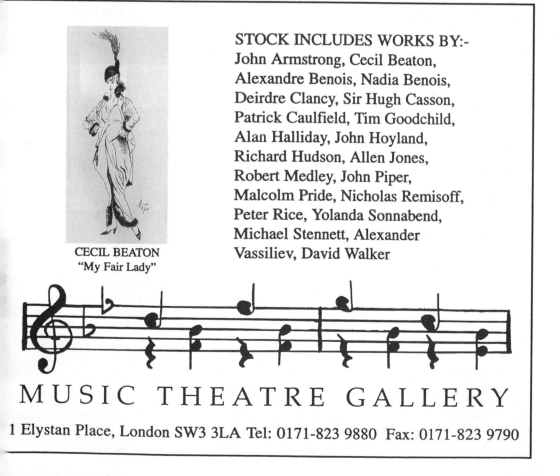

Claude Lovat Fraser
British (1890–1921)
Equestrienne Anglaise
Inscribed, pencil, pen and
black ink and gouache
heightened with gold
12¾ x 8in (32.5 x 20cm)
£340–440 *CSK*

Richard Hudson
British (20thC)
English National Opera
Costume design for Don Basilio,
Figaro's Wedding
Signed, dated '1991', watercolour
14¼ x 10½in (36 x 26cm)
£300–400 *MTG*

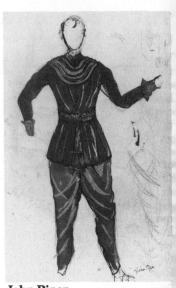

John Piper
British (1903–1992)
Costume design for Tamino in The
Royal Opera House production of
The Magic Flute, 1956
Signed, gouache
17¾ x 13¾in (45 x 35cm)
£1,000–1,500 *MTG*

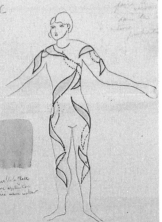

Henri Matisse
French (1869–1954)
Costume design for *Rouge et Noir,* for Ballet Russe de
Monte Carlo, 1938
Inscribed, watercolour, India ink and pencil on buff paper,
a double-sided drawing
10¼ x 8¼in (25.5 x 20.5cm)
£5,400–6,000 *S(NY)*

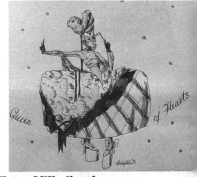

Katya Milhailovsky
Russian (b1963)
Costume design for the *Queen of Heart*
Watercolour on paper
13 x 17¾in (33 x 45cm)
£300–340 *ALG*

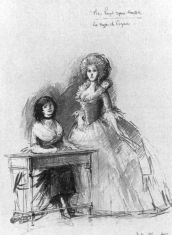

l. **Michael Stennett**
British (20thC)
Costume design for
Countess Almaviva,
Le Nozze di Figaro,
the Royal Opera House
Signed and dated '71',
watercolour
19¾ x 15¾in (50 x 40cm)
£600–800 *MTG*

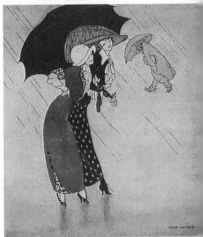

Gerda Wegener
Danish (1889–1940)
The Promenade
Signed, pen and black in
and watercolour on pape
10¾ x 9½in (27 x 24cm)
£1,200–1,500 *C*

TWENTIETH CENTURY REVIEW:
Contemporary Paintings

Works by living painters are illustrated throughout the book, but to conclude this edition of *Miller's Picture Price Guide*, we have devoted an entire section to contemporary painting in Britain. The majority of the following works come from galleries throughout the British Isles or were shown at exhibition over the past year. Many of the artists are young and most are from Britain or Ireland. Contemporary art is often misrepresented in the popular press. The artists who grab the headlines tend to be the more controversial figures producing installations, 'art' objects, and ultra-modern work. A dead sheep preserved in formaldehyde (Damien Hirst), wrapping the Reichstag (Christo) or a bizarre artistic happening make far better newspaper copy than a show of traditionalist landscapes. Nevertheless, as the following section shows, representational painting is alive and well in Britain today and there are contemporary paintings for every taste.

In addition to works in galleries, there are exhibitions every year where one can see and buy the work of living painters. In the Autumn, the Contemporary Art Society holds a major sale of members' work, January sees Britain's major twentieth century Art Fair at the Business Design Centre in Islington, the Mall Galleries in London hosts regular selling exhibitions of works by the various artistic societies (from animal painters to watercolourists) and most famous of all is the Summer Exhibition at the Royal Academy. As well as buying works through dealers, the purchaser can buy direct from the painter. Artist's studios will often have open weekends, whilst art school degree shows give collectors the chance to meet young artists and do their own talent spotting. Everyone dreams about finding a Rembrandt in their attic, but failing that, how much more satisfying to discover a young unknown artist who might become a Rembrandt of the future.

Warren Baldwin
British (20thC)
Vilhelmine resting III
Pencil and charcoal on paper
36 x 40in (91.5 x 101.5cm)
£850–950 *RCA*

Norman Blamey, RA
British (b1914)
The Settle
Oil on canvas
58 x 30in (147 x 76cm)
£12,000–12,500 *RAA*

Graham Clarke
British (b1941)
Providence
Etching, hand coloured,
edition size 400
5¼ x 4½in (13 x 11cm)
£80–115 *GCP*

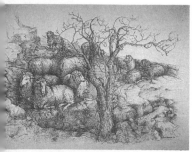

Lynne Broberg
British (20thC)
Sheep by the old Tree (March)
Signed and dated '94', pencil on textured and toned paper
14 x 20in (35.5 x 51cm)
£900–950 *LyB*

r. **Phillippa Clayden**
British (b1955)
Hopscotch
Pastel
22 x 30in (56 x 76cm)
£1,500–1,700 *BOU*

l. **Mervyn Charlton**
British (b1945)
Another Time,
another Place, 1993
Oil on board
12 x 36in (30.5 x 91.5cm)
£550–600 *CASoc*

Graham Dean
British (b1951)
Momento
Watercolour, 1993
57 x 45in (144.5 x 114cm)
£5,500–5,900 *JGG*

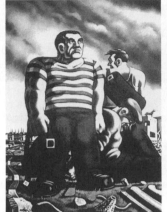

John Duffin
British (20thC)
Waiting for the Boat
Signed, oil on canvas
54½ x 35¾in (138 x 91cm)
£2,500–3,000 *GK*

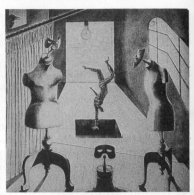

David Grice
British (b1946)
Balancing on the Void
Signed and dated '92',
oil on canvas laid on panel
48in (122cm) square
£8,000–10,000 *TG*

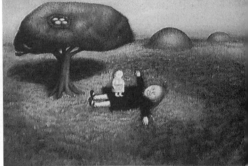

Helen Flockhart
Scottish (20thC)
Base Weed in Bloom
Oil on board, 1993
12 x 16in (30.5 x 40.5cm
£500–550 *RHF*

Luke Elwes
British (20thC)
Refuge, 1993
Oil on canvas
48 x 52in (122 x 132cm)
£2,800–3,000 *RHF*

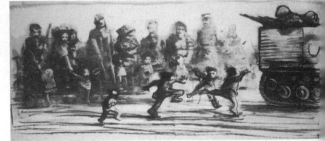

Peter Howson
Scottish (b1958)
Bon Bon Alley
Screenprint, edition 100
30½ x 53¼in (77 x 135cm
£300–355 *RAA*

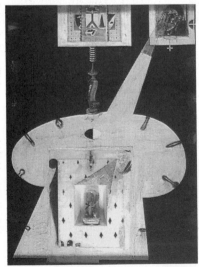

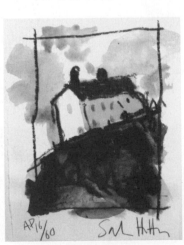

Ian Howard ARSA
Scottish (20thC)
The Dreamer Dreamt
Mixed media
53 x 39in (134.5 x 99cm)
£2,000–2,350 *RB*

l. **Sarah Hutton**
British (20thC)
House on Moors
Signed, numbered 'AP 16/6(
hand-finished, blockprint
12½ x 9in (32 x 22.5cm)
£80–90 *HVM*

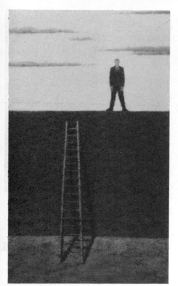

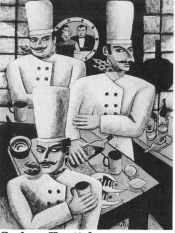

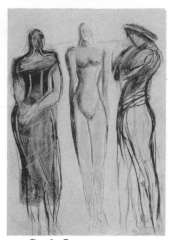

Graham Knuttel
Irish (20thC)
Untitled, 1992
Signed, acrylic on canvas
72 x 48in (182.5 x 122cm)
£10,000–12,000 *NAG*

Sonia Lawson
British (b1934)
Three standing Figures
Mixed media on paper,1994
38 x 28in (96.5 x 71cm)
£1,000–1,200 *BOU*

Rod Judkins
British (20thC)
On Top
Oil on canvas
40 x 23in (101.5 x 58.5cm)
£1,500–1,600 *JGG*

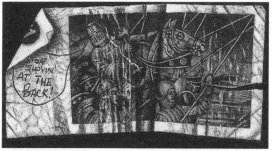

r. **James McDonald**
Scottish (20thC)
Battle
Oil on panel
5 x 8in (12.5 x 20cm)
£550–650 *RB*

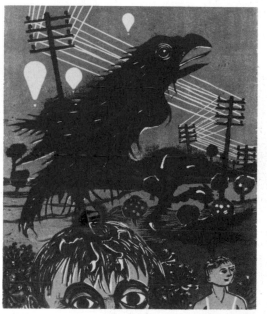

Colum McEvoy
Irish (20thC)
The Tree
Signed and dated '95', watercolour
14 x 21in (35.5 x 53cm)
£300–375 *Art*

Colum McEvoy
Irish (20thC)
Pigeon
Signed and dated '95', watercolour
14 x 22in (35.5 x 55.5cm)
£325–400 *Art*

Alex McKenna
Irish (20thC)
End of Keel Village, 1989
Signed, oil on canvas
18 x 30in (45.5 x 76cm)
£750–1,000 *NAG*

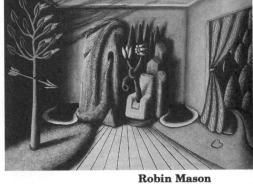

Robin Mason
British (b1958)
Interior with red Chair
Watercolour
11 x 14½in (28 x 37cm)
£500–600 *LG*

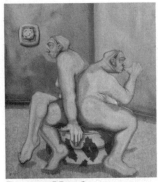

Duncan Mosely
British (b1966)
The Non-Smokers, c1994
Oil on canvas
40 x 36in (101.5 x 91.5cm)
£1.550–1,750 *Tr*

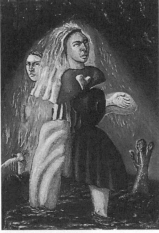

Neil Macpherson
Scottish (b1954)
The Penitent's Journey, 1993
Signed, oil on canvas
47 x 34½in (119 x 88cm)
£3,000–3,250 *BOU*

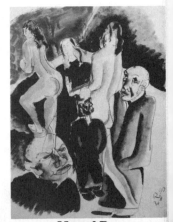

Marcel Ronay
Hungarian (b1910)
Six Figures, Vienna
Signed and dated '30',
ink and wash
11 x 9in (28 x 22.5cm)
£450–500 *JDG*

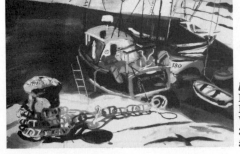

l. **Robert Soden**
British (20thC)
Boats at Seaham Harbour
Watercolour
30 x 41in (76 x 104cm)
£600–650 *VCG*

Neill Speers
British/Irish (20thC)
Rock near Berwick, 1993
Signed, acrylics
14 x 16in (35.5 x 40.5cm)
£225–250 *Art*

Frank Taylor
British (20thC)
In Delphi
Watercolour
22 x 31in (55.5 x 78.5cm)
£1,750–2,000 *PHG*

Vonn Ström
British (b1962)
Untitled
Oil on board, 1993
75 x 48in (190.5 x122cm)
£3,400–3,800 *BOX*

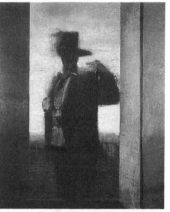

Patricia Terrell
British (20thC)
Pet
Signed, mixed media
12 x 18in (30.5 x 45.5cm)
£300–400 *GK*

Jago Max Williams
British (20thC)
Pastoral
Oil on canvas
70 x 60in (177.5 x 152cm)
£1,350–1,450 *RCA*

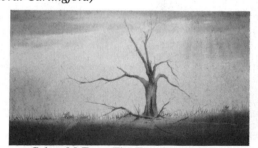

TWENTIETH CENTURY REVIEW:
Artistic Collectables

Artists have always dabbled in the decorative arts, some for pleasure others through necessity. The following is a selection of objects designed or bearing images by 20thC artists. On the one hand they can provide a collectable, more affordable, alternative to buying an original painting, but as the Laura Knight/Clarice Cliff plate shows, if you make the right choice, the value of your collectable can rise to the price of a picture.

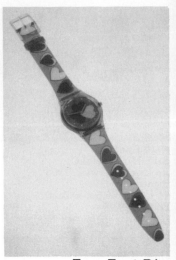

Terry Frost, RA
British (b1915)
Affections
A watch by Tikkers
£25–28 *RAS*

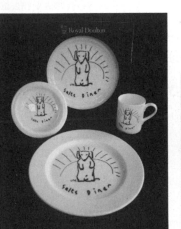

Peter Blake, CBE, RA
British (b1932)
I love You
Needlepoint cushion kit retailed by
The Royal Academy
11⅛in (29cm) square
£40–45 *RAS*

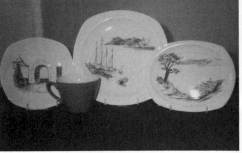

Sir Hugh Casson
British (b1910)
A selection of Midwinter pottery
consisting of a Fashion Tableware
cup and saucer, Cannes design,
1960 and 2 Stylecraft plates,
Riviera design, 1954
Largest 9in (22.5) diam
£8–12 each *AND*

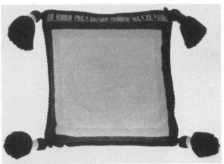

David Hockney
British (b1937)
A selection of Royal Doulton
pottery including dinner
plate in presentation box
Largest 10⅝in (27cm) diam
£8–15 *1853*

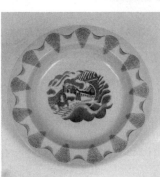

Eric Ravilious
British (1903–43)
Travel – A Wedgwood
Queensware Windsor grey soup
dish, 1953
9in (22.5cm) diam
£50–60 *Bon*

*Although designed c1937, this
pattern was not introduced until
c1953, after Ravilious' death. A
dinner set for six people at that
time would have cost £17. 3s. 6d.*

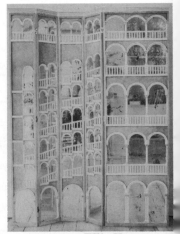

Ellie Yannas
Greek (20thC)
Mirror Screen
Wood and mirrors
76in (193cm) high
£600–650 *CSKe*

l. **Dame Laura Knight**
British (1877–1970)
A Clarice Cliff plate, 1934
7in (17.5cm) diam
£500–700 *RIC*

BIBLIOGRAPHY

Archibald, E.H.H.; Dictionary of Sea Painters, Antique Collectors' Club, 1980.

Arts Council of Great Britain; British Sporting Painting, 1650–1850, 1974.

Arts Council of Great Britain; The Modern Spirit: American Painting 1908–1935, 1977.

Baron, Wendy; The Camden Town Group, Scholar Press, 1979.

Baudelaire, Charles; Art in Paris 1845–1862, Phaidon, Oxford, 1981.

Beetles, Chris, Ltd; The Illustrators, London, 1991, 1992, 1993.

Benezit, E.; Dictionnaire des Peintres, Sculpteurs, Dessinateurs et Graveurs – 10 vols. Paris, 1976.

Bernard, Denvir; The Impressionists at First Hand, Thames and Hudson, 1987.

Bryan, Michael; Dictionary of Painters and Engravers – 2 vols. George Bell & Sons, 1889.

Crofton, Ian; A Dictionary of Art Quotations, Routledge, 1988.

de Goncourt, Edmond and Jules; French Eighteenth Century Painters, Phaidon, Oxford, 1981.

Farmer, David Hugh; The Oxford Dictionary of Saints, Oxford University Press, 1987.

Fielding, Mantle; Dictionary of American Painters, Modern Books and Crafts Inc, Connecticut, 1974.

Griego, Allen J.; The Meal, Scala Books, 1992.

Hall, Donald; and Corrington Wykes, Pat; Anecdotes of Modern Art, Oxford University Press, 1990.

Hall, James; Dictionary of Subjects and Symbols in Art, John Murray, 1979.

Hardie, Martin; Watercolour Painting in Britain, B.T. Batsford Ltd, 3 vols. 1966/67/68.

Heller, Nancy G.; Women Artists, An Illustrated History, Virago, 1987.

Hemming, Charles; British Painters of the Coast and Sea, Victor Gollancz Ltd, 1988.

Hibbert, Christopher; The English Social History 1066–1945, Paladin Books, London, 1988.

Hinde, Thomas; Courtiers, Victor Gollancz, London, 1986.

Holdsworth, Sarah; and Crossley, Joan; Innocence and Experience, Images of Children in British Art from 1600 to the Present, Manchester City Art Galleries, 1992.

Hook, Philip and Poltimore, Mark; Popular 19th Century Painting, Antique Collectors' Club, 1986.

Johnson, J. and Greutzner A.; Dictionary of British Artists, 1880–1940, Antique Collectors' Club, 1988

Lucie-Smith, Edward; Faber Book of Art Anecdotes, 1992.

Lucie-Smith, Edward; The Thames and Hudson Dictionary of Art Terms, 1988.

Maas, Jeremy; Victorian Painters, Barrie & Jenkins, 1988.

Mackenzie, Ian; British Prints, Antique Collectors' Club, 1987.

Mallalieu, H.L.; Understanding Watercolours, Antique Collectors' Club, 1985.

Mallalieu, H.L.; British Watercolour Artists up to 1920, Antique Collectors' Club, 1976.

Mallalieu, Huon; How to Buy Pictures, Phaidon-Christie's, 1984.

Mallalieu, Huon; The Popular Antiques Yearbook, Phaidon-Christie's, 3 vols. 1985/87/88.

Marsh, Madeleine; Art Detective, Pelham Books, 1993.

Mitchell, Sally; The Dictionary of British Equestrian Artists, Antique Collectors' Club, 1985.

Murray, Peter and Linda; The Penguin Dictionary of Art and Artists, Penguin Books, 1991

Osborne, Harold; The Oxford Companion to Twentieth Century Art, Oxford University Press, 1988.

Ottley, H.; Dictionary of Recent and Living Painters and Engravers, Henry G. Bohn, 1866.

Oxford University Press; Dictionary of National Biography, 1975/81/86/90.

Payne, Andrew Clayton; Victorian Flower Gardens, Weidenfeld & Nicholson, London, 1988.

Radice, Betty; Who's Who in the Ancient World, Penguin Books, 1984.

Redgrave, Richard and Samuel; A Century of British Painters, Phaidon, Oxford, 1981.

Rosenberg, Jakob; Slive, Seymour; and ter Kuile, E. H.; Dutch Art and Architecture 1600–1800, Penguin Books, 1982.

Rothenstein, John; Modern English Painters, Macdonald, 1984.

Spalding, Frances; 20th Century Painters and Sculptors, Antique Collectors' Club, 1990.

Strong, Roy; The British Portrait 1660–1960, Antique Collectors' Club, 1990.

Waterhouse, Ellis; Painting in Britain 1530–1790, Penguin Books, 1978.

Waterhouse, Ellis; The Dictionary of 16th and 17th Century British Painters, Antique Collectors' Club, 1988.

Waterhouse, Ellis; The Dictionary of British 18th Century Painters, Antique Collectors' Club, 1981.

Wilton, Andrew; The Swagger Portrait, Tate Gallery, 1992.

Wingfield, Mary Ann; A Dictionary of Sporting Artists 1650–1900, Antique Collectors' Club, 1992

Wood, Christopher; The Dictionary of Victorian Painters, Antique Collectors' Club, 1978.

GENERAL CATALOGUING TERMS

For every picture, *Miller's Picture Price Guide* has followed the basic description provided by the auction house or dealer. As all the auction houses stress in their catalogues, while full care is taken to ensure that any statement as to attribution, origin, date, age, provenance and condition is reliable and accurate, all such statements are opinion only and not to be taken as fact. The conventional cataloguing system used by the auction houses has been maintained.

A work catalogued with the name(s) of an artist, without any qualification, is in their opinion, a work by the artist.

The following meanings are also used:

'Attributed to...' In their opinion probably a work by the artist, but less certainly than in the preceding category.

'Studio of...' 'Workshop of...' In their opinion a work by an unknown hand in the studio of the artist which may or may not have been executed under the artist's direction.

'Circle of...' In their opinion a work by an as yet unidentified but distinct hand, closely associated with the named artist, but not necessarily his pupil.

'Follower of...' 'Style of...' In their opinion a work by a painter working in the artist's style, contemporary or nearly contemporary, but not necessarily his pupil.

'Manner of...' In their opinion, a work in the artist's style, but of a later date.

'After...' In their opinion, a copy of a known work by the artist.

'Signed...'/ 'Dated...'/ 'Inscribed...' In their opinion signature/date/inscription are from the hand of the artist.

'Bears signature, date, or inscription...' In their opinion, signature/date/description have been added by another hand.

Measurements: Dimensions are given height before width.

SELECT GLOSSARY

Academy: A group of artists meeting for teaching and/or discussion. The first art academies were linked to Leonardo da Vinci and flourished Europe-wide. The Royal Academy was founded in London in 1768.

Acrylic: A synthetic emulsion paint.

Airbrush: A small mechanical paint sprayer permitting fine control and a smooth finish, and similar in appearance to a fountain pen.

Alla Prima: From the 19thC, a popular way of completing a picture in one session, using final colours so that earlier sketching is completely disguised beneath.

Allegory: A work of art conveying an abstract subject, under the guise of another subject.

Aquatint: Etching technique in which a metal plate is sprinkled with resin and then bathed in acid which bites into any uncovered areas. According to the amount of acid used and the density of the particles, darker or lighter shading is obtained.

Art Nouveau: 'New Art' which enveloped Europe and USA during 1890s, relying on patterns of free-flowing vegetable shapes.

Bistre: A brown pigment made from charred wood, often used as a wash on pen and ink drawings.

Bitumen: Widely used as a rich brown pigment, made from asphaltum during 18th and 19thC, especially in England. As it never dries completely, it has caused severe damage to many paintings of that period.

Bodycolour: Opaque pigment made by mixing watercolour with white pigment. Same as gouache.

Burin: Main tool used in engraving on wood or metal to mark out lines for the surface of the plate or block. Also known as a graver.

Cabinet Pictures: Popularised by Dutch and Fleming old masters, (small easel paintings), usually genre, still life or landscape, less than 36in (91.5cm) wide.

Cartoon: A full size early design for a painting.

Casein: Protein of milk, the basis of cheese.

Charcoal: Made from willow or vie twigs, charred away by air. Sometimes used for drawings on paper, but mostly used for making early drawing on canvas as first stage of painting.

Collage: A work of art in which pieces of paper, photographs and other materials are pasted to the surface of the picture.

Conté: A brand name for synthetic black, red or brown chalk.

Conversation piece: A group portrait with the sitters placed informally as in conversation.

Counterproof: A mirror-image reproduction, achieved by wetting a drawing or engraving, laying a damp sheet of clean paper on it and then running both through a press.

Daguerreotype: Discovered by Daguerre in 1838, this early photographic invention was a single-image process using mercury vapour and an iodine sensitised silver plate.

Diptych: A picture made up of two parts, commonly hinged together.

Drawing: Representation with line.

Dry-point: The process of making a print by engraving directly on to a copper plate with a steel or diamond point.

Edition: The run of a print published at any one time.

Engraving: The process of cutting a design into a hard surface (metal or wood) so that the lines will retain the ink. Engravings can

be roughly divided into 3 types: Relief, Intaglio and Surface. Each has its own special method of printing.

Etching: A technique of print making developed in the 16thC, in which a metal plate is covered with an acid-resistant substance and the design scratched on it with a needle revealing the metal beneath. The plate is then immersed in acid, which bites into the lines, which will hold the ink.

Fête Champêtre: A rustic festival or peasant celebration – also known as a Kermesse in Dutch and Flemish works.

Fête Galante: Ladies and gentlemen at play, often in a parkland setting.

Fixative: A thin varnish sprayed on to drawings and pastels to prevent rubbing.

Fresco: Painting in watercolour laid on a wall or ceiling before plaster is dry.

Genre: Art showing scenes from daily life.

Gouache: Opaque watercolour paint.

Grisaille: Painting in grey or greyish monochrome.

Gum arabic: Gum from acacia trees, used in the manufacturer of ink.

Icon: A religious painting on panel usually by a Greek or Russian Orthodox artist, its subject and representation conforming to established traditions.

Impression: An individual copy of a print or engraving.

Lithograph: A print made by drawing with a wax crayon on a porous prepared stone which is then soaked in water. A grease-based ink is applied to the stone which adheres only to the design. Dampened paper is applied to the the stone and is rubbed over with a special press to produce the print.

Medium: The materials used in a painting, i.e. oil, tempera, watercolour, etc.

Mezzotint: The reverse of the usual printing process - the artist begins with a black ground, a metal plate that is completely roughened, and the design is polished or burnished into it, thus the image remains white while the background takes all the ink.

Mixed Media: Art combining different types of material.

Montage: The sticking of layers over each other, often done with photographs using an unusual background.

Oil: Pigment bound with oil.

Oleograph: A form of reproduction achieved by printing from blocks inked with oil paint, not printer's ink.

P. Pinx., Pinxit: (Latin 'he painted'). Following a name or a painting, or more often, an engraving after a painting, tells you who painted the original.

Panel Painting: Painting on wood.

Papier Collé: (French 'glued paper'). A type of collage achieved by sticking layers of paper onto a ground, eg. canvas. Used by Picasso, Braque and Matisse.

Pastel: A dry pigment bound with gum into stick-form and used for drawing.

Patina: Refers to the mellowing with age, which occurs to all works of art.

Pendant: One of a pair of pictures.

Pentimento: Sketch-like lines of artists' drawings, which sometimes show through the paint as it ages.

Plein-air: A landscape painted outdoors and on the spot.

Plate: The piece of metal etched or engraved with the design used to produce prints.

Polyptych: A picture, often an altarpiece, made up of 4 or more separate panels.

Print: An image which exists in multiple copies, taken from an engraved plate, woodblock, etc.

Proof: A print of an engraving usually made by the artist for his own information before a professional printer is given the plate.

Proof Before All Letters: A proof made before lettering engraver worked on it adding title, dedication, etc.

Provenance: The record of previous owners and locations of a work of art.

Recto: The front of a picture.

Remarque Proofs: Proofs with some kind of mark in the margin to denote superiority to ordinary proofs.

Sacra Conversazione: (Italian 'holy conversation'). Name used for representation of Madonna and Child with Saints

Sanguine: Red chalk containing ferric oxide used in drawing.

Silkscreen: A print-making process using a finely meshed screen, often of silk, and stencils to apply the image to paper.

Silverpoint: Fashionable method of drawing in 15th and 16thC. Silver wire used in place of lead in modern pencil. Produces indelible mark, silver-grey in colour.

Size Colour: Powdered pigment mixed with hot glue-size. Now used mostly in scene painting.

State: A term applied to prints – to the different stages at which the artist has corrected or changed a plate – and the prints produced from these various 'states', which are numbered first state, second state, third state, etc.

Still Life: A composition of inanimate objects.

Tempera: A medium for pigment mostly made up of egg yolk and water, commonly used before the invention of oil painting.

Tondo: A circular painting.

Topographical painting: A landscape in which the predominant concern is geographical accuracy rather than imaginative content.

Triptych: A set of 3 pictures, usually in oils, with hinges allowing the outer panels to be folded over the central one – often used as an altarpiece.

Vanitas: An elaborate still life including various elements such as a skull, symbolising the transience of earthly life.

Verso: The back of a picture.

Wash: A thin transparent tint applied over the surface of a work.

Watercolour: Transparent, water soluble paint, usually applied on paper.

Woodcut: Print made from a design cut into a block of wood.

DIRECTORY OF SPECIALISTS

If you wish to be included in next year's directory or if you have a change of address or telephone number, please advise Miller's Advertising Department by July 1st 1996. Entries will be repeated in subsequent editions unless we are requested otherwise. Finally we would advise readers to make contact by telephone before a visit, therefore avoiding a wasted journey, which is both time consuming and expensive. Most dealers are only too happy to help you with your enquiry, however, they are very busy people and your consideration would be appreciated.

ART CONSULTANTS

London

Arts Direction,
60 Alberts Court,
Prince Consort Road,
Knightsbridge, SW7 2BH.
Tel: 0171 823 8800

CLUBS & SOCIETIES

London

Contemporary Art Society,
20 John Islip Street,
SW1P 4LL.
Tel: 0171 821 5323

Fine Art Society Plc,
148 New Bond Street,
W1Y 0JT.
Tel: 0171 629 5116

Royal College of Art,
Kensington Gore, SW7 2EU.
Tel: 0171 584 5020

COMMEMORATIVES

London

Coronets & Crowns
(Robert Taylor),
Unit J12, Grays in the
Mews, 1-7 Davies Mews,
W1Y 1AR.
Tel: 0171 493 3448

EXHIBITION & FAIR ORGANISERS

London

Machin, Julian,
Grove House,
92 Crawthew Grove,
SE22 9AD.
Tel: 0181 693 3178

FRAMERS

Essex

Pearlita Frames Ltd,
30 North Street,
Romford, RM11 2LB.
Tel: 01708 760342

Gloucestershire

Cleeve Picture Framing,
Coach House Workshops,
Stoke Road, Bishops Cleve,
Cheltenham, GL52 4RP.
Tel: 01242 672785

London

Campbell, John
Master Frames,
164 Walton Street,
SW3 2JL.
Tel: 0171 584 9268

Chelsea Frameworks,
106 Finborough Road,
SW10 9ED.
Tel: 0171 373 0180

Cooper Fine Arts,
768 Fulham Road,
SW6 5SJ.
Tel: 0171 731 3421

Court Picture Framers,
8 Bourdon Street, W1X 9HX.
Tel: 0171 493 3265

Deansbrook Gallery,
134 Myddleton Road,
N22 4NQ.
Tel: 0181 889 8389

John Jones Art Centre Ltd,
Stroud Green Road,
Finsbury Park,
N4 3JG.
Tel: 0171 281 5439

Lamont Gallery,
65 Roman Road,
Bethnal Green, E2 OQN.
Tel: 0181 981 6332

Porcelain & Pictures Ltd,
The Studio,
Gastein Road, W6 8LT.
Tel: 0171 385 7512

Woolcock Framing,
8 Huguenot Place,
Wandsworth, SW18 2EN.
Tel: 0181 874 2008

Scotland

Inverbeg Galleries,
Nr Luss, Loch Lomond,
G83 8PD.
Tel: 01436 86277

Surrey

Boathouse Gallery,
The Towpath,
Manor Road,
Walton-on-Thames,
KT12 2PG.
Tel: 01932 242718

Limpsfield Watercolours,
High Street,
Limpsfield, RH8 0DT.
Tel: 01883 717010

GALLERIES

Avon

Adam Gallery,
13 John Street,
Bath, BA1 2JL.
Tel: 01225 480606

Alexander Gallery,
122 Whiteladies Road,
Bristol, BS8 2RP.
Tel: 0117 9734692

Alma Gallery,
31A Rivers Street,
Bath, BA1 2HG.
Tel: 01225 317060

Arnolfini Gallery,
16 Narrow Quay,
Bristol, BS1 4QA.
Tel: 0117 9299191

Cleveland Bridge Gallery,
8 Cleveland Place East,
Bath, BA1 5DG.
Tel: 01225 447885

Cross Gallery, David,
30 Boyces Avenue,
Clifton, Bristol,
BS8 4AA.
Tel: 0117 973 2614

Fine Art & Antiques,
4 Miles Buildings
(off George St),
Bath, BA1 2QS.

Ginger Gallery,
84/86 Hotwell Road,
Bristol, BS8 4UB.
Tel: 0117 9292527

Quadrat, Suzi,
38a Princess Victoria Street,
Clifton, Bristol, BS8 4BZ.
Tel: 0117 923 8824

Russell, Sarah,
Antiquarian Books
and Prints, 11 Oxford Row,
Lansdown Road,
Bath, BA1 2QW.
Tel: 01225 427594

St James's Gallery,
9 Margaret Buildings,
Brock Street,
Bath, BA1 2LP.
Tel: 01225 319197

Wells Gallery, Patricia,
Morton House,
Lower Morton, Thornbury,
Bristol, BS12 1RA.
Tel: 01454 412288

Bedfordshire

Charterhouse Gallery Ltd,
14 Birds Heath,
Leighton Buzzard,
LU7 0AQ.
Tel: 01525 237379

Questor,
13/14 Margaret Place,
Woburn, MK17 9PZ.
Tel: 01525 290658

Woburn Fine Arts,
12 Market Place,
Woburn, MK17 9PZ.
Tel: 01525 290624

Berkshire

Alway, Marian & John,
Riverside Corner,
Windsor Road, Datchet,
Slough, SL3 9BT.
Tel: 01753 541163

Contemporary Fine
Art Gallery,
31 High Street, Eton,
Windsor, SL4 1HL.
Tel: 01753 854315

CSK Gallery,
55 Eton High Street,
Windsor, SL4 6BL.
Tel: 01753 840519

Emgee Gallery,
60 High Street,
Eton, SL4 6AA.
Tel: 01753 856329

Graham Gallery,
Highwoods, Burghfield,
Nr Reading, RG7 3BG.
Tel: 01734 832320

Heath Galleries,
Tel: 01491 875758

Jaspers Fine Arts Ltd,
36 Queen Street,
Maidenhead, SL6 1HZ.
Tel: 01628 36459

Omell Galleries,
55 High Street,
Ascot, SL5 7HP.
Tel: 01753 852271

Pearson Antiques, John A,
Horton Lodge, Horton Road,
Horton, Nr Slough,
SL3 9NU.
Tel: 01753 682136

Buckinghamshire

Gregory Gallery, Noel,
Farnham Common,
SL2 3PQ.
Tel: 01753 645522

Hone, Angela,
The Garth, Mill Road,
Marlow, SL7 1QB.
Tel: 01628 484170

Penn Barn Gallery,
By The Pond, Elm Road,
Penn, HP10 8LB.
Tel: 01494 815691

Queen Adelaide Gallery,
76 High Street, Kempston,
Bedford, MK42 7BS.
Tel: 01234 854083

Windmill Fine Art,
2 Windmill Drive,
Widmer End,
High Wycombe,
HP15 6BD.
Tel: 01494 713757

Cheshire

Baron Fine Art,
68 Watergate Street,
Chester, CH1 2LA.
Tel: 01244 342520

Betley Court Gallery,
Betley, Nr Crewe, CW3 9BH.
Tel: 01270 820652

Harper Fine Paintings,
Overdale, Woodford Road,
Poynton, Stockport,
SK12 1ED.
Tel: 01625 879105

Cleveland

Charlton Fine Art, E & N R,
69 Cambridge Avenue,
Marton-in-Cleveland,
Middlesbrough, TS7 8EG.
Tel: 01642 319642

Jordan, T B & R
(Fine Paintings),
Aslak, Aislaby, Eaglescliffe,
Stockton-on-Tees, TS16 0QN.
Tel: 01642 782599

Cornwall

Copperhouse Gallery,
14 Fore Street,
Copperhouse,
Hayle, TR27 4DX.
Tel: 01736 752787

The Broad Street Gallery,
9 Broad Street,
Penryn, TR10 8JL.
Tel: 01326 377216

Cumbria

Haworth, Peter,
Temple Bank, Beetham,
Milnthorpe, LA7 7AL.
Tel: 01539 562352

Devon

Collins & Son, J,
63 High Street,
Bideford, EX39 2AN.
Tel: 01237 473103

Honiton Galleries,
205 High Street,
Honiton, EX14 8LF.
Tel: 01404 42404

New Gallery,
Abele Tree House,
9 Fore Street,
Budleigh Salterton,
EX9 6NG.
Tel: 01395 443768

Pyke, Beverley J,
The Gothic House,
Bank Lane,
Totnes, TQ9 5EH.
Tel: 01803 864219

Dorset

Alpha Gallery,
21a Commercial Road,
Swanage, BH19 1DF.
Tel: 01929 423692

Chome Fine Art,
2 West Lane,
North Wooton,
Sherborne, DT9 5UR.
Tel: 01935 812986

Dorchester Gallery,
10a High East Street,
Dorchester, DT1 1HS.
Tel: 01305 251144

Finesse Fine Art,
9 Coniston Crescent,
Weymouth, DT3 5HA.
Tel: 01305 770463

Hampshire Gallery,
18 Lansdowne Road,
Bournemouth, BH1 1SD.
Tel: 01202 551211

Hedley Gallery, Peter,
10 South Street,
Wareham, BH20 4LT.
Tel: 01929 551777

York House Gallery,
32 Somerset Road,
Boscombe,
Bournemouth,
BH7 6JJ.
Tel: 01202 391034

East Sussex

John Day of Eastbourne
Fine Art,
9 Meads Street,
Eastbourne, BN20 7QY.
Tel: 01323 725634

Essex

Brandler Galleries,
1 Coptfold Road,
Brentwood, CM14 4BM.
Tel: 01277 222269

Chappel Galleries,
Colchester Road, Chappel,
Nr Colchester, CO6 2DE.
Tel: 01206 240326

Hilton, Simon,
Flemings Hill Farm,
Great Easton,
Dunmow, CM6 2ER.
Tel: 01279 850107

Iles Gallery, Richard,
10a, 10 &12 Northgate
Street, Colchester,
CO1 1HA.
Tel: 01206 577877

Gloucestershire

Campbell, Gerard,
Maple House, Market Place,
Lechlade-on-Thames,
GL7 3AB.
Tel: 01367 52267

Church Street Gallery,
Stow-on-the-Wold,
GL54 1BB.
Tel: 01451 831698

Davies Fine Paintings, John,
Church Street,
Stow-on-the-Wold,
GL54 1BB.
Tel: 01451 831698/831790

Fosse Gallery,
The Square,
Stow-on-the-Wold,
GL54 1AF.
Tel: 01451 831319

Kenulf Fine Art Ltd,
5 North Street, Winchombe,
Cheltenham, GL54 5LH.
Tel: 01242 603204

Manor House Gallery,
Manor House,
Badgeworth Road,
Cheltenham, GL51 6RJ.
Tel: 01452 713953

Newman Gallery, Heather,
Milidduwa, Cranham,
Nr Painswick, GL6 6TX.
Tel: 01452 812230

Sinfield Gallery, Brian,
Compton Cassey Galleries,
Compton Cassey House,
Nr Withington, GL54 4DE.
Tel: 01242 890500

Upton Lodge Galleries,
6 Long Street, Also at
Avening House, Avening,
Tetbury, GL8 9AQ.
Tel: 01666 503416

Zborowska, Nina,
Damsels Mill, Paradise,
Painswick, GL6 6UD.
Tel: 01452 812460

Greater Manchester

Corner House,
70 Oxford Street, M1 5NH.
Tel: 0161 228 7621

Fulda Gallery,
19 Vine Street,
Salford, M7 3PG.
Tel: 0161 792 1962

Hampshire

Bell Fine Art,
67b Parchment Street,
Winchester, SO23 8BA.
Tel: 01962 860439

Fleet Fine Art Gallery,
1/2 King's Parade,
Kings's Road,
Fleet, GU13 9AB.
Tel: 01252 617500

Furzeley Gallery,
Horseshoe Cottage,
Closewood Road, Denmead,
Waterlooville, PO7 6TR.
Tel: 01705 254729

Morton Lee, J,
Cedar House, Bacon Lane,
Hayling Island, PO11 0DN.
By appointment
Tel: 01705 464444

On Line Gallery,
76 Bedford Place,
Southampton, SO15 2DF.
Tel: 01703 330660

Oxley, Laurence,
The Studio Bookshop
& Gallery,
Alresford, SO24 9AW.
Tel: 01962 732188

Petersfield Bookshop,
16a Chapel Street,
Petersfield, GU32 3DS.
Tel: 01730 263438

Hereford & Worcester

Coltsfoot Gallery,
Hatfield, Leominster,
HR6 0SF.
Tel: 01568 760277

Haynes Fine Art,
The Bindery Gallery,
69 High Street,
Broadway, WR12 7DP.
Tel: 01386 852649

Kilvert Gallery,
Ashbrook House, Clyro,
Hay-on-Wye, HR3 5RZ.
Tel: 01497 820831

Mathon Gallery,
Mathon Court,
Nr Malvern, WR13 5NZ.
Tel: 01684 892242

Noott Fine Paintings, John,
14 Cotswold Court,
Broadway, WR12 7AA.
Tel: 01386 852787

Hertfordshire

Gallery One Eleven,
111 High Street,
Berkhamsted, HP4 2JF.
Tel: 01442 876333

Humberside

Steven Dews Fine Art, J,
66-70 Princes Avenue,
Kingston-upon-Hull,
HU5 3QJ.
Tel: 01482 345345

Ireland

Apollo Gallery,
18 Duke Street,
(off Grafton Street),
Dublin 2.
Tel: 00 353 1 671 2609

Artistic License,
The Old Coach House,
Dundalk Street,
Carlingford, Co Louth.
Tel: 00 353 427 3745

Brown, Patrick F,
28 Molesworth Street,
Dublin 2.
Tel: 00 353 1 661 9780

Kerlin Gallery,
38 Dawson Street,
Dublin 2.
Tel: 00 353 677 9179

O'Connor Gallery, Cynthia,
17 Duke Street, Dublin 2.
Tel: 00 353 679 2177/679 2198

Solomon Gallery,
Powerscourt Townhouse
Centre, South William
Street, Dublin 2.
Tel: 00 353 1679 4237

Stacpoole, Michelina
& George,
Main Street, Adare,
Co Limerick.
Tel: 00 353 6139 6409

Taylor Galleries,
34 Kildare Street,
Dublin 2.
Tel: 00 353 1 676 6055

Kent

Bank Street Gallery,
3-5 Bank Street,
Sevenoaks, TN13 1UW.
Tel: 01732 458063

Bowlby, Nicholas,
9 Castle Street,
Tunbridge Wells,
TN1 1XJ.
Tel: 01892 510880

Clarke, Graham & Co,
White Cottage, Green Lane,
Boughton Monchelsea,
Maidstone, ME17 4LF.
Tel: 01622 743938

Clarke, Graham (Prints) Ltd,
White Cottage, Green Lane,
Boughton Monchelsea,
Maidstone, ME17 4LF.
Tel: 01622 743938

Drew Gallery,
16 Best Lane,
Canterbury, CT1 2JB.
Tel: 01227 458759

Edwards Gallery,
Eley Place,
Royal Victoria Place,
Tunbridge Wells,
TN1 2SP.
Tel: 01892 514164

Graham Gallery,
1 Castle Street,
Tunbridge Wells,
TN1 1XJ.
Tel: 01892 526695

Green Fine Art, Roger,
Hales Place Studio,
High Halden,
Ashford, TN26 3JQ.
Tel: 01233 850794

> **The Hunt Gallery,**
> 33 Strand Street,
> Sandwich, CT13 9DS.
> Tel: 01304 612792
> Tel/Fax: 01227 722287
> *Established in 1972,
> specialising in the work of
> Michael John Hunt.*
> *Topographical and
> architectural paintings and
> peaceful, serene interiors.*

Iles, Francis,
Rutland House,
La Providence,
Rochester, ME1 1NB.
Tel: 01634 843081

Jarrotts,
Hales Place,
Woodchurch Road,
High Halden, TN26 3JQ.
Tel: 01233 850037

Lotus House Studios,
25 Station Road, Lydd,
Romney Marsh, TN29 9ED.
Tel: 01797 320585

Royall Fine Art -
Watercolours, Prints, Framing,
52 The Pantiles,
Tunbridge Wells,
TN2 5TN.
Tel: 01892 536534

Sundridge Gallery,
9 Church Road, Sundridge,
Nr Sevenoaks, TN14 6DT.
Tel: 01959 564104

Tabor Gallery,
The Barn, All Saints Lane,
Canterbury, CT1 2AU.
Tel: 01227 462570

Turtle Fine Art,
Tel: 01580 200834

Lancashire

Neill Gallery,
4 Portland Street,
Southport, PR8 1JU.
Tel: 01704 549858

Leicestershire

Fine Art of Oakham,
4-5 Crown Walk,
Oakham, LE15 6AL.
Tel: 01572 755221

Goldmark Gallery,
Orange Street,
Uppingham,
Rutland, LE15 9SQ.
Tel: 01572 821424

Lincolnshire

Jigger (Golf Art),
3 Sunny Hill,
Kirton-in-Lindsey,
Gainsborough,
DN21 4ND.
Tel: 01652 640118

Lincoln Fine Art,
33 The Strait,
Lincoln, LN2 1LS.
Tel: 01522 533029

London

20th Century Gallery,
821 Fulham Road,
SW6 5HG.
Tel: 0171 731 5888

Abbey Mills Gallery,
Watermill Way,
SW19 2RD.
Tel: 0181 542 5035

Ackerman & Johnson Ltd,
Lowndes Lodge Gallery,
27 Lowndes Street,
SW1X 9HY.
Tel: 0171 235 6464

Adams Fine Art Ltd, John,
200 Ebury Street,
SW1W 8UN.
Tel: 0171 730 8999

Alberti Gallery,
114 Albert Street,
NW1 7NE.
Tel: 0171 485 8976

Alpine Gallery,
74 South Audley Street,
W1Y 5FF.
Tel: 0171 491 2948

Alton Gallery,
72 Church Road,
Barnes, SW13 ODG.
Tel: 0181 748 0606

Andipa & Son, Maria,
Icon Gallery,
162 Walton Street,
Knightsbridge,
SW3 2JL.
Tel: 0171 589 2371

Argile Gallery,
7 Blenheim Crescent,
W11 2EE.
Tel: 0171 792 0888

Art Collection Ltd,
3-5 Elystan Street,
SW3 3NT.
Tel: 0171 584 4664

Art of Africa,
158 Walton Street,
SW3 2JL.
Tel: 0171 584 2326

Art Space Gallery,
84 St Peter's Street,
N1 8JS.
Tel: 0171 359 7002

Bankside Gallery,
48 Hopton Street,
SE1 9JH.
Tel: 0171 928 7521

Barbican Centre,
EC2Y 8DS.
Tel: 0171 638 4141

Barnes Gallery,
51 Church Road,
Barnes, SW13 9HH.
Tel: 0181 741 1277

Bartley Gallery, Stephen,
62 Old Church Street,
SW3 6DP.
Tel: 0171 352 8686

Baumkotter Gallery,
63a Kensington Church
Street, W8 4BA.
Tel: 0171 937 5171

Beardsmore Gallery,
22-24 Prince of Wales
Road, Kentish Town,
NW5 3LG.
Tel: 0171 485 0923

Beetles Ltd, Chris,
8 & 10 Ryder Street,
St James's,
SW1Y 6QB.
Tel: 0171 839 7551

Blond Fine Art,
Unit 10, Canalside Studios,
2-4 Orsman Road, N1 5QJ.
Tel: 0171 739 4383

Bonham, John,
Murray Feely Fine Art,
46 Porchester Road,
W2 6ET.
Tel: 0171 221 7208

Bornholt Gallery, Anna,
3-5 Weighhouse Street,
W1Y 1YL.
Tel: 0171 499 6114

Boundary Gallery,
98 Boundary Road,
NW8 ORH.
Tel: 0171 624 1126

Browse & Darby Gallery,
19 Cork Street, W1X 2LP.
Tel: 0171 734 7984

Bruton Street Gallery,
28 Bruton Street,
W1Y 7DB.
Tel: 0171 499 9747

Burlington Fine
Paintings Ltd,
12 Burlington Gardens,
W1X 1LG.
Tel: 0171 734 9984

Burlington Gallery,
10 Burlington Gardens,
W1X 1LG.
Tel: 0171 734 9228/9984

Cadogan Contemporary,
108 Draycott Avenue,
SW3 3AE.
Tel: 0171 581 5451

Caelt Gallery,
182 Westbourne Grove,
W11 2RH.
Tel: 0171 229 9309

Campbell Contemporary
Art, Duncan,
15 Thackeray Street,
W8 5ET.
Tel: 0171 937 8665

Campbell Gallery, Lucy B,
123 Kensington Church
Street, W8 7LP.
Tel: 0171 727 2205

Cardiff Fine Art, Peter,
Tel: 0171 736 5916

Catto Animation,
41 Heath Street,
NW3 6UA.
Tel: 0171 431 2892

Catto Gallery, London,
100 Heath Street,
Hampstead, NW3 1DP.
Tel: 0171 435 6660

CCA Galleries,
8 Dover Street,
W1X 3PJ.
Tel: 0171 499 6701

Century Gallery,
100 Fulham Road,
Chelsea, SW3 6HS.
Tel: 0171 581 1589

Chadwick, Anna-Mei,
64 New Kings Road,
SW6 4LT.
Tel: 0171 736 1928

Churzee Studio Gallery,
17 Bellevue Road,
SW17 7EG.
Tel: 0181 767 8113

Collins & Hastie Ltd,
5 Park Walk, SW10 0AJ.
Tel: 0171 351 4292

Colman Fine Art, James,
The Tower,
28 Mossbury Road,
SW11 2PB.
Tel: 0171 924 3860

Concourse Gallery,
Barbican Centre, Level 5,
EC2Y 8DS.
Tel: 0171 638 4141

Cooper Fine Arts,
768 Fulham Road,
SW6 5SJ.
Tel: 0171 731 3421

Cox & Co,
37 Duke Street,
St James's,
SW1Y 6DF.
Tel: 0171 930 1987

Crane Kalman Gallery,
178 Brompton Road,
SW3 1HQ.
Tel: 0171 584 7566/225 1931

Curwen Gallery,
4 Windmill Street,
(off Charlotte Street),
W1P IHF.
Tel: 0171 636 1459

Daggett Gallery, Charles,
153 Portobello Road,
W11 2DY.
Tel: 0171 229 2248
Mobile 0374 141813

Davenport, Sara,
(Fine Paintings),
206 Walton Street,
SW3 2JL.
Tel: 0171 225 2223

Denham Gallery, John,
50 Mill Lane, NW6 1NJ.
Tel: 0171 794 2635

Dover Street Gallery,
13 Dover Street,
W1X 3PH.
Tel: 0171 409 1540

Drummond, William,
8 St James Chambers,
Ryder Street, SW1 6QA.
Tel: 0171 930 9696

Durini Gallery,
150 Walton Street,
SW3 2JJ.
Tel: 0171 581 1237

Ealing Gallery,
78 St Mary's Road, W5 5EX.
Tel: 0181 840 7883

East West,
8 Blenheim Crescent,
W11 1NN.
Tel: 0171 229 7981

Eaton Gallery,
34 Duke Street, St James's,
SW1Y 6DF.
Tel: 0171 930 5950

Entwistle Gallery,
37 Old Bond Street,
W1X 3AE .
Tel: 0171 409 3484

Fleur de Lys Gallery,
227A Westbourne Grove,
W11 2SE.
Tel: 0171 727 8595

Florence Trust,
St Saviour's Church,
Aberdeen Park,
Highbury, N5 2AR.
Tel: 0171 354 0460

Flowers East,
199 Richmond Road,
E8 3NJ.
Tel: 0181 985 3333

Flying Colours Gallery,
8/15 Chesham Street,
SW1X 8ND.
Tel: 0171 235 2831

Frith Street Gallery,
60 Frith Street,
W1V 5TA.
Tel: 0171 494 1550

Gagliardi Design
& Contemporary Art,
507-509 Kings Road,
SW10 0TX.
Tel: 0171 352 3663

Gallery K,
101-103 Heath Street,
Hampstead, NW3 6SS.
Tel: 0171 794 4949

Gallery Kaleidoscope,
64-66 Willesden Lane,
NW6 7SX.
Tel: 0171 328 5833

Gallery on Church Street,
12 Church Street, NW8.
Tel: 0171 723 3389

Gallery, Stephen Lacey,
Redcliffe Square,
SW10 9JX.
Tel: 0171 370 7785

George Gallery, Jill,
38 Lexington Street,
Soho, W1R 3HR.
Tel: 0171 439 7343/7319

Gisela van Beers,
34 Davies Street, W1Y 1LG.
Tel: 0171 408 0434

Gregory Gallery, Martyn,
34 Bury Street, St James's,
SW1Y 6AU.
Tel: 0171 839 3731

Grosvenor Gallery Fine
Arts Ltd,
18 Albemarle Street,
W1X 3HA.
Tel: 0171 629 0891

Grosvenor Prints,
28-32 Shelton Street,
Covent Garden,
WC2H 9HP.
Tel: 0171 836 1979

Gruzelier Modern
& Contemporary Art,
16 Maclise Road,
West Kensington,
W14 0PR.
Tel: 0171 603 4540

Hallett, Laurence,
(LAPADA),
Tel: 0171 798 8977

By appointment only.
Free catalogue and mail
order available.

Hamilton Forbes Fine Art,
The Garden Market,
Chelsea Harbour,
SW10 0XE.
Tel: 0171 352 8181

Hardware Gallery,
277 Hornsey Road,
Islington, N7 6RZ.
Tel: 0171 272 9651

Hicks Gallery,
2 Leopold Road,
Wimbledon, SW19 7BD.
Tel: 0181 944 7171

Hildegard Fritz-Denneville
Fine Arts Ltd,
31 New Bond Street,
W1Y 9HD.
Tel: 0171 629 2466

Holland Gallery,
129 Portland Road,
W11 4LW.
Tel: 0171 727 7198

Hossack Fitzrovia, Rebecca,
35 Windmill Street,
W1P 1HH.
Tel: 0171 436 4899

Hossack Gallery, Rebecca,
35 Windmill Street,
W1P 1HH.
Tel: 0171 436 4899

Houldsworth Fine Art,
The Pall Mall Deposit,
124 Barlby Road, W10 6BL.
Tel: 0181 969 8197

Hull Gallery, Christopher,
17 Motcomb Street,
SW1X 8LB.
Tel: 0171 235 0500

Hunter Fine Art, Sally,
Tel: 0171 235 0934

Indar Pasricha Fine Arts,
22 Connaught Street,
W2 2AF.
Tel: 0171 724 9541

Innes Gallery, Malcolm,
172 Walton Street,
SW3 2JL.
Tel: 0171 584 0575

Ker Fine Art, David,
85 Bourne Street,
SW1W 8HF.
Tel: 0171 730 8365

Knapp Gallery,
Regent's College,
Inner Circle,
Regent's Park, NW1 4NS.
Tel: 0171 487 7540

L'Acquaforte,
49a Ledbury Road,
W11 2AA.
Tel: 0171 221 3388

Lamont Gallery,
65 Roman Road,
Bethnal Green, E2 OQN.
Tel: 0181 981 6332

Lantern Gallery,
27 Holland Street, W8 4NA.
Tel: 0171 937 8649

Lawson Gallery, Enid,
Antiques Centre,
36a Kensington Church
Street, W8 4DB.
Tel: 0171 376 0552
 0171 937 9559

Liz Farrow T/As Dodo,
Stand F037, Alfie's Antique
Market, 13-25 Church Street,
NW8 8DT.
Tel: 0171 706 1545

Llewellyn Alexander
(Fine Paintings) Ltd,
124-126 The Cut,
Waterloo, SE1 8LN.
Tel: 0171 620 1322

Maak Gallery,
Blackburn Road, NW6 1RZ.
Tel: 0171 372 4112

Manya Igel Fine Arts Ltd,
21-22 Peters Court,
Porchester Road, W2 5DR.
Tel: 0171 229 1669

Mark Gallery,
9 Porchester Place,
Marble Arch, W2 2BS.
Tel: 0171 224 9416

Martin of London, John,
38 Albermarle Street,
W1X 3FB.
Tel: 0171 499 1314

Mathaf Gallery,
24 Motcomb Street,
SW1X 8JU .
Tel: 0171 235 0010

Mayor Gallery,
22a Cork Street, W1X 1HB.
Tel: 0171 734 3558

Mercury Gallery,
26 Cork Street, W1X 1HB.
Tel: 0171 734 7800

Merrifield Studios,
110-112 Heath Street,
Hampstead, NW3 1AA.
Tel: 0171 794 0343

Miles Gallery, Roy,
29 Bruton Street,
W1X 7DB.
Tel: 0171 495 4747

Miller Fine Arts, Duncan,
17 Flask Walk,
Hampstead, NW3 1HJ.
Tel: 0171 435 5462

Mistral Galleries,
10 Dover Street, W1X 3PJ.
Tel: 0171 499 4701

Mitchell, John, & Son,
160 New Bond Street,
W1Y 9PA.
Tel: 0171 493 7567

Montpelier Sandelson,
4 Montpelier Street,
SW7 1EZ.
Tel: 0171 584 0667

Moreton Street Gallery,
40 Moreton Street,
SW1V 1PB.
Tel: 0171 834 7773

Morrison, Guy,
91 Jermyn Street,
SW1Y 6JB.
Tel: 0171 839 1454

Music Theatre Gallery,
1 Elystan Place, SW3 3LA.
Tel: 0171 823 9880

Narwhal Invit Art Gallery,
55 Linden Gardens,
W4 2EH.
Tel: 0181 747 1575

New Grafton Gallery,
49 Church Road,
SW13 9HH.
Tel: 0181 748 8850

O'Shea Gallery,
120a Mount Street,
Mayfair, W1Y 5HB.
Tel: 0171 629 1122

Park Walk Gallery,
20 Park Walk,
Chelsea, SW10 0AQ.
Tel: 0171 351 0410

Parkin Gallery, Michael,
11 Motcomb Street,
SW1X 8LB.
Tel: 0171 235 8144

Paton Gallery,
2 Langley Court, E8 3QS.
Tel: 0181 986 3409

Patterson, W. H.,
19 Albermarle St,
W1X 3HA.
Tel: 0171 629 4119

Pike Gallery,
145 St John's Hill,
SW11 1TQW.
Tel: 0171 223 6741

Polak Gallery,
21 King Street,
St James's, SW1Y 6QY.
Tel: 0171 839 2871

Portland Gallery,
9 Bury Street,
St James's, SW1Y 6AB.
Tel: 0171 321 0422

Primrose Hill Gallery,
81 Regent's Park Road,
NW1 8UY.
Tel: 0171 586 3533

Pyms Gallery,
13 Motcomb Street,
Belgravia, SW1 8LB.
Tel: 0171 235 3050

Raab Gallery,
9 Cork Street, SW7 4JA.
Tel: 0171 734 6444

Rafael Valls Limited,
11 Duke Street, SW1Y 6BN.
Tel: 0171 930 1144

Railings Gallery,
5 New Cavendish Street,
W1M 7RP.
Tel: 0171 935 1114

Reynolds Gallery, Anthony,
5 Dering Street, W1R 9AB.
Tel: 0171 491 0621

Rhodes Gallery, Benjamin,
4 New Burlington Place,
W1X 1FB.
Tel: 0171 434 1768

Savannah Gallery,
45 Derbyshire Street,
E2 6HQ.
Tel: 0171 613 0474

Senior, Mark,
240 Brompton Road,
SW3 2BB.
Tel: 0171 589 5811

Spink, John,
14 Darlan Road, SW6 5BT.
Tel: 0171 731 8292

Spink & Son Ltd,
5, 6 & 7 King Street,
St James's, SW1Y 6QS.
Tel: 0171 930 7888

Stephanie Hoppen Ltd,
17 Walton Street,
SW3 2HX.
Tel: 0171 589 3678

Stern Art Dealers,
49 Ledbury Road, W11 2AB.
Tel: 0171 229 6184

Talent Store Gallery,
11 Eccleston Street,
SW1 9LX.
Tel: 0171 730 8117

Tesser Galleries,
106 Heath Street,
Hampstead, NW3 1DR.
Tel: 0171 794 7971

Thackeray Rankin Gallery,
18 Thackeray Street,
W8 5ET.
Tel: 0171 937 5883

Thuiller, William,
180 New Bond Street,
W1Y 9PD.
Tel: 0171 499 0106

Todd Gallery,
1-5 Needham Road,
W11 2RP.
Tel: 0171 792 1404

Totteridge Gallery,
61 Totteridge Lane,
N20 OHD.
Tel: 0181 446 7896

Tyron & Swann Gallery,
23-24 Cork Street,
W1X 1HB.
Tel: 0171 734 6961

Uri Art Gallery, Ben,
21 Dean Street,
W1V 6NE.
Tel: 0171 437 2852

Waddington Gallery,
10 Cork Street,
W1X QLT.
Tel: 0171 437 8611

Waterman Fine Art Ltd,
74a Jermyn Street,
SW1Y 6NP.
Tel: 0171 839 5203

Westbourne Gallery,
331 Portobello Road,
W10 5SA.
Tel: 0181 960 1867

Wildenstein Gallery,
147 New Bond Street,
W1Y 0NX.
Tel: 0171 629 0602

Wilkins and Wilkins Gallery,
1 Barrett Street,
W1A 6DN.
Tel: 0171 935 9613

Wimbledon Fine Art,
41 Church Road,
Wimbledon Village,
SW19 5DG.
Tel: 0181 944 6593

Wiseman Originals Ltd,
34 West Square,
SE11 4SP.
Tel: 0171 587 0747

Wolsely Fine Arts Plc,
4 Grove Park,
SE5 8LT.
Tel: 0171 274 8788

Wood Gallery, Christopher,
141 Bond Street,
W1Y 0BS.
Tel: 0171 499 7411

Wyllie Gallery,
44 Elvaston Place,
SW7 5NP.
Tel: 0171 584 6024

Middlesex

Anderson, Joan & Bob,
Hatch End Antiques Centre,
294 Uxbridge Road,
Hatch End, Pinner,
HA5 4HP.
Tel: 0181 561 4517

Hampton Hill Gallery,
203-205 High Street,
Hampton Hill,
TW12 1NP.
Tel: 0181 977 1379/5273

Judge, Janet,
24a Argyle Avenue,
Hounslow, TW3 2LF.
Tel: 0181 898 8939

Linda Blackstone Gallery,
The Old Slaughter House,
Rear of 13 High Street,
Pinner, HA5 5QQ.
Tel: 0181 868 5765

World of Transport,
37 Heath Road,
Twickenham, TW1 4AW.
Tel: 0181 891 3169

Norfolk

Bank House Gallery,
71 Newmarket Road,
Norwich, NR2 2HW.
Tel: 01603 633380

Crome Gallery,
34 Elm Hill,
Norwich, NR3 1HG.
Tel: 01603 622827

Northamptonshire

Savage Fine Art,
The Gate House,
Haselbech, Northampton,
NN6 9LQ.
Tel: 01604 20327

Northumberland

Dean Gallery,
42 Dean Street,
Newcastle upon Tyne,
NE1 1PG.
Tel: 0191 2321 208

Potts, Henry,
School House,
Chillingham,
Alnwick, NE66 5NJ.
Tel: 01668 215309

Nottinghamshire

Hart Gallery,
23 Main Street, Linby,
Nottingham, NG15 8AE.
Tel: 0115 963 8707

Mitchell Fine Arts, Sally,
Thornlea, Askham,
Newark, NG22 0RN.
Tel: 01777 838234

Oxfordshire

Bohun Gallery,
15 Reading Road,
Henley-on-Thames,
RG9 1AB.
Tel: 01491 576228

Brightwell Antiques,
The Swan Antiques Centre,
Tetsworth, OX9 7AB.
Tel: 01844 281777

Dickens, H C,
High Street, Bloxham,
Nr Banbury, OX15 4LT.
Tel: 01295 721949

Harvey-Lee, Elizabeth,
Original 15th-20th
Century Prints,
1 West Cottages,
Middle Aston Road,
North Aston, OX6 3QB.
Tel: 01869 347164

Horseshoe Antiques
& Gallery,
97 High Street,
Burford, OX18 4QA.
Tel: 0199 382 3244

Oxford Gallery,
23 High Street,
Oxford, OX1 4AH.
Tel: 01865 242731

Wren Gallery,
4 Bear Court, High Street,
Burford, OX18 4RR.
Tel: 01993 823495

Scotland

Barclay Lennie Fine Art,
203 Bath Street,
Glasgow, G2 4HZ.
Tel: 0141 226 5413

Billcliffe Fine Art, Roger,
134 Blythswood Street,
Glasgow, G2 4EL.
Tel: 0141 332 4027

Bourne Fine Art,
4 Dundas Street,
Edinburgh, EH3 6HZ.
Tel: 0131 557 4050

Carlton Gallery,
10 Royal Terrace,
Edinburgh, HU5 4JY.
Tel: 0131 556 1010

Gatehouse Gallery,
Rouken Glen Road,
Giffnock, Glasgow,
G46 7UG.
Tel: 0141 620 0235

Glasgow Print Studio,
22 King Street,
Glasgow, G1 5QP.
Tel: 0141 552 0704

Hanover Fine Arts,
22a Dundas Street,
Edinburgh, EH3 6JN.
Tel: 0131 556 2181

Hardie Gallery, William,
141 West Regent Street,
Glasgow, G2 5SG.
Tel: 0141 221 6780

Hayes Gallery, Paul,
71 High Street,
Auchterarder,
Perthshire, PH3 1BN.
Tel: 01764 62320

Inverberg Galleries,
Nr Luss, Loch Lomond,
G83 8PD.
Tel: 01436 86277

Laurance Black Ltd -
Antiques of Scotland,
60 Thistle Street,
Edinburgh, EH2 1EN.
Tel: 0131 557 4545

McEwan Gallery,
Glengarden, Ballater,
Aberdeenshire, AB35 5UB.
Tel: 01339 755429

Mundy Fine Art Ltd, Ewan,
211 West George Street,
Lower Ground Floor,
Glasgow, G2 2LW.
Tel: 0141 248 9755

Open Eye Gallery,
75-79 Cumberland Street,
Edinburgh, EH3 6RD.
Tel: 0131 557 1020

Portfolio Gallery,
43 Candlemaker Row,
Edinburgh, EH1 2QB.
Tel: 0131 220 1911

Shropshire

Gallery 6,
6 Church Street,
Broseley, TF12 5DG.
Tel: 01952 882860

Valentyne Dawes Gallery,
Church Street,
Ludlow, SY8 1AP.
Tel: 01584 874160

Wyle Cop Gallery,
71 Wyle Cop,
Shrewsbury, SY1 1UX.
Tel: 01743 240328

Somerset

Armytage, Julian,
The Old Rectory, Wayford,
Nr Crewkerne, TA18 8QG.
Tel: 01450 73449

Staffordshire

Oliver, H. J., & Sons,
17, St Georges Avenue
South, Wolstanton,
Newcastle, ST5 8DB.
Tel: 01782 633248

Victoria Des Beaux Arts Ltd,
11 Newcastle Street,
Burslem, Stoke-on-Trent,
ST6 3QB.
Tel: 01782 836490

Suffolk

Carter Gallery, Simon,
23 Market Hill,
Woodbridge, IP12 4LX.
Tel: 01394 382242

Equus Art Gallery,
Sun Lane, Newmarket,
CB8 8EW.
Tel: 01638 560445

Mangate Gallery,
The Old Vicarage, Laxfield,
Nr Woodbridge, IP13 8DT.
Tel: 01986 798524

Russell Gallery, John,
Orwell Court,
13 Orwell Place,
Ipswich, IP4 1BD.
Tel: 01473 212051

Surrey

Asplund Fine Art, Jenny,
Open by appointment only.
Tel: 01372 464960
Mobile 0860 424448

Boathouse Gallery,
The Towpath, Manor Road,
Walton-on-Thames,
KT12 2PG.
Tel: 01932 242718

Bourne Gallery Ltd,
31-33 Lesbourne Road,
Reigate, RH2 7JS.
Tel: 01737 241614

Boxer, Henry,
98 Stuart Court,
Richmond Hill,
Richmond, TW10 6RJ.
Tel: 0181 948 1633

Cedar House Gallery,
High Street, Ripley,
Woking, GU23 6AE.
Tel: 01483 211221/224571

Cobham Galleries,
65 Portsmouth Road,
Cobham, KT11 1JQ.
Tel: 01932 867909

Lloyd Gallery, Andrew,
17 Castle Street,
Farnham, GU9 7JA.
Tel: 01252 724333

Marine Watercolours
Tel: 01372 272374

New Ashgate Gallery,
Waggon Yard,
Farnham, GU9 7PS.
Tel: 01252 713208

Piano Nobile Fine Paintings,
26 Richmond Hill,
Richmond, TW10 6QX.
Tel: 0181 940 2435

Sussex

Antique Print Shop,
11 Middle Row,
East Grinstead,
RH19 3AX.
Tel: 01342 410501

Barclay Antiques,
7 Village Mews,
Little Common,
Bexhill-on-Sea,
TN39 4RZ.
Tel: 01797 222734

Barnes Gallery,
8 Church Street,
Uckfield, TN22 1BJ.
Tel: 01825 762066

Botting, Susan & Robert,
Rosedene, 38 Firs Avenue,
Felpham, Nr Bognor Regis,
PO22 8QA.
Tel: 01243 584515

Cooke, David,
Old Post House, Playden,
Rye, TN31 7UL.
Tel: 01797 280303

Stacey-Marks Ltd, E.,
24 Cornfield Road,
Eastbourne, BN26 5ST.
Tel: 01323 482156

Towner Art Gallery,
High Street, Old Town,
Eastbourne, BN21 1HH.
Tel: 01323 411688

Weald Smokery,
Mount Farm, The Mount,
Flimwell, TN5 7QL.
Tel: 01580 891601

Tyne & Wear

MacDonald Fine Art,
2 Ashburton Road,
Gosforth, NE3 4XN.
Tel: 0191 284 4214

The Dean Gallery,
42 Dean Street,
Newcastle-upon-Tyne,
NE1 1PG.
Tel: 0191 232 1208

Vicarage Cottage Gallery,
Preston Road,
Northshields,
NE29 9PJ.
Tel: 0191 257 0935

Wales

Davies, Philip,
130 Overland Road,
Mumbles, Swansea,
SA3 4EU.
Tel: 01792 361766

Rowles Fine Art,
Station House Gallery,
Llansantffraid,
Powys, SY22 6AD.
Tel: 01691 828478

Tinney Gallery, Martin,
6 Windsor Place,
Cardiff, CF1 3BX.
Tel: 01222 641411

Webb Fine Art, Michael,
Cefn Llwyn, Llangristiolus,
Bodorgan, Gwynedd,
LL62 5DN.
Tel: 01407 840336

Williams Gallery, Betty,
The Gallery, Tyr Eglwys,
Tredunnock, Usk,
Gwent, NP5 1LY.
Tel: 01633 450301

Warwickshire

Castle Gallery,
1 Twickenham Mews,
Kenilworth, CV8 2SH.
Tel: 01926 58727

Chadwick Gallery,
By appointment.
Tel: 01564 762661

Fine Lines Fine Art Ltd,
The Old Rectory, 31 Sheep
Street, Shipston-on-Stour,
CV36 4HD.
Tel: 01608 662323

Loquens Gallery,
The Minories,
Rother Street,
Stratford-upon-Avon,
CV37 6NF.
Tel: 01789 297706

Sport and Country Gallery,
Northwood House,
121 Weston Lane,
Bulkington, Nuneaton,
CV12 9RX.
Tel: 01203 314335

West Midlands

Driffold Gallery,
The Smithy,
78 Birmingham Road,
Sutton Coldfield,
B72 1QR.
Tel: 0121 355 5433

Graves Gallery,
3 The Spencers,
Augusta Street, Hockley,
Birmingham, B18 6JA.
Tel: 0121 212 1635

Wiltshire

Courcoux & Courcoux,
90-92 Crane Street,
Salisbury, SP1 2QD.
Tel: 01722 333471

Jerram Gallery,
7 St John Street,
Salisbury, SP1 2SB.
Tel: 01722 412310

Lacewing Fine Art Gallery,
124 High Street,
Marlborough, SN8 1LZ.
Tel: 01672 514580

Worcestershire

Hayloft Gallery,
Berry Wormington,
Broadway, WR12 7NH.
Tel: 01242 621202

Yorkshire

1853 Gallery,
Salts Mill, Victoria Road,
Saltaire, Shipley,
BD18 3LB.
Tel: 01274 531163

Blissett, Gary K,
Summerfield,
3 Station Road,
Long Preston,
BD23 4NH.
Tel: 01729 840384

Hutton Van Mastrigt Art,
26 North View Terrace,
Mytholmes Lane,
Haworth, BD22 8HJ.
Tel: 01535 643882

Kentmere House Gallery,
53 Scarcroft Hill,
York, YO2 1DF.
Tel: 01904 656507

Lawrence Art Galleries, J & M,
40-44 High Street,
Bridlington, YO16 4PX.
Tel: 01262 670281

Marine Prints,
21 Meadowcroft Road,
The Ridings,
Driffield,
YO25 7NJ.
Tel: 01377 241074

Starkey Fine Art
International, James,
49 Highgate, Beverley,
HU17 0DN.
Tel: 01482 881179

Sutcliffe Galleries,
5 Royal Parade,
Harrogate, HG1 2SZ.
Tel: 01423 562976

Titus Gallery,
1 Daisy Place, Saltaire,
Shipley, BD18 4NA.
Tel: 01274 581894

Treadwell, Nicholas,
Upper Park Gate,
Bradford, BD1 5DW.
Tel: 01274 306065/64

Walker Galleries,
6 Montpelier Gardens,
Harrogate, HG1 2TF.
Tel: 01423 567933

GENERAL ANTIQUES

Hampshire

Tarrant Antiques, Lorraine,
7-11 Market Place,
Ringwood,
BH24 1AN.
Tel: 01425 461123

Hereford & Worcester

Gandolfi House Interiors,
211-213 Wells Road,
Malvern, WR14 4HF.
Tel: 01684 569747

Kent

Berry Antiques,
The Old Butcher Shop,
Goudhurst, TN17 1AE.
Tel: 01580 212115

Lancashire

Roberts Antiques,
Tel: 01253 827794

London

Arenski,
185 Westbourne Grove,
W11 2SB.
Tel: 0171 727 8599

Oosthuizen, Pieter,
1st Floor, Georgian Village,
Camden Passage, N1.
Tel: 0171 359 3322/376 3852

Rogers de Rin,
76 Royal Hospital Road,
SW3 4HN.
Tel: 0171 352 9007

Oxfordshire

Witney Antiques,
96-100 Corn Street,
Witney, OX8 7BU.
Tel: 01993 703902

GLASS

London

Rankins Glass Company Ltd,
The London Glass Centre,
24-34 Pearson Street,
E2 8JD.
Tel: 0171 729 4200

INSURANCE

Dorset

Gibbs Hartley Cooper,
Beech House,
28-30 Wimborne Road,
Poole, BH15 2BJ.
Tel: 01202 660866

London

Burke Fine Art & Jewellery Ltd,
136 Sloan Street,
SW1X 9AY.
Tel: 0171 824 8224

Crowley Colosso Ltd,
Ibex House, Minories,
EC3N 1JJ.
Tel: 0171 782 9782

Miller Art Insurance,
Dawson House,
5 Jewry Street,
EC3N 2EX.
Tel: 0171 488 2345

Minet, J. H.,
Minet House,
100 Leman Street,
E1 8HG.
Tel: 0171 481 0707

Oxfordshire

Penrose Forbes,
29-30 Horsefair,
Banbury, OX16 0NE.
Tel: 01295 259892

Sussex

Bain Clarkson Ltd,
Harlands Road,
Haywards Heath,
RH16 1GA.
Tel: 01444 414141

LIGHTING

Kent

Burch, St John A,
Myrtle House,
Headcorn Road,
Grafty Green, ME17 2AR.
Tel: 01622 850381

Surrey

Acorn Lighting Products,
21a Kings Road, Shalford,
Guildford, GU4 8JU.
Tel: 01483 64180

NATIONAL GALLERIES

London

Royal Academy of Arts,
Piccadilly, W1V ODS.
Tel: 0171 439 5615

Royal Academy Shop,
Royal Academy of Arts,
Piccadilly, W1V 0DS.
Tel: 0171 439 7438

PACKERS & SHIPPERS

London

Featherston Shipping,
24 Hampton House,
15-17 Ingate Place, SW8 3NS.
Tel: 0171 720 0422

Hedley's Humpers Ltd,
Units 3 & 4, 97 Victoria Road,
NW10 6ND.
Tel: 0181 965 8733

Middlesex

Burke Fine Art
& Specialised Forwarding
Vulcan International
Services Group,
Unit 8, Ascot Road,
Clockhouse Lane,
Feltham, TW14 8QF.
Tel: 01784 244152

PHOTOGRAPHERS

London

A C Cooper Ltd,
10 Pollen Street, W1R 9PH.
Tel: 0171 629 7585

Flashlight,
Unit 15, 7 Chalcot Road,
NW1 8LH.
Tel: 0171 586 4024

PICTURE PLAQUES

London

A C Cooper Ltd,
10 Pollen Street, W1R 9PH.
Tel: 0171 629 7585

Picture Plaques,
142 Lambton Road, SW20 0TJ.
Tel: 0181 879 7841

Somerset

Berkeley Studio,
The Old Vicarage,
Castle Cary, BA7 7EJ.
Tel: 01963 50748

PUBLICATIONS

London

Art Loss Register,
13 Grosvenor Place,
SW1X 7HH.
Tel: 0171 235 3393

Antiques Trade Gazette,
17 Whitcomb Street,
WC2H 7PL.
Tel: 0171 930 9958

West Midlands

Antiques Bulletin
HP Publishing,
2 Hampton Court Road,
Harborne, Birmingham,
B17 GAE.
Tel: 0121 428 2555

RESTORATION

Avon

International Fine Art
Conservation Studios,
43-45 Park Street,
Bristol, BS1 5NL.
Tel: 0117 929 3988

Cambridgeshire

Candy, Alan,
Old Manor House,
4 Cambridge Street,
Godmanchester,
Huntingdon, PE18 8AP.
Tel: 01480 453198

Essex

Hilliard, Terry,
The Barn, Master Johns,
Thoby Lane, Mountnessing,
Brentwood, CM15 0SY.
Tel: 01277 354717

Gloucestershire

Bannister, David,
26 Kings Road,
Cheltenham, GL52 6BG.
Tel: 01242 514287

Cleeve Picture Framing,
Coach House Workshops,
Stoke Road,
Bishops Cleeve,
Cheltenham,
GL52 4RP.
Tel: 01242 672785

Hampshire

Congdon-Clelford, Paul,
BA(Hons) ABPR, UKIC,
FATG, GADR,
14 Bostock Close,
Sparsholt,
Winchester,
SO21 2QH.
Tel: 01962 776495

Hereford & Worcester

George Jack & Co
Picture Restorers,
Notre Val, Laverton
Broadway, WR12 7NA.
Tel/Fax: 01386 584691

Kent

Green Fine Art, Roger,
Hales Place Studio,
High Halden,
Ashford, TN26 3JQ.
Tel: 01233 850794

London

Bates and Baskcomb,
191 St John's Hill,
SW11 1TH.
Tel: 0171 223 1629

Campbell, John,
Master Frames,
164 Walton Street,
SW3 2JL.
Tel: 0171 584 9268

Chapman Restorations,
10 Theberton Street,
N1 0QX.
Tel: 0171 226 5565

Cooper Fine Arts,
768 Fulham Road,
SW6 5SJ.
Tel: 0171 731 3421

Cumine, Trevor,
133 Putney Bridge Road,
SW15 2PA.
Tel: 0181 870 1525

Deansbrook Gallery,
134 Myddleton Road,
N22 4NQ.
Tel: 0181 889 8389

Harries Fine Art,
712 High Road,
North Finchley,
N12 9QD.
Tel: 0181 445 2804

Lamont Gallery,
65 Roman Road,
Bethnal Green,
E2 0QN.
Tel: 0181 981 6332

Mitchell Ltd, Paul,
99 New Bond Street,
W1Y 9LF.
Tel: 0171 493 8732/0860

Plowden & Smith Ltd,
190 St Ann's Hill,
SW18 2RT.
Tel: 0181 874 4005

Relcy Antiques,
9 Nelson Road,
SE10 9JB.
Tel: 0181 858 2812

The Conservation Studio,
The Studio,
107 Shepherds Bush Road,
W6 7LZ.
Tel: 0171 602 0757

The Conservation Unit,
Museums and Galleries
Commission,
16 Queen Anne's Gate,
SW1H 9AA.
Tel: 0171 233 3683

Woolcock Framing,
8 Huguenot Place,
Wandsworth,
SW18 2EN.
Tel: 0181 874 2008

Zagel, Jane,
31 Pandora Road,
NW6 1PS.
Tel: 0171 794 1663

Middlesex

Hampton Hill Gallery,
203-205 High Street,
Hampton Hill,
TW12 1NP.
Tel: 0181 977 1379

Nottinghamshire

Florence Conservation
& Restoration,
102 Nottingham Road,
Long Eaton,
Nottingham,
NG10 2BZ.
Tel: 0115 973 3625

Roberts, Mark,
1 West Workshops,
Tan Gallop, Welbeck,
Nr Worksop, S8O 3LW.
Tel: 01909 484270

Scotland

Alder Arts,
57 Church Street,
Highland, Inverness,
IV1 1DR.
Tel: 01463 243575

Butterfield, Fiona,
Overhall, Kirkfieldbank,
Lanark, Strathclyde,
ML3 9JU.
Tel: 01555 66291

Shropshire

Wyle Cop Gallery,
71 Wyle Cop,
Shrewsbury, SY1 1UX.
Tel: 01743 240328

Surrey

Association of British
Picture Restorers,
Station Avenue, Kew,
Richmond, TW9 3QA.
Tel: 0181 948 5644

Boathouse Gallery,
The Towpath,
Manor Road,
Walton-on-Thames,
KT12 2PG.
Tel: 01932 242718

Limpsfield Watercolours,
High Street, Limpsfield,
RH8 0DT.
Tel: 01883 717010

Sussex

Leslie, Michael,
ABPR, Dip AD,
The Garden Studio,
Denniker Cottage,
Fletching, Uckfield,
TN22 3SH.
Tel: 01825 724176

Wiltshire

Beach, M,
52 High Street,
Salisbury, SP1 2NT.
Tel: 01722 333801

SECURITY

London

Simba Security Systems Ltd,
Security House,
Occupation Road,
Walworth, SE17 3BE.
Tel: 0171 703 0485

SERVICES

London

Joseph, E (Booksellers),
1 Vere Street, W1M 9HQ.
Tel: 0171 493 8353

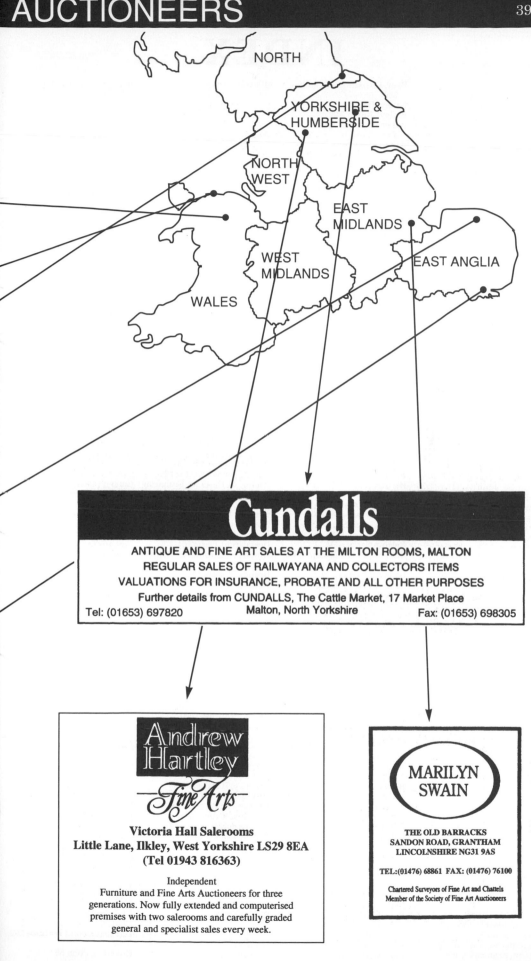

NORTH

YORKSHIRE &
HUMBERSIDE

NORTH
WEST

EAST
MIDLANDS

WEST
MIDLANDS

EAST ANGLIA

WALES

INDEX

INDEX TO ADVERTISERS

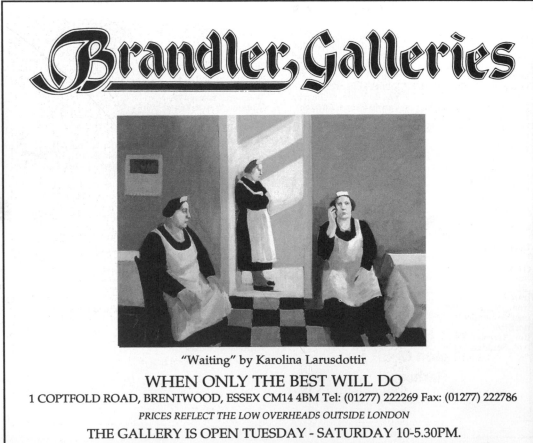

What's in
ANTIQUES
BULLETIN?

☞ The most comprehensive Auction Calendar

☞ The only weekly Fairs Calendar

☞ More news and prices than any other antiques trade publication

Plus

Art Prices Index ◆ Saleroom Reports ◆ Fairs News
Exhibitions ◆ Talking the Trade ◆ Features

Subscribe NOW and receive a FREE subscription to the Antiques Fairs Guide – a publication that no serious fair goer can afford to miss.

1 years' subscription is £39.50 UK (46 issues), Europe £60.00, USA/Canada £80.00, Australia/New Zealand £120.00

Whether you are a dealer, a collector, or just furnishing your home, a subscription to Antiques Bulletin makes sense.

Subscribe to what interests you most

Each week on a four-weekly rotation, we focus on:

1. Furniture, clocks, bronzes and architectural items;

2. Silver, ceramics, glassware and jewellery;

3. Art and sculpture; and

4. Collectables.

Subscribe to all four if you wish, or choose one, two or three sectors from the four – please phone for details.

Post cheque/postal order to
H.P. Publishing
2 Hampton Court Road
Harborne,
Birmingham B17 9AE

SPEEDPHONE ORDERING SERVICE
Access/Visa/Amex
☎ **0121~426 3300**
Mon–Fri 9am–5.30pm

Interiors
by Judith and Martin Miller

PERIOD FIREPLACES
An informative and practical survey of fireplace styles over the centuries which will be an invaluable guide for the amateur and experienced decorator interested in repairing or recreating original and period style fireplaces.

Publication May 1995
£16.99 1 85732 397 1

PERIOD KITCHENS
Provides an in-depth and practical pictorial survey of structural and decorative style of kitchens and their contents over the centuries.

Publication May 1995
£16.99 1 85732 398 X

PERIOD DETAILS P/B
Provides a unique survey of structural and decorative styles, fixtures and fittings, feature by feature throughout the house.

£14.99 1 85732 043 3

PERIOD STYLE P/B
Shows how to convey a sense of the past by using a combination of imaginative flair, historical knowledge and practical know-how.

£14.99 1 85732 301 7

PERIOD FINISHES AND EFFECTS
A fully illustrated, practical guide to the secrets of the surface finishes and effects that compliment period homes and furniture.

Publication August 1995
£19.99 085533 946 2

VICTORIAN STYLE
Examines Britain's most popular look, from architectural details to furniture, colour schemes, collectables, fabrics and wallpapers.

£25.00 1 85732 098 0

COUNTRY STYLE P/B
A beautifully illustrated book celebrating the simplicity, warmth and strength of the rural tradition in interior design and furnishing.

£16.99 1 85732 465 X

Reed Book Services Ltd, PO Box 5, Rushden, Northants NN10 6PU
TELEPHONE 01933 414000 OR FAX 01933 414047